A HISTORY OF THE CRUSADES

Kenneth M. Setton, GENERAL EDITOR

A HISTORY OF THE CRUSADES

Kenneth M. Setton, GENERAL EDITOR

Volume IV

THE ART AND ARCHITECTURE
OF THE CRUSADER STATES

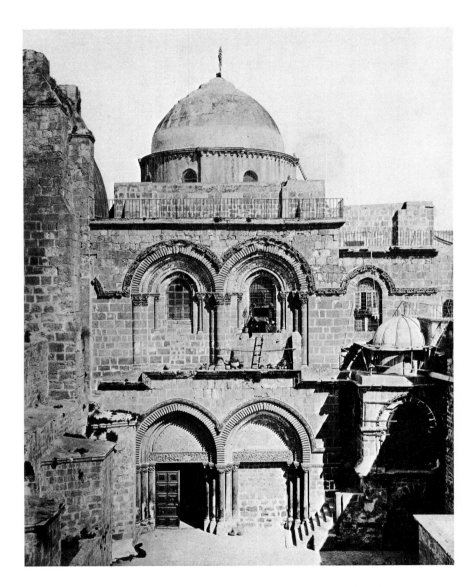

Church of the Holy Sepulcher, Jerusalem, south façade

A HISTORY OF

THE

CRUSADES

KENNETH M. SETTON

GENERAL EDITOR

Volume IV

THE ART AND ARCHITECTURE
OF THE CRUSADER STATES

EDITED BY

HARRY W. HAZARD

THE UNIVERSITY OF WISCONSIN PRESS

Published 1977
The University of Wisconsin Press
Box 1379, Madison, Wisconsin 53701

The University of Wisconsin Press, Ltd.
70 Great Russell St., London

First printing

Printed in the United States of America
For LC CIP information see the colophon

ISBN 0-299-06820-X

Pulchra fortitudo

CONTENTS

ix

FIGURES

xi

PLATES

MAPS

*Maps compiled by Harry W. Hazard and executed by the
Cartographic Laboratory of the University of Wisconsin, Madison*

FOREWORD

That the present volume should follow its predecessor so quickly, despite some unforeseen delays, is a source of satisfaction to the editors. Unfortunately, however, the satisfaction is overshadowed by the recent deaths of three of our crusading comrades—Professor Marshall W. Baldwin, Dr. T. S. R. Boase, and Professor Urban T. Holmes. Baldwin was co-editor of the first volume of this work. Holmes wrote the first chapter in the present volume, for the rest of which Boase has been largely responsible.

President of Magdalen College, Oxford, for more than twenty years, vice-chancellor of the University, director of the Courtauld Institute, and sometime professor in the University of London, T. S. R. Boase was a generous friend, an inspiring teacher, and a gifted scholar. For almost twenty-five years he watched, with his customary patience and good humor, our prolonged efforts to get these volumes into print. He never complained of our slow progress although, as I recall, we first received his chapters in 1950. Two years before his death, however, he undertook the revision which brought them up to date. As critical in the appraisal of his own work as he was charitable in the judgment of others', he would have welcomed the enlargement of his treatment of art in the Latin kingdom of Jerusalem which Professor Jaroslav Folda has added to this volume.

We are grateful to Mrs. Jean T. Carver for the preparation of much of the typescript of this volume and to Dr. David L. Gassman for his careful proofreading. As we turn to Volume V, we begin to hope that the end of our long journey is finally in sight.

KENNETH M. SETTON

The Institute for Advanced Study
Princeton, New Jersey
March 15, 1976

PREFACE

There is little I need add to Professor Setton's Foreword, though I should like to express my hearty concurrence with his tribute to Dr. Boase and his thanks to Mrs. Carver and Dr. Gassman. To these I here append my appreciation to Mrs. Mary Maraniss of the University of Wisconsin Press for her meticulous preparation of the manuscript for the printers, to Professor Randall T. Sale and his cartographic staff for transforming my crude sketch maps into those which again embellish these pages, to the anonymous technicians who have worked so diligently and successfully in preparing the plates chosen by Dr. Boase and Professor Folda, and not least to my friend and classmate Thompson Webb, director of the Press, for all his helpfulness.

A special word of explanation and appreciation is due Professor Folda, younger colleague and firm friend of Dr. Boase, who in addition to supplying his own chapter and plates (some from photographs he took especially for this volume during his recent year in Israel) has cheerfully undertaken the chore of reading proofs of Dr. Boase's chapters and checking his footnotes (adding his own comments, distinguished by his bracketed initials). Without his comparatively recent addition to our team, the finished volume could not have been so complete, nor incorporated the latest scholarship so knowledgeably.

HARRY W. HAZARD

Rochester, New York
April 9, 1976

ABBREVIATIONS

PL *Patrologiae latinae cursus completus* . . ., ed. J.-P. Migne, 221 vols., Paris, 1841 and ff.

PPTS *Palestine Pilgrims' Text Society,* 13 vols. and Index, London, 1896–1897.

RHC *Recueil des historiens des croisades,* Académie des inscriptions et belles-lettres, Paris, 16 vols. in fol., 1841–1906.

 Arm. *Documents arméniens,* 2 vols., 1869–1906.

 Grecs *Historiens grecs,* 2 vols., 1875–1881.

 Lois *Assises de Jérusalem,* 2 vols., 1841–1843.

 Occ. *Historiens occidentaux,* 5 vols., 1841–1895.

 Or. *Historiens orientaux: Arabes,* 5 vols., 1872–1906.

ROL *Revue de l'Orient Latin,* 12 vols., Paris, 1893–1911.

Rolls Series *Rerum britanicarum medii aevi scriptores: The Chronicles and Memorials of Great Britain and Ireland during the Middle Ages,* 244 vols., London, 1858–1896.

SBF Studium Biblicum Franciscanum, Jerusalem, 1961-date.

Volume IV

THE ART AND ARCHITECTURE OF THE CRUSADER STATES

I
LIFE AMONG THE EUROPEANS IN PALESTINE AND SYRIA IN THE TWELFTH AND THIRTEENTH CENTURIES

Any attempt to reconstruct medieval daily living in detail must result in a series of generalizations. Scattered remarks can be gathered from chronicles, travel accounts, and letters, with some attention paid to literature, and this evidence can be set into a framework which is acceptably accurate for the time and place. In a treatment of the social history of medieval Europe or its Syrian outposts, the framework is that of an unmechanized society with pale memories and incomplete records of the glories of ancient Rome. Members of western European society took for granted a common way of life which spread principally from France. True, we know much about certain non-royal Englishmen, Flemings, Germans, Italians, and Catalans, with a few from elsewhere, but we probably do not err too much in considering them all as a fairly homogeneous unit. Writing in 1148, Anna Comnena grouped them all together as "Franks," whom she characterized as shameless, violent, greedy for money, disrespectful, and possessed of a flow of language which was greater than that of any other race of mankind.[1] She feared, and sought to disparage, their remarkable military prowess. In Palestine and Syria, the extent of land held by the Latins varied in the centuries covered by this chapter. It was divided into the kingdom of Jerusalem, the county of Tripoli, the principality of Antioch, and the county of Edessa (until it fell to Zengi in 1144); the island of Cyprus was added in the Third Crusade.[2] Our present concern is with Jerusalem and Tripoli.

1. Anna Comnena, *The Alexiad,* trans. E. A. S. Dawes (London, 1928), pp. 248, 251, and *passim.*
2. On the history of the Latin States in Syria, see volumes I and II of this work.

3

The Christians lived in close proximity to the Moslems. On the surface the two peoples were frequently friendly, courteous, and even kind to one another. When they dwelt in each other's territory they had the discomfort of a few additional taxes and the unpleasantness of being called dog or infidel on occasion, but conditions were usually tolerable. Although underneath the surface lay emotion which could quickly flare into a fanatic desire for holy war, only the Franks who were newly come from home were rude and overbearing to the people of Islam.[3] Moslems in Acre would watch gangs of their co-religionists in chains, men and women, doing heavy work;[4] free themselves, they would piously toss them alms. The same would be true of Latins visiting Jerusalem after the fall of that city.[5] Among the Christians of the region the crusaders from the west remained a relatively small proportion. Besides the many Greek Orthodox, there were other Christians: the Jacobites, the Maronites (who adhered to Rome in 1182), the Nestorians, the Armenians, and the Syrian Christians, who dressed like Moslems but wore a special woolen girdle. Their bishop was Greek, and Saturday was their holy day; they frequently acted as servants in Moslem households.[6] The Armenian and Georgian priests wore white linen cloths over their shoulders and necks.[7] The Jacobites had their own archbishop; they impressed James of Vitry with their potential, although they had no auricular confession, made the sign of the cross with one finger only, and practised circumcision.[8] We can easily imagine the confusion felt by a moderately well informed incoming pilgrim, seeing these people who seemed to be associated with the Saracens, and who were considered by the Latins schismatics or heretics (and one could not be sure which they were).

Acre was notorious for its mixed population. Among the Latin Christians, schismatic sects, and Moslems of various types, there was an excessive number of curiosity-seekers and adventurers, many of

3. Usāmah ibn-Munqidh, *Kitāb al-i'tibār*, trans. P. K. Hitti as *An Arab-Syrian Gentleman and Warrior in the Period of the Crusades* (Records of Civilization, New York, 1929), pp. 163-164.

4. Ibn-Jubair, *Riḥlah*, trans. R. J. C. Broadhurst as *The Travels of Ibn Jubayr* (London, 1952), p. 322.

5. Ambrose, *L'Estoire de la guerre sainte*, trans. E. N. Stone as "History of the Holy War," in *Three Old French Chronicles of the Crusades* (Seattle, 1939), p. 156.

6. James of Vitry, *Historia Iherosolimitana*, excerpts trans. Aubrey Stewart as "The History of Jerusalem, A.D. 1180 [error for *c.* 1220]," *PPTS*, XI-2 (London, 1896), 67-84, including much bigotry and irrelevant theological musings.

7. Burchard of Mt. Sion, *Descriptio Terrae Sanctae*, trans. Aubrey Stewart as "A Description of the Holy Land [A.D. 1280]," *PPTS.* XII-1 (London, 1896), 109.

8. James of Vitry, *Epistolae*, ed. R. Röhricht as "Briefe des Jacobus de Vitriaco (1216-1221)," *Zeitschrift für Kirchengeschichte*, XIV (1893-1894), 109; *Historia*, pp. 73-76.

them dangerous.[9] They had come to the east usually to do penance, but some had stayed on to gain an "easy" livelihood. The weary pilgrim,[10] when he went ashore on the quay at Acre, had to hold his money in a tight grasp. If he were not able-bodied enough to be "persuaded" into military service by some ambitious count,[11] he was likely to be "sold the city gates" by a confidence man. Of course, most of the pilgrims were capable of bearing arms and were pleased to do so, deeming it an act of expiation to strike a blow at the infidel. Tancred of Antioch wrote an introduction for such a man, who wished to meet the Moslem horsemen (Arabic sing., *fāris*) who had nearly killed him in a skirmish: "This is a revered knight of the Franks who has completed the holy pilgrimage and is now on his way back to his country. He has asked me to introduce him to you Treat him well."[12] Not all crusaders were improved by their trip, according to popular feeling. Although the early branches of the *Roman de Renart* are quite bitter, and must be read with a grain of salt, they are informative. In one episode Renart offers to take the cross to go "outre la mer." Grimbert pleads that when Renart gets back in five months he will be needed, because he is brave. Noble the king replies: "That cannot be said. When he gets back he will be worse, for all of them have that custom: those good men who go return as evil men. He will do the same if he escapes from peril."[13] Note the mention of five months as the normal duration of a quick journey to the Holy Land and back.

Acre was the chief port and, after the loss of Jerusalem, the capital of the kingdom, located on a fine bay across from Haifa.[14] To the east was a swift stream which had stretches of sand along its banks—excellent for glass manufacture[15]—beside which the armed knights

9. James of Vitry, *Historia,* pp. 89-90.

10. On the pilgrims to the Holy Land after 1095, see chapter II, below.

11. Bahā'-ad-Dīn Ibn-Shaddād's biography of Saladin, *Kitāb an-nawādir as-sulṭānīyah* . . . , trans. C. R. Conder and C. W. Wilson as " 'Saladin'; or, What Befell Sultan Yûsuf . . . , " *PPTS,* XIII (London, 1897), 239. An old pilgrim had been pressed into service and captured by Saladin, who freed him.

12. Usāmah, p. 98; cf. "Assises de Jérusalem," ed. Auguste Beugnot in *RHC, Lois* (2 vols., Paris, 1841), I, xxi: a pilgrim should fulfil his vows, get a palm at Jerusalem, and then go home.

13. *Le Roman de Renart,* Branch I, vv. 1402-1410, ed. Ernst E. Martin (4 vols. in 2, Paris, 1882-1887), I, 39-40.

14. The city and harbor can be seen on a map in E. G. Rey, *Étude sur les monuments de l'architecture militaire des croisés en Syrie et dans l'île de Chypre* (Paris, 1871), p. 171. For comments on it by Arabic geographers see Guy Le Strange, *Palestine under the Moslems* (London, 1890), pp. 328-334.

15. *Itinerarium peregrinorum et gesta regis Ricardi,* ed. William Stubbs, in *Chronicles and Memorials of the Reign of Richard I,* vol. I (Rolls Series, XXXVIII; London, 1864), p. 76; this work is probably by one Richard of London.

were accustomed to pitch their tents. Some orchards and vineyards were immediately adjacent to the city, and there were many gardens in the nearby villages.[16] Two main roads led from there to Jerusalem: an upper road which passed through Nazareth and Nablus, and a seaside road which went by Caesarea and Lydda.[17] The walls of Acre had many towers, a stone's throw apart. On the land side of the peninsula the wall was double and bordered by a huge moat.[18] Inside the town there appears to have been a tower at each street corner, enclosed by chains. The nobles lived on the outer edge of the inhabited area, close to the walls; the mechanics and merchants were in the center, each trade having a special street.[19] Houses occupied by Christians had a cross marked on the front wall. Many banners and pennants were flying. Ibn-Jubair, who was a hostile witness, comments upon the filth; he says that pigs and crosses were everywhere, and that there was a terrific odor from refuse and excrement.[20] John Phocas also comments on the "evil smells."[21] The harbor was double: an inner one for local ships and an outer for the pilgrim traffic.[22] Like most port cities of the time, this outer harbor had a long mole with a central opening flanked by towers, between which a chain was stretched when needed, to close the entrance.[23] The Tower of Flies stood on a rock in the center.[24] Theoderic mentions the fine building of the Templars on the shore. This city was so crowded that we can surmise that almost everyone was renting rooms, or parts of rooms, to the travelers. Several hostelries were reserved for Moslems, and part of a mosque even continued in use.[25]

Ibn-Jubair approached the city from the landward side, in a caravan.[26] There was a customs house there, a plain building with a large room on the upper floor for sleeping accommodations. In front

16. Ibn-Jubair, p. 325; James of Vitry, *Historia*, p. 5; Burchard, p. 9.
17. Theoderic, *Descriptio Terrae Sanctae*, trans. Aubrey Stewart as "Theoderich's Description of the Holy Places (circa 1172 A.D.)," *PPTS*, V-4 (London, 1896), 69.
18. Bāhā'-ad-Dīn, p. 261.
19. Ludolph of Suchem, *De itinere Terrae Sanctae liber* . . . , trans. Aubrey Stewart as "Description of the Holy Land . . . A.D. 1350," *PPTS*, XII-3 (London, 1895), 50-53.
20. Ibn-Jubair, p. 318: Broadhurst annotates "pigs" as "(Christians)."
21. John Phocas, *Ekphrasis* . . . , trans. Aubrey Stewart as "The Pilgrimage of Joannes Phocas in the Holy Land (. . . 1185 A.D.)," *PPTS*, V-3 (London, 1896), 11. Ambrose (p. 123) seems to have been dissatisfied with his lodgings in Acre.
22. Theoderic, p. 73.
23. Ambrose, p. 53; "L'Estoire d'Eracles empereur et le conquête de la terre d'Outremer," *RHC, Occ.*, II (Paris, 1859), 108.
24. Ambrose, p. 58.
25. Ibn-Jubair, p. 318; he and his companions lodged with "a Christian woman."
26. *Ibid.*, pp. 313-317.

of this building there were stone benches covered with carpets where sat Christian clerks with ebony inkstands ornamented with gold.[27] They could read and speak Arabic and, of course, their European vernacular. Saracen scribes were, to be sure, employed by Europeans; for instance, the master of the Temple had one at his beck and call.[28] The customs officials had mostly to do with caravans that approached from Damascus and other commercial cities. One that the Franks captured carried gold, silver, silks, Grecian textiles, purple-dyed stuffs, quilted jackets, garments, tents, biscuits, barley meal, medicines, basins, leather bottles, chess tables, silver pots and candlesticks, pepper, cumin, sugar, wax, spices, and arms.[29] Large mule caravans from Damascus were wont to pass through Toron, twenty-five miles south of Sidon; other caravans approached Acre from Tiberias.[30] At the time Ibn-Jubair was writing, these caravans were composed of peaceful Moslems. The customs, working for the king of Jerusalem, collected at Chastel-Neuf (Ḥūnīn) one dinar plus one twentieth of the value of the goods. The toll at Acre was one twenty-fourth part of each dinar's worth of goods.[31]

The coins in circulation were the good bezant, the base silver (*billon*) or copper denier, and the obol or half-denier. The ratio of value must have varied. In Beugnot's notes to the *Assises de Jérusalem* it is stated that three bezants are the equivalent of twenty-four sous (288 deniers).[32] The amount required for the support of an individual for a month was between one and two bezants.[33] In order to secure men, Philip Augustus offered the large wage of three bezants a month; Richard topped him with four.[34] Bezants were required for the vast turnover of money in trade and ransom. Petty commerce still needed the base silver and copper denominations. For the kings of Jerusalem we find deniers and obols struck in a fair quality of billon by Baldwin II, Amalric, Guy of Lusignan, Henry of Champagne, and John of Brienne.[35] Some of the issues approach

27. *Ibid.*, p. 317.

28. Anouar Hatem, *Les Poèmes épiques des croisades* (Paris, 1932), p. 297, in *Règle du Temple*.

29. Ambrose, p. 139.

30. Ibn-Jubair, p. 324.

31. *Ibid.*, p. 316.

32. "Assises de Jérusalem," II, 36, note b.

33. *Ibid.*, II, 117.

34. *Itinerarium*, pp. 213-214.

35. The most comprehensive discussion of the coins is G. L. Schlumberger, *Numismatique de l'orient latin* (Paris, 1878-1882), pp. 130 ff.

copper; a few are respectable silver. There is a *pougeoise*, or half-obol, by Henry of Champagne, for which we possess the *piedfort* or engraver's model. It is the only one of all these coins which has its value marked on it, as *puges;* this was because it was a new value, and unfamiliar.

The counts of Tripoli had their own money. Bertram (1109-1112) struck a denier which is the oldest extant crusader coin. Under Raymond II (1137-1152) there was a silver denier, with no name on it, followed by a copper coinage. In 1148 began the *denier raimondin*, which shows the design of Toulouse—the crescent moon and eight-rayed sun surrounded by circlets. Money without a lord's name customarily means a regency or a vacancy: during the captivity (1164-1174) of Raymond III (1152-1187) the pennies do not bear his name. With Bohemond VI of Tripoli (1252-1275) the *gros* or groat was introduced. Secondary barons of the kingdom of Jerusalem who struck their own coins were the counts of Jaffa and Ascalon, the lords of Sidon, and especially the lords of Beirut and of Tyre. The lords of Toron also have left a few pieces. Certain other fiefs are mentioned in the Assises of Jerusalem as having the right of coinage, but we have nothing from them. These were held by the lords of Montréal, Tiberias, Arsuf, Belinas (Banyas), Bessan (Baisan), Blanche Garde, Ramla, and Scandelion. We have observed that the crescent and sun were peculiar to Tripoli. The *fleur de lys* occurs on some issues from Acre; the arrow appears to have been a mint mark of Sidon.

Presumably the currency of the Moslem lords also passed freely everywhere. The Near Eastern peoples had their own money, which was of gold, billon, and copper. Their dinar of gold was worth half a pound in western money.[36] For a little while these Moslem coins were actually imitated by the Venetians, who had their authorized mints (*zecche*) in Acre, Tripoli, and Tyre (after 1124). At Tyre in 1127 they began to make Christian imitations of the Moslem dinar, called *besanz saracinois au pois de Tyr;* the Moslems called them *dīnār Sūrī*.[37] These Venetian imitations were modeled after the Fāṭimid dinar of al-Āmir (1101-1130). This minting of Moslem imitations by Christians was considered a scandal in the mid-thirteenth century. As a result, on the initiative of Louis IX, a Christian bezant, but still with Arabic language and lettering, came into existence.

36. These dinars were so coveted by the crusaders that dead Saracens who might have swallowed their gold before being killed were "split open" and their bellies searched; Fulcher of Chartres, *Historia Hierosolymitana,* trans. Frances R. Ryan, ed. H. S. Fink as *A History of the Expedition to Jerusalem 1095-1127* (Knoxville, Tenn., 1969), p. 122.

37. On these coins see also below, p. 42.

Great quantities of silver must have been sent to the Near East from western Europe,[38] and individuals undoubtedly carried with them a considerable supply of money, for the most part silver (or billon) deniers or pennies. The English did not mint any other values than this penny of some 22 grains. The French had also half-deniers or obols (or *mailles*). Pennies and mailles were frequently cut into halves, with the half-maille thus made termed a *parti*, or farthing. Two knights at the siege of Acre had only a *denier angevin* between them, for which they drew lots by pulling hairs from a pellice. Ambrose has a reference to "not all the gold which is in Russia,"[39] which makes it likely that some of the gold in use in Asia Minor was brought across the Black Sea. Except when buried or lost, all these coins continued in use indefinitely, although the money-changers may have discounted many of them as they became obsolete or worn from handling. Although the practice of banking was still in the most rudimentary stage, that of money-changing was far advanced. Of the changers we hear of those "who sat upon the change"[40] These men must have handled by the scoopful money from all the areas which sent pilgrims to the Holy Land. Perhaps they were even capable of changing, at a liberal discount, the silver and gold that came from buried treasure. Oliver tells of a hoard that was uncovered when men were building Château Pèlerin, between Haifa and Caesarea: "coins unknown to us moderns were discovered in a clay jar."[41] (Such finds were made everywhere: William of Malmesbury speaks of ancient British coins "of which many are dug up in this age.")[42] Henry II of England stored his "treasure" with the master of the Temple,[43] who, both in Jerusalem and later at Acre, was doubtless the chief treasurer for the area.[44]

Conditions of housing are not well documented. Medieval commentators took houses for granted, and those that have survived were the more expensive ones made of stone, whose construction has been

38. Bahā'-ad-Dīn, p. 235.

39. Ambrose, p. 46.

40. "Eracles," p. 193: "qui se seoient sur la Change"

41. Oliver, *Historia Damiatina*, ed. R. Röhricht as "Die Briefe des Kölner Scholasticus Oliver," *Westdeutsche Zeitschrift für Geschichte und Kunst*, X (1891), 172.

42. William of Malmesbury, *De gestis regum Anglorum*, ed. William Stubbs (Rolls Series, XC; 2 vols., London, 1887-1889), I, 6.

43. "Eracles," p. 47: at Henry's command the master, Gerard of Ridefort, delivered this treasure to Guy of Lusignan to use in fighting Saladin.

44. John of Joinville (*Vie de Saint Louis*, ed. Natalis de Wailly, trans. Joan Evans, London, 1938, p. 123) also deposited his money with the Templars, and had considerable difficulty in getting it back.

much altered in the course of centuries. We can only generalize on the dwellings in crusader Acre. Any walled town, teeming with thousands of people, had a serious housing problem. Even the kings and nobles in their better quarters had to fill all available space with guests and retainers. In Acre, John of Joinville was given the quarters of the priest of St. Michael's; close by his bed was the entry into the church itself, from which he could hear the chanting of the burial service.[45] The simplest houses at Acre were probably one-room dwellings of wattle material daubed with clay, surrounded by a drainage ditch. Such a shed in Europe would have had a thatched roof; probably in the east it had a flat roof of sunbaked tiles. In the simplest style of dwelling there were no windows; light came from the open door and from the fireplace.[46] There would be a mud floor with a few stones set in the middle for a hearth. A hole in the roof acted as chimney. Huts of this type must have been erected in all available open spaces within the walls.

Better houses were made of the same material, if what Ibn-Jubair says of Damascus was true of Acre, but they would have an additional room on each floor and could be three stories high.[47] Tyre, which was cramped for space because of its peninsular location, had houses—considered very beautiful—that rose to five and six stories.[48] Certainly these better houses had the inevitable double windows on the principal floor, facing the street or courtyard. Young Henry of Champagne broke his neck when he fell from such a window and struck the stone coping of the town ditch of Acre.[49] There must have been a means of closing off the light from the windows, perhaps with glass, since it is recorded that James of Vitry opened his windows in the morning and gazed with longing toward Nazareth.[50] (He did not visit the towns which were in the hands of the Saracens.) There might be a balcony.[51] Windows on the lower floor could be barred.[52] Each house had its own well or cistern.[53] Theoderic says the houses of Jerusalem were tall and of squared

45. *Ibid.*, p. 124.
46. *Ibid.*, p. 177.
47. Ibn-Jubair, p. 295.
48. *Ibid.*, p. 319: Tyre's "dwellings are larger and more spacious" and "its roads and streets are cleaner than those of Acre."
49. James of Vitry, *Historia*, p. 117; *La Chronique de Rains*, trans. E. N. Stone as "The Chronicle of Rains" in *Three Old French Chronicles of the Crusades*, p. 272.
50. James of Vitry, *Epistolae*, p. 113.
51. Usāmah, p. 154.
52. Joinville, p. 128.
53. Ibn-Jubair, p. 325; Fulcher of Chartres, trans. Ryan, p. 117: "The many cisterns inside the city, reserved for winter rains, have a sufficiency of water."

stone, with flat roofs; water was caught on these roofs and conveyed to the cisterns, for none had wells. Theoderic adds that wood could not be obtained for use as a building material.[54] The so-called crusader's house at Mt. Ophel in Jerusalem, which is given this name because the building had a cross over the door, had a paved court from which a small corridor led into a room with a lime-clay floor and a stone central hearth.[55] A house might have a stone bench placed beside the front entrance, where one could take the air.[56] A pole also might be set up on which things could be hung temporarily; a passing camel or ass might take a bite out of fruit hung in this way.[57]

The stabling of horses in any medieval town is difficult to picture. Horses were in constant use and must have been kept close by; on the other hand, there was little room for stable enclosures. Presumably horses when in quantity might be stabled below ground; it is probable that the Temple at Acre, like its counterpart at the Aqsâ mosque in Jerusalem, had subterranean stalls.[58] This was a practice frequent in Europe: at Géronville above Bordeaux "a great cave which Saracens had made was in the castle, which was very old. The horses were in this underground place, as well as food—bread and wine."[59] One can see similar underground galleries, which may well have housed horses, at Château Gaillard, Montlhéry, Kenilworth, and elsewhere—medieval horses could go up and down stairs, evidently, unless there were winding ramps.

Two ever-present problems were lighting and sanitation. Lighting was done mostly by oil lamps of brass or clay resembling somewhat the ancient Roman type. Joinville mentions a candle set in a metal tray.[60] Candles, of course, had a religious use. One of the loveliest passages in Ibn-Jubair describes the observance of All Saints on the ship in which he was returning from Acre. Every Christian, man, woman, and child, had a candle, and the ship was ablaze with moving light, and there were sermons and prayers almost all night.[61] In a

54. Theoderic, p. 5.

55. R. A. S. Macalister and J. G. Duncan, "Excavations on the Hill of Ophel, Jerusalem, 1923-1925," Palestine Exploration Fund *Annual*, IV (1923-1925, publ. 1926), 133-137. Usāmah (p. 160) notes that the floors of his father's house were paved with marble.

56. "Assises de Jérusalem," II, 104.

57. *Ibid.*, II, 106.

58. John of Würzburg, *Descriptio Terrae Sanctae*, trans. Aubrey Stewart as "Description of the Holy Land (A.D. 1160-1170)," *PPTS*, V-2 (London, 1896), 21; John says there was room for 2,000 horses or 1,500 camels.

59. *Gerbert de Mez: chanson de geste du XIIe siècle*, ed. Pauline Taylor (Namur, 1952), p. 73, vv. 2791-2794.

60. Joinville, p. 196.

61. Ibn-Jubair, p. 328.

household the kitchen fire was the central one; when this was blazing brightly, no other light was needed, at least in the vicinity. We are not always certain about the whereabouts of the kitchen; in many instances, it may have been in a lean-to set against the house.

Sanitation, such as it was, was primitive. A ditch of some kind, or a pit, was the best that one could hope for. If there was a moat, temporary or permanent, that was considered an excellent place for the disposal of filth.[62] In places as crowded as the Syrian and Palestinian cities, it must have been extremely difficult for the more cleanly to construct proper *longaignes*. Our ancestors were not as concerned about odors and filth as we are. Urination took place almost anywhere: Usāmah tells us of a Saracen whose head was crushed by a catapult stone when he turned toward a wall for that purpose.[63] We may assume that the castles and the larger houses were properly provided with indoor latrines. Sometimes this may have been a mere gesture towards sanitation, because where a pit was impracticable such a latrine would lead no further than to open ground at the base of the house or castle wall. But Château Gaillard in Normandy, which Richard built to eastern specifications, had a double latrine pit, through which Philip Augustus was able to send invaders on that fateful night in 1204. In contemporary illustrations for Cantigas 17 and 34 of Alfonso X, which show a similar Christian and Arab mixed civilization, there are representations of a latrine seat—a circular hole in a slightly slanting board.[64]

Household furnishings in the Holy Land were even simpler than those in Europe. It was quite usual to follow the Moslem custom of sitting on rugs or mats, and not benches, when eating a meal; the tables were low enough to permit this.[65] It is clear that the crusaders seldom ate on the floor itself, though it is specifically stated in one reference that a cowardly Templar was required to eat on the floor for a year, with no napkin provided, as a matter of discipline; when the dogs troubled him, he could not drive them away.[66] Ewers and other containers could be made of wood. Presumably there were also cups and dishes of pottery, glass, and metal. A clothes pole, or rack,

62. *Itinerarium*, p. 100. Fulcher of Chartres (trans. Ryan, p. 119) says of Jerusalem, "There were gutters in the streets of the city through which in time of rain all filth was washed away."

63. Usāmah, p. 144.

64. José Guerrero Lovillo, *Las Cántigas* [*de Alfonso el Sabio*]: *Estudio arqueológico de sus miniaturas* (Madrid, 1949), pls. 21, 39.

65. *Las Cántigas*, pls. 44, 151, show tables; pl. 105 has a cooking tripod. Usāmah, p.158, mentions a wooden jar (ewer?); Joinville, p. 177, speaks of pots and glasses on the table.

66. "Anonymous Pilgrim V.2," trans. Aubrey Stewart, *PPTS*, VI-1 (London, 1894), 30.

fastened horizontally, is pictured in the house of a Mozarab in Spain;[67] doubtless the same device was used in the Holy Land, as well as in Europe. Wooden beds are mentioned: Philip of Novara had a hawk which perched upon his bed,[68] and Joinville had his bed so placed that he could always be seen from the doorway.[69] But where space was greatly needed, it is not unlikely that individuals slept on *coutes*, or thin mattresses, placed upon the floor.[70] Everywhere there were chests in which clothing and objects of all kinds could be stored; books were kept in this way.[71] In the walls of medieval buildings that are still standing one sometimes encounters a niche which gives no evidence of having been closed by a door. Probably these were quite frequent, and held shelves on which lamps and figurines could be placed. Where there was a door present the niche served as a cupboard. A description of a house in Egypt at this time states that it had "carpets, furniture, and a complete outfit of brass utensils."[72]

There were good craftsmen in the Holy Land. Many of the rich houses of the upper class of crusaders were ornamented by Arab artists.[73] Nails, doors, pipes, and cisterns could be made of iron,[74] which probably came from near Beirut. The mountain there was filled with iron mines,[75] and this iron took a good temper. A forest of pines stretched inland for twelve miles in all directions, as far as Mt. Lebanon. The city of Beirut had a good wall, but the town's chief attraction for pilgrims was an image of Christ which had reputedly itself been crucified.[76] Outside the wall were "spacious meadows" and the customary gardens.[77]

As one traveled north from Acre toward Beirut there was more fraternization between Christian and Moslem.[78] Tyre was an attractive port on the sea, surrounded by water on three sides. The port, enclosed by a mole, was a protection for ships, but it was not as good

67. *Las Cántigas*, pl. 28.

68. Philip of Novara, *Mémoires,* ed. Charles Kohler (Paris, 1913), p. 29.

69. Joinville, p. 152: "this did I to remove all wrong beliefs concerning women."

70. *Itinerarium,* p. 225.

71. James of Vitry, *Epistolae,* p. 102.

72. Usāmah, p. 30.

73. Hatem, p. 297.

74. Ibn-Jubair, p. 269; cf. P. K. Hitti, *History of Syria, including Lebanon and Palestine* (2nd ed., London, 1957), pp. 489, 620.

75. Hitti, p. 571; al-Idrīsī, trans. Le Strange, *Palestine under the Moslems,* p. 410.

76. Theoderic, pp. 71-72; "Eracles" (manuscrit de Rothelin), *RHC, Occ.,* II (Paris, 1859), 514; "Fetellus (circa 1130 A.D.)," trans. J. R. MacPherson, *PPTS,* V-1 (London, 1896), 51-52.

77. Phocas, p. 9; "Assises de Jérusalem," II, 458.

78. Ibn-Jubair, pp. 319-320.

as that at Acre. On the land side, there was a fine suburb where glass
and clay pots were manufactured. A good weaving industry produced
white cloth which was shipped far and wide.[79] Vineyards, gardens,
fruit trees, and grain fields extended far on that side of the town. At
Tyre lived people of all kinds, and bishop James of Vitry found that he
had to preach through an Arabic interpreter.[80] The strange sect
known as the Assassins had their territory not far distant, and many
beduins were to be seen pasturing their flocks in the great plain. The
fertility of the area was evident in the gardens, which reached to
Homs and from there lined the road to Damascus;[81] there grapes
were picked twice a year. Irrigation was accomplished with the aid of
those huge water wheels which still persist in the Near East. Wind-
mills were not unknown, though Lamb errs in stating that they had
been introduced by German settlers.[82] A great plain extended east
from Tyre, and on this plain about a mile from the city was a famous
(artesian?) fountain, encircled by an octagonal tower, so high that it
was a good observation post. It had spouts at the corners from which
water splashed noisily onto the ground.[83] To the north, Sidon, with
its fine ramparts and good markets, had hundreds of villages depen-
dent on it. The nearby mountains were famed for their springs, one
of which was supposed to have aphrodisiac fish.[84]

Still farther north was Tripoli, which, like Tyre, possessed a fine
harbor and was well fortified and almost entirely surrounded by sea.
Although rather small in area, this was the chief commercial and
manufacturing town of its region, and many middlemen were active
there. As usual, the surrounding land was rich with vineyards, olive
groves, fig trees, and fields of sugar cane.[85] Tiberias, which the
Franks lost in 1187, was on a hill beside the Sea of Galilee, a sweet-
water lake about twelve miles in length; most of its provisions came
across the lake from the Moslem side. This town manufactured beau-
tiful mats called Sāmānīyah.[86] Oddly, the port of Haifa, across the
bay from Acre, was not much used. Twenty-five miles farther south

79. Al-Idrīsī, trans. Le Strange, *Palestine under the Moslems*, p. 344; Theoderic, p. 73; cf.
Phocas, p. 10.

80. James of Vitry, *Epistolae*, p. 117.

81. Ibn-Jubair, p. 270.

82. Harold Lamb, "Crusader Lands Revisited," *National Geographic Magazine*, CVI
(1954), 843; Hitti (p. 619) points out that they were unknown in Europe before 1180;
Ambrose, p. 51; Usāmah, p. 171.

83. Phocas, p. 11.

84. Al-Idrīsī, trans. Le Strange, *Palestine under the Moslems*, pp. 346-347.

85. *Ibid.*, p. 350; James of Vitry, *Epistolae*, p. 115. Hitti (p. 597) says that it had a
population of 20,000 in 1103, and that its principal manufactures were glass and paper.

86. Al-Idrīsī, trans. Le Strange, pp. 338-339.

was Caesarea, which had no convenient harbor, though it had the usual gardens and pasture-land.[87] At Jaffa, which was important because it was the rallying place for Jerusalem, there was little more than a castle and some gardens; pilgrims camped in open fields outside the walls.[88] Farther down the coast, Ascalon, when it was not being destroyed or rebuilt, had double walls and good markets, but there were no gardens or trees in the vicinity.[89]

One of the principal manufactured products was sugar; Burchard gives a brief résumé of the process. The canes were cut into pieces of half a palm's length; these were crushed in a press, and then the juice was boiled in copper boilers and allowed to settle in baskets of twig, where it dried quite hard. This product was known as honey of sugar, useful in making cakes.[90] No lime was added—later the chief ingredient for producing crystalization; this process was probably discovered in Jamaica, whence it was carried to Louisiana, many centuries after the last crusader was laid to rest. Acre was famous also for its peach preserves.[91]

Most important was the production of glass, at both Acre and Tyre.[92] The glass was formed from very sharp sand and "sea-gruel," identified as a sea plant (Sallosa) which, when burned, furnished soda. To this mixture of silicate (sand) and soda the workmen doubtless added varying quantities of lime, alumina, and oxide of iron (iron slag), to make what is today termed bottle glass. The glass discovered at Pompeii had this same formula, plus some oxide of manganese and copper. The ingredients must have been placed in an earthen pot of proper size and thrust through a hole into a furnace, heated very, very hot—some 2500°F. When the glass reached the right consistency, a workman would gather some of the molten material onto a metal blowpipe. After he had swung this and blown into it at intervals, the resulting glass globule would be thrust into an earthen bottle, or other form, and then blown into the required shape. It is probable that the earthen bottle form was in two segments, which were fastened together after the glass globule was inserted. We do not have a description of such manufacture from a source at Tyre or Acre, but no other process could have been followed. Glass enamel must have been manufactured in abundance. In

87. James of Vitry, *Historia*, p. 5. Al-Idrīsī (trans. Le Strange, p. 474) calls it "a very large town, having also a populous suburb. Its fortifications are impregnable."

88. Ambrose, p. 97.

89. Al-Idrīsī, trans. Le Strange, pp. 401-402.

90. Burchard, pp. 99-100; James of Vitry, *Historia*, p. 28.

91. Burchard, p. 100.

92. James of Vitry, *Historia*, pp. 92-93.

making this, oxide of tin was added instead of oxide of iron, and a coloring material was needed. Oxides of copper, cobalt, and manganese produced the colors.[93] As for painted glass, or stained glass as we are accustomed to calling it, the oldest of this in western Europe is probably in the cathedral at Le Mans, dating from around 1090; the very early glass at Saint Denis dates from the middle of the twelfth century. How much improvement in the process could have come from Syria we cannot say, but this was an art well practised in the Holy Land. The glass was made by the pot-metal process, where the lines on the figures are drawn with brown or black enamel, the whole then being fused by firing. The figures themselves were put into place in the pane by leading. Each stretch of glass of uniform color was produced in a roller mold, from soda glass.

The textiles made in this region are taken for granted in the chronicles and other accounts, but they were something very special. Silkworm culture had been brought to the Mediterranean in the sixth century, in Justinian's time. Persia and Constantinople became the important centers, and they continued to be so. Cotton also was grown.[94] In Marie de France's "Le Freisne" we find that "they wrap the lovely child and place it on a coin-dot cloth. Her husband had brought it to her from Constantinople where he was. Never had they seen so fine a one"[95] Probably the husband of the lady had been to Constantinople at the time of the Second Crusade. By the twelfth century nearly every noble in Syria, and probably in Palestine, Sicily, and Moslem Spain, had his *tirāz* or weaving establishment. The crusaders must have encouraged their own Christian servitors to practise this art while in Syria and Palestine, especially at Tripoli. The Koran forbids figure-weaving, and even frowns on such a luxury as pure silk. Many of the weavers were Christian slaves, working at times with a cotton warp to avoid the Moslem "sin" of pure silk. Basic Syrian designs were fantastic animals (such as griffons, unicorns, and basilisks), flowers, tigers, elephants, lions, eagles, wild ducks, and antelopes—all framed in circular bands, or in geometrical compartments, or sometimes in horizontal and parallel bands. Sāsānid hunting scenes from Persia were occasionally copied.[96]

93. R. G. Haggar, *Glass and Glassmakers* (New York, 1961), pp. 9-12, 19-21; cf. Alexandre Sauzay, *Wonders of Glass Making in All Ages* (New York, 1885), pp. 78 ff.

94. Cotton is listed along with dates, bananas, lemons, limes ("Adam's apples"), sugar cane, and balsam by "Anonymous Pilgrim V.2," p. 34.

95. Marie de France, "Le Freisne," vv. 122-126, *Les Lais,* ed. Jeanne Lods (Paris, 1959), p. 43.

96. Further information on textiles is in George L. Hunter, *Decorative Textiles* (Philadelphia and London, 1918). Hitti (p. 619) lists damask (Damascus), muslin (Mosul), baldachin (Baghdad), sarcenet (Saracen), atlas, taffeta, velvet, silk, and satin.

The basic foods demanded by those who came from Europe were much the same as those they ate at home: bread, wine, meat, and sometimes fish.[97] Joinville laid in a supply of pigs, sheep, flour, and wine, prices for which were apparently fixed by proclamation in each community.[98] According to their plentifulness these basic foods would be supplemented by the "roots," and by beans and peas of all kinds. Wheat and barley were made into those round loaves of bread observed in Europe. There was also a kind of biscuit which was favorite shipboard or marching rations.[99] Eastern grains were popular among these westerners: sesame, carob, millet, and rice.[100] There were many fruits, including olives, figs, apples, cherries, oranges, lemons, melons, apricots (called Damascus plums), and "apples of paradise"–bananas.[101] Medieval taste required much seasoning; there was always commerce in pepper, cumin, "e especes e laitueres": ginger, cloves, aloes, and alum. The damask rose and manufactured perfumes became popular. It was apt to be the monastic communities, among the Christians, which became most expert in the keeping of bees, the making of wine, and the growing of fruits and flowers.[102] Eggs and chickens were consumed in quantity. Meat, as usual, was kept on the hoof as long as possible: pigs, oxen, and sheep.[103] Young camels were eaten by the natives, and it is reported that crusaders took a bite now and then.[104] Horse, mule, and donkey were used for meat in time of necessity.[105]

Wine criers roamed the streets just as at home. A man would fill a bottle from a new supply and would proclaim its availability as he moved about the town to advertise his wares.[106] It is unlikely that this was a municipal employment in Syria and Palestine, as it frequently was in France. More probably the crier's reward for his

97. "Assises de Jérusalem," II, 243: "le pain et le vin, la char et le poisson, selonc le banc crié."

98. Joinville, p. 152; on p. 178 he also mentions his "hens."

99. *Ibid.*, p. 194; Ambrose, p. 80.

100. Hitti, p. 618. Ibn-Jubair (p. 316) says that most of the farmers were Moslems, who shared their crops evenly with their Frankish overlords.

101. Daniel, *Putesestvie* . . . , trans. C. W. Wilson as "Pilgrimage of the Russian Abbot Daniel in the Holy Land, *circa* 1106-1107," *PPTS,* IV-3 (London, 1895), 45; Burchard, pp. 100-101.

102. Hitti, pp. 487, 618-619; cf. Phocas, p. 26.

103. Abū-Shāmah Shihāb-ad-Dīn, *Kitāb ar-raudatain* . . . , extracts trans. A. C. Barbier de Meynard as "Le Livre des deux jardins," *RHC, Or.,* IV-V (Paris, 1848, 1906), V, 4, 8.

104. Ambrose, p. 140: "the young camels they killed, and ate the flesh thereof right willingly; for it was white and savoury, when it was larded and roasted."

105. "Eracles," p. 150: "les gens de l'ost manjassent . . . char de cheval ou de mule ou de asne." Cf. Fulcher of Chartres, tr. Ryan, p. 131.

106. Usāmah, p. 165.

efforts was the bottleful of wine. In the warmer months, the men of
the west adopted with avidity the Saracen convention of drinking
syrups cooled with snow brought down from the Lebanon moun-
tains.[107] When Richard was ill he asked for fruit and snow:[108] a
"sirop a boivre por le rafreschir."[109] Other Franks varied this by
adding snow to their wine. Particularly in August the snow was
brought down in journeys of two or three days, piled under straw in
a cart.[110]

The favorite pastimes of the crusaders were sex, dicing, and
checkers,[111] baths, hunting, and celebrations of an elaborate kind. It
was said of count Robert of Flanders and his men that they kept
playing *tables* (checkers) and chess, went about in their tents bare-
foot with light clothing, and repaired frequently to Antioch for
baths, taverns, eating, and other "bad" practices.[112] Both Ambrose
and the author of the *Itinerarium* report how the French knights
when they got to Tyre gamed and danced, put on foppish attire and
drank till matins, and waited in turn to get to the women, where
they would frequently push ahead, cursing and swearing.[113] To be
sure, this is an unfavorable comment on the French from followers
of king Richard, but there is no reason to doubt its essential
accuracy. At a time when venereal disease was not prevalent and in a
place where female slaves could be purchased at a low price, it is to
be expected that prostitution was rife in all its forms. It was more a
problem of where than with whom. A Moslem captive woman could
be ransomed for five hundred silver dinars or deniers,[114] which gives
some idea of what her temporary services were worth. Ecclesiastics as
well as laymen were accused of renting out quarters within the walls
of Acre for purposes of vice, an immoral profiteering which James of
Vitry deplores.[115] It seems that prostitutes paid higher than normal
rent, so canons regular permitted them to use their houses.

The oriental bath was particularly enjoyed, sometimes as often as
three times a week. On occasion women entered with the men,[116]

107. "Eracles," p. 67.
108. Abū-Shāmah, V, 18.
109. "Eracles," p. 67.
110. James of Vitry, *Historia*, p. 92.
111. William of Tyre, *Historia rerum in partibus transmarinis gestarum*, in *RHC, Occ.*, I
(Paris, 1844), 706; Joinville, pp. 121, 125.
112. William of Tyre, p. 1047, rendered in "Eracles" as "ès bainz et ès tavernes et ès
mengiers; à luxure et à mauvès deliz"
113. *Itinerarium*, pp. 330-332; Ambrose, p. 115.
114. Usāmah, p. 100.
115. James of Vitry, *Epistolae*, p. 111: "non solum laici sed persone ecclesiastice"
116. Usāmah, p. 165.

but this could not have been a common practice. Monks and nuns also attended.[117] When requested, the bath keeper would shave the pubic hair.[118] Baths are described as having a number of rooms,[119] which would suggest a warm pool, a hot one, and a cold plunge; a special guardian watched the clothing of the bathers.[120] It is stated in one instance that such baths were kept undefiled from natural functions.[121] A stone bench is mentioned as being outside the bath building.[122]

Game was abundant in this region and the men from Europe adapted themselves easily to the chase. There were gazelles,[123] boars, roedeer, hares, partridge, and quail.[124] Fulk of Anjou was chasing a hare in the plain of Acre when his horse fell upon him, with fatal result.[125] There were also animals of a wilder sort: some lions in the north,[126] bears, camels, stags, and buffaloes.[127] Occasionally a lion won the hunt and ate the crusader; this was an infrequent, but constant, danger. The westerner was used to depending on his horse and personal strength, and these were insufficient equipment for opposing a lion. The Holy Land has its plentiful share of snakes, and snake-charming is noted in the thirteenth century.[128] There are mentions of a crusader thrusting his hand into a bundle of fodder or brush and being fatally bitten, probably by a desert saw viper—a small, thin, but deadly reptile.[129] The black flies could be very bad in June near Jerusalem; the warriors were obliged to make veils to cover their faces and necks.[130] Locusts were a perennial threat to the crops.[131]

Festivals and celebrations were very splendid in Syria. On a great occasion, hangings were stretched from house to house across the narrow streets, and the paving stones and the muddy, packed earth

117. James of Vitry, *Historia*, p. 63.
118. Usāmah, p. 165.
119. Ibn-Jubair, p. 265.
120. *Ibid.*, p. 289.
121. *Ibid.*, p. 265.
122. Usāmah, p. 166.
123. Joinville, p. 153; Usāmah, p. 223.
124. Burchard, p. 102.
125. "Assises de Jérusalem," II, 442.
126. Usāmah, pp. 97, 155, and elsewhere; Burchard, p. 102.
127. Burchard, p. 102.
128. "Ernoul's Account of Palestine," trans. C. R. Conder, *PPTS*, VI-2 (London, 1896), 58.
129. Ambrose, p. 131; Urban T. Holmes, "Gerald the Naturalist," *Speculum*, XI (1936), 115-116. Fulcher of Chartres (trans. Ryan, p. 300) discusses primitive antidotes.
130. Ambrose, p. 128.
131. Fulcher of Chartres, trans. Ryan, p. 218.

were covered with rugs. Censers with burning incense would be set in the streets and silk curtains hung before the houses;[132] rugs and incense were common commodities in the Near East. Musicians appeared, enjoyed perhaps not so much for their own sake as for the fact that they were an accompaniment for festive occasions. Timbrels, trumpets, horns, pipes, and flutes were played, and choruses went singing through the streets, as cups of wine were passed about.[133] On one occasion a string player and a singer, belonging to Saladin, charmed king Richard.[134] Later Louis IX was delighted with three Armenian brothers who performed a horn trio while tumblers did somersaults on a mat.[135] Many minstrels and acrobats, sets of dice, and, of course, public women were required to keep such a population amused. Horse-racing was not organized in our sense of the word, but it was there in the germ. "He who will first reach the *cité* and ride on to the Loire bridge, if he has witnesses, will win a thousand marks of white silver and a hundred of bright gold, and he shall do what he wants with the horses."[136] This elemental racing purse was offered in France, but similar races were doubtless arranged in the Holy Land. People were forced to compete in obstacle races of a ridiculous nature.[137] Medieval men enjoyed practical jokes; it seems a little sad that people who were only an uncertain step removed from disease and mutilation should have derived so much fun from mocking the blind, the stupid, and the helpless. But this was a society where one could be clapped into a foul underground dungeon for next to no reason, or for none, and be ruined physically for life, if indeed life continued.

A mention of "mulieres ducentes choros"[138] makes us wonder about the practice of using vernacular literature as an entertainment. There is considerable evidence of satirical songs, often directed by the English against the French and vice versa. Hugh of Burgundy had a biting song against Richard.[139] Arnulf, chaplain of duke Robert of Normandy and later patriarch, was attacked in much the same way.[140] In the next century Philip of Novara records a portion of the

132. Ambrose, p. 123; *Itinerarium,* p. 349: "mulieres ducentes choros."
133. Ambrose, p. 41.
134. Hatem, p. 297.
135. Joinville, pp. 158-159.
136. *Aiol: chanson de geste,* ed. J. Normand and G. Raynaud (Paris, 1877), p. 125, vv. 4298-4303; cf. Usāmah, p. 94.
137. Usāmah, p. 167.
138. *Itinerarium,* p. 349.
139. Ambrose, p. 141: "and a right villainous song it was."
140. Hatem, p. 300.

Roman de Renart which was composed for a similar purpose.[141] This device of using a song with animal names was quite safe because "ce qui n'i est ne peut on trover." Refrains were composed exalting prowess. When Richard was leaving for home people stood around and recited his deeds of valor and largesse; perhaps these were *cantilenae*, sung by women.[142] Ambrose speaks of something "since the days of Roland and Oliver," which presupposes familiarity with the *Chanson de Roland*. Indeed Ambrose, who was a minstrel, mentions several epics, such as the *Chanson d'Aspremont*, and songs of Charlemagne and of Pepin. He includes romances of Arthur of Britain, of Tristan, and of the death of Alexander, and a *Paris et Hélène* which has been lost.[143] Ambrose moralizes on several of the epics.[144] We have reason to believe that the first form of the *Chanson d'Antioche* and that of the *Chanson de Jérusalem* were pieced together in Syria. It is certain that the *Chétifs* reflects its Syrian environment.[145]

It is more difficult to estimate the extent to which men of the west were influenced by Arabic love poetry. We wonder how much of the pre-Islamic verse, not in great favor with the average follower of the Prophet, could have been heard by even a cultivated crusader. Orthodox love poets who could have been influences were ʻUmar ibn-abī-Rabīʻah, Jamīl al-ʻUdhrī, and Majnūn Lailâ.[146] Those most affected would be Franks of the second and third generation in the Holy Land who spoke and read Arabic well, often better than their European vernaculars. We know some of the translators by name: Renard "de Sagette" (of Sidon), Baldwin of Ibelin, Yves le Breton, Nicholas of Acre—"drugemens qui enromançoient le Sarrazinnois."[147] In 1127 Stephen of Antioch translated the physician ʻAlī ibn-al-ʻAbbās into Latin.[148] Fulcher of Chartres said of such people: "We who were occidentals have now become orientals We have already forgotten the places of our birth Some have taken [as] wives . . . Syrians or Armenians or even Saracens who have [accepted] baptism. . . . Some tend vineyards, others till fields. People

141. Philip of Novara, pp. 81-88.
142. Ambrose, p. 159.
143. *Ibid.*, pp. 63, 69.
144. *Ibid.*, p. 116.
145. Urban T. Holmes and W. M. McLeod, "Source Problems of the *Chétifs*, a Crusade *Chanson de geste*," *Romanic Review*, XXVIII (1937), 99-108.
146. See P. K. Hitti, *History of the Arabs* (2nd ed., London, 1940), pp. 250-251, and, for a full discussion, A. R. Nykl, *Hispano-Arabic Poetry* (Baltimore, 1946).
147. Hatem, p. 298.
148. *Ibid.*, p. 296.

use . . . diverse languages in conversing back and forth."[149] James of Vitry asserts that such Syrianized Franks are soft, effeminate, more addicted to baths than to battles, wearing soft robes, keeping their wives locked up in harems and letting them go to church only once a year, while the same wives will go to the baths three times a week, but under strict guard.[150] On the other hand, Usāmah thinks that these westerners domesticated in Syria are much superior to their confreres. He knew of one who had Egyptian women doing his cooking and who ate no pork.[151] Humphrey II of Toron's son had a perfect command of Arabic, and served as interpreter between Richard and Saladin. Of course, any influence of the Holy Land on Europe was minimized by the fact that those who knew Arabic well usually stayed in the east; those who went back to France and England knew the least. The casual pilgrim who passed through under arms seeking his palm must have carried home with him "horrible," or perhaps "gilded," impressions of a fleeting nature. A dreadful homeward voyage of up to three months could shake from such an observer any lyrical ideas he might have gathered. Moslem love motifs could have entered Europe through Sicily and Spain under much better auspices.

It was customary for a Latin in the Levant to be bareheaded and clean shaven, while the eastern Christian and the Moslem were bearded.[152] Franks were characterized as shaven, surrounded by pigs and crosses. A vogue for beards, however, became almost a fad for some of the crusaders. Washerwomen in the Holy Land were adept at washing heads, as well as linen, and they "were deft as monkeys in removing fleas."[153] We have already commented on what Ambrose and the author of the *Itinerarium* had to say about the Frankish knights vacationing in Tyre. Ambrose further reports that these "warriors" had openings in their sleeves which were closed by lacing. They wore fancy belts and showed the tails of their pleated *bliauts* by carrying their mantles twisted on their arms, in front, covering stomachs and not posteriors. They wore necklaces of gems, and had flower garlands around their heads.[154] To judge by their sexual behavior these men were not effeminate—they were just ultrafashionable. The basic European dress was the same in Tyre as it was in the

149. Fulcher of Chartres, trans. Ryan, p. 271.
150. James of Vitry, *Historia,* p. 65.
151. Usāmah, pp. 169-170.
152. "Anonymous Pilgrim V.2," pp. 27-29.
153. Ambrose, p. 81.
154. *Ibid.,* p. 115.

west. Every man began his dressing by putting on *braies* or linen underdrawers (unless he were a Scot or a member of the Cistercian order!).[155] Over these went a linen shirt, and over that a *bliaut*, which had open sleeves (not necessarily laced). A Phrygian-style cap might be worn, with the peak tilted forward, and in spring young folk often wore a wreath of flowers. There were, of course, shoes and stockings, the latter being held by a broad garter band above or below the knee. Working people omitted the linen shirt. They wore a *gonne* or *froc* instead of the *bliaut*, and this had long and tighter sleeves. A worker might wear a snood cap or a flat hat in the fields.[156] But in the Near East the fashion of wearing a scarf over the head was coming into use, imitated from the Moslem natives. The beduins, for instance, were a common sight, usually dressed in red shirt and flowing mantle, with a scarf over the head.[157]

It is assumed that the Frankish women also wore the basic European clothing: a long shirt, long bliaut (or *cote*) tighter above the waist, with a double (or single) belt, shoes and stockings, and a wimple over the head. In the thirteenth century varieties of stiff headdresses were placed under the wimple. Both men and women wore mantles draped over the torso and fastened often with a brooch, or a ring, at either the neck or the right shoulder. Jewelry was extremely common. The mercer's wife who was the mistress of the patriarch Heraclius was loaded with gold, samite cloth, pearls, and precious stones.[158] New dye shades were coming into use in the east among the Christians, notably indigo, lilac, carmine, and crimson. Sequins were being used. Some European women even went so far as to wear the Moslem veil when seen in the street and public places.[159] But most Frankish women did not impress Moslems by their desire to remain aloof. Usāmah has a famous comment on his astonishment that a Frankish man and his wife, on meeting another man, might separate to permit the woman to talk alone with the other.[160] He was disgusted too that a Christian captive who had become "mother of a son" of a Moslem potentate should seek an opportunity to escape and eventually marry a Frankish cobbler.[161] But such independence could have a charm and fascination.

155. Philip of Harveng, "De institutione clericorum," ed. J. P. Migne, *PL*, CCIII (Paris, 1855), col. 730.

156. On dress see further Urban T. Holmes, *Daily Living in the Twelfth Century* (Madison, Wis., 1952), especially pp. 159-165, 203.

157. Burchard, p. 105.

158. "Eracles," p. 60: "ele avoit nom Pasque de Riveti [or Riveri]."

159. Hitti, pp. 619-620.

160. Usāmah, p. 164.

161. *Ibid.*, pp. 159-160.

Ibn-Jubair describes a Frankish wedding and the bride very prettily. The guests, both men and women, formed two lines while entertained by trumpet and flute music as they waited. The bride appeared, supported on each side by male relatives, in a dress which had a train of golden silk. On her hair and across her breast she also had a net of woven gold, held on the head by a gold diadem. She walked "like a dove, or . . . a wisp of cloud." The men walked before her and the women came after. The musicians led the procession to the groom's house, where there was feasting which lasted all day.[162] Philip of Novara had described such a feast, doubtless of more prominent people, that continued for a fortnight, varied by tourneying, dancing, and the wearing of fine clothes.[163] The betrothal requirements are recorded in the *Assises*: the future groom swears "on the saints" that he has no living wife and no other fiancée, and two companions take the same oath for him; the woman swears that she has no living husband; the date for the solemnization of the marriage is then set. Banns were cried for three days at the first mass.[164] In such a land of violence, where fighting men died daily, there were a multitude of young widows; a widow could take *le ten de plor*, so that for a whole year she was not obliged to marry a new husband.[165]

We can say in general that the routine of men in the crusader states did not vary greatly from that to which they were accustomed at home.[166] One rose early, not long after dawn (sometimes before), and doubtless began the day with some liquid refreshment. Some individuals then went to mass, seldom receiving the Eucharist more than once a year except on a special occasion. Several hours of work could then be put in, followed by a little leisure before the principal meal at the end of the morning. This meal, usually about an hour in length, was followed by a siesta, when the individual was quiet or actually took a nap. Then came *relevée* and the afternoon work period, followed by supper at vespers, with entertainment, and after that might come study or reading. This kind of routine was not very exacting. Hunting, buying in the markets, even writing, provided variation. When there was fighting, or when a journey had to be made, these necessities became the chief occupation of the day. Even

162. Ibn-Jubair, pp. 320-321: "this alluring sight, from the seducement of which God preserve us."

163. Philip of Novara, p. 3.

164. "Assises de Jérusalem," II, 111-112.

165. William of Tyre, p. 1029.

166. See Holmes, *Daily Living,* for further information on daily routine.

then, the rest at the middle of the day was taken, if possible. Usually not more than six or seven hours a day were spent in travel on horse-, ass-, or mule-back, and consequently thirty to thirty-five miles a day was the average distance covered.

Tradesmen opened their shops shortly after dawn and continued till after dark, which makes their hours of work seem excessively long. But within this pattern they devoted time to meals and siestas like everyone else, and on the holy days, which were many, as well as on the days of absence required by feudal duties, they did not open their stalls at all. Merchants in Europe spread their wares on stalls, or shelf and table surfaces, sometimes in the complete open, more often in a shop open to the street;[167] those in the Near East were more used to spreading their things on the ground, on mattings or rugs. The pilgrim merchant who tried to sell at Acre or elsewhere probably mixed the two customs. Although merchants tended to congregate in the central area of Acre,[168] manufacture of heavy goods, which required furnaces, must have been clustered more on the outer edges of the towns, where fire and water could be used more freely. As in Europe, there was a tendency for merchants and workmen of the same specialty to dwell together, often in streets that bore the name of the trade. It was not uncommon for Christians and Moslems to hold fairs together.[169] In the neighborhood of Banyas, forty miles southwest of Damascus, Christian and Saracen farmers cultivated their land side by side, using the same irrigation system.[170]

We have described some of the routine of an average man in the Holy Land. The sources provide more detail on such a prominent figure as John of Joinville.[171] He had a considerable number of knights in his entourage, and two chaplains who said the daily hours. He slept alone, and his bed was set up facing the door of his room or of his pavilion. In the morning he bought meat on the hoof and tuns of wine, mixed well with water. While at table (which was low on the floor) he and his followers sat on mats. Each knight had a phial of water with his wine. The daily routine of bishop James of Vitry was more ascetic.[172] He said early mass and then heard confessions until noon. He ate with difficulty because he had lost his appetite. Proba-

167. *Las Cántigas,* pls. 120, 188.
168. Ludolph of Suchem, p. 51.
169. Hatem, p. 310.
170. Ibn-Jubair, p. 315; Ernoul, trans. Conder, p. 51, says this was true in many places on Mt. Lebanon.
171. Joinville, pp. 151-152.
172. James of Vitry, *Epistolae,* p. 113.

bly after his midday rest he visited the sick until vespers (three to six o'clock). At that point he would eat once more; then he received widows and orphans before hiding away somewhere where he could read. He prayed and meditated much at night. Such a severe routine, for a man who had a sufficiently light touch to compose the *Exempla*, shows how obsessed he was by the need for labor in the Holy Land. This same bishop used to purchase, and even pick up, young Saracen children in order to have them baptized. He would beg children from armed men who had captured them,[173] and would distribute these among the religious houses.

It was claimed that all Syrians and Samaritans knew something of herbs and medicines.[174] Eastern medicine was milder and less drastic than much of the treatment practised in the west. More use was made of herbs and less of talismans. But Usāmah has praise for a Frankish remedy for a skin disease, which consisted mostly of vinegar and glasswort.[175] Opium and spices were more easily obtained in the Holy Land. Perhaps the factor that made western medicine more ineffective, as practised in Europe, was an unavoidable reliance on *antibolomina,* lists of substitutes for more efficacious drugs which were not easy to obtain. The doctor in the east could get the real thing. Bishop James remarks upon the too frequent use of poisons in Acre.[176] In a land of so much violence it was automatic to attribute mysterious deaths to that cause, but infectious maladies were rife, and many an accusation of poison must have been false. James says that there were homicides constantly, day and night; men would slay their wives after dark, and wives bought fatal doses for their husbands openly in the streets.[177] The practice of establishing *maladeries* or hospitals of a kind may have spread to the Latins from the Moslems, particularly in the case of leper hospitals.[178] The many churches and secular places in Europe with the name Saint Lazare were probably a by-product of the crusades. Nursing care was understood. Mention is made of the sick in a castle being treated two in a room.[179] Jerusalem had a *maladerie* for men and another for women.[180] After a military foray the sick and wounded were loaded onto pack animals and returned to such a place as Acre, along with

173. Oliver, p. 171.
174. William of Tyre, p. 879.
175. Usāmah, p. 163.
176. James of Vitry, *Epistolae,* p. 111.
177. *Ibid.*
178. Hitti, p. 614; cf. Ibn-Jubair, p. 346.
179. "Eracles," p. 42.
180. *Ibid.,* p. 82.

the booty and the captives.[181] In the case of privileged patients, the parched throats were cooled by sherbet.

We must say a few words about the judicial system as it appeared to the average man, but this is too specialized a subject for much attention here. It is true that "les institutions judiciaires d'un peuple sont le miroir fidèle de ses idées, de ses moeurs et de ses intérêts,"[182] although the reflection is not always immediately apparent. At Jerusalem, in addition to the Haute Cour of the principal lords and ecclesiastics there was a Cour des Bourgeois, which was transferred to Acre in 1187.[183] This latter court met on Mondays, Wednesdays, Fridays, and feast days. Its principal officer was a viscount, the *bailli de la ville*. He was assisted by twelve *jurés* or jurors, by a scribe, and by a band of sergeants. The town watch was headed by the viscount on alternate nights, and by the chief sergeant on the other occasions.[184] This court had banns cried and regulations promulgated prescribing good order and defense and fixing prices on grains, wines, oils, meat, fish, fruit, and herbs. [185] The same court had jurisdiction over sales, challenges, gifts, inheritances, and exchanges of property. It presided also over rents (limited and unlimited), partitionings, escheats, marriage arrangements, transferral of fiefs, freeing of slaves, and some criminal proceedings.[186] The scribe seems to have been the best paid. He received twelve bezants a month and extra fees: twelve pence for a sale, sixpence for a gift, and sixpence for a wager. He was obliged to submit his accounts every three months.[187] The records were stored in special *huches* or chests, each one having two keys, and these were placed in the house of a juror in whom the ruler had special trust. [188] Oaths were sworn on the Gospel.[189] The viscount collected his lord's rents and deposited them with the court every three months, as required by the *Segrete dou Roi*.[190] There was something similar to this in all the towns. There was also a Cour des Reis (magistrate), later Cour de la Fonde (bazaar), which handled Moslem affairs. [191] This consisted of the bailie, two Syrians, and two Franks. The lawyer

181. Oliver, p. 171.
182. "Assises de Jérusalem," I, i (introduction).
183. *Ibid.*, II, *passim*.
184. *Ibid.*, II, 240.
185. *Ibid.*, II, 250.
186. *Ibid.*, II, 251-252.
187. *Ibid.*, II, 243.
188. *Ibid.*, II, 250; probably each of two jurors kept one key, but the text is confused.
189. *Ibid.*, II, 237.
190. *Ibid.*, II, 241.
191. *Ibid.*, II, xxiv.

who spoke for his client before a court was called an *avantparlier*; [192] those who were required to appear received a summons;[193] the plaintiff or *actor* made his *clamor*, and the *reu* or defendant came back with his *respons*.[194]

Presumably the local lord's courts throughout the Holy Land functioned in those fiefs that had criminal jurisdiction. The system of a lord sitting in judgment with the aid of six or seven knights, perhaps with a trained jurist present, aroused the criticism of Usāmah, who felt that a lord should make his own decisions. [195] Criminal justice was not efficient, but it could be swift when it caught up with the guilty. Hanging was in great favor. One way of doing this was to erect the gallows on a wall or tower, and place the criminal on the ground beneath with arms tied and a rope around his neck; he was dragged aloft by ropes tied to his ankles and allowed to hang by the neck when he got on high.[196] Mutilation was much practised, and the stream of blind, one-armed, earless, and noseless criminals increased the throng of beggars, who were present everywhere; eyeballs or hands were pierced by hot irons.[197] A witch would be thrown into a fire.[198] For rape a man had three choices: to marry the girl, pay nun's fees for her, or be castrated.[199] There was much trial by combat, even among villagers or tradesmen.[200]

Winter was not a time for warfare because of the rains. We find such a question as this: "Sire, por quei avez vos assemblé ci cest ost contre yver?"[201] Ambrose indicates that the winter was spent repairing the fortifications.[202] The knights, and sergeants too, were usually mounted, though at times the sergeants fought on foot. Infantry formed the outer defense of the crusader host; horsemen were in the center, ready to charge from that vantage. Sometimes there was a tower on wheels in the very center, to which the standard of the leader was attached.[203] Bahā'-ad-Dīn portrays the crusader infantry at Arsuf as going first, followed by the horsemen, with a supporting division of infantry behind;[204] the infantry in the van

192. *Ibid.*, II, 245.
193. *Ibid.*, II, 249.
194. *Ibid.*, II, 21.
195. Usāmah, pp. 93-94.
196. Philip of Novara, p. 100.
197. Usāmah, p. 169; "Assises de Jérusalem," II, 68.
198. "Eracles," p. 54: the witch was a Saracen, charged with casting spells on Franks.
199. "Assises de Jérusalem," pp. 92-93.
200. Usāmah, pp. 167-168.
201. "Eracles," p. 35.
202. Ambrose, p. 51.
203. Abū-Shāmah, V, 13, 35.
204. Bahā'-ad-Dīn, pp. 290-291.

could be relieved by the reserve division.[205] Usāmah says that the
Franks were most cautious and that they liked to make a stand on a
hill.[206] The Saracens' method of fighting was to run away when
chased and turn back against the Franks at the opportune
moment.[207] Both Franks and Moslems observed the custom of
making a terrific uproar when facing the enemy; horns were blown,
drums were beaten, and there was great shouting.[208] Greek fire was
thrown about very freely by both sides, to destroy any brush that
might be used for cover and to burn wooden siege engines and
supplies.[209]

The fighting equipment of the knight was just about the same as
he used at home; he must often have envied his Saracen adversary,
who usually wore no armor, but only a light quilted jacket, and who
carried bow, mace, javelin, knife, and sword or short lance.[210]
Usāmah stated that the Franks preferred their knights to be tall and
thin.[211] The sergeants wore much the same equipment as the
knights, but it was not always complete; a sergeant might be without
shield or without helmet.[212] The Saracens remarked upon the thick
quilted *cotes* or *gambisons* which the footmen wore under their
armor, and most carried crossbows;[213] Joinville records how the
artillier of the king of Jerusalem went to Damascus to buy horn and
glue for such bows.[214] The defensive garments were so tight that
arrows pierced them only with difficulty.[215] A hauberk, if in good
condition, would resist many a thrust, particularly with a padded
cote underneath. An instance is recorded where an attendant forgot
to fasten the hook of the hauberk over the left breast, and the result
was disastrous.[216] These coats of mail were rubbed with sand to
take off the rust,[217] and then they may have been lacquered.[218] A

205. Abū-Shāmah, V, 34. On the whole topic see R. C. Smail, *Crusading Warfare (1097-1193)* . . . (Cambridge, 1956).

206. Usāmah, p. 42.

207. Ambrose, p. 81.

208. Ambrose, p. 53; Usāmah, p. 68.

209. William of Tyre, p. 723.

210. Fulcher of Chartres (trans. Ryan, p. 178) also mentions daggers.

211. Usāmah, p. 94. Cf. the description of Bohemond by Anna Comnena, *Alexiad,* p. 347.

212. Usāmah, p. 104.

213. Bahā'-ad-Dīn, p. 282.

214. Joinville, p. 134.

215. Abū-Shāmah, V, 34.

216. Usāmah, p. 80. Frankish arms are described by Anna Comnena, *Alexiad,* p. 341.

217. Ambrose, p. 119; *Itinerarium,* p. 338.

218. *Girart de Roussillon: chanson de geste,* ed. and trans. Paul Meyer (Paris, 1884), p. 93.

hauberk mentioned as "white and tough and stout"[219] may not have had this lacquer or protecting coat, since the gum usually carried some coloring matter. Swords and helmets were burnished to keep them clean and rust-free. The twelfth- and thirteenth-century swords in the Bavarian National Museum at Munich are wonderfully preserved. The blade is quite stout, with sharp hacking edges and a good point. The hilt is a crosspiece of metal—not hollow—and below this is the grip; the *pom* or counterweight is at the end. One wonders how the Saracen sword in the *Chanson de Roland* could have had "mil mangon entre les helz."[220] A small knife might be carried in the chauce, Scots-fashion.[221]

Many sumpter or pack animals accompanied an army. Some of these would be sent over a field of battle for gathering up the dead for burial;[222] otherwise beduins would swarm over the area and strip from the bodies all that they could use.[223] Richard, when in the Holy Land, did some head-hunting on the field of battle,[224] as a means of frightening the enemy; doubtless it provoked some reprisals. Men called *herbergeors* were sent ahead of the army to prepare for a stop.[225] They unloaded the tents from the pack animals and saw that they were unfolded. If the enemy pressed hard at that moment it was difficult to repack in a hurry.[226] As in Europe, siege engines were too heavy to transport; when required, they were built by *engignieres* on the spot, and were destroyed by fire when the siege was lifted.[227] The author of *Gerbert de Mez* writes of Maurin, an engineer who had been trained in Outremer, "he knew more about wood than a clerk did of Latin."[228] Ambrose speaks of an engine which threw a stone that took two men to carry, and goes on to say that these stones penetrated a foot deep into the ground when they landed. He claims to have observed how on one occasion a knight was hit in the back and did not even receive a bruise, as it so happened, by a rare chance, that the force of the

219. Ambrose, p. 149.
220. *Publications of the Modern Language Association,* LIII (1938), 34-37.
221. Philip of Novara, p. 19.
222. "Eracles," p. 44.
223. Usāmah, p. 67.
224. Ambrose, p. 121. See also *Gesta Francorum et aliorum Hierosolimitanorum,* ed. and trans. Louis Bréhier as *Histoire anonyme de la première croisade* (Paris, 1924), pp. 96-97, and Anna Comnena, *Alexiad,* p. 270, for earlier instances.
225. Ambrose, p. 85.
226. Usāmah, p. 40.
227. Philip of Novara, p. 80; "Eracles," p. 110, reports that Saladin did the same in 1187 after failing to take Tyre.
228. *Gerbert de Mez,* p. 72, v. 2724: "Plus sot de fust que nus clers de latin."

throw was spent at that very point.[229] Usāmah tells how a stone from a Frankish *perriere* crushed a man's head when it made a clean hit there.[230] Wooden towers, on wheels and covered with hides, were used for surmounting the walls of a besieged town, as were ladders.[231] Battering rams with metal heads were used against walls.[232] For checking the progress of the enemy, particularly at night, nets might be stretched and traps set.[233] Where a trench was required for holding a defense line, it was dug long, deep, and wide, and braced with timbers, while targes and long shields were placed along the upper edge for added protection.[234] Timber supports were used for destructive purposes as well. The wall of a town could be undermined by digging a trench at its base and shoring this up with timber supports as the sappers worked. When the wooden beams were set on fire, the sudden withdrawal of support would cause the wall to collapse.[235] Saracens were not above putting poison into wells; the Franks must have done the same.[236]

The principal reason for a castle was to serve as a forward point for attack against the enemy.[237] All the cities except Sidon, which received its crusader walls in 1227-1228, were well fortified, but the great castles were located nearer Moslem territory. East of the Dead Sea was Kerak, or Krak of Moab, south of it Krak de Montréal (ash-Shaubak). These made splendid points of support from which to attack caravans to and from Egypt, and they were used against the wild beduins. As crusader castles were usually on an eminence, one could get a view of neighboring castles. From Krak des Chevaliers both Chastel-Blanc and 'Akkār were visible; from Subaibah, the castle of Belfort. Signals could be exchanged by bonfires. From the Moslems the lords had learned to use carrier pigeons. In Acre there was a *colombier de l'Hospital*, the name of which speaks for itself. In 1271, when Baybars was laying siege to Montfort, he killed a pigeon which was conveying a message to the besieged from a Frankish spy in his camp. There is a passage in the *Chanson de Jérusalem* in which

229. Ambrose, p. 55.
230. Usāmah, p. 144.
231. Fulcher of Chartres, trans. Ryan, pp. 119-120, 153.
232. Ambrose, p. 58.
233. *Itinerarium*, pp. 102-103.
234. Ambrose, p. 49.
235. "Eracles," pp. 84-85; Fulcher of Chartres, trans. Ryan, p. 253.
236. Abū-Shāmah, V, 57.
237. R. C. Smail, "Crusaders' Castles of the Twelfth Century," *Cambridge Historical Journal*, X (1950), 143-144. On the castles see Paul Deschamps, *Les Châteaux des croisés en Terre Sainte* (2 vols., Paris, 1934-1939; vol. III now in press).

king Cornumarant sends out pigeons, all of which are captured or killed.[238]

The crusader castles were not slavish imitations of what the French, English, Italian, and German lords had left behind them in the west of Europe. They incorporated in their construction new influences from the Byzantines and from the Moslems. A European castle of the smaller type was primarily a tower set upon a hillock called a *motte,* surrounded by a curtain wall. Space between the wall and the tower was the court, which was often used for kitchen supplies on the hoof. A large European castle might have a rectangular keep in the midst of a wide court or bailey surrounded by a wall and moat and, at times, by a second wall beyond the moat. Other buildings would be built inside the bailey. Such strongholds were usually occupied by the castellan and his family, and the comforts of home were not neglected. But in the Near East the crusader was confronted with the need of housing larger bodies of men and of storing the vast supplies required for the forays. Then again, as the military orders secured control there was no longer any thought for the comforts of "home." The donjon or keep began to be placed in the weakest spot for defense; the storerooms were set in the middle of the court. Crusader castles were apt to be built massively on great heights. An example of such design carried to France by Richard the Lionhearted was Château Gaillard at Les Andelys, on the Seine below Paris; there is a rugged rocky court, with underground stables, storage buildings, and the keep on the very edge of the drop, all of which was reminiscent of the Holy Land. The inner chamber of the castellan might be attractively done, with bays and sculptures. The tympana of the windows were often beautifully carved, as they were back in Europe. The castle had its big hall or *salle*; at Krak des Chevaliers this opened onto a gallery or cloister portico. There were plenty of latrines: at the end of a narrow corridor at Krak des Chevaliers there were twelve toilet seats with a drain underneath. Castle construction after 1187 shows round towers and smooth stonework.

The crusader castles had mills for operation by human hands, animals, and even wind: there was a windmill on a tower of the outer wall at Krak des Chevaliers. The water supply was most important; aerial reconnaissance has confirmed the fact that there were wells some thirty miles apart up the whole inner line of the Palestine-Syrian area. During the rainy season, the occupants of the castles collected water in great artificial reservoirs of Moslem design

238. Deschamps, I, 99, note 1, and see I, 89-103, for "Les Conditions de l'existence dans les châteaux-forts."

(*berquils*, from Arabic sing. *birkah*). The Christians took care also to drain off the water from their terraces through terra-cotta drains into cisterns, which were constructed at a safe depth. Krak des Chevaliers and Krak de Montréal had wells also. A berquil in the open air could be used for bathing or for watering animals. Between the first and second walls of Krak des Chevaliers there was such a berquil, but usually these reservoirs were set outside the castle proper. An aqueduct sometimes brought water from a nearby summit to the berquil, as was the case at Krak. Chastel-Blanc stood on a hill more than a thousand feet above the valleys below. There were barbicans, on man-made hillocks, and then one approached the great outer wall, which was polygonal with three rectangular towers. This was entered on the northern side, past a barbican and then past a flanking tower. The large enclosed area must have been full of storehouses of all sorts of construction. In the very center was a rectangular donjon of which the immediate curtain wall was irregular in shape, somewhat resembling a maze. The entrance through this was not immediately obvious, and overlapping stretches of wall made it possible for defenders to catch attackers at a disadvantage. The lower floor of the donjon was a church. Above this was the hall where the occupants, the Templars, lived. Food must have been carried up through the church, and there was no water supply on the upper floor. It is not surprising that this donjon fell so easily when attacked in 1271.

Some details on the fortifications of Jerusalem concern us. This city extended lengthwise from north to south upon several low hills and was strongly provided with defense works.[239] There was a moat outside the rampart bristling with covered ways or barbicans. The city had seven gates, of which six were heavily bolted every night until sunrise. The seventh gate was walled shut and opened only on Palm Sunday and on the day of the Exaltation of the Holy Cross. The city wall had five corner angles; within the west gate, which was obtuse, was the Tower of David, which had annexed to it an upper gallery or solar and a newly constructed hall, well supplied with moats and barbicans.[240] It was the property of the king of Jerusalem. The squared stones of this tower were of extraordinary size, set with lead and with great bands of iron fastened from one block to the other "que a trop grant painne et a trop grant force la porent ruer jus."[241]

239. Phocas, p. 17.
240. Theoderic, p. 6; cf. Phocas, p. 18.
241. "Eracles" (manuscrit de Rothelin), p. 530; cf. Fulcher of Chartres (trans. Ryan, p. 117), who says the masonry blocks were "sealed with molten lead."

Turning to naval warfare, we cannot with certainty identify the types of ships used. There were *dromons, galions,* galleys (*galees*), and barks (*barches*), in that descending order of size,[242] as well as *catos,* for carrying siege engines.[243] The dromon was a heavy transport. The term *botsa* is applied occasionally to a Saracen galion;[244] Richard attacked a large fleet of these with forty of his own lighter-armed vessels and was victorious. A division of galleys might be termed a "caravan"; on one occasion the Genoese are reported as having a caravan of four galleys and on another one of nine.[245] Some of these vessels had narrow slits through which crossbowmen could shoot;[246] larger ships might be crenelated also—probably on the front and rear castles.[247] The largest galley could hold some five hundred men, including three hundred oarsmen;[248] it was intended for swifter movement than the dromon.[249] King Richard's galley at Jaffa was painted red, its deck was covered over with red awning, and it flew a red pennon.[250] Ibn-Jubair mentions a bark with four oars.[251] Probably all these vessels had oarlocks made of cords or rope. These galleys, or the larger galions, were the ships best suited for naval combat. Like the heavy transports, they must have had a long deck and a single mast with a single sail placed amidships, suitable for tacking.[252] Platforms stood fore and aft, where awnings could be stretched if there was no permanent roofing. There must have been a second deck, for a true galley had to provide space and seats for the oarsmen. The galley and the galion never had more than two banks of oars on each side—one bank to a deck. Shields were set along the gunwale on the upper deck, and sand and vinegar were carried on board for putting out Greek fire.[253] The oarsmen may have been slaves or prisoners even at so early a date as the crusades.

The most formidable weapon in all sea fights was Greek fire. Attempts were made on every occasion to send flaming arrows and other burning torches into the enemy's ship, while the men on both

242. *Itinerarium,* p. 80.
243. H. S. Fink, notes to Fulcher of Chartres, trans. Ryan, p. 296, note 3, with references.
244. Abū-Shāmah, V, 12 (Arabic, *butsah*).
245. Philip of Novara, p. 80.
246. "Eracles," p. 106.
247. *L' Histoire de Guillaume le Maréchal . . . ,* ed. Paul Meyer (3 vols., Paris, 1891-1901), I, 348, vv. 9645-9668.
248. Joinville, p. 47.
249. "Eracles," p. 169.
250. Bahā'-ad-Dīn, p. 370.
251. Ibn-Jubair, p. 327.
252. *Ibid.*
253. *Itinerarium,* p. 81.

sides stood ready to shoot stray individuals and to prevent boarding.[254] A certain amount of ramming must have been practised, but this was no longer the efficient attack that it had been in the ancient world. Ships did not have the proper metal beaks for the purpose, and their crews could not develop sufficient speed at the oars. The captain of a ship stood aft on the deck, where he could handle a double steering oar [255] and direct the use of the capstan, a wheel with projecting marlin spikes which turned perpendicularly to the deck, not horizontally. The mast could be easily stepped with the aid of a rope around the drum of such a wheel, and by the same means a heavy sail could be raised or lowered. Presumably the kegs of Greek fire were lifted through a hatch from the hold. The owner or chief guest would repose under the awning of the rear castle, from which he could watch fascinated by the drive and labor of the oarsmen. The anchor was carried on the side of the ship's bow.[256] In the defense of harbors it was not uncommon to employ fishermen, who would stretch their nets underwater to catch swimmers;[257] for instance, a Turkish swimmer who was carrying Greek fire in a *pelle lutrina* was thus intercepted at Acre. Entry of strange ships into a harbor was prevented by heavy chains stretched across the entrance towers. Such ships might be privateers or pirate vessels, such as those maintained by Gerard of Sidon, which sometimes pillaged Christians as well as Moslems. (King Baldwin III of Jerusalem, "irrité contre lui," managed to capture and burn Gerard.)[258] The Venetians and Genoese, the crusaders' naval allies, kept control of the eastern Mediterranean until long after the fall of Acre in 1291; it was only this dominance that had enabled the remnant of the Latin states to survive for more than six generations.

254. *Gerbert de Mez*, p. 202, vv. 7526-7544.
255. Ibn-Jubair, p. 336; Joinville, p. 198.
256. As portrayed on many bas-reliefs of ships.
257. *Itinerarium*, pp. 105-106.
258. Michael the Syrian, "Chronique," *RHC, Arm.*, I (Paris, 1869), 354.

II

PILGRIMAGES AND PILGRIM
SHRINES IN PALESTINE
AND SYRIA AFTER 1095

The flow of pilgrims to the shrines of the Near East long preceded and has long survived the era of the crusades; even today that flow has not ceased, as individuals and groups have followed one another throughout the centuries to the Holy Land. One means of transportation gave place to another; walking and riding horseback overland were abandoned for the quicker and safer passage by Venetian or Genoese galley; sail and oar were superseded by steam and electricity; and the ocean liner is now in its turn losing out to the jet airplane. But much has not changed, at least not beyond recognition.

Crusade and pilgrimage are quite different. Neither one begat the other, though at times the purpose of one blended with that of the other: a man who took the cross in order to deliver the sacred shrines from the "infidel" might also have it in mind to visit and pray at them for the good of his soul. But pilgrims had been going to Palestine long before Urban II proclaimed the holy war at Clermont in 1095,[1] and they continue to go today. Western crusading is dead; western pilgrimage is still alive.

These two manifestations of medieval Christianity were grouped together for the first time in Urban's speech. The pope twice used the term *peregrinari*, making clear that he looked upon the movement to which he was summoning the warriors of the west as an "armed pilgrimage." The ensuing First Crusade, which captured Jerusalem in 1099, set the background and to some extent determined the day-by-day procedure of subsequent pilgrimages, even those undertaken when the holy places were again under Moslem

1. For pilgrimages to Palestine before 1095 see the account by Sir Steven Runciman in volume I of this work, pp. 68-78.

rule. Possession of the holy city enabled the church to define the *loca sancta* and determine what measure of indulgence should be accorded supplicants at each one. And the completion of the church of the Holy Sepulcher by the crusaders about 1168 suitably enclosed the tomb of Christ, the chief goal of Christian pilgrims, and presented to newcomers from the west a church whose ground plan, ambulatory, and arched entry into the rotunda must have been familiar.[2]

Two other outgrowths of the crusaders' victory were to enhance the well-being of the voyaging pilgrim. One was a duty performed by the two religious orders, the Hospitallers and the Templars, the guardianship of the pilgrim routes to the holy city. Unescorted bands of pilgrims going to or returning from Jerusalem, and at times even armed volunteers for the Christian army, were attacked, robbed, and often murdered by beduin brigands. Such attacks the two orders undertook to prevent. The second improvement was the provision for housing, feeding, and medical care of so large a transient population making *le sainte voyage de Jherusalem*. The journey was long and arduous, particularly for those of advanced years. On the way there were no conveniences, so that pilgrims must often have arrived worn out from the fatigues of the journey, in need of rest and of medical attention. While *hospitia* existed in Jerusalem before the Latin kingdom, only under the crusading kings did the great Hospital of the Knights of St. John of Jerusalem provide an infirmary for the sick and lodging for the healthy.[3]

In these ways the successful outcome of the First Crusade and the almost century-long possession of the holy city and Holy Land fostered pilgrimage, and determined and molded the form of its

2. At the beginning of the twelfth century the crusaders built a large Romanesque church which embraced all the chapels and holy places. Destructive acts were committed within this church in 1187, at the time of Saladin's capture of the city, and again in 1244 by Khorezmian Turks. The rotunda around the Holy Sepulcher on the west, and a church with a semicircular choir on the east, are remains of the church of the crusaders; see chapter III, below.

3. The early meaning of "hospital" is the same as that of "hospice," a house for the reception of pilgrims, not necessarily a place for the care of those who were ill. Such a building was authorized by pope Gregory the Great about 600, and was erected in Jerusalem in the locality immediately south of the church of the Holy Sepulcher, now known as the Muristān (Arabic, "madhouse." possibly used by the Moslems as a term of derision). If not destroyed by the Persian sack of the city in 614, it must have been in very bad repair. Two hundred years later Charlemagne had it restored or rebuilt. About 1023 the merchants of Amalfi obtained permission to found an asylum for pilgrims on the site of the previous building of Gregory I. On the arrival of the crusaders, Gerard of Provence, who had been rector of the asylum before the capture of the city, was promoted to the headship of a new order of Hospitallers. The mastership of his successor Raymond of Le Puy saw the erection of the new convent of the order.

expression. Without the support of Latin military power and of the church, its subsequent history would have been altogether different. True, the Moslem conquest of Palestine affected it adversely; pilgrims were no longer free to ramble within or roam around the city. Al-Ḥarām ash-Sharīf, the old Jewish Temple area, and all mosques were forbidden ground to them; they were not allowed to ride horses or to carry arms. They had to be prepared during their sojourn to put up with occasional insults and curses. And of course, they had to pay the head tax levied on every pilgrim who set foot in Palestine. They had to beware—as must every modern traveler in the Near East—of being overcharged, though probably the native Christians—Orthodox, Armenian, and Nestorian—were every bit as rapacious as the Moslems.

Allowing for all the changes, however, which Moslem suzerainty wrought in the life of the pious visitor, his daily round remained pretty much what the First Crusade had shaped for him. The governor of Jerusalem forbade the carrying of weapons, and prescribed for the infirm or sedentary the humble ass or donkey, but not the horse. Yet the pattern of pilgrim activity and procedure remained much the same through the centuries, and remains so today. The Roman Catholic pilgrim pays his devotions at the stations of the Via Dolorosa much as his fellow did eight centuries ago. The pilgrimage may be understood better, however, not by cumulating generalities, but by following in the footsteps of the individual pilgrim: walking beside him up the gangplank of his ship; enduring with him—in imagination—the poor rations and the seasickness on a Venetian or Genoese galley bound for Joppa (Jaffa); being amazed and daunted by the wild cries of the native vendors; suffering the internal rumblings and qualms produced by strange wines and victuals; and finally, if fortunate in escaping the diseases bred prolifically in Palestine, undergoing the anticlimactic stress of the long haul home.

Pilgrimage to Jerusalem, whether made singly or in groups, was never without its risks, but the risks were somewhat less if it was undertaken with the blessing of the church. The individual might initially be urged to visit the shrines of Palestine by the admonition of his own conscience or by the encouragement of his confessor,[4]

4. Runciman (*op. cit.*, p. 72) points out that the idea of pilgrimage was encouraged by the appearance of numerous little books written by churchmen recommending private penance, the *Poenitentialia*. The *Poenitentialia* helped spread the idea of pilgrimage as a means of penance, perhaps a more popular penitential exercise than many a confessor would impose. Runciman remarks that these little books did not recommend specific destinations for pilgrimage, but the absence of a destination in such a manual is in no way remarkable. The confessor, not the manual, was to indicate the destination of an imposed pilgrimage.

but having made his decision to go, he was in the hands of the church, and must receive permission from the pope, through his proper local officials, to depart.[5] Indeed, one who set out for the Holy Land without the *licentia Romani pontificis* was risking the loss of a number of benefits granted by law and the church: a three-year truce for the security of home and property; assurance against civil and criminal suits during his absence; the grant of stays in suits brought against him for debt; a letter granted by his diocesan bishop commending him to the hospitality and charity of hostelries and religious houses on his road; and access to special facilities for borrowing money.[6]

It is clear, therefore, that the church was the *fons et origo* of pilgrimage, regulating and supervising its practice;[7] at times inciting men to attain a higher state of holiness by taking the pilgrim staff and scrip; at other times commanding them publicly to assume the pilgrim habit if they wished to avoid the greater excommunication for heinous sins. Excommunication, however, was less and less resorted to as time went on. Their own fears, not public anathema, sent thousands on the *passage d'outre mer*. Many went to make sure of their salvation. Probably a greater number, such as Ogier of Anglure,[8] went because their confessors urged them so to do. Fewer, perhaps, were those whom sheer devotion, not contrition or anxiety, impelled; who went *pour l'amour de Dieu* to behold the places where Jesus suffered for their sake.

During the existence of the kingdom of Jerusalem there must have been many a mercenary or free companion who enlisted in the contingents of the crusading princes without bothering his head about the *benedictio crucis*. After its fall one can be certain that many a Venetian or Genoese entrepreneur sailed on one of his own trading ships to correct some business maladjustment at Jerusalem or Joppa with no thought whatever of episcopal license or priestly

5. There seem to have been, on nearly every trip from the Italian cities to Palestine, however, a few who, for one reason or another, had failed to obtain this papal permission. This they could belatedly receive from the Custos Terrae Sanctae, who was empowered to grant absolution for this fault of omission; see "Journal de voyage à Jérusalem de Louis de Rochechouart, évêque de Saintes (1461)," ed. C. Couderc, *ROL,* I (1893, repr. 1964), 239: "Primum quidem, absolvit eos qui, sine licencia Romani pontificis, ad Terram Sanctam appulerant."

6. See Émile Bridrey, *La Condition juridique des croisés et le privilège de croix* (Paris. 1900) for a full discussion of these and other benefits, especially as they applied to crusaders, but not excluding other pilgrims.

7. The correctness of this last statement is attested by the number and variety of the indulgences attached to Palestinian *loca sancta*; see below.

8. See H. L. Savage, "Fourteenth Century Jerusalem and Cairo through Western Eyes," in *The Arab Heritage,* ed. N. A. Faris (Princeton, 1944), pp. 200-202.

blessing. But despite their presence on many of the pilgrimages, this
chapter has little to do with such mavericks: its concern is with the
bona fide pilgrim, man or woman.

At the start of a typical pilgrimage the potential pilgrim, whether
prompted by pure devotion or by the fear of spiritual penalty,
announced his intention to his parish priest (probably after con-
siderable family discussion and a careful analysis of his financial
resources). Priest and parishioner settled the day on which his
consecration as a pilgrim should take place in the parish church. In
the interval the priest probably communicated with the diocesan
bishop for the issuance of letters of commendation under the
episcopal seal addressed to civil and ecclesiastical authorities to attest
the bearer's *bona fide* character.[9]

On the day appointed the prospective pilgrim repaired to the
parish church. There he first made confession, after which the service
of consecration, *ordo ad servitium peregrinorum*, began. The
candidate prostrated himself before the altar while Psalms 24, 50,
and 90 were chanted over him, after which came the *Gloria Patri* and
the *Pater Noster* and a number of pious ejaculations to the effect
that God would protect his servant's footsteps. After the candidate
had risen to his feet, there ensued the blessing of scrip and staff and
the *Benedictio crucis pergentis Hierusalem* with its prayer *Deus
invictae potentiae*. The priest then placed over the pilgrim's shoulders
the pilgrim scrip, which hung down at his side, saying a prayer as he
did so, and sprinkling his garb with holy water. If he was Jerusalem-
bound the pilgrim next received a cowl with a red cross stitched to it,
the priest praying as he gave it: "Accipe vestimentum, cruce Domini
Salvatoris nostri signatum; ut per illud salus, benedictio et virtus
prospere proficiscendi a sepulchrum ejus tibi comitetur. Qui cum
Deo Patre, etc." He then put into the pilgrim's hands a staff,[10]
uttering the prescribed prayer. The mass for pilgrims (*pro iter
agentibus*) followed, during which the pilgrim made an offering. The
mass over, the priest uttered two final prayers over the pilgrim, now
prostrate before the altar, after which he partook of Communion, *et
ita recedat in nomine Domini*.

9. One occasionally comes upon the statement that it was necessary for a lay pilgrim to
secure the blessing and permission of his diocesan before setting out on his journey. There
seems, however, to be no instance of such a requirement in the narratives of the travelers.
Apparently all that was necessary was the sanction of the parish priest, who would in any
case report to the bishop before the issuance of the letter of commendation; if the bishop
disapproved of the journey, he had ample power to forbid it.

10. The *baculus,* a long staff having a metal point at one end, useful against unarmed
footpads and aggressive dogs.

After leaving his parish church, the pilgrim need have been in no uncertainty as to the path to follow. Even if he were illiterate, those who had blessed his going forth could have directed the first few stages of his journey, and when he had arrived at the last of these, there were advisers to point out his next stopping-place. Wynkyn de Worde's *Information for Pilgrims unto the Holy Land*, printed about 1498, which charts the distances between the French and Italian towns on one's road to Rome, and from Rome to Venice, the most popular port of embarkation, is an epitome of previous guides no longer extant, as well as a printing of information handed down through the years by word of mouth. Sir Steven Runciman in a previous volume of this history has described the land routes taken by pilgrims up to 1095, through the Holy Roman and Byzantine empires and across the Fāṭimid frontier, and thence to Jerusalem. [11] But the pilgrims of the twelfth and later centuries pursued their journey by sea, and the chief ports they sailed from were Genoa, Marseilles, and Venice. These, though distant for northern French, German, Flemish, or English travelers, were accessible by well-known and marked roads, which were dotted with hospices for the reception of pilgrims on journeys of devotion. There were two main reasons for the greater popularity of sea transportation: the Turkish conquests in Anatolia and Syria, and a rapid growth in the capacity of the Mediterranean ports to handle passenger transportation to Egypt and Palestine.

In order to focus attention upon the experiences encountered by a pilgrim and the problems he was called upon to meet, let us follow two who went to Palestine, one in the fourteenth and the other in the fifteenth century, Leonard Frescobaldi of Florence (*fl.* 1384) and canon Peter Casola of Milan (1427-1507). Possibly they are not wholly representative cases, for their journeys were rendered somewhat easier by a wide acquaintance with influential fellow-countrymen. Casola, a Milanese, lodged with a compatriot, a merchant living in Venice, while Frescobaldi put up at a relative's house. [12] For the ordinary pilgrim who lacked friends or connections in Venice, the state provided the piazza guides or *tholomarii*, who met the pilgrim on his arrival at the Rialto or the Piazza San Marco. Their duty was to conduct him about the city, find him lodgings, aid him in the exchange of money, and introduce him to the *patroni* or shipmasters with whom he was to make an agreement for passage to

11. See volume I of this work, pp. 68-78.
12. L. Frescobaldi, *Viaggio in Terrasanta*, ed. Cesare Angelini (Florence, 1944), trans. T. Bellarini and E. Hoade in *Visit to the Holy Places of Egypt, Sinai, Palestine, and Syria in 1384*, pp. 29-90 (Jerusalem, 1948), p. 32.

Palestine and back; in brief, to help him in every possible way while he sojourned in the city, accepting only what the pilgrim gave of his own free will, without solicitation, and no more. Aristocrats who knew few or none of the Venetian nobility were careful to provide themselves with letters of introduction to members of the signory, which often obliged by assigning to the noble petitioner a galley for the use of himself and his retinue—of course for adequate compensation.[13]

"The pilgrims, whether Italian or ultramontane, who chose Venice as their port of embarkation, came on foot or on horseback as far as Pavia or Padua, Treviso or Mestre, according to the route selected, and then performed the rest of the voyage to the lagoon city by river or canal. Those who had come on horseback generally either sold their horses, or left them with an innkeeper, or a friend, to be kept for them till they came back."[14]

One of the first steps after arrival in Venice was to get one's money exchanged into currencies acceptable in the Levant. Indeed, after the fall of Jerusalem the Venetian commercial houses which had branches in Palestine struck a gold coin, the *byzantinus saracenatus,* for the express purpose of trade with the Moslem hinterland. Until 1249, when pope Innocent IV protested their issue, these coins bore Arabic inscriptions, a text from the Koran, a reference to the Prophet, and a date calculated from the Hegira.[15] But even though papal horror that Christians should pay such deference to "the false prophet and his accursed law" led to the discontinuance of the *byzantinus saracenatus*, the Moslems were not averse to the gold and silver ducats of Venice, which passed current everywhere in the Levant. Frescobaldi and canon Casola were well supplied with them.[16] Even when a pilgrim found that he had coins in his purse

13. J. Delaville Le Roulx, *La France en Orient au XIVe siècle,* II (Bibliothèque des Écoles françaises d'Athènes et de Rome, no. 45, Paris, 1886), 25, prints the request of Enguerrand VII, count of Coucy, to the senate (May 17, 1396, from the Misti, Reg. 43, fol. 127) for transportation from Venice to Segna (Senj) in Croatia; the request was granted on May 29 (*ibid.,* fol. 137). Enguerrand and his son-in-law Henry of Bar were going to join the crusading army which was to be defeated at Nicopolis.

14. Canon Pietro Casola's *Pilgrimage to Jerusalem in the Year 1494,* ed. and trans. M. M. Newett (Manchester, 1907), p. 351.

15. Ernest Barker, "The Crusades," in *The Legacy of Islam,* ed. Sir Thomas Arnold and Alfred Guillaume (Oxford, 1931), p. 62.

16. The cavalier Santo Brasca of Milan, who journeyed to the sepulcher in 1480, insists that the gold and silver carried by the traveler should be fresh from the Venetian mint, "otherwise the Moors will not accept the coins, even if they were ten grains overweight," and that the shipmaster must be paid in new coins also, for he has to pay the same to the Moors (*Casola's Pilgrimage,* p. 13). This might be true of the tax and customs officials, but the Moors of the streets would assuredly accept any coin offered them.

that he had neglected to change into ducats at Venice, he could turn to the money-changer (*campsor*), who was to be found in any Mediterranean town or port of any size. Not only the pilgrim tours, but even large, well-organized crusades constantly depended upon the money-changers, as shown by the detailed financial records kept by Antoine Barbier, the accountant for the crusade of count Amadeo VI of Savoy in 1366-1367.[17] Frescobaldi informs his readers that he carried a letter of credit, issued by the Florentine banking house of the Portinari, which could be used in Alexandria and also in Damascus.[18]

The amount of money that a pilgrim carried with him varied with his social status, resources, wants, the comforts thought necessary, and the length of his proposed sojourn. Those who wished to visit not only the Palestinian shrines but also that of St. Catherine at Sinai would pay a good deal more than those who planned only the Jerusalem journey. What one paid would also depend upon how comfortably he wished to travel. Thus in 1382 bishop Paul of Agram (Zagreb, in Croatia) requested permission to equip a galley at his own expense for the Palestinian journey. The senate granted his request, though it made an alternate suggestion that if the bishop preferred to take passage in an unarmed sailing ship, instructions would be issued to the Beirut and Alexandrian trading fleets to bring him and his ménage back free of charge.[19] It is not known whether the bishop elected to pay for the return ticket or to plump for the one-way free trip.

From the accounts of travelers who journeyed to Jerusalem after the fall of the crusading kingdom, it is a safe assumption that the wise, affluent pilgrim boarded ship at Venice with not less than two hundred Venetian gold ducats in his purse.[20] Two hundred ducats was more than most pilgrims were able to put up, but Casola's family was a noble one. He had been secretary to the Milanese embassy at Rome, and certainly had private means. Frescobaldi, also of noble

17. Barbier's accounts are published in F. E. Bollati di Saint-Pierre, ed., *Illustrazioni della spedizione in Oriente di Amedeo VI (il Conte Verde)*, in *Biblioteca storica italiana*, V (properly VI, Turin, 1900).

18. *Visit to the Holy Places*, p. 35.

19. *Casola's Pilgrimage*, p. 32, from the Misti, Reg. 37, fol. 67v, dated April 10, 1382.

20. The trip to Joppa and return cost forty-five ducats per person, payable half at departure, half on arrival. Casola, however, desired only the best, and so arranged to pay sixty gold ducats to be kept "by sea and by land" and seated at the captain's table (*Pilgrimage*, pp. 153-154). The advice to carry two hundred ducats occurs in the treatise on travel to the Holy Land by Santo Brasca (*ibid.*, p. 10); Casola had read the work and followed its author's advice about money. On the value of the ducat and other contemporary coins, see B. Bagatti's introduction to *Visit to the Holy Places*, pp. 7-9.

blood, was an important person in his native city; he had held a diplomatic post as Florentine representative on two occasions. Certainly both made the trip more comfortably than the average pilgrim. Yet the Jerusalem journey was by no means impossible to the pilgrim of modest means. He could quite likely obtain a donation for his expenses by promising to pray for the donor at the Holy Sepulcher. The red cross stitched on his garment would not infrequently bring him a meal or a night's lodging from a householder whose village he passed through. At certain spots on his road there were hospices or monastic houses where he would be welcome, and when he arrived at Venice, it might well be that when a shipmaster learned that he was poor, he would agree to carry him for thirty or thirty-two ducats, which would cover passage, hire of donkeys, duties, and tribute. The pilgrim would have to provide food out of his own purse, and perhaps could do so more economically than those with fatter purses. He would have been allowed access to the ship's galley to cook his own meals.[21]

Thus it was possible for rich and poor alike to make the *viaggio in Terra Santa*, the former with some comfort, the latter with less. But woe betide the pilgrim whose money gave out! If he became bankrupt before he reached the Holy Land, he was in serious trouble, but if caught penniless in Palestine, his lot was indeed unfortunate. A modern author draws a vivid picture of the hopeless crowd of famished European pilgrims congregated outside the gates of Jerusalem, through which entrance was denied them by the guards, because their money was gone. Their only hope was the gift of a gold piece by some charitable knight or devout bishop.[22] Though he describes a scene occurring before the First Crusade, the same was true of times long after the fall of the crusading kingdom. The Moslems regarded the fundless pilgrim much more unfavorably than we regard the stowaway, whom we brusquely return to his place of origin; the Mamluks gave themselves no such trouble, but treated him as one subject to their own laws and whims. Their usual custom seems to have been to force him to abjure his own faith and embrace theirs. Father Mariano of Siena utters this direful warning: "Let him not go to Palestine who has not means, or woe to his skin He would be sawn in twain, or other pilgrims would have to pay for him, or he would have to renege our faith."[23] The Egyptian sultans were

21. *Casola's Pilgrimage*, pp. 12-13.

22. C. R. Conder, *The Latin Kingdom of Jerusalem, 1099 to 1291 A.D.* (London, 1897), pp. 1-2.

23. *Viaggio in Terra Santa* (Florence, 1822), pp. 13, 130, trans. B. Bagatti, *Visit to the Holy Places*, p. 7.

quick to realize that to forbid access to the holy places would be to deprive themselves of a rich revenue. They charged each pilgrim what the traffic would bear, and it would bear a good deal.[24]

Having escaped the clutches of the money-changers, who no doubt paid back to the pilgrim less than he paid in to them, he was ready to board his galley. As the most convenient point of departure for the Levant, Venice became, and for several centuries remained, one of the wealthiest cities of Europe. Its senate found it advisable to take under its close supervision the whole business of Palestinian pilgrimage, the protection and guidance of those who came to the city semi-annually, the construction of transport vessels, and the regulation of shipowners. To control the traffic, which increased steadily through the years, the senate decreed that each year there should be two *passagia ad Palestinam*, a *passagium vernale circa mensem Martium* and a *passagium aestivale in mense Junio aut Julio*.[25] Throughout the years these sailings varied as to the times of departure. Thus Theoderic, who was in Palestine in 1171-1173, went at the vernal sailing, rather than the summer sailing in August[26] (apparently a sailing booked for June or July did not leave port till the end of August). In 1441 the senate increased the price of licenses for galleys destined for the pilgrim service, and ordered the *passagium vernale* to run from January 1 to June 30, and the *aestivale* from July 1 to December 31.[27] Though these dates were well known beyond the bounds of Italy, and would probably apply to the majority of those going to Palestine in a particular year, one cannot help being struck by the number of those to whom the Venetian state offered transportation at times other than these biannual passage dates. Any person of importance from a foreign land that had trading relations with Venice, or any group of pilgrims who could exert influence upon the senate, appears to have been granted a galley, for which he or the group was duly billed, unless the senate deemed it advisable to favor persons "of such great power and reputation."[28]

24. They realized also that the barring of pilgrimage might lead to interruption of east-west trade. They probably were not greatly affected by the prospect of hostilities; crusading days were over.

25. For a description of these two *passagia*, see Charles du Fresne du Cange, *Glossarium mediae et infimae latinitatis* (rev. ed., Paris, 1938), VI, 195.

26. "Theoderich's Description of the Holy Places," trans. Aubrey Stewart, *PPTS*, V-4 (London, 1896), ix.

27. M. M. Newett, introduction to *Casola's Pilgrimage*, pp. 69-71. The dates given cover each entire "passage" and do not imply that there were frequent passages, especially in the winter months.

28. *Ibid.*, pp. 31-36, 46-48.

On his arrival in Venice, as he walked across the piazza, the ordinary pilgrim would find himself heavily solicited by the sailors of the different galleys on the point of sailing to the Levant, to engage passage on some particular boat. Having selected his galley, he signed with the *patronus* (shipmaster) [29] an agreement for transportation to the Holy Land and return. The contract signed provided a good deal more than the mere return ticket. It covered all taxes imposed by the Moslem rulers, the price of the safe-conduct, the rental of donkeys for the several journeys, and the regular and expected tips to the Moslem guides and animal attendants. The contract signed, the pilgrim and shipmaster proceeded to the palace of the doge to register it and their names and ranks with the state prothonotaries.

These preliminaries over, the pilgrim went aboard. His vessel was a merchant galley, about 175 feet long and 70 feet wide, capable of carrying 170 paying passengers, or merchandise when the pilgrim season was over. The mainmast carried one large square sail, while a small bow mast, the *trinquetto*, and a stern mast taller than the *trinquetto*, the *mezzana*, were lateen-rigged. On either side of the deck were the rowers' benches, with thirty oars on the port and twenty-seven on the starboard sides. The deck between the benches was crowded with merchandise or supplies for the journey, or even with animals penned up and destined for consumption. Below the deck was the hold, reached by several companionway ladders. Within the hold the passenger set his mattress down on the planked floor, as near the middle of the galley as he could get it, and near the middle door, in order to breathe a little more fresh air. [30] In the stern of the vessel was a roofed superstructure of two floors called the "castle."

The first floor of this superstructure was on a level with the tops of boxes and crates so arranged in the middle of the ship that one could walk over them from bow to stern. Within the castle on its first floor were three tables, two at its sides and one in the center—the dining salon. When the trumpeters blew four blasts, there was a general rush to get seats. Nearly always someone was late and had to sit outside the castle on one of the rowers' benches and eat in whatever weather there was, sunshine, wind, or rain. After having dispatched, if he could, what was placed before him, he could enjoy (or not enjoy) the sight of the shipmaster, the captain, and others of influence sitting down to a better cooked and served repast at a table in the rear of the castle, farthest removed from wind and weather.

29. *Patronus* is often erroneously translated as "captain" (*capitaneus*); he was the owner's representative, the shipmaster.
30. *Casola's Pilgrimage,* p. 12, in Santo Brasca's advice.

When meals were not being served, the first floor of the castle served as the cabin for the captain and shipmaster. From the forward portion of the second floor, which was covered by a tent, the shipmaster and the officers could see all that was happening on the lower deck. At the rear of this floor was fixed the compass, whose observer sang out directions to the steersman.

Below the first floor of the castle a companionway descended to a lower deck, where some tackle and arms were kept, as well as the shipmaster's treasury, and into which female passengers were herded for the night—one imagines hardly to their comfort, for ventilation was of the poorest. On the starboard side of the galley was the kitchen, occupying a space from which the rowers' benches had been removed, quite open to the air, and near a pen for animals destined for eating. Probably the tempers of the cooks were none of the sweetest, for cooking two large meals a day under the sky, in hot weather or in rain, must have been a trying business.

But what of the pilgrims? There is little evidence that any pilgrim enjoyed the trip to Palestine, and a great deal of evidence that they positively hated it. Their sleeping quarters in the hold were cramped; one and one-half feet was the allowance for each mattress, and that space was chalked out on the deck of the hold. At each pilgrim's feet were his chest and chamber-pot, so two long lines of chests and chamber-pots running the length of the hold greeted the eyes of him who had climbed down the companionway ladder. There was little to attract anyone below during daytime, but at bedtime it was thickly populated. Each pilgrim with his lantern began the arrangement of his bed, and of bedmaking as of philosophy *quot homines tot sententiae*. In the process quarrels frequently arose, one pilgrim claiming that his fellow's mattress overhung part of his territory, and the second denying it. These sometimes led to fisticuffs, especially if drunken Flemings were a party to them. "Some," says Felix Fabri, "after all lights are put out, begin to settle the affairs of the world with their neighbors, and go on talking sometimes up to midnight." [31] Particularly irritating were the latecomers, who brought in their lanterns and got to bed with considerable conversation. Fabri had once seen an irate pilgrim throw his chamber-pot at an offensive lantern, an action which in itself did not foster quietness. In addition to these annoyances there were others: the excessive heat of the hold, causing one to sweat all night, which, Fabri assures us, "greatly mars one's rest"; smells of various origins; the presence and activity of

31. "The Wanderings of Felix Fabri" [trans. Aubrey Stewart], I, *PPTS*, VII (London, 1887), 155.

fleas, lice, rats, and mice; and the noise of restless sleepers who talked and snored, and of the sick who moaned, coughed, and cursed. Sometimes one had to rise in the night and take the long march to the latrine in the ship's bow, where there were two places only, both exposed to the wind.[32]

Often day was no more comfortable. If there was a fresh breeze blowing and much motion on, "the pilgrims are made dizzy and sick, and all within them is shaken so that they vomit up all that is in their stomachs, and their bowels are entirely upset."[33] When the ship heeled over, it was sometimes necessary for a pilgrim who was trying to enjoy a siesta to rise and shift his bed, placing his head where his feet had been. Any moderate wind would blow smoke from the kitchen into the hold. The meals were hurried affairs, cooked, as one would expect, in the Italian way, and therefore not to the liking of a German like Fabri. When on the high sea away from any harbor where fresh bread could be had, "twice-baked cakes" were served, "hard as stones." Wine was plentiful, "sometimes good, sometimes thin, but always well mixed and baptized with water."[34] The meat served left much to be desired, for it came from animals in the ship's pen which were quite noticeably dying, possibly diseased sheep. "They slaughter any animal which they see is sick and will soon die of itself."[35]

Under conditions such as these, a careful pilgrim brought with him extra foodstuffs and medicaments to piece out the inadequacies of the table d'hôte and to ease any indispositions or minor illnesses resulting from the sea voyage. Canon Casola, who journeyed to the Holy Land in 1494, was careful to provide himself with a large and well-selected larder and an adequate medicine chest. He had the great advantage of being a bookish man and living in a bookish town, Milan. He did not, therefore, have to learn what to take with him by bitter experience, since the written accounts of previous travelers were accessible to him in his native city. He must have read the *Viaggio in Terra Santa* (about 1459) of Robert of Sanseverino, who went as a pilgrim in 1458. It seems fairly certain that he had read carefully the account of the journey made in 1480 by his fellow townsman, Santo Brasca, which had been printed in 1481.[36] Indeed, Casola might have had no need to read Santo Brasca's book, for in

32. Jules Sottas, *Les Messageries maritimes de Venise aux XIVe et XVe siècles* (Paris, 1938), p. 169.

33. Fabri, in *PPTS,* VII, 156.

34. *Ibid.,* VII, 153.

35. *Ibid.,* VII, 154.

36. *Casola's Pilgrimage,* pp. 7, 9-10.

the year that Casola left for Jerusalem its author was living in Milan, a man of note, twice quaestor of Milan and ducal chancellor under Ludovico (il Moro) Sforza.

Brasca laid down clear instructions for the traveler who wished to make his journey with reasonable ease and safety:

Let him take with him a warm long upper garment to wear on the return journey, when it is cold; a good many shirts, so as to avoid lice . . . and also tablecloths, towels, sheets, pillowcases, and suchlike.

He should go to Venice, because from there he can take his passage more conveniently than from any other city in the world. Every year one galley is deputed solely for this service;[37] and although he may find it cheaper to go on a sailing ship, he should on no account abandon the galley. He should make an arrangement with the captain [that is, the shipmaster], who usually requires from fifty to sixty ducats.

Next he should cause to be made an overcoat reaching down to the ground to wear when sleeping in the open air, and buy a thin mattress instead of a bed, a long chest, two barrels—to wit, one for water, the other for wine—and a night-stool or covered pail.

Let him take a supply of good Lombard cheese, and sausages and other salt meats of every sort, white biscuits, some loaves of sugar, and several kinds of preserved sweetmeats, but not a great quantity of these last because they soon go bad. Above all he should have with him a great deal of fruit syrup, because that is what keeps a man alive in the great heat; and also syrup of ginger to settle his stomach if it should be upset by excessive vomiting, but the ginger should be used sparingly, because it is very heating. Likewise he should take some quince without spice, some aromatics flavored with rose and carnation, and some good milk products.

When he goes ashore in any place, he should furnish himself with eggs, fowls, bread, sweetmeats, and fruit, and not count what he has paid the [shipmaster], because this is a voyage on which the purse must not be kept shut.[38]

It is easy to see that Brasca's advice was addressed to those whose purses were well filled. The poorer pilgrims, embarked by the shipmaster at a reduced rate, did without ginger, aromatics, and fresh eggs. We have few accounts of how they fared, for most of the *Viaggi in Terra Santa* were written by well-educated clerics. It is obvious that if wealthier shipmates suffered discomfort, the poor did so too, and to a worse degree, and that they waited even more eagerly for the lookout's cry that he saw the twin towers of Joppa.

The duration of the run from Venice to Joppa varied from four to six weeks, depending upon the weather and the necessity of taking

37. Santo Brasca is evidently mistaken in his statement. In 1483 two galleys carried pilgrims from Venice to Palestine, and such appears to have been the regular procedure until 1518, when the senate reduced annual sailings from two to one (cf. M. M. Newett, introduction to *Casola's Pilgrimage*, pp. 98, 108).

38. *Casola's Pilgrimage*, pp. 11-12.

on fresh supplies or of delivering dispatches from the Venetian senate to the governors of the republic's island possessions. Casola's galley, running into a heavy storm and making a number of stops, took a month to reach Joppa (June 17 to July 17), as against twenty-six days by Agostino Contarini's galley, which bore Fabri on his second trip.[39] Then, as now, there was no harbor at Joppa, nothing in the way of docking facilities. Ships had to lie off from the shore; communication was by rowboat.

Arrival at Joppa, however, did not mean immediate debarkation for any group of pilgrims. Indeed, Casola and his grumbling fellow passengers were not allowed to land until after ten days in harbor, though usually the interval between arrival and debarkation was less. The reason for such a delay was the necessity of obtaining a safe-conduct from the governor of Jerusalem, the representative of the sultan at Cairo. The safe-conduct required the pilgrims (after names and residences had been checked off) to proceed, always accompanied by the shipmaster of their galley and a dragoman, who collected such taxes as were levied on a pilgrim,[40] regulated the movement of the caravan, preserved good order among the pilgrims, and enforced discipline in the Moslem escort. In the case of Casola's journey, the Moslems were evidently determined to play a little game for their own advantage. The governor of Ramla had authority to allow the pilgrims to land, but he warned them that they would not be allowed to depart until the arrival of the governor of Gaza. On the 25th of July, taking advantage of the permission to land, the captain dispatched two boatloads of passengers to shore, but the scribe whose duty it was to count and register them said he could stay no longer in the sun and that other pilgrims must not be landed. Before reaching shore, the pilgrims had found as they left the vessel that the chief officer of the galley, the shipmaster's clerk, the pilot, the trumpeters, the drummers, the chief rowers, the crossbowmen, the stewards, and the cooks came forward, each with a cup in his hand, and that it was advisable to give something to each of them. Verily, tipping for "service" aboard ship is no new practice.

Had they only known more, the pilgrims on shipboard would not have been eager to leave. Nearly all pilgrims who wrote accounts of their journeys speak quite strongly about the reception-place at

39. Sottas, *Les Messageries,* p. 183: "c'était un record; je n'ai pas trouvé d'autre example d'une pareille célerité." It is interesting to note that both Casola and Fabri sailed with Agostino Contarini, a somewhat sharp and unscrupulous shipmaster, but a splendid seaman.

40. Upon embarkation the pilgrim had paid these to the shipmaster, who acted in Palestine as paymaster for the whole group.

Joppa. It was a cave in the hillside into which they were herded before they set out for Jerusalem. It was dark and filthy with Saracen ordure, and armed guards at its mouth permitted no wandering from it. The writer of the account of the journey of Ogier of Anglure, recalling that Joppa was the scene of the activities of St. Peter, remarked, "Pilgrims are accustomed to sleep in a chapel of St. Peter, where there's nothing in a decent condition."[41] Once in the cave, the pilgrim found that his bedstead was the native rock, and uncleanly rock at that. Before he put his mattress down he had to scrub and brush. The Saracens, Jews, and native Christians of the locality were quick to seize the opportunity of making money, and flocked to the cave with drinking water, fruit, and straw for bedding, which last must have proved quite saleable. The reason for such protracted incarceration was that it took a considerable time to register the pilgrims, to compute the tax due for admission, the tax on the safe-conduct, and the amount due for hire of the riding animals, and to present the bill to the shipmaster of the pilgrim vessel. It may be added that canon Casola, who had cultivated friendly relations with the *patronus*, had heard all about the cave, and preferred to pass the time on the galley until notified to land.

At last the great hour arrived. Sometimes it came early in the morning, at others late in the afternoon.[42] But whatever the hour, the Mamluk guards herded the pilgrims together and marched them off to a spot where their mounts were assembled. Their arrival produced great confusion; three or four donkey boys would surround one pilgrim, each asserting his own merits and those of his beast and denigrating those of his rivals. Many of the pilgrims, unused to donkeys with makeshift saddles, were thrown, so that the scene must have resembled a badly run rodeo, with mounted riders on unfamiliar animals dashing about and running into their comrades, and dismounted riders sitting on the sand or being helped up by the donkey boys, who asked a tip for their efforts. Finally, however, the party moved off in a cloud of dust, the dragoman and officials riding ahead, then the pilgrims on their donkeys,[43] and finally the servants of the Saracen officials bringing up the rear.

It was a three-hour ride to their first halting place, Ramla (Rama, ar-Ramlah). Before reaching it they were forced to dismount

41. Savage, in *The Arab Heritage,* p. 204.

42. Canon Casola's caravan departed at vespers (*Pilgrimage,* p. 236).

43. Asad-ad-Dīn Shīrkūh (about 1167) forbade Christians to ride on horses or mules in Egypt. The law was not repealed by the Mamluk dynasty, who ruled Palestine from Cairo; see A. S. Tritton, *The Caliphs and their Non-Moslem Subjects* (Oxford, 1930), p. 121.

and carry their baggage on their shoulders.[44] At Ramla they found more comfortable housing in the hospice donated by Philip III the Good, duke of Burgundy (1419-1467), and served by the Franciscans of Mt. Sion. It had a narrow entrance, but within its layout was of caravansary style, with a central courtyard, a fountain in the center, and roofed apartments on all sides. In these they put down their mattresses on straw peddled by the people of Ramla and prepared to spend the night. An important figure now enters the scene, the Custos of the Holy Land, *le Père Gardien*, the head of the Franciscan religious house on Mt. Sion. This official was to be regarded as the guide, counselor, and friend to all pilgrims. He had some influence with Moslem officialdom, and his experience with thousands of pilgrims made his counsel to the newcomer invaluable. The friars under him acted as guides to the sacred sites, and were prepared to admit serious cases of illness to their infirmary.

It was customary for the Custos to meet all pilgrim ships at Joppa, and at the hospital at Ramla to deliver a lecture about conduct and wise behavior in a country ruled by infidels. Felix Fabri, standing beside the Custos, Francis Suriano, translated his Latin into German for the benefit of his fellow pilgrims, most of whom were of that nation. The advice given was most pertinent, and indeed the manuals issued to troops who served in Algeria and Tunisia in World War II largely repeat the Franciscans' instructions. (1) The Custos was empowered to absolve from excommunication anyone who had failed to obtain permission from ecclesiastical authority to make the journey; any so situated should present himself at the close of the lecture. (2) No pilgrim should walk alone about the holy places without a Saracen guide. (3) Pilgrims should avoid stepping over Saracen graves, an act offensive to the Moslems, who believe it disturbs the dead. (4) A pilgrim must never return a blow struck by a Saracen; if struck, one should complain to the Custos or the dragoman. (5) Pilgrims must not chip off souvenirs from the Holy Sepulcher or other sacred buildings, or deface walls by drawing their coats of arms or writing their names upon them. Saracens resent such conduct and regard the offenders as fools. (6) Pilgrims should visit holy places in an orderly manner, not attempt to outrun one another to get there first. There is time enough for all to pay devotion. (7) Pilgrims should not laugh together as they walk about, as Saracens are suspicious of laughter. Above all, one must not laugh at or with the

44. Casola (p. 237) says that it was because they were passing a Moslem cemetery; Fabri (VII, 246), because infidels will not endure Christians entering their town mounted, unless at night.

Saracen men and boys; mischief may arise. (8) Pilgrims should not gaze upon any woman, as all Saracens are exceedingly jealous. (9) Should a woman beckon to a pilgrim to enter a house, he must not do so, lest he be robbed or slain. (10) It is dangerous to give a Saracen wine to drink, even when he asks for some, as he is likely to become mad and attack the giver. (11) Each must keep the ass assigned, and not exchange it for another, unless with the driver's consent. (12) A nobleman should beware of revealing his nobility to Saracens: it is imprudent. (13) No pilgrim should ever wear a white turban or wind a white cloth about his head, since that color is worn by Saracens alone. (14) No pilgrim may carry arms or even have a knife about him, as the infidels will relieve him of either. (15) It is dangerous to form a friendship with Saracens, for they are treacherous. One must not, even in jest, ever touch the beard of a Saracen or his turban, for this is a disgrace among them. (16) If any possessions are left lying around, they will vanish. (17) Pilgrims should never drink wine in the presence of a Saracen. To see one doing so arouses envy, because wine is forbidden them. (18) Pilgrims should have no financial dealings with Saracens, German Jews, or native Christians, all of whom cheat and rob unwary pilgrims. (19) When pilgrims make agreements with Saracens, let them never lose their tempers, but rather maintain the character of a Christian. (20) No pilgrim should ever enter a mosque. (21) One should not laugh at a Saracen at prayer, for they do not laugh at Christians so engaged. (22) Pilgrims should not blame the Custos if they are detained at Ramla or anywhere else. This is the fault of the Saracens "who do what they please in these matters, not what is convenient to us." (23) One should not grudge paying money to free oneself from annoyances, but give without grumbling. (24) The pilgrims must give something to the hospice where they now are (Ramla), for its up-keep. (25) The pilgrims must make a donation to the poor convent of the Franciscans at Mt. Sion, whose inmates act as their guides into and out of the Holy Land, who dwell among the infidels for the benefit of their fellow Christians, and who are prepared to nurse sick pilgrims in their own infirmary.[45]

Having received this good advice from one thoroughly conversant with the country, its customs, and its people, the pilgrims, after several days' delay, rode over the stony and hilly road to Jerusalem. To men and women of the present age, separated by the passage of

45. Fabri, in *PPTS*, VII, 247-255.

centuries from medieval ways of thinking and feeling, the first sight of the holy city would be exhilarating, but those who first gazed upon it in those days were stirred to their very depths. Some fell upon their knees, while tears of happiness ran down their cheeks. In Fabri's party the priests and monks raised the *Te Deum.* George Gucci's party took off their shoes and went barefoot.[46] Canon Casola, however, gave way to no such emotional displays. "God willing, at an early hour we reached the holy city of Jerusalem, almost dead of heat and thirst, and those dogs made us dismount outside the city."[47] Quite clearly the good canon loved his comfort. Before entering through the Fish Gate (Gate of Joppa) below the Tower of David, all pilgrims were again rechecked by the dragoman and the Moslem gatekeepers. With all present and accounted for, the party, preceded by some of the religious of Mt. Sion, entered the city, and eventually reached the church of the Holy Sepulcher. There they were told by one of the Franciscans that the place where they were was the holiest in the world. Many gave way completely to their emotions; tears, prostrations, screams, and breast-beatings echoed in the narrow court before the doorway. Fortunately entrance at that time was not on the agenda.

The final stop on the day of entry was at what had once been the hospital of the Knights of St. John, and is now the Muristān. Saladin had lodged there after the fall of the city, but in subsequent years it had been allowed to fall into decay. While not the most comfortable of domiciles, it was the only place capable of housing 250 people. It did have a roof and many chambers or stalls.[48] In these stalls the pilgrims placed their mattresses, often upon the straw they had purchased, and took their meals in small groups, paying local merchants to cater for them. More influential or wealthier pilgrims were able to arrange accommodations through the dragoman. Priests of the party were always guests of the convent of Mt. Sion, where they fared well.

The day after their arrival, having assisted at an early mass, the pilgrims, led by two Franciscans and the dragoman, began the visits of the "holy circuit." Setting out before dawn from the porch of the

46. "Pilgrimage of Giorgio Gucci to the Holy Places," trans. T. Bellerini and E. Hoade, in *Visit to the Holy Places . . . in 1384,* pp. 91-156 (Jerusalem, 1948), p. 127.

47. *Pilgrimage,* p. 244.

48. Cf. Nicholas of Martoni, *Liber peregrinationis ad loca sancta,* ed. Léon Legrand as "Relation du pèlerinage à Jérusalem de Nicolas de Martoni, notaire italien (1394-1395)," in *ROL,* III (1895, repr. 1964), 613: "quod hospitale alias . . . erat hedeficium magnum et mirabile . . . modo vero est tantum una lamia magna et longa ac larga, cum columpnis in medio et cum pluribus cameris in quibus manent peregrini."

church of the Holy Sepulcher, they proceeded along the Via Dolorosa to the Gate of Ephraim (or of St. Stephen), crossed the Kidron to the garden of Gethsemane, and descended the Mount of Olives. Coming down, they passed the tomb of Absalom and continued to the pool of Siloam, whence, passing south of the city through the vale of Hinnom, they ascended to Mt. Sion.[49] All through the journey there were halting-places to be visited by the devout, at which indulgences were to be secured. Some spots possessed greater spiritual significance than others less notable in sacred history. A halt at one of the former carried a plenary indulgence (*absolutio culpae et poenae*) for past sins; at one of those of less significance, a temporal indulgence of 7 years, 320 days. Both kinds of indulgence were dependent on the recipients' *vere penitentibus et confesses*.

The following sites on the "holy circuit" were visited by all pilgrims (spots that provided a temporal indulgence are designated "T", with a "P" against those affording a plenary [50]): (1) the entry into the holy city (P); (2) the spot where the three Marys cried out at the sight of Jesus bearing the cross (T); (3) the house where the Virgin had gone to school (T); (4) the spot where the Virgin fainted as her son bore the cross (T); (5) the house where the Virgin was born (T); (6) the house of Herod (T);[51] (7) the valley of Kidron (Jehoshaphat?) (T); (8) the site where Stephen was stoned, at the upper end of the valley (T); (9) the church containing the tomb of the Virgin on the farther side of the valley; payment for entrance was demanded by the Saracens (P); (10) the grotto of the Agony (T); (11) the spot in the garden of Gethsemane at which Jesus left his disciples in order to pray (T); (12) the place where the Jews captured Jesus (T), and the place nearby where Peter cut off the ear of the high priest's servant (T); (13) the place where the Virgin ascended to heaven, throwing, as she did so, her girdle to St. Thomas (T); (14) the spot on which Jesus stood as he wept over the fate of Jerusalem (T); (15) the spot where the angel announced to the Virgin her approaching death, and gave her a palm leaf as spiritual comfort (T); (16) the mount of "Galilee," where Jesus appeared to the

49. Sometimes the order of visitation was varied, possibly because of Moslem objections at a particular time to the usual order. Nicholas of Martoni, Frescobaldi, and Casola followed, with very minor variations, the path described above. Other pilgrims, as Sottas tells us (*Les Messageries,* pp. 191-192) followed another order, going first to the convent of Mt. Sion, and to the Holy Sepulcher in the evening of the same day. Cf. Bagatti, *Visit to the Holy Places,* pp. 9-17.

50. The source for this marking is Nicholas of Martoni, in *ROL,* III, 613-619.

51. "Domus Herodis que non sunt integre, sicut fuerunt, ad quas non potuimus intrare" (*ibid.,* III, 613).

disciples after his resurrection (T);[52] (17) the Mount of Olives, from which Jesus ascended into heaven (P); (18) the spot where the apostles composed the creed (T); (19) the spot where Jesus taught the apostles the Lord's Prayer (T); (20) the spot where St. James the Less died (T); (21) Bethphage, where Jesus mounted the ass's colt (T); (22) the spring in the valley of Kidron in which the Virgin washed the garments of the infant Jesus (T); (23) the pool of Siloam, where Jesus sent the blind man to wash his eyes (T). Near this was the place where the Jews were alleged to have sawed the prophet Isaiah asunder with a wooden saw (T).

It never seems to have occurred to any of the authors who describe their journeys in the Holy Land that some of the shrines or sites they visited were fraudulent. Thus Nicholas of Martoni visited a spot near Hebron where Adam was said to have been created, and solemnly reports that he did so.[53] Frescobaldi assures us that "at the beginning of the ascent to Mt. Olivet, is where Our Lady gave the cincture to St. Thomas, when she went into heaven."[54] Nicholas of Martoni explains that St. Thomas, arriving "de partibus Indie," was late for the funeral, but the Virgin in her ascent to the skies "projecit suam zonam beato Thome."[55] The pilgrim came piously inclined to the Holy Land. When shown a shrine or site mentioned in Holy Writ, or around which a tradition had formed, he was in no position, nor had he any inclination, to disagree with his Franciscan guide. Indeed, the Franciscan himself was in no position to question sacred tradition. He had been sent to his present post not to question but to believe, and to lead others to believe, and his monastic education had taught him not to criticize but to accept. Among the authors who wrote of their Palestinian journeys there was no disposition to question the authenticity of any *locus sanctus*, and where the more literate took no exception to what was told them others were scarcely likely to. There need be no doubt that the pilgrims "believed all they were told, and would have believed more had it been told them."[56]

52. The northern crest of the Mount of Olives is said to have been called "Galilee," and was (wrongly) believed in pilgrim times to have been the spot at which Jesus directed his disciples to meet him after his resurrection; see S. Merrill, "Galilee, Mountain in," in James Hastings, ed., *A Dictionary of the Bible . . . ,* II (New York, 1899), 102.

53. *ROL,* III, 611: "In illis partibus dicti montis est locus ubi Deus creavit primum hominem Addam."

54. *Visit to the Holy Places,* p. 72.

55. Nicholas of Martoni, in *ROL,* III, 614.

56. Savage, in *The Arab Heritage,* p. 207. An exception to this generalization must be made in the case of Louis of Rochechouart; see "Voyage à Jérusalem," *ROL,* I, 242, 246, 248.

The pilgrim's path ended at Mt. Sion, with the Franciscan convent on its summit. In its church were a few sacred spots which the pilgrims would feel obliged to see because of the indulgences there to be acquired, and outside that sanctuary were many more holy places. Inside the church was the altar where Jesus gave his disciples holy communion (T); to its left was the place where he washed their feet (P). Outside the church were the place where the Holy Ghost descended upon the apostles at Pentecost (P), the spot where St. Thomas professed his belief in the resurrection (P), the place of prayer where the Virgin resorted for the fourteen years she survived Jesus (T), the place where St. Matthew became an apostle (T), the spot where St. John the Evangelist celebrated mass before the Virgin (T), the place where the Virgin was translated to heaven (P), and many others accorded temporal indulgences, such as the spot where the water used in the washing of the disciples' feet was heated.

Inspiring and awesome as such sites must have been, the goal and crown of every pilgrim's journey was the tomb of Christ. Generally two visits were made to the church of the Holy Sepulcher, their timing probably having been dependent on the convenience of the Moslem guardians of the building. As they entered, the pilgrims were enumerated by the Saracens and their own interpreter. One of these two visits was made at nightfall, for they were to be at their devotions all night long. When they were all safely in, the Moslem guardians locked the doors. The candles with which they had been furnished were lit and, led by the friars of Mt. Sion, the devout visitors formed a procession to visit the many holy sites, starting with the reddish and black stone on which the Savior's body was laid preparatory to its anointing (P), the chapel of the Virgin (P), and the spot where Mary Magdalen beheld Jesus, whom she took for a gardener (T). [57] On leaving the chapel the procession, singing appropriate anthems and chanting litanies, entered the body of the church. [58] They visited the *Carcer Christi* (T), the chapel of the Dividing of the Vestments (T), the chapel of the Column (T), and the sloping subterranean spot where Helena found the three crosses (P). [59] The procession next wound its way up the stone staircase to

57. The various relations of the pilgrimages differ from one another as to the order in which the sacred sites were visited. Nicholas of Martoni evidently visited the Holy Sepulcher both before and after the trip to the Jordan. Father Fabri visited the Sepulcher, walked the Via Dolorosa, and made a second visit to the Sepulcher after his walk. Canon Casola went first to the Sepulcher, then to Bethlehem, and again to the Sepulcher.

58. In the church the Holy Sepulcher itself was under the dome of the apse, so that the procession was at this point entering the nave.

59. Nicholas of Martoni (*ROL*, III, 618) reports that the three crosses were brought to

the elevated rock of Calvary, [60] where are the cavities in the rock into which the three crosses were thrust. One part of the small chapel belonged to the Greek Orthodox, the other to the Roman Catholic church. Within the former was the orifice in which the Savior's cross was inserted (P). [61] At the altar of that part of the chapel that belonged to the Romanists, mass was celebrated and the party received communion (P).

The high point of the pilgrimage was the entry into the Holy Sepulcher itself. Present-day guidebooks often describe the appearance of the Sepulcher as it was in crusading and post-crusading days. One entered the little vestibule to the tomb called the chapel of the Angel (10 by 7 feet), because it was believed that on that spot the angel announced to the holy women the fact of the resurrection. At the end of this chapel there is an opening four feet high by which one enters the Sepulcher chamber, which had room for four or five persons and no more (P). [62] The tomb of the Savior is covered by a marble slab, to guard against such souvenir hunters as James of Verona or Leonard Frescobaldi. [63] On that slab it was allowable to say mass, as canon Casola did on August 8, 1494. [64] When a large body of pilgrims visited the church, it was necessary for the Franciscan guides to separate the group into three companies, select from each a priest to say mass, and allot to each company one of three altars, that of Calvary, that of the chapel of the Virgin, or that of the Sepulcher. One can well believe that the traveler who heard mass at the Sepulcher of his Lord enjoyed the *summum bonum* of his entire journey—perhaps of all his life. But all great moments pass, and early in the morning the Moslem guardians of the church opened its doors and ordered them out.

After following the pilgrims in some detail as they trudged about Jerusalem, our accounts of two side trips, to Bethlehem and to the Jordan and Dead Sea, will be brief. Bethlehem, distant some five

the chapel of the Virgin and a corpse was placed on each one in turn. When placed upon the true cross, the corpse revived, proving its genuineness.

60. Casola (*Pilgrimage*, p. 260) says the staircase was of wood.

61. James of Verona, *Liber peregrinationis,* ed. Reinhold Röhricht as "Le Pèlerinage du moine augustin Jacques de Vérone (1335)," in *ROL,* III (1895, repr. 1964), 186, describes how he stole pieces of the rock of Calvary as relics by getting his fellow pilgrims to lead the two Greek Orthodox guardians away temporarily.

62. Nicholas of Martoni (*ROL,* III, 618): "non est capax nisi forte quinque hominum"; Casola (*Pilgrimage*, p. 277): "When four persons are in the said little chapel there is no room for more. It is entered by a hole, as there is no door, and a man has to stoop greatly in order to enter there."

63. *Visit to the Holy Places,* p. 71.

64. *Pilgrimage,* p. 261.

miles from Jerusalem, the pilgrims would reach after a short ride; canon Casola assures us that it was a hot one. In the basilica dedicated to the Virgin, the usual masses were offered at the grotto of the Nativity and at the Manger, cradle of the newborn babe. Plenary indulgence was to be had at both places. The trip to Bethlehem lasted not more than three days.

A trip to the Jordan was a more serious affair. The road to it ran through the stony passes of the Judean mountains, the very locality where thieves attacked the traveler whom the good Samaritan rescued.[65] The existence of such thieves infesting the route necessitated a military escort under the command of a Mamluk. A stop was made at the Fountain of the Apostles (some two miles from Jerusalem), but there was no long tarrying anywhere, for their Moslem guards hurried them on.[66] Jericho (twenty-two miles from Jerusalem) did not detain them, and the convoy pushed on to the Jordan, six miles distant. Those who wished were allowed to bathe in the river, and nearly all filled bottles with the holy water to carry back with them (T). Sometimes the trip to the Jordan was extended to its outlet in the Dead Sea, the sight of which filled the pilgrims with horror, for they remembered the submerged cities and *peccatum sodomiticum*. Gucci reports that "they say that this water holds up nothing, and that every living thing sinks, wood and the lightest thing."[67] The convoy returned home, stopping at the fountain of Elisha, who had changed water once bitter to sweet, and the Mount of Quarantine, where Jesus had fasted in the wilderness. Then, after passing through Bethany, they reached Jerusalem, thoroughly exhausted from two strenuous days. But fatigued though they were, they were eager to reach Joppa and see the galley that would take them home.

One must conclude that, between Venetians, Moslems, and Franciscans, the pilgrimage business was on the whole well run. Despite all the complaints about delays and illicit charges, the pilgrim saw what he had come to see, and saw it in a brief time. Canon Casola was just nine days over a month in the Holy Land. Nicholas of Martoni, who made the much longer pilgrimage by visiting Cairo and Sinai, was ashore just over three months. James of Verona visited not

65. Nicholas of Martoni, in *ROL,* III, 620: "per montes et valles montium petrosas et ruginosas ultra quam dici potest."

66. *Ibid.*: "ambulantes quasi tota nocte et die."

67. *Visit to the Holy Places,* p. 134. A. H. M. Jones, "Dead Sea," in *Chambers' Encyclopaedia,* new ed., IV (London, 1963), 400, says "the water is so buoyant that bathers cannot sink"; evidently Gucci never bathed in it.

only Jerusalem but Sinai and Cairo as well, and finished his travels by taking ship from Beirut, after having visited Damascus and passed through Galilee, yet his stay lasted only a few days over two months.

Quite frequently there were delays in the plans for the return. Often the Moslems, reluctant to let such wealthy paying guests escape, invented pretexts that halted the exit from Jerusalem. Or there arose misunderstandings between the shipmaster and the Custos of the Holy Land on one part and the governor of Jerusalem on the other. One is unable at times to decide whether the misunderstanding was accidental or intentional.[68] Casola and his fellow travelers waited eight days with their luggage packed before their galley was allowed to sail, passing six of those days at Ramla uncertain whether or when they would be allowed to leave the country. But finally clearance was given, and the galley hoisted sail, weighed anchor, and pointed its prow westward. It did not leave, however, with all those it had brought, for some remained under the care of the Franciscans of Mt. Sion, too ill to travel; others, more frail and elderly, would never return. Heat, exhaustion, and the crowded schedule had been too much.

It is difficult to assess with precision the effect upon Europe of these centuries of pilgrimage. Did those who returned bring back with them ideas that would radically alter for their fellow countrymen accustomed ways of thinking and living? In minor ways the answer is yes. Small conveniences which the east had revealed to them were acquired for their own lives. Fashions, appetites, and desires which their journeys had shown them were adopted or transplanted. By and large, however, the answer must be no. The pilgrim went out a Catholic Christian and returned a more rigid one. Certainly there was not much meeting of minds between Christian pilgrim and Moslem inhabitant. To the pilgrim the occupants of Palestine were either "Moors" or "Saracens," two terms which served to characterize all Moslems with whom they came in contact, regardless of whether they were Arabs, Kurds, or Turks, or the natives of Palestine, descendants of the Canaanites. The pilgrims were not interested in distinctions of language or nationality.

Some comments reveal Christian opinion of the religion and manner of their unwilling hosts. One pilgrim, an Englishman who was in Palestine in 1345, said that he would be willing to narrate

68. Sometimes there was conflict of authority between the governor of Jerusalem and his counterpart of Gaza, and although in the end the latter had to give way, the pilgrims waited on shore until he did.

briefly their habits and appearance to any one who wished to hear about them.

> Their clothing is linen exclusively. They do not comb or smoothe their hair, nor do they put on shoes. The upper part of their thighs are swathed down to the curve of the leg. They wear stuff of carpet material instead of shoes, so that this stuff does not cover the heel or the rear portion of the sole of the foot, so that their shoes as they walk always make their feet clatter; and this was prescribed to them by that worst counterfeit of sanctity, Mohammed At head or neck they wear no covering unless a linen cloth wound around thickly many times. Wherever they may be, at certain hours of the day, on bended knees they prostrate themselves to the ground and facing south they worship God devoutly. And if I may trespass upon nature's secrets, they urinate as women do. In their mosques five or six loud-mouthed fellows mount up through the day and night hours, and to three directions of the compass, the last being omitted, shout out with strong voices, instead of bells. They [the Saracens] check all worldly vicious appetites.[69]

Few pilgrims ever saw the inside of a mosque. They were ignorant, therefore, of what went on within it. Any who were caught inside its walls had the alternative of embracing Islam or death.[70] The westerners were quick to notice in Jerusalem the absence of bells, to whose ringing so much of their religious life was attuned; Fabri tells us that there is a commandment in the Koran not to use them. The functions of the bell were taken over by the muezzin five times a day and once in the evening.[71] The Romanticists loved to dwell upon the musical and penetrating resonance of the muezzin's call, as it echoed from the minaret at sunset. It had no such charm for the medieval pilgrim. Canon Casola, while admiring the bell tower of the lord of Ramla (then quite useless), tells us that during the night a man stood on it, "who, to my hearing, did nothing but yelp."[72] James of Verona had an equally unpleasant experience, for at the hour of compline he heard from the same tower "clamare tres Sarracenos

69. "Itinerarium cuiusdam Anglici Terram Sanctam . . . visitantis (1344-45)," in *Biblioteca bio-bibliografica della Terra Santa* . . . , ed. G. Golubovich, IV (Quaracchi, 1923), 450-451.

70. See the account of the "martyrdom" in Cairo (1345) of one Livinus, a French Franciscan, who entered a mosque to bid the congregation turn Christian (in *Biblioteca . . . della Terra Santa*, ed. Golubovich, IV, 390-392). The chronicler of the pilgrimage of Ogier of Anglure recounts that his party was astonished by the beauty and cleanliness of the mosques in Cairo, and by their lamps and marble doors, and admitted that Saracen *oratoires*, "unlike Gothic chapels in the entire absence of sculpture, painting, or gilding, could still be beautiful in the simplicity of white unpainted plaster" (Savage, in *The Arab Heritage*, p. 211).

71. "Mag. Thietmari peregrinatio," ed. J. C. M. Laurent as appendix to *Peregrinatores medii aevi quatuor* (2nd ed., Leipzig, 1873), p. 12: "Loco campanarum precone utuntur, ad cuius vocationem solent sollempniter ad ecclesiam convenire."

72. *Pilgrimage*, p. 240.

terribiliter illam legem pessimam et execrabilem Mahometi."[73] The anonymous fourteenth-century Englishman is no less severe: "in their mosques five or six ribald fellows ascend through the hours of night and day, turning to all directions of the horizon, except the last, shouting with resonant clamorings, instead of bells."[74] Frescobaldi is no less censorious: "and on the steeples stand their chaplains and clerics day and night, who shout when it is the hour, just as we ring. And their shouting is to bless God and Mohammed; then they say: increase and multiply, and other dishonest words."[75] His companion Gucci tells the same story: "all their churches have steeples but no bells: and when the hour comes, a man mounts the steeple, and that of the principal church of the city begins to shout and to praise God, and so do all the others on the other steeples: and so many are they throughout the city that when they all begin to shout, it would seem a riot has broken out in the city. They halt several times, and then they begin again."[76] Gucci objected to the noise; Simon Sigoli was more affected by the moral content of the muezzin's message: "when they wish to notify that it is the ninth hour, the priests of the mosques go up the towers, and there where the cupola of the tower begins there is outside a wooden gallery, and they go around this gallery three times, shouting at the top of their voices that it is nine, at the same time recounting something of the dishonest life of Mohammed and of his companions Then they shout: do such a thing, which would be dishonest to write down just as distinctly as they say it: increase and multiply so the law of Mohammed increases and multiplies."[77] One may observe that Sigoli's church encouraged the same practice which the muezzins urged, but with more propriety and reticence.

Another practice disgusted the pilgrim historians. Moslem law enjoins perfect bodily cleanliness before one prays. Consequently they proceed to wash any part of the body they believe in need of washing—to the disapproval of the westerners: "Sarraceni nunquam loquuntur mingendo et reputant pro magna iniuria sic loqui, et quando mingunt curvantur sicut mulieres, et habent ex lege, et tergere anum cum lapide, et multas alias stulticias faciunt."[78] James of Verona is no less shocked by these habits of ablution: "ante oracionem servant illud turpissimum documentum, quod dedit eis,

73. James of Verona, in *ROL,* III, 181.
74. In *Biblioteca . . . della Terra Santa,* ed. Golubovich, IV, 451.
75. *Visit to the Holy Places,* p. 41.
76. *Ibid.,* p. 144.
77. *Viaggio al Monte Sinai,* ed. Cesare Angelini (Florence, 1944), trans. T. Bellarini and E. Hoade in *Visit to the Holy Places . . . in 1384,* pp. 157-201 (Jerusalem, 1948), p. 166.
78. Louis de Rochechouart, in *ROL,* I, 273.

quia primo lavant manus, postea pedes, postea faciem, postea virilia sua et membrum genitale, et hoc publice coram omnibus, et alio modo non orarent, nise prius facerent hanc enormem ablucionem, quod est abhominabile in natura et in omni lege." [79] Thietmar, who made the voyage to Palestine and Sinai in 1217, is more objective and laconic: "Religiosi vero Sarraceni ad quamlibet horam solent se lavare aqua, vel sabulo, si defuerit aqua. Incipientes a capite, faciem lavant, deinde brachia, manus, crura, pedes, pudibunda et anum. Postea vadunt orare, et numquam orant sine venia. [80] Multas venias faciunt. Versus meridiem orant. Tundunt pectora sua, et in pupplico [81] et altis vocibus. Super pannos quadratos, quos semper sub cingulo suo secum portant, venias querunt, et in veniis terram fronte pulsant." [82]

Most pilgrims, however, did not bother to describe the religious or social customs of the folk whose land they visited. Canon Casola has one word for any and all Moslems—"dogs." Gucci complains of his scurvy treatment at Damascus, and Sigoli corroborates him. [83] Louis of Rochechouart, bishop of Saintes, has no stories of overcharging or insult; apparently he experienced little difficulty in going where he wanted to go when he wanted to go there, but he saw little good in Moslems: "Sarraceni qui habitant in Siria et Egipto Barbarica, usque ad Asiam Minorem, sunt gentes bestiales." [84] A more fair-minded observer is Ricold of Monte Croce. He says that he will speak briefly of certain works of perfection among the Saracens, more to the shame of Christians than to the commendation of those heathens. He praises their zeal for study, their faithfulness and devotion in prayer, their charity and kindness to the poor, and their legacies to provide ransoms for captives held by Christians. He is struck by their reverence for the name of the deity, their extreme gravity and the propriety of their bearing, their affability to strangers, their perfect hospitality, and the peace they maintain with one another, and concludes, "the words written above we have not put down for the commendation of the Saracens, but for the shame of the Christians, who are unwilling to perform for the law of life, what the damned do for the law of death." [85]

79. "Liber peregrinationis," in *ROL,* III, 264.

80. *Venia,* defined by Thietmar's editor Laurent as *genuum flexione* (p. 12, no. 136).

81. Laurent (p. 12, no. 137) comments: "Lingua Latina cadente reviviscebant formae antiquae."

82. "Peregrinatio," p. 12.

83. *Visit to the Holy Places,* pp. 143-144 (Gucci) and 181 (Sigoli).

84. "Voyage," in *ROL*, I, 272. The bishop comments (I, 239) on the death of Mamluk sultan Inal: "obierat soldanus a quadragesima, mortuus quidem et sepultus in infernum."

85. "Fratris Ricoldi de Monte Crucis . . . liber peregrinacionis," ed. J. C. M. Laurent in *Peregrinatores medii aevi quatuor,* pp. 131-135.

All pilgrims, to whom the fasting enjoined by the Roman church meant real deprivation, express their surprise and horror at Moslem behavior during the feast of Ramadan. Bishop Louis informs us that "they [the Moslems] eat nothing until a star appears in the sky . . . but through the whole night they eat and are given over to riot and wantonness, eating flesh and fish at the same time." James of Verona is equally horrified at the Moslem idea of a fast. "He [Mohammed] taught that they should fast on the first moon of the month of May because Moses fasted on that moon . . . and when the Saracens fast, they eat or drink nothing the whole day, but at evening they begin to eat and drink the whole night through flesh and any kind of food they wish, following those most vile teachings of that Mohammed."[86] Sigoli is less reticent than the bishop and James: "The Saracens make one Lent a year, which begins with the first quarter of the moon which comes after the month of September and lasts 30 days, and all the day they neither eat nor drink; then in the evening, when the stars appear in the sky, everyone begins to eat meat and everything they like, and they eat all night. And each priest of every people goes about three times in the night with a small drum playing for his people, calling his faithful by name, saying Eat and sleep not, and do such a thing well, that is of luxury, that the law of Mohammed be increased; and so they live like animals."[87]

Though viewing Moslem customs, the Moslem way of life, and Moslem religion with virulent disapproval, the westerners were surprised by the beauty of Moslem architecture. Indeed, it is astonishing that priests and laymen who were so contemptuous of things Islamic, and who had grown up in a culture featuring Gothic or Romanesque, should be so admiring of and so sensitive to Saracenic architecture. The chief object of this admiration was, of course, the Qubbat aṣ-Ṣakhrah, the Dome of the Rock,[88] though since entrance was forbidden, it could be viewed only from a distance. Enough of it could be seen, however, to compel the beholder to acknowledge that it was the most beautiful building in the city. Thietmar, apologizing for his brevity, states that it was *mirifice adornatum.*[89] Gucci's allusion to it, though brief, is

86. "Liber peregrinationis," in *ROL,* III, 263. Ramadan is the ninth month of the lunar Moslem year, which is about eleven days shorter than a solar year; thus it may fall within any season.

87. *Visit to the Holy Places,* p. 167.

88. To one standing on Mt. Sion the Dome of the Chain (Qubbat as-Silsilah) must have been invisible, and only the upper part of the Aqṣâ mosque, including its cupola, could have been seen.

89. "Peregrinatio," p. 26.

sufficient to distinguish it as an outstanding piece of architecture: "then you find the place where stood the temple of Solomon: and today it is a Saracen mosque,[90] where entrance is forbidden to the Christians; but to see it from the outside it appears a great building and a work of art, and so it looks when seen from the Mount of Olives." Even the carping Casola cannot refuse his tribute of praise: "As it was on our way we afterwards saw the mosque which they say stands on the site of the temple of Solomon. It is a beautiful building to look at from the outside, and strong compared with the greater part of the habitations in Jerusalem. It is wonderful to see the courts—so well paved with the whitest marble—which are built around at the base of the mosque." Indeed, Casola cannot forget the impressive beauty of the great structure which loomed up so impressively even at a distance. He alludes to it twice more: "The city has one beautiful building; that is its mosque. Neither Christian nor Jew can enter there. Outside one can see what a beautiful place it is with those courts round it as I mentioned above. I heard from the Moors that there are neither paintings nor images inside. They say that there are a thousand lamps within, which on certain occasions are all lighted at the same moment.[91] . . . It is a stupendous thing; and it appears to me that the Moors do not lack good master workmen for their buildings."[92]

It would be quite unfair to leave the reader with the impression that pilgrims were consistently insulted, robbed, or maltreated by the natives of Palestine. The governor of Jerusalem advised them that in making their visits to the holy places they should always have some Saracen with them, so that they would not be annoyed by "rude boys," whom the authorities found it difficult to control.[93] Indeed, it can be safely said that when a formal complaint of assault on a pilgrim or one of overcharging reached the administative officials of the sultan, justice was quick, and the guilty summarily punished. Thus when a Saracen assaulted and beat two Franciscan monks traveling from their convent on Mt. Sion to Bethlehem, the governor promised that he "would so deal with him that he would never trouble any Christian again." He also said in the case of the doorkeeper of the church of the Ascension, who had demanded bakshish for the privilege of entry, that they should have given him

90. Actually it is not a mosque, having none of the fittings for worship, but simply a building over the sacred rock—the Qubbat aṣ-Ṣakhrah.

91. The dragoman of Ogier of Anglure told him that 12,000 lamps were regularly lit, except twice in the year, when 36,000 shone forth; Savage, in *The Arab Heritage*, p. 206.

92. The last three quotations come from pages 249, 251, and 253 of Casola's *Pilgrimage*.

93. In *PPTS*, IX (London, 1893), 113.

nothing, and "that henceforth he would never demand anything" more. [94] There are many such examples of Moslem correctness of feeling and conduct. One who reads Fabri's account of the journey to Sinai closes the book with the firm belief that the second dragoman, Elphahallo, was in wisdom, faithfulness, courtesy, tolerance, and kindness superior to any one of those he guided, not excepting Felix Fabri himself.

Probably many of those who traveled to the Holy Land after the fall of the crusaders' kingdom were less single-minded than their earlier predecessors, for many of them journeyed to obtain for themselves the indulgences attached to the several shrines and sites, whereas the earlier visitors had come out of sheer devotion to the saints and the Savior. That the church did not overexert itself to induce a higher motive than mere safety from future punishment is apparent in a number of *Viaggi in Terra Santa* where the several sites have the amount of their indulgences marked down by the author. Still, a reading of the numerous accounts of pilgrimages which began to appear in the fourteenth and fifteenth centuries proves that devout Christians were not extinct.

The surviving evidence suggests the conclusion, paradoxical as it may seem, that pilgrimage to the Holy Land during the two centuries after the fall of the crusaders' kingdom surpassed all previous records. Behind this growth were the naval supremacy and commercial policy of Venice. The aristocracy who dictated that policy saw that if Venice were to prosper, she must trade, and that Egypt and Syria were her best markets. With the increase of sea traffic, especially in the era of the crusades, the state began to take over its regulation. The demands of the west for the silks, spices, and paper of the east led to more frequent voyages, so that doge and senate asked themselves whether they could not kill two birds with one stone, and add passenger to commercial service for the benefit of the thousands who yearned to pay their devotions to the holy places and to secure by doing so some mitigation of the punishment for their sins; the benefit their action conferred upon their fellow Christians would also redound to the advantage of the Venetian state. After the defeat of Genoa in 1380 Venice held the monopoly of passenger and freight service, a monopoly that resulted not only from the victories of her superbly handled fleet, but also from the fact that the Moslem powers of the Levant were astute enough to encourage commercial relations with the "queen of the Adriatic" and to sanction the very profitable *peregrinatio ad Terram Sanctam*. In the thirteenth century the annual number of those who visited Palestine amounted to many

94. *Ibid.*

thousands: in the next two centuries it had hardly shrunk.[95] To estimate the numbers who embarked àt Venice for Joppa or Alexandria during the years of Venetian maritime supremacy would be fruitless, for one must remember that twice a year numbers of vessels crowded with pilgrims left for the Levant. As a result of this policy, wealth came to the republic and to the Mamluk sultans of Egypt, and thousands of westerners saw what they ardently wished to see, and would not otherwise have seen.

But dark days lay ahead for the republic, for the Egyptian sultans, and for prospective pilgrims. The small principality of the Osmanli Turks had become an aggressive "Ottoman" empire. Under Mehmed II, the conqueror of Constantinople, Selim I, who captured Cairo, and the great Suleiman I the Magnificent, the eastern Mediterranean had become almost a Turkish lake. The Venetian navy was unable to withstand the fleets of Selim and Suleiman, and since it could no longer protect its carrying trade and pilgrim galleys, commercial and passenger traffic ceased. Though Selim did allow Venice some trading privileges in Egypt, Turkish policy was to divert the valuable Indian traffic to Constantinople, now called Istanbul. Since Venetian seapower had been driven away from the Levantine and North African seaports, those who meditated a pilgrimage had to weigh the chance of safe voyage to Palestine against the likelihood of dangers run after landing there, or of capture at sea and toil as a galley slave at a Turkish oar. Indeed, had they reached Palestine, they would have found their former protectors in disfavor, for in 1551 Suleiman I had ordered the expulsion of the Franciscans from Mt. Sion. The belief had been promulgated that the tomb of David was beneath the lower hall of the Cenacle (the "upper room" of the Last Supper), and as the Moslems reverenced David, Suleiman finally enforced an earlier edict which had been allowed to lapse, and commanded "the expulsion of the infidels from the convent and church of the Cenacle."[96]

Thus pilgrimage fell off because of the rise of Turkish and the decline of Venetian naval power. There was, however, another, and a most important, reason for its lapse. This lay not in political events, but in the spread of another and different way of thinking about the motives and results of a visit to *alia loca ultramarina*. After Luther

95. Albert Hauck, "Pilgrimage," in *Encyclopaedia Britannica*, 11th ed., XXI (1911), 608.

96. In addition to the assertion that their presence desecrated sacred territory, the friars were charged with collecting and secreting weapons of war; Barnabas Meistermann, *New Guide to the Holy Land* (London, 1907), p. 125. The Franciscans were finally domiciled in the Holy Savior convent, where they still are.

had nailed his ninety-five theses to the door of the castle church at Wittenberg, the opening gun of the Reformation, the validity of many of the pious practices and procedures of the western church came under serious questioning, among them pilgrimage. Milton succinctly phrased the gist of the reformers' thinking on the practice in his description of Chaos:[97]

> Here Pilgrims roam, that stray'd so farr to seek
> In Golgotha him dead, who lives in Heav'n;
>
> .
>
> then might ye see
> Cowels, Hoods, and Habits with thir wearers tost
> And fluttered into Raggs; then Reliques, Beads,
> Indulgences, Dispenses, Pardons, Bulls,
> The sport of Winds: all these upwhirld aloft
> Fly o'er the backside of the World farr off

The first couplet strikes at the essence of the idea of pilgrimage. If Christ is risen and near to all men, why journey at such expense, to such a distance, with such risks of disease, captivity, and possible death? The question thus posed convinced many of the uselessness of going to Palestine to get what could be had at home. Pilgrimage almost died. It ceased to concern diplomats and historians. It seemed to have flown "o'er the backside of the World farr off."

Yet there were, and are today, a few who felt that a piety and grace that they knew they did not possess could be kindled in their hearts by the penance of the journey and the sight of the spots where Jesus and his disciples had walked and died. So no historian can write the epitaph of pilgrimage to the Holy Land. True, the mighty stream of Palestinian pilgrims shrank in the sixteenth century to the mere trickle that it is today. But that trickle has not gone dry; it still meanders on in our own century.

97. *Paradise Lost,* book III, lines 476-477, 489-494. Needless to say, there were others, even in the medieval period, who questioned the spiritual value of pilgrimage. Wyclif considered it "blind," for "Christ is in every place of the world," ready to take away sin; Herbert B. Workman, *John Wyclif: a Study of the English Medieval Church,* II (Oxford, 1926), 18.

III

ECCLESIASTICAL ART
IN THE CRUSADER STATES
IN PALESTINE AND SYRIA

A. Architecture and Sculpture

The rediscovery of the monuments of the crusaders has something of the romance of their creation. Some of them had never lacked notice. The main shrines were continually described by pilgrims, and the piety of the west was ever eager for news of them. Beginning with the Bordeaux pilgrim who left a record of his visit in

Contemporary accounts of the buildings and cities are found mainly in the narratives of pilgrims, too numerous to list in detail here; for them see J. C. M. Laurent, ed., *Peregrinatores medii aevi quatuor: Burchardus de Monte Sion, Ricoldus de Monte Crucis, Odoricus de Foro Julii, Wilbrandus de Oldenborg* ... (Leipzig, 1864), T. Tobler, ed., *Descriptiones Terrae Sanctae ex saeculo VIII., IX., XII., et XV.* (Leipzig, 1874), and R. Röhricht, ed., *Bibliotheca geographica Palaestinae: Chronologisches Verzeichniss der auf die Geographie des Heiligen Landes bezüglichen Literatur von 333 bis 1878, und Versuch einer Cartographie* (Berlin, 1890). A useful compendium can be found in D. Baldi, ed., *Enchiridion locorum sanctorum* (Jerusalem, 1935), and references will generally be given to that work. Translations of many of the pilgrims' narratives have been published by the Palestine Pilgrims' Text Society and by the Studium Biblicum Franciscanum in Jerusalem (1941 onward). G. Zuallardo (Johann Zvallart), *Il Devotissimo viaggio di Gierusalemme: Fatto, et descritto in sei libri* (Rome, 1587), B. Amico, *Trattato delle piante et imagini de i sacri edificii di Terra Santa* (Rome, 1609; Florence, 1620), tr. as *Plans of the Sacred Edifices of the Holy Land* by T. Bellorini and E. Hoade, with a preface and notes by B. Bagatti (SBF, no. 10; Jerusalem, 1953), and Eugène Roger, *La Terre Saincte, ou Description topographique très-particulière des saincts lieux, et de la terre de promission* ... (Paris, 1646: particularly valuable for Nazareth) begin a more scientific approach. F. Quaresmi, *Historica, theologica et moralis Terrae Sanctae elucidatio* ... (2 vols., Antwerp, 1625) was edited by P. Cypriano de Tarvisio (2 vols., Venice, 1880-1882); E. Horn (d. 1744), *Ichnographiae locorum et monumentorum veterum Terrae Sanctae*, ed. by H. Golubovich (Rome, 1902), has appeared in a new edition with parallel Latin and English text ed. by E. Hoade and B. Bagatti (SBF, no. 15; Jerusalem, 1962). George Sandys, *A Relation of a Journey begun An: Dom: 1610: Foure Bookes, Containing a Description of the Turkish Empire, of Ægypt, of the Holy Land, of the Remote Parts of Italy, and Ilands Adjoining* was published in London in 1615 and went through many editions. C. Le Bruyn's account of his travels was translated into English by W. J. London as *A Voyage to the Levant: or, Travels in the Principal Parts of Asia Minor, the Islands of Scio, Rhodes, Cyprus, &c., with an Account of the Most*

333, there was a constant succession of testimony to the condition of the holy places in Jerusalem. The writers, however, were preoccupied with edification. They repeat endlessly the local legends, the confirmation of the Gospel narrative that was to be experienced by visiting the actual scene. Ecclesiastical ceremonies might be recounted, but architecture was described only as large and splendid, and it was the abiding sanctity of the spot rather than any sense of history that attracted. It is only incidentally that we are informed about schemes of decoration or the layout of buildings, and the castles or other secular edifices pass almost unnoticed.

Considerable Cities of Egypt, Syria and the Holy Land, Enrich'd with above Two Hundred Copperplates, Wherein are Represented the Most Noted Cities, Countries, Towns, and Other Remarkable Things, All Drawn to the Life (London, 1702). See also Henry Maundrell, *A Journey from Aleppo to Jerusalem at Easter, A.D. 1697; Also a Journal from Grand Cairo to Mount Sinai and Back Again,* tr. R. Clayton (London, 1810), and R. Pococke, *A Description of the East and Some Other Countries* (2 vols., London, 1743-1745). In the nineteenth century illustrated volumes on the Holy Land became popular, and the engravings, though generally romanticized, sometimes provide details of buildings no longer extant or much altered: see as examples J. Carne, *Syria, the Holy Land, Asia Minor, & c. Illustrated, in a Series of Views Drawn from Nature . . . with Descriptions of Plates* (3 vols., London, Paris, and America, 1836-1838); A. and L. de Laborde, *Voyage de la Syrie* (Paris, 1837); W. H. Bartlett, *Walks about the City and Environs of Jerusalem* (London, 1844); and David Roberts, *The Holy Land, Syria, Idumea, Egypt, & Nubia . . . ,* with historical descriptions by . . . George Croly (6 vols., London, 1855-1856). George Williams, *The Holy City: Historical, Topographical, and Antiquarian Notices of Jerusalem* (2nd ed., with additions, including an architectural history of the church of the Holy Sepulcher by Robert Willis; 2 vols., London, 1849) is still of value.

Modern archaeological research on the subject opens with C. J. M. de Vogüé, *Les Églises de la Terre Sainte* (Paris, 1860). See also A. Salzmann, *Jérusalem: Étude et reproduction photographique des monuments de la ville sainte depuis l'époque judaïque jusqu'à nos jours* (2 vols., Paris, 1856); E. Pierotti, *Jerusalem Explored, being a Description of the Ancient and Modern City,* with numerous illustrations, consisting of views, ground plans, and sections, tr. T. G. Bonney (2 vols., London, 1864); V. Guérin, *Description géographique, historique et archéologique de la Palestine, accompagnée de cartes détaillées;* I. *Judée* (3 vols., Paris, 1868), II. *Samarie* (2 vols., 1874), III. *Galilée* (2 vols., 1880); C. R. Conder and H. H. Kitchener, *The Survey of Western Palestine: Memoirs of the Topography, Orography, Hydrography and Archaeology,* ed. with additions by E. H. Palmer (3 vols., London, 1881-1883); C. R. Conder, *The Survey of Eastern Palestine . . . ;* I. *The 'Adwân Country* (London, 1889); C. Clermont-Ganneau, *Archaeological Researches in Palestine during the Years 1873-1874,* with numerous illustrations from drawings . . . by A. Lecomte de Noüy, tr. A. Stewart and J. Macfarlane (2 vols., London, 1896-1899); M. van Berchem and E. Fatio, *Voyage en Syrie* (Mémoires publiés par les membres de l'Institut français d'archéologie orientale du Caire, vols. XXXVII-XXXVIII; 2 vols., text and plates, Cairo, 1913-1915); L. H. Vincent and F. M. Abel, *Jérusalem: Recherches de topographie, d'archéologie et d'histoire;* II. *Jérusalem nouvelle* (Paris, 1914-1926); P. Deschamps, "La Sculpture française en Palestine et en Syrie à l'époque des croisades," *Fondation Eugène Piot, Monuments et mémoires,* XXXI (1930), 91-118; R. Dussaud, *Topographie historique de la Syrie antique et médiévale* (Haut Commissariat de la République française en Syrie et au Liban, Service des antiquités, Bibliothèque\archéologique et historique, vol. IV; Paris, 1927); R. Dussaud, P. Deschamps, and H. Seyrig, *La Syrie antique et médiévale, illustrée* (*idem,* Bibliothèque archéologique et historique, vol. XVII; Paris, 1931); S. Langè, *Architettura delle crociate in Palestina* (Como, 1956); M. Join-Lambert, *Jerusalem,* tr. C. Haldane (London and New York, 1958); E. A.

In the late fifteenth century the "skilled painter" Erhard Reuwich of Utrecht sketched the façade of the church of the Holy Sepulcher with some accuracy (fig. 1),[1] but it is not until the late sixteenth

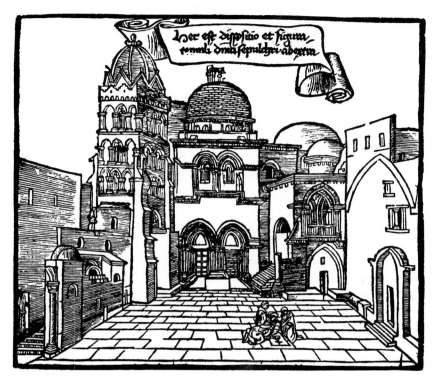

1. Church of the Holy Sepulcher, Jerusalem, south façade. Erhard Reuwich, 1486

Moore, *The Ancient Churches of Old Jerusalem: The Evidence of the Pilgrims* (London and Beirut, 1961); P. Deschamps, *Terre Sainte romane* (La Nuit des Temps, 21; [La Pierre-qui-Vire, Yonne], 1964); T. S. R. Boase, *Castles and Churches of the Crusading Kingdom* (London, 1967); C. N. Johns, *Palestine of the Crusades: A Map of the Country . . . with Historical Introduction and Gazetteer* (Survey of Palestine, 3rd ed., Jaffa, 1946); J. Prawer and M. Benvenisti, "Palestine under the Crusaders" (map with commentary and bibliography), *Atlas of Israel* (Jerusalem and Amsterdam, 1970), section IX: "History," ed. M. Avi-Yonah, no. 10. There is much useful information in the various guidebooks, particularly B. Meistermann, *Guide de Terre Sainte* (rev. ed., Paris, 1923); P. Jacquot, *L'État des Alaouites, terre d'art, de souvenirs, et de mystère: Guide* (Beirut, 1929) and *Antioche* (Antioch, 1931); and Stewart Perowne, *The Pilgrim's Companion in Jerusalem and Bethlehem* (London, 1964). C. Enlart, *Les Monuments des croisés dans le royaume de Jérusalem: Architecture religieuse et civile* (Haut Commissariat . . . , Bibliothèque archéo-logique et historique, vols. VII-VIII; 2 vols. and 2 albums of plates, Paris, 1925-1928) is the most comprehensive work on the subject. M. Benvenisti, *The Crusaders in the Holy Land* (Jerusalem, 1970; New York, 1972) has much information about minor crusading buildings. M. Barasch, *Crusader Figural Sculpture in the Holy Land: Twelfth Century Examples from Acre, Nazareth and Belvoir Castle* (New Brunswick, N.J., 1971) deals with recent discoveries and a reassessment of the five Nazareth capitals found in 1908.

1. See *Bernhard von Breydenbach and his Journey to the Holy Land, 1483-1484: A Bibliography,* compiled by H. W. Davies (London, 1911), plates 30-33.

century with Giovanni Zuallardo, and the seventeenth with Bernardino Amico, Eugène Roger, and Francesco Quaresmi, that there is any attempt to investigate the origins and style of the monuments and to plan and draw them. Zuallardo's plates, published in Rome in 1587, were frequently reused, notably by John Cotovicus in his *Itinerarium Hierosolymitanum*, published in Antwerp in 1619, and by George Sandys, who in 1610 "began my journey through France, hard upon the time when that execrable Murther was committed upon the person of Henry IV," and published his account of his travels in 1615, a work that was to enjoy great popularity and pass through many editions. In 1681 Palestine was visited by Corneille le Bruyn, who perceived in himself "an insuperable Propension of Travelling into Foreign Parts," and who fortunately decided that there was "nothing more requisite and advantageous for a Traveller, who would reap any benefits from his Travels, than to be skilled in the Art of Designing, that thereby he might imprint Things the more deeply into his Mind, and represent them before his Eyes as always present, which is the surest way of keeping him from forgetting what he has observed." The work of Elzear Horn, prior of the convent of the Holy Sepulcher from 1725 to his death in 1744, may be taken as concluding this period of investigations.

New forms of patronage and new skills in watercolor and reproduction were to reach a wider public. Robert Bowyer, for instance, published from the Historic Gallery in Pall-Mall in 1804 a folio *Views of Palestine*, illustrated with colored aquatints after drawings by Luigi Mayer, made for Sir Robert Ainslie, Lord Elgin's predecessor as ambassador to the Sublime Porte. Mayer was the forerunner of a long series of travelers, some of them, such as David Roberts, artists of merit, who were anxious to leave a record of places and customs seen, and of biblical and classical antiquity. Medieval remains as such, however, were regarded as of little interest, though hilltop castles fitted well with the current romanticism; there was no serious attempt to estimate the crusaders' architectural achievement until the book *Les Églises de la Terre Sainte*, by the Marquis de Vogüé, appeared in 1860, to be followed by that of Baron Rey on the castles in 1871. Initiated by French savants, this study has remained primarily indebted to them. Guérin, Clermont-Ganneau, Van Berchem, Dussaud, and the indefatigable and immensely learned Dominicans Father Vincent and Father Abel are the leading names, though England in *The Survey of Palestine* added some useful and systematic work, continued under the mandate by the Department of Antiquities in Palestine. The

crowning achievement, however, was the publication from 1925 to 1928 of Camille Enlart's *Les Monuments des croisés dans le royaume de Jérusalem: Architecture religieuse et civile.*

Twenty-five years earlier Enlart had written of the buildings of Cyprus; now he brought to Palestine and Syria a rich and unequaled maturity of information. His trained and observant eyes took in every detail of architectural plan or sculptured ornament, and his memory could find unfailingly some parallel in western Europe. In a work of this scale, much of it pioneer investigation, there were inevitably some inconsistencies, some facts which later research has modified; but to anyone familiar with Enlart's book its exhaustiveness and its profound scholarship must always remain matter for astonishment and admiration. Facts since discovered may have supplemented his statements; they have not invalidated them. If his main thesis, that the crusaders brought with them French types and French methods, is at times too strongly stated, the evidence against it is always implicit in his own examination of the particular buildings. Any treatment of this subject must largely be a recapitulation of his conclusions.

The problems raised are sufficiently complicated. Of the major crusading churches, only the church of the Holy Sepulcher, that of St. Anne in Jerusalem, and the cathedrals of Tortosa and Jubail remain in any way intact. Those of Hebron, Gaza, Ramla, Beirut, and Tripoli have been converted into mosques, whitewashed and mutilated; Sebastia is a beautiful skeleton of unroofed walls and piers; the churches of Acre, the great cathedral of Tyre, the splendors of Antioch, the magnificent Cluniac church on Mount Tabor, the cathedral of Caesarea exist for us only as ground plans, reconstructed on partial indications, or as mere references in contemporary accounts. Figure carving, where it existed, was destroyed with fervor by the Moslem iconoclasts. "The voracity of time," to borrow Maundrell's phrase, "assisted by the hands of the Turks, has left nothing but a few foundations remaining."

The general type of building can, however, be determined with some degree of probability. With the exception of the church of the Holy Sepulcher, crusading churches were on the whole small in scale. The cathedral of Tyre and the church of the Annunciation at Nazareth, two of their largest achievements, measured, as nearly as can now be ascertained, 244 by 82 feet and 244 by 98 feet respectively. Most of the churches were considerably smaller two-aisled buildings, ending in triple apses, often embedded in a rectangular chevet; the nave was covered with a barrel vault, the

aisles with groined vaulting; projecting transepts were, with the exception of the cathedral of Tyre and the church of Jacob's Well, not employed. The chapels of the castles and the lesser churches of towns were generally aisleless, composed of a nave ending in a semicircular apse; certain shrines were covered by small cupolas raised on arches, a design particularly associated with the Temple area; the Templars' castle at Château Pèlerin ('Atlīt) had a polygonal chapel, modeled possibly upon the Dome of the Rock.

Of the organization of all this considerable building activity we unfortunately know but little. No chronicler nor cartulary gives any details of workmen employed or funds expended. Here and there a name occurs among the masons' marks: "Jordanis me fecit," formerly on the tower of the Holy Sepulcher, suggests a man baptized in the Jordan, but gives no clue as to his nationality; the name Ode occurs several times on the church of Jacob's Well; that of Ogier on the apse at Nazareth. We can only infer from the buildings themselves and the probability of events that western master masons presided over local workmen who themselves had a long tradition of mason's craft behind them; and that among the pilgrims were some sculptors of outstanding ability.

The earliest extant example of a crusading church may well be the small building of St. Paul at Tarsus, with a square-ended choir and a nave and aisles divided by columns alternating with square pillars supporting a wooden roof. The capitals are roughly blocked out in cubes and the whole is a crude piece of work, reminiscent of some early Romanesque churches in France rather than of any local style. Apart from this outlying example it is difficult to trace any clear chronology in crusading building. The type of capital employed gives some suggestion of sequence, but the main forms of building alter little between the Frankish conquest and the victory of Saladin. The slightly pointed arch, found even at Tarsus, seems to have been consistently adopted. In Arab work it was already a recognized feature, and the crusaders appear to have used it readily.

The church of the Holy Sepulcher was the goal of crusading endeavor and the most elaborate product of their building enterprise.[2] The claim of the site to authenticity rests on the contempo-

2. The literature on the church of the Holy Sepulcher would require a large bibliography to itself. There are said to be eighty-eight accounts dealing with it before 1808; extracts from the most important can be found in Baldi, *Enchiridion*, pp. 784-896. Of recent works the most authoritative are de Vogüé, *Églises de la Terre Sainte*, pp. 118-232; Vincent and Abel, *Jérusalem*, II, 89-300; A. W. Clapham, "The Latin Monastic Buildings of the Church

rary account written by Eusebius of Caesarea of the rediscovery of the tomb under Constantine. This assumes the existence of a continuous Christian tradition as to the burial place of Christ, a tradition that had survived the rebuilding of Jerusalem under Hadrian, when a temple to Venus had been erected in the area of Golgotha. In the Constantinian excavations, a cave sepulcher was discovered, and identified as Christ's tomb. The rock around it was cut away, so that it became free-standing, and an edicule was built over it; to the west it was framed in a hemicycle of walls, with a central apse and an apse closing each end of the half circle; to the east a basilica church was erected, known as the Martyrium. Between the church and the edicule of the tomb, the summit of Calvary was left clear, though the gap between its lower slopes and the opposite hillside was partially filled in to support the platform above.

Constantine's buildings were, however, largely destroyed by the Persians in 614, and were rebuilt by the patriarch Modestus (d. 634). In 966 the doors and roofs were burnt in a riot, and in 1009 a more complete demolition was carried out on the orders of the Fāṭimid caliph al-Ḥākim. In 1048 restoration was once more undertaken, largely financed by emperor Constantine IX Monomachus, and within the ruins of the hemicycle a domed rotunda was constructed, supported on a circle of eighteen pillars, with the edicule of the tomb as its central feature. On the east the main altar was in a polygonal apse, projecting on the western face from a straight wall with four doorways, stretches of wall that still survive with their upper

of the Holy Sepulchre, Jerusalem," *The Antiquaries Journal,* I (1921), 3-18; and W. Harvey, *Church of the Holy Sepulchre: Structural Survey, Final Report* (London, 1935). See also T. Tobler, *Golgotha, seine Kirchen und Kloster: Nach Quellen und Anschau* (St. Gall and Berne, 1851); K. Schmaltz, *Mater ecclesiarum: Die Grabeskirche in Jerusalem* (Strassburg, 1918); N. C. Brooks, *The Sepulchre of Christ in Art and Liturgy, with Special Reference to the Liturgic Drama* (University of Illinois Studies in Language and Literature, VII, no. 2; [Urbana], 1921); George E. Jeffery, "The Church of the Holy Sepulchre, Jerusalem," *Journal of the Royal Institute of British Architects,* ser. 3, XVII (1910), 709-729, 750-763, and 803-828; H. T. F. Duckworth, *The Church of the Holy Sepulchre* (London, 1922); C. W. Wilson, *Golgotha and the Holy Sepulchre,* ed. C. M. Watson (London, 1906); L. H. Vincent, D. Baldi, L. Marangoni, and A. Barluzzi, *Il Santo Sepolcro di Gerusalemme: Splendori, miserie, speranze* (Bergamo, 1949); A. Parrot, *Golgotha et Saint-Sépulcre* (Cahiers d'archéologie biblique, no. 6; Neufchâtel and Paris, 1955); K. J. Conant, "The Original Buildings at the Holy Sepulchre in Jerusalem," *Speculum,* XXXI (1956), 1-48; and, in *Revue biblique,* LXIX (1962), 100-107, a report by L. Collas, Ch. Coüasnon, and D. Voskertchian on the results of recent excavations undertaken with a view to restoring the church. I am much indebted to Mr. Collas for his help and advice in Jerusalem in the spring of 1963. Finally, see the Schweich lectures for 1972: Ch. Coüasnon, *The Church of the Holy Sepulchre in Jerusalem* (London, 1974), especially, pp. 54-62 [J. F.].

windows visible above later rebuilding. Immediately to the south, aligned on the façade of the rotunda, were three chapels, of St. John, of the Holy Trinity, and of St. James. No attempt was made to restore the Martyrium.

The rock surface on which traditionally Christ's body had lain was destroyed under al-Ḥākim, and the greater part was cut away and leveled. Enough remained, however—or was replaced—for the Greeks to hide the slab at the crusaders' approach, fearing the Latin Christians and their rapacity for relics. It was soon found and enclosed in marble, to which in 1170 Manuel Comnenus added a covering of gold. Parts of it seem to have been left visible and to have been pared away rapidly by the devout thefts of pilgrims.[3] Abbot Daniel in 1106 describes the tomb as a grotto in the rock, the outside of which was covered with marble like an ambo, surrounded by ten columns and surmounted by a cupola on which stood a figure of Christ in silver, more than life-size and the work of the Franks.[4] The whole scheme suggests a western Romanesque design. The cupola was again a feature of the restoration of the tomb after its pillage by the Khorezmian Turks in 1244. Earlier, by the time of Theoderic's account (about 1172), the silver figure had been replaced by a golden cross, possibly part of the enrichment made at the expense of Manuel Comnenus. There is nothing that can be taken as an accurate drawing of the edicule until those of Zuallardo (1585) and Bernardo Amico (1609), and they show it as it was restored in 1555. Unfortunately Zuallardo depicts the arcade with round arches, Amico with pointed. The latter is the more careful draftsman, and it is probable enough that the twelfth-century shrine showed the Palestinian partiality for the pointed arch. In the Franciscan convent of the Holy Sepulcher there is an early Gothic fragment of the capital of a small twin column, found in the rubble of nineteenth-century rebuilding, which almost certainly comes from the cupola of the edicule. The present ornate edicule was erected after the fire of 1808.

The scheme evolved by the crusaders was a spacious and ambitious one, to include, as William of Tyre puts it, the whole in one building (fig. 2). The eastern apse of the rotunda was removed, and a triumphal arch led to a crossing, covered by a dome and followed by

3. This remained a regular practice; see Brother James of Verona, "Liber peregrinationis," ed. R. Röhricht, in *ROL,* III (1895), 186.
4. The relevant passages from pilgrims' accounts can be found in Baldi, *Enchiridion,* pp. 784-896.

a rectangular vaulted compartment and semi-dome forming the choir and the presbytery. From the apsidal ambulatory opened three radiating chapels; to the southeast a flight of stairs led up to the chapel of Calvary, another flight led downwards to the chapel of St. Helena, probably the crypt of the Constantinian basilica; the south

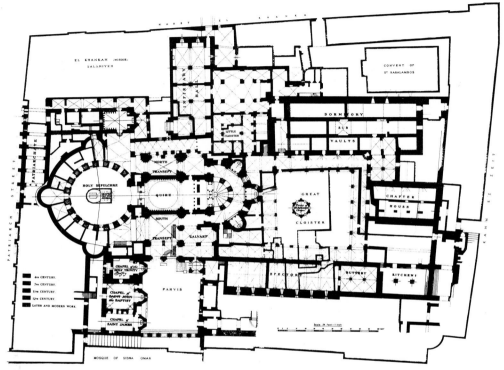

2. Plan of the church and priory of the Holy Sepulcher, Jerusalem

transept ended in a double doorway which formed the main entrance. In the northern transept the plan was complicated by the retention of the old Byzantine courtyard colonnade, forming a second row of pillars slightly off the main crusading axis, which was governed by the eastern orientation of the high altar—a point on which the crusaders laid great emphasis, whereas the Constantinian basilica had its altar in a western apse, oriented toward the sepulcher. The obvious prototype of the crusading work would be a Cluniac pilgrimage church of southern France, but for the nature of the vaulting. This is ogival in form with finely molded ribs, a style little used elsewhere in the crusading kingdom. The stones are laid horizontally in the French fashion and their rough finish suggests

that originally the vaults were plastered. From various accounts of the splendor of the interior decoration, they were almost certainly painted. The type of vault is therefore similar to that which Suger was introducing at St. Denis, almost contemporaneously with the building in Jerusalem; the abbey church of St. Denis was consecrated in 1144, five years before the new church of the Holy Sepulcher, which, as is established by an inscription preserved by Quaresmi and confirmed by calendar entries, was consecrated on the 15th of July, 1149, the fiftieth anniversary of the taking of the city.

Over the crossing was raised a tall dome, carried on a drum with pointed arcading, pierced with eight pointed windows and supported on pendentives. The construction is Aquitainian rather than Byzantine. On the outside, completely restored after earthquake damage in 1927, the dome was surrounded by a band of corbels, many of them of carved heads, and a circular stairway ran up its face to a small pillared cupola which must have been somewhat similar in design to that above the tomb. The roofs of the transepts and the ambulatory were flat in accordance with ordinary Palestinian practice. This allowed for a wide tribune gallery of even height, and on the interior elevation the tribune openings are almost equal in scale to the ground sections. Restorations in the 1960's have brought to light and, with the opening of windows, to visibility much of the twelfth-century work, in particular the coupled columns, which had been plastered over into solid blocks in the drastic repairs of the early nineteenth century.

The main façade, leading into the southern transept, is approached through the parvis, a small courtyard bounded on the east and west by chapels and on the south by an eleventh-century pillared colonnade, of which now only one pillar survives. The façade itself, except for the slightly pointed arches, reveals, no longer disfigured by supporting scaffolding, a Romanesque plan of severe grandeur, which though it has no exact parallels would not seem out of place in southern France (frontispiece). The design is based on a division into two approximately equal spaces, defined by great carved cornices. In the lower story are two arched doorways, in the upper similar arches enclose two windows, and the hoodmolds of these arches continue as stringcourses across the façade, enclosing on either side smaller windows, the western one now being blocked by the bell tower. Right-angled bends in the central cornice repeat the trace of the stringcourses. Beneath this structure and the paved parvis were the filled-in quarries of the slopes of Golgotha and the Constantinian

arched supports. The central pilaster of the doorways rests on a rock projecting from the hillside, but undercut beneath. This lower face was smoothed down, presumably by the crusaders, so as to be built up by masonry supports, but these, whether by inadvertence or from a lack of supervision, were never supplied till the discovery in 1962 of the precarious basis on which the whole structure rested.

The balance of the scheme of the façade was destroyed by the crusaders themselves, when on the west side they raised a four-storied bell tower, crowned with a cupola. The tower, now much truncated, was clearly a later addition, cutting across the cornices, and as al-Idrīsī in 1154 refers to a tower there seems no reason to doubt that as early as this, possibly even before the consecration, the first design had been modified. The colonnettes of the windows have early Gothic capitals, flat leaves curving over at the tips, quite distinct from any of the ornaments found elsewhere in the church. The façade can never have been wholly symmetrical, for on the eastern side a stair leads up to the portico of the chapel of Calvary, with below it the chapel of St. Mary of Egypt. The rocky mound of Golgotha had, before the crusades, been squared and hollowed out into an architectural feature of superimposed chapels, and it was in the upper chapel, representing the original summit, that was shown the cavity where the cross had been erected, and the fissure where the earth had opened. Beyond the bell tower, forming the west flank of the parvis, were the Byzantine baptistry, part of the rebuilding of the mid-eleventh century, and the chapel of St. James the Less. Opposite, the eastern side was formed by the chapels of St. Michael and of St. James and the convent of St. Abraham, commemorating the site of the proposed sacrifice of Isaac.

Around the main buildings were grouped on the north the prison of Christ and the chapel of the Relic of the Holy Cross. At the northwest corner was the palace of the patriarch, as well as various monastic buildings, some of them now embodied in the mosque founded by Saladin in 1187. The fragment of an inscription on an interior doorway of the mosque refers to a foundation by the patriarch Arnulf, who was responsible in 1114 for reorganizing the chapter of the cathedral and enforcing the Augustinian rule of communal life. As entrance to these quarters the crusaders opened a doorway from Patriarch Street, which still exists with its godroon decoration, though partially built over by shops. From this door a great stairway led downward to the triple-arched portico, which survived, and still survives, from the eleventh-century rebuilding. On

the east was the great cloister, built by the crusaders; the northwest bay retains its vaulting, and the western wall has the springers of the vault supported on the characteristic shafts fixed with a right-angle bend into the wall, so much used by the crusaders and one of the least happy of their inventions, particularly here where it is combined with some surprisingly eccentric capitals (pl. Va). The arcades had an ovoid decoration, such as is worked out on a more lavish scale on the cornices of the façade. In the center of the cloister rose the dome of the subterranean chapel of St. Helena, a mainly Byzantine building with magnificent Byzantine pillars and capitals, the approach to which is by a stairway from the ambulatory.

The sculpture of the south façade is a notable example of the Franco-Byzantine style. The crusaders were close to sources they had before known only remotely, and it is still difficult to separate their work from that which is more ancient. In particular it is difficult to tell a crusading acanthus capital from a Byzantine one. The former, particularly in work of the mid-twelfth century, tends to have a deeper indentation between the volutes, but, cut from the same building stone, worked in all probability with the assistance of Syrian masons in whom an old tradition was still strong, it is hard to draw clear distinctions. Nor is the facing of the stone necessarily a guide, for when the crusaders took Byzantine capitals and friezes, joins often needed repairing, and their own tool work was superimposed on older cutting. The most impressive feature of the façade is the two cornices, which are on a massive scale, composed of large blocks, deeply undercut. Their design is highly Hellenistic, recalling those friezes of which Baalbek, never held by the crusaders, has the supreme examples, but which were also to be found in other ruins, such as at Tyre. It consists of an inner ovoid pattern with a rope molding, a central feature of stiff acanthus, leading to coffered compartments with inset petaled flowers, and, above, a rich acanthus border (pl. Ia). Enlart has argued that these carvings must be reëmployed work from an earlier building, but the exactness with which the corners are fitted and the absence of any patchwork and adjustments in so elaborate a scheme make this hardly credible.

The stringcourses over the windows and doorway arches are also highly decorated. The upper course is a rich and flowing acanthus theme, springing from an elaborately carved pine cone in the central spandrel. The stringcourse above the doorways is much more stylized; a flat, spiky acanthus forms regular circular coils in a manner strongly reminiscent of Coptic carving and quite different in

inspiration from either the cornice or the upper stringcourse, though excellently done in its own way. Yet another style is found in the marble impost to the door arch, where palm leaves and bunches of dates, treated with some observation, coil under a molding of egg and dart pattern. This impost continues, as does the stringcourse, until the junction of the façade with the portico to the chapel of Calvary. Here the same motif of foliate curves takes on yet new forms, and there is a rich design where birds inhabit the scroll, more western in feeling than the other friezes. The tympanum of the doorway through to Calvary provides the climax to these variations; the whole space is filled with intricate vine patterns, carved with great freedom and forming one of the most elaborate pieces of medieval foliage decoration that has come down to us, worthy of its subject, the True Vine, on the supreme position of the threshold of Golgotha (pl. Ib).

Below the stringcourses the windows and doorways of the façade have voussoirs formed of godroons, or rows of deeply beveled stones. This was a style popular in the Near East. An early example of it can be found in the Bāb al-Futūḥ at Cairo, the great gateway built in 1087 under Syrian influence. Contemporaneously with the Holy Sepulcher, godroons were being used on the Martorana Tower begun in 1143 in Palermo, another center of Arab influences. They were to become the most characteristic feature of crusading decoration, though one seldom copied in the west.

The capitals of the main portal and the chapel of Calvary, both on the exterior and interior, are strongly Byzantine in feeling and have their nearest parallels in the almost contemporary examples in St. Mark's at Venice. They are composed of acanthus leaves, sometimes curling around the capital instead of rising upwards, sometimes windswept, a Byzantine mode of which there were certainly local examples. Within, the great capitals of the ambulatory of the choir are in some cases reëmployed from earlier buildings, sometimes crusading work; here and there on imposts and friezes patterns recur from the decoration of the façade. In the north transept there is a crowned and winged man, probably Solomon, seated under a canopy, which conforms to a familiar French type and is clearly twelfth-century work. On another capital of the same transept, grotesque figures grasp the acanthus fronds, so closely imitated from the antique, so completely different from the Solomon that it may be reëmployed material. These are not the only pieces of figure sculpture that survive, for the two lintels of the main doorway, which long remained *in situ*, are now preserved in the Rockefeller

Museum in Jerusalem (pl. II). The tympana above them seem to have been decorated in mosaic and that on the right still bears traces of a patterned inlay; Fra Nicholas of Poggibonsi, writing of their state in 1345, describes a representation in mosaic of the Virgin with the Child in her arms, by then much damaged.

The whole iconography of the doorway is a puzzling business. The left-hand lintel has a series of scenes from Passion Week, the subjects and arrangement of which caused some confusion to pilgrims. The first scene is that of the raising of Lazarus, followed illogically by the appeal of Martha and Mary to Christ (which Louis de Rochechouart described in 1461 as Mary Magdalen kissing Christ's feet, admitting that apart from the Entry into Jerusalem he could not identify any other subjects). Next Christ in an upper chamber dispatches Peter and John for the ass, while below two men are engaged in some activity with sheep. An alternative interpretation was given by Felix Fabri (1480) of Christ driving the money-changers from the Temple; this is repeated by Zuallardo and is therefore probably one that had been adopted by the Franciscan guardians; the group, however, is linked with the bringing of the ass and the Palm Sunday entry. The panel ends with the Last Supper; this should normally have led on to the Betrayal, Crucifixion, and Entombment, and Fra Nicholas, who describes the existing carving in detail, adds the Kiss of Judas, for which there is no place on the present lintel slab. Zuallardo indicates in his small drawing a continuous row of figure subjects.

Instead of any such scenes, the right-hand or eastern lintel has a series of coiling tendrils in which naked men and winged monsters intertwine in the style of the Toulousan school. Doubtless with some allegorical meaning, it is yet a somewhat pagan piece with which to greet the pilgrim at the climax of his journey. The molding of the western slab exactly fitted the impost of the capitals at either end, whereas this scroll slab (made up of three pieces of marble, one of which has Arab carving on its reverse) was more roughly adjusted and the molding does not continue round the ends. On this score it might be considered a later insertion, though in execution both pieces must date from the twelfth century. De Thevenot in 1656 describes the doorway as "having over it many Bas-Reliefs, representing the several sacred Histories." John Madox, a careful observer, describes in 1825 "a small bas relief, representing the triumphal entry of Our Saviour into Jerusalem; on the right of this is the subject of the Supper, and at the other end, the Tomb or Resurrection." By this last he must mean the Raising of Lazarus, and as he is so specific it seems probable that by this date there were no other scriptural scenes. Possibly the Crucifixion scenes were at some time destroyed by

Moslem fanatics, and replaced by this less-provocative theme already existing in some other position.[5] In the center of the left-hand panel, the figure of Christ is missing from the Entry into Jerusalem, and there is here a gap in the relief. Strangely enough, a broken fragment of Christ on the ass was found by the archaeologist Clermont-Ganneau in 1873 built into the wall of an Arab house. He thought it to be the missing piece, but comparison of a cast (the fragment itself is now in the Louvre) with the gap shows that it could never have been part of the lintel and must be the remains of some other similar frieze.[6]

The weathered condition of the lintel figure sculpture, and the treatment it received in the 1930's for conservation purposes (pl. III) make it hard to assess its quality; the figures are treated with some attempt at naturalism and facial expression, but it is all somewhat clumsy and uncertain. The Clermont-Ganneau fragment is less worn and considerably finer work; it is genuinely Romanesque in treat-

5. "Journal de voyage de Louis de Rochechouart, évêque de Saintes," ed. C. Couderc, in *ROL*, I (1893), 241; *The Travels of Monsieur de Thévenot into the Levant, . . . I. Turkey; II. Persia; III. The East Indies* (London, 1687), p. 191; J. Madox, *Excursions in the Holy Land, Egypt, Nubia, Syria, etc.* (2 vols., London, 1834), I, 213.

6. E. T. Richmond, "Church of the Holy Sepulchre: Note on a Recent Discovery," *Quarterly of the Department of Antiquities in Palestine*, I (1931), 2; Clermont-Ganneau, *Archaeological Researches*, I, 112-115; E. Henschel-Simon, "Note on a Romanesque Relief from Jerusalem," *Quarterly of the Department of Antiquities in Palestine*, XII (1946), 75-76, and pl. XXIV; M. Aubert, *Description raisonnée des sculptures du moyen âge, de la Renaissance, et des temps modernes; I. Moyen âge* (Paris, 1950), 83.

The south transept façade is the subject of a recent study which stresses the local artistic tradition in its sculptural decoration and draws a parallel between the Golden gate to the city of Jerusalem and this entrance to the church, to help explain its design and meaning; see Nurith Kenaan, "Local Christian Art in Twelfth Century Jerusalem," *Israel Exploration Journal*, XXIII (1973), 167-175, 221-229. [J. F.]

Of the two lintels carved for the main doors, it is the historiated one which has received most of the attention. Arthur Kingsley Porter, among others, studied it in the 1920's, before any conservation work had been done, and concluded that the style was comparable to Condrieu, in the Rhône valley; see his "Condrieu, Jerusalem and St. Gilles," *Art in America*, XIII (1924-1925), 117-129. More recently Alan Borg has questioned the traditional views of Camille Enlart (*Monuments des croisés*, II, 165-171), Paul Deschamps ("Sculpture française en Palestine," *Fondation Eugène Piot, Monuments et mémoires*, XXXI, 92-93), and others, who linked the lintel stylistically to Provence with a date shortly before 1149. Borg suggests Tuscan formal and iconographic connections and proposes that the sculpture was done between 1149 and 1187; see his "Observations on the Historiated Lintel of the Holy Sepulchre, Jerusalem," *Journal of the Warburg and Courtauld Institutes*, XXXII (1969), 25-40. Although Borg was working only from photographs, his article points up the need for a thorough restudy of all aspects of the historiated lintel. N. Kenaan will attempt to reinterpret the iconography in a forthcoming number of the *Israel Exploration Journal*.[J.F.]

The other lintel, with its boldly naked men and fearsome beasts amidst the vine scrolls, is discussed by L. Y. Rahmani, "The Eastern Lintel of the Holy Sepulchre," *Israel Exploration Journal*, XXVI (1976), 120–129. A satisfactory understanding of the program of the south façade can be achieved only through such serious studies of these lintels, along with the other elements. [J. F.]

ment, with the familiar circular folds on knees and shoulders, and has been drilled with holes along the borders of the drapery, where presumably colored paste was inserted. It has recently been suggested that it links up with a group of sculpture, now mainly in the museum of the Greek patriarchate, which is said to have come from the site of the buildings south of the parvis constituting the headquarters of the Knights Hospitaller. Today of all this complex there remain only the church of St. Mary Latin, transformed into the German Romanesque building of the Erlöserkirche, and the much rebuilt church of St. John the Baptist.[7] In the early years of this century the Greek church authorities, the owners of this area, cleared it to build the present banal and somewhat shoddy market, but unfortunately no competent archaeologists were able to make an examination of the site during its reconstruction. Something was in fact learnt, but the evidence was not accurately observed and even the exact provenance of the carved fragments is uncertain.

On the south side of the parvis stood the actual Hospital, stretching southwards to the church of the Baptist, which latter still retains its original Byzantine trefoil form of a choir and two transepts, all three ending in a semicircular apse, with a dome over the crossing. East of the Hospital were the church of St. Mary the Great and the conventual buildings of the Benedictine nuns, who supplied much of the nursing and general work of the Hospital. This name of "the Great" came into use only in the second half of the twelfth century and probably refers to some rebuilding. The design was a characteristic one, with a nave and aisles ending in three apses, but its exact characteristics are largely conjectural. The bell tower, converted into a minaret, was still standing in the nineteenth century, and some magnificent acanthus capitals from the site are preserved in the convent of St. Abraham (pl. VIa), the museum of the Greek patriarchate, and the Rockefeller Museum.

The patriarchal church of St. Mary Latin, of which parts, including an arcade of the cloister, still exist in its German reconstruction, had the main door on the north (pl. IVa), a cupola over the crossing, a nave of three bays, and the usual apsidal chevet. In the reconstructed doorway there are a cornice with carved metopes, an elaborate

7. Vincent and Abel, *Jérusalem*, II, 642-668, 953-965, and pl. LXXXVII. See, for accounts before the rebuilding, Salzmann, *Jérusalem*, I, 68; Pierotti, *Jerusalem Explored*, I, 130-134; Enlart, *Monuments des croisés*, atlas, II, plates 102 and 103; de Vogüé, *Églises*, pp. 255-262, plates XVI-XVIII. There has been much confusion over the sites of St. Mary the Great and St. Mary Latin, a confusion which is unfortunately reflected in Enlart's account. The current excavations under the Church of the Redeemer by Dr. Ute Lux of the German Archaeological School will no doubt shed new light on St. Mary Latin [J. F.].

stringcourse with signs of the zodiac over the archway, and some fragments of a tympanum which must once have been composed of a central figure with groups on either side. The fragments in the patriarchal museum seem to come from similar voussoirs or cornices, notably an archer with his dog, carved in very high relief, an admirable piece in which the archer's head seems a reminiscence of some Syrian model (pl. VIIa), and, also from a voussoir, in marble not in the local stone, a headless figure, whose pose and finely treated drapery have suggested the Virgin Annunciate but which from traces of the fringe of a beard below the broken neck must clearly be a prophet. Two sadly mutilated capitals, where the angel's message to Zacharias, the Visitation, the figure of the Baptist, and his execution can be distinguished, set out the story of the patron saint of the Hospital. They must have been work of high merit. Fragmentary as this evidence is, it is enough to establish that working on these buildings was a band of skilled sculptors, with considerable range and variety of style.

The Jerusalem masons' yard must have been a reservoir from which workmen were drawn for undertakings elsewhere. During excavations in 1962 at the castle of Belvoir, at a part of the site thought to be the chapel, a slab was found with a carved angel (pl. XIXa) holding a book, slightly battered but with the folds of the garment, the feathers of one wing, and much of the head still crisply cut and little weathered. The slab has a beveled edge that suggests the frame of some central feature, which would most probably have been a Christ in Majesty. The angel with the book is the normal emblem of St. Matthew, though here placed on the right instead of the more usual position on the left—that is, on Christ's right hand. The order of the evangelist symbols could, however, vary, and at St. Sernin, at Toulouse, and at Angoulême St. Matthew is placed as at Belvoir. Stylistically the closely pleated robe, looped at the waist, and the large head are not unlike the treatment of some of the figures on the lintel of the Holy Sepulcher, allowing for the fact that the latter are much more worn and blurred. Belvoir was sold to the Hospitallers in 1168, during the lavish mastership of Gilbert of Assailly, and it would be likely enough that they should send out masons from their Jerusalem undertakings. Certainly in scale and accomplishment the Belvoir tympanum must have been a splendid piece.[8] Also from Belvoir, and now in the Israel Museum at

8. I am very grateful to Dr. J. Prawer for information about and a photograph of this relief, which is now in the Rockefeller Museum in Jerusalem. The beveled edge is on the upper part of the left side. For the Belvoir relief see Barasch, *Crusader Figural Sculpture,* pp. 189-207 [J. F.].

Jerusalem, is a striking carved head, life-size, of a young man (pl. XIXb). Despite its battered condition, this smiling face still has considerable charm and is certainly the work of a skilled carver.

Constantly visible from roof-top or alley stairway throughout the city, the Dome of the Rock, the Byzantine octagonal temple built by the Umaiyads in the early days of the conquest, serene and complete, is, or was before recent restorations which have replaced the dome and much of the tile work, one of the loveliest buildings in the world (volume I, p. 79). It stands over the rock of Jacob's Dream and David's Threshing Floor, where the souls of the righteous of Islam shall assemble on the last day, sacred alike to Christian, Jew, and Moslem. To the crusaders, undisturbed by any historical sense of architectural styles, it was *Templum Domini*, the most characteristic and outstanding feature of the holy city. "A quocumque sit constructum/Templum sanctum Domini/Fuit, est, et erit/Usque ad extrema seculi." So wrote Achard, prior of the Temple, in a Latin poem dedicated to king Baldwin (probably Baldwin II) and appealing for help in securing the release of some property wrongfully detained, in order to hasten the rededication of the building.[9] That event does not seem to have taken place until 1142, though William of Tyre, our only authority for it, does not date it exactly. By that time control of the Temple area had largely passed from the hands of the Augustinian canons, to whom it was originally given, to those of the Knights Templar. Meanwhile, however, a cloister and monastic buildings were built on the enclosed platform of the Haram. Inside the Dome the naked rock was covered with a marble facing to make a choir and a position for the high altar. The decoration—whether in painting, carving, or metal work—seems to have been of the highest order. On the open spaces of the platform small shrines were built with open arches and cupolas, modeled on the eighth-century Dome of the Chain. These, now with the arcades filled in, still exist; in particular the edicules of the Ascension of Mohammed (possibly the crusading baptistry) and of the so-called Throne of Jesus.

At the south end of the enclosure stood the Aqṣâ mosque. To the crusaders it was the palace of Solomon, and it was used as the palace

9. De Vogüé. "Achard d'Arrouaise: Poème sur le 'Templum Domini'," *Archives de l'Orient latin,* I (1881), 562-579; A. C. Clark, "Achard d'Arrouaise, Poème sur le Temple de Salomon: Fragment inédit," *ROL,* XII (1909-1911), 263-274. For the crusading buildings of the Temple area see de Vogüé, *Églises,* pp. 266-291, and *Le Temple de Jérusalem: Monographie du Haram-ech-Chérif, suivie d'un essai sur la topographie de la ville-sainte* (Paris, 1864); Vincent and Abel, *Jérusalem,* II, 969-973; and Robert W. Hamilton, *The Structural History of the Aqsa Mosque: A Record of Architectural Gleanings from the Repairs of 1938-1942* (London, 1949).

of the kings of Jerusalem, who, after the creation of the order of the
Temple in 1118, first gave part of the building to the order and
eventually the whole site, moving the royal palace to the Tower of
David. Until the restoration of 1938-1942 there was still much
crusader work in the eastern aisles of the mosque and the long
vaulted rooms adjoining them. The Templars' design for a new and
larger church does not seem to have been completed. John of
Würzburg saw the foundations, and Theoderic some years later
(1172) still describes it as unfinished. Most popular of all in the
pilgrims' accounts are the stables of the Templars in the Herodian
vaults at the southeast corner of the enceinte. Otherwise there is
little that can be securely known about the appearance or lay-out of
crusading times. The upper part of the façade, though closely
influenced by western style and likely enough the work of Christian
builders, is dated by an Arabic inscription to 1227, and the rich
details of Romanesque carving which are frequent both on the façade
and within are all reused pieces which may have come from
anywhere in the Temple area, an area which Saladin in 1187 purged
with particular thoroughness. It is in these fragments that something
of the crusading splendor, to which so many travelers testify, still
survives.

Foliage and geometric ornament were less obnoxious to, in fact
were admired and copied by, the Moslems. They therefore provide
more generous data for an estimate of crusading carving than the
mutilated remnants of figure sculpture. The stiff pointed acanthus of
the Holy Sepulcher recurs in the cloisters of the church of the
Nativity at Bethlehem and at the church of the Tomb of the Virgin,
where an impost frieze of upturned leaves on the façade and a capital
from the tomb shrine are notably fine examples (pl. Vb). More
elaborate, but still employing the flat, spiky leaf, are some capitals at
the Bāb as-Silsilah, the main entrance to the Temple area. Here much
shifting of material and rebuilding has taken place, and it cannot be
certain whether the capitals are in their original position, though
some undamaged animals and a seated human figure in the upper
range suggest that they have long been out of reach. Their abaci show
a great freedom and inventiveness, one having a particularly charming
pattern of rosettes. The same type is also to be found on the façade
of the Aqṣâ mosque. Outside Jerusalem, it recurs in the great portico
of the church of the Resurrection at Nablus (pl. XVII), which was
begun in 1167 and may be taken as showing the final development in
Palestine of this particular decorative form. Most unhappily, the
doorway, which had already been moved by the Moslems and inse-

curely reërected, fell in the earthquake of 1927, and now nothing
remains. The capitals had the typical flat acanthus, with strongly
marked veining, but the leaves instead of being pointed bend over in
broad, crotchet-like curves; the continuous impost relief was freer
and almost naturalistic in its treatment and included human heads,
birds, and beasts and a symbolic lamb between a mermaid and a lion,
a little scene which unaccountably had escaped mutilation.

The most splendid use of the ever-popular acanthus was that by
the masons working in the Temple area. It is a deeply cut leaf,
rounded and full with all the flatness gone, bending backward at the
tip or twisting into a circular terminal where the fronds separate into
an almost swastika-like pattern. It is employed on capitals where the
volutes are formed by the backward-bending tips and where the same
leaves decorate the abacus, and also very largely on voussoirs or
friezes where it forms a continuous curving design, interspersed with
pine cones or rosettes, and sometimes including birds, beasts, or
human figures in its interlaces. The work is curiously distinctive and
recognizable, and of the highest quality. It has many near parallels in
the Romanesque art of southern France and southern Italy, but it
has the uniqueness of a mature and independent workshop. Acanthus
leaves coil with a similar rhythm on the frieze below the triforium of
Langres cathedral; they swell and burgeon with the same fullness on
the capitals of San Clemente a Casauria at Torre de' Passeri or in the
cloisters of Fossanova or Monreale; with a flatter, less articulated
leaf, but with the same combination of rosettes and pine cones, they
decorate magnificently the lintel of the north doorway at Bourges.
Germer-Durand, Abel Fabre, and Enlart have all noted and discussed
these carvings, and suggested western correspondences with them.[10]
They remain, however, a style of their own.

Examples are numerous enough, but nearly all are fragmentary
and detached from their original position. One important exception,
visible today, is the doorway to the cave of the Dome of the Rock,
where a pointed arch is supported on pillars with the typical
acanthus work on the capitals and abaci; the upper part of the
tympanum has been filled with an Arabic scroll, but the lower part
has a design of two curling acanthus sprays with a central erect
branch ending in a small cone. It fits the space, and the whole
doorway, except for the Arabic insertion and the heavy gilt with

10. A. Fabre, "La Sculpture provençale en Palestine au XIIe siècle," *Échos d'Orient,* XXI
(1922), 45-51; J. Germer-Durand, "La Sculpture franque en Palestine," *Conférences de
St.-Étienne* (École pratique d'études bibliques, 1910/11; Paris, 1911), pp. 233-257; Enlart,
Monuments, I, 115-118.

which it was covered, may well stand just as the crusaders left it, built into their great iron grill, an example of the crowning achievement of their carvers in the closing years before Saladin restored the Temple area to Islam. Particularly significant in this respect are the carvings of the small edicule on the northwest corner of the Ḥaram platform. Here there are two Arab bulbous capitals, surmounted by abaci showing the familiar acanthus sprays; on one of them only two sides are fully carved, the remaining two being blocked out, without finished cutting; it is clearly an example of incompleted crusader material being used by the Arabs, and the presumption is that it was being worked close to the place of its use. It is, however, in the Aqṣâ mosque that the richest collection of the style can be found. Here the great *dikkah* or reading platform, approximately 12 feet by 6 in extent, is made up of crusading columns, capitals, and friezes ingeniously fitted together (pl. VIIIa). The frieze appears at first sight a continuous whole, but is in fact composed of several fragments, closely similar in style and exactly matching in dimensions, but with sufficient variations in the acanthus pattern to show that originally they belonged to independent schemes. Throughout the mosque such patchwork recurs, in most cases less skillfully fitted than on the *dikkah*. A splendid panel framed in knotted columns seems to be the side of some tomb catafalque (pl. VIIIb).

Outside, but still in the Temple area, the pulpit of Burhān-ad-Dīn (pl. Xd) uses columns and arcading which may once have formed a small shrine. In one of the capitals a mermaid is exquisitely cut, but is now decapitated, as are all the other figures, man or beast, in these reused fragments. The same style reappears in arcading at the Bāb Ḥiṭṭah (pl. Xc) and on the fountain outside the Bāb an-Nāẓir. Two examples require more particular mention. These are in the Dome of the Rock, one formerly inside the metal grill which surrounded the rock, one in the cave underneath it. The grill has been removed in recent restorations, but the sculptures remain. They are in the form of small altar tables supported on colonnettes, but have been somewhat altered from their original form.[11] The first, which had been cut to fit the angle of the grill, is a flat slab supported on two niches

11. J. Strzygowski, "Ruins of Tombs of the Latin Kings on the Haram in Jerusalem," *Speculum*, XI (1936), 499-508; Horn, *Ichnographiae* (ed. 1962), p. 74. Compare William H. Paine Hatch, *Greek and Syrian Miniatures in Jerusalem* (Mediaeval Academy of America, Publications, no. 6; Cambridge, Mass., 1931), pl. XXIV, for the use of knotted columns in miniatures, and J. Baltrušaitis, *Études sur l'art médiévale en Géorgie et en Arménie* (Paris, 1929), pl. X, for an Armenian example.

with a band of highly ornamented sculpture between the niches and the table. The niches are divided and framed by three sets of knotted columns, of which the third pair is mutilated. There are figures of birds in the curling acanthus of the top panel and possibly there were other figures also, as there are gaps in the design where pieces have been broken off. The second piece is a single niche supported on knotted columns with acanthus leaves, while in the spandrels there are two whorls of acanthus leaves, in their way as remarkable as any of these carvings. Strzygowski has pointed out that these niches correspond very closely to the design of the tomb of Baldwin V as drawn by Elzear Horn in the first half of the eighteenth century, a tomb destroyed, or at least dismembered, by the Greeks in 1809. In this sketch it is impossible to gauge the exact quality of the foliage, but it has the true sweeping pattern, and the knotted columns are strikingly similar to our actual pieces. This somewhat clumsy device was a not uncommon Byzantine formula, though usually limited to two loops, and the exuberant interlaces of the crusading examples suggest Armenian influence, where in a flatter style, relief rather than free-standing, the interlaced patterns of these tomb slabs can be paralleled. Thicker intertwined columns, with a curious capital of interlacing birds, frame a mihrāb in the Aqṣā mosque (pl. IXa). Similar columns form an outdoor mihrāb in the Temple area, and there are smaller examples built into the Bāb as-Silsilah. A nineteenth-century photograph shows three such columns still supporting the blocked arches of an arcade on the east side of the Temple platform; since then there has been considerable rebuilding, but originally an open arcade supported on twisted columns must have been one of the Temple's most distinguishing features.

Baldwin V's tomb was in the church of the Holy Sepulcher, but might well have been commissioned from the Temple workshop, for the child king's obsequies were the occasion of the coup when Guy of Lusignan seized the throne with the aid of Gerard of Ridefort, the master of the Templars. This elaborate monument may therefore in its style have been a token of Templar influence. A fragment of knotted columns recently found at the Holy Sepulcher in the rubble of nineteenth-century rebuilding almost certainly comes from it. Outside the Temple area there are few examples of the style. At Latrun (Le Toron des Chevaliers), a Templar holding, six capitals, linked in triplets, brilliant examples of the Temple acanthus, were found by the monks in a peasant's hut. These capitals were carried off by the Germans in 1917 and are now in the archaeological

museum of Istanbul (pl. XI).[12] Extremely well preserved, they have carved among the acanthus foliage some human heads, a dog licking its paw, and two birds with outspread wings. There are some fragments in the Franciscan museum of the Flagellation, one a fine piece of a frieze where a lion pursues a deer (pl. VIIb), said to come from the site of St. Mary the Great; another piece of acanthus carving seems to be the same that Clermont-Ganneau saw and sketched at a house in Bethany in 1872.[13] There are further pieces from the former museum of Notre Dame de France and in the Greek patriarchate, and the corner piece of a frieze including two birds and a seated figure has found its way to a private collection in Norway.[14]

From all these data one or two facts can be summarized. This Palestinian acanthus style is associated with the Temple area and therefore must precede 1187; the two unfinished abaci suggest that the tradition was in full force at the time of its recapture by Saladin. The theory sometimes put forward that it dates from the time of Frederick II's truce, when there was no Christian reoccupation of the Temple, is an impossible one. The fragments are much too numerous and clearly come from cloisters or some elaborate series of arcading, and the ease with which the *dikkah* has been constructed from various different but allied pieces suggests that there must have been a rich supply of such material. We have here a type of Romanesque foliage carving which has connections with contemporary work, as also a direct Byzantine-Coptic descent, but which reached an unsurpassed mastery in the Templars' workshop and preceded similar classicizing motifs as used in southern Italy.

On the northwest corner of the Temple platform were the ruins of Herod's palace, the Antonia. Here the crusaders built a chapel, the chapel of Repose, thought to be the site of Christ's prison on the first night of his captivity. A minaret rises above this chapel and reset in its gallery are three capitals (pl. XII), sadly mutilated and now even

12. Deschamps, "Sculpture française en Palestine," *Fondation Eugène Piot, Monuments et mémoires,* XXXI, 110-113. In the upper story of the ruins of the castle at Latrun there is the base of a wall respond which may be the doorway of the castle chapel and would correspond in scale with the capitals. This part of the ruins is known by the villagers as al-Kanīsah, "the church." (Information from Mr. C. N. Johns.)

13. Clermont-Ganneau, *Archaeological Researches,* II, 52; B. Bagatti, *Il Museo della Flagellazione in Gerusalemme: Note illustrative* (SBF; Jerusalem, 1939), p. 133. Similar fragments were found in recent excavations at Bethany: see S. J. Saller, *Excavations at Bethany, 1949-1953* (SBF, no. 12; Jerusalem, 1957), p. 122, plates 81 and 82.

14. Reproduced by Enlart, *Monuments des croisés,* pl. 20: in the collection of Dr. Harry Fett at Christinelund, Bryn, Oslo, with provenance from the Ustinov collection made in Syria. The piece in the former museum of Notre Dame is now lost [J. F.].

more decayed than when the Dominican fathers Vincent and Abel
had them drawn in 1922. Built into the back wall of a cupboard in
the entrance to the chapel is a battered fragment that may be the
remains of a fourth capital. The iconographical theme of the carvings
seems to be Christ ministered to by angels: the Dominicans suggest
that they refer to the first night of his captivity, but the damage is too
great for any certainty as to their subject. The figures are long and
slender, posed with much feeling and ingenuity, and enough can be
seen to prove their quality. Unfortunately on the narrow minaret
platform they are hard to photograph. Their interpretation is all the
more difficult because of the varying traditions as to the site of
Pilate's Praetorium. [15] In the twelfth century it was still generally
placed on Mount Sion, and it was here that a group of chapels
around the great church of Our Lady celebrated the incidents of
Christ's trial. The column of the Flagellation was treasured here,
possibly that fragment which was eventually taken to Rome, and
here the crusading pilgrim came to submit himself to scourging "after
the example of our Lord." [16] But already the Greeks argued for
another site, and there was uncertainty and dispute.

Whereas history and legend were constantly confused and there
was no sense of the style of a building, topographical accuracy was
much discussed, not without a shrewd eye to possible economic
advantages if the point were proved. The Templars no doubt were
anxious to attach these associations to their area, as they were also
trying to secure recognition for their "Pool of Bethesda." In the
account of the city of Jerusalem included in many of the
manuscripts of the continuators of William of Tyre the sites are given
as now generally accepted, and this, which appears to have been
written before 1187, may mark the change of the tradition. The
thirteenth century, when the sanctuaries of Mount Sion had been
destroyed, firmly accepted the cult, destined to such enduring
popularity, of the Via Dolorosa; the chapels along its route, now
mainly rebuilt, of the Ecce Homo, the Flagellation, and the Virgin's
Swoon seem to have been largely thirteenth-century work, or where,
as in the case of the chapel of the Flagellation, there was earlier

15. Clermont-Ganneau identified one subject, unconvincingly, as the Presentation in the
Temple: *Archaeological Researches,* I, 144-152; cf. Vincent and Abel, *Jérusalem,* II,
587-595. J. Folda is preparing a new study of these capitals, with photographic
documentation.

16. Baldi, *Enchiridion,* p. 750. There is a large body of controversial literature: see
Enchiridion, p. 783, for bibliography, and L. H. Vincent, "L'Antonia et le Prétoire," *Revue
biblique,* XLII (1933), 83-113.

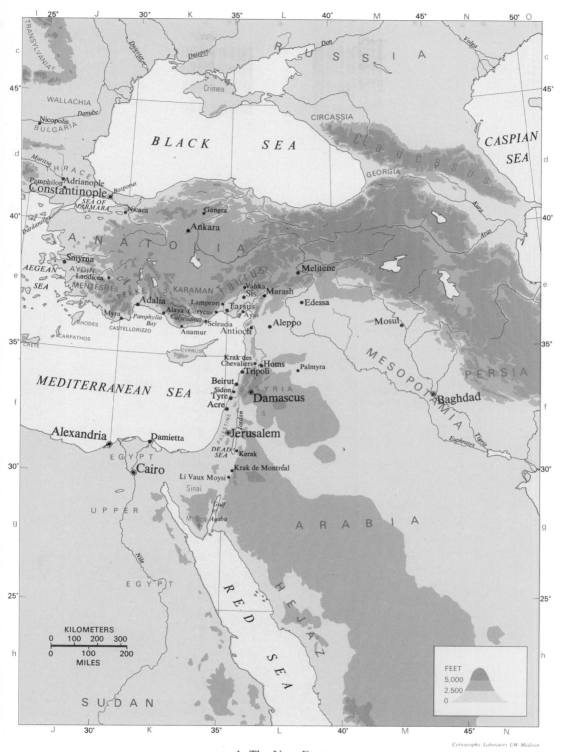

1. The Near East

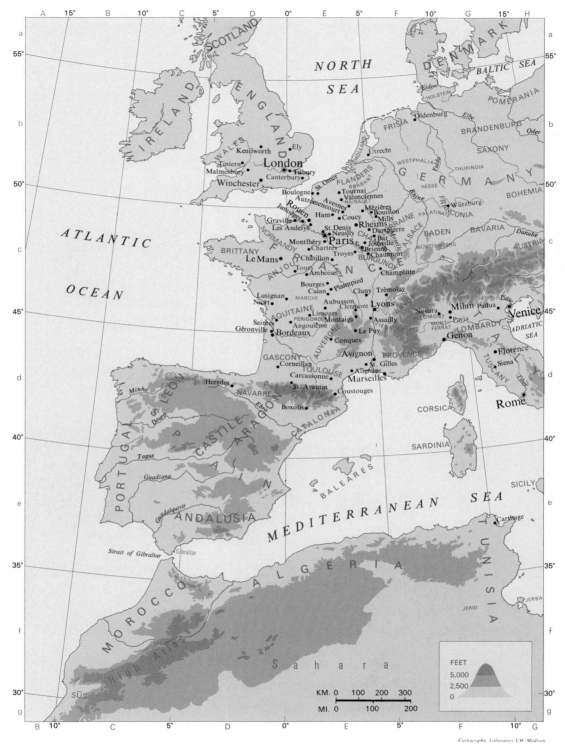

2. Western Europe

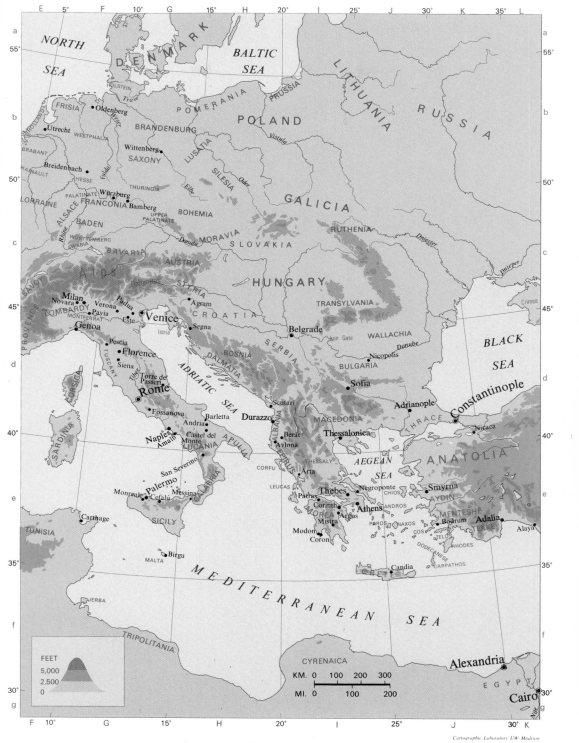

3. Central Europe

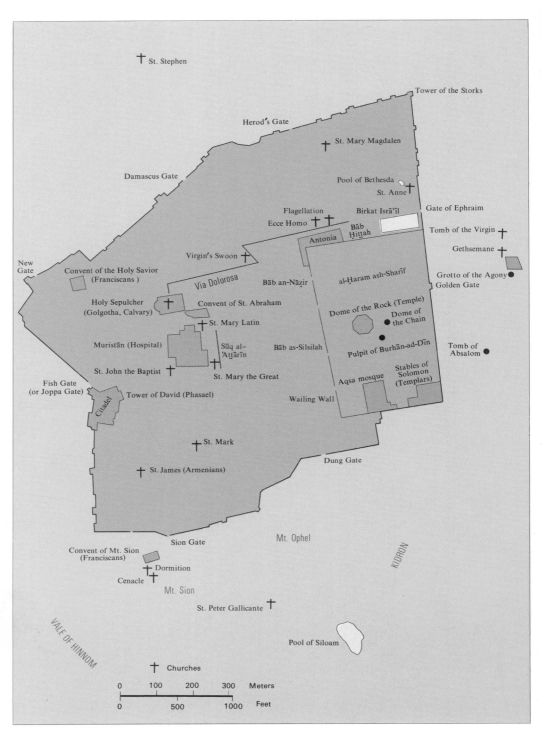

† St. Stephen

Tower of the Storks

Herod's Gate

St. Mary Magdalen

Damascus Gate

Pool of Bethesda
St. Anne

Flagellation Birkat Isrā'īl Gate of Ephraim
Ecce Homo Bāb
 Hittah Tomb of the Virgin †
 Antonia Gethsemane †
Virgin's Swoon Grotto of the Agony ●
New al-Ḥaram ash-Sharīf
Gate Golden Gate
 Convent of the Holy Savior
 (Franciscans)
 Via Dolorosa Bāb an-Nāẓir
 Holy Sepulcher Convent of St. Abraham Dome of the Rock (Temple)
 (Golgotha, Calvary) Dome of
 St. Mary Latin ● the Chain
 Tomb of
 Muristān (Hospital) Sūq al- Bāb as-Silsilah ● Absalom
 'Aṭṭārīn Pulpit of Burhān-ad-Dīn
 St. John the Baptist † Stables of
 St. Mary the Great Solomon
Fish Gate Aqsa mosque (Templars)
(or Joppa Gate) ● Tomb of
 Citadel Tower of David (Phasael) Absalom
 Wailing Wall

 † St. Mark

 † St. James (Armenians)
 Dung Gate

 Sion Gate Mt. Ophel
Convent of Mt. Sion
(Franciscans) KIDRON
 † Dormition
Cenacle †
 Mt. Sion

 St. Peter Gallicante †

VALE OF HINNOM Pool of Siloam

 † Churches

 0 100 200 300 Meters

 0 500 1000 Feet

Cartographic Laboratory UW-Madison

4. Medieval Jerusalem

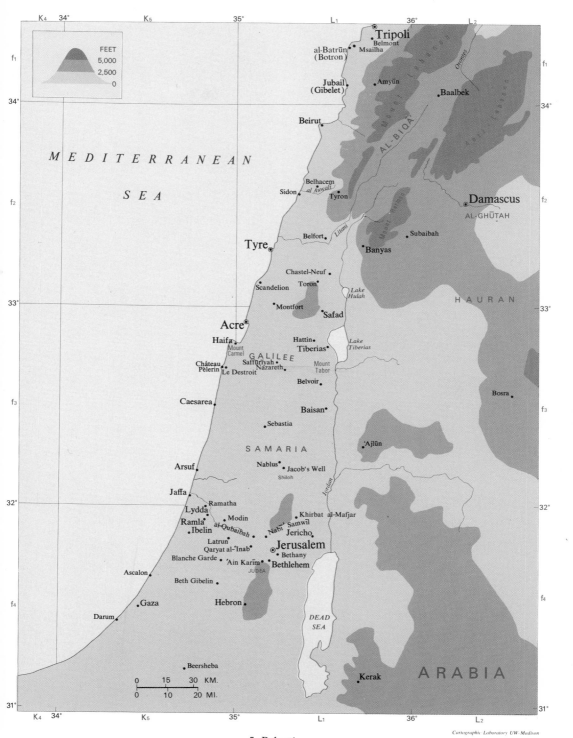

5. Palestine

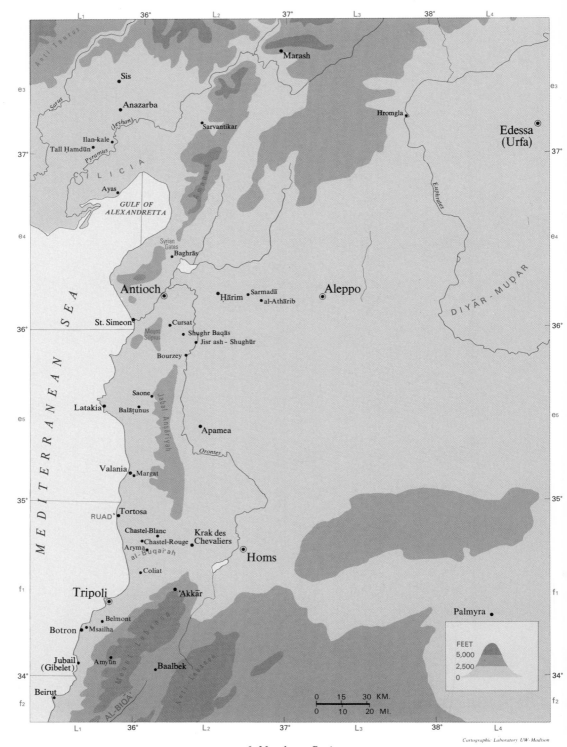

L₁ 36° L₂ 37° L₃ 38° L₄

•Marash

Sis•

Anazarba•

•Sarvantikar

Hromgla•

Ilan-kale•

Tall Ḥamdūn•

Edessa
(Urfa)⊙

Ayas•

GULF OF
ALEXANDRETTA

CILICIA

Anti Taurus

Sarus

Pyramus

(Jeyhan)

Syrian
Gates

•Baghrās

DIYĀR - MUDAR

Antioch⊙

•Ḥārim •Sarmadā
•al-Athārib

Aleppo⊙

St. Simeon•

•Cursat

Mount
Stylus

•Shughr Baqās
•Jisr ash - Shughūr

Bourzey•

Euphrates

MEDITERRANEAN SEA

Saone•

Latakia•

•Balāṭunus

Jabal Ansariyah

•Apamea

Orontes

Valania•

•Margat

RUAD•

Tortosa•

Chastel-Blanc•

•Chastel-Rouge

Krak des
Chevaliers•

Aryma•

al-Buqai'ah

•Homs

Coliat•

Tripoli⊙

•'Akkār

Palmyra•

Belmont•

Botron•

•Msailha

Mount Lebanon

Jubail
(Gibelet)•

Amyūn•

•Baalbek

Anti Lebanon

Beirut•

AL-BIQĀ'

FEET
5,000
2,500
0

0 15 30 KM.
0 10 20 MI.

e₃ 37° e₄ 36° e₅ 35° f₁ 34° f₂

L₁ 36° L₂ 37° L₃ 38° L₄

6. Northern Syria

Cartographic Laboratory UW-Madison

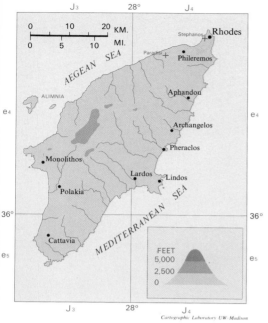

7. The Island of Rhodes

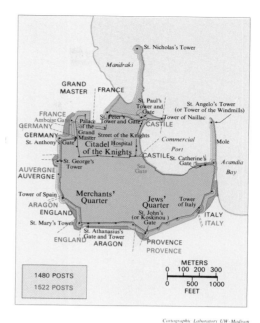

8. The City of Rhodes

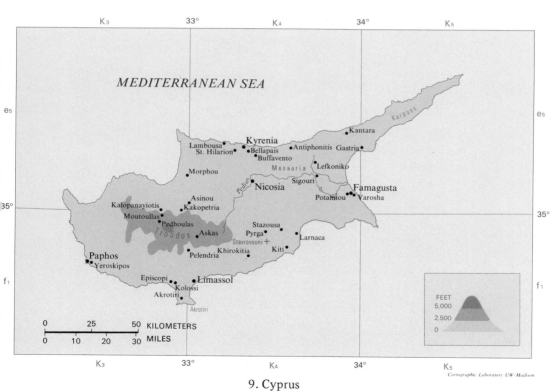

9. Cyprus

10. Frankish Greece

Romanesque work, it was only in the thirteenth century that it received its present designation.

The best preserved of all crusading churches is that of St. Anne (pl. XIII).[17] In the northeast corner of the walls of Jerusalem were the traditional sites of the Pool of Bethesda and the house of Joachim and Anna. In the sixth century a basilica was built over the crypt that represented the original dwelling. Saewulf in 1102 calls it the church of St. Anne, whereas its earlier name seems to have been that of St. Mary. William of Tyre writes that there were only three or four poor nuns there until Baldwin I in 1113 repudiated his wife Arda and placed her in this convent, increasing its patrimony and possessions. It remained in royal favor and it was there that Yvette, sister of Melisend, made her profession in 1130. The convent owned lands in the valley they called Jehoshaphat and a market in the town. Several arches in the Sūq al-'Aṭṭārīn still bear the inscription *Sca. Anna.* When in 1144 Melisend founded for her sister the new convent of St. Lazarus at Bethany, the repute of St. Anne may have somewhat lessened, but much of the work, in which two stages are clearly marked, had already been undertaken, and the sacred nature of the site, which throughout all the Arab and Turkish domination remained one of the most popular places of pilgrimage, was sufficient to secure its prosperity without any special royal patronage.

Handed over to the French in 1856, following the Franco-Turkish alliance of the Crimean War, the church of St. Anne was restored with remarkable skill and tact by the architect Mauss; fortunately, though it had been used alternately as a shelter for camels or as a mere refuse heap, the walls and the greater part of the vaults were still standing, so that it was a genuine task of repair, not a speculative reconstruction. It consists of a nave and two aisles ending in semicircular apses; on the outside the central apse is an irregular three-sided projection; the aisle apses are embedded in the end wall; over the crossing rises a cupola on pendentives, supported by four equal arches, and resembling in general plan that built by the crusaders in the church of the Holy Sepulcher. This dome, a nineteenth-century restoration, was damaged in the capture of Jerusalem by the Israelis in 1967, as was also the western façade, fortunately not too seriously. The aisles are covered with groined

17. N. van der Vliet, *"Sainte Marie: où est elle née" et la piscine probatique* (Paris, 1938); cf. *Revue biblique,* LXIX (1962), 107-109, for a report by J. M. Rousée on recent excavations.

vaults made of small and rather rough-cut stones; the vaulting of the nave is also groined but of more carefully cut masonry, reinforced with cross-arches. In parts of the outer walls a change in masonry reveals that the church was built on some earlier foundations.

Inside and out the decoration is severely plain, though one or two capitals, such as that carved with two sandals and a scroll, emblems probably of pilgrimage, are unusual in type. Slight variations in detail suggest that the westernmost of the three bays was a later extension, and this is borne out by a cross-wall found in excavation. The façade has a central doorway, separated by a straight cornice from a middle window, above which is the most elaborate piece of decoration on the building, a window with two side colonnettes and voussoirs of godroons, surrounded by a palmette frieze. This exactly corresponds to the work of the masons' yard of the Holy Sepulcher, and the whole scheme of the façade is a derivative from its greater neighbor. St. Anne's church must have been completed contemporaneously or very shortly afterward, in the mid-twelfth century. All the arches throughout are pointed. The length is 120 feet, by 66 feet wide. Beneath the church lay the crypt, the birthplace of the Virgin; and close by was the Pool of Bethesda, much encumbered by ruins, but with some of its Byzantine colonnades still standing, which the crusaders sought to identify with the five porches mentioned by St. John. Respect for the site did not prevent them, with their curious lack of archaeological feeling, from reusing some of the stones in building St. Anne's, but they built also a single-naved church, the apse of which can still be traced over one basin of the Pool. Then a curious controversy arose. The Templars claimed that the true Bethesda was the open pond bordering the Temple area, the Birkat Isrā'īl, now a piece of waste land filled up by deposits, but which from the fourteenth century till the excavations on the other site at the end of the nineteenth was generally regarded as the scene of the miracle.

St. Anne's with its severe simplicity, relieved as faint traces show and as travelers report by wall paintings, may be taken as the type of aisled crusading church in Jerusalem. The churches of St. Mary Magdalen and of Gethsemane must have been somewhat similar in conception. The numerous chapels of the Via Dolorosa were more modest buildings of a nave only. The Armenian church of St. James has a cupola over the crossing, built in the Arab manner on six ribs, and the aisles of equal heights with the nave, but the masonry and the apses, masked in a rectangular chevet, are close to crusading work, while the south door has the godroons and general workman-

ship of the Holy Sepulcher masons. The Armenians, who seem to have built it as their cathedral, used crusading models and probably employed some of the same workmen. A remarkable acanthus capital with dog-like creatures still survives, undamaged by any Moslem occupation of the building (pl. Vc). Several smaller churches can still be traced: St. Agnes and St. Elias, now respectively the mosques of al-Maulawīyah and of Dair al-'Adas; St. Mark's, now the church of the Syrian patriarch. Outside the Damascus gate, built in the ruins of an earlier basilica, was the chapel of St. Stephen. It belonged to the monks of St. Mary Latin and adjoined the stables of the Hospitallers.[18]

Without the walls were two main groups of ecclesiastical buildings, those on Mount Sion and those on the Mount of Olives. The former consisted of a large church enclosing a group of shrines, the room of the Last Supper and of Pentecost, and the Chamber of the Dormition; close by were the house of Caiaphas and one of the sites claimed for the Judgment Seat of Pilate; below on the slopes of the hill was the Byzantine church of St. Peter Gallicante. Confused with and at times overlaid by these Christian recollections were the traditions of David's city and the tombs of the Psalmist and of Solomon. It was on Mount Sion that Raymond of Toulouse placed his siege engines to attack the city, amid the remains of a basilica that had originally been built in the Constantinian period, but which in its exposed position had frequently been destroyed and was then in ruins. Larger even than that at Bethlehem, it seems to have been similar in type, with a nave and four aisles ending in a single apse, but in this case without transepts. The southeast corner enclosed a two-storied chapel, the Coenaculum.

The crusaders installed here a convent of Augustinian canons, and by 1142 the church was sufficiently restored for it to be the scene of a general church council for the kingdom. Its exact form is largely conjectural, but the Franks appear to have adapted the ruins to their usual design, reducing the four aisles to two, and making a triple-apsed chevet. On the left of the entry was the shrine of the

18. For the smaller churches in Jerusalem see Vincent and Abel, *Jérusalem,* II, 945-973, and Moore, *The Ancient Churches of Old Jerusalem, passim.* Two other crusader churches have recently been located in the old city: St. Mary of the Germans (see A. Ovadiah, "A Crusader Church in the Jewish Quarter of Jerusalem," *Eretz Israel: I. Dunayevsky Memorial Volume,* XI [1973], 208-212, in Hebrew, with an English summary on p. 29*) and a church possibly to be identified as St. Julian's (to be published by M. Burgoyne in a forthcoming number of *Revue biblique*). These discoveries indicate the urgent need for a rigorous archaeological survey of medieval Jerusalem and a carefully drawn map of the sites to supersede those of Vincent and Abel, Moore, and Benvenisti, *Crusaders in the Holy Land,* p. 50. [J. F.]

Dormition, an edicule surmounted by a cupola and lined with mosaics of the death of the Virgin; at the end of the north aisle was the chapel of St. Stephen. As stated already, in the southeastern corner were the Upper Chamber of the Last Supper (the Coenaculum) with, adjoining, the chapel of Pentecost, and below, the Galilee (so-called in a Latin inscription, the initial use of the term), the scene of the washing of the feet, the appearance of the risen Christ, and the incredulity of St. Thomas. With the removal of the outer aisle this corner building must have projected from the main line, and part of its southern wall appears in fact to be classical masonry. Exact measurement and investigation of it has always been difficult, reverenced as it is by the Moslems as the tomb of David, and there has been considerable controversy as to the date of the building as it now exists. In 1342, after a series of purchases of neighboring pieces of land, the Franciscans obtained possession of it through the aid of their devoted patrons, Robert the Wise of Naples and his wife Sancia. They built a cloister and conventual rooms adjoining it, some walls of which still remain. Undoubtedly they must have carried out repairs on the Coenaculum as well, but it is clear from the account of James of Verona that the rooms were standing in 1335 complete with their vaults.[19] The Upper Room, while containing some reused Romanesque capitals, has naturalistic foliage impost decoration and a ribbed vault which must come from a period when the Gothic style was fully developed. In 1523, after the Turkish conquest, the Franciscans were driven out and the building became and remained a mosque, till from 1949 to 1967 it was on the edge of the no-man's-land between Israel and Jordan.

The group of churches which commemorated the Gospel incidents connected with the Mount of Olives were dominated by the influence of the wealthy abbey of St. Mary of Jehoshaphat, which lay in the valley of Kidron at the foot of the hill.[20] The particular charges of the abbey, a Benedictine foundation under Cluniac influence, were the church of the Tomb of the Virgin, the grotto of the Agony, and the church of Gethsemane. The shrine of the Virgin's tomb, stripped of its cupola and arcading, still exists in the cruciform

19. Baldi, *Enchiridion,* p. 641.

20. C. N. Johns, "The Abbey of St. Mary in the Valley of Jehoshaphat, Jerusalem," *Quarterly of the Department of Antiquities in Palestine,* VIII (1939), 117-136; G. Orfali, *Gethsémani, ou notice sur l'église de l'Agonie ou de la Prière, d'après les fouilles récentes accomplies par la Custodie franciscaine de Terre Sainte* (Paris, 1924); L. H. Vincent, "L'Éléona, sanctuaire primitif de l'Ascension," *Revue biblique,* LXIV (1957), 48-71; V. Corbo, *Ricerche archeologiche al Monte degli Ulivi* (SBF, no. 16; Jerusalem, 1965), pp. 97 ff.

crypt, which is reached by a staircase of forty-eight steps, covered with a groined vault and built in well-cut stone; the doorway to it is in the ruins of an imposing Romanesque façade, which has been sadly degraded by alterations and has lost proportion through the rising of the ground level in this narrow valley, but the details of its carving are of fine quality and the stairway when lit by apertures now blocked must have been a striking work, well worthy of the admiration which pilgrims bestowed on it. The evidence as to an upper church, over the crypt, is somewhat conflicting, but the chance driving of a new municipal sewer brought to light considerable remains of the monastic buildings, paving stones, mosaic floors, and pieces of wall frescoed in floral patterns, and the impressive base of a large pier with engaged columns. Much patronized by the royal house, the monastery received in particular gifts from queen Melisend, who was buried there in 1161 in a recess of the great stairway. It is probably to her munificence that the building of it was due.

The twelfth-century church of Gethsemane has also been excavated (1920). Built on the site of a former basilica but correcting its faulty orientation, it was a typical crusader church of the usual three-apse form. Details of its mosaic floor and pier bases show that it was closely related to the monastic buildings of St. Mary of Jehoshaphat.

Olivet was crowned by the two churches of the Teaching of Christ (known as the Eleona) and the Ascension. The former was—with the churches of the Resurrection and the Nativity—the third of the great Constantinian basilicas, and seems originally to have been associated with the Ascension, an event which Eusebius places close to the grotto of Christ's prayers and teaching, so that the basilica too enclosed a sacred cave. The highest point of the Mount, where stands the edicule of the Ascension, was, however, even by the end of the fourth century, attracting its own particular cult, strengthened during the fifth century by the "invention" of the stone bearing the imprint of Christ's foot. The basilica of the Eleona was completely destroyed by the Persians in 614, and replaced only by small shrines of the Paternoster and Credo, commemorating Christ's teaching. In 1152 two pious Danish pilgrims were buried there, leaving bequests which enabled a larger church to be constructed, of which nothing now stands and little can be known in detail.

The shrine of the Ascension crowned the hill, and the present edicule is largely twelfth-century work, though probably restored by the Arabs after Saladin's victory. It is the central shrine of a circular

Byzantine church, which in the twelfth century was replaced by an octagon, standing in a fortified enclosure, rendered necessary by its exposed position. As with the church of the Sepulcher, the cupola of the shrine was open at the center, leaving free the path of Ascension from the sacred rock, marked with Christ's footprints, to the sky above. The arcaded gallery round this rock is the basis of the present domed building. Its capitals, well preserved, are the final development of the type used by the masons of the façade of the Holy Sepulcher. The windswept leaves are here slender, deeply undercut but with a new naturalism. On one an owl, strikingly rendered, spreads its wings; on another, more conventionally, are two confronting griffons (pl. Vd). Tendrils interlace with all the ingenuity of the fully developed Romanesque style.

The small township of Bethany was associated with the house of Mary and Martha, and the tomb of Lazarus, which was shown in a grotto. Here also was located, on Gospel authority, the house of Simon the leper, the scene of the anointing of Christ with the ointment of spikenard. From the fourth century there was a church on the site, with the tomb of Lazarus in a courtyard opening off it. Later this church was extended eastward, and was largely rebuilt by the crusaders, who seem to have added a chapel over the tomb, probably at the time (1144) that Melisend founded there her richly endowed convent, over which her sister Yvette presided. Since 1953 a new Franciscan church has been built, but only after excavation had been carefully carried out. The foundations of the two apses have been left visible, and some of the old material incorporated. Carved fragments found show that there was figure sculpture of some distinction, and capitals and friezes which recall both the mason's work of the Tomb of the Virgin and the coiling acanthus of the Temple. There were probably several building stages, and different masons' yards employed.[21]

Outside Jerusalem, the episcopal towns as organized by the crusaders varied considerably in the importance of their buildings. The suffragans of the patriarch of Jerusalem were the bishops of Bethlehem, Hebron, Lydda, Ramla, and Gaza. Of these Bethlehem had a place apart, both through its unique religious associations and because of the scale of its surviving buildings. The great basilica as the crusaders found it—and as, in its main structure, it exists today—was the work of Justinian, much of it on Constantinian

21. Saller, *Excavations at Bethany, 1949-1953,* pp. 117 ff.

foundations (pl. XXXIb).[22] In 1109 Baldwin I obtained a papal grant raising it to the status of a cathedral. A community of Augustinian canons was installed. Some alterations were made to the church, particularly to the choir and the entrances to the cave, a star with gilded rays was fixed above the roof, and an elaborate scheme of redecoration was undertaken in the opening years of the reign of Amalric (1163-1174). A bell tower was built, the base of which still stands. But the main work undertaken by the Franks was the monastery, much of which is still incorporated in later buildings, and the cloister, restored in 1948-1951, where the capitals have variants of the flat acanthus leaf, interspersed with human figures and beasts, all much defaced. The roof, unusual in Palestine, was constructed of wooden beams rising to a point, without a ceiling and covered with lead. By a remarkable display of diplomatic ingenuity on the part of the Franciscan custodians, it was completely restored in 1479, with the aid of two shiploads of worked wood and lead sent by Edward IV of England.

Hebron also had earlier buildings and a particular cult.[23] Here was the cave of Machpelah, the traditional tomb of Abraham. Early travelers, such as Saewulf and the abbot Daniel, describe the site as an open paved court, surrounded by a well-built wall with small cupolas over the tombs of Abraham and his family. The massive enceinte with its huge masonry is a Herodian construction; the domed buildings above the tombs are probably Umaiyad, and the church, set in the rectangle of the outer walls, was a Byzantine building of the sixth century. The present mosque occupies almost half of the enclosure, and is oriented to the southeast (pl. XV). Its construction is largely that of a crusading church, based on Byzantine foundations but adapted to carry groined vaults by the insertion of four central pillars, possibly enclosing Byzantine columns, and half pillars on the façade and side walls. Much of the Byzantine façade was retained, and it is possible that a crusading cloister was erected in the forecourt.

22. W. Harvey et al., *The Church of the Nativity at Bethlehem* (London, 1910); L. H. Vincent and F. M. Abel, *Bethléem: Le Sanctuaire de la Nativité* (Paris, 1914); L. H. Vincent, "Bethléem: Le Sanctuaire de la Nativité d'après les fouilles récentes," *Revue biblique*, XLVI (1936), 116-121; R. W. Hamilton, *The Church of the Nativity, Bethlehem: A Guide* (2nd ed., Jerusalem, 1947, repr. 1968); B. Bagatti, *Gli Antichi edifici sacri de Betlemme: In seguito agli scavi e restauri praticati dalla Custodia di Terra Santa (1948-1951)* (SBF, no. 9; Jerusalem, 1952).

23. L. H. Vincent and E. J. H. Mackay, with F. M. Abel, *Hébron: Le Haram el-Khalil, sépulture des patriarches* (2 vols., text and album of plates; Paris, 1923).

The cathedrals of the united bishoprics of Lydda and Ramla and of that of Gaza follow a common pattern. Of the three, Ramla, now a mosque but on the whole well preserved, seems the earliest (pl. XVIb). The type is that with nave and two aisles ending in three apses, set in a rectangular chevet. The capitals at Ramla are of the early Gothic type, those at Lydda somewhat similar but more developed. Lydda was destroyed in the wars of Saladin, and a hundred years later Baybars used some of the material to build a bridge nearby, a bridge which is still in use. Only the central and northern apses survive, embodied in a church built in 1874 by the Greek Orthodox. The workmanship is outstandingly good and the crusading church, as befitted the shrine of St. George, must have been a notable building.

The cathedral at Gaza was hit by a shell in the English artillery bombardment of 1916, when it was being used as a munitions store. The minaret, built on the eastern apses, fell, destroying part of the nave. The church has been restored, and the western doorway (pl. XVIa), with graceful crocket capitals, survives. Inside, the pointed arcade is supported on piers with attached semicolumns, reused Byzantine work; above there is a clerestory, and a second order of similar pillars standing on the cornice of the piers. It is a heavy and ungainly elevation, very unlike the elegant simplicity of the doorway, and seems to originate in the variety of size of columns available. The inner columns of the arcade have Corinthian capitals, and similar ones were used in the Greek Orthodox church of St. Porphyria, which also survived the bombardment of the town. Baldwin III fortified Gaza in 1149, and it is probably then that work on the cathedral was begun. Another casualty of the 1914-1918 war was the church at Ibelin (Yabnâ), where now a ruined doorway with some godroon voussoirs still in position is almost all that remains of the crusading church. Here too, as at Lydda, material from the church was used under Baybars to build a bridge, constructed under the supervision of Khalīl ibn-Shavar, the emir of Ramla who plotted the attempted assassination of Edward (I) of England.[24]

Four archbishoprics depended on the Jerusalem patriarchate—Petra, Caesarea, Nazareth, and Tyre. Of the southern archbishopric of Petra little is known. The main center of the "Terre oultre le Jourdain" was the town of Kerak, the Petra Deserti of William of Tyre, and here in 1908 Meistermann saw a ruined church, the

24. Conder and Kitchener, *Survey of Western Palestine,* II, 267-268, and III, 248-251; Clermont-Ganneau, *Archaeological Researches,* II, 98-118, 167-184, 381-389; M. S. Briggs, "The Architecture of Saladin and the Influence of the Crusades (A.D. 1171-1250)," *Burlington Magazine,* XXXVIII (1921), 18.

doorway of which was still standing; there now remain only some column bases of a normal twelfth-century pattern.[25] This was probably the cathedral church of the diocese. No other crusading churches in this area are known with any certainty. James of Vitry tells us that the Greek bishop on Mount Sinai, who was also abbot of the monastery, was a suffragan of the archbishop of Petra, but this form of intercommunion was probably of the slightest nature. Some Franks visited Sinai and had their own chapel there, called St. Catherine of the Franks. Armorial carvings and names cut in the walls attest to their presence.[26]

The cathedral of St. Peter at Caesarea, rebuilt where the crusaders found a church in use as a mosque but possibly never completed by them, is now only foundations from which the stones have been moved for newer building along the coast.[27] Caesarea had only one suffragan bishop, who had his cathedral at Sebastia, containing as its main shrine the tomb of the Baptist.[28] Here, building on the foundations and in places on the lower courses of a Byzantine church, the crusaders raised one of their noblest buildings, of which sufficient still stands to show the excellence of its workmanship. The church was about 150 feet long by 75 broad. It had the normal plan of nave, two aisles, and triple apse, with the central apse projecting and, as recent excavations suggest, polygonal on the exterior (fig. 3). The vaults were supported on alternate composite piers and twin pillars, and appear from the disposition of the shafts to have been carried on ribs, a rare practice in the kingdom. The masonry was laid without cement, and the capitals were early Gothic acanthus of a severe but splendid simplicity (pl. XVIIIa). The whole style suggests a date in the second half of the century. The museum of Instanbul has four capitals (pls. XVIIIb and c) taken from this church in 1897 (and probably originally intended to decorate its west portal); on one of them is a dancer with musicians, another depicts Herod's feast, and on a third volute heads emerge from late Romanesque foliage. Stylistically they resemble two capitals of unknown prove-

25. P. Deschamps, *Les Châteaux des croisés en Terre Sainte; II. La Défense du royaume de Jérusalem: Étude historique, géographique et monumentale* (Haut Commissariat de la République française en Syrie et au Liban, Service des antiquités, Bibliothèque archéologique et historique, vol. XXXIV, 2 parts, text and album: Paris, 1939), p. 97; B. Meistermann, *Guide du Nil au Jourdain par le Sinaï et Pétra sur les traces d'Israël* (Paris, 1909), p. 256.

26. Jacques de Vitry, *The History of Jerusalem: A.D. 1180*, tr. A. Stewart (*PPTS*, vol. XI; London, 1896), p. 34; L. Eckenstein, *A History of Sinai* (London, 1921), p. 147; H. Skrobucha, *Sinai*, tr. G. Hunt (London and New York, 1966).

27. *Revue biblique*, LXIX (1962), 412-413 (report by A. Negev on recent excavations).

28. R. W. Hamilton, *Guide to Samaria–Sebaste* (Jerusalem, 1944).

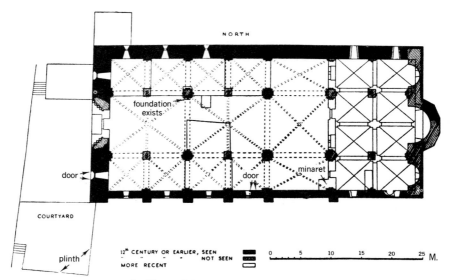

NORTH

foundation
exists

door door

minaret

COURTYARD

plinth

12ᵗʰ CENTURY OR EARLIER, SEEN
" " " " NOT SEEN
MORE RECENT

0 5 10 15 20 25 M.

3. Plan of the cathedral of Sebastia

nance (found in Damascus), on each of which there is a mounted
warrior, sometimes identified as Constantine.[29] They may well have
come from the Sebastia area. In 1187 Saladin captured that town
and it remained in Moslem hands. Burchard of Mount Sion in 1283
describes how the cathedral had become a mosque. He, as Theoderic
a hundred years before him, wondered at the great Herodian ruins
that crowned and still crown the hill, and moralized over so great a
city come to such wretchedness.

Next only to Jerusalem and Bethlehem in sacred association,
Nazareth was made an archbishopric by the Franks. As early as 1107
the abbot Daniel states that the crusaders had found the town
devastated but had rebuilt the church with the greatest care. "A great
and high church with three altars," he calls it, which suggests the
normal triple-apsidal plan. There was, Daniel adds, a very rich Latin
bishop, who gave him friendly welcome. Rich the see of Nazareth
certainly was; the church of St. Mary of Barletta in Apulia was held

29. G. Mendel, *Catalogue des sculptures grecques, romaines et byzantines des musées
imperiaux ottomans*, II (Constantinople, 1914), 585-592; Deschamps, "Sculpture française
en Palestine," *Fondation Eugène Piot, Monuments et mémoires*, XXXI, 109-110; D. A.
Walsh, "Crusader Sculpture from the Holy Land in Istanbul," *Gesta,* VIII (1969), 20-29. One
of the Damascus capitals is now in the Louvre; the other is a well-head in the al-Ḥanābilah
mosque in the aṣ-Ṣāliḥīyah suburb of Damascus; the miḥrāb in the mosque has two Gothic
capitals, one of which has two disfigured heads; E. Herzfeld, "Damascus: Studies in
Architecture–IV," *Ars Islamica*, XIII-XIV (1948), 120; J. Sauvaget, *Les Monuments
historiques de Damas* (Beirut, 1932), p. 95.

from it and administered by a vicar who controlled its numerous other European holdings. Its archbishops, such as Achard, who died in Constantinople in 1158 while negotiating the marriage of Baldwin III, and his successor Lietard, whom William of Tyre describes as having held the diocese for twenty-three years, were men who played a considerable part in the affairs of the kingdom.

It is this Lietard, prior before he became archbishop, who must have undertaken the extension of the cathedral in the second half of the century. It was a large building, 244 feet long by 98 broad, consisting of a nave and two aisles.[30] The side apses were encased in a rectangular outer wall from which the central apse, also rectangular on the exterior, projected some distance. Of the twelve piers of the nave, eight were square, four polygonal; the surviving capital of a small column, probably from a composite pier, is a finely carved acanthus with a grinning mask between the volutes. The crypt, the traditional house of Joseph and scene of the Annunciation, was below the two eastern bays of the north aisle and was faced with marble slabs and decorated with paintings. Some fragments of carving, including an elaborate chevron pattern on a voussoir stone, show the normal Romanesque motifs, but in 1908 a much more important find was made, that of five capitals buried in a pit and apparently hidden away without ever having been put in position, presumably at the loss of the town in 1187 while work on the cathedral was still in progress. The capitals are incompletely worked; the backgrounds are still rough and clearly it was intended to recess them further to a smooth finish, but the figures are elaborately wrought. Well might such treasures, doomed as they would have been to destruction at Moslem hands, have been hurriedly buried in the hope of a speedy Christian return. Four of the capitals are octagonal with two faces uncarved; the fifth is quadrilateral carved on three sides, and its semicircular base must have fitted a column, presumably the trumeau of the doorway for which they were designed.

30. P. Viaud, *Nazareth et ses deux églises de l'Annonciation et de Saint-Joseph*, . . . (Paris, 1910); Guérin, *Description . . . de la Palestine*, II, part 2, pp. 188-196; C. Kopp, "Beiträge zur Geschichte Nazareths," *Journal of the Palestine Oriental Society*, XIX (1939-1940), 82-119; P. Egidi, "I Capitelli romanici di Nazaret," *Dedalo*, Anno I (1920), 761-776 (with good photographs); Deschamps, "Sculpture française en Palestine," *Fondation Eugène Piot, Monuments et mémoires*, XXXI; *French Sculpture of the Romanesque Period, Eleventh and Twelfth Centuries* (Florence and Paris, 1930), pp. 95-99; and "Un Chapiteau roman du Berry, imité à Nazareth au XIIᵉ siècle," *Fondation Eugène Piot, Monuments et mémoires*, XXXII (1932), 119-126, pl. XI; B. Bagatti, "Ritrovamenti nella Nazaret evangelica," *Studii biblici franciscani Liber annuus*, V (1954-1955), 5-44; *Illustrated London News*, CCXXIX (1956), 1074; E. Testa, "Nuove scoperte a Nazaret," *La Terra Santa*, XLII (1966), 308-312; Barasch, *Crusader Figural Sculpture*, pp. 73-177.

Cut in a local yellow stone, which allows of much delicacy of carving, completely sharp and unweathered, the capitals are among the finest examples of the whole of Romanesque art (pl. XXI). Deschamps has suggested, very convincingly, that their character-istic features—the feathered devils, drilled ornament, and long-nosed faces—correspond with a capital of the Temptation of Christ in the church of Plaimpied near Bourges. A memorial relief from the same church is by the same hand, commemorating a canon, Sulpice, who can be traced in documents between 1120 and 1136, and the date 1142, carved roughly on the slab by a later hand, may well be that of his death. So close is the stylistic correspondence between these Plaimpied and Nazareth works, that they might well be by the same hand. It is tempting to think that their carver joined the Second Crusade in 1147, came with it to Palestine, and continued his trade there. Not, however, without learning from this transition. Some of the heads have the ascetic, pointed features of the Christ at Plaimpied; others are fuller-faced, broad-browed, with the staring eyes and elaborately curled hair of the Greco-Roman busts familiar at Palmyra. Whoever he may have been, the Nazareth master absorbed some Syrian Hellenistic influences into his western style. The capitals seem to depict scenes from the lives of St. Peter, St. Thomas, St. James, St. Matthew, and St. Bartholomew. The St. Peter's healing of Tabitha at Jaffa and the execution of St. James at Jerusalem are Palestinian subjects. The other three apostles are the missionaries of India, which Gervase of Tilbury divides into *India superior* (St. Bartholomew), *India inferior* (St. Thomas), and *India meridiana* (St. Matthew).[31] Already men were looking to distant lands with which before long new contacts were to be made.

In the course of the excavations various other fragments similar in kind were discovered, one of which appears to belong to a large-scale figure seated in a mandorla. In the Greek patriarchate's museum in Jerusalem there are two heads of prophets, dug up at Nazareth in 1867, which could well be work of the same masons' yard.[32] Carved in one block, approximately life-size, they are designed for column figures in the angle of a doorway or shrine and have the remote gravity of the sculptures of Chartres (pl. XXa). Then in 1955 it was decided to demolish the seventeenth-century church and build across the line of the crusading cathedral. In the course of excavations that

31. "Otia Imperialia," in G. W. von Leibnitz, ed., *Scriptores rerum Brunsvicensium . . . ,* I (Hanover, 1707), 911.
32. Conder and Kitchener, *Survey of Western Palestine,* I, 328.

followed a sixth, but unfortunately much battered, capital came to light, showing yet another struggle between an apostle and devils, here again a scene from one of the apocryphal acts. Even more interesting was the lower half of a life-size figure carved in almost full relief, of which the drapery has the same folds, circles, and drill-marks as that of the capitals (pl. XXIIa). It forms a close link with a very similar torso, now widely separated from it. In the duke of Devonshire's collection at Chatsworth there is the headless figure of a prophet, where the round whorls and patterned neckband recall the Nazareth workshop, though by a coarser hand than that of the master himself (pl. XXIIb). When it came to the collection its provenance was said to be "the mountainous country between the coasts of Tyre and Sidon and the river Jordan." [33] The torso now stands 41 inches high; that recently found at Nazareth, cut off at the waist line, measures 33 inches. It is likely that they came from the same workshop; certainly they belong to a common stylistic tradition. Until the results of the recent excavations are completely published there can only be hints and guesses at what the full achievement included. Tiberias, the only suffragan see of Nazareth, has no remains of its cathedral, probably built on the site where the mosque al-Baḥr now stands.

The metropolitan see of Syria was placed at Tyre; from it depended the suffragan sees of Acre, Sidon, Beirut, Jubail, Tripoli, and Tortosa, though the last three were constantly claimed by the patriarch of Antioch and with the union of Tripoli and Antioch in the thirteenth century passed under the control of the northern patriarchate. They all remain, however, curiously united by the course of history, differing much in circumstances from their Palestinian neighbors. They lacked the vivid biblical associations of the sites of the Holy Land proper, and their places of pilgrimage, such as the shrine at Tortosa, which claimed to be the first church dedicated to the Virgin, were less immediately compelling. Stretching along the seacoast, they remained in crusading hands throughout the thirteenth century and therefore show in their buildings the development of the Gothic style. Not that they have escaped ravages. Acre's churches are mainly a memory. At Sidon all trace of the cathedral is lost under the buildings of the Great Mosque; a thirteenth-century building, on a rock overlooking the beach, recalls the site of the hospital but has been much altered; for the rest there

33. *The Athenaeum: Journal of Literature, Science, and the Fine Arts* (1847), p. 339, and information in the manuscript catalogue at Chatsworth.

are only a few fragments of tombstones inscribed in thirteenth-century Gothic script.

The cathedral of Tyre, St. Mary of the Sepulcher of Our Lady of Tyre, was a rebuilding of the cathedral consecrated by Eusebius of Caesarea, the burial place of Origen, which the crusaders found still standing when they occupied the town. The exact date of the crusading work is not known, and today only some foundations and reërected granite columns mark its site. The ruins of its three apses long stood and are known in photographs, but now they have shared the fate of the whole building, and most of the stones, finely cut masonry set without mortar, have been carried off for other work. Probably damaged in the earthquake of 1170, its restoration may have been aided by the gifts given by emperor Manuel Comnenus to its great archbishop, the historian William. When Barbarossa's bones were buried there in 1190, it must have been one of the most magnificent churches of the Latin settlements. Controversy has been considerable as to its exact plan. The excavations of Professor Sepp in 1874, in search of the tomb of Frederick I, were enthusiastic but ill equipped for accurate observation. The fragments of carving are insufficient to establish a clear style of ornament, but certain points are established. About 244 feet long by 82 feet broad, it ended in three semicircular apses, but with the feature, unusual for the crusaders, of transepts projecting some 15 feet, the northern of which ended in a small apse, with a room on either side set in the thickness of the wall, a scheme that suggests Byzantine or Armenian models (fig. 4). The four great granite pillars, admired for their size by Burchard and other travelers, may have stood at the crossing; there were smaller columns of the same stone, all of which must have come from ancient Tyre.[34]

The cathedral of St. John the Baptist at Beirut is more fully preserved. Converted into a mosque, the whole building still stands, and its apses, round on the exterior with applied columns as buttresses running up to an elaborate series of carved metopes, constructed out of a golden-yellow stone with thin layers of mortar, are as good a piece of Romanesque architecture as any in Syria (pl. XXIXb). Inside, the junctions of the apses and the nave clearly mark

34. Enlart, *Monuments*, II, 352-375; J. N. Sepp, *Meerfahrt nach Tyrus zur Ausgrabung der Kathedrale mit Barbarossa's Grab* (Leipzig, 1879); F. W. Deichmann, "Die Ausgrabungs-funde der Kathedrale von Tyrus," *Berliner Museen*, LVI-3 (1935), 48-55; Conder and Kitchener, *Survey of Western Palestine*, I, 72-74. The long-awaited book on medieval Tyre by Maurice Chehab will no doubt shed much light on the crusader churches there. In the meantime recent excavations have unearthed a small church tentatively identified as St. Thomas of Canterbury; see P. M. Bikai, "A New Crusader Church in Tyre," *Bulletin du Musée de Beyrouth*, XXIV (1971), 83-90 [J. F.].

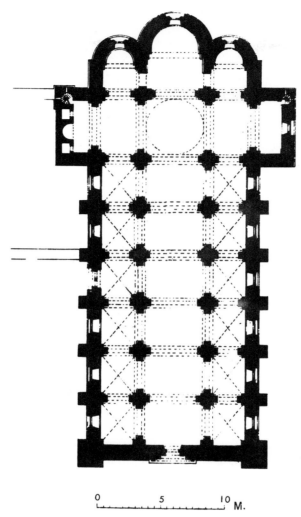

0 5 10 M.

4. Plan of the cathedral of Tyre. After R. Jusserand

two different stages of the work. The long episcopate of Baldwin of
Boulogne, 1112-1147, is the probable first period of construction,
but the building seems to have been completed before Saladin's
conquest, and the thirteenth century added little to it. The cathedral
had as its shrine the tomb of the Baptist, a claim that must have been
disputed with Sebastia but which is still accepted by its present
Moslem owners.

The little cathedral of Jubail (Gibelet), a less distinguished
building, has a charming, open-arched baptistry on its north exterior
wall, decorated with chevrons, rosettes, dog-tooth, and godroons and
crowned with a carved cornice.

Of the many churches of Tripoli, most have perished completely. In the Great Mosque, the north doorway, the capitals of the door to the ablution room, the west doorway, and the tower of the minaret are remnants of the cathedral of St. Mary of the Tower, the carving hidden and blunted under thick green and red paint. They are, however, remnants of considerable interest. The north door, with a Romanesque scroll of ovoids set in interlaces and a rope pattern archivolt, must come from the first building, which is known to have been much damaged in the great earthquake of 1170. The west doorway has a pointed arch, columns with early Gothic capitals, and voussoirs decorated with chevron patterns. It should date from the late twelfth or early thirteenth century. The great rectangular tower projects from the main building south of the west porch, a position similar to the bell tower on the main façade of the Holy Sepulcher; but here it is built without buttresses and its twin and triple window openings are less deeply recessed, recalling the towers of Italy rather than France.[35] A bathhouse, the Ḥammām 'Izz-ad-Dīn, has a doorway with two shells, the inscription "Sanctus Jacobus," and a lamb between two rosettes.

One of the most beautiful of all crusading churches is the cathedral of Our Lady of Tortosa (pl. XXVIII).[36] An ancient tradition held that St. Peter had dedicated here the first church in honor of the Virgin, and an ingenious arrangement of one of the pillars of the nave may have as its reason the preservation of the original chapel. Its early history is undocumented, but there were clearly two building stages. Halfway down the nave, the stone changes, and the ornament of the capitals alters from flat-leaf acanthus to a more luxuriant naturalism (pl. XXIXa). Beside one capital the mason has carved a jackal, a lively rendering of a familiar beast. On the façade a central west door (much restored) is surmounted by two windows, with a third smaller window above; a large window opens on either side and the whole is flanked with two square towers. Projecting towers were built as far as the roof level at the east end. The side walls were strengthened by flat buttresses, but there were no buttresses on the façade (fig. 5). It was a fortress church, similar to St. Victor of Marseilles, but distinguished by the quality of its detail. The probability is that the apses and two eastern bays were completed before Saladin took the town in 1188, when the cathedral is known

35. Enlart, *Monuments,* II, 430-440; van Berchem, *Voyages,* I, 11-30.

36. The account by Enlart, *Monuments,* II, 395-426, is the most detailed survey yet made. See also M. Pillet, "Notre-Dame de Tortose," *Syria,* X (1929), 40-51. The church is now used as a museum.

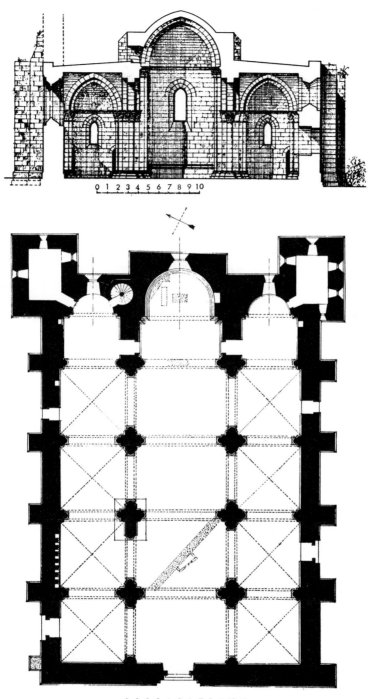

5. Plan of the cathedral of Tortosa. After C. Enlart

to have been damaged. In the thirteenth century, however, the pilgrimage revived and enjoyed considerable popularity. There was sufficient wealth to complete the building. Then in 1265, with the Mamluk menace growing closer and closer, the demolition of the church was discussed in order to narrow the defenses of the town. Instead, its fortifications seemed to have been strengthened and it was probably then that the apsidal towers were begun.

The monastic orders, apart from the Augustinian canons, who were installed at the Holy Sepulcher, the Temple, Mount Sion, the site of the Ascension, and Hebron, played no great part in the settlement. The countryside was too precarious for isolated communities, and the rise of the military orders diverted enthusiasm into other channels. St. Mary of Jehoshaphat and the convent at Mount Tabor were Benedictine houses using the Cluniac rule, though not in dependence on the archabbot. The Cistercians had two small houses, Belmont near Tripoli and St. Sergi near Jubail, the Premonstratensians two also, Montjoie at Nabī' Samwīl, the hill from which the pilgrims first saw Jerusalem, and St. Habakkuk at Ramatha (Kafr Jinnis) near Lydda. In the towns, monastic houses were much more numerous, and in the thirteenth century those of the friars were added to them; the Franciscans from their first mission onward played a considerable part in the affairs of the Holy Land.

Of the monastic churches outside Jerusalem, that of the Savior at Tabor was the most splendid.[37] Founded by Tancred, it was pillaged in 1113 and the monks were massacred. The restored monastery in 1130 accepted the Cluniac rule, and it is probably from that date that the fine Romanesque church was undertaken, inside a strong line of defensive walls. In 1187 it was destroyed by Saladin, but returned to Christian hands under Frederick II, who placed a group of Hungarian monks there. The church was restored, only to be destroyed once more by Baybars in 1265. Travelers long continued to describe the great apse as still standing, with its mosaic of the Transfiguration preserved. Excavated by the Franciscans in the last years of the nineteenth century, the ground plan has been reconstructed but contains some puzzling features. The main body of the church had the normal nave and two aisles, without transepts and with the apses set in a rectangular chevet, but the façade appears to have been composed of two towers with apsidal chapels in their bases, built at a lower level than the main church, to which a stairway

37. B. Meistermann, *Le Mont Thabor: Notices historiques et descriptives* (Paris, 1900); Enlart, *Monuments,* II, 380-395.

ascended between the towers. Fragments of figure sculpture, some of excellent quality, suggest that the west door was elaborately ornamented. Enlart suggests as a parallel the church of Graville Sainte Honorine in Normandy. There are gaps in our information, but it is clear that it was an ambitious and finely worked out scheme. Possibly the thirteenth-century reconstruction, to which some Gothic capitals seem to belong, dealt only with the main church, leaving the tower chapels, which almost certainly were dedicated to Moses and Elias, more or less detached.

The Cistercian abbey of Belmont[38] was very different. Its situation on a steep hilltop southwest of Tripoli was as inaccessible as the strictest solitaries could have wished, though, contrary to the practice of the order, it stood for protection's sake on the summit, not in the valley. Founded in 1157, destroyed in 1169, and later reoccupied till the final fall of the kingdom, it then passed into the hands of the Orthodox church and remains in monastic occupation to this day. So remote was it that the Moslems did not trouble to destroy it. In the course of centuries much has been rebuilt and adapted to other purposes. The chapter-house is now a chapel, and the main entrance has been driven through the refectory, but there is enough to show that it was well constructed in faced stone, and that it adhered rigorously to the order's standard of simplicity. The few pieces of carving, capitals and consoles, indicate that if the main work is twelfth-century there were repairs and additions in the thirteenth.

In addition to its cathedrals and monastic houses, crusading Palestine was rich in lesser churches. These are too numerous to receive individual mention, and many are still uncertainly identified, blocks of solid masonry absorbed into the confused erections of some squalid village. A few, however, deserve notice, either for the merit of their remains or for the interest of their associations. The church of the Resurrection at Nablus, the Neapolis of crusading chronicles, built between 1167 and 1187, has already been mentioned. A mile outside the town, the crusaders rebuilt a Byzantine church over the Well of Jacob.[39] Destroyed during Saladin's conquest, possibly before it was completed, it long remained a ruin. A new church, built by the Orthodox patriarchate, was in course of construction when war broke out in 1914, and it too remains an unfinished shell. The general plan had however been

38. Enlart, *Monuments*, II, 45-63. See now C. Asmar, "L'Abbaye de Belmont...," *Bulletin du Musée de Beyrouth*, XXV (1972, publ. 1975), 1-69 [J. F.].

39. P. Séjourné, "Nouvelles découvertes au puits de la Samaritaine," *Revue biblique*, IV (1895), 619-622; Enlart, *Monuments*, II, 289-292.

noted, and it is clear that it resembled in its use of alternate columns and pillars the cathedral of Sebastia, its nearest neighbor, but with the unusual feature of projecting transepts. The chevet was more normal; the main apse was pentagonal on the exterior, the apses of the aisles set in the east wall. At Saffūrīyah, some five miles from Nazareth, the church of St. Anne and St. Joachim still has its eastern end standing. It was a vaulted church of five bays, ending in three apses set in a square chevet. The northern apse was enlarged into a rectangular chapel, possibly about 1253 at the time of Louis IX's crusade, when the church was temporarily restored to Christian hands.[40]

Guarding the entry to the hills on the road from Jaffa to Jerusalem was the castle of Latrun. The origin of this name seems to come from a corruption, through the Arabic, of the crusading term "Le Toron," for a hill castle. In the sixteenth century a derivation from *latro* was invented, and it was held to be the tomb of the penitent thief, Dysmas; but this was not known to the crusaders of the kingdom, who seem to have called it "Turo Militum" after the Templars to whom it belonged. In the twelfth century the religious associations were with Modin, the burial place of the Maccabees, and with Emmaus, for which the site of 'Amwās, at the foot of the hill, was sometimes claimed and which was the name of one of the battles of Judas Maccabaeus as well as the scene of the supper after the Resurrection. At 'Amwās, within the ruins of a basilica dating from the third century and rebuilt in the sixth, the crusaders constructed a church of a single nave, using the main apse of the old basilica and filling in the colonnade between nave and aisles. Little remains, but it seems to have been a simple and severe building, probably fortified on the exterior.

Meanwhile a rival site for both Modin and Emmaus was being claimed by the Hospitallers in their territories at Qaryat al-'Inab, now called Abū-Ghosh after a celebrated nineteenth-century brigand. Here was a fountain which was said to be the place of Christ's supper with the two disciples, while the castle of Belmont nearby was the birthplace of the Maccabees, and here the Hospitallers, using the foundations of the old Roman water tank, built a church with its three apses all set in a thick outer wall. The typical bent-arm consoles, so much employed in Jerusalem, figure conspicuously. The Umaiyad

40. Viaud, *Nazareth*, pp. 179-184. For an account of Saffūrīyah in the early nineteenth century see E. D. Clarke, *Travels in Various Countries of Europe, Asia and Africa; part II: Greece, Egypt and the Holy Land* (London, 1812), p. 407.

caravanserai adjoining seems to have remained in use during the crusading period with but little alteration. This locality, more conveniently situated in relation to Jerusalem, seems to have gained the day in the twelfth century, and 'Amwās to have taken the martyrdom of the mother of the Maccabees and her children as its particular act of sanctification. By the sixteenth century Abū-Ghosh in its turn had yielded its association with Emmaus to al-Qubaibah, the "Petite Mahomerie" of the crusaders, and had become instead the birthplace of Jeremiah and the scene of David's victory over Goliath.[41] At 'Ain Karım, nearer Jerusalem, a small Byzantine church built over a cave was enlarged by the crusaders in honor of the Visitation and the birthplace of the Baptist.[42]

The year 1187 is a sharply dividing line in the development of crusading art. Much that had been achieved perished in Saladin's purging of the holy places, holy both to Islam and to Christianity. Never again did Jerusalem become a main center; some work may have been done there in the period following Frederick II's treaty of 1229, but it cannot be surely identified, and with the Khorezmian sack of 1244 Jerusalem passed out of any crusading control. In the church of the Holy Sepulcher and some other shrines later ages left their mark; baroque paintings and decorations were sent from Europe; then an age of tawdriness set in that still tastelessly distracts the mind from the most profound emotions that any site can evoke. The Romanesque art of Syria was displaced, disfigured, and forgotten.

Along the coast at Château Pèlerin, Acre, or Tortosa, across the sea on Cyprus, or at inland strongholds such as Krak des Chevaliers, the Gothic style gained some footing. Acre was the capital and center of this second phase. Up to its capture by Saladin and its long siege from August 1189 to July 1191, as the first port of the kingdom it already had a position of some importance and large hostelries for pilgrims. After its capture by Richard Coeur-de-Lion it became the crusading capital and one of the greatest markets of the Levant. It was also a city of refuges, with a population considerably larger

41. L. H. Vincent and F. M. Abel, *Emmaüs: Sa Basilique et son histoire* (Paris, 1932); R. de Vaux and A. M. Steve, *Fouilles à Qaryet el-'Enab (Abū Ġôsh), Palestine* (École biblique et archéologique française, Études archéologiques; Paris, 1950).

42. B. Bagatti, *I Monumenti di Emmaus el-Qubeibeh e dei Dintorni: Risultato degli scavi e sopralluoghi negli anni 1873, 1887-90, 1900-2, 1940-44* (SBF, no. 4; Jerusalem, 1947) and *Il Santuario della Visitazione ad 'Ain Karim (Montana Judaeae): Esplorazione archeologica e ripristino* (SBF, no. 5; Jerusalem, 1948).

than that of crusading Jerusalem. The patriarchate was transferred there; the monks of St. Mary of Jehoshaphat built a new church and monastery to replace that which they had lost; the displaced communities found themselves new abodes, and the coming of the two orders of friars, Franciscan and Dominican, gave a new impetus to religious foundations; some forty churches demonstrated the number of Acre's varied orders rather than the actual spiritual needs of the population. The narrow streets still follow much of their ancient pattern, and with Israeli excavations more and more of the medieval town is coming to light. The so-called crypt, originally a hall at ground level, has since 1954 been cleared of the rubble that filled it, and is revealed as a noble pillared room with early pointed arches and ribbed vaulting. It was probably the refectory of the Hospitallers,[43] and further clearings have opened up a whole complex of rooms and passages.

Even before the city was lost, the church of the monks of St. Mary of Jehoshaphat was falling into disrepair and had become a dumping place for refuse; there was no money to repair it, and papal permission was obtained in 1289 to sell it to the Hospitallers. Part of the payment was a golden chalice, a portable object which there might be some hope of saving in those desperate days.[44] Here and there an inscription or a battered piece of sculpture recalls the crusading past. The local museum has a holy-water basin with carved heads that suggest south Italian influence (pl. XXIIIb). A fragment of an incised tomb slab shows a kneeling figure at the feet of a prelate, or so the vestments suggest, but the upper portion is missing, and of the French inscription there remains only the date July 1290, hardly a year before the final loss of the town. Given the popularity of incised memorials in Cyprus, it is of particular interest to have this fur-

43. Z. Goldmann, "The Hospice of the Knights of St. John in Akko," *Archaeology*, XIX (1966), 182-189. For the streets and fortifications of Acre see Benvenisti, *The Crusaders in the Holy Land*, pp. 78-113. The most useful of the older publications are E. G. Rey. "Étude sur la topographie de la ville d'Acre," *Mémoires de la Société nationale des antiquaires de France*, XXXIX (1878), 115-145, and XLIX (1888), 1-18; N. Makhouly and C. N. Johns, *Guide to Acre* (Jerusalem, 1946); and J. Prawer, "The Historical Maps of Acre" (in Hebrew), *Eretz Israel*, II (1953), 175-184. In 1962 a survey of the city was published by the supervising architect, A. Kesten, *Acre, the Old City: Survey and Planning* (Office of the Prime Minister, Department for Landscaping and the Preservation of Historic Sites [Tel Aviv, 1962]), some plans from which are used in Benvenisti's book; this survey was a valuable first step in assessing the extant remains of the medieval city, despite the heavy destruction of 1291. A serious and sustained project to investigate crusader Acre, in the manner of the survey of Mamluk monuments in Jerusalem currently in progress by the British School of Archaeology, would not only be of interest for the crusader port, but would shed light on other crusader cities as well. [J. F.]

44. *Cartulaire général de l'ordre des Hospitaliers de S. Jean de Jérusalem*, ed. J. Delaville Le Roulx, III (Paris, 1899), no. 4044, p. 538.

ther example from the crusading mainland, for incised figures, as opposed to inscriptions, are known from crusading Palestine only in a broken slab with a head, sensitively cut, and part of an inscription with the name Hugo.[45]

At Montfort, in the hills beyond Acre, some carved capitals, one with a man crawling through foliage, some fine bosses, and a corbel head have been discovered in the ruins of the castle of the Teutonic Knights. In 1748, when the Franciscan Ladislaus Mayer visited Acre, he saw and drew the considerable remains of the Templars' house and chapel, with a graceful oriel window; when he returned four years later it had been leveled to the ground.[46]

The most complete and distinguished relic from Acre is the doorway of the church of St. Andrew, which was transported on camel back and embodied in the madrasah of an-Nāṣir Muḥammad in Cairo (pl. XXV). St. Andrew's was the largest church of the town, and something can be learned of it from the engravings made of it by le Bruyn in 1681 and by d'Orcières five years later.[47] A nave and aisles of five bays, almost certainly with ribbed vaulting, ended in three apses. The flat roofs of the aisles were arched with flying buttresses supporting the vault of the nave, but there were no outer buttresses. Instead, an arcaded gallery seems to have run the whole length of the church, a continuation of the porch which preceded the façade. The windows were narrow, sharply pointed lancets; the Cairo doorway shows that the decoration was of a simple but refined Gothic foliage style. The recession of its columns blends harmoniously with the shallow arches of the neighboring mausoleum of Kalavun. This remnant of crusading Acre stands today in one of the finest of medieval streets, and holds it own;[48] here and there in the

45. I am indebted to Dr. J. Prawer for information about and a photograph of the Acre fragment; see E. Sivan, "Palestine during the Crusades (1099-1291)," in *A History of the Holy Land,* ed. M. Avi-Yonah (Jerusalem, 1969), p. 236. For other memorials see C. Clermont-Ganneau, *Album d'antiquités orientales: Recueil de monuments inédits ou peu connus: Art–archéologie–épigraphie* (Paris, 1897), pl. XLVII, and Sabino de Sandoli, *Corpus inscriptionum crucesignatorum Terrae Sanctae (1099-1291)* (Jerusalem, 1974), pp. 258-259, 281, 314-316. For other sculpture at Acre see Barasch, *Crusader Figural Sculptures,* pp. 13-65, and "An Unknown Work of Medieval Sculpture in Acre," *Scripta hierosolymitana,* XXIV (1972), 72-105.

46. *Reisebeschreibung nach Jerusalem,* Munich, Bayerische Staatsbibliothek, MS. 2967, fol. 56. See also Giovanni Mariti, *Viaggi per l'isola di Cipro e per la Soría e Palestina fatti . . . dall' anno MDCCLX al MDCCLXVIII,* II (Lucca, 1769), 72.

47. Enlart, *Monuments,* II, 2-35; atlas, I, plates 51 and 52 (reproducing both the le Bruyn and the d'Orcières drawings of St. Andrew): Makhouly and Johns, *Guide to Acre.* For Montfort see Bashford Dean, "The Exploration of a Crusaders' Fortress (Montfort) in Palestine," *Bulletin of the Metropolitan Museum of Art, New York,* XXII, part II (1927).

48. K. A. C. Creswell, *The Muslim Architecture of Egypt,* II (Oxford, 1959), 234-235.

magnificent mosques of Cairo, other fragments of crusading work can still be found. Baybars shipped wood and stone from destroyed Jaffa for the mosque he was building, and in the fourteenth century the masons of the madrasah of sultan al-Ḥasan used some twelfth-century crusading foliage capitals for the miḥrāb, and on a small stone pillar by the entrance can still be seen Romanesque interlaces and three carvings of buildings, one of which seems to be the Temple, the other two possibly Bethlehem and the Holy Sepulcher.

No mention has as yet been made of Antioch. A patriarchate that at times raised pretensions of rivalry with Jerusalem, an independent principality in an ancient city of fine buildings, it had two centuries of Frankish rule and its wealth and luxury were something of a legend to the dispossessed feudatories of the south. Its own expansion eastward had, it is true, been short-lived, but the thirteenth century saw it gradually extending its power over the remnant of the county of Tripoli. Jealously eyed by Byzantium, it was of all crusading states the one most closely in touch with its civilization. Of its churches, hardly the site of one is now known.[49] The Latin cathedral was dedicated to St. Peter and was certainly a Byzantine church, though possibly the crusaders added to it; it is known that the earthquake of 1170 caused much damage, which may well have led to rebuilding. It contained a tomb of Barbarossa, where his flesh was buried; the bones were carried farther south to Tyre. Near it was the round church of St. Mary, one of the few sites known. St. Mary Latin was presumably a Frankish church, and the monastery of St. Paul, at the easternmost point of the walls, had many Frankish additions. Nothing now remains of the "good and strong city, hardly second to Rome itself in sanctity," which Wilbrand of Oldenburg described in 1211.[50] Earthquake, fire, pillage, and quarrying have done their work. A small and undistinguished modern Turkish town clings to the river banks; only the foundations of the walls can still be seen stretching to the summit of Mount Silpius, forming a circuit seven miles in length.

49. C. Cahen, *La Syrie du nord à l'époque des croisades et la principauté franque d'Antioche* (Institut francais de Damas; Bibliothèque orientale, vol. I; Paris, 1940), pp. 129-132.
 50. Laurent, *Peregrinatores*, p. 171.

B. Mosaic, Painting, and Minor Arts

In the decoration of the crusading churches mosaic and painting played a great part. The former was probably the work of local craftsmen, and in the fragments that remain it is the Byzantine style that predominates. Both Latin and Greek inscriptions were used, Latin the more commonly, at least in those texts handed down to us, but this may reflect the interests and language of the pilgrim writers rather than any exact proportion.

Nāṣir-i-Khusrau, writing between 1035 and 1042, when the Byzantine restorations, culminating in that of Constantine IX Monomachus, were already in hand, describes the church of the Holy Sepulcher as ornamented with sculptures and paintings and much use of gold.[1] Abbot Daniel in 1106-1107 states that in the rotunda there were lifelike mosaics of the prophets in the arches above the tribunes, Christ in mosaic above the altar, an Exaltation of Adam on the high altar with the Ascension in the vault above, and the Annunciation on the arch of the sanctuary. Theoderic (about 1172) refers to this last mosaic but qualifies it as ancient, and completes Daniel's list with the figures of the apostles, Constantine, and St. Helena. Fra Nicholas of Poggibonsi (1345) still talks of these mosaics, and they continue to be mentioned until the account by Quaresmi in 1625, by which time they were already much obliterated. They probably dated from the mid-eleventh century. The mosaics in the twelfth-century choir had by Quaresmi's time mainly perished, which is all the more to be regretted as they must have been crusading work.

Theoderic describes them as they were when newly completed. In the apse was a great mosaic which he calls the Ascension: Christ was shown with his left foot raised, his right still resting on the ground, a typical Byzantine posture for the Anastasis; in his right hand he held a cross, his left was stretched out to Adam (possibly a version of the exaltation of Adam seen by Daniel on the original high altar,

1. Baldi, *Enchiridion*, pp. 832-896, contains the relevant extracts from travelers' descriptions. De Vogüé, *Églises*, pp. 188-194, discusses the mosaics of the church of the Holy Sepulcher in detail.

moved when the crusading choir was built); it is roughly reproduced on the seals of the patriarchs Fulcher (1147-1157) and Amalric (1157-1180).[2] Below, so Theoderic states, stood the Virgin, St. John the Baptist, and all the apostles; above was inscribed the text "Ascendens Christus in altum captivam duxit carnem, dedit dona hominibus." From the arch of the apse hung three paintings (*icona*, probably painted panels) of the Virgin, St. John the Baptist, and the archangel Gabriel. Further information comes from Nicholas of Poggibonsi, who describes the tribune, presumably the choir screen, as "figurata d'opera musaica" with scenes of Pentecost at the top and St. Peter, Solomon and the Church, Samson, Job, and David and the Synagogue below—a curious and somewhat puzzling iconographical list, but one that must refer to the replacement of the Old Law by the New and therefore had its appropriateness here in Judea.

The two chapels of Calvary were also decorated with mosaic. De Vogüé, using the account of Quaresmi and the inscriptions given by him, has worked out that the series was comprised of prototypes and scenes of the Passion linked by a Latin verse commentary; it included the Last Supper, Abraham and Isaac, the Crucifixion, the Descent from the Cross, the Entombment, and the Ascension, paralleled by Elijah's sojourn in the desert and his fiery chariot. On the pillars and soffits of the arches were figures of prophets and of St. Helena and emperor Heraclius. Of all these works only a fragment remains, the figure of Christ from the Ascension (pl. XXX). It has a frontal position, the left hand holding a book which is rested on the knee, the right hand raised, probably in blessing, but the damage here is too extensive for the design to be followed. The face is finely drawn and has something of the mysterious gravity of Cefalù or Daphne; the drapery is treated with great freedom, but stylistically could as well be Byzantine work of the mid-eleventh century as crusader-Byzantine work of the mid-twelfth. The chapel is, however, twelfth-century work, and the inscription is in Latin.

Such elaborate use of mosaic was by no means restricted to the church of the Holy Sepulcher, nor to Jerusalem, for there were notable mosaics at Nazareth and Mount Tabor, though these may have been made by artists from the capital. It seems certain that there was a considerable workshop, probably Graeco-Syrian, avail-

2. Chandon de Briailles, "Sur Deux bulles de l'Orient latin," *Mélanges syriens offerts à Monsieur René Dussaud par ses amis et ses élèves,* I (Haut Commissariat de la République française en Syrie et au Liban, Service des antiquités, Bibliothèque archéologique et historique, vol. XXX; Paris, 1939), 139-150.

able under crusading patronage for this type of decoration. In the Dome of the Rock and the dome of the Aqṣâ mosque the crusaders found eighth- and eleventh-century floral mosaics of the finest quality. These were, and fortunately still are, partially preserved. The anonymous pilgrim published by De Vogüé states that when the crusaders occupied the Temple there was nothing depicted there either Christian (of the law) or Greek. William of Tyre took enough interest in them to try to decipher the Arabic inscriptions.[3] To these splendid gracious works, the fine flower of the Umaiyad style, the crusaders added a series of their own mosaics (or paintings, for the texts here are not specific) with scenes of the events of scripture specially connected with the site, and placed Latin texts "in great characters" around the dome.[4] The figure of the Virgin surrounded by angels in the apse of the church of the Tomb of the Virgin was also probably in mosaic.

Outside Jerusalem, the most ambitious scheme of mosaic decoration was that undertaken at Bethlehem.[5] Here we have, for the crusaders' work, some unusually definite information. An inscription, of which the Latin version, now only fragmentarily extant, is given by various travelers, still exists in its Greek form stating that "the present work was finished by the hand of Ephrem the monk, painter and mosaic worker, in the reign of the great emperor Manuel Porphyrogenitus Comnenus and in the time of the great king of Jerusalem, our lord Amalric, and of the most holy bishop of holy Bethlehem, the lord Ralph, in the year 6677, second indiction" (1169). Amalric in 1169 married Manuel's niece Maria, and there were at the time vague discussions as to a possible reunion of the churches. Bishop Ralph, "English by birth, a very handsome man, most acceptable to the king and queen—and indeed, to all of the court" (so William of Tyre tells us),[6] was also chancellor and was

3. William of Tyre, *Historia rerum in partibus transmarinis gestarum* . . . , I, 2 (*RHC, Occ.,* I, 13) and VIII, 3 (*ibid.,* I, 325).

4. John of Würzburg, "Descriptio Terrae Sanctae," in Baldi, *Enchiridion,* pp. 567-570.

5. For the mosaics and paintings at Bethlehem see Baldi, *Enchiridion,* pp. 100-207; R. W. Hamilton, "Note on a Mosaic Inscription in the Church of the Nativity," *Quarterly of the Department of Antiquities in Palestine,* VI (1938), 210-211; H. Stern, "Les Représentations des conciles dans l'église de la Nativité à Bethléem," *Byzantion,* XI (1936), 101-152, and XIII (1938), 415-459; W. Harvey, W. R. Lethaby, O. M. Dalton, H. A. A. Cruso, and A. C. Headlam, *The Church of the Nativity at Bethlehem* (London, 1910); Vincent and Abel, *Bethléem;* Hamilton, *The Church of the Nativity, Bethlehem;* and B. Bagatti, *Gli Antichi edifici sacri di Betlemme.*

6. William of Tyre, XVI, 17 (*RHC, Occ.,* I, 733).

certainly, from his office, involved in the negotiations, which the mosaics commemorate. It is by no means clear how far the work of Ephrem extended; the fragment of the inscription, which Quaresmi copied complete, is in the apse of the choir, but the pictorial mosaics there have all perished, though Quaresmi in 1625 could still decipher the subjects: the Virgin and Child between David and Abraham on the arch in the apse; the Annunciation above; on the north wall Pentecost; on the south the burial of the Virgin and the Presentation. The north transept held Christ's appearance to St. Thomas and the Ascension, the south the Adoration of the Magi, Christ and the Samaritan woman, the Transfiguration, the Entry into Jerusalem, and the Betrayal. Of these the Incredulity of St. Thomas and the Entry into Jerusalem are fairly complete; of the Ascension there remains the standing row of the Virgin and Apostles; of the Transfiguration only a crouching apostle. In all cases the mosaics had Latin inscriptions and above them were prophets and apostles. Even in Quaresmi's time many were totally destroyed, among them presumably some representation of the Crucifixion. Despite the Latin inscriptions the treatment is essentially Byzantine and the work must have been largely by Greek artists.

The mosaic decoration extended to the nave and the crypt. John Phocas, a Cretan monk who visited Bethlehem in 1177 and who assigns not only the decoration of the church but its actual building to emperor Manuel, gives a vivid description of the mosaic of the Nativity in the apse of the Grotto. It is much damaged, but enough remains to confirm that the design was the familiar Byzantine rendering of the Nativity (pl. XXXIa). Phocas describes in detail the shepherds, the dogs, and the sheep, and adds the Magi, who cannot now be distinguished, but who frequently figure in the Byzantine type known in eleventh-century manuscripts and in the Cypriote wall paintings.[7] The inscription, however, of which the words "Pax hominibus" remain, was in Latin.

In the nave there is another series of mosaics. On the south wall are represented the seven ecumenical councils, on the north wall are the six provincial councils of Carthage, Laodicea, Gangra, Sardica, Antioch, and Ancyra. The ecumenical councils are represented by two arcades, each enclosing an altar with above it an inscription in Greek (with the exception of the seventh council which is in Latin); the provincial councils, all labeled in Greek, have more elaborate architectural settings and enclose only one altar. On both walls the

7. Baldi, *Enchiridion,* pp. 143 ff.

councils are divided by panels of elaborate decorative work based on vases of acanthus foliage. There are now only fragmentary remains, but Quaresmi has left a detailed account and copied the inscriptions. The researches of Dr. H. Stern have established that this program and the accompanying inscriptions are based on a Greek synodicon of the late seventh or early eighth century, a profession of faith which in the Bethlehem inscriptions has been modified to bring out the condemnation of heresies that still survived among the Christian sects of Syria. Stylistically the designs of the provincial councils have much in common with the Umaiyad decorations of Damascus and the Dome of the Rock. It is tempting to think, though there is no record of such work at Bethlehem, that they represent an eighth-century scheme, and that the south wall was reworked by the crusaders in order to include the Council of Nicaea, whose Latin text proclaims its origin and includes anathemas by name against the Greek iconoclast emperors. This would explain the more meager decoration, and also the selection of themes so unknown in western Europe, but possibly related to the dealings of bishop Ralph with Byzantium.

Under the councils there were friezes of the ancestors of Christ (according to St. Matthew on the south and St. Luke on the north), of which seven heads survive, with Latin inscriptions. These figures connected the transept scenes of the life of Christ with the great Tree of Jesse with which the crusaders filled the west wall; it is described in detail by Quaresmi, and served as a link between the doctrinal Greek designs and the more narrative Latin scheme. Of the Tree nothing now exists. Above the councils, between the clerestory windows, the crusaders placed a procession of angels, of which six survive, figures of great elegance and distinction, advancing with outstretched hands towards the choir and the actual place of the Nativity, their curved postures echoed in the flow of their drapery. Under one of them appears in Latin script the name Basilius Pictor.

The columns of the nave have another form of decoration, paintings, clearly by different hands, in some thick medium, possibly mixed with oil (pls. XXXII and XXXIII). Set above eye level, they have escaped mutilation, but have flaked and faded considerably. They were cleaned and photographed in 1946. The subjects can be identified from names given in Latin, or in some instances in Latin and Greek, beside the figures. Beginning at the west, the paintings on the north aisle columns are as follows: St. Macarius, St. Anthony Abbot, St. Euthymius, St. George, St. Leonard, St. Cosmas, St. Damian, St. Cataldus, the Virgin and Child, St. John the Evangelist, and a

much damaged scene of several figures shown by Greek inscriptions to be Mary the mother of James, Salome, Mary Magdalen, and the Virgin Mary; the other half of the painting is completely obliterated. The columns of the south aisle have St. Theodosius, St. Sabas, St. Stephen, St. Canute, St. Olaf, St. Vincent, St. John the Baptist, Elijah, St. Humphrey, St. Fusca, and St. Margaret of Antioch. On the colonnade between the two southern aisles are St. James, St. Bartholomew, St. Blaise and the Virgin and Child on the same column, St. Leo (the best preserved of all the paintings) and St. Anne also on one column, St. Margaret, and a second Virgin and Child. The list suggests no iconographical system but rather a series of votive paintings. In three cases donors in fact kneel below the saints (St. Olaf, St. James, and the Virgin on the fifth column of the south aisle). This also might explain certain groupings. Thus three hermit saints, Macarius, Anthony, and Euthymius, come in succession; the two Scandinavian saints are on adjacent pillars and have their names in Latin only.

It is by no means clear that all the paintings are of one date, and there are certainly stylistic differences between them. On one pillar, the Virgin and Child of the south aisle, there is a Latin inscription, an invocation for mercy, referring to the donors kneeling below, with the date May 15, 1130.[8] This dissociates the frescoes from the decorative schemes of 1169. They are not the work of skilled artists such as those entrusted with the mosaics. The inscribed Virgin and Child belongs to a group in the south aisle which are somewhat stiffer in drawing than the bulk of the paintings, particularly than the neighboring figures in the same aisle of St. Fusca (a Venetian saint) and St. Margaret. The prophet Elijah, fed by ravens (with text in Latin but name in both Greek and Latin), is the finest figure, thoroughly Romanesque in feeling. St. Olaf, St. Canute, and St. George have a certain lightness of pose and their feet and hands are smaller than those in most of the paintings. The colors are mostly dark reds, purples, and brown on a cobalt blue background. The donors kneeling at the feet of some of the figures have the pointed cloaks and close-fitting tunics of the mid-twelfth century. Some of them carry pilgrims' scrips at their belts. Such paintings, with their mixed origins, reflect the cosmopolitan nature of the crusading state.

Unfortunately, though chroniclers refer to painted decorations in other churches, few now survive; some fast-fading fragments appear on the walls of the church at Abū-Ghosh (pls. XXXIV and XXXV),

8. For this inscription see Bagatti, *Betlemme*, p. 102, and S. de Sandoli, *Corpus inscriptionum*, pp. 224-225.

for which conservation work is desperately needed; some frescoes on the life of the Baptist occur in the crypt of the church of the Invention of the Head of St. John the Baptist at Sebastia. In the small church of St. Phocas at Amyūn figures like those on the Bethlehem columns are painted on the piers, but this, though possibly a twelfth-century church, was dedicated to a Greek saint, and its paintings, with their Greek inscriptions, are entirely Byzantine. In 1965, in excavations outside the Damascus gate, a small crusading chapel was found, with fragments of wall painting still visible: a much damaged head with a halo, and a piece of drapery showing the long pointed folds of the Bethlehem figures.[9]

9. For Abū-Ghosh see Ch. Diehl, "Les Fresques de l'église d'Abou-Gosch," *Comptes-rendues de l'Académie des inscriptions et belles-lettres* (Paris, 1924), pp. 89-96; Enlart, *Monuments des croisés,* II, 315-325 and plates 137-139 bis; and R. de Vaux and A. M. Steve, *Fouilles à Qaryet el-'Enab, Abū Gôsh, Palestine* (Paris, 1950), pp. 92-104. For the church of the Invention of the Head of St. John the Baptist see J. W. Crowfoot, *Churches at Bosra and Samaria-Sebaste* (British School of Archaeology at Jerusalem, Supplementary Paper 4; London, 1937), pp. 24-39, frontispiece and plates 16b and 16c, and Hamilton, *Guide to Samaria-Sebaste,* pp. 56-59 and figures 23 and 25. For St. (Mar) Phocas at Amyūn see Enlart, *Monuments des croisés,* II, 35-37, pl. 58, and M. Tallon, "Peintures byzantines au Liban: Inventaire," *Mélanges de l'Université Saint-Joseph,* XXXVIII (=Mélanges offerts au père René Mouterde, II; 1962), 290. For the church of St. Abraham just outside the present-day Damascus gate (but just inside the crusader gate) see Kathleen M. Kenyon, *Jerusalem: Excavating 3000 Years of History* (London, 1967), pp. 160 (pl. XIX),162-163, 195-196, and pl. 78, and J. B. Hennessy, "Preliminary Report on Excavation at the Damascus Gate, Jerusalem," *Levant,* II (1970), 24-27 and plates XXIIa, XXIIb, and XXIIIa. [J. F.]

To this group of extant frescoes some other important ones should be added. There is at Bethphage a large rectangular rock (roughly 49 inches square and 47 inches high), discovered in 1876, with fresco fragments on all five main surfaces. The stele seems to have been established by the crusaders in the 12th century to commemorate the Gospel accounts of Bethphage, especially Matthew 21:1-8, and to mark the spot where Jesus mounted the ass. Two of the scenes depict the events of Matthew 21:6 and 8, and a third shows the raising of Lazarus in Bethany, just down the hill. Though restored in 1950, some of the original 12th-century painting is still to be seen. On the basis of the painted inscriptions it has been suggested that the frescoes date to the second half of the 12th century, which would correspond to the extant pilgrim accounts of John of Würzburg (1165) and Theoderic (1172). See Ch. Clermont-Ganneau, "La Pierre de Bethphagé," *Revue archéologique,* n.s., XXXIV (1877), 366-388; B. Bagatti, "Le Pitture medievali'della pietra di Betfage," *Liber annuus,* I (1950-1951), 228-246; and S. de Sandoli, *Corpus inscriptionum,* pp. 185-188. [J. F.]

At Bethlehem, on the north side of Justinian's narthex, the crusaders built a small chapel on the ground level under the northwest tower of the church of the Nativity. Some of the frescoes are extant, including a Deësis group on the east wall, an *etimasia* in the vault immediately above, a group consisting of the Virgin and Child with Joseph and another figure on the eastern intrados of the northern (the present entrance) arm of the chapel, and fragments suggesting that an Ascension once appeared in the main central vault. There are also a number of standing saints including St. John Climachus. These paintings, which have been heavily restored, may possibly date originally from the second half of the twelfth century. See Bagatti, *Gli Antichi edifici sacri de Betlemme,* p. 70, fig. 20, and pp. 74-79, and pl. 59. [J. F.]

In mosaic and wall painting Byzantine influence predominates. Illumination drew its inspiration from more varied sources.[10] Byzantine examples set the standard, but the local Syrian schools practised the art, and in the course of the twelfth century the Jacobites formed a style which was a provincial derivation from Byzantium, but which kept a certain harsh intensity from the older Syrian tradition of the Rabula and Rossano Gospels and incorporated also some Islamic details. Similarly in Islam a school of miniaturists, apparently centering on Aleppo, a town at this time fertile in all the arts, showed marked reflections of Byzantine types.[11] In Cilicia, the refugee kingdom of Armenia brought with it a tradition of illumination which in the twelfth century, under the patronage of the great archbishop Nersēs of Lampron, reached high standards of execution, endowing Byzantinism with a fresh inventiveness of brilliantly colored interlaced arabesques in the rectangular headings of the canon tables, feathery, irregular initials, and marginal

In the vicinity of Tripoli there is, besides St. Phocas at Amyūn, the grotto dedicated to St. Marina just above the little village of Qalamūn. Typical of the many Byzantine cave chapels with paintings in Lebanon, which are currently being studied by Erica C. Dodd of the American University of Beirut, this shrine is unusual in having a second set of frescoes painted over the first. Though badly damaged, scenes of the life of St. Marina, a Maronite virgin born in Qalamūn, are still visible with painted Latin inscriptions in 13th-century crusader style superimposed on an earlier St. Demetrius. See Ch. L. Brossé, "Les Peintures de la Grotte de Marina près Tripoli [sic]," *Syria*, VII (1926), 30-45, and Tallon, "Peintures byzantines au Liban," *loc. cit.* [J. F.]

The study of fresco painting has been one of the most neglected areas in the spectrum of crusader art. Heretofore, the puzzling Byzantine style and iconography of most of these works, as well as their fragmentary condition, seemed to frustrate an understanding of their crusader characteristics. Now, however, with the researches of Hugo Buchthal and Kurt Weitzmann on crusader manuscript illumination and icons respectively, the way lies open for a fuller explanation of these monumental paintings, even as physically they grow dimmer on the walls. Indeed, other Byzantinizing frescoes can profitably be discussed in this context, such as the angel with the halo of Christ found in the excavations at Gethsemane, or Joachim with the angel in the monastery of Saints John and George at Choziba. The former, though originally published as 4th-century, has often been suggested to be a 12th-century crusader work; see G. Orfali, *Gethsemani* (Paris, 1924), p. 13 and pl. IX; Vincent and Abel, *Jérusalem*, II, 1007 and pl. LXXXVIII, 2; Enlart, *Monuments des croisés*, II, 468-469; and B. Bagatti, "Tempera dell' antica basilica di Getsemani," *Rivista di archeologia cristiana*, XV (1938), 153-159. For Choziba see A. M. Schneider, "Das Kloster der Theotokos zu Choziba im Wadi el Kelt," *Römische Quartalschrift*, XXXVIII (1931), 311-312 and pl. VI, fig. 3. [J. F.]

10. On questions of crusading illumination see H. Buchthal, *Miniature Painting in the Latin Kingdom of Jerusalem*, with liturgical and palaeographical chapters by F. Wormald (Oxford, 1957). I am most grateful to Dr. Buchthal for much advice and information that he kindly gave me before his book had actually appeared. All the manuscripts discussed here are treated there in detail, and the illuminations reproduced in full. There are also for each manuscript exhaustive bibliographies, which are not repeated here.

11. H. Buchthal and O. Kurz, *A Hand List of Illuminated Oriental Manuscripts* (Studies of the Warburg Institute, vol. XII; London, 1942); H. Buchthal, "The Painting of the Syrian Jacobites in its Relation to Byzantine and Islamic Art," *Syria*, XX (1939), 136-150, and

sketches.[12] To the south, Coptic manuscripts painted in Damietta about 1180 break away from the normal Coptic styles and show affinities with the Islamic group. The great Coptic Gospel Book in Oxford (Bodley MS. Hunt 17) painted in 1173 has a splendor and dignity of its own.

In this complex, the crusading states, or at least the scriptorium of the church of the Holy Sepulcher in Jerusalem, have their own particular place. A psalter in the British Library (MS. Egerton 1139) had long been recognised as coming from Jerusalem and had been given the name "Queen Melisend's Psalter." The fragment of a sacramentary in the Fitzwilliam Museum and a missal in the Bibliothèque nationale had been recognized as having crusading associations, but it was not till the researches of Dr. Hugo Buchthal, begun after 1945 and carried through with immense industry and detective skill to the publication in 1957 of his definitive work, *Miniature Painting in the Latin Kingdom of Jerusalem*, that the full extent and significance of the surviving material became apparent.

The Melisend Psalter was purchased by the British Library in 1845 from the collection of Dr. Comarmont of Lyons, who stated that he had obtained it from the Grande Chartreuse of Grenoble. The Carthusians had no close links with Palestine, and this provenance suggests nothing as to the manuscript's earlier migrations. The calendar, however, contains three entries which place it firmly in the crusading kingdom: the obits of Baldwin II, "rex Ierusalem," and of his wife Morfia, "Ierusalem regina," and the statement on July 15 "eodem die capta est Ierusalem." Baldwin II died in 1131; his Armenian wife Morfia predeceased him. There is no obit for Baldwin's son-in-law and successor, Fulk, who died in 1143, and it has therefore been argued that the book must be placed between these two dates. The Psalter is shown by some of the prayers to have been written for a woman, and Melisend's sister Yvette could be considered a possible alternative owner, but there is no mention in the calendar, prayers, or litany of Lazarus, to whom the abbey over which Yvette presided was dedicated. It is true that in the calendar the commemoration on July 15 is only that of the capture of the city, whereas after 1149 it was usual, as we shall see, to commemo-rate also the dedication of the church of the Holy Sepulcher, which

" 'Hellenistic Miniatures' in Early Islamic Manuscripts," *Ars Islamica,* VII (1940), 125-133.

12. There is a considerable literature on Armenian illumination. See, for a general summary, S. Der Nersessian, *Armenia and the Byzantine Empire: A Brief Study of Armenian Art and Civilization* (Cambridge, Mass., 1945), where a bibliography is given; A. Sakisian, "Thèmes et motifs d'enluminure et de décoration arméniennes et musulmanes," *Ars Islamica,* VI (1939), 66-87; L. A. Dournovo, *Armenian Miniatures,* with preface by S. Der Nersessian, tr. I. J. Underwood (London, 1961 [1962]); and L. Azarian, *Cilician Miniature Painting of the XIIth and XIIIth Centuries* [in Armenian] (Erevan, 1964).

took place on the fiftieth anniversary of the taking of Jerusalem. The probabilities therefore point to a date in the second quarter of the twelfth century.

The book begins with twenty-four full-page miniatures (pl. XXXIXa). The predominant colors are blue, vermilion, and magenta against a gold background. The figures are elongated, with long slender necks, the features strongly marked with a tendency to prolong the eyebrows into a continuous line. They are by a hand of considerable distinction and the placing of the scenes within the decorative borders of the frame shows a real sense of the space at the disposal of the artist. The final scene, Christ enthroned, is signed in Latin "Basilius me fecit," the same name as is found on the Bethlehem angel mosaics. Iconographically and stylistically these miniatures are in the Byzantine tradition. The Nativity approximates to the formula already noted in the mosaic of the crypt at Bethlehem; in the Presentation, where Simeon, not the Virgin, holds the Child, Anna carries a scroll inscribed in Greek; the Baptism has a small river god and Christ largely submerged in conventionally stylized water; the Temptation seems to suggest the Ḥaram with its edicules; the Crucifixion shows the Virgin and John on one side, Longinus and the sponge-bearer on the other; with the angel at the tomb (pl. XXXIXb) there are three women (reflecting western influence); the Incredulity of St. Thomas has a setting and grouping very similar to that of the Bethlehem mosaic, and there is the same correspondence between the Psalter scenes of the Transfiguration and Ascension and the mosaic fragments; in the Pentecost scene, below the apostles in the open doorway, Chosmos is depicted as a crowned and robed figure surrounded by five others more scantily clad, a variant of the formula for the peoples of the world to whom the gift of tongues will make the Gospel accessible.

The whole doctrinal significance of the series of scenes from the life of Christ is thus stated in the fully developed system worked out in earlier Byzantine books. Parallels are to be found in some Syrian manuscripts, where the "Melisend" scenes, or some of them, are very closely followed. [13] In a Syriac lectionary in the Bibliothèque

13. H. Omont, "Peintures d'un évangéliaire syriaque du XIIe au XIIIe siècle," *Fondation Eugène Piot, Monuments et mémoires,* XIX (1911), 201-210 (unfortunately the plates give little idea of the merits of the original); William H. Paine Hatch, *Greek and Syrian Miniatures in Jerusalem* (Mediaeval Academy of America, Publications, no. 6; Cambridge, Mass., 1931), pp. 122-129 and plates LXV-LXXI; J. Reil, "Der Bildschmuck des Evangeliars von 1221 im syrischen Kloster zu Jerusalem," *Zeitschrift des deutschen Palästina-Vereins,* XXXIV (1911), 138-146; J. Leroy, "Le Manuscrit syriaque 356 de la Bibliothèque

nationale (Syriac 355), in which only eight of the twenty-four narrative illustrations listed at the beginning survive, the Entry into Jerusalem, the Washing of the Feet, and the Ascension follow the Melisend type. The faces are strongly characterized, and the apostles in the Washing of the Feet have an individuality bordering on caricature. Much damaged, in places mutilated, these paintings remain evidence of a very individual artistic personality, known to us by name, as the manuscript is inscribed as painted by Joseph of Malatia (Melitene), and made under bishop Mar Joannes, who can be dated to 1193-1220. In another manuscript, Codex 28 of the Syrian convent of St. Mark in Jerusalem, dated 1222 and written by a scribe named Bacchus in the convent of the Mother of God at Edessa, there are parallelisms in the eight scenes represented (though there are two Marys, not three, at the empty tomb, and in the Pentecost the Chosmos group is replaced by a closed door) and the type of borders in which they are framed. It is to be noted that Morfia came from Melitene, as did Ignatius, the Jacobite patriarch in Jerusalem protected by Melisend, and that Baldwin II had been count of Edessa. These Syriac works are both later than the Jerusalem Psalter, but they show the close interconnection between the art of the western foundations and that of the local churches. After the fall of Edessa Melisend settled some of the Syrian Christian refugees in Jerusalem, continuing a policy begun by Baldwin I. The development of crusading ecclesiastical art must be seen against this background of the dominant Catholic church presiding over a community of Armenian and Syrian Christians, whose art was based on Byzantine models but who handled their examples with the freedom of their own ancient traditions.[14]

The full-page miniatures do not exhaust the interest of the Melisend Psalter. The eight initials of the Psalms (pl. XXXIXc) present some admirable examples of decorative work in an unusual technique of black on gold, a practice more common in Arab than in western art. Some of the designs however are curiously western, interlacing foliage among which centaurs hunt wild beasts, in the manner of the right-hand lintel of the Holy Sepulcher; others, such as one

nationale: Sa Date et son lieu de composition," *Syria*, XXIV (1944-1945), 194-205; and W. H. Paine Hatch, *An Album of Dated Syriac Manuscripts* (American Academy of Arts and Sciences, Monumenta palaeographica vetera, ser. 2; Boston, 1946), pp. 132-144.

14. For the population of Jerusalem see J. Prawer, "The Settlement of the Latins in Jerusalem," *Speculum*, XXVII (1952), 490-503. An account of the Edessa refugees is written as a colophon in a lectionary still in use in the Syrian convent of St. Mark in Jerusalem; a translation is published by P. Gabriel, "A Voice from Crusading Jerusalem," *Lines of Communication*, V, no. 1 (Jerusalem, 1929), 12-16.

where a winged griffon is set in interlocked squares, recall more eastern types, though the east in forms common to Romanesque art. The prayers for the various offices are accompanied by small half-page figures of saints, Byzantine in type, but with their names and scrolls inscribed in Latin (pl. XXXIXd). The green band along the foot of the paintings, which in the larger ones is used as standing ground, is here decorated with a formal pattern. The Psalter throughout is written in a very fine minuscule, which is certainly the product of a skilled western hand.

The most puzzling and curious feature of all is the calendar. Its very full list of saints, with no day left vacant, shows no particular emphasis on names associated with Jerusalem. Apart from the apostles and major feasts, St. Martin of Tours alone is given gold lettering. But the most marked characteristics are English, so marked that there must have been some English prototype for it or strong English influences on its compilation. Some explanation is needed for the inclusion of saints such as Eormenilda of Ely, Chad, Winwaloc, Cuthman, Erkenwald, Botolph, Augustine of Canterbury, Alphege, Alban, Etheldreda, Hedda, Cuthbert (with the translation on September 4 of St. Cuthbert and St. Birinus), Aidan, Willibrod, Wilfred, and the three martyr kings, Oswald, Edmund, and Edward. Strangest of all is the entry on July 18 of the translation of St. Edburga, a local Winchester feast. It is tempting to find the reason in the dominating position held at the court of Jerusalem by Ralph the Englishman, the chancellor and favorite of Melisend and Baldwin III, who later as bishop of Bethlehem employed a Basilius, the same name as is signed on a page of the Psalter, to design the mosaics in the church of the Nativity. The English names do not, however, reappear in the litany, which liturgically is quite unrelated to the calendar. Whatever the solution, the Psalter remains a great achievement, wonderfully preserved in its original carved ivory covers; its pages, which were perused by some great lady in Jerusalem at the height of its prosperity, are examples of the many-sided culture so rapidly evolved in the crusading states.

The "Melisend" calendar is all the more striking because the chief scriptorium of Jerusalem, probably that of the church of the Holy Sepulcher, used a special calendar, including the feasts of St. Augustine (appropriate to a community of Augustinian canons), a group of bishops of Jerusalem, and several local feasts such as that of St. Cleophas, disciple of the Lord; Abraham, Isaac, and Jacob, patriarchs; and St. Lazarus "whom the Lord raised." This calendar is known to us in several examples: a sacramentary, part of which is in the Biblioteca Angelica in Rome (D.7.3), part in the Fitzwilliam

Museum, Cambridge (McClean 49); a missal in the Bibliothèque nationale in Paris (MS. Lat. 12056); a psalter in Florence (Riccardiana 323); and a sacramentary in the British Library (Egerton 2902). Of these the first two on July 15 commemorate only the capture of the city, the second two add the dedication of the church of the Holy Sepulcher. All four use a minuscule script and small decorative initials which are related to the hand of the Melisend Psalter, though in the Egerton sacramentary the script is degenerating into a larger, looser form. The Angelica-Fitzwilliam sacramentary and the Paris missal have very similar illuminations, a fine half-page of Christ between angels, and an elaborate P with a winged angel and knots of interlaces (pl. XLa). The Paris missal also has some historiated initials (pl. XLb; see also pl. XLIc) and is the finer, more developed work. The interlocked squares found in the Melisend Psalter appear in one of the initials. In the Angelica calendar there is an obit, "Warmundus patriarcha"; this is Gormond, who died in 1128, and it is therefore natural to assume that the sacramentary was completed fairly soon after that date. The only other obit is that of "Azo" on February 19, possibly the canon of the Holy Sepulcher of that name who witnessed a charter of the Sepulcher in 1129.

The Riccardiana psalter is a more elaborate work. It contains a sequence of illustrations which, with some omissions, is similar to that of the Melisend Psalter but treated as small rectangular panels in the text, with the exception of the opening Beatus initial, which occupies a full page: David is transferred to the bar of the letter, and the two loops are filled with the Annunciation and the Nativity, the latter based on the normal Byzantine iconography. Above and below David in the bar stand Isaiah and Habakkuk, whose scrolls contain Latin texts, which are translated from the Septuagint, not taken from the Vulgate (pl. XLIa). Byzantine influences are therefore not lacking, but the treatment of the draperies and the rich coloring of dark blues, greens, and purples have a parallel in the splendid Virgin and Child in the missal from Messina now in the national library in Madrid (Cod. 52) and probably executed for archbishop Richard Palmer (1182-1195).[15] The psalter opens with a table of solar cycles

15. H. Buchthal, "A School of Miniature Painting in Norman Sicily," in *Late Classical and Mediaeval Studies in Honor of Albert Mathias Friend, Jr.*, ed. K. Weitzman, with S. Der Nersessian (Princeton, 1955), pp. 312-339; A. Daneu-Lattanzi, *Lineamenti di storia della miniatura in Sicilia* (Storia della miniatura: studi e documenti, 2; Florence, 1966). Dr. H. Bober, in an important review of Buchthal (*The Art Bulletin*, XLIII [1961], 65-68), suggests that the Riccardiana psalter may have been Sicilian in origin, copying a Palestinian calendar and litany, but it seems more likely that it was illustrated in Palestine by an artist familiar with Sicilian work. The Palestinian evidence is much stronger than the Sicilian stylistic affinities.

of twenty-eight years beginning in 1100 and ending in 1212; this suggests strongly that the book was written in the fifth cycle, that is between 1212 and 1240, a date borne out by a table for the computation of Easter which begins with 1230. This would place it in the period of Frederick II's reoccupation of Jerusalem, and Dr. Buchthal has suggested, on the grounds of various English associations in the calendar, that it was produced as a wedding gift in 1235 for Frederick's third wife, Isabel of England. The prayers seem designed for a Benedictine convent of nuns, with special devotion to St. Anne, which fits less well with Jerusalem, where the convent of St. Anne was at this time in Moslem hands, but which could be explained as copied from some earlier psalter. There is also a special prayer "pro comite," who could well be count John of Brienne, ex-king of Jerusalem, who died in 1237.

The British Library sacramentary (Egerton 2902) is a less ambitious book. Its one full-page scene, the Crucifixion, with the body of Christ curved outwards from the cross, is clearly in a later style than that of the Melisend Psalter and is somewhat flat in treatment. Its initials are debased versions of those of the earlier manuscripts. Its calendar, containing the ususal Jerusalem festivals, has also the feast of St. Thomas à Becket, so it is later than 1172. It can, however, be more precisely dated by comparison with another British Library manuscript, a pontifical written, as is established by a colophon, for a bishop of Valania after 1214.[16] Valania was by then combined with Apamea, which was in the hands of the

The field of Sicilian manuscript illumination in the period of the crusades, also pioneered by Hugo Buchthal and now furthered by Signora Lattanzi, is still controversial and needs more study. While many scholars now accept the Riccardiana psalter as crusader, the important bible in San Daniele del Friuli with its strongly Byzantine-influenced decoration is thought by Buchthal to be Sicilian, though others have attributed it to Jerusalem. See S. Bettini, "La Bibbia 'bizantina' della Guarneriana di San Daniele . . . ," in *La Miniatura in Friuli*, ed. and with catalogue entries by G. C. Menis and G. Bergamini (Udine, 1972), pp. 179-185 and entry no. 6, p. 60. [J. F.]

The lack of consensus in the study of 12th- and 13th-century manuscripts exhibiting a blend of western and Byzantine styles and iconography is not unique to the field of Sicilian miniature painting, although at the moment this certainly presents the most difficult problems. Venetian illumination in this period, also characterized by strong Byzantine influence, has led some to attribute crusader manuscripts there. In particular, the Perugia missal (capitular library MS. 6; see below) has lately been argued to be purely Venetian in style as opposed to Buchthal's characteristic crusader formal melange at Acre; see A. Caleca, *Miniatura in Umbria*; I. *La Biblioteca di Perugia* (Raccolta pisani di saggi e studi, 27; Florence, 1969), pp. 11, 79-82, 169-171, and 301-303. This attempt must however be rejected in favor of the crusader attribution. The Perugia missal remains one of the most important examples of the rich blending of French and Venetian traditions among extant Acre codices. [J. F.]

16. F. Wormald, "The Pontifical of Apamea," *Het Nederlands kunsthistorisch Jaarboek*,

"infidel," and there are several references to Apamea in the prayers. Script and initials connect this book closely with the Egerton sacramentary, and it is clearly under the influence of the earlier Jerusalem scriptorium. As the Egerton manuscript contains prayers for the defense, not the recapture, of Jerusalem it should probably be assigned to a date after 1229.

Such are the known illuminated manuscripts which can be associated by their calendars, prayers, or close approximation of style with the crusading scriptorium of Jerusalem. There is, however, a further problem in various manuscripts of Latin psalters or gospels, where the illustration, in contrast with the language, is definitely Byzantine in character. Several examples of this combination date from the twelfth and thirteenth centuries, and it seems reasonable to connect them with the Latin occupation of the Levant. An early example is a Gospel of St. John (Paris, B.N., Latin 9396) with a frontispiece of a seated evangelist, and one elaborate initial I which in its decorative detail recalls that of the earlier crusading work. The evangelist portrait, in a border similar to those found in the "Melisend" work, is a conventional Byzantine piece, but a tendency to circular treatment of the drapery suggests that it might be a copy by a western hand. The Latin Gospels (Paris, B.N., Latin 276) is a much finer work: its seated evangelists in horizontal half-page frames are Byzantine paintings of considerable quality. Among its decorated initials is one where a head is framed in a letter Q of which the tail is formed by a peacock; this frame also is found in one of the Jerusalem group (Paris, B.N., Latin 12056), and the treatment of the head suggests a relationship between the two works, though one found only in the single instance of this Q initial. The Byzantine work is close in style to that of a Latin Gospels in the Vatican (Lat. 5974) which must come from the same scriptorium.

With the fall of Jerusalem in 1187 and the recapture of Acre in 1191, the latter city became in the following century the hub of crusading activities and the main ecclesiastical center. A missal in the capitular library at Perugia (MS. 6; see pl. XLIb) has in its calendar on July 12 the entry "Dedicatio ecclesie Acconensis." It was on July 12, 1191, that the city surrendered to Richard Coeur-de-Lion and Philip Augustus, and the date therefore commemorates this event; the "ecclesia" must be the cathedral of Acre, Holy Cross, somewhat

V (1954), 271-275. By the close of the century the archbishopric of Apamea was in Moslem hands, and the Latin archbishop resided mainly at Latakia. See J. Richard, "Note sur l'archdiocèse d'Apamée et les conquêtes de Raymond de Saint-Gilles en Syrie du nord," *Syria*, XXV (1946-1948), 103-108.

ironically named as the True Cross had not been regained, owing to Richard's massacre of his prisoners. The one full-page illustration is a Crucifixion, Byzantine or Venetian-Byzantine in type but with some occidental features, in particular the use of three nails instead of four, a practice that is found in Germany, France, and England in the first quarter of the thirteenth century. On a half-page is a T (for *Te igitur*), which resembles those of the Paris missal and Fitzwilliam sacramentary, but in much more naturalistic terms, and by the same hand as the Crucifixion. The four historiated initials are less accomplished work, and could easily be by a western painter, but some of the details, in particular the treatment of the faces with heavily accentuated eyes, copy the mannerisms of the Crucifixion and *Te igitur* master.

With the Perugia missal we come to the end, with one exception, of documentary evidence in the form of calendars, prayers, or colophons. The remaining manuscripts to be considered have stylistic reasons only for assignment to the crusading kingdom. Dr. Buchthal's arguments are very persuasive, but it must be borne in mind that they are hypotheses, unsupported by any contemporary references. The Perugian rounded heads and facial types are found again in two manuscripts that have a similar conflation of Byzantine and western characteristics, a volume in the capitular library at Padua (MS. 12) containing the psalms, Daniel, the minor prophets, and the Maccabees, and the great manuscript of a selection of books from the Old Testament known as the Arsenal Bible (Bibliothèque de l'Arsenal, MS. 5211). The Paduan manuscript has a series of historiated initials, the work of a single master, and stylistically close to the Perugian missal. Iconographically it follows French examples and would be conveniently placed in the third quarter of the thirteenth century. Though French in inspiration, some of the initials show familiarity with Byzantine types and techniques. The round heads and prominent eyes of the Perugia missal are everywhere in evidence.

They recur as markedly in a far finer book, the Arsenal Bible (pl. XLII). The text is an abbreviated version in Old French of twenty books of the Old Testament made in the first half of the thirteenth century and soon abandoned in favor of the complete translation made for Louis IX. Each book has a frontispiece, generally full-page, and, with three exceptions, containing several scenes in ornamental settings, recalling the patterns found in the *Bible moralisée* and in some English psalters. The artist had, however, some close knowledge of the east. Balaam and Job's comforters wear correctly wound turbans, and Job's camels are realistically observed, not the strange monsters that often figure in western renderings. There are, too, heraldic

details of some significance. The Maccabees carry on their shields an eagle spread, a lion rampant, and three crescents; the lion and the crescents reappear in the arms of Joshua. Similar arms (lion and eagle) appear in an illustrated manuscript of Villehardouin's *La Conquête de Constantinople*, which is now in the Bodleian Library (MS. Laud Misc. 587). It seems clear that these emblems were associated with the thirteenth-century crusading movements. Heraldry was not as yet an exact science: the lion was used by Baldwin of Flanders and also by the Lusignans; the three crescents appear on the seal of Odo of Ham, another of the leaders of the Fourth Crusade. Three pages of the Arsenal Bible have, instead of several scenes, single illustrations, showing Solomon inspired by wisdom and dictating. These have various Byzantine prototypes, and here the derived image rivals its forerunners. The artist must have seen fine Byzantine works, and have been in touch with contemporary Byzantine artistic movements. The stylistic kinship with the Perugian and Paduan manuscripts makes Acre a likely place of origin, and its accomplishment suggests as a likely period the crusade of Louis IX.

The same stylistic features are found in three secular manuscripts, all of them containing the *Histoire universelle*, a medley of stories from the Old Testament and from Assyrian, Greek, and Roman legends and history, compiled in the first half of the thirteenth century. The earliest known manuscript is in Dijon (MS. 562), and has a set of small illustrations, of no great distinction, but of great interest as an early experiment in illustrating classical scenes. Though some French prototype may lie behind them, these scenes, particularly those from the Old Testament, are undoubtedly influenced by Byzantine examples. The Acre type of head is, perhaps, less strongly marked here, but it once more is very apparent in the second copy of the *Histoire* (Brussels, Bibliothèque royale, MS. 10175; see pl. XLIIIa), which follows the same cycle of illustration and must be based on the Dijon manuscript. Here, too, we once more have some documentary evidence. The Brussels manuscript has a signature, "cest livre escrist Bernart dacre" (Bernard of Acre wrote this book), and some entries showing that in the fifteenth century it belonged to the Lusignan family in Cyprus. It is thirteenth-century work, presumably written in Acre, and must at some time, before or at the loss of the city, have been brought with other rescued treasures to Cyprus.

The Brussels manuscript is artistically no great matter. Far otherwise is it with the splendid *Histoire* that is now in the British Library (MS. Add. 15268). It is a folio volume; the illustrations extend over half a page, and, while following the Dijon-Brussels

cycle, reinterpret the scenes with vigor, skill, and imagination. The full-page frontispiece, scenes of the Creation set in roundels (pl. XLIV; see also pl. XLIIIb), has on its borders hunting scenes and a group of Arab musicians playing their instruments that recall similar representations in some twelfth-century Arabic manuscripts of the Baghdad school, associated with Mosul under Badr-ad-Dīn Lu'lu', a period when figure representation was much used in metal work and other media.[17] Byzantine influences in drapery and mountain settings are also evident. As in the Arsenal Bible, the Acre type of head is markedly present. Certainly these two noble works have much in common, and each must have been made for some patron of high standing. In the *Histoire* prominence is given to the battles of the Amazons, and it is tempting to associate this book with the great festivities in Acre for the coronation of Henry II in 1286, when the knights dressed as women and reënacted the battle of "the Queen of Feminie" among other scenes from the tale of Troy.[18]

Equally vigorous handling of similar themes is found in a volume of the translation of William of Tyre (Paris, B.N., fr. 9084), where the first five illustrations seem to come from the Acre workshop. The battling knights in the capture of Antioch are well worthy of their distinguished predecessors. The manuscript was completed by western artists, and may have been taken to France on the fall of Acre. Two other manuscripts of the translation (Paris, B.N., fr. 2628 and Lyons MS. 828) suggest an Acre provenance by their similarities respectively with the Dijon and Brussels *Histoires*. They are undistinguished works, but of much historical interest. The kings of Jerusalem can be seen kneeling before the patriarch at their coronation, a ritual quite different from that of France; queen Melisend in a wide, shady hat rides side-saddle out hunting with king Fulk, while a black dog, the same as the one that accompanies the hunters in the Dijon scene of Oedipus, pursues the fatal hare that tripped up Fulk's horse; the nobles play at chess; mourning women tear their hair and beat their breasts at the death of kings; the Augustinian canons attend the ceremonies in long, wide-sleeved surplices. In the Paris manuscript, which breaks off in 1265, the script changes in the concluding passages, and the last initial,

17. D. S. Rice, "The Aghānī Miniatures and Religious Painting in Islam," *Burlington Magazine*, XCV (1953), 128-136; T. W. Arnold, in *The Legacy of Islam*, ed. T. W. Arnold and A. Guillaume (Oxford, 1931), p. 118. A splendid example of a Mosul engraved bowl in the Louvre has the traditional name of "Baptistère de Saint Louis"; see G. Migeon, *Les Arts musulmans* (Bibliothèque de l'histoire de l'art; Paris, 1926), pl. XLIX. For the Baghdad School see H. Buchthal, "Early Islamic Miniatures from Baghdad," *Journal of the Walters Art Gallery*, V (1942), 19 ff.

18. See G. F. Hill, *A History of Cyprus*, II (Cambridge, 1948), 181.

Louis IX attacking Damietta, is by a more advanced artist, a bridge with the contemporary western styles.

Another manuscript of William's history (Vatican MS. Pal. Lat. 1963), the only extant copy from the Levant of the French translation without any continuations, has a particular interest in that its illustrations show a special knowledge of events in Antioch. The painter, a western artist familiar with some eastern models, has less skill than the best practitioners of the Acre school, and there is a more provincial touch about his work, but all probably points to the volume being the product of some Antiochene scriptorium, and a rare instance of the arts in that city, whose famed splendor has left so little trace.[19]

In addition to wall paintings, mosaics, and illuminations, there were also paintings on panels. In 1958 and 1960 a joint expedition of the universities of Michigan, Princeton, and Alexandria photographed the vast collection of icons, more than two thousand, that has been preserved in the monastery of St. Catherine on Mount Sinai, a sacred spot protected by Arabs and Turks alike, and relatively inaccessible to the collecting activities of more recent times. The results are now being published, and Professor Weitzmann has described a group of icons which he claims convincingly as products of the crusading school (pls. XLV-XLVII).[20] The earliest of these panels shows a Christ enthroned, with the drapery forming large oval folds, with little relation to the limbs beneath, a typical Romanesque convention: the fingers of the right hand give the western blessing, with both the third and fourth fingers bent towards the thumb. The initials of Christ are given in Greek, but the open book bears no inscrip-

19. J. Folda, "A Crusader Manuscript from Antioch," *Rendiconti della Pontificia accademia romana di archeologia*, ser. 3, XLII (1969-1970), 283-298. Professor Folda's forthcoming book, *Crusader Manuscript Illumination at St. Jean d'Acre, 1275-1291*, which he has kindly allowed me to read in typescript, contains much additional information about the illustration of William of Tyre's history. [It was published at Princeton in 1976.]

20. K. Weitzmann, "Thirteenth Century Crusader Icons on Mount Sinai," *The Art Bulletin*, XLV (1963), 179-203, and "Icon Painting in the Crusader Kingdom," *Dumbarton Oaks Papers*, XX (1966), 49-83. On earlier contacts between Sinai and the west see E. A. Lowe, "An Unknown Latin Psalter on Mount Sinai," *Scriptorum*, IX (1955), 177-199, and "Two Other Unknown Latin Liturgical Fragments on Mount Sinai," *Scriptorum*, XIX (1965), 3-29. Additional studies on the Sinai icons include three more by Weitzmann, "An Encaustic Icon with the Prophet Elijah at Mount Sinai," *Mélanges offerts à Kazimierz Michałowski* (Warsaw, 1966), pp. 713-723, "Four Icons on Mount Sinai: New Aspects in Crusader Art," *Jahrbuch der österreichischen Byzantinistik*, XXI (1972), 279-293, and "Three Painted Crosses at Sinai," *Kunsthistorische Forschungen: Otto Pächt zu seinem 70. Geburtstag* (Salzburg, 1972), pp. 23-35. In contrast to the hundreds of crusader icons at St. Catherine's, there are only a few related miniatures; see Weitzmann, *Illustrated Manuscripts at St. Catherine's Monastery on Mount Sinai* (Collegeville, Minn., 1973), pp. 24-27. [J. F.]

tion, possibly, Weitzmann suggests, because the artist was unfamiliar with the Greek inscription of some Byzantine model. There is no close parallel to this work in other crusading products; the Bethlehem paintings are too damaged for any secure comparison, but it is not out of keeping with the figure sculpture on the lintel of the Holy Sepulcher. Another icon has a double row of standing saints, using the western blessing, and strongly reminiscent of the Bethlehem figures in the patterning of their garments. The central position in the top row is assigned to St. James the Greater, from whom the Jerusalem patriarchate claimed its succession, and among the others are two western saints, St. Martin of Tours, who figures prominently in the Melisend calendar, and St. Leonard, who is represented at Bethlehem. Other of the Bethlehem saints also occur in these crusader icons: St. Sabas, St. Humphrey, and St. Marina, who had a chapel in the church at Sinai.

Other icons are related to the Acre school. Here once more the Perugian missal is the key piece. In its full-page illumination of the Crucifixion, both Mary and John have curiously individual gestures, she pressing her thumb against her lip, he his little finger against the side of his nose. These gestures recur in a group of icons, in some of which the lettering is in Latin. Not all by the same hand, they all follow a close iconographical pattern. Stylistically they suggest an Italian origin, and while Byzantine elements are not lacking, the feet of Christ are fixed with one nail in the northern fashion. Even more striking are the facial resemblances in some of the icons. In the scene of Christ and the doctors, where the whole treatment in its feeling for family sentiment is entirely western, the face of Christ follows the same morphological pattern as that of the reading boy in the page from the Arsenal Bible of wisdom inspiring Solomon. In a painting where Venetian influence seems evident, the artist has shown two of the Magi as clearly marked racial types; one is undoubtedly a Mongol, the other, with a black pointed beard, seems to be a Frank. Weitzmann has intriguingly suggested that this work may date from the Christian hopes of Mongol assistance in the mid-thirteenth century.[21]

There are still many gaps in the argument. Sinai and in particular the saint, Catherine, whose relics were its greatest treasure, enjoyed much medieval repute. Early in the eleventh century the abbey of Holy Trinity at Rouen claimed to possess some fragments of the saint brought by a visiting monk. Some pilgrims penetrated to the monastery in the crusading period, and it was vaguely considered to

21. See volume III of this work, chapter XV.

be "in the land of the lord of Kerak."[22] But it was a perilous business. Thietmar, whose place of origin is uncertain, has left a vivid account of his journey in 1217 to the mountain, "desiring with the greatest desire to see the body of St. Catherine, sweating with sacred oil." "Many are the perils of these desert places, frequented by lions, of whom I saw many recent traces, and harmful reptiles and serpents. When it rains, the water collected on the mountains fills the desert with such a flood that none can avoid the danger of it. The heat, also, with its excess destroys the travelers, water is scarce, Arabs and beduins lay ambushes. In summer no one can cross this desert. There are few birds in it."[23] It is clear that the journey had indeed many dangers and was not often undertaken. It seems in fact to have been more often accomplished in the fourteenth and fifteenth centuries, after the final loss of the crusading states. How and when the crusading icons were brought there remains unknown.

Meanwhile in Cilician Armenia the art of illumination, with a long tradition behind it, still prospered. Byzantine influences were strongly felt, but in this highly eclectic art western motifs were also absorbed, and in the arts, as in their territorial position, the Armenian kingdom of Cilicia was a link between Constantinople and the crusading states. In few places were costly manuscripts more prized. The colophons, which are frequent, carry injunctions such as "In times of wars and invasions carry the books to the cities and bury them." Ṭoros Roslin, working at Hromgla under the patronage of the catholicus Constantine I (1221-?1288), was a man of great talent, whose figures have a genuine solidity of form and expressiveness of feature, while his decorative panels have to the full the Armenian brilliance of invention and subtlety of coloring.[24] In the colophon that he wrote to a fine Gospels dedicated to Heṭoum II, now in the library of St. James, Jerusalem, he states that it was completed in 1268, "at this time great Antioch was captured by the wicked king of Egypt, and many were killed and became his prisoners, and a cause of anguish to the holy and famous temples, houses of God, which are in it; the wonderful elegance of the beauty of those which were destroyed by fire is beyond the power of words."[25]

22. *Chronique d'Ernoul,* ed. L. de Mas Latrie (Société de l'histoire de France; Paris, 1871), p. 68.

23. J. C. M. Laurent, ed., *Mag. Thietmari peregrinatio* (Hamburg, 1857), pp. 20, 37-51.

24. Dournovo, *Armenian Miniatures,* pp. 112-138. See also *A Catalogue of the Armenian Manuscripts, A. Chester Beatty Library,* with an introduction by S. Der Nersessian (2 vols., Dublin, 1958), I, xxiv-xxix; S. Der Nersessian, *Manuscrits arméniens illustrés de la Bibliothèque des Pères Mekhitharistes de Venise* (Paris, 1936-1937), pp. 50-86.

25. *Catalogue of Twenty-Three Important Armenian Illuminated Manuscripts,* Sotheby & Co. (14 March 1967). The manuscripts were withdrawn before the sale.

The Moslem conquerors of 1187 were amazed at the splendor and luxury that they found in Jerusalem; "the infidel," wrote Ibn-Khallikān,[26] "had rebuilt it with columns and plaques of marble . . . with fair fountains where the water never ceased to flow—one saw dwellings as agreeable as gardens and brilliant with the whiteness of marble; the columns with their foliage seemed like trees." But what impressed him above all else was the iron work, which "took every form as though the rebel metal had become as malleable as gold." When the Moslems tore up the marble pavement with which the crusaders had faced the Rock, pulled down the golden cross from the pinnacle of the dome, and destroyed the figured mosaics and paintings, they left the great iron grille, made in eight parts, which stood in its original place until the restorations of the 1960's. It is one of the greatest surviving pieces of medieval metal work. Over a network of spirals linked by rings and forming varying patterns is a crown of fleurs-de-lys on the central spike of each of which candles could be fixed; when the whole screen was thus illuminated, with the light flickering on the mosaics of the dome and reflected from the marble floor, the scene must have been a very splendid one. In France, at Conques, St. Aventin (Haute Garonne), and Coustouges (Pyrénées Orientales) there are grilles, ending in candle points as in the Temple; the treasury of Henry III in Winchester cathedral has a fine piece of linked iron work, which must be of approximately the same date; but nowhere is the work more expert or better designed.[27] Little is certainly known of the glazing of windows in crusading churches; some fragments of glass have been found in the chapel of the castle of Montfort, and there is in the Rockefeller Museum in Jerusalem a window panel reconstructed from glass found at Château Pèlerin.

Of works in ivory, a medium in which Byzantine workers were so expert, only one survives whose crusading provenance is at all certain, the splendid book cover of the Melisend Psalter. On one side in six circles connected by interlaces is told the life of David: in the spaces between is a psychomachia, following a traditional western iconography; on the opposite side, carved by a somewhat heavier hand but similarly arranged, are the works of mercy, with fighting beasts and birds in between. At the top of the panel is a falcon, labeled Herodius, its common bestiary title. It has been argued that the bird (also known as fulica) is a rebus for Fulk, but while such a puzzle would have been in twelfth-century taste, this can only be

26. Ibn-Khallikān (quoting from Saladin's official account of the taking of Jerusalem) in *RHC, Or.*, III, 421. For the minor arts in general see Enlart, *Monuments*, I, 172-202.

27. For a fragment of crusader ironwork in the mausoleum of Kalavun at Cairo see K. A. C. Creswell, *The Muslim Architecture of Egypt*, II (Oxford, 1959), 191.

regarded as an ingenious hypothesis. The carving was certainly done under western influence and, particularly on the David plaque, is of high quality.[28]

An interesting group of objects was found in excavations at Bethlehem in 1869. They include some Limoges work, two silver candlesticks (pl. XLIX) and two brass bowls engraved with scenes from the life of St. Thomas.[29] All these are now preserved in the Franciscan museum of the Flagellation in Jerusalem. The two bowls, which can be closely paralleled by one in the Louvre and one in the British Museum dealing with the same subject, are twelfth-century work; the other pieces are thirteenth-century. They may very probably have been brought or sent to Bethlehem by Godfrey de' Prefetti, bishop from 1244 to 1253, who attempted to restore the equipment and amenities of the church after the disastrous rule of his predecessor, John Romano. Both candlesticks are inscribed "Maledicatur qui me aufert de loco Sce. Nativitatis Bethleem." A further find at Bethlehem in 1906 was of an even more curious nature: thirteen small bells arranged as a peal, and one larger bell with an elaborate dragon mount; the bells are probably thirteenth-century. With them were found some organ pipes, so they had all probably been buried when Mehmed II after 1452 enforced the prohibition against Christian use of bells.

The treasury of the Armenian church of St. James has the head of a pastoral staff in Limoges work; the treasury of the Greek patriarch, a crystal reliquary, possibly of local work, containing a relic of the English saint, Oswald.[30] There was a street of goldsmiths in Jerusalem, and Arab jewelers worked at their traditional craft for Christian overlords. The list of the treasure and vestments of the cathedral church of St. Peter at Antioch, drawn up in 1209, contained forty-six items.[31] The treasures with which the patriarch Heraclius escaped from Jerusalem must have been even costlier and more numerous.

28. Ch. Cahier and A. Martin, *Nouveaux mélanges d'archéologie, d'histoire et de littérature sur le moyen âge; I. Ivoires, miniatures, émaux* (Paris, 1874), pp. 1-14; O. M. Dalton, *Catalogue of the Ivory Carvings of the Christian Era in the British Museum* (London, 1909), pp. 22-26; A. Goldschmidt and K. Weitzmann, *Die byzantinischen Elfenbeinskulpturen des X.-XIII. Jahrhunderts*, II (Berlin, 1934), 79; and Fr. Steenbock, *Der kirchliche Prachteinband im frühen Mittelalter* (Berlin, 1966), no. 90.

29. O. M. Dalton, "On Two Medieval Bronze Bowls in the British Museum," *Archaeologia*, LXXII (1922), 133-160; Enlart, *Monuments des croisés*, I, 181-196; and S. de Sandoli, *Corpus inscriptionum*, pp. 227-232.

30. Vincent and Abel, *Jérusalem*, II, 667.

31. E. G. Rey, *Les Colonies franques de Syrie au XII*[me] *et XIII*[me] *siècles* (Paris and Geneva, 1883), pp. 228-234. For Syrian crusader glass see D. B. Harden, Hugh Tait, et al., *Masterpieces of Glass* (Trustees of the British Museum, London, 1968), no. 205, pp. 151-152 [J. F.].

IV

MILITARY ARCHITECTURE
IN THE CRUSADER STATES
IN PALESTINE AND SYRIA

In the extent of its remains and the scale of its building, crusader fortification is more immediately impressive than crusader church building. Guillaume Rey in 1871 published his *Étude sur les monuments de l'architecture militaire des croisés en Syrie et dans l'île de Chypre* with numerous plans and drawings. It was a revelation to western archaeologists. Sauvageot's drawing for it of a "vue restaurée" (something in the manner of Viollet-le-Duc) of Krak des Chevaliers kindled the imagination. With the development of photography and eventually the interest taken in them under the French mandate in Syria, the castles became well known. It was generally held that in these vast and massive buildings medieval military science of the west had found its greatest stimulus and fullest development.

In addition to E. G. Rey, *Étude sur les monuments de l'architecture militaire des croisés en Syrie et dans l'île de Chypre* (Collection de documents inédits sur l'histoire de France; Paris, 1871), and *Les Colonies franques de Syrie au XII*me *et XIII*me*siècles* (Paris and Geneva, 1883), both of which are still valuable, the main authority is P. Deschamps, *Les Châteaux des croisés en Terre Sainte; I. Le Crac des Chevaliers: Étude historique et archéologique, précédée d'une introduction générale sur la Syrie franque* (Haut Commissariat de la République française en Syrie et au Liban, Service des antiquités, Bibliothèque archéologique et historique, vol. XIX, 2 parts, text and album; Paris, 1934); II. *La Défense du royaume de Jérusalem: Étude historique, géographique et monumentale* (idem, Bibliothèque archéologique et historique, vol. XXXIV, 2 parts, text and album; Paris, 1939); III. *La Défense du Comté de Tripoli et de la Principauté d'Antioche* (idem, Bibliothèque archéologique et historique, vol. XC, 2 parts, text and album; Paris, in press) [J. F.] . See also the bibliographical note of chapter III for general works on Syrian archaeology. R. C. Smail, "Crusaders' Castles of the Twelfth Century," *Cambridge Historical Journal*, X (1951), 133-149, and *Crusading Warfare, 1097-1193* (Cambridge Studies in Medieval Life and Thought, n.s., vol. III; Cambridge, 1956) are important contributions to the subject, and R. Fedden and J. Thomson, *Crusader Castles* (London, 1957) is a sound and well-illustrated summary, particularly valuable for Armenian castles. T. E. Lawrence, *Crusader Castles* (2 vols., London, 1936) is a provocative study, which owes much of its interest to the personality of the author. See also W. Müller-Wiener, *Castles of the Crusaders,*

Camille Enlart did not live to write his account of crusader military architecture, which with his wide knowledge of western castles and his incredible memory for detail would certainly have added much to our knowledge of interrelationships between east and west. His work was carried on by Paul Deschamps, under whom Krak des Chevaliers was cleared of its villagers and excavated. The result was published in 1934 in an exhaustive work, the most important study any medieval castle has received. C. N. Johns meanwhile was carrying out a survey of Château Pèlerin ('Atlīt), and hoping there also to free the site of its encumbering inhabitants, a hope defeated by the unhappy history of Palestine; but much had been achieved before the end of the mandate brought an end also to this enterprise.

Certain questions have recurrently been raised. How far did the crusaders choose the site of their castles as a strategic and coherent scheme? What was their debt in building them to Byzantine and Moslem example? Did innovations in the east precede similar stages in the west? The answers are not easy, for the evidence is often insecure. The castles as a whole are little documented, and dating is often speculative. Many of them incorporated earlier works; most have undergone some form of rebuilding; only Krak, Château Pèlerin, Montfort, and Belvoir have had any serious excavation, and for some of them we are still dependent on Rey's hundred-year-old plans. But any account of crusading castles must attempt to deal with these central disputes.

The sites chosen for the castles vary widely: some, such as Krak des Chevaliers, Margat (al-Marqab), Subaibah, Belfort, Toron, and Belvoir, placed on isolated hilltops difficult of access, surveyed a

tr. J. M. Brownjohn (London, 1966) and T. S. R. Boase, *Castles and Churches of the Crusading Kingdom* (London, 1967). The articles of G. Beyer in *Zeitschrift des deutschen Palästina-Vereins*: "Das Gebiet der Kreuzfahrerherrschaft Caesarea in Palästina siedlungs- und territorialgeschichtlich untersucht," LIX (1936), 1-91; "Neapolis (*nāblus*) und sein Gebiet in der Kreuzfahrerzeit: Eine topographische und historisch-geographische Studie," LXIII (1940), 155-209; "Die Kreuzfahrergebiete von Jerusalem und S. Abraham (Hebron)," LXV (1942), 165-211; "Die Kreuzfahrergebiete Akko und Galilaea," LXVII (1944-1945), 183-260; and "Die Kreuzfahrergebiete Südwestpalästinas," *Beiträge zur biblischen Landes- und Altertumskunde*, LXVIII (1946-1948), 148-192, 249-281, and those of J. Prawer, "Colonization Activities in the Latin Kingdom of Jerusalem," *Revue belge de philologie et d'histoire*, XXIX (1951), 1063-1118; "The Settlement of the Latins in Jerusalem," *Speculum*, XXVII (1952), 490-503; "Étude de quelques problèmes agraires et sociaux d'une seigneurie croisée au XIII^e siècle," *Byzantion*, XXII (1952), 5-61, and XXIII (1953), 143-170; and *Israel Argosy*, ed. by I. Halevy-Levin (Jerusalem, 1956), pp. 178-191, are essential for the economic background of the settlement and its effect on the siting of castles. An article by R. B. C. Huygens, "Monuments de l'époque des croisades: Réflections à propos de quelques livres récentes," *Bibliotheca orientalis*, XXV (Leyden, 1968), 9-14, is valuable for information about the present state and nomenclature of the castles.

wide extent of territory; some, such as Tripoli, Tortosa, Jubail, Tyre, Beirut, Acre, and the citadel of Jerusalem, were part of a system of town defenses, either incorporated in them or, as in the case of Tripoli, controlling the approaches. This last, now mainly rebuilt, was originally established by Raymond of Toulouse to blockade the town, which then lay mainly around the port of al-Minā'. The new town grew around the castle, until Tripoli became the terminus of the pipeline from Iraq and developed into a large and flourishing modern town. Within the castle, the vaulted apse of the chapel survives among much rebuilding. Château Pèlerin has a unique position among the major castles, built as it is on a low, rocky peninsula jutting out into the sea; the sea castle at Sidon, an island fortress attached by a causeway, is too small to be compared with it. Saone (Ṣahyūn) is situated in a steep and narrow defile, as are some of the castles near Antioch, such as Gaston (Baghrās). A few smaller castles were built in the plain (or rather on small hillocks in comparatively flat country), such as Coliat (al-Qulai'ah), Chastel-Rouge, Ibelin, Blanche Garde, and Darum. Some were outposts perched on inaccessible crags. Belhacem (Qal'at abū-l-Ḥasan) crowns a mountain top in the valley of the al-Auwalī river, which forms a defile from the mountains to the coast above Sidon, and which in its upper reaches was guarded by a cave fortress, cut in the rock at Tyron (Shaqīf Tīrūn). Farther up the coast, beyond Botron (al-Batrūn), a similar valley has the small fortress of Msailha, built on a pinnacle of rock with a picturesqueness much admired by nineteenth-century travelers, who took this route to avoid the precipitous coastal paths.[1]

Viewed as a whole, the distribution of castles cannot be said to reflect any strategic scheme, nor is it probable that in any conscious sense it did so. The sites were largely determined by preëxisting remains: William of Tyre enunciates the principle that a castle destroyed is a castle half made. In his account of the castle building of Baldwin II and Fulk, he constantly refers to the previous buildings and the material they provided, the ruins of Beersheba for Beth Gibelin (Bait Jibrīn) and those of Gath for Ibelin (Yabnâ).[2] These same passages describe those castles as built rather as a base for attack against Ascalon than for defense, though the watch they kept

1. For Belhacem see Deschamps, *Défense du royaume*, pp. 222-224; for Msailha, J. Carne, *Syria, the Holy Land, Asia Minor, & c. Illustrated, in a Series of Views Drawn from Nature . . . with Descriptions of Plates*, I (London, Paris, and America, 1836), 45.

2. William of Tyre, *Historia rerum in partibus transmarinis gestarum*, XIV, 22, and XV, 24 (*RHC, Occ.*, I, 638-639, 696-698). For Beth Gibelin see C. R. Conder and H. H. Kitchener, *The Survey of Western Palestine*, III (London, 1883), 268.

on that town partook of both functions. Later, when Saladin was attacking from Egypt, they became defensive points, inasmuch as they were the nearest garrison posts. To the crusaders themselves the castles had an economic function, to protect the cultivation round them and to provide a shelter for livestock in times of raids. Such needs could run directly counter to strategic requirements, and economically the critical frontier positions were less desirable sites for exploitation. The Hospitallers in 1170 complained of their master, Gilbert of Assailly, that he prejudiced their finances by undertaking the charge of frontier posts.[3]

In estimating the development of crusading fortification and its debt to Byzantine and Arab models, much depends on accurate dating. Here, the loss of Jerusalem in 1187 forms a dividing line; in and after that year certain castles passed into Saladin's hands and were never recovered. The castles captured by the Moslems were often rebuilt by them, at least in part; those remaining in crusading hands throughout the thirteenth century were enlarged and remodeled; in neither case is the original twelfth-century work clearly apparent, nor is masonry a sure guide either to date or to builder. The crusaders dressed their stones with rusticated bosses, then with smooth, flat surfaces, then returned to bosses. Bosses were popular also with the Arabs and Armenians. Clermont-Ganneau took a particular form of stone tooling, made with a toothed hammer, as a test of crusader work, but the Arabs also used a toothed instrument, though generally one giving a narrower ridge.[4]

William of Tyre gives some indication of the types of building erected. Of the castles of the south of the kingdom, Ibelin, Blanche Garde built by Fulk, and Darum built by Amalric are all described as quadrilateral buildings with corner towers: at Darum, William tells us, one of the towers was larger and stronger than the others, and he refers to it as the arx or citadel in which the besieged took refuge when attacked by Saladin, holding out in its upper story even when the Saracens had broken in below. At Blanche Garde he specifically states that the towers were of equal size.[5] The meager vestiges of these castles are now insufficient to establish the ground plan,

3. *Regesta regni Hierosolymitani (MXCVII-MCCXCI)*, ed. R. Röhricht (Innsbruck, 1893), no. 480.

4. C. Clermont-Ganneau, *Archaeological Researches in Palestine . . .* , tr. A. Stewart and J. Macfarlane (2 vols., London, 1896-1899), I, 1-47; Deschamps, *Crac des Chevaliers*, pp. 229-233.

5. William of Tyre, XV, 24, 25, and XX, 19 (*RHC, Occ.*, I, 696 ff., 975), and note 3 above. For Blanche Garde see F. J. Bliss, *Excavations in Palestine during the Years 1898-1900* (London, 1902), pp. 36-38.

though in Rey's time two towers were still visible at Blanche Garde, and some signs of an interior keep. Farther north, however, castles of this type are still standing. Aryma (al-'Arīmah) is a rectangle with four corner towers and a larger tower in the west wall; Coliat has central towers, of slight projection, in the middle of each wall, as well as more developed angle towers; Belvoir (Kaukab), a castle on a larger scale (rectangular enclosure of 512 feet by 400), follows the same system. On the slopes of the Taurus, Marash, and in southern Cilicia, Corycus, have similar plans but are basically Byzantine constructions. This is in fact the normal type of small advanced Byzantine fortress; earlier it was a common form of Roman fortification, familiar as such to western feudalism.

Much play has been made with the similarity between crusading plans and those of Byzantine castles in North Africa, largely because these latter have been described and planned in some detail,[6] but there is no need thus to elaborate the thesis: rectangular fortifications with corner towers are an obvious and convenient form of protection, known from Roman examples in the west, and much used in Byzantium. The crusaders doubtless saw many such castles and in some cases actually occupied Byzantine buildings or rebuilt on their sites, and even without such stimulus could have arrived at this solution of the problem. Their early elaboration of the type was to strengthen it with a central keep, though here too, as at Saone, there were possible Byzantine models.

Jubail, taken by Raymond of St. Gilles in 1104, has a castle which from its plan and its type of archère (square-headed, with broad recesses with segmental vaults) must belong to an early, though not the earliest, stage of the settlement. Its first form appears to have been a rough quadrilateral with corner towers, one, the northwest, being larger than the others; the original scheme possibly included a central tower on the north wall. At some later date, probably not much later for it still has a simple though distinct type of archère, a central keep was built, 58 feet by 72 (pl. La). Some old masonry was employed—the site was that of Phoenician Byblos—and some large blocks, one measuring 16 feet 9 inches by 4 feet; so strong was it that when Saladin ordered its destruction, his workmen had to abandon the attempt.[7] Though retaken by the Franks in 1197 and in their hands till 1291, no new defensive scheme seems to have been

6. Ch. Diehl, *L'Afrique byzantine: Histoire de la domination byzantine en Afrique, 533-709* (Paris, 1896).

7. Wilbrand of Oldenburg in J. C. M. Laurent, ed., *Peregrinatores medii aevi quatuor* (Leipzig, 1864), p. 167.

constructed. The keep has none of the flat buttresses which would be found in contemporary France or England; its masonry, in this country of fine building stone and native stone workers, was sufficient guarantee of stability. But it is notwithstanding characteristically western in plan, and its central position and massive strength have no exact parallel in eastern forms.

The small Byzantine fortress of Chastel-Rouge (Qal'at Yahmur) near Ṣāfīthā, a small quadrilateral with two diagonally opposed corner towers, includes a keep of superior masonry, almost completely filling the enclosed space and almost certainly a crusading addition. Chastel-Blanc (Burj Ṣāfīthā) is another great tower, surrounded by a ring wall and built on a small eminence, protecting the village on the lower slopes. Its ground story forms a great vaulted hall, a noble room that the Templars used as a chapel; above it is another spacious and vaulted room supported on pillars (pl. Lb). Similar vaulted rooms are found in a far greater building, the keep of Saone.

Saone is a castle whose history during the crusading period is a blank until in July 1188 it fell to Saladin.[8] An ancient site, possibly the Phoenician Sigon, Ṣahyūn, the crusading Saone, was occupied by John Tsimisces in 975, and it is presumably from then that its Byzantine fortifications date. It was by its position linked with Bourzey (Qal'at Barzah) overlooking the Orontes valley and with Balāṭunus (Qal'at al-Mahalbah) to the south on the track to Jubail. In its deep, precipitous valley, Saone commands no wide sweep of country, and in crusading times as now the main and easier route from Latakia to the bridge at Jisr ash-Shughūr passed farther north. It must always have been a site of great natural strength, rather than of strategic importance, and Saladin's determined siege of it was pressed largely because he had had to leave Krak and Margat untaken. Joscelin II of Edessa married the widow of a William of Saone in 1131; the family therefore was of some standing; but there is no record of the building of this vast fortress, the largest in extent of all the known castles.

8. The fullest account is that of P. Deschamps, "Au Temps des croisades: Le Château de Saone dans la principauté d'Antioche," *Gazette des beaux-arts,* ser. 6, IV (1930), 329-364; see also Smail, *Crusading Warfare,* pp. 236-243; C. Cahen, "Note sur les seigneurs de Saone et de Zerdana," *Syria,* XII (1931), 154-159; and P. Deschamps, "Le Château de Saone et ses premiers seigneurs," *Syria,* XVI (1935), 73-88. I have made much use of an unpublished account by D. J. C. King, and also of an unpublished thesis (University of Oxford, 1937) by J. W. Hackett, "Saladin's Campaign of 1188 in Northern Syria, with Particular Reference to the Northern Defenses of the Principality of Antioch."

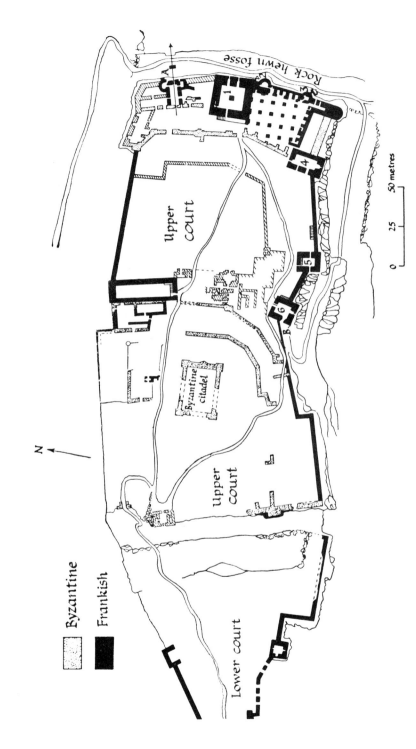

Rock hewn fosse

Upper court

Byzantine citadel

Upper court

N

Byzantine

Frankish

Lower court

0 25 50 metres

6. Plan of Saone. After F. Anus

Approaching from the north, from Latakia, one comes to a deep gully with a stream flowing through it; the southern face of the gully is formed by a long spur of land, rising in sheer cliffs; on the east where it joins the main hillside, this spur has been cut by a ditch 450 feet long and 64 feet wide; rising in the ditch at the north end is a great needle, 90 feet high, capped with a small masonry tower; along the whole crest of the western side of the ditch are massive fortifications, with a postern protected by two round towers facing the needle, in the center a huge keep 80 feet square (no. 1 on plan, fig. 6) and three more round towers, whose bases fit buttresses left in the cutting of the rock (pl. LI). The masonry, mainly in large bossed stones, is, as later discussion will show, certainly crusading; the ditch with its needle and buttresses is a vast artificial creation, but who its makers were is less certain. The main entrance is in the third of the three rectangular towers which defend the south front; here too the rock has been cut away leaving an artificial escarpment. The gate was reached by a path running across the slope of the hill and therefore fully exposed to defenders on the wall, and was set in the angle between the tower and the wall, at right angles to the line of approach. It was defended by a machicolation formed by an arch, slightly advanced from the main wall. As one passes through it another right-angle turn leads by a second gateway into the interior; immediately in front are Arab buildings, a square minaret and the remains of a hall, which appear to be thirteenth-century work. But Saone has been little rebuilt; there was a village in the lower court, besieged and evicted by Ibrahim Pasha in the mid-nineteenth century; the castle proper seems to have been held by the Arabs until the Ottoman conquest; it then disappears from history and the inner buildings have slowly been overgrown or have crumbled away. The original village, east of the castle on the plateau beyond the ditch, has left only a few vague remains.

Much of the building has defied time. From the entrance, beyond the minaret, rise the massive towers and the great keep of the ditch face; westward on the highest point of the ground stand the remains of the original Byzantine citadel, a quadrilateral with square angle towers and a polygonal tower on the eastern face. Round it was an elaborate system of defenses, of which there are still remains: first two parallel walls at a short distance from the Byzantine keep; then shortly behind the crusading front on the ditch another wall, defended by rectangular salients and small polygonal towers; all these are constructed in masonry of small stones embedded in thick mortar. Was this the outer Byzantine wall, leaving a space between

the curtain and the ditch, or did the crusaders rebuild their line on Byzantine foundations? The needle tower is in Byzantine masonry, which suggests strongly that the ditch existed in Byzantine times; underneath the curtain by the two gate towers opposite the pinnacle, at the base of the most easterly of the rectangular towers on the south front, and in the south curtain there are traces of this earlier masonry. It seems tolerably certain that the Byzantine scheme came right up to the ditch and that the latter is mainly their work. The crusading addition was the great keep with its massive stone work and the eight towers, five round and three rectangular; they may have quarried the stone from the ditch, deepening and widening it, and at the same time carving out the rock buttresses on which some of their towers stand.

Such were the eastward defenses; westward from the Byzantine fortress the ground fell to another ditch cut across the spit of land from north to south. The sides have fallen away, but it can never have rivaled the other, though it included a similar type of pillar supporting a bridge between the two courts. The upper bank of the ditch was fortified by a wall with rectangular towers, and a similar wall surrounded the whole of the irregular tongue of land which formed the lower court. Some of this is crusader work of bossed masonry.

Two points of detail are worth noting. The archères in the crusading work at Saone are straight slits formed by leaving an aperture between the blocks equal in height to two or three courses of masonry. A similar method is used at Kerak. The normal method as employed in most crusader castles and in the west was to cut the archères in the masonry, with an arched head. In this respect the archères of the keep at Saone are more primitive than those at Jubail; they are also of a form used in some Byzantine buildings. The doorway to one of the towers of the base court is formed by a straight stone lintel with a relieving arch of seven voussoirs or splayed stones set vertically to the arch. This type is also used in the southeast rectangular tower, where it seems to be part of the original Byzantine work. It is found again in the keep at Jubail. This is a common Byzantine feature, and one rarely used in the west.

Here then we have a thoroughly composite work: an important Byzantine site taken over by a Frankish noble, who added to it a western keep built by Syrian masons. Inside both the ground and upper floors of the keep are groined vaults resting on a central pillar. A curious feature is the use of round towers on the ditch front, one (no. 2 on plan, fig. 6) being in close proximity to the keep, as though

to supplement its field of fire; it has in fact seven archères opening from its ground chamber. Its lower masonry is in smooth ashlar, the upper in bossed, as in the other towers, and two stages of work are probably represented. Similar smooth ashlar is used in the building of a vaulted hall which abuts on the wall south of the citadel and which is usually explained as a stable.

Two other castles must serve as examples of those built before 1187: Kerak, whose role in the struggle against Saladin was so disastrous and significant, and Subaibah, the vast ruin above Banyas. The "Terre oultre le Jourdain" was controlled by three castles: Krak de Montréal (ash-Shaubak) built by Baldwin I in 1115, about eighteen miles from Petra, notable for its internal staircase of three hundred and sixty-five steps down to a spring in the rocks; the castle of "Li Vaux Moysi" (al-Wu'airah); and to the east of the Dead Sea Kerak, founded in 1142 by Pagan le Bouteiller and enlarged by his immediate successors.[9] Under Reginald of Châtillon the castle endured two sieges by Saladin, October to December 1183 and July to August 1184; even after Hattin it withstood a seven months' siege in 1188 before it finally passed into Moslem hands. Al-'Ādil ordered its refortification in 1192, and the great semi-octagonal tower, which protects the most accessible approach and is built in fine rusticated masonry, may date from his reign, though it could also be the work of Baybars (pl. LIIb). The crusading ground plan has, however, been maintained, and some of the walls are crusading work. In this outpost the Frankish masonry is poor, a hard lava stone roughly shaped. The castle lies along a narrow spur cut at each end by an artificial ditch, with the main tower, as at Saone, fronting the junction with the hillside. Down below, as at Krak des Chevaliers, a great water tank had been formed, though here it was outside the main defenses, not within the walls. The east side originally had a single wall from which the apse of the small chapel projected slightly, but the crusaders at some stage strengthened it with a second wall. On the west a lower bailey ran all the length of the castle. The towers everywhere are square or rectangular, with no great projection or skillful placing. The Frankish castle cannot have been a very

9. Deschamps, *Défense du royaume,* pp. 39-98; Smail, *Crusading Warfare,* pp. 218-221. For Krak de Montréal see Deschamps, *op. cit.,* pl. I; a note by R. Savignac in *Revue biblique,* XLI (1932), 597; and J. J. Langendorf and G. Zimmermann, "Trois monuments inconnus des croisés; I. La Chapelle du château de Montréal (Jordanie)," *Genava,* XII (1964), 125-143. For Li Vaux Moysi see R. Savignac, "Ou'aïrah," *Revue biblique,* XII (1903), 114-120.

distinguished work. But its natural position was strong, and its wall, if coarsely built, stood solidly. In the end it was only starvation that reduced it.

The history of Kerak can be followed in the narratives of the chroniclers, but that of Subaibah, the L'Assebebe of the Franks, is much less easily traced.[10] Built on a hilltop above Banyas, its considerable ruins present no very clear picture, and here too thirteenth-century Mamluk rebuilding is more conspicuous than the crusading work. The former includes rounded towers with well-made circular talus which suggest the work of Baybars; the crusading design consisted in rectangular towers of low projection. At the highest point of the ridge, as usual facing the junction with the main hillside, was a rectangular keep with square corner towers. The masonry is largely undressed stone. The castle seems to have been built between 1129 and 1132 and was finally lost in 1164. It represents therefore an early, undeveloped stage of crusading work. Compared with the masonry of Kerak and Subaibah, that of Saone and Jubail and many of the churches stands out as a superior achievement.

Arab workmanship and its fine quality have figured in the account of these two castles. It was work with a long tradition behind it. The twentieth century has seen the rediscovery of a great art period, that of the Umaiyads. The excavation of Khirbat al-Mafjar, near Jericho, has completed the picture of an advanced architectural achievement, in which figure sculpture, stucco ornament, and mosaic played a large decorative part, but which was also capable of castles with some claim to planned fortification. 'Abbāsid building, of which the round city of Baghdad was the great example, is less fully known, but the walls of Cairo, erected under the Fāṭimid caliph al-Mustanṣir (1036-1094) by his vizir Badr al-Jamālī (1074-1094) and planned by engineers from Edessa, remain with their great gateways as an example of magnificence in fortification, an example which crusading embassies, such as that sent to Cairo in 1097, cannot have been slow to notice.

In Syria eleventh-century work is less clearly dated, and was certainly less ambitious in its scale. Nūr-ad-Dīn enlarged the citadel at Aleppo, but it has been much altered, and the magnificent gateway was built by Saladin's son aẓ-Ẓāhir, who also faced the tell with the

10. Deschamps, *Défense du royaume*, pp. 144-175; *Survey of Western Palestine*, I (London, 1881), 125-128. See also A. Grabois, "La Cité de Baniyas et le château de Subeibeh pendant les croisades," *Cahiers de civilisation médiévale*, XIII (1970), 43-62 [J. F.].

marble slabs that still largely remain. Saladin's own most famous work was the citadel at Cairo,[11] but later his brother and successor al-'Ādil much enlarged the defensive works, encasing Saladin's round towers with ones of much greater size, and breaking the pattern of circular towers with some of rectangular shape such as he had used at Damascus, where the citadel, covering an area of 500 feet from north to south and 750 feet from east to west, was on flat low-lying ground and, apart from some water defenses, depended on the massive strength of its fortifications.[12] Al-'Ādil's large rusticated blocks can be found in Moslem work at Baalbek, on Mount Tabor, and at Bosra. He was a great builder, and his followers worked on similar lines, as can be seen, for instance, in the castle of 'Ajlūn overlooking the Jordan valley.[13]

The Franks, however, during the period of al-'Ādil's undertakings, had not been idle. The turn of the century saw some of their most striking and accomplished building enterprises. In particular the two military orders of the Hospital and the Temple now emerged as the vigorous leaders in the reorganization of defense and in plans for reconquest. More and more the strongholds of the kingdom passed into their keeping.

In 1186 the castle of Margat near Latakia was ceded by Bertrand Mazoir to the Hospitallers; two years later Saladin on his northern campaign did not dare to attack it, though his troops defiled past it on the coastal road. The castle then was already a position of some strength, though any fortification on that steep mountain spur would present problems to a besieger. Only an exhaustive analysis accompanied by excavation could establish its history.[14] Today it

11. K. A. C. Creswell, *Early Muslim Architecture: Umayyads, Early 'Abbāsids and Ṭūlūnids* (2 vols., Oxford, 1932-1940); "Fortification in Islam before A.D. 1250," *Proceedings of the British Academy* (1952), pp. 89-125; "Archaeological Researches at the Citadel of Cairo," *Bulletin de l'Institut français d'archéologie orientale*, XXIII (1924), 89-167; and *The Muslim Architecture of Egypt*, I (Oxford, 1952), 161-219; J. Sauvaget, *Alep: Essai sur le développement d'une grande ville syrienne, des origines au milieu du XIX^e siècle* (Haut Commissariat de l'État français en Syrie et au Liban, Service des antiquités, Bibliothèque archéologique et historique, vol. XXXVI, 2 parts, text and album; Paris, 1941); J. Barthoux, "Description d'une forteresse de Saladin découverte au Sinaï," *Syria,* III (1922), 44-57.

12. D. J. C. King, "The Defences of the Citadel of Damascus: A Great Mohammedan Fortress of the Time of the Crusades," *Archaeologia*, XCIV (1951), 57-96. See also J. Sauvaget, "La Citadelle de Damas," *Syria,* XI (1930), 59-90, 216-241.

13. C. N. Johns, "Mediaeval 'Ajlūn," *Quarterly of the Department of Antiquities in Palestine,* I (1931), 21-33; A. Abel, "La Citadelle Eyyubite de Bosra Ecki Cham," *Annales archéologiques de Syrie,* VI (1956), 95-138.

14. M. van Berchem and E. Fatio, *Voyage en Syrie* (Mémoires publiés par les membres de l'Institut français d'archéologie orientale du Caire, vols. XXXVII-XXXVIII; 2 vols., Cairo, 1913-1915), I, 292-320; Chandon de Briailles, "Lignages d'Outre-Mer: Les Seigneurs de

exists as a great triangle, the southern angle of which is cut off by a wall, separating the castle from the base court; the latter had a double line of fortifications, with either a rock face or a natural precipice beyond. The inner enceinte is almost entirely destroyed, the outer much ruined and its battlements fallen. The Hospitallers built here with comparatively small stones, and the villagers have steadily pulled down the walls, but the great circular tower, which controlled the southern point, still looms up over the ruins (pl. LIIa). Beside it are the remains of the hall and the chapel, whose foliage capitals recall the earlier work at Tortosa. Wilbrand of Oldenburg in 1211 writes of the greatness and splendor of Margat, whose towers "seem to support the heavens, rather than exist for defense,"[15] and it is reasonable to think that by that date the main building campaign had been carried out. The castle, however, must have been well maintained. It was the last of the great northern castles to fall, as Kalavun did not undermine its walls until 1285, fourteen years after the surrender of Krak des Chevaliers.

Among crusading castles, among castles of any place or period, Krak des Chevaliers has a proud preëminence.[16] Known to the Arabs as Ḥiṣn al-Akrād, the castle of the Kurds, it was called by the Franks "Le Crat," and then by a confusion with *karak* (fortress), "Le Crac." Its present, slightly romanticized, title of Krak des Chevaliers is a later embellishment. Nowhere can the development of crusading schemes of fortification be so clearly followed, and nowhere is the general effect of the building more completely preserved. Alone of crusading castles it has been systematically excavated and restored. The castle from its hilltop looks down over fertile country. Burchard of Mount Sion, writing about 1280, after Krak had been lost, describes the plain stretching from Krak· to Tortosa as containing "many villages, and fair groves of olive-trees, fig trees and other trees of diverse sorts, and much timber. Moreover, it has plentiful streams and pasture; wherefore the Turcomans, and Midianites, and Bedouins dwell there in tents with their wives and children, their flocks and their camels. I have seen there a very great herd of camels, and I believe that there were several thousands of camels there."[17]

Margat," *Syria,* XXV (1948), 231-258; and R. Breton, "Monographie du château de Markab, en Syrie," *Mélanges de l'Université Saint-Joseph,* XLVII (1972), 251-274.

15. Laurent, *Peregrinatores,* p. 170.

16. Deschamps, *Crac des Chevaliers*; D. J. C. King, "The Taking of Le Krak des Chevaliers in 1271," *Antiquity,* XXIII (1949), 83-92.

17. "Burchard of Mt. Sion A.D. 1280," tr. A. Stewart (*PPTS,* vol. XII; London, 1896), p. 18; Laurent, *Peregrinatores,* p. 29.

The importance of the castle was partially economic. The fortified village on the northeast slope was a protected dwelling place for the cultivators of this profitable land, and as the Moslem danger grew stronger the actual castle walls were enlarged so that men and beasts could take refuge there. Defensively it was well placed, though strategically it did not, as is sometimes claimed, control the gap of Homs, for the easiest route between Homs and Tripoli passes some eleven miles south of the castle, though at various points it can be seen from it. It was a base from which inroads could be made on enemy territory. "What think you," wrote Ibn-Jubair about Homs, "of a town that is only a few miles from Ḥiṣn al-Akrād, the stronghold of the enemy where you can see their fires whose sparks burn you when they fly, and whence each day, should they wish, the enemy may raid you on horseback?"[18] And when in their turns the Moslem raiders came, Krak was the refuge and the rallying point for counterattack.

In 1110 a crusading force occupied an Arab castle on the site, and for some thirty years it was held from the county of Tripoli; its last baronial occupier was William of Le Crat, who is mentioned in a document by which Raymond II of Tripoli ceded the castle to the Hospitallers in 1142. The two military orders were rapidly becoming the only reliable source for manpower and building finance. How far the Arab castle had already been rebuilt is not clear, but the central block as it stands today was probably built by the Hospitallers shortly after they occupied the castle (fig. 7). It is an irregular polygon, following the lie of the ground, rounded on the north side, but at an obtuse angle on the south enclosing an inner courtyard from which opened a chapel and a hall. The chapel, a nave of three barrel-vaulted bays ending in an apse, has blind pointed arches with double voussoirs on the side walls, a system found in many Provençal churches. In restoration work on the porch in 1965 a fresco of the Presentation in the Temple was uncovered and is now in the museum at Tortosa. It seems to be twelfth-century work, showing both Byzantine and western influences.[19] Between the courtyard and the

18. *The Travels of Ibn Jubayr*, tr. R. J. C. Broadhurst (London, 1952), p. 268.

19. A. Rihaoui ('Abd-al-Qādir ar-Rīḥāwī), *The Krak of the Knights* (2nd ed., Damascus, 1966), p. 33. The Presentation fresco was not the only painting found at Krak des Chevaliers. Paul Deschamps reports (*Terre Sainte romane* [1964], p. 137): "En 1935 on découvrit les restes d'une chapelle située hors du Crac à 40 mètres de l'entrée principale. ... Cette chapelle était entièrement couverte de peintures à personnages où se combinent l'art français et l'art syrien. Une partie était en bon état; on déposa ce fragment et on le reporta sur une toile. Une inscription latine a révélé qu'une des figures représentait saint Pantaléon, médecin martyrisé à Nicomédie en 303." Deschamps says this fresco was taken to Tortosa with the Presentation, but it is not there, and so far all attempts to locate it have failed. [J. F.]

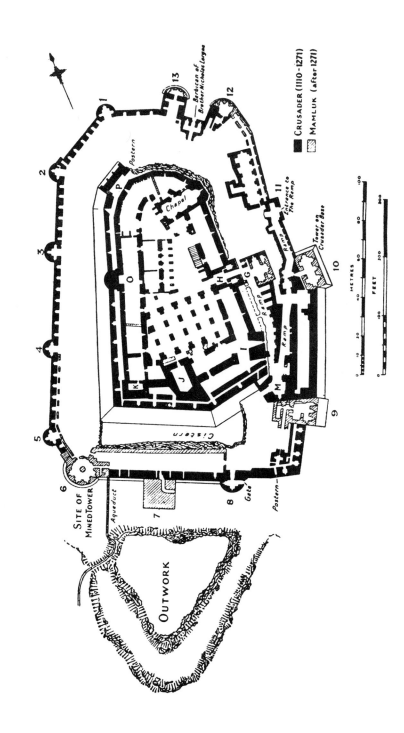

7. Plan of Krak des Chevaliers. After F. Anus

wall are vaulted chambers providing kitchen and other accommodation. The projecting towers of the outer wall were rectangular, and there were two entrances, one on the east face (H) between two towers and leading directly into the court, the other a right-angled entry in a tower (P) on the northwest face. On the outer face of the tower the wall is slightly advanced from the main curtain and provided with three large arches, which could be used from the top platform as machicolations, through which missiles could be thrown. It was a primitive form, which can be found also at Niort and elsewhere in France, and it seems soon to have been abandoned at Krak, for the wall was reinforced, the arches closed, and more conventional brattices placed on it.

The second half of the century was a period of considerable seismic disturbance, and much earthquake damage was done in 1170 and again in 1202.[20] Between these years, in 1188, Saladin had left Krak unassailed, and its strength must already have been impressive. Then at some time around the turn of the century a new enlargement was undertaken. A second outer enceinte was built, at a distance varying from 52 to 75 feet from the original outer wall. This new enceinte was provided with semicircular towers, with stirrup-shaped loopholes allowing of direct downward shooting at the base of the walls. Towers and walls were crowned with merlons, and the chemin-de-ronde was supported on a vaulted passage from which opened loopholes and brattices. Once this new outer defense was completed it was possible to undertake considerable rebuilding of the inner enceinte. The central tower (O) of the west face was enclosed in a round tower, and a talus was built all along the west and south faces, forming a vaulted passage with, on the west face, the old wall, and on the south a new building, as the defenses here were advanced considerably beyond the earlier line. From this southern talus rise three towers, rounded on the exterior side and joined to the slope of the talus by most carefully worked masonry (pl. LIIIb). These towers were the living quarters of the knights, the western being designed for the commandant and containing a fine vaulted chamber with decorative carving on the windows and capitals. On the interior side the towers were separated from the main court, at this point covered over so as to form a raised esplanade, and were connected to it only by a stepped bridge. The knights were always a minority in a garrison of mixed races, and such means of isolation were probably a safeguard against interior mutinies, rather than to establish a final

20. *RHC, Or.,* IV, 154. On the question of earthquakes see D. H. K. Amiran, "A Revised Earthquake-Catalogue of Palestine," *Israel Exploration Journal,* II (1952), 48. On the earthquake of 1202 see H. E. Mayer, "Two Unpublished Letters on the Syrian Earthquake of 1202," *Medieval and Middle Eastern Studies in Honor of Aziz Suryal Atiya,* ed. S. A.

strong point. Wilbrand of Oldenburg in 1212 estimated the garrison of Krak at 2,000 combatants. These would be largely native Maronites or Syrian mercenaries, and the proportion of knights and lay-brothers of the Hospital must always have been a small one. Fifty or sixty knights was a normal complement.

Below the inner south face was a great water tank, providing a moat and a bathing and watering place. On the east face, the most important feature of the thirteenth-century work was the long ramp leading, with a series of sharp turns, to the original gateway, and protected by a rectangular tower (M), and by an elaborate but much rebuilt gateway. Last of the defense works, not including hasty repair work of which there are several indications, is the barbican protecting a postern on the north face, which is dated by an inscription to the command of Nicholas Lorgne (most probably 1254-1259).

Much of this outer enceinte has been rebuilt by its Moslem conquerors. The continuous machicolations which are now such a conspicuous feature of the south and east walls suggest their handiwork, and the great rectangular tower of the south front carries an inscription in honor of Kalavun dating it to 1285. Much of this was repair work after the siege, when in 1271 Baybars forced his way into the outer court but, confronted by the great south work, resorted to the ruse of a forged letter to induce surrender.

Krak's immense impressiveness depends on its mass, its masonry, and the great skill with which it fits its hilltop site (volume I, frontispiece; pl. LIIIa). In defensive science it is a more completely concentric castle than any other in the crusading kingdom. The inner walls overlook the outer, and at no point is the space between too broad for support to be given. But on one building, the loggia to their hall, the knights indulged themselves in ornament, and the naturalistic leaves of the capitals and the traceries of the openings are elegant Gothic of the mid-thirteenth century, rare survivors of that period of new hope when Louis IX came to the Holy Land. On a pillar in the gallery is carved a Latin couplet warning that pride can destroy all virtues, perhaps a useful admonition in this mighty fortress.

The other military order had meanwhile been extending its territories and building new fortresses. It has been argued[21] that each

Hanna (Leyden, 1972), pp. 295-310.

21. Lawrence, *Crusader Castles,* I, 42; J. S. C. Riley-Smith, "The Templars and the Castle of Tortosa in Syria: An Unknown Document concerning the Acquisition of the Fortress," *English Historical Review,* LXXXIV (1969), 278-288.

order had its own distinctive type of building and that while the Hospitallers evolved the complex interrelated defenses of Krak, the Templars remained constant to simpler Byzantine patterns. This view, however, can hardly be substantiated. It is true that the two Templar castles whose layout can still be traced, Tortosa and Château Pèlerin, are both built on the seashore and therefore entirely different in scheme from the hill castles of Margat or Krak; but the defenses of Château Pèlerin are as carefully devised in their system of support as anything worked out by the Hospitallers. Of the Templars' hill castle at Safad there are insufficient remains for any accurate assessment of its plan.

The Templars in their keep at Tortosa had held out successfully against Saladin. It seems that from the early thirteenth century they made it their main center and the treasury of the order. Wilbrand of Oldenburg tells us of its "pulchra fortitudo," and its great tower built by a king of France (presumably, that is, financed by a royal grant).[22] This tower must have been the keep on the center of the sea front, cut off by ditches from the enceinte. From the sea landward two concentric and roughly semicircular curtains defended the castle, while the town walls provided yet a further line. Now only one wall of the Templars' great hall and the talus of a corner tower on the sea front remain. Here and there fragments of old masonry appear amongst the thickly packed houses of Tartus.

Next to Tortosa in importance for the order was their Palestinian castle Château Pèlerin, on the rocky promontory at 'Atlīt south of Mount Carmel.[23] In the twelfth century the order had held a small outpost east of here at Le Destroit or Pierre Encise, a narrow defile close to the coast. In 1217 they began work on the promontory with its small harbor, aided by the Teutonic Knights (who did not complete their own castle of Montfort till 1229) and partially financed by a Fleming, Walter of Avesnes, while a short way south on the coast the Hospitallers busied themselves with the refortification of Caesarea.

The castle of Château Pèlerin is one of the most splendid and significant undertakings of the crusading revival (fig. 8). Surrounded on three sides by the sea, all its defensive strength was concentrated on the east front where it joined the mainland. Here there was a triple line of defense: a ditch with a low fortification on its eastern side, an outer wall with three rectangular gate towers, in which there

22. Laurent, *Peregrinatores*, p. 169.
23. C. N. Johns, *A Guide to 'Atlit* (Jerusalem, 1947). See also his articles in the *Quarterly of the Department of Antiquities in Palestine*, I-VI (1932-1938).

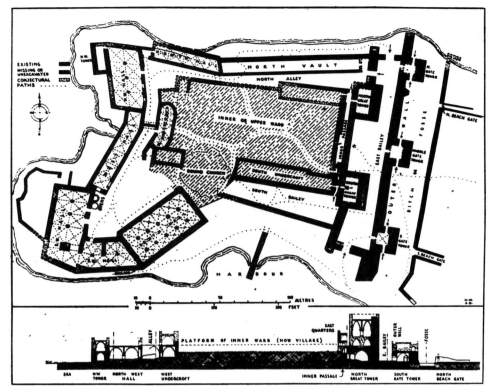

8. Plan of Château Pèlerin

were right-angle entrances and which rose to a height of some fifty-eight feet. Wall and towers were supplied with double rows of loop-holes, which in the case of the wall were manned from an inner gallery and from an open parapet. Beyond lay the east bailey with towering above it the two great towers, 110 feet high, linked by a wall of massive masonry, possibly coming from the ancient ruins which the scholasticus Oliver tells us were found, along with a hoard of gold, when the foundations were dug.[24] Excavations have shown that this was the site of a Phoenician settlement, and these great blocks, larger than any the crusaders used elsewhere (a single one, Oliver says, could hardly be pulled by two oxen) may have come from their walls. This triple line of defense was arranged concentrically, that is, the inner wall commanded the outer and the two great towers were placed opposite the spaces between the three towers of

24. Oliver Scholasticus, *Historia Damiatina* (ed. H. Hoogeweg as *Die Schriften des kölner Domscholasters, späteren Bischofs von Paderborn und Kardinal-Bischofs von S. Sabina, Oliverus*; Bibliothek des litterarischen Vereins in Stuttgart, CCII; Tübingen, 1894), 169-172.

the outer wall. Lesser walls followed the irregular sea front of the little peninsula and on its farthest point, at sea level, were grouped some vaulted halls, with ribbed vaulting supported on pillars and tracery windows, very pleasant places in the summer heat. The chapel, of which only a few courses of the wall remain, was a twelve-sided building with a pentagonal apse and two radiating chapels; its ribbed vaults were supported on a central pillar. Pococke in 1745 described it as "built in a light Gothic taste."[25] Two English naval officers in 1817-1818 speak of a cornice "in alto-relievo," with heads of different animals and a double row of arch arcades on the outside.[26] It must have been a building of some distinction, and is the one known example in Palestine of a type which was to become familiar in Europe as a Templar church. The hall of the north great tower, one wall of which is standing, shows masonry of the same type, ribbed vaults and corbels with human heads (pl. XXIV). Hall and chapel probably date from some last stage of building, for the hall is a third story and the original towers are described by Oliver as composed of two. Here, more than anywhere else, fragmentary as it is, some idea can be obtained of the Gothic splendor of the mid-thirteenth century in Acre and its surrounding strong points.

Château Pèlerin was never taken; it was evacuated, the fortifications were dismantled, but the castle, never occupied as a Moslem fortress at least before the eighteenth century, remained little changed. Badly shaken by the earthquake of 1837, its destruction was completed by Ibrahim Pasha, who carried off its stone for the refortification of Acre.

The castle of Safad had originally been one of the many sites fortified by Fulk of Anjou. Taken by Saladin, it had been dismantled and the route from Damascus and Galilee left unprotected, along with the rich lands lying around the north of Lake Tiberias (the Sea of Galilee). Ceded to the Franks by aṣ-Ṣāliḥ Ismā'īl at the time of the crusade of Theobald of Champagne (1239-1240), its rebuilding was due to the enthusiasm of a pilgrim, Benedict of Alignan, bishop of Marseilles. His preaching roused the people of Acre, and his appeal to the master of the Temple, Armand of Perigord, persuaded the order to undertake the work.[27] In 1240 building was begun: knights and

25. R. Pococke, *A Description of the East and Some Other Countries,* I (London, 1743), 57.

26. Ch. L. Irby and J. Mangles, *Travels in Egypt and Nubia, Syria and Asia Minor, during the Years 1817 and 1818* (London, 1823), p. 191.

27. R. B. C. Huygens, "Un Nouveau texte du traité 'De constructione castri Saphet'," *Studi medievali,* ser. 3, VI-1 (1965), 355-387.

citizens gave their labor and many prisoners of war were employed. Twenty years later, when the bishop revisited Palestine, he found a magnificent castle on the site where he had laid the first foundation stone. For all its ditches and seven great towers, it was not to remain in Christian hands. In 1266 Safad fell. Today, among its vague ruins, the ground plan and scheme of defenses cannot be clearly traced.

The last work undertaken by the Templars was at the castle of Belfort (Qal'at ash-Shaqīf).[28] This too was one of Fulk's buildings, originally a rectangular keep of two stories overlooking a rock-cut ditch, the central point of an irregular circuit of walls surrounding the plateau above the river Litani. The type of masonry and scheme of the building suggest a date contemporary with the crusading works at Saone and the first buildings at Krak. Belfort then belonged to the lords of Sidon, and its siege by Saladin, when Reginald of Sidon's negotiations and eventually his fortitude under torture gained time for the crusading concentration on Acre, was a critical episode of the campaign. Belfort fell, however, and from 1190 to 1240 was in Moslem hands. The two round towers with their skillfully rounded glacis, the finest work of the building, may date from the time of al-'Ādil, though they have closer points of resemblance with Baybars's work at Krak. In 1240 it was restored by treaty, and in 1260 Julian of Sidon, after his irresponsible raids had roused the Mongols to the plunder of his city, sold it to the Templars. The fine hall, built in smooth-faced masonry, with ribbed vaults, much decayed since Rey drew it in 1859, must be their work. In 1268 the castle finally fell: a carved lion, the emblem of its conqueror, Baybars, has been found among the ruins.

The castles as such by no means represent the whole of the crusaders' activity in fortification. Much of their work consisted of town walls, and some of their most celebrated strong points are elements in schemes of city defense. The strength of the city of Tyre was such that, Ibn-Jubair says, "it was spoken of proverbially."[29] Across the narrow isthmus which joined it to the mainland there were three walls with twelve towers: "I have never seen better ones," wrote Burchard, "in any part of the world."[30] Along the coast the story of the town walls is one of constant rebuilding. Acre, Jaffa, Ascalon were erected only to be overthrown. Acre in the thirteenth

28. Deschamps, *Défense du royaume,* pp. 176-209.
29. *RHC, Or.,* III, 451-455; *The Travels of Ibn Jubayr,* tr. Broadhurst, p. 319.
30. Laurent, *Peregrinatores,* p. 25.

century had as fine walls as any, extended to include the outer suburbs at the time of Louis IX's visit. Caesarea, Jaffa, fortified by Frederick II but again ruined, and Sidon were all repaired by the pious king Louis, who worked with his own hands at the task of building. In 1227 some crusaders, waiting for the dilatory Hohenstaufen emperor, had occupied themselves in building the small sea castle on an isolated rock in the port of Sidon; now on the land side Louis built a citadel in the winter of 1253-1254, the foundations of which, in the old Phoenician acropolis, can still partially be traced under later Turkish rebuilding. Tiberias still had in 1837 a complete circuit of walls with round projecting towers, which may well have included crusading work, but in the great earthquake of that year they were completely destroyed.[31] At Beirut under John I of Ibelin the walls and castle were splendidly maintained. Wilbrand of Oldenburg (1211) gives us a rare glimpse of the interior of a seigneurial establishment. The great hall opened on the sea; its mosaic pavement simulated waves; the vaulted ceiling was painted with the signs of the zodiac; a fountain in the middle, figured with dragons and other beasts, cast a jet of water upwards, whose sound "soothed to sleep those who came to repose themselves."[32]

Most notable of all were the walls and citadel of Jerusalem. To the Franks the Herodian tower of Phasael with its great courses of masonry was the Tower of David, and here the kings eventually fixed their palace, building an irregular courtyard defended by rectangular towers. The Tower of Phasael itself, so familiar a landmark on medieval maps of Jerusalem and on the seals and coins of the Latin kings, was dismantled by an-Nāṣir Dā'ūd of Kerak in 1239. "The stones were so large that all wondered at them."[33]

With the exception of Saone and Margat nothing has been said as yet of the fortresses of the principality of Antioch.[34] The city itself

31. A. and L. de Laborde, *Voyage de la Syrie* (Paris, 1837), pls. LXI, LXII.

32. Laurent, *Peregrinatores,* pp. 166-167. See also, for Beirut, Du Mesnil du Buisson, "Les Anciennes défenses de Beyrouth," *Syria,* II (1921), 235-257, 317-327, and lithographs in de Laborde, *op. cit.,* pls. XXVII, XXVIII.

33. Continuation of William of Tyre, *RHC, Occ.,* II, 529. See C. N. Johns, "Excavations at the Citadel, Jerusalem: Interim Report, 1935," *Quarterly of the Department of Antiquities in Palestine,* V (1935), 127-131; "The Citadel, Jerusalem: A Summary of Work since 1934," *ibid.,* XIV (1950), 121-190; and *Guide to the Citadel of Jerusalem* (Jerusalem, 1944).

34. For the Antiochene castles see C. Cahen, *La Syrie du nord à l'époque des croisades et la principauté franque d'Antioche* (Institut français de Damas, Bibliothèque orientale, vol. I; Paris, 1940), pp. 109-176. See also Deschamps, *La Défense du Comté de Tripoli et de la Principauté d'Antioche* (in press) [J. F.].

had its great circuit of Byzantine walls stretching up the slopes of Mount Silpius to the citadel that crowned the summit. Today mostly mere foundations (vol. I, 1958 ed., fig. 2A), they still cause wonder at the scale and problems of their construction. History has given to the Antiochene castles a character of their own. Small Byzantine strongholds were numerous on the defiles of the Amanus mountains and in the plain stretching towards Aleppo; these were occupied by the crusaders and in many cases little altered. The principality in its early days threatened Aleppo, and the Franks fortified Sarmadā and al-Athārib as advanced posts against it, but their hold was brief and uncertain and Moslem reconquest swept them back to a confined area around Antioch itself, destroying or rebuilding their castles in the plain. Ḥārim, where on a large tell the Franks enlarged a Byzantine strong point, was completely rebuilt by aẓ-Ẓāhir at the beginning of the thirteenth century and the slopes faced with stone as in the great citadel at Aleppo. To the southeast, controlling the Orontes valley, were a group of fortresses, many of them known only as names of uncertain identification. To the northwest of the bridge at Jisr ash-Shughūr was the double castle of Shughr Bakās. It is built on a narrow spur separated from the hillside by an artificially cut ditch, similar to that at Saone but much less deep. The peculiarity of the setting is a depression in the middle of the spur, which has been emphasized by ditches cut at either end of it and which separates the castle into two independent units. Taken by Saladin in 1188, it was not recaptured, and the present somewhat scanty ruins seem mainly Moslem rebuilding of the thirteenth century.

To the south of the river crossing, high in the hills overlooking the path through to Latakia, the castle of Bourzey, possibly the Rochefort of some crusading documents, still has a tower of roughly bossed masonry which may be Frank, but which is poor and hurried building. It depended on its natural strength rather than its walls. Hidden in the hills in the bend made by the Orontes, off the main tracks, the "little castle" (al-Quṣair), the Cursat of the crusades (Qal'at az-Zau), is somewhat better preserved.[35] The property of the Latin patriarch of Antioch, frequently his retreat in times of dispute, its repair was financed by the papacy in 1256, and the two rounded towers still standing are owed to this assistance. They are built in bossed stone, the bosses being chiseled smooth, and are indeed of a "pulchra fortitudo" worthy of the special interest of Rome in their

35. Van Berchem and Fatio, *Voyage*, I, 241-251.

erection (pl. LIVa). But with them the rebuilding ceased and the remaining defense works are undistinguished.

From Antioch the Syrian Gates led through the Amanus range to the coastal plain, the main route to Cilicia. On one of the approaches to the pass the castle of Baghrās, the Gaston of the crusaders, was held in turn by the Templars, the Armenians, and the Moslems, and each occupation has left its mark. Farther north a group of castles controlled the fertile eastern Cilician plain, the center of the kingdom of Little Armenia.[36] These castles are generally placed on rocky hills, and their walls follow the line of the natural escarpment. Rounded towers, in small, bossed masonry, project from the walls; and the bent entrance is generally employed, sometimes with a complicated ramp. Byzantine and crusading methods mingle with local practice. At the castle of Seleucia above the Calycadnus, the Hospitallers, after receiving it from Leon II in 1210, used fine ashlar masonry and vaulting, which are worthy of the standards of their contemporary building at Krak (pl. LIVb). At the opposite eastern end of the kingdom, another Hospitaller holding at Tall Ḥamdūn (Toprakkale) has horseshoe towers rising as at Krak from a talus faced with masonry.

The Armenian castles have not yet been fully studied. Some of them, such as Ilan-kale, the castle of the serpents, have no documented history, though Ilan-kale with its great flanking towers is still a most impressive ruin. At Sis, the fortress protecting the Armenian capital sprawls unevenly along a narrow ridge, and at places the natural rock provides the defense works, or only a thin breastwork gives some additional cover. At Anazarba the castle stands on a precipitous limestone crag rising from the plain. It includes stretches of Byzantine wall, some Arab rebuilding after its

36. V. Langlois, *Voyage dans la Cilicie et dans les montagnes du Taurus, exécuté pendant les années 1852-1853 . . .* (Paris, 1861); L. M. Alishan, *Sissouan, ou l'Arméno-Cilicie: Description géographique et historique avec carte et illustrations* (Venice, 1899); Fedden and Thomson, *Crusader Castles* (1957); J. Gottwald, articles in *Byzantinische Zeitschrift:* "Die Kirche und das Schloss Paperon in Kilikisch-Armenien," XXXVI (1936), 86-100; "Die Burg Til im südöstlichen Kilikien," XL (1940), 89-104; and "Burgen und Kirchen im mittleren Kilikien," XLI (1941), 82-103; P. Deschamps, "Le Château de Servantikar en Cilicie: Le Défilé de Marris et la frontière du comté d'Edesse," *Syria,* XVIII (1937), 379-388; E. H. King, "A Journey through Armenian Cilicia," *Journal of the Royal Central Asian Society,* XXIV (1937), 234-246; M. Gough, "Anazarbus," *Anatolian Studies,* II (1952), 119-125; J. G. Dunbar and W. W. M. Boal, "The Castle of Vagha," *Anatolian Studies,* XIV (1964), 175-184; E. Herzfeld and S. Guyer, *Monumenta Asiae Minoris antiqua;* vol. II, *Meriamlik und Korykos: Zwei christliche Ruinenstätten des rauhen Kilikiens* (Manchester, 1930); and G. R. Youngs, "Three Cilician Castles," *Anatolian Studies,* XV (1965), 113-134.

capture by Hārūn ar-Rashīd in 796, and some characteristic Armenian rounded towers; a narrow col joins the two enceintes and on it stands a rectangular tower, dated by an inscription to 1188. At Sarvantikar, which was in Antiochene hands from 1185 to 1194, the keep may be Frankish work. Lampron, north of Tarsus, was the center of a powerful fief and many of its living rooms are still standing, inside two rounded towers above the rock moat. Vahka, on an outcrop of rock, has round towers of comparatively slight projection, machicolations, and a right-angled entrance: the main building stage can probably be assigned to the prosperous reign of Leon II (1187-1219). At Corycus (Le Courc, Goṛigos) there is an island fortress, partially built, according to an inscription, by Heṭoum I in 1251, joined at one time by an aqueduct to a land citadel that incorporates a Roman gateway and a tower with a classical doorway.

Farther west, in the sweep of the bay of Pamphylia, three fortified sites, still strikingly preserved, Adalia (Antalya), 'Alaya (Alanya), and Anamur, still have much thirteenth-century work, but Selchükid, not Armenian. 'Alaya, or more correctly 'Alā'iyah, takes its name from the Selchükid sultan 'Alā'-ad-Dīn Kai-Kobād I (1220-1237), a great builder, whose octagonal tower, walls, and citadel still stand in remarkable completeness. Anamur still awaits exhaustive study, and certainly its excellent repair is partially due to later rebuilding (vol. II, 1962 ed., pl. 1b), but its main plan and much of the work date from this impressive if brief period of Selchükid building initiative.[37]

No short summary can do justice to the tangled problem of crusading castles. Making the fullest allowance for previous work and native skill, the crusaders showed a resourcefulness and determination in building which must always be a considerable factor in any assessment of their achievement. The narrow stretch of country from the Taurus mountains to the gulf of Aqaba contains some of the most impressive of surviving medieval fortifications. That the crusaders were innovators in methods of defense remains unproven. They borrowed eclectically from the west and the east, from the present and the past, and they learned from a prolonged and rarely broken experience. They accomplished such achievements as Krak des Chevaliers, and, whatever the origin of its details, they were by then master builders.

37. Seton Lloyd and D. Storm Rice, *Alanya ('Alā'iyya)* (British Institute of Archaeology at Ankara, Occasional Publications, 4; London, 1958).

V

THE ARTS IN CYPRUS

A. Ecclesiastical Art

As with Syria, so with Cyprus the basis for the history of its arts in the period of Frankish domination is the work of Camille Enlart. His *L'Art gothique et la Renaissance en Chypre* was published in 1899, some twenty-five years before his account of the Latin kingdom in Syria, but the exhaustive care and the informed insight with which he studied the monuments have left little need for revision.

Syria enjoyed the first convinced enthusiasm of the crusades, and its twelfth-century pilgrimages included able masons in their ranks. The thirteenth century saw the seacoast towns on the defensive, still hectically prosperous, extravagant in festivity, occasionally prodigal in church building of resources that necessity more usually diverted to military defense work, while the west became more critical and less generous. The Latin empire of Constantinople was a fleeting episode which left little trace on the monuments of the capital city. In Greece, a penurious baronage found no continuing tradition of building among its scattered subject population, while the trading ports were from the first in Venetian hands. Rhodes remained Greek until after 1300. It is in Cyprus alone that the art history of the crusades works itself out over some three centuries. Concentrated within the protection of its island boundaries; well supplied with good building stone and local laborers who, though unskilled, proved apt pupils; rich, at least for a time, through the diversion of Levantine trade to its harbors, Cyprus under Lusignan rule, however turbulent in its brawls, experienced a rounded period of artistic opportunity.

The foundations for the study of Cypriote medieval archaeology were laid by L. de Mas Latrie in his *Histoire de l'île de Chypre sous le règne des princes de la maison de Lusignan* (3 vols., Paris, 1852-1861) and *L'Île de Chypre, sa situation présente et ses souvenirs du*

165

The actual conquest by Richard Coeur-de-Lion and the brief occupation under the Templars have left little mark, though there is enough to show that even then building was begun. The main undertaking of the early thirteenth century, under Hugh I and his bountiful queen, Alice of Champagne, was the cathedral of Nicosia, the greatest example of the new Gothic style to be erected in the Near East. The struggle between John of Ibelin and the bailies of Frederick II interrupted such activities, but the coming of Louis IX in 1248 brought a new impetus. With the fall of Acre, Famagusta became the chief emporium of the Christian Levant, and in its brief spell of opulence, ended by the Genoese seizure of the town in 1373, it became a city of churches, whose ruins are still today bewildering in their number. In Nicosia, meanwhile, the archbishop, John del Conte (1312-1332), was introducing a more Italianate style of Gothic, and the typical Cypriote decoration of somewhat heavy, clumsy foliage was being evolved. The splendid reign of Peter I (1359-1369) saw the island at the height of its magnificence.

The Genoese invasion and the disastrous Mamluk raid of 1426 destroyed much that the thirteenth and fourteenth centuries had created; decline set in. With weakening Frankish hold, a provincial Byzantine art reasserted itself and, furthered by the marriage of John II to Helena Palaeologina, Cypriote culture was permeated with

moyen-âge (Paris, 1879). Some important plans and drawings were published by E. l'Anson and S. Vacher in "Mediaeval and Other Buildings in the Island of Cyprus," *Transactions of the Royal Institute of British Architects, Session 1882-1883*, pp. 13-22, pls. I-XX. The definitive work is C. Enlart, *L'Art gothique et la Renaissance en Chypre* (2 vols., Paris, 1899). This is corrected in certain details by George E. Jeffery, *A Description of the Historic Monuments of Cyprus: Studies in the Archaeology and Architecture of the Island* (Nicosia, 1918), though Jeffery's conclusions are not always reliable. See also on points of detail the *Reports of the Department of Antiquities, Cyprus,* Jeffery's series of monographs *Historical and Architectural Buildings* [*Cyprus Monuments,* n.s., nos. 3-7], and R. Gunnis, *Historic Cyprus* (London, 1936). There is a short but valuable chapter in G. F. Hill, *A History of Cyprus,* III (Cambridge, 1948), 1105-1142, and W. Müller-Wiener, *Castles of the Crusaders,* tr. J. M. Brownjohn (London, 1966), pp. 85-91.

Mention of buildings is frequent in the Cypriote chroniclers and travelers; the most important are Estienne de Lusignan ("Steffano di Lusignano"), *Chorograffia et breve historia universale dell' isola de Cipro principiando al tempo di Noè per in sino al 1572* (Bologna, 1573) and *Description de toute l'isle de Cypre et des roys, princes, et seigneurs, tant payens que chrestiens, qui ont commandé en icelle* (Paris, 1580); *Chroniques* [*de Chypre*] *d'Amadi et de Strambaldi,* ed. R. de Mas Latrie (Collection de documents inédits sur l'histoire de France; 2 pts., Paris, 1891-1893); and Giovanni Mariti, *Viaggi per l'isola di Cipro e per la Soría e Palestina fatti . . . dall' anno MDCCLX al MDCCLXVIII,* I (Lucca, 1769). Many of the relevant extracts are collected and translated in C. D. Cobham, *Excerpta Cypria, with an Appendix on the Bibliography of Cyprus* (Cambridge, 1908), and T. A. H. Mogabgab, *Supplementary Excerpts on Cyprus, or Further Materials for a History of Cyprus,* parts I-III (Nicosia, 1941-1944).

Hellenism. The Venetian rule of the sixteenth century left as its memorial the walls of Famagusta; it brought no general stimulus to the arts. The façade of the Palazzo del Provveditore in Famagusta, built between 1552 and 1554, is one of the few pieces of genuinely Renaissance decorative architecture in the island. It was before its triple-arched portico some twenty years later that Bragadin was to suffer his awful martyrdom, the final heroic scene of the Venetian rule.

Of the island's churches pride of place goes to the cathedral, Hagia Sophia, of Nicosia. Its design and carvings reflect much of the history of the times. Through the survival of its cartulary, we are unusually well informed as to the doings of the cathedral chapter,[1] but even with this guide, and with that of chroniclers such as Amadi and Estienne de Lusignan, there are uncertainties as to the various stages of the building. The main construction certainly dates from the archbishopric of Eustorgue of Montaigu (1217-1250), but Amadi dates the commencement of the building in 1209, and Lusignan as far back as 1191. These conflicting statements probably reflect some preliminary stages which lacked continuous fulfilment.

On the doorway to the north transept there are two deeply undercut acanthus capitals and a frieze, forming an abacus for one of the capitals, which are exactly in the style of the Temple workshop in Jerusalem;[2] the capital opposite has a finely carved vine scroll of a quality more common in Palestine than in Cyprus; the bases of the columns have the characteristic Palestinian fluting. These details suggest that some beginning was made during the Templars' brief period of control, or at least that some of their masons found a home in the island. There was a Templars' church in which Guy of Lusignan was buried in 1194, and it seems probable that of this church only the eastern arm was completed. If this was replaced by the larger scheme of the cathedral, some of the earlier material may well have been reused. Certainly the north transept door as it stands is a patchwork of different styles, but its present form may date from the earthquake of 1491, when the east end of the cathedral was seriously damaged. Inside the ambulatory there is another fragment curiously misplaced. Four slender columns close the presbytery; of these three rest on the floor without bases or on bases now covered, but the fourth is placed on an upturned Gothic capital, with plain

1. J. L. LaMonte, "A Register of the Cartulary of the Cathedral of Santa Sophia of Nicosia," *Byzantion,* V (1929-1930), 439-522.

2. See above, pp. 80-86.

somewhat heavy volutes, of a type repeated on the window colonnettes of the ambulatory and transepts. The actual capitals of these pillars are more elaborately cut; two of them might well be from Byzantine building; the other two have the normal stiff-leaf foliage of the early thirteenth century. The transepts, rising only to the height of the aisles, have apsidal chapels of a typical twelfth-century Palestinian type, but the plan of the east end, an ambulatory without side chapels, is nearer to French practice, and its ribbed vaults, though somewhat clumsily fitted to the bend of the semicircle, are finely molded. The date of 1209 would fit well with the scheme. It is to be noted that the archbishop in that year, Thierry, is known to us only through his obit registered at Notre Dame in Paris, and that a close connection with the Île de France may be presumed.

During the episcopate of Eustorgue of Montaigu the progress of the building can be followed by references to the problem of financing it. The struggle with Frederick II brought an interruption; the coming of Louis IX, a new contact with metropolitan France, for the king is said to have brought some of his chief masons with him. Archbishop Eustorgue accompanied him on his crusade and died at Damietta in 1250. By then the choir and transepts had been in use for some time (there is some indication that they were consecrated in 1228). The completion of the nave, delayed by repairs necessary after an earthquake in 1270 and by brief episcopates, was not achieved till 1326, when archbishop John del Conte celebrated a great service of dedication. He embellished the church with a marble screen, wall paintings, and rich fittings, strengthened the buttresses of the chevet, and began work on the west porch, the most richly decorated part of the whole building.

Externally, the nave presents no abrupt contrast with the eastern arm, but the cornice changes from a curious Burgundian twelfth-century pattern to a Gothic stiff-leaf design, and there are variations also in the window moldings. Inside, cylindrical columns with plain octagonal bases, echoed by octagonal abaci, support the ribs of a quadripartite vault. The capitals, now heavily covered with paint, have been mutilated. There is in the Medieval Museum a capital of a similar size with elaborate stiff-leaf foliage volutes on ribbed stems; it comes from the ruins of a church, known only by its Turkish name of Yeni Jami, but it may well preserve the type of carving used in the cathedral. Such ornament would have relieved the present severe simplicity of the nave, so uneasily at variance with its mosque equipment of crude chandeliers, vivid carpets, and splashes of green

and red paint (pl. LV). The most marked feature is the gallery which runs below the aisle windows, raised on broad arcades, with a short flight of steps where the side columns separate the bays. This open passage is found in Burgundy and Champagne, but nowhere is the step design so completely or successfully worked out. Enlart has suggested, with some plausibility, that the connection maintained by the queen, Alice of Champagne, with the lands of her forefathers may account for some of the Champenois influences in Cypriote building. The windows of the clerestory of the nave have four lights, in contrast with the single lights in the chevet and the two lights of the remainder of the eastern arm. Their upper tracery is composed of trefoils set in circles. With the great west window they must date from about 1300, either from the episcopate, largely an absentee one, of Gerard of Langres (1295-1312) or from that of his successor, John del Conte. The south doorway (moved in the second half of the nineteenth century to the east end)[3] with its marble framework, flat smooth leaves, and rounded monsters is quite unlike any other extant Cypriote work.

In 1491 Hagia Sophia was severely damaged in an earthquake. Dietrich of Schachten, a visiting pilgrim, describes how much of the choir fell, destroying the chapel of the sacrament behind it, and how in clearing the damage the tomb of a king was found, with the body fresh and undecomposed, clad in robes of state, with his golden crown, orb, and spurs, and documents dating his death to a period two hundred and more years earlier. This was probably Hugh III (1267-1284). The Venetians took the gold treasure.[4]

The west porch added by John del Conte was intended to support two towers advanced in front of the original façade. The upper tracery of the blocked north and south windows of the first façade can still be seen in the respective tower chambers. The towers were unfinished at the Turkish conquest. Presumably the new west front would have linked the towers with a chamber or gallery in front of the central west window, but here only the springing of an arch gives any indication as to the final scheme. The porch itself consists of three vaulted bays, with pinnacled gables above the entrance arches. The doorways have a series of capitals and consoles covered with luxuriant foliage characterized by the close spacing of the leaves and by their swollen centers and crinkled, uneven outlines. This is

3. It was still in position when Mas Latrie described it in 1848.
4. R. Röhricht and H. Meisner, eds., *Deutsche Pilgerreisen nach dem Heiligen Lande* (Berlin, 1880), p. 211; Hill, *History of Cyprus*, II, 177.

thenceforth the most characteristic form of Cypriote decoration, one that degenerates easily into an ungainly monotony.

Of figure sculpture it was thought till recently that little remained: two censing angels on either side of the main tympanum, again more Italianate than French; some battered remnants in small niches round the northern door; some decapitated beasts and defaced masks in the foliage; a figure with a sundial high up on one of the buttresses; some corbels and consoles; and some mutilated but striking gargoyles, which resemble those that are such a conspicuous feature of the church of St. Urbain at Troyes. In 1948, however, an opportunity occurred to clean the porch and replace the crumbling plaster covering the main tympanum. It was then discovered that under this plaster covering, the voussoir sculpture still existed, singularly undamaged. The arch has four orders, the outermost one with a small decorative pattern, then the other three with figures set in niches, as on the northern door, but here perfectly preserved—ecclesiastics, prophets, kings and queens (pl. LVIa). The two middle rows contain thirty figures each; the innermost one twenty-eight, fourteen kings balanced by fourteen queens. The niches are flat and round-headed, and figure and niche are carved from the same block so that there is no projection. A similar but single row of niched figures can be seen on the south doorway of the church of St. Jean-Baptiste at Chaumont-en-Bassigny, where the foliage is also not unlike that of Hagia Sophia. Their survival is probably due to their unambitious technique. The solid, squat forms were difficult to break off, easy to plaster over. Their large heads, staring eyes and the straight line of the garments above their ill-formed feet suggest a local, thoroughly provincial sculptor, but there are strong echoes of the greater achievements of the Île de France; some of the kings crook their thumbs through the bands of their cloaks with the famous gesture that passed from Chartres to Rheims, and from Rheims to the rider of Bamberg. The little queen holding her pet dog gathers her draperies with a swing of true French elegance (pl. LIXa).[5] The mason who directed the carving knew either in the drawings of some sketch book or at first hand the style of northern France, though he and his assistants were not skilled in the execution of it. The removal of a band of plaster from the foot of the tympanum revealed carved figures below the three central niches, which with a smaller niche on either side had always been visible.

5. The statues, out of deference to Moslem feelings, have been covered over with removable boards at times, but lately have been left exposed.

The figures have been cut back flat to the main face, but the outlines of their poses and their haloes strongly suggest the apostles at the foot of a Transfiguration. The outside niches may have held figures of founders or particular patron saints, with, beyond, the censing angels, the only figures tolerated by the Turks. These angels are of a quality much superior to that of the voussoir figures. Between the doors must have stood a trumeau figure, for which the canopy still survives, and there are similar canopies for two other column figures on either side of the central entrance.

All three doorways are flanked by twin niches, of little depth and framed in elaborate foliage borders; above them two hands hold a crown; they must have contained paintings rather than sculpture, possibly panel icons, for two of them still have hooks fixed below the crowns. On some of the foliage carving there are still faint traces of color. In the shadow of its arched bays the porch must have been a rich and glowing spectacle in its original completeness, and a fitting entry to the cathedral as decorated within by John del Conte, with its marble choir screen, echoing presumably the style of the porch, its painted ceiling of stars on a blue ground, its woven fabrics, and its wall paintings. The archbishop also added a chapel, opening from the second bay on the south side, dedicated to St. Thomas Aquinas. John del Conte was himself a Dominican, and the Friar Preachers were always an important force in the island; it was for the young Hugh II that Thomas Aquinas himself had written his *De Regno ad regem cypri.*[6] This chapel Felix Fabri tells us was, when he visited it in 1484, "exquisitely painted with the legends of the Holy Doctor, while a gilt plaque on the altar sets forth his acts."[7] Possibly to this same period belongs the rebuilding of the two-storied treasury in the north transept, the upper room of which, with its store cupboard built into the wall, is one of the best preserved parts of the whole church, and one where the stonework can be admired without the thick layers of whitewash that elsewhere blur all the details.

The silhouette of the great cathedral rises above the houses of Nicosia; despite its two Turkish minarets, it has a strangely familiar air to western eyes, familiar but disconcerting, for it lacks the high-pitched roofs of northern Gothic. From the arrangements of

6. See Thomas Aquinas, *On Kingship, to the King of Cyprus . . . ,* tr. G. B. Phelan, rev. with introduction and notes by I. T. Eschmann (Pontifical Institute of Mediaeval Studies, Toronto, 1948), pp. xxvi-xxxix.

7. *Fratris F. Fabri evagatorium in Terrae Sanctae Arabiae et Egypti peregrinationem,* ed. C. D. Hassler (Bibliothek des literarischen Vereins in Stuttgart, II-IV; 3 vols., Stuttgart, 1843-1849), III, 230.

the earliest buttresses for the vault of the choir, it seems probable that such a roof was at first intended, but that soon it was decided to adopt the flat roofs of the island with their terraces of lime concrete, lightened at times by the insertion of pottery jars. It was the first compromise between Gothic art and local custom.

On the east coast of the island, later in date than Hagia Sophia but its only rival in scale and excellence, is the cathedral church of St. Nicholas of Famagusta. It appears to have been begun about 1300, when the will of Isabel of Antioch left five bezants for work on the cathedral. Bishop Baldwin Lambert engraved an inscription on the buttress to the west of the south doorway stating that by the fourth of August, 1311, the money collected for the building had been expended and that it was resumed by his orders on the first of September of that year, when six vaults of the two aisles had been completed and ten vaults of the aisles and eight of the nave remained to be built. It seems therefore that the terminal apses and two bays of the aisles were completed up to the vaulting but that neither choir nor nave was as yet covered; probably the side walls had been carried farther, as the inscription is placed well beyond the vaulted bays. The ground plan had also been established, with a nave and two aisles of seven bays, all terminating in polygonal apses, with no transepts.

Famagusta was the coronation church, where the Lusignans received the crown of Jerusalem, and therefore Rheims was probably in the mind of its designers, but the detail of the building, particularly of the chevet, comes, as at Nicosia, strangely close to the style of St. Urbain of Troyes, founded in 1262 and notable for its advance towards a freer, more flowing type of Gothic. It is not known how far Baldwin Lambert, a member of a wealthy Cypriote family, completed the building, and even the exact date of his death is uncertain. But with the exception of the four side chapels added later to the aisles, in imitation of those at Hagia Sophia, the cathedral is remarkably uniform. The west front (pl. LVII) maintains the purity of the true French Gothic style with none of the heavier richness of the porches at Nicosia. The figure sculpture, save for a few minor pieces, was all destroyed after the fall of the town in 1571, and the cathedral was much battered by cannon-balls during the siege. Then a long period of fanatical possession, lasting until the British occupation of the island, excluded all Christian visitors.

During the second world war Famagusta suffered some damage from the vibration of depth charges off the coast and from anti-aircraft fire, but the building has stood such tests with much

endurance; the twin towers, the pointed gables of the façade and chevet, still rise most nobly above the massive Venetian walls of the town. The central doorway has niches for six column figures and a central trumeau; the supports are carved with oak leaves; in two of the canopies small corbels still show the Agnus Dei; the voussoirs have the swelling, crinkled leaves so popular in the island and once had human or animal terminals, now sadly defaced. On a doorway on the south of the cathedral parvis, similar foliage has as terminals confronting winged dragons and two figures of Samson and the lion; the dog-tooth and zigzag embodied in the doorway suggest a later date than the cathedral porch, for in Cyprus these motifs enjoyed a belated popularity. The tracery of the great west window and of the wide windows of the aisles and the gables of the three porches of the façade, so much more French than that of Hagia Sophia, still reflect the charm of the last phase of geometric Gothic, before the curvilinear movement had gained the day; while the interior, somewhat bare and stern under its whitewash, with plain undecorated capitals, reminds us that this is an outpost, a little *retardataire* in its methods, hampered perhaps by an insufficiency of skilled carvers. At the foot of one or two of the columns is carved a curious motif, a pyramid crowned with a ball, which recurs in many other buildings of the town.

The two cathedrals, so romantic in their evocation of France, each presided over a large concourse of lesser buildings. Estienne de Lusignan states that Nicosia had eighty churches when in 1567 the Venetians took the drastic decision to withdraw the town within the new ramparts and level to the ground all that lay outside. His own church of St. Dominic was one of the most distinguished victims of this desperate defensive measure, which, before the menace of the Turks, sacrificed a great part of the city's architectural heritage. Today the few extant churches, not all surely identified and mostly diverted from their original purpose, serve to show something of the architectural development in the capital, but form an insubstantial list indeed compared with the buildings recorded but now destroyed.

Of the thirteenth century, Hugh II's foundation of St. Dominic (1250) must, next to the cathedral, have been the most splendid piece of Nicosian church architecture, but Lusignan tells us only of its beauty and royal tombs in general terms which give little information as to its plan or type. The Cistercian church of Our Lady of the Fields was destroyed at the same time, as was also that of Holy Savior of the Cemetery, where Henry I was buried in 1253 and

the boy king, John I, in 1285. The only remaining fragment of the thirteenth-century Gothic style, as it is found in the choir and nave of Hagia Sophia, is the much rebuilt inner aisle in the complex of buildings now known as the Bedestan.

The building activities of the turn of the century have left more trace. From the fall of Acre in 1291 to the coup d'état against Henry II in 1308, Cyprus enjoyed a period of comparative peace. The church begun by Henry II for the nuns of Our Lady of Tyre, a Jerusalem foundation, illustrates the position that the island now held as a place of refuge for the Latin east. The abbess, Margaret of Ibelin, remained a loyal supporter of their benefactor, and the nunnery was the scene of a riotous attack at the time of the murder of Henry's usurping brother Amalric, the titular prince of Tyre. These events left the building incomplete; it remains today, if the proposed identification with the church of the Armenians is accepted, a building of one vaulted bay and a polygonal choir, roughly completed by a section with a barrel vault and no windows. The tufted, flat-leafed foliage of the capitals of the south door, now used as a window, comprises early examples of the popular Cypriote type.

The period from the restoration of Henry II to the Genoese war of 1373 was the most prosperous and splendid of medieval Cyprus, though the foreign schemes of Peter I diverted resources from undertakings at home, and in Nicosia it is John del Conte's porch that sets the main features of the style of the century. Its structurally somewhat conservative Gothic, and elaborately ornamented doorways with friezes and capitals of luxuriant foliage, recur in the pleasant so-called church of St. Catherine (Haidar Pasha mosque), in the ruined fragment of the Yeni Jami (unidentified), in the porch of the Augustinian church (Omerieh mosque), and in its fullest elaboration, with an Italianate but provincial dryness of symmetrical design, in the rebuilt doorway ascribed by Enlart to St. George of the Latins but more likely always, as now, the doorway of a bath.

It is, however, in the building known as the Bedestan, on the south side of the cathedral parvis, that its influence is most clearly marked. Little is known of its history, but in the fifteenth century it was in the hands of the Greek Orthodox church. At some period after the conquest it was relegated to secular usage as a storehouse and market (*bedestan*). Recently it has been partially restored and the west end freed of some small shops built against it. Of its curious complex of four aisles, ribbed vaults, and dome, it is the two southern aisles that seem the earliest work. The nave, north aisle, and dome were added

at a later date, possibly when it was adapted for the Greek rite; a capital of the nave is carved with two hands giving the Greek gesture of blessing. On the exterior of the north wall are three doorways, of which the central one, blocked up with carefully fitted masonry, is the earliest. The small relief of the Dormition of the Virgin set in the lintel has escaped mutilation, but a well-carved figure on the keystone of the arch, which resembles a similarly placed figure on the Carmelite church at Famagusta, has been decapitated. The eastern of the three doors has a recessed porch of five orders carved with thick crinkled foliage; on either side are two shallow recesses above which hands hold crowns, copied, somewhat heavily, from those of Hagia Sophia. On the lintel is the figure of a saint holding a book, identified by the eighteenth-century traveler Giovanni Mariti as St. Nicholas;[8] from this the Bedestan has sometimes been thought to be the church of St. Nicholas belonging to the order of St. Thomas of Canterbury and mentioned in fourteenth-century documents. The third doorway is modeled on the west door of St. Catherine's. The whole north wall seems to have been increased from its original thickness, and it is possible that all three doors are additions, brought from destroyed churches, possibly in 1567, possibly after the conquest when the Greek church in contrast to the Latin enjoyed a measure of patronage from the occupying Turks. To complete this strange, confusing history, a door from the west façade was moved during some clearance work in 1906 to the gardens of the then Government House. A second western door has now been revealed by the demolition of a shop. Whatever its history, the decorative motifs of the Bedestan present, along with genuinely Gothic features, a truly Cypriote blend of elaborate, somewhat debased detail, where late Gothic and Renaissance elements meet and intermingle. Similar patterns can be seen in the church of the Panagia Chrysolaniotissa, traditionally said to have been founded by Helena Palaeologina, wife of John II, in the mid-fifteenth century but now much rebuilt, and again in the Orthodox cathedral, which is probably on the site of the church of the Hospital.

The splendor and luxury of Nicosia did not, however, consist in its ecclesiastical buildings only. The royal palace, adjoining the church of St. Dominic, seemed to travelers the finest in the world. Its great throne room, its balconies, its golden ornaments, its tapestries, pictures, organs, and clocks, its baths, gardens, and menageries suggest the most sumptuous of medieval residences. All the buildings

8. Mariti, *Viaggi per l'isola di Cipro*, I, 99.

were sacrificed in the demolitions of 1567. The simpler existence of a Cypriote bishop, even of one of great family, can be seen in the inventory of Guy of Ibelin, bishop of Limassol from 1357 to 1367. At the time of his death much of the furniture of his palace and even his miters and crosses had been pledged for loans, and his house at Nicosia, either from necessity or as befitting a member of the Dominican order, was sparsely furnished with rugs and cushions in the oriental manner.[9] Here and there in the town there are fine doorways reflecting the same mixture of French Gothic, Italian Renaissance, and Catalan styles as exists in the churches. A fine flamboyant window, coming from the doorway arch of a palazzo used by the Turks as the Serail and pulled down early in this century, is preserved in the museum, and in its almost exaggerated richness is an eloquent example of Cypriote taste (pl. LVIIIa).

For a time, but only for a time, the prosperity of Nicosia was excelled by that of Famagusta. Today the two cities harbor their memories in very different ways. In each the Gothic cathedral rises high above the town, but while in Nicosia the streets are still full and lively, the old buildings submerged by later work, in Famagusta the new town has grown up outside the circuit of the ancient walls, within which a small Turkish village spreads its houses and streets among the ruins and still uses the great cathedral for its local mosque. From the ramparts this graveyard of churches, whose foreign style seems emphasized by the palms growing among them, is an unforgettable spectacle. Something of its recent strange remoteness has gone, for the wartime revival of Famagusta as a port brought intruding sheds and storehouses within the circuit, and a new prosperity has come to the old village, bringing fresh building and fresh activities, which the Department of Antiquities, for all its excellent work, has not been able entirely to control.

But Famagusta is still one of the most moving of the dead cities of the Middle Ages. It had but a brief life and its splendor was the ostentation of a sudden, ill-starred prosperity. The fall of Acre made it the Christian mart of the eastern Mediterranean, and a small Byzantine town, originally peopled by refugees from Salamis, rapidly became a Gothic city. The Franks had previously done little to it:

9. J. Richard, "Un Évêque d'Orient latin au XIVe siècle: Guy d'Ibelin, O. P., évêque de Limassol, et l'inventaire de ses biens (1367)," *Bulletin de correspondance hellénique,* LXXIV (1950), 98-133.

now the cathedral was begun, and perhaps even before it the church of St. George of the Latins, which may be given the first place in Famagusta's architectural history. The bombardment of 1571 and probably the explosion of some stored ammunition have heaved the debris of its vaults to some distance and left only one wall and part of the apse standing. Much of its excellent masonry is reused classical stone, brought probably from Salamis and reset with the most exact and careful calculation. Only the soundness of the building has allowed this skeleton of an unsupported wall to endure so long. The church was a single nave of four bays ending in a three-sided apse; the vaults rose from clusters of three pillars; the west façade had two turrets, one of which still partially stands, rising little above the level of the roof, though on Gibellino's drawing of the siege (1571)[10] the southern tower, of which there is now no trace, seems to have risen somewhat higher. The capitals of the columns, which still retain much of the sharpness of their cutting, have double rows of naturalistic foliage in which oak leaves figure prominently; in one instance, instead of leaves, the sculptor has carved a swarm of bats. The north porch has a pointed gable, filled with a large trefoil and ornamented with curving crotchets. The corbeling of the tower has a pair of fighting animals (pl. LXb), a reminder of the many classical carvings that, as well as squared building stone, must have been brought from Salamis to Famagusta (a fragment of such a frieze lies in front of the cathedral); the gargoyles of the apse are human figures, very sensitively carved, and belonging to the same type as those of Hagia Sophia. No documents date the building, but it is the work of highly skilled masons, contemporary with the cathedral, if not the prototype for it, and must therefore belong to the early years of the fourteenth century.

 To the west and the south of the cathedral two large churches are still standing, that of St. Peter and St. Paul and the Greek cathedral of St. George. The identification of the former was made by Enlart on the basis of Gibellino's drawing and cannot be considered as certain. It was built, Estienne de Lusignan states, under Peter I by a wealthy merchant, Simon Nostrano. The design and a Syriac inscription found on the walls in 1939 suggest it must have belonged to one of the eastern churches, and possibly Nostrano should read Nestorano: this would then be the Nestorian church built by the

10. Stephano Gibellino, . . . *Il Ritratto della celebre città di Famagosta* . . . (Brescia, 1571), reproduced in Enlart, *L'Art gothique*, II, pl. XXI.

brothers Lachas, the wealthiest merchants of Famagusta, of whose
prodigality and ostentation Machaeras tells many anecdotes.[11]
Whatever its origin, it is still mainly standing, composed of a nave
and two aisles, ending in a triple apse of three semicircles set in a
square base. As in the cathedral, which has clearly influenced the
whole design, the vaulting of the nave is carried on round pillars with
plain capitals. Originally neither façade nor side walls had any
buttresses, a custom probably borrowed from the churches of Acre,
but the vault of the nave is supported by flying buttresses above the
flat terraces of the aisles as in the cathedrals of St. Nicholas and
Hagia Sophia. Such a structure depends on sound building and
considerable thickness of wall. The church has both, but they have
not saved it from danger, and some time before the Turkish conquest,
probably after the earthquake of 1546 or that of 1568, the south
aisle wall had to be supported by a row of five flying buttresses,
which somewhat distort the present appearance of the building. The
whole effect is severe; it lacks good sculpture and must have
depended much on the richness of its interior decoration; only on
the main north door, similar in type to that of St. George of the
Latins, is there work of good quality. Carved in inset white marble,
the capitals of the two door columns on either side have foliage with
crotchets of a twelfth-century design; the marble jambs have a frieze
of oak and vine leaves with one large palm front and as inner
consoles two angels, one censing, the other holding the sacred vessels
under a veil; it is expert decorative work in the best French manner
of a style earlier than the church. Marble carving was not a native
craft, and this must surely be some reused material, possibly from
some unfinished undertaking at the time of Louis IX's passage (pl.
LVIb).

The plan of St. Peter and St. Paul, itself probably taken from that
of St. Andrew at Acre, was used almost contemporaneously in the
Greek Orthodox cathedral of St. George. Built beside and adjoining
the small church of St. Epiphanius, it marked a resurgence of Greek
feeling and in scale is an attempt to rival the Latin cathedral. It
differed from St. Peter and St. Paul in the height of its central apse;
whereas the earlier church had a square end to the nave, rising above
the semicircular apse, in St. George the apsidal semicircle continues

11. See Enlart, *Les Monuments des croisés dans le royaume de Jérusalem*, II, 17, note 5;
Th. Mogabgab, "Excavations and Researches in Famagusta, 1937-1939," *Report of the
Department of Antiquities, Cyprus, 1937-1939* (Nicosia, 1951), p. 188; and L. Machaeras
("Machairas"), *Recital Concerning the Sweet Land of Cyprus, Entitled 'Chronicle',* ed. and
tr. R. M. Dawkins (2 vols., Oxford, 1932), I, 83.

unbroken to the height of the nave vault (pl. LVIIIb). Both inside
and outside this gives a much greater vertical emphasis and adds grace
and distinction to the building. The vaults have fallen, probably
brought down in the Turkish bombardment; a cupola covered the
second bay from the east, as in the church of the Bedestan at
Nicosia. The ornamental foliage of the west door is the usual thick,
crinkled Cypriote leaf. The main apse retains shadowy frescoes of the
life of Christ, set in a double row, and in the south apse the
Deposition, Entombment, Harrowing of Hell, and Resurrection are
reasonably visible. The building of this spacious, conspicuous church
marks a break with the policy of Latin ecclesiastical exclusiveness.

Two churches recur constantly in the history of Famagusta, those
of the Franciscans and the Carmelites. Of both there are considerable
remains: well-built churches, single naves ending in polygonal apses,
with side chapels forming transepts in the middle of their three bays.
Vaulting, tracery, and carving, where they remain, are French Gothic
of good quality. The Franciscan church certainly dates from about
1300; the Carmelite church of St. Mary, whose severe façade,
buttressed with short polygonal towers, is a magnificent piece of
regular ashlar, may possibly be somewhat later, from the time of the
legate Peter Thomas, the companion of Peter I's crusade, who was
buried in it and venerated by the Latins as a saint, though to the
Greeks he was, at least on his first coming, an intolerant persecutor.
It has a fine west window and as keystone of the doorway arch a
well-carved figure, now headless, holding a book.

The church of St. Anne, which seems to have belonged to one of
the Syrian churches, recalls St. Mary of Carmel in the beauty and
simplicity of its building and in some of the details of its ornament.
The church of St. George Exorinus (the Exiler) has Syriac
inscriptions on its frescoes of saints, and was thought by Enlart to be
the church of the Nestorians, mentioned above as built by the
merchant princes of the Lachas family. The building is of excellent
stone work but simple ornamentation, clearly by local workers. Here
again hangings, painting, and metalwork must have constituted an
inner richness, and the fragments of fresco painting still show that
walls and vaults were completely covered by it.

The little church of the Armenians, probably built by immigrants
from Ayas (Lajazzo) as the Cilician kingdom crumbled before the
Mamluks, is composed of one bay; its masonry is that of the yard
which worked at the three previous churches, but its size reflects the
indigence of this refugee community. Space does not admit of any
analysis of other and unidentified churches: two twin chapels are

sometimes thought from a blazon on the center of the smaller of them[12] to be the chapel of the Temple (built in the first years of the fourteenth century) and that of the Hospital, added when they took over the Temple's forfeited possessions. On the fragment of an arch, on the church of St. George Exorinus, and on the doorway of an unidentified building (the so-called Tanners' mosque), a chevron ornament is used, here as in Syria long surviving its Romanesque popularity.

In 1373 Genoa seized the town, and it was not till 1464 that James II reconquered it for Cyprus. Under the Genoese and their insistence on a trade monopoly, the town languished. No churches can be traced to this period: the building tradition, so masterly in its use of stone, if unadventurous in design and ill supplied in sculpture, suddenly ends. The elaborate loggias and trading houses of the merchants had already been turned into storehouses by the end of the fifteenth century. The Lusignan reconquest lasted for only twenty-five years, and it was from Famagusta that Catherine Cornaro sailed in 1489, leaving the standard of St. Mark flying on the piazza before the cathedral. Venice in her hundred years of domination transformed the medieval fortress into a circuit of walls, adapted for artillery. There was little time or means for church building: opposite the cathedral, they rebuilt for their governor the old royal palace, masking the earlier Gothic building with a Renaissance façade. The frontal colonnade, recently restored, is an impressive enough piece of Renaissance work, whether or not Giovanni Sanmicheli actually designed it.[13] But it was only to serve as a setting for the final tragedy.

Venice could not spare much building energy or resources from the main defenses of the island, but one piece of fantasy is recorded of her rule. Estienne de Lusignan tells us that the Venetians carried out excavations at Paphos in 1564. In this enterprise Renaissance archaeology joined with medieval relic-seeking, for the search was prompted by the cult of Venus, whose tomb was identified with an antique sarcophagus from Salamis (a similar one is still in the courtyard at Bellapais), placed by the Venetians before the west front of Famagusta cathedral. Nicosia, not to be outdone, showed in Hagia Sophia a hollowed green jasper block as the coffin of the island's patroness. This latter has disappeared; the sarcophagus of Famagusta now serves as monument to the first English commis-

12. Now in the museum of Famagusta.
13. Hill, *History of Cyprus,* III, 859.

sioner, Captain Robert Inglis (d. 1880), in the little graveyard at Varosha. [14]

It is in the two main towns, Nicosia and Famagusta, that the great Gothic buildings survive. Elsewhere, with the exception of Bellapais, the churches are mainly unpretentious buildings on a Byzantine model, made of rough, unsquared stones, quite unlike the excellent masonry, well cut and set with thin mortar, of the Frankish masons. At Paphos and Limassol, the other two Latin bishoprics, the Franks built cathedrals; of the former only a fragment is standing, sufficient to show that it was a vaulted building of well cut stone. In the ruins of a nearby mosque, some large Gothic capitals have been built into a roughly constructed archway; they are decorated with chevrons, foliage volutes, and palmettes; on one there is a headless figure of a man and a horse; they are crude in workmanship and should be early thirteenth-century, but may be a later imitation.

At Limassol little of the medieval work can be seen, though recent excavations have established that the core of the castle, beneath many later rebuildings, is a thirteenth-century church. A few monastic ruins—Stazousa, between Nicosia and Larnaca, St. Nicholas of the Cats at Akrotiri—have Gothic remains, but monasteries in the open country, particularly in the southern half of the island, were mostly destroyed in the Mamluk raid of 1426 and seem never to have recovered from it. Even on its hilltop, a conspicuous landmark from many parts of the island, the monastery of Stavrovouni, traditionally founded by St. Helena, was sacked on this occasion, but its buildings were Byzantine and the Latins added little to them.

Cyprus is rich in country churches, but here Byzantinism dominates. The buildings are exceedingly difficult to date, and in the rare instances where an inscription gives some year, it often refers to restoration or minor alteration. Certainly the small cruciform single-domed churches include among their number some pre-Frankish examples, and the type continued to be built throughout the whole medieval period. Sometimes in the mountains they are covered, as at Moutoullas (dated 1279), with wooden, high-pitched roofs whose eaves reach almost to the ground, and which possibly are a northern importation by the Franks. Relations between the two churches, Greek and Latin, were often strained: nowhere in the Near East were the Latins so intolerant, and the Council of Limassol in 1220, which reduced the Greek bishoprics to four and banished them

14. Enlart, *L'Art gothique*, II, 637; Jeffery, *Historic Monuments*, pp. 126, 226.

to the lesser towns, was a prelude to active persecution, resisted by the Greeks, even to martyrdom at the stake. By the end of the first century of their rule the Latins were, however, learning the need for a less rigid policy. As in Syria, it was the new arrivals from the west who exacted the most uncompromising standards. Peter I protested to pope Innocent VI in 1358 against the intransigency of the legate, Peter Thomas. The finest and purest examples of Gothic ecclesiastical architecture belong to the period of the most exclusive domination of Rome: there is a zealous boldness about Hagia Sophia or St. George of the Latins which is lacking in the more ordinary compromises of later buildings. In the country districts, save for monastic settlements, the true Gothic style never penetrated, nor did legatine authority much affect the ordinary agrarian life. Gradually, with generations of Franks born in the island, the distinctions are blurred. A Franco-Byzantine style emerges, shown in the villages by some Gothic details in the domed church built by a local lord; in the larger centers, by a combination of dome and Gothic vault and an interpretation of Gothic ornament with something of classical roundness and solidity, not always very happy in its effect.

Of such hybrid churches, outside of Nicosia and Famagusta, the most notable is that of Morphou, the church of a Greek monastery built over the tomb of St. Mamas. There has been much argument about its date, whether in its present form it is a late-eighteenth-century rebuilding, or whether it retains its medieval design with only minor modifications. The pillars of the old iconostasis, carved only to the front, show that it was even under Lusignan rule built for the Orthodox rite; the emphatic treatment of the capitals under the dome suggest that the latter was an integral part of the scheme. The carving on them, rich Gothic foliage interspersed with masks, could belong to the second half of the fourteenth century. The shrine of the saint, a tomb set in a wall niche, has undergone many alterations, the latest in 1907; here too the foliage is the typical Cypriote swollen, crinkled leaves, so full and heavy that they might well be insensitive imitations of the medieval style. A possible explanation of this puzzling building is that the cupola-covered church and rich, clumsy ornament are a product of the Byzantine-Orthodox revival led by queen Helena in the mid-fifteenth century. The present iconostasis and the baldacchino are Venetian work of the sixteenth century.

It would not be possible here to make any systematic survey of the lesser churches. Some can be fairly definitely ascribed to Latin patronage, but there is none that is clearly Gothic in style. Mostly

the Gothic work is additions, a nave added for the Latin rite as at
Pelendria and the Gibelet chapel at Kiti, or a Gothic narthex built
onto a Byzantine cruciform church, a practice which seems to have
been curiously popular in the Venetian period, and which has given us
at Antiphonitis and the Akhiropietos church at Lambousa two of the
most charming of the island's examples of late Gothic building. Of
exactly dated churches, Hagia Paraskeve near Askas, with its
curiously foreign dedication to St. Christina, is inscribed as built in
1411; the chapel of the Passion at Pyrga must shortly precede the
fatal year 1426; and at Potamiou the church of St. Marina, still with
dog-tooth molding as one of its decorative elements, is dated 1551.

In Cypriote architecture, the monastery of Bellapais, to use the
most familiar name (though it is in fact a corruption of the Abbey of
Peace), has a place apart. The buildings are of high quality and set
out with a sense of plan far from usual in the island (fig. 9), but
there is a harmony between them and their site which enhances their
actual architectural merits. Bellapais, like Tintern or Jumièges, is a

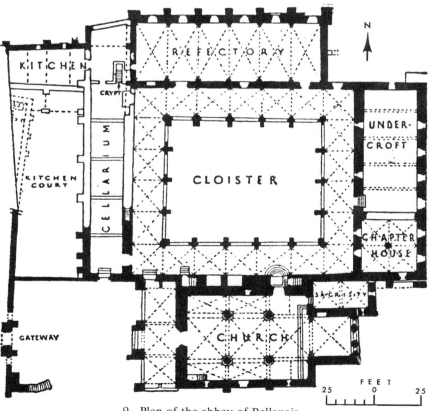

9. Plan of the abbey of Bellapais

ruin which retains much of its structural beauty and has added to it a close communion with the landscape. The olive and carob trees covering the hillside have that contrast of greens which is one of the main charms of the island, and from the Gothic arches of the windows, over the sheen of the trees and beyond the wide space of water, can be seen the distant hills of Asia Minor. Its early history is little known. By 1205 there was a house of Premonstratensian canons established there, and it is probably from this period that the church dates, composed of a nave and narrow aisles of two bays, a crossing, and shallow transepts and a square chancel, all with rib vaults except the two transepts, which have barrel vaults. The capitals of the window columns and the west doorway belong stylistically to the first half of the thirteenth century.

In 1246 the abbey received an important bequest from a knight, Roger Normand, namely a fragment of the True Cross and 600 bezants. The prosperity of the monastery now grew rapidly; Estienne de Lusignan states that Hugh III raised the status of the abbot by permitting him to carry a sword and wear golden spurs, and, wrongly, that he was buried there. The cloister, which forms a square north of the church, with the monastic buildings opening off it, probably dates from the reign of Hugh IV (1324-1359), who frequently visited the abbey. Most of the tracery has gone from the cloister arches, but enough remains to show that it was similar to that on the façade of Famagusta cathedral; the capitals are good examples of the popular Cypriote foliage of the first half of the fourteenth century. The refectory, a splendid room 98 feet long by 33 feet broad and 38 feet high, is of approximately the same period. Its stone pulpit with openwork carving is completely preserved and of great elegance and distinction. The vaults of the chapter-house and of the dormitory have fallen, but the walls still stand, and in them too there is excellent workmanship. The cloisters and the chapter-house have some striking figure corbels, which have escaped mutilation, as the monastery was never for long occupied by the Turks. A man between two sirens (possibly Ulysses) and a young man fighting with two beasts are two of the subjects that are represented. By the last quarter of the fourteenth century all building must have been at an end. In the fifteenth century the abbey was generally held by absentee abbots, and in the sixteenth the corruption of its monks had become an open scandal. The Turks sacked it and passed on, leaving the Greek villagers to take over the church and to stable their beasts in the monastic buildings.

There remain for consideration some isolated pieces of sculpture, detached from their original buildings. The discoveries in Hagia Sophia have much increased our knowledge of Cypriote figure sculpture, and if the main cathedral of the island was content with work of this quality, it is unlikely that there was much superior workmanship among the carvings that Turkish iconoclasm destroyed. The decapitated gargoyles of St. George of the Latins or of Hagia Sophia suggest that in the early fourteenth century there were a few western sculptors of some merit at work in the island, but certainly there was never available the talent that served the Latin kingdom of Jerusalem. The riches of Cyprus could not buy or did not seek the master workmen who made the journey to the Holy Land in the first century of crusading enthusiasm. There are, however, sufficient fragments of carving to show the general range of accomplishment. The large standing figure of Christ (pl. LIXb) in the Pancyprian Gymnasium at Nicosia must come from some important sculptural group. At first sight it might well be a column figure from a porch, but the flat stone on which it is carved indicates rather the central figure of a tympanum or reredos. Though flat in modeling, it is a not unimpressive piece.

The Medieval Museum in Nicosia[15] has a series of fragments, largely from tombs, which in Cyprus were often sarcophagi placed under elaborate niches (as at Morphou) and carved with figures or coats of arms. In fact the passion for wall niches unduly weakened many of the structures, as for instance in the Greek cathedral in Famagusta. One such fragment of a sarcophagus has a crowned and kneeling figure with the Lusignan arms, probably some youthful prince rather than any of the kings.[16] Another, that of Adam of Antioch, is a triangular coffer which must have stood on short columns and in form corresponded closely to the tombs of Godfrey of Bouillon and Baldwin I in Jerusalem. It is carved with rosettes and leaves but the shields have no crests, as though, Enlart suggests, originally prepared for stock with no particular patron in view. The tomb chest of the Dampierre family has shields set in an arcade of

15. This collection of carved stones, known by Enlart's name of Musée Lapidaire or as Jeffery's Museum, was formerly housed in a fifteenth-century house to the east of Hagia Sophia. Some of the collection has now been moved to the medieval annex of the Cyprus Museum in the old arsenal (Topkhane), inside the Paphos gate. Here the great vaulted basement is probably part of the Lusignan palace.

16. Now in the Louvre: see M. Aubert, *Description raisonnée des sculptures du moyen âge, . . . ,* I (Paris, 1950), 186.

typical Cypriote tracery and foliage. Built into the wall of the chapel of the present Orthodox archbishop's palace is another tomb front; here in a series of Gothic niches is the Crucifixion between the Virgin and St. John, with a knight and his lady kneeling on either side. It is rude, coarse carving, the figures flat and thick, and is probably late fourteenth- or early fifteenth-century work.

The little relief of the death of the Virgin above the lintel of one of the doorways of the Bedestan is a still inferior piece and could possibly be Greek work after the Turkish conquest. A fragment of a frieze in the museum, with a lion chasing a deer, seems to be a medieval copy of a classical design. More interesting and more ably executed are the curious sculptures which form the lintel and imposts of the south door of the Trypioti church in Nicosia. In the center a masklike figure rises between the branches of a highly stylized vine; on either side a grotesque lion paws the branches; the imposts have a mermaid and a monster-like creature and human-headed birds emerging from some very formal coils of foliage. It is cut with exactness and care despite the primitive types used and is almost impossible to date. The present church is a seventeenth-century building reusing older material. The formal coils of vine leaves and tendrils and the flat, featureless treatment of the figures recall the type of art found on the tomb of St. Theodora, the great shrine at Arta built about 1280 by the despot of Epirus, Nicephorus. Perhaps the Trypioti lintel reflects some Epirote tradition in the building undertakings of the Greek revival under Helena Palaeologina after her marriage to John II in 1442. In the church of St. Lazarus at Larnaca, Mariti saw in 1767 a marble pulpit with signs of the evangelists "well worked, in as much as Gothic taste allows."[17]

A marble tympanum (33 inches long by 24 inches high) in the Pitt-Rivers Museum at Farnham, Dorset, suggests in its squat figures the work of the Hagia Sophia voussoirs (pl. LIXc). It was found by Cesnola at Larnaca, but probably had come with other building material from the Famagusta area.[18] It represents Christ in a

17. *Viaggi,* I, 42.
18. Hill, *History of Cyprus,* III, 1137, pl. XVIII; A. Palma di Cesnola, *Salaminia, Cyprus: The History, Treasures, and Antiquities of Salamis* (London, 1882), pp. 109-110, pl. IX; L. de Feis, "Le Antichità de Cipro ed i fratelli Luigi ed Alessandro Palma di Cesnola," *Bessarione,* VI (1899), 442, pl. III. In 1841 in Smyrna Sir David Wilkie saw a small group in marble showing Christ crowned with thorns by Roman soldiers, said to have been found in Cyprus; it was thought to be fifth- or sixth-century work, but it sounds as though it might well have been similar to the Farnham tympanum: Allan Cunningham, *The Life of Sir David Wilkie, with his Journals, Tours, and Critical Remarks on Works of Art . . . ,* ed. Peter Cunningham, II (London, 1843), 372.

mandorla supported by angels; on his right hand are the Crucifixion, where a flying angel removes the crown of thorns from Christ's head, and the Carrying of the Cross; on his left hand are the Baptism, Annunciation, and Resurrection; below are the Virgin between two angels and six apostles on either side of her. The main theme is therefore the Ascension; the selection of the minor scenes appears somewhat unusual. It probably comes from the late fourteenth century, the period of fusion into a Byzantino-Gothic style. The soldiers wear chain mail. The hand of Christ makes the sign of benediction in the Greek manner, but this is so general throughout Cypriote carving and painting that little importance can be attached to it, and on artistic evidence it would seem probable that in the island the Latins came to use the Greek placing of the fingers. On a thirteenth-century tomb slab, which Enlart found reused in the minbar of Hagia Sophia, archbishop Theobald gives the Latin blessing:[19] the lady abbess, Eschiva of Dampierre, on her tomb in Our Lady of Tyre of 1340, uses the Greek gesture. As an example of a more purely Italianate style of sculpture can be quoted the relief of St. Mamas on his lion, carrying the Agnus Dei, now in the cloisters of the modern church of the Holy Cross in Nicosia. It is dated 1524 and is a provincial Venetian work, a votive offering, in which the donor, supported by an angel, kneels before the saint in a setting of rocks and palms.

Heraldic carving probably played a large part in Cypriote as in Rhodian decoration. Two examples must serve, both drawn from an outpost of Cypriote rule, the town of Adalia on the south coast of Asia Minor, captured by Peter I in 1361 and held till 1376.[20] In the barracks here were, until recently, two carved marble slabs: on one were the arms of Peter I; on the other, now in the museum at Istanbul, two shields, each held by clasped hands. The shields displayed the arms of Peter's Order of the Sword, the Lusignan arms, and a lozengy coat which, if John de Sur can be identified (as seems probable) with John de Nevile of Arsuf, is his arms and a record of his governorship, which was distinguished by an art-historical incident, the theft of the icon of St. Nicholas from the church at

19. Enlart, *Monuments des croisés*, I, 169-170, pl. 39. Although no Theobald is named by Gams or Eubel among the archbishops of Nicosia, there is a gap in the lists between 1264 and 1270; Theobald is called archdeacon of Troyes (*Trecensis*) in the fragmentary inscription, but Enlart identifies him as an archbishop because he wears the pallium.

20. F. W. Hasluck, "Frankish Remains at Adalia," *Annual of the British School at Athens*, XV (1909), 270-273, and "A French Inscription at Adalia," *ibid.*, XVI (1910), 185-186. There are similar heraldic pieces in the National Archaeological Museum at Istanbul.

Myra and the bringing of it to Famagusta. This same lozengy coat of the Nevile family, or at least a variant of it, can be seen on the shrine at Geraki, one of the most curious monuments of Frankish rule in Greece.

If sculpture in the round is rare and, save at Hagia Sophia, battered, and if the canopied tomb recesses are empty and fragmentary, Cyprus possesses a considerable inheritance of incised stone funeral slabs. Reused as paving stones, frequently face downwards or covered by thick carpets, a surprising number have survived. For Nicosia many of them were published by Tankerville Chamberlayne (with drawings by M. W. Williams), in his *Lacrimae Nicossienses* in 1894,[21] but examples are found in all parts of the island. Incised memorial stones were in use in Palestine in the thirteenth century, though only scant traces remain; in Cyprus they are frequent throughout the fourteenth and fifteenth centuries, being replaced at the end of the Lusignan period by slabs in low relief. Here we have priests, nobles, and ladies in their habiliments as they lived; a list of them would be a roll-call of the great names of the island. The church of Our Lady of Tyre is particularly rich in them: Marie de Bessan (died aged twenty-eight in 1322), a very well-preserved piece of simple outline incising; Johanna Gorap (died 1363), wife perhaps of that John Gorap who cut the head from the corpse of Peter I; John Thenouri (died 1363) in full armor with blazoned shield and wide flowing surcoat, cut in a grayish stone, as are some of the other better preserved and executed pieces; Balian Lambert (died 1330), perhaps a relative of bishop Baldwin of Famagusta, the chief builder of the cathedral, in simple chain mail. Finest perhaps of all, in Hagia Sophia, is the tombstone of Arnato Visconti (died 1341) with his feet on two twisting dragons, standing beneath an elaborate Gothic canopy whose foliage decoration recalls that on the porch outside. The slabs in low relief seem to have come in with the Venetian occupation. They survive mainly in outlying villages, where their inscriptions are in Greek.

If the gradual return of the Byzantine style is a marked feature of Cypriote architecture and carving, in painting this style remained the dominant pattern throughout, little modified by trends from the

21. *Lacrimae Nicossienses: Recueil d'inscriptions funéraires, la plupart françaises, existant encore dans l'île de Chypre,* I (Paris, 1894; part II did not appear); L. de Mas Latrie, *L'Île de Chypre,* pp. 340-401; A. K. Intianos, "Κυπριακὰ μεσαιωνικὰ μνημεῖα: Ἐπιγραφὲς I," Κυπριακαὶ Σπουδαί, IV (1940), 17-32.

west. [22] The crusaders found in the island a tradition of fresco work that was already a distinguished one. In the mountain church of Asinou in the Troödos forest, there is a series of paintings which show the persistence of this school. Remote and somewhat inaccessible, away from Latin ecclesiastical centers, a place of country pilgrimage and originally founded in 1106 (as a dated painting of the donor proves) by a Magister Nicephorus, possibly a member of the Comnenus family, it remained little affected by the Lusignan world, but its frescoes, by script or actual date, can be ascribed to the early twelfth, mid-thirteenth, and mid-fourteenth century. The earliest, particularly that of the Dormition, are the finest, but the Praying Virgin of about 1250 is a noble work with little provincial hesitancy about it.

Of the major frescoes of the Frankish period nothing now remains, or at least is visible, for there are possibilities of survival behind the whitewash of Hagia Sophia and St. Nicholas of Famagusta, and in the latter a shadowy painting of the Crucifixion can still be seen. Famagusta in fact seems to have had a considerable school of painters. Blackened and mutilated, long used as targets by Turkish children, fragments of paintings cling to the walls of its ruins. The south chapel of the Franciscan church had in Enlart's day the figure of a knight standing by his horse, possibly the founder of the chapel, but this has now disappeared. Much of the painted work seen by him in St. Mary of Carmel has also perished. The frescoes in the churches of St. Anne, St. George of the Greeks, and the Nestorians are now the best preserved, and the heads of some of the saints in St. Anne's are particularly fine. Here the titles are in Latin; elsewhere in the town, as in St. George of the Greeks and the Armenian church, the inscriptions use the respective languages, though the paintings still belong to this Italo-Byzantine style.

It is, however, the richness of some of the smaller village churches that remains surprising. The chapel of the Virgin above the village of

22. G. A. Soteriou. Τὰ βυξαντινὰ μνημεῖα τῆς Κύπρου, I (Πραγματεῖαι τῆς Ἀκαδημίας Ἀθηνῶν, Θιλολογικὴ-Ἱστορικὴ Σειρά, vol. III; Athens, 1935); W. H. and G. G. Buckler, "Dated Wall-Paintings in Cyprus," Université libre de Bruxelles, Annuaire de l'Institut de philologie et d'histoire orientales et slaves, VII (1939-1944, New York, 1944), 47-70; W. H. Buckler, "Frescoes at Galata, Cyprus," Journal of Hellenic Studies, LIII (1933), 105-110; Bishop of Gibraltar, V. Seymer, W. H. and G. Buckler, "The Church of Asinou, Cyprus, and its Frescoes," Archaeologia, LXXXIII (1933), 327-350; A. and J. A. Stylianou, The Painted Churches of Cyprus (Cyprus, 1964); Cyprus: Byzantine Mosaics and Frescoes, preface by A. H. S. Megaw, introduction by A. Stylianou (UNESCO World Art Series, 20; Greenwich, Conn., 1963); M. Sacopoulo, Asinou en 1106 et sa contribution à l'iconographie (Brussels, 1966).

Moutoullas has frescoes including portraits of the donors, John and Irene Moutoullas, dated 1279; these are purely Byzantine in conception. Away from the chief towns Greek patronage was still active, and it continued to be so, though gradually western settlers came to use Greek inscriptions and it is not always possible to distinguish with certainty the creed of the founder. By the fifteenth century, queen Charlotte wrote French with difficulty, as it was to her a foreign language. The well-preserved paintings of the church of the Archangel Michael at Pedhoulas, built in 1474-1475 by Basil Chamades, are an example of this enduring tradition; here the original iconostasis survives, more open than in later examples and painted with the Lusignan arms. The year in which the church was built and probably decorated was that in which James II married Catherine Cornaro; soon the Lusignan arms would no longer be significant. Kakopetria, in its chapel of the Virgin, has a series of frescoes dating from 1520, with the donors, under their Greek inscription, looking solidly Venetian in dress and type.

Even in the villages, however, some of the painting was carried out under Latin patronage. Pelendria has a small church with a double nave, the second probably added for the Latin rite. The donors are in fourteenth-century costume and their escutcheons make it almost certain that they are portraits of John de Lusignan and his wife, the prince murdered by the bravoes of Eleanor of Aragon, as the queen held before him the bloodstained shirt of her husband Peter I. As ill-fated in their associations are the frescoes of Pyrga, where king Janus and his queen, Charlotte of Bourbon, kneel at the foot of the cross. The chapel of the Passion at Pyrga probably formed part of a royal manor and must have been built by Janus shortly before the Mamluk invasion of 1426 swept over the south of the island and he himself fell a captive into their hands on the battlefield of Khirokitia. There was little time for him to build after that. The frescoes are poor enough, local works in the Byzantine manner, curiously at variance with their French titles, "La Pentecouste," "La Cene dou Jeusdi saint." More notable and vigorous are the paintings at Yeroskipos, which from their costumes and armor must date from about 1400, and which are certainly western in their inspiration. The church of St. John Lampadhistis at Kalopanayiotis has, in a Latin chapel attached to the earlier Byzantine building, a well-preserved series of frescoes which, though with Greek inscriptions, clearly show Italian influences.

A similar process can be seen in the surviving medieval icons of the

island.[23] In the church of St. Cassianus at Nicosia, one of the richest repositories of this type of work, the Virgin stretches out her robe in protection of a group of Latin monks; the much-damaged border scenes may be from some Carmelite legend. Tradition affirms that this painting came from Hagia Sophia, and its style and importance (it is 79 inches by 61 inches in size) make this seem probable enough. The Madonna is crowned, an Italian rather than Byzantine custom, and it seems more likely that the design is influenced by Tuscan work of the thirteenth century than that it is a pure example of the Greek style from which Tuscany borrowed so largely. The noble icon of St. Nicholas in the church of the same name at Kakopetria is almost certainly by the same hand and corresponds in size and technique, but whereas the scenes of the legend in the former have Latin titles, here they are in Greek. The armor of the knight kneeling at the feet of St. Nicholas suggests a date toward the close of the thirteenth century.

Among the outstanding icons of Nicosia are a series of tall, narrow panels, formerly in the church of the Panagia Chrysolaniotissa, now in the collection of icons in the annex of the church of the Phaneromene. That of Christ blessing, with a group of donors below, is inscribed in Greek to the memory of Maria, daughter of the lord Manuel (died 1356). The portrait figure of this young girl, in an elaborate red dress with a pattern of stars and goldfish, is one of the loveliest pieces of painting on the island. All these panels are of high quality, suggesting the work of an artist from Constantinople or some artistic center such as Mistra, rather than the Greek milieu, still a somewhat dependent one, of Cyprus. Finest perhaps of all the Cyprio-Byzantine panels, though it lacks the charm and individuality of the Chrysolaniotissa pieces, is one, again in the church of St. Cassianus, of the Ascension, a vigorous piece with the strong colors characteristic of the island's art. It dates probably from the reassertion of Byzantine influences at the end of the fifteenth century. In Cyprus as in Crete, Venetian domination seemed favorable to the formation of a local Byzantine school.

23. D. Talbot Rice, *The Icons of Cyprus* (Courtauld Institute Publications on Near Eastern Art, no. 2; London, 1937); A. Stylianou, "An Italo-Byzantine Series of Wall-Paintings in the Church of St. John Lampadhistis, Kalopanayiotis, Cyprus," *Akten des XI. internationalen Byzantinistenkongresses, München, 1958*, ed. F. Dölger and H. G. Beck (1960), pp. 595-598. Some color reproductions have been published by A. Papageorgiou, *Icons of Cyprus* (Geneva, 1969). The fate of some of these icons remains unknown as a result of the damage done to Nicosia in recent (1974) fighting [J. F.].

There remains one branch of painting about which little is known, the art of illumination. Fine manuscripts were prized in Cyprus, but it is uncertain whether or not there was a local school for their production. When queen Charlotte, in the course of her long appeals to Rome, made a present to Innocent VIII, it was a manuscript of the Acts and the Epistles (now Vatican Gr. MS. 1208). The script appears to be of the twelfth century, but the miniatures, figures of apostles finely painted on a gold ground, are almost certainly later and may have been added to the manuscript shortly before Charlotte presented it. Another manuscript, the Hamilton Psalter with Greek and Latin text (No. 78 A.9 in the Kupferstichkabinett at Berlin), has an inscription "isto libro la regina Charlotta de Jerusalem de Chypre et de Armenie" which has been questioned, not altogether convincingly, as a forgery. The numerous paintings, Byzantine in style, are of considerable quality, though much damaged; in one of them a lady and her consort kneel before an icon of the Virgin. Particularly fine is a marginal painting of the Ascension to illustrate Psalm XVII, "et ascendit super cherubim"; Cyprus seems a likely place of origin. [24] In the Bodleian Library there is a manuscript (MS. Laud Misc. 487) where the arms of Savoy are supported by two angels, figures obviously painted under Byzantine influence. This may also have belonged to Charlotte, whose husband was Louis of Savoy, or it may be associated with the lavish and extravagant Anna, daughter of Janus, who married Louis of Geneva, the son of Amadeo VIII of Savoy, in 1434. These same ladies are, with their Savoyard connection, the possible channel through which another manuscript passed into the library of Margaret of Austria, wife of Philibert II, and from there to the Bibliothèque royale in Brussels (MS. 10175), [25] the *Histoire universelle* of Bernard of Acre, which has already been discussed in connection with the Acre scriptorium. After the writer's name, in the colophon, comes the date 1432 and the notice of the birth of a daughter, "Goza de Lezenian," to whom Janus and his daughter Anna stood sponsors. The book therefore belonged to some

24. Hill, *History of Cyprus,* III, 613, note 6; P. Wescher, *Beschreibendes Verzeichnis der Miniaturen . . . des Kupferstichkabinetts der staatlichen Museen, Berlin* (Leipzig, 1931), pp. 25-30. See also H. Belting, *Das illuminierte Buch in der spätbyzantinischen Gesellschaft* (Heidelberg, 1970), pp. 5-6 and note 12 with relevant bibliography [J. F.].

25. A. Bayot, "Les Manuscrits de provenance savoisienne à la Bibliothèque de Bourgogne," *Mémoires et documents publiés par la Société savoisienne d'histoire et d'archéologie,* XLVII (Chambéry, 1909), 372-375. For Bodleian MS. Laud Misc. 487 see O. Pächt and J. J. G. Alexander, *Illuminated Manuscripts in the Bodleian Library, Oxford*; vol. II, *Italian School* (Oxford, 1970), p. 88, no. 884, and pl. LXXVIII.

member of the royal house, possibly Janus's bastard son Phoebus, who was to be the most loyal supporter of his unhappy niece Charlotte.

It was in Venice, as much a meeting place of east and west as Cyprus or Acre, that there was being produced in the early fourteenth century another group of manuscripts with close crusading associations, copies of Marino Sanudo's *Secreta fidelium*, which that industrious propagandist was preparing for circulation to the western rulers. There are two splendid examples in the Bibliothèque royale at Brussels (MSS. 9347-8 and 9404-5), each with a dedicatory letter to Philip VI of France dated 1332 and practically replicas of one another. They are illustrated with maps and scenes of crusading combat. The British Library's *Secreta* (MS. Add. 27376) is a somewhat similar production of the same book, and the Bodleian copy (MS. Tanner 190) addressed to Robert of Boulogne, count of Auvergne, is a less lavish version of the same type. Another Bodleian manuscript (MS. Laud Misc. 587), a copy of Villehardouin's *Histoire de la conquête de Constantinople*, seems to be the product of the same workshop; it has a lively scene of the attack on the city, where the heraldic emblems recall those used in the Arsenal Bible, as also in the copies of the *Histoire universelle*. Philip of Mézières's illustrations of his new crusading order, the Order of the Passion, are purely western work, commissioned by him after he had left Cyprus following the murder of his hero, Peter I.[26]

Frescoes, tomb slabs, and paintings give us some visual picture of the costumes and manners of the Franks in Cyprus. Travelers and chroniclers give many verbal descriptions of the splendid festivities of the island: the entertainments of Francis Lachas at Famagusta for Peter I when four men carried in a dish loaded with precious stones, sweet-smelling aloes were burned in the chimneys, and eighty silken carpets were laid on the floors; the splendors of the royal palace; the gardens filled with strange beasts; the sumptuous equipment of the churches. All this has disappeared, carried off in Turkish vessels or destroyed in earlier plundering raids. Of the lesser arts there is hardly any survival. A fine copper enameled bowl of Arab work inscribed in

26. British Library, MS. Royal 20 B. VI, and Bodleian Library, MS. Ashmole 813; see Maude V. Clarke, *Fourteenth Century Studies*, ed. L. S. Sutherland and M. McKisack (Oxford, 1937), pp. 286-292. For the Tanner and Laud manuscripts see Pächt and Alexander, *Illuminated Manuscripts*, II, 12, no. 118 (MS. Tanner 190) and pl. XI; no. 120 (MS. Laud Misc. 587) and pl. XI [J. F.]

French and Arabic as made for "Hugh of Jerusalem and Cyprus," most probably Hugh IV, and a somewhat similar bowl with the Lusignan arms, also Arab work, serve as reminders that not all relations with Islam were hostile.[27] Famagusta cathedral still retains iron candelabra, somewhat similar to that which survives from the Dome of the Rock. A small cypress-wood box with metal medallions was seen by Enlart in a private collection in France, with an inscription that it was made in Cyprus. Many such small objects must have been exported, and doubtless among the medieval collections of western museums there are pieces of Cypriote origin without identifying marks. The great export, however, was in woven stuffs and embroideries, of which only fragmentary examples are known, and the bulk of which must have perished in the course of time.[28]

Pottery has been somewhat more lasting, and through a Cypriote custom of burying a bowl in a grave many examples have survived, with designs, many of them figure subjects, drawn in graffito through a white clay slip, colored with greens, yellows, and browns, and completed with a transparent glaze. It is a type of pottery that seems to have had its main center at St. Simeon, the port of Antioch, but fragments of similar ware have been found, along with Cypriote coins, in excavations at the Palestinian castle of Château Pèlerin. It recurs at Corinth and at some Hohenstaufen sites in south Italy, and may prove to be a valuable guide to the dispersion of crusading influences. In Cyprus the great days of the craft appear to have been the fourteenth century, and it may well have owed much to refugees from the Syrian mainland. In the late fifteenth and sixteenth century it seems to have given way before the importation of pottery from Italy. A popular art, it catered mainly for Greek customers, and any lettering that occurs is Greek, but the scenes and costumes have the usual echoes of the Latin settlement. A bowl in a private collection, showing a knight embracing his lady, has something of the light-hearted gaiety, the love of splendid clothes, which made Cyprus

27. H. R. d'Allemagne, "Notice sur un bassin en cuivre exécuté pour Hugues IV de Lusignan, roi de Chypre (1324-1361)," in Enlart, *L'Art gothique,* II, 743-756.

28. An example of the sumptuous materials and skillful work that characterized Cypriote ateliers is an altar frontal now in Berne. Except for the later end panels, the crimson silk altar frontal was commissioned by Otto of Grandison as a thank-offering for his personal survival of the final siege of Acre in 1291. See M. Stettler, *Bildteppiche und Antependion im Historischen Museum, Bern* (Berne, 1959), sect. IVA with plates, catalogue list, and bibliography (no pagination). [J. F.]

despite all its misfortunes the envy, or the scandal, of the western world.[29]

29. Catalogue, *Loan Exhibition: Medieval Cypriot Pottery from the collection of Mr. Christakis Loizides* (Cyprus Museum, Nicosia, 1947) p. 6, no. 6, and fig. 4; J. du Plat Taylor and A. H. S. Megaw, "Cypriot Glazed Medieval Pottery: Notes for a Preliminary Classification," *Report of the Department of Antiquities, Cyprus, 1937-1939* (Nicosia, 1951), pp. 1-13. See also C. N. Johns, "Medieval Slip-ware from Pilgrim's Castle, 'Atlīt (1930-1)," *Quarterly of the Department of Antiquities in Palestine*, III (1934), 137-144; A. Lane, "Medieval Finds at Al Mina in North Syria," *Archaeologia*, LXXXVII (1938), 19-78; and J. S. P. Bradford, "The Apulia Expedition: An Interim Report," *Antiquity*, XXIV (1950), 84-95. Additional crusader pottery has been reported from Cyprus; see J. Herrin, "Appendix: Kouklia 1972–The Medieval Pottery," *Report of the Department of Antiquities, Cyprus, 1973* (Nicosia, 1973), pp. 199 ff., and J. D. Frierman, *Medieval Ceramics VI to XIII Centuries* (Frederick S. Wight Art Gallery, University of California, Los Angeles, 1975), p. 26; the latter also covers pottery from the mainland crusader states (pp. 39-54). [J. F.]

B. Military Architecture

Of military architecture in Cyprus there has survived from the Frankish kingdom a varied heritage, ranging from town defenses to hilltop fortresses and isolated watch-towers; much more has disappeared. One type, the baronial castle, which had been a feature of the crusader settlements on the mainland, does not recur in Cyprus. The castles which the Byzantines surrendered to Richard passed to the crown on the establishment of the kingdom, under which castellation, like coinage, was a royal prerogative; only the military orders were permitted to possess castles of their own.

In Nicosia, the capital, nothing has survived above ground of the Lusignan fortifications, which the Venetians demolished in 1567 to build the present ramparts and bastions on a smaller circuit. The walls of the city were evidently derelict at the conquest, but it had near its center a Byzantine keep, where the Templars had to defend themselves in 1191. This was doubtless the castle which Wilbrand of Oldenburg saw being rebuilt in 1211; the *teichokastron*, begun by Henry II and still under construction in 1340,[1] was perhaps connected with it. The site of this "old castle"—on which the church of St. Clare, known as Castigliotissa, was later erected—has not been identified. The Frankish city walls, circular in plan with round towers, a ditch, and eight gates, were started under Peter I and hurriedly completed on the approach of the Genoese in 1372. Peter I also left incomplete a moated outwork to the south, known as the Margarita tower, in which it was said he planned to incarcerate his enemies. This was demolished, at least partly, with other buildings in 1376, when Peter II started work on a new citadel. This seems to have taken the form of a curtain wall encircling an extensive area adjoining the south sector of the city wall and including the royal court and the monastery of St. Dominic. It extended from the neighborhood of the present Paphos gate, outside which a short stretch of wall with a projecting rectangular tower has been found, to the Hagia Paraskeve gate, which was incorporated in it. In the citadel

1. Laurent, *Peregrinatores,* p. 181; Machaeras (ed. Dawkins), I, 43 and 71.

196

James I added royal apartments, which were completed in 1426 by Janus, to replace the palace which the Mamluks had burnt.

In Famagusta the Venetians were less drastic and contented themselves for the most part with the line of the existing Frankish town defenses, strengthening or rebuilding them as the requirements of artillery warfare dictated. Consequently much of the fourteenth-century citadel and town walls has survived, incorporated in the Venetian work. The citadel bestrides the sea wall and runs out to form one side of the harbor entrance, at the other side of which was the chain-tower, at the end of the breakwater.[2] It is a compact castle of modest size and replaces an earlier tower,[3] possibly the work of Guy of Lusignan; like the town wall, it dates from the reign of Henry II, when the loss of Acre and the influx of crusader refugees called for the strengthening of Famagusta's defenses. The work was pressed forward by Amalric during his usurpation, and evidently completed before his death in 1310, when the city declared for the king and was put in a state of defense, with the gates walled up and the drawbridges demolished.[4] It is unlikely that any important alterations were made before the Genoese invested the city in 1373. The sea gate to the citadel, through which their troops treacherously entered, on the heels of the envoys who were admitted to negotiate, has disappeared either in the Venetian remodeling or in the course of improvements which the Genoese themselves carried out during their 92-year occupation of the city. The latter included the cutting of a moat, filled by the sea, to isolate the citadel from the rest of the town. The town walls which Nicholas of Martoni saw in 1394—"high with broad alleys round them, and many and high towers all round"[5]—were probably much as they had been built nearly a hundred years earlier. Some modernization may have followed the first appearance of artillery in Cyprus, in 1404, when Janus besieged the Genoese in Famagusta and both sides used cannon furnished by Venice. Of such Genoese modernizations little is to be seen—some primitive circular gun-ports inserted in the earlier work may belong

2. Enlart, *L'Art gothique*, II, pl. XXII.

3. Estienne de Lusignan, *Chorograffia*, p. 49b, attributes its foundation to Guy of Lusignan; it was surrendered to Philip of Novara on the return of Henry I to the island in 1232 (*Gestes des Chiprois*, pp. 93 and 98). Part of it may survive in the wall and gateway below the floor in the undercroft of the great hall in the citadel, discovered by Mr. Mogabgab in excavations for the Cyprus Department of Antiquities.

4. Amadi, *Chronique*, p. 335.

5. "Relation du pèlerinage de Nicolas de Martoni, notaire italien (1394-1395)," ed. L. LeGrand, in *ROL*, III (1895), 628.

to them—and where the medieval work has been spared in the Venetian improvements, it dates in most cases from the original construction of the early fourteenth century.

A stretch of the sea wall north of the citadel is in something like its original condition; the octagonal Diamante tower at the angle has survived internal alterations. Standing on a conical base, into which the octagon interpenetrates, two stories survive, the lower built in bossed masonry. The Signoria tower next to it is almost intact, with its two superimposed vaulted chambers linked by a stair in the thickness of the wall. A landward extension contains a gateway which formerly gave access to the beach. The curtain wall between these two towers, patched externally and thickened on the town side, is also largely original, while in the sea, some hundred yards from shore, is the artificial reef designed to keep enemy vessels at a distance. Elsewhere, between the Venetian bastions, can be seen stretches of the original curtain, distinguished by their slender arrow-slits, notably in the south wall, in parts of which two superimposed rows of embrasures exist below the Venetian battlements. Finally, in the heart of several of the bastions can be seen the masonry of the original Frankish towers around which they were formed.

In the citadel, within the sheath of early Venetian bastions and ramparts, much of the Frankish fortress remains, ranged round the four sides of a small rectangular courtyard with square towers at the corners. That at the southeast angle was pierced by the Venetians to serve as the entrance, replacing the earlier landward gateway, traces of which can be seen in a section of the original south curtain adjoining this tower. The undercroft of the great hall on the north side comprising five cross-vaulted bays is the principal surviving feature, which, as the Jerusalem crosses carved on the bosses indicate, is part of the pre-Genoese fortress. In the Venetian rampart raised over this undercroft the plan of the upper chamber, with triple-engaged colonettes dividing the bays, has been recovered by excavation. Of the east range, which was demolished to extend the courtyard when the entrance was moved, only the main (east) wall survives.[6]

At Limassol the kingdom inherited a Byzantine castle, which Frederick II made his headquarters in 1228, unless a Frankish

6. Outside this wall Mr. Mogabgab's excavations have revealed an alley closed on the east by an outer wall with a "chemin-de-ronde" corbeled onto its inner face. The space between the inner and outer walls was filled later to form the artillery rampart.

building had meanwhile replaced it. This early castle, which seems to have passed to the Templars, only to revert to the crown on their suppression, was destroyed when the Genoese sacked the town in 1373. The new castle, variously attributed by the chroniclers to James I and to Janus, was constructed in the shell of a thirteenth-century church; despite the destruction of the upper part by the Mamluks in 1425, much of it has survived within the plain Turkish exterior of the existing building. The western bay of the church was turned into a keep of three or more floors, rising above the rest of the building, as is proved by a slender arrow-slit surviving in the upper part of its east wall.

The two castles on the sea wall at Paphos were minor works, if we may judge by the remains of the landward one incorporated in the Turkish fort: a small tower enclosed by a walled yard on three sides.[7] At Larnaca the earlier structure incorporated in the corresponding Turkish building may well be part of the tower and lodging burnt in 1425.

All these, including even the Famagusta citadel, are minor works beside the Frankish fortress at Kyrenia, which despite Venetian additions and modern disfigurements remains the most imposing military monument of the Lusignans.[8] The castle stands on a blunt peninsula between two small bays, the westward forming the harbor proper and the other a larger anchorage originally closed by an artificial reef but for a single narrow opening. The reef survives where it passes in front of the north wall of the castle to join the east breakwater of the harbor, of which the trace and the terminal chain-tower have been spared in the modern extension of the harbor. Of the walled *bourg*, which lay to the south and west, three Frankish towers survive: that at the southwest angle, circular and constructed in massive bossed masonry; to the north of it, a machicolated tower, evidently one of a pair flanking a west gate constructed in the late fourteenth or fifteenth century; and the third, also circular, at a reëntrant of the curtain wall which separated the town from the

7. On the landward Byzantine-Lusignan fortifications at Paphos harbor, northeast of the Turkish fort, see A. H. S. Megaw, "Excavations at Saranda Kolones, Paphos: Preliminary Report on the 1966-67 and 1970-71 Seasons," *Report of the Department of Antiquities, Cyprus, 1971* (Nicosia, 1971), pp. 117-146, and *idem*, "Supplementary Excavations on a Castle Site at Paphos, Cyprus, 1970-71," *Dumbarton Oaks Papers*, XXVI (1972), 322-344. [J. F.]

8. This summary and the plan (fig. 11) incorporate the results of a survey carried out for the Cyprus Department of Antiquities, in the summer of 1948, by Mr. C. N. Johns and Mr. J. S. Last.

harbor. A wide ditch isolates the castle on the south and west, on which latter side it separates the castle from the town. Probably this is the Venetian enlargement of a Frankish or earlier ditch, the southern arm of which would have been continuous with that which ringed the town.

On the castle site the Lusignans took over an early Byzantine fortress, originally an enclosure about 264 feet square with hollow angle-towers of circular form, to which was added on the south a massive outer curtain with solid pentagonal towers. Dating from the period of the Arab wars or earlier, a considerable section of the pre-Frankish castle is still visible at the south end of the present courtyard, where the outer Byzantine wall now serves to retain the south and west ramparts on the inner side (fig. 10). An entrance in the outer south curtain is flanked by two couchant lions in relief and surmounted by a third, which, like the column drums and other blocks reused in the extremely irregular masonry, may well be of earlier date. At the northwest corner, reaching out toward the harbor, there seems to have been a salient within which the chapel, later known as St. George of the Donjon, was erected, probably in the twelfth century. The outer wall enclosing this salient probably ran on southward to enclose an outer ward along the west wall, corresponding to that on the south. We can hardly doubt that in the main it was this Byzantine castle which Wilbrand of Oldenburg saw in 1211 and in which the imperial faction were besieged in 1228 and 1232. The earliest Frankish repairs and improvements are, however, attributable to this period. Such are the upper story of the original inner northwest tower and perhaps the vaulted undercroft to the north of the gateway in the west range, built within the line of the Byzantine curtain.

At a later date much more drastic improvements were undertaken in ashlar masonry akin to thirteenth-century work on the Syrian mainland. These improvements form a single conception but were executed piecemeal, and in part at least must date from the turn of the century, when the kingdom's defenses were strengthened upon the fall of Acre. At this stage the Byzantine walls on the north and east were entirely replaced, the former by a high curtain with two fighting galleries below the parapet and the latter by a similar curtain, to judge from what remains of its fighting gallery at the courtyard level and the ruins of an intermediate tower which had an upper story. The eastern fighting gallery is backed by, but otherwise unconnected with, a lofty vaulted range which was divided by wooden floors into an upper story of residential chambers and a

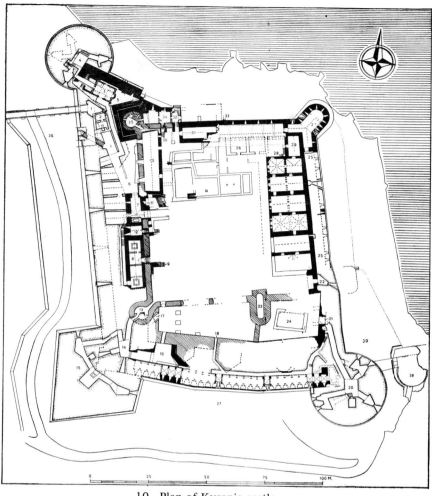

10. Plan of Kyrenia castle

Hatched walls = Byzantine castle

Black walls = Frankish reconstructions and addittions

Dotted walls = Venetian reconstructions and addittions

1— Entrance passage.
2— Guardroom.
3— Byzantine Chapel.
4— North-West Tower.
5— West Ward (north end).
6— West Ward (centre).
7— Gate-House (chapel over).
8— Undercroft with oubliettes.
9— To West Range (upper storeys).
10— Early Frankish Undercroft.
11— To Gate-House (middle storey).
12— Vaulted cell.
13— South-West Tower (Byzantine).
14— West Ward, South End (Venetian gun-chamber).
15— South-West Bastion.
16— South Ward.

17— To South-West Bastion (lower level)
18— To South Fighting Gallery.
19— Venetian Gallery.
20— South-East Tower.
21— Gate to East Outwork.
22— Gun-Chamber (site of Frankish tower).
23— Horseshoe Tower.
24— Water Tank.
25— East Fighting Gallery.
26— North Range (foundations).
27— North-East Tower.
28— North-East Staircase.
29— Chamber with reconstructed floor.
30— North-West Staircase.
31— Undercroft.
32— Postern Gate.
33— Site of Frankish Postern.
34— Forebuilding.
35— Inner North-West Tower.
36— West Ditch.
37— South Ditch.
38— Base of Tower.
39— Site of East Outwork.

lower series of rooms at courtyard level. Basement cisterns and some
traces of an external wooden gallery overlooking the courtyard and
providing access to the upper chambers have also survived. The
arrangements within the north fighting galleries were evidently
similar. At the northeast angle the fighting galleries meet in a
horseshoe tower of two stories, where a development may be noted
from the simple embrasures of the lower level (shown on the plan,
fig. 10) to the recessed form of those above. The latter form recurs in
the single remaining gallery of the south curtain, which was erected
well outside the line of the outer Byzantine curtain and the towers
attached to it. The Venetian tower constructed at the southeast angle
has obscured the earlier arrangements at this point, but they
evidently included access to the sea through a gate in the east
curtain, the landward approach to the foreshore being blocked by a
wall running out to a terminal tower washed by the sea. In the lowest
level of the Venetian southwest bastion the third angle of the
Frankish fortress can be seen, at the point of junction of the present
south and west curtains, without any surviving trace of a corner
tower. The position of this angle suggests that on the west the
Frankish curtain coincided with the outer Byzantine wall, and that
the present west wall, of Venetian date, in turn followed the
Frankish line. The latter reappears at the north end where it sheathes
the Byzantine salient towards the harbor, but at no point have its
fighting galleries survived.

The Frankish entrance from the town was probably at the point in
the west wall where the present one was constructed by the
Venetians. It would have led into an outer court or barbican, with
the chapel of St. George standing at its northern end. Projecting into
the barbican from the inner Byzantine west wall, a gatehouse
encloses the L-shaped entrance to the main courtyard, constructed in
the massive masonry of the later Frankish style. The southern end of
the barbican is now filled by the ramp which the Venetians
constructed to reach their ramparts; originally it extended as a level
approach to the southwest corner of the castle where a wide
gateway, still almost intact, led to the spaces between the outer
Byzantine and the Frankish south curtains, from which the south
fighting gallery was reached. At the north end the barbican was
commanded by a strong rectangular tower encasing the original
northwest angle tower and itself buttressed by later masonry. This
tower stands forward from the main line of the north curtain; at the
angle where the latter is bent northward to close with it a postern
leads to the northern foreshore. Here traces of a small protecting
barbican are to be seen, and, on the main curtain, the corbels of a

projecting brattice which covered the entrance in its east wall. In its final Frankish form the castle is thus seen to conform with the principle of concentric planning so far as circumstances permitted; the outer ward was ample only on the west, cut up by the Byzantine towers on the south, and on the north and east reduced at least in part to the dimensions of fighting galleries isolated from the domestic accommodation within them.

Within these strong defenses, which in 1374 withstood all efforts of the Genoese to penetrate them, was the royal residence, used by queen Eleanor during the siege and by James I, who as constable had defended the castle, after his return from captivity in Genoa. Something of these royal apartments remains in the upper part of the west range, which to the south of the gatehouse backs onto the original Byzantine curtain and which would have been screened by the outer west wall. The chapel was in the third story of the gatehouse, lit by large windows opening on the barbican, and there were other chambers to the south communicating with it, but also reached and bypassed by a stone gallery corbeled onto the inner wall. Access to the stairs by which the gallery was reached from the yard was controlled by a gate leading to an alley between the northern section of the west range, constructed within the Byzantine wall, and the domestic quarters which occupied the northern part of the yard but of which only the foundations remain. South of the gatehouse in the west range survives an undercroft of three cross-vaulted bays, itself raised on basement vaults entered from both the courtyard and the barbican. In the floor of these basements are two shafts opening out below the neck into the virgin rock, perhaps the "grotte oscurissime et horrende" where the supporters of the usurper Amalric were thrown in 1315 to starve to death.[9]

The damage sustained in the siege of 1374 was evidently made good by local repairs which did not affect the layout of the castle. Nor is there any evidence of new works after the castle was surrendered to James II, who in 1460 had attacked this last stronghold of Charlotte and Louis with artillery. It remained for the Venetians to attend to the modernization of the fortress.

The treaty assigning Famagusta to the Genoese introduced the new feature of a land frontier, to defend which James I built the castle of Sigouri in 1391, a typical castle of the plain, rectangular with square towers at the angles and a ditch filled seasonally from

9. F. Bustron, *Chronique de l'île de Chypre,* ed. R. de Mas Latrie (Collection de documents inédits, Mélanges historiques, 5; Paris, 1886), p. 245.

the Pedias. Of its masonry nothing is now visible. James also improved the castle of La Cava, which had been built by Peter II at the Nicosia end of the route to Larnaca, whose importance as a port increased with the loss of Famagusta. Built across the narrowest point of a long plateau which was cut by a ditch, its meager ruins constructed in very massive bossed masonry are noteworthy for their conservative character: two massive towers linked by a curtain, recalling the early thirteenth-century sea castle at Sidon.

If we pass over the isolated watch-towers, of which the best preserved, at Kiti, is of Venetian date, there remain only the three hilltop castles of the Kyrenia range—St. Hilarion (Dieudamour), Buffavento, and Kantara—and what little survives of the fortifications erected by the military orders. The three castles were first built by the Byzantines, probably not before the opposite Cilician coast was overrun by the Selchükids and perhaps as part of the measures taken by Alexius I for the greater security of the island after the revolt of 1092. Only at St. Hilarion does much remain of the original work (fig. 11). Here there have survived from the Byzantine castle

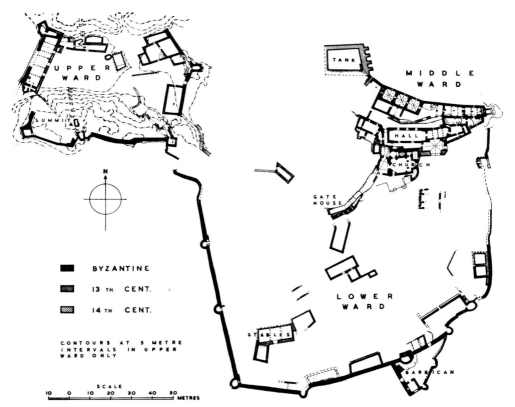

11. Plan of St. Hilarion

the main entrance, reduced by a later Frankish arch, and the carved
corbels of the brattice which overhung it, the greater part of the
encircling walls at all levels with their semicircular towers and, in the
middle ward, much of the gatehouse, the church, and chambers
immediately adjoining it. The earlier Frankish improvements and
additions, such as the rampart on the summit with its rectangular
towers characterized by flat terrace roofs on timber, may date from
the Lombard war, when first the imperial faction and then Henry's
supporters were besieged here. The later and more substantial
Frankish additions and reconstructions, for which a fourteenth-
century date is indicated, had either steep-pitched wood-and-tile
roofs, as in the case of the hall in the middle ward and the royal
apartments in the upper, or like the undercroft of the latter building
and the "belvedere" were covered with barrel or cross-vaults.

At Buffavento and Kantara the same characteristics are to be seen,
except that the Byzantine work is less in evidence. Of the two,
Kantara better illustrates the work of the Lusignan castle-builders
(fig. 12). It is a walled enclosure as regular as the site permitted, with
barrel- and cross-vaulted quarters attached to the curtain. On the
more accessible eastern side there is a double line, forming a barbican
about the entrance. Both lines run out on the flanks to horseshoe
towers, forming an ensemble as dramatic as it is effective for defense

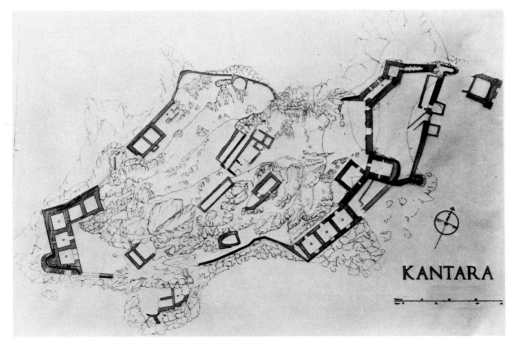

12. Plan of Kantara

(pl. LXa). Though the towers recall the semicircular contour fa-
vored in local Byzantine work, the castle seems to date in the main
to the fourteenth century. James I is known to have put the finishing
touches to it as part of the encirclement of the Genoese in
Famagusta.

In contrast to their splendid fortresses in Syria, the military orders
have left scant remains in Cyprus. Of the Templar castle at Gastria on
the north side of Famagusta bay only the rock-cut ditch remains,
which is to be regretted, as it was probably the first all-Frankish
castle to be built on the island, mentioned as early as 1211. Of the
tower at Khirokitia, where the marshal of the Temple was impris-
oned when the order was disbanded, little remains above ground. The
Hospitallers have left, at Kolossi, the keep which was erected as the
grand commander's headquarters in the mid-fifteenth century. With
its drawbridge, machicoulis, and battlements, which make no
provision for artillery, it is a fitting representative of the later Middle
Ages, unconnected with the defense of the kingdom but built for the
security of a great landowner in troubled times. The ornamentation
of the fireplaces is closely modeled on the contemporary carving of
the buildings of the knights in Rhodes.

To sum up the achievements of the Lusignans in this field, it can
be said first that no general program of fortification was undertaken
on the establishment of the Franks on Cyprus. They inherited from
the Byzantines a network of useful if somewhat outmoded fortresses,
which were only gradually supplemented, improved, or replaced.
Surviving thirteenth-century works are on a modest scale and owe
not a little to the local Byzantine tradition. The big effort was made
after the fall of Acre. It extended well into the fourteenth century,
and it had behind it the experience of the builders of the great castles
in Syria and the fine masonry tradition of that country.[10] To it
belong the walls and citadel of Famagusta, and to it we may attribute
the main Frankish works of Kyrenia, which might reasonably be
styled the last of the great crusader castles. With the prosperous years
of the mid-fourteenth century came a greater, though mistaken,
sense of security, reflected in the spacious residential accommoda-
tion added at St. Hilarion and Kyrenia. The Frankish walls of Nicosia
were indeed started at this time, but they neglected an elementary
principle of security in their multiplicity of gates, of which there
were no fewer than eight. The misfortunes which assailed the

10. The inspiration was not, however, exclusively Syrian. The steep-pitched tiled roofs
used at St. Hilarion reflect the direct influence of European practice.

kingdom with the coming of the Genoese did not at first affect the work of its castle-builders, who seem to have dealt promptly and effectively with the new problem of a land frontier. The scale and workmanship of what remains of La Cava are most impressive, and we must regret the destruction of the contemporary citadel in Nicosia. Nevertheless, there are conservative features in these later works indicating that the builders followed the thirteenth-century tradition of *outremer* rather than contemporary work in Europe. From the later disaster of the Mamluk invasion and the burden of the Egyptian tribute there could be no real recovery. Thus the fifteenth century passed without the erection of any important military monument, and it was left to the Venetians to convert the high-walled fortresses of Famagusta and Kyrenia so that they could mount and sustain artillery bombardments.

VI

THE ARTS IN FRANKISH
GREECE AND RHODES

A. Frankish Greece

The territories of the Latin empire created after the fall of
Constantinople in 1204 were always somewhat ill defined. In Asia
Minor the Greeks maintained their rallying point at Nicaea, and in
Europe little was secure against Bulgarian inroads north of Adria-
nople or west of the Maritsa valley. Epirus was never conquered, and
the kingdom of Thessalonica was wrested from the Franks by the
Epirote ruler Theodore in 1224; Thessaly remained debatable
ground; only in Phocis, where the marquisate of Bodonitsa guarded

Much of this section is based on the notes and the corpus of photographs made by David
Wallace in the four years before the second world war, at a time, remote as it is, when this
corporate history of the crusades was already being discussed. Wallace was killed in an
attack on a German fortified post at Menina, near Preveza, in August 1944. His photographs
are deposited at the Courtauld Institute of Art in the University of London.

The articles by C. Enlart, "Quelques monuments d'architecture gothique en Grèce,"
Revue de l'art chrétien, ser. 4, VIII (1897), 309-314, and by R. Traquair, "Frankish
Architecture in Greece," *Journal of the Royal Institute of British Architects,* ser. 3, XXXI
(1923), 34-48, 73-83, are the only general surveys of ecclesiastical architecture. J. A.
Buchon, *La Grèce continentale et la Morée: Voyage, séjour et études historiques en 1840 et
1841* (Paris, 1843), and *Atlas des nouvelles recherches historiques sur la principauté franque
de Morée et ses hautes baronnies, fondées à la suite de la quatrième croisade* (Paris, 1845),
and H. F. Tozer, "The Franks in the Peloponnese," *Journal of Hellenic Studies,* IV (1883),
207-236, deal mainly with the castles, of which some have been studied in more detail by R.
Traquair, "Laconia; I. Mediaeval Fortresses," *Annual of the British School at Athens,* XII
(1906), 259-276, and "Mediaeval Fortresses of the North-Western Peloponnesus," *ibid.,* XIII
(1907), 268-281; and by A. Bon, "Forteresses médiévales de la Grèce centrale," *Bulletin de
correspondance hellénique,* LXI (1937), 136-208, "Note additionelle sur les forteresses
médiévales de la Grèce centrale," *ibid.,* LXII (1938), 441-442, and "Recherches sur la
principauté d'Achaïe (1205-1430)," in *Études médiévales offertes à M. le Doyen Augustin
Fliche* . . . (Publications de la Faculté des lettres de l'Université de Montpellier, IV;
Montpellier, 1952), pp. 7-21. Professor Bon's book *La Morée franque: Recherches
historiques, topographiques et archéologiques sur la principauté d'Achaïe (1205-1430)*
(Bibliothèque des Écoles françaises d'Athènes et de Rome, fasc. 213; Paris, 1969) is a
detailed and complete survey of the subject. I am indebted to him and to the Librarian of
the Sorbonne for the loan of this work in typescript before it appeared. Supplementing
Bon's work is W. McLeod, "Castles of the Morea in 1467," *Byzantinische Zeitschrift,* LXV
(1972), 353-363; McLeod also cites a useful book by J. Th. Sphekopoulos, Τὰ Μεσαιωνικὰ
Κάστρα τοῦ Μορηᾶ (Athens, 1968), no. 5, pp. 161-199. K. Andrews, *Castles of the*

the Frankish northern frontier, Boeotia, Attica, the Morea, and some of the islands was there any lasting Frankish settlement. In Constantinople, Latin emperors ruled for some sixty years, but they left no buildings behind them in the capital. The famous fortifications of the city received no addition, hardly even upkeep, till Michael VIII Palaeologus rewon his capital. In the surrounding country little can now be traced of the castles they erected or rebuilt. Henry of Valenciennes tells us how the emperor, Henry of Flanders, fortified Pamphilon near Adrianople in 1208, impressing workers and masons wherever they could be found and ordering all his men to lend a hand in the work.[1] Such rough and ready methods suited the urgency of his campaigns; they did not leave lasting results.

Morea (Gennadeion Monographs, 4; Princeton, 1953) is a valuable contribution to the subject, and see W. Müller-Wiener, *Castles of the Crusaders,* tr. J. M. Brownjohn (London, 1966), pp. 82-85.

The Catalan castles have been studied from a historical rather than an archaeological standpoint by A. Rubió i Lluch, "Els Castells catalans de la Grècia continental," *Anuari de l'Institut d'estudis catalans,* [II] (1908), 364-425; "Atenes en temps dels Catalans," *ibid.,* [I] (1907), 225-254; "La Grècia catalana des de la mort de Roger de Lluria fins a la de Frederic III de Sicilia (1370-1377)," *ibid.,* V-1 (1913-1914), 393-485; and "La Grècia catalana des de la mort de Frederic III fins a la invasió navarresa (1377-1379)," *ibid., secció històrico-arqueològica,* VI (1915-1920), 127-199. See also K. M. Setton, *Catalan Domination of Athens, 1311-1388* (rev. ed., London, 1975). For general questions see J. Longnon, *L'Empire latin de Constantinople et la principauté de Morée* (Bibliothèque historique; Paris, 1949), and an important review of it by A. Bon in *Journal des savants,* 1951, p. 33. For conditions preceding the crusading period see A. Bon, *Le Péloponnèse byzantin jusqu'en 1204* (Bibliothèque byzantine, Études, 1; Paris, 1951), and K. M. Setton, "The Archaeology of Medieval Athens," in *Essays in Medieval Life and Thought Presented in Honor of Austin Patterson Evans* (New York, 1955), pp. 227-258, and, for the later period, *idem,* "Catalan Society in Greece in the Fourteenth Century," in *Essays in Memory of Basil Laourdas* (Thessalonica, 1975), pp. 241-284.

There are many references to the castles in the numerous accounts of travel in Greece, but the authors were primarily interested in classical remains. The most useful for the medieval period are V. M. Coronelli, *Memorie istoriografiche delli regni della Morea, e Negroponte e luoghi adiacenti* (Venice, 1686), tr. R. W. as *An Historical and Geographical Account of the Morea, Negropont, and the Maritime Places, as far as Thessalonica* (London, 1687); O. Dapper, *Naukeurige, Beschryving van Morea, eertijts Peloponnesus: en de eilanden onder de kusten van Morea, en binnen en buiten de golf van Venetien: waer onder de voornaemste Korfu, Cefalonia, Sant Maura, Zanten, en andere en grooten getale...* (Amsterdam, 1688); F. C. H. L. Pouqueville, *Voyage de la Grèce* (2nd ed., 6 vols., Paris, 1826); William Gell, *Narrative of a Journey in the Morea* (London, 1823) and *Itinerary of the Morea, being a Description of the Routes of that Peninsula* (London, 1817); Edward Dodwell, *A Classical and Topographical Tour through Greece during the Years 1801, 1805, and 1806* (2 vols., London, 1819); W. M. Leake, *Travels in Morea* (3 vols., London, 1830), *Travels in Northern Greece* (4 vols., London, 1835), and *Peloponnesiaca* (London, 1846); and E. Curtius, *Peleponnesos: Eine historisch-geographische Beschreibung der Halbinsel* (2 vols., Gotha, 1851-1852). See also James M. Paton, *Chapters on Mediaeval and Renaissance Visitors to Greek Lands,* ed. L. A. P. (Gennadeion Monographs, 9; Princeton, 1951), and E. Forbes-Boyd, *In Crusader Greece: A Tour of the Castles of the Morea* (New York, 1964).

1. Henry of Valenciennes, ed. and tr. N. de Wailly in Geoffrey of Villehardouin,

The Latins destroyed rather than created. Their sack of Constantinople stands out as one of the great moments of devastation, when the human inheritance was permanently impoverished. The great bronze Juno of the forum was pulled down and melted; the statue of Paris, the carved obelisk with its scenes of country life, the bronze Hercules of Lysimachus, the statue of Helen "whose grace posterity will never know"—all were overthrown. Nicetas in his *Narratio* gives us the mournful catalogue, this final record of a splendor of achievement which we can only fragmentarily imagine.[2] Much of the destruction was wanton and barbaric; relics were more prized than Greek paintings or carvings, though the Venetians had more discrimination in their pillage than the western feudatories, removing even large-scale works such as the bronze horses that now bestride the porch of St. Mark's. Faced with the wonders of this greatest of capitals, the crusaders defaced or stole.

There are, however, some traces that show western artists at work in the ravaged city. Fragments of leaded glass windows suggest that western workers may have been brought in to aid in adapting churches to the Latin rite, and, in a blocked-up chapel, fragments of frescoes dealing with the life of St. Francis have emerged from long obscurity (pl. XLVIII). They must be mid-thirteenth-century work, the earliest frescoed series of the legend known. The listening birds are still visible, and the head of a man from whom the devil is driven forth; the other scenes are not identifiable, but probably followed the sequence used in the Berlinghiero painting at Pescia (1235) and the similar portrait with miracles in Santa Croce in Florence. The head of a friar is painted with some feeling, and is strongly reminiscent of the Arsenal Bible and works associated with the Acre school.[3]

Compared with the transitory existence of the Latin empire or the

Conquête de Constantinople, avec la Continuation de Henri de Valenciennes (3rd ed., Paris, 1882), p. 334, and ed. J. Longnon as *Histoire de l'empereur Henri de Constantinople* (Documents relatifs à l'histoire des croisades, 2; Paris, 1948), p. 50.

2. Nicetas ("Acominatus") Choniates, *Narratio de statuis antiquis, quas Franci post captam anno 1204 Constantinopolin destruxerunt,* ed. F. Wilken (Leipzig, 1830). Cf. J. F. Michaud, *Bibliothèque des croisades,* III (Paris, 1829), 425; for relics see J. Ebersolt, *Constantinople: Recueil d'études, d'archéologie et d'histoire* (Paris, 1951), pp. 105-151.

3. See above, pp. 133-134, and also K. Weitzmann, "Constantinopolitan Book Illumination in the Period of the Latin Conquest," *Gazette des beaux-arts,* ser. 6, XXV (1944), 201 ff., and A. H. S. Megaw, "Notes on Recent Work of the Byzantine Institute in Istanbul," *Dumbarton Oaks Papers,* XVII (1963), 333 ff., especially pp. 347-367. Megaw meticulously publishes the glass and concludes that it is 12th-century. In response, J. Lafond argues that it is 13th-century, done at the time of the Latin occupation; see his "Découverte de vitraux historiés du moyen âge à Constantinople," *Cahiers archéologiques,* XVIII (1968), 231-238; C. L. Striker and Y. Doğan Kuban, "Work at Kalenderhane Camii in Istanbul: Second Preliminary Report," *Dumbarton Oaks Papers,* XXII (1968), 185-193; R. L. Wolff, "The Latin Empire of Constantinople and the Franciscans," *Traditio,* II (1944), 213-237.

even more fleeting phase of the kingdom of Thessalonica, the Frankish settlement of Greece seems solid and durable; but even here little of note has been left in architectural monuments. The Gothic cathedrals of Cyprus might well be standing in northern France, and would seem there of equal quality with their untransplanted fellows; the carvings of Syria, the Nazareth capitals, the rich foliage of the Temple masons' yard, are among the triumphs of Romanesque art. But in Greece, so rich in artistic memories, not ill provided with building stone, the Franks contented themselves with rude, unambitious construction. On the north slopes of the Acropolis the ruined apse of the Hypapanti church that Enlart drew and attributed to the thirteenth century has been pulled down to make way for excavations, and proved in the dismantling to be later, partially eighteenth-century work. The Villehardouin and De la Roche arms still surmount the doorway of the Little Metropolitan, but the building itself is a Byzantine church. Outside Athens, at Daphne, where the Cistercians had been installed by Othon de la Roche in 1211, the western porch has a curious outer row of pointed arches and the rebuilt cloister follows the outline of pointed arches formerly visible on the enclosing wall.[4]

In the sloping fields near Bitsibardi, above the Alpheus river, the church of Our Lady of Isova was built in the first half of the thirteenth century and destroyed by fire in 1262. Its ruins show it to have been an aisleless hall church, 135 feet long and 50 feet broad on its outside measurements, ending in a polygonal apse. It is carefully built of well-cut stones mixed with tiles, and the west end, with three windows, still rises to a high pitched gable (pl. LXIIc). A displaced piece of vaulting rib suggests that the roof of the choir may have been vaulted. All the details, simple but competently handled, seem to be the work of western masons. The church was never rebuilt after the fire. Instead a new and smaller church, St. Nicholas, was built beside it, divided into a nave and aisles and ending in three semicircular apses. There is no trace of an iconostasis and it must have been built for the Catholic rite, presumably in the fourteenth century and most likely by local workmen.[5]

The Cistercian convent of Zaraca (Kionia) near Stymphalia has some blocks of walls still standing, a jumble of fallen masonry,

4. G. Millet, *Daphni* (Paris, 1910), pp. 25-42, and cf. *Le Monastère de Daphni: Histoire, architectures, mosaïques* (Monuments de l'art byzantin, I; Paris, 1899); H. D. Kyriakopoulou and A. Petronotes, *The Daphni Monastery* (Society for Peloponnesian Studies, I; Athens, 1956) is an excellent recent guidebook, but difficult to find.

5. N. Moutsopoulos, "Le Monastère franc de Notre-Dame d'Isova (Gortynie)," *Bulletin de correspondance hellénique*, LXXX (1956), 76-94, 632.

foundations traceable on the surface, and a square entrance tower of its outer circuit. The church had a nave and two aisles leading to a choir with a chapel on either side and a rectangular eastern end. The total length was 124 feet, the width at the western end 50 feet. There is sufficient evidence to show that it was vaulted throughout, and that the moldings were carefully worked, though the actual masonry is unevenly composed of reused antique stones, including columns, mixed with later blocks. The church of Hagia Sophia at Andravida still retains its choir, much damaged by Turkish use, and some foundations of the western porch and nave. The total length was approximately 179 feet, the width 62 feet. As at Zaraca it had a rectangular east end, a choir with two side chapels, a nave, and aisles, but what evidence there is suggests that the nave was unvaulted, whereas the choir still retains its vaults and on the main arch some simple carved leaf capitals and a human head on one of the imposts. The external angles of the eastern end are strengthened by sloping buttresses, such as were common in Cistercian architecture in the west at this period. There seems no reason to doubt that the present remains are those of the church built by the Dominicans shortly after 1245.

At Glarentsa was another large church, the ruins of which were destroyed during the German occupation of 1941 to 1944. It was a rectangular hall, without aisles and with a square, projecting choir without chapels. Roughly built, it had no distinguishing stylistic features, but its scale and plan are those of a Frankish church, and it may be the church of St. Francis to which the chroniclers refer. To the east of Glarentsa, in a sheltered valley, the monastery church of Blachernae is clearly mainly Byzantine work of the late twelfth century, but with western elements that indicate some Frankish share in its completion. At Gastouni there is an arched doorway, now blocked up, with leaf capitals. Karytaina has a tower with dog-tooth moldings, but it is a hybrid building, probably of the late fourteenth or early fifteenth century. In Laconia the fortress village of Geraki has four churches, all of which bear traces of western influence; and nearby in Mistra the buildings of the Byzantine revival of the late thirteenth, fourteenth, and fifteenth centuries have Gothic details, and the bell tower of the church of the Pantanassa, completed as late as 1428, still recalls the belfries of Champagne.[6] At Negroponte

6. L. Magne, "Mistra," *Gazette des beaux-arts*, ser. 3, XVII (1897), 135-148; G. Millet, *Monuments byzantins de Mistra: Matériaux pour l'étude de l'architecture et de la peinture en Grèce aux XIVe et XVe siècles* (Monuments de l'art byzantin, no. 2; Paris, 1910); A. Struck, *Mistra* (Vienna, 1910); and the articles by A. K. Orlandos in ᾽Αρχεῖον τῶν βυξαντινῶν μνημείων τῆς῾Ελλάδος, III (1937), 3-114.

(Chalcis), on the island of Euboea, the Franks turned the Byzantine church of Hagia Paraskeve into a Gothic cathedral with a square apse flanked by side chapels, of which the southern one has two bays of ribbed vaulting supported on consoles where vine leaves are carved with considerable naturalism, the skilled work of some western sculptor of the thirteenth century (pl. LXIIIb).

The military architecture of the Frankish conquest survives in greater abundance than the ecclesiastical. The main routes were watched by castles built on hilltops, where in most cases previous fortifications could be reused and where the nature of the site provided a strong defensive position. As elsewhere the castle had a dual purpose; it was both the center of a fief and a unit in a strategic scheme. In the former capacity, it was required to be centralized with reference to a particular area and to provide in its base court a place of refuge for the local inhabitants; in the second it had wider responsibilities to watch frontiers and control communications. To further the latter aim, towers were built along the main routes, such as that at Moulki, where the road from Thebes to Livadia enters the plain of Copais.

The tide in the affairs of the Frankish principalities moved with great rapidity. Frontiers changed; castles passed from Franks to Greeks or Catalans or Venetians. At one moment a key position, at another isolated and forgotten, these fortresses had widely varying fates. Some, firm on their Hellenic foundations, have continued to play a part in history, centers for Turkish garrisons, or strongholds of national resistance in the wars of independence. Others have crumbled, merging with the hillside, till even their exact site is lost. All are singularly undocumented, and, with battlements dismantled for artillery or fallen from disuse, with little care for ornament or fashion in their building, they are hard to date. The masonry is undistinguished and the stones, either small trimmed blocks or undressed, provide no clues. A common formula is a foundation of well-cut antique blocks on which the walls are continued in uncoursed rubble with brick tiles scattered throughout and the angles reinforced by larger cut stones. The later Byzantine Greeks, the Franks, and the Turks in this respect built alike. Only in some of the fifteenth-century Venetian buildings was well-cut ashlar at all generally used.

One of the earliest blows to Frankish security was the destruction of the Latin kingdom of Thessalonica in 1224. Theodore of Epirus led forays into Boeotia. Honorius III ordered Salona and Bodonitsa, now holding the frontier, to be put into the best possible repair.

Bodonitsa was the medieval guardian of Thermopylae, but now the security of the hills was preferred to the coastal plain and the castle is built on a spur of Mt. Callidromon, guarding the ancient track leading inland from the coast. With a wide view over the Gulf of Lamia and beyond to the hills of Euboea, it has been given by nature and history as romantic a site as could be wished for (fig. 13; pl.

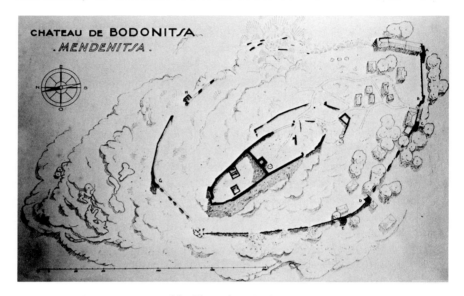

13. Plan of Bodonitsa

LXIb). Granted by Boniface of Montferrat to Guy Pallavicini, the fief remained in the hands of that family till in 1335 the Venetians established a new line, the Zorzis, who held it till it was taken by the Turks in 1410.[7] The castle has survived its Turkish conquest and escaped the common fate of constant rebuilding, and even the punitive burning of the village below in the second world war. Based on Hellenic substructures and reusing many ancient stones, it is still today an example of Frankish work, of which it must always have been one of the most impressive monuments. The plan is that of a central keep and two curtains: an outer curtain wall, running for the most part half way up the slope of the hill, but coming close to the main enceinte at the northwest point, where the hill falls more abruptly, polygonal in form and enclosing an area some 1,000 feet long; and an inner enceinte 460 feet long by 125 feet at the center, in shape an irregular oval with remains of three

7. William Miller, *Essays on the Latin Orient* (Cambridge, 1921), pp. 245-260.

flat, slightly projecting towers on the south face, where the ground slopes away less steeply. Here too are remains of a large barbican or outwork. The outer curtain has towers, which are of flat, shallow projection, unscientific in plan and quite irregular in scale. The north point of the inner enceinte appears to have been strengthened by a tower, and at its mid-point a dividing wall cuts the interior space into two courts; on this wall is built the keep, a three-storied building, approximately 24 feet square, commanding a gateway between the two courts. This gateway is composed of three great monoliths as jambs and lintel, with above a little pattern in Byzantine style of bricks edged in diamond shape, probably made by Greek workmen in Frankish employment. The keep itself was entered by a doorway raised some way above ground level. Here therefore are all the characteristic features of Frankish castle building as practised in Greece: the strong natural position, the careless, unscientific planning, the reëmployment of ancient material, and the dependence on local labor.

The parallel fortress of Bodonitsa, holding the other route into Attica and overlooking the Gulf of Corinth, was that of Salona, the ancient Amphissa. Here an outer curtain follows the irregular outline of the hilltop; on the northwest face of this curtain a large rectangular tower is still standing, the lower part of which appears to be good Hellenic masonry. To the northeast the hill slopes abruptly, and here was placed the rectangular keep within a second enceinte, 376 feet long and 172 feet broad. Ancient masonry is freely reused, and there is a monolithic doorway, similar to that at Bodonitsa. As it stands today, the inner enceinte is a bewildering but impressive complex of ruins. On the north curtain a small round tower is embedded in the wall, possibly a relic of a Byzantine fortification. At some later date a part of the walls was flattened into an artillery emplacement. A larger round tower (diameter 28 feet) of small masonry clearly dates from a different epoch of building and may be Catalan work of the fourteenth century, or even Turkish work. From 1205 to 1311 it was a possession of the Autremencourt family, and it is to them that most of the fortifications, urgently needed after the loss of Thessalonica, must be attributed.

"Le plus beau et le plus riche manoir de toute la Roumanie" was said by the Moreote chronicler to be the castle of St. Omer at Thebes, or Estives as the Franks called it. The castle was built by Nicholas II of St. Omer with the aid of the fortune of his wife, Marie of Antioch. The interior walls of this great building were covered with frescoes of the doings of the crusaders in the Holy Land, and in

this wealthy town something of true French civilization seems for a
time to have taken root. But in 1331 the Catalans destroyed the
castle "for fear that the duke of Athens should by any means take it
and thereby recover the duchy." Only one tower remains, which by
its scale (44 by 52 feet, walls nearly 10 feet thick) and by the
solidity of its masonry and vaulting, though still composed of reused
and unequal stones, does something to justify the praises of
Raymond Muntaner (pl. LXIIa).[8] In Athens itself a tall tower, 85
feet high, stood on the Acropolis till 1874, but who erected it
remains unchronicled.[9]

Livadia, already partly built in the thirteenth century, achieved its
greatest importance under the Catalans. It is to them almost certainly
that is due the general scheme of the fortifications, a triple enceinte,
the first entry protected by a barbican. The ditch cut in the rock,
where the spur on which the castle stands joins the main hillside,
may date from some earlier fortification. Here there was little
antique material at hand, and the masonry is mainly of small blocks
mixed with brick. In placing of the towers and general plan, the
Catalan castle, allowing for the difference of site, varies little from
the scheme of Bodonitsa.

The other main Catalan strongholds were Zeitounion, Neopatras,
Siderokastron, and Gardiki. Of Zeitounion there are considerable
remains, and the building is unusually homogeneous in masonry,
except where some artillery bastions have been made by the Turks.
There is, however, nothing to date the existing castle at all
accurately. In type it is a single enceinte, following the hillside, with
a strong point at its northeastern end. Neopatras is a confusion of
ruined masonry, of which a round Turkish tower is the most
distinctive feature. Siderokastron has remains of walls on its rocky
site. Gardiki, the ancient Pelinnaeon, has walls and some towers,
mostly of classical workmanship.

Guarding the entry from Attica to the Morea was the great and
ancient fortress of Acrocorinth. The main fortress dates from many
periods and combines Byzantine work of the tenth and eleventh
centuries with a Frankish keep and considerable Venetian rebuilding
from the period of their reoccupation in the late seventeenth

8. Bon, "Forteresses médiévales," *Bulletin de correspondance hellénique*, LXI (1937),
152-163.

9. J. Baelen, *La Chronique du Parthénon: Guide historique de l'Acropole* (Paris, 1956),
p. 156; Setton, *Catalan Domination of Athens*, p. 246; and G. Daux, "L'Athènes antique en
1851: Photographies d'Alfred Normand," *Bulletin de correspondance hellénique*, LXXX
(1956), 619-624.

century. The keep, which forms the southwest redoubt and is built on a point where the natural defenses are at their strongest, follows the plan of Bodonitsa, two courts with the tower on the dividing wall. About a mile away, on the conical hill opposite Acrocorinth's main western defenses, can still be seen the fortress of Mont Escové, now called Pendeskouphi, which was built by Othon de la Roche as a base from which to conduct his siege of the citadel in 1205, and which is one of the earliest examples of the medieval keep and outer wall that remain in Greece.[10] From Corinth the routes branch south to Argos or east over the rough country between the coast and Mt. Cyllene and Mt. Chelmos into Achaea. On these wild defiles stood the castle of Kalavryta, given to Othon of Tournai in 1208. Now completely ruined, it can still be seen to have had an outer and inner enceinte, the former built amongst the rocks of the hillside, with a keep at the highest point.

Patras, the main town of Achaea, was an ancient fortified site and has consistently remained a port of some importance. William l'Aleman built a castle here in the early part of the conquest, and the fortified enclosure with rectangular projecting towers, dominating the plateau above the city, may preserve some of his work, but for the greater part the ruins of Patras are Byzantine or Turkish. South of Patras was the castle of Chalandritsa belonging to the Dramelay family, but even its site is today uncertain.

It was in the Morea that the great strength of the conquest centered. The northern corner of Elis, the base of the Villehardouin power, was one of the wealthiest and most enduring parts of the Frankish occupation. Andravida, with its four churches, was the capital; Glarentsa, the port, with a circuit of walls round the town, and a castle, now only a confused mass of rubble; to the south Beauvoir (or Pontikokastron, above Katakolon) controlled the other arm of the shallow bay, and now also lies in ruins, a mass of foundations with the base of a tower still visible. Inland from Glarentsa the castle of Clermont (Khloumoutsi or Castel Tornese) is better preserved. Situated on a hill commanding a wide view of both sea and land, with a comparatively gentle slope to the west whereas the southern and eastern sides are steep and rocky, it consists of a hexagonal strong point on the summit with an outer enceinte

10. R. Carpenter and A. Bon, *The Defences of Acro-Corinth and the Lower Town*; vol. III, pt. 2 of *Corinth: Results of Excavations Conducted by the American School of Classical Studies at Athens* (Cambridge, Mass., 1936); Andrews, *Castles of the Morea*, pp. 134-145, and for Patras, pp. 116-129.

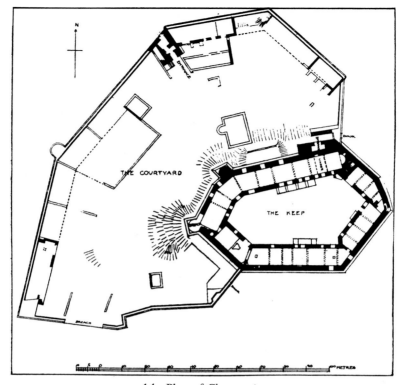

14. Plan of Clermont

stretching down the hillside to the north and west (pl. LXIa; fig.
14). The hexagon is a walled courtyard with living accommodation
built on the inner side, including chambers vaulted with high-pitched
ovoid barrel vaults of an unusual type, carefully planned and worked
but severely plain and undecorated. Built by Geoffrey I of Ville-
hardouin in the years 1220 to 1223, it has been little altered by later
occupiers. The enceinte seems to belong to the same building stage as
the hexagon. The courtyard enclosed by living quarters had already
been used in the first design of Krak des Chevaliers; in a polygonal
form it is found at the castle of Boulogne (1228-1234); and it
reaches its most splendid manifestation in Frederick II's Castel del
Monte, near Andria, begun in 1240. Whether Clermont was influ-
enced from the east or from the west cannot be determined, but as
the greatest castle of the Morea it must have enjoyed some renown
and made its own contribution to the development of castle design.[11]

11. Traquair, " Laconia; I. Mediaeval Fortresses,"*Annual of the British School at Athens*,
XII (1906), 272-276; A. Bon, "À Propos des châteaux de plan polygonal," *Revue
archéologique*, ser. 6, XXVIII (1947), 177-179; Andrews, *op. cit.*, pp. 146-158.

Frankish sites are numerous in this neighborhood: Gastouni or Gastogne; Santameri, a corruption of St. Omer; Vlesiri or La Glisière; but it is not till Arcadia, the classical Cyparissia, that there are any considerable medieval remains. Here the eastern point of the castle hill is defended by a round tower built of small, rectangular stones, with a masonry batter sloping down to a smooth rock face. This seems to be Frankish work, following the capture of the castle by William of Champlitte in 1205, and is in marked contrast to the larger blocks of the earlier Byzantine square tower at the highest point of the hill. Inland in the hills the site of Siderokastron is marked only by fragmentary and much overgrown masonry remains, but farther south on the route from Arcadia to Kalamata, the castle of Androusa, the Druges of the *Chronicle of the Morea*, is well preserved. It is a large single enceinte, fortified with semicircular, polygonal, and rectangular towers, the largest of which, on the east, possibly served as a keep. On part of the standing walls, the platform walk is carried on an arcading of pointed arches, whose voussoirs are decorated with a brick pattern. Though the masonry is of small uneven stones, there are signs of unusual skill and workmanship in the whole building. The nearby church of St. George, of typical Byzantine bonded masonry, embodies a blocked-up Gothic door, whose moldings are of good quality. Little is known of this castle; its competence, in this remote southwest corner of the Morea, redeems some of the ruder works which elsewhere recall the medieval settlement (pl. LXIIIc).

A short distance to the east of Androusa the fallen walls of Pidhima look out over the Messenian plain; "Le petet mayne," the castle of Messenia, is now an unknown site. Modon and Coron on either side of the Messenian peninsula are purely Venetian towns. The wild and rocky Maina, the other arm of the bay of Messenia, was guarded by Kalamata. It was here that William (II) of Villehardouin was born in 1218, and here that he died in 1278; the castle, much of which stands, may be Frankish work. When captured in 1205, the citadel was found to have been converted into a monastery, and it still includes a small Byzantine chapel.[12] Its outer court was repaired by the Venetians, who occupied Kalamata in the seventeenth century, and the third enceinte is clearly their work of that period.

12. A. Bon, "Églises byzantines de Kalamata," *Actes du VI^e Congrès international d'études byzantines, Paris, 27 juillet-2 août, 1948*, II (1951), 35-50, and "La Prise de Kalamata par les Francs en 1205," *Mélanges d'archéologie et d'histoire offerts à Charles Picard à l'occasion de son 65^e anniversaire*, I [= *Revue archéologique*, ser. 6, XXIX-XXX (1949)], 98-104. William succeeded his brother Geoffrey II in 1246.

Farther down the coast, where the peninsula begins, the ruin of a castle with a square keep on a rocky eminence near Leftro is probably Villehardouin's castle of Beaufort. Toward the tip of the peninsula, the walls of the fortified village of Tigani are still partially standing, and a pillar among the fallen masonry has a Latin cross. A short distance south is Maina, the possible site of Le Grand Mayne, but Porto Kaio is another claimant. On the eastern side of the peninsula, the castle of Passavá (so-called from the "Passe-avant" battlecry of its lord, John of Neuilly) is now a Turkish reconstruction with a mosque and round towers for gun emplacements.

In 1249 William II took Monemvasia, the last Greek stronghold in the Morea. It was then that he fortified Mistra, where his castle still crowns the summit looking down upon this marvelous hillside of Byzantine churches; eleven years later, the defeat of Pelagonia left William a prisoner in the hands of Michael Palaeologus, and he bought his liberty by surrendering Monemvasia, Mistra, and Maina. The Frankish settlement here is only a brief passage. The churches and paintings of Mistra belong to Byzantine art, though stimulated by western contacts, and in Monemvasia the older churches, the Christ Elkomenos and Hagia Sophia, with its fine slab of confronting peacocks, are also Byzantine, while the fortifications date mainly from the Venetian occupation of 1464-1540.[13]

To the northeast of Sparta, Arachova still has one wall of its keep standing, a conspicuous landmark. In the central Morea the main route passed across the bridge over the Alpheus below the mountain fortress of Karytaina, most romantically perched of all the mountain fortresses. Much that remains is probably Frankish, though interspersed with later additions, and no doubt its strong position attracted occupants whose doings have not always been chronicled. To the north Akova, the castle of Matagrifon, much disputed among the Frankish feudatories, has three towers standing of its enceinte.

On the eastern coast Argos is still crowned by a great castle, which at the time of the conquest stood a seven years' siege from 1205 to 1212. Partly Byzantine, partly Frankish, partly Turkish, its four round towers are almost certainly Frankish and are not bonded to the—probably—Byzantine curtain wall. Similar round towers are visible in the walls of the castle of the Franks at Nauplia behind the great talus with which the Venetians later strengthened the fortifications, but at Nauplia it is Venetian building that predominates, from the great round tower of the fifteenth-century bastion to the

13. M. G. Soteriou, *Mistra: Une Ville byzantine morte* (Athens, 1935); Miller, *Essays on the Latin Orient*, pp. 231-244.

octagonal tower in the small island fortress of Bourtsi guarding the entrance to the harbor. In the greater towns, where life went on at varying pace but with some consistent growth, Frankish buildings, rarely of much merit, were replaced or refashioned. It is only in the more outlying parts that they survive, an undistinguished style hard to identify exactly save by the absence of the finer work that both Greeks and Venetians brought to their undertakings.

Venice, the prime mover in the Fourth Crusade, was also its eventual heir, and it is Venetian building that has left the clearest marks on the land of the conquest, and of which we have the most detailed records. For in the period 1685 to 1715 the Venetians under Francesco Morosini reoccupied many places in the Morea and the islands, captured Athens after the fatal bombardment of the Parthenon, and in the course of rebuilding this eastern dominion, the *provveditore generale dell' armi* in Morea, Francesco Grimani, drew up a long report, illustrated with forty-one plans, of the state of the fortifications under his charge, a document still extant and very informative about the works included in it.[14] Restored in this seventeenth-century venture, much of the Venetian building is still impressive enough, nowhere more so than in the southwest corner of the Morea where Navarino, Modon, and Coron all have imposing stretches of wall. Old Navarino, crowning precipitous cliffs, was built about 1278 by Nicholas of St. Omer on the site of a classical fortress, and partially on its foundations. Amid later Genoese, Venetian, and Turkish rebuilding, there are still some portions that might well be Frankish work. New Navarino, round the port, is Turkish work, repaired by the Venetians after 1686. Modon, where the Venetian lion was still in place on one of its walls until looted by Italian soldiers in 1943, was much rebuilt at the time of the reconquest under Morosini; its most attractive feature, the little hexagonal island fort, is Turkish sixteenth-century work, but even so it presents as good a picture as can be obtained today of a Venetian trading port in the Levant, little changed in general outline from what it might have been in the later Middle Ages.

In the islands it is again Venice that predominates. In Euboea, the fortifications of Negroponte date from the Venetian rebuilding of 1304. At the southernmost point the ruins of the castle of Carystus, rising above the narrow coastal plain, must, to judge by its history, have some building in it that goes back to the rule of the triarchs and

14. See Andrews, *Castles of the Morea*, pp. 8-10.

the disturbed times of the thirteenth century; but its well-built pentagonal tower with its merlon battlements still standing is clearly Venetian, as is also a similar tower at the small port below. The outer enceinte, remade for artillery, is now mainly of coarse rubble, and much of the walls of the inner enceinte seems Turkish rebuilding. Haliveri has a rectangular enceinte divided by a cross-wall with a keep tower built upon it as at Bodonitsa. The masonry is of the roughest kind, and this may well be largely Frankish work. At Dystos there is a Venetian tower among the classical ruins; at Gymno two churches and a tower, probably Venetian. Of Larmena, whose name figures so often in the medieval history of the island, there remain only a few sections of walls, filling fissures in the rock, and the bases of two towers.

Naxos, the center of the Sanudo duchy, has no medieval buildings that can be clearly dated. The Jesuit father, Robert Saulger, writing at the end of the seventeenth century,[15] states that Mark Sanudo on his occupation of the island built "a great square tower with walls of extraordinary thickness, with an open space round it, which in its turn was enclosed within a wall strengthened by great towers 29 or 30 feet from one another." He also built the Latin cathedral within the Kastro, which still stands but was completely rebuilt in 1915 and had already been largely restored in 1865. Today the outer enceinte of the castle can hardly be traced among the houses which have been built on and out of it. Of the main central block, however, one floor still stands, a vaulted room which recalls in scale and quality the masonry at Thebes. This may well be, though Saulger is a late and not always reliable source, part of Sanudo's original building. Of the other Naxos castles, Paliri was the original Byzantine stronghold; its solid foundations remain, blending indistinguishably with the rock on which they stand. Apanokastro, which Saulger with some probability attributes to Mark II (1262-1303), has later Venetian and Turkish rebuilding, and the walls have been flattened out for artillery bastions. The neighboring island of Paros has a medieval tower which is made largely of cross-sections of columns and is one of the most extreme examples of the reuse of classical materials.

A similar account can be given of most of the islands; castle ruins crown the hills: Sant' Angelo in Corfu; the square tower in its small rectangular enceinte of Katokastro on Andros; a few churches, still distinguished by some Gothic arches and marked with Latin crosses;

15. Printed in J. K. Fotheringham, *Marco Sanudo, Conqueror of the Archipelago* (Oxford, 1915), pp. 113-122.

some late medieval or early Renaissance houses, Italian in their basic style, but borrowing eastern decorative motives or making use of the local colors of the stones, as in the patterned façades of red and yellow Thymiana sandstone of the Genoese houses in Chios, that preserve the memory, despite massacre and earthquake, of one of the most prosperous and cultured of the Latin settlements.[16]

Of all the conquests of the Fourth Crusade, Crete was held the longest. Candia, after a siege of twenty years, fell to the Turks in 1669. For most of five hundred years Venice controlled the island, though not without great difficulty, for the islanders were vigorous and restless; religious and racial feeling ran high, and first the Genoese and then the Turks were always ready to encourage internal revolt. Culturally the island was a province of Venice.[17] Here, as so often in dealing with this wide-flung settlement, the influences have little connection with the original crusading impulse. The great trading republic became the last defender of Christendom in the eastern Mediterranean, but the defense of its interests, splendidly heroic as it was in such closing scenes as those at Famagusta and Candia, had none of the aggressive fervor which characterized the genuine crusading settlers. As the Gothic style gives place to the Renaissance, we enter a period where crusading terminology, whatever the continuity of events, becomes rather anachronistic.

Of sculpture that can be assigned with any certainty to the Latins, little now remains, either in Greece or in the islands. In the Genoese settlement of Chios a series of reliefs of St. George (made in the fifteenth century for the decoration of door lintels) are based on a design familiar in Genoa from several still existing examples. The same process was almost certainly at work in the towns and islands under Venice. The decoration still to be found on Cretan arches and windows has many Italian motifs, with here and there suggestions of Arab influence. For the rest, the Byzantine tradition in Venice was already strong, and her citizens found much that was familiar in the provincial Byzantine styles of her colonies. Last of their surviving

16. J. A. Buchon, "Excursions historiques dans les îles de Tinos et d'Andros," *Revue indépendante*, XIII (1844), 567; F. W. Hasluck, "The Latin Monuments of Chios," *Annual of the British School at Athens*, XVI (1910), 168-177; G. Gerola, "Zea (Keos)," *Annuario della R. Scuola archeologica di Atene e delle missioni italiane in Oriente*, IV-V (1921-1922, publ. 1924), 177-221; A. Tarsoulé, Δωδεκάνησα (3 vols., Athens, 1947-1950); and Hasluck, "Monuments of the Gattelusi," *Annual of the British School at Athens*, XV (1909), 248-269.

17. G. Gerola, *Monumenti veneti nell' isola di Creta: Ricerche e descrizione* (2 vols., Venice, 1905-1908).

works of carving in Crete is probably the Morosini fountain in the square at Candia, and here the full Italian Renaissance with its wreaths and sea goddesses triumphs completely.

Gothic sculpture has left even fewer traces. On the mainland of Greece there are a few moldings on windows and ribs and some foliage capitals that recall the art of France. The tomb slab of princess "Agnes" (Anna Ducaena, widow of William of Villehardouin and Nicholas of St. Omer; d. 1286) at Andravida has a French inscription, but the ornament is almost purely Byzantine. There is little to indicate that the great craftsmen who found employment in Syria came to the courts of the Morea or Athens. There is, however, at Geraki in Laconia a group of churches with carved ornamentation of some interest, around which has centered a minor art historical controversy. The doorway of the church of Zoodochos Pege has a pointed archway decorated with checker and triangular pattern (pl. LXIIIa); the one remaining door jamb is carved with rosettes and has a stiff acanthus-leaf capital; in the wall beside it is a slab with a Maltese cross and two slabs of interlace pattern; above the doorway is a painted Madonna in a niche, the frame of which has rosette decoration and ends in two crude animal heads. Similar heads and a somewhat ruder version of the same pattern can be seen in another church at Hagia Paraskeve.

Far finer but still similar in style is the shrine in the baronial church of St. George. Here the interlace is openwork tracery of great delicacy, with rectangular grills cut above the arch, and a coat of arms in the center panel and at the top angle of the arch which, though not certainly identifiable, may be that of the Nivelet family,[18] and is certainly western. Above the pointed arch of the main doorway is a shield "chequy of nine," and this coat is repeated on the shield of St. George in a painting on the iconostasis. The shrine niche is supported by two pairs of linked columns, that custom so popular in Syria, but here in its simplest and more Byzantine form of a single loop; on either side of the niche are other, probably fictitious, coats, a crescent between six stars and a fleur-de-lys between four rosettes. Wace, who first published the shrine in detail, thought it to be Saracenic; Traquair and Van de Put favored south Italian influence.[19] The castle of Geraki, a section of

18. If the Nivelets can be held to be the same stock as the de Neviles or de Nivillis family in Cyprus and Syria.

19. A. J. B. Wace, "Laconia; V. Frankish Sculptures at Parori and Geraki," *Annual of the British School at Athens*, XI (1905), 139-145; Traquair, "Laconia; I. Mediaeval Fortresses," *ibid.*, XII (1906), 263-269; A. van de Put, "Note on the Armorial Insignia in the Church of St. George, Geraki," *ibid.*, XIII (1907), 281-283.

whose walls is remarkably complete, appears to be Frankish in design and construction. It was built by John of Nivelet after 1230 and was ceded to Michael VIII Palaeologus some time between 1261 and 1275. The presumption is that all this work dates from the mid-thirteenth century and, judging by the arms, is Frankish in origin, though there is a very similar shrine now in the museum at Mistra. In the metropolitan church of the same town a knotted column and two niches with pierced interlacing arches are probably Byzantine; the arches are round, not pointed like those at Geraki.[20] It is in fact an eastern Mediterranean style, known also in Jerusalem, and one that in Spain and south Italy touched the art of the west. Here unexpectedly it is found in Greece on this forgotten Franco-Byzantine frontier. Later in Rhodes the same pierced interlaces and rosette patterns become a strikingly beautiful decoration to some medieval house façades at Lindos.

Of medieval painting in Greece a similar but more puzzling story can be told. We know that the castle of Thebes, like the Painted Chamber at Westminster, was frescoed with scenes of crusading exploits in the Holy Land. But we know nothing of their style, whether they were a Gothic romance or a Byzantine battle scene. In 1395 in the archiepiscopal palace of Patras Nicholas of Martoni saw paintings of the siege of Troy, and those may well have resembled the illustrations to manuscripts of the *Histoire universelle*.[21] In miniature painting the evidence is fragmentary. At some point in the first half of the thirteenth century the painter of the apostle portraits in the Greek gospel book that is now in the national library at Athens (Cod. 118) inscribed the texts on their scrolls in Latin. This accomplished artist certainly belonged to a Byzantine center of some importance; he was illustrating a Greek book, but the Latin wording suggests a Frankish patron somewhere and Frankish connections. Latin texts also occur in the evangelical portrait of St. John in the Iviron Gospels (Mt. Athos, Iviron, cod. 5), a very splendid book, stylistically close to the Athens Gospels; but here the Latin words are inscribed over the Greek text, and occur only on one portrait, suggesting adaptation rather than commission. There exists, however, in Paris (Bibl. nat., Cod. gr. 54), a gospel book with both Greek and Latin text that is clearly, in the evangelist portraits and in the cycle

20. Millet, *Monuments byzantins de Mistra*, pls. XLV and LI.

21. Nicholas of Martoni, "Relation du pèlerinage de Nicolas de Martoni, notaire italien (1394-1395)," ed. L. LeGrand, in *ROL*, III (1895), 661.

of narrative scenes, based on the Iviron Gospels.[22] The *Manuscrit du roi*, a thirteenth-century collection of ballads and their musical settings, contains a poem by "the prince of Morea" (William II of Villehardouin), and the page, now mutilated, was formerly headed, to judge from other instances in the book, by an equestrian portrait of him. There is however nothing to suggest that this was a locally produced work, and its Gothic style has no eastern elements in it. [23]

Of the magnificent revival of wall painting at Mistra in the fourteenth century, Frankish Greece has no certain echoes. At Geraki in the church of the Zoodochos Pege there is a fresco of Christ standing beside the cross. The fine folds of the garment, almost like those of Burgundian sculpture, and the pronounced elongation of the figure are not related to the great school of Mistra. It is tempting to think that here in a town where Latin influences can be traced the paintings too owed something to Latin example or even practice. They remain the nearest point of contact between the Gothic spirit and that rich flowering of thought and literature and painting which so strangely adorned the despotate of Mistra. The renown of Crete was of a somewhat later date. It was in the fifteenth and sixteenth centuries that the island gave its name to a phase of Byzantine painting.

On the northern frontier of the mainland Latin states, hemming them in and gradually encroaching upon them, were the Byzantine powers, often enough opposed to one another, of the despotate of Epirus and the revived empire of the Palaeologi. The coast towns of the former bear traces of Venetian occupation, based on the original partition of 1204, though, inland, Venice never secured more than a nominal suzerainty. [24] The round tower of Durazzo is probably Venetian fourteenth-century work; a Venetian church still stands at

22. Weitzmann, "Constantinopolitan Book Illumination in the Period of the Latin Conquest," *Gazette des beaux-arts*, ser. 6, XXV (1944), 193-214.

23. See Jean and L. Beck, *Le Manuscrit du roi, fonds français n⁰ 844 de la Bibliothèque nationale* (Corpus cantilenarum medii aevi, ser. 1: Les chansonniers des troubadours et des trouvères, no. 2; 2 vols., Philadelphia and London, 1938), I, fol. 4ᵗ–4ᵛ; II, p. 17, and Longnon, *L'Empire latin*, p. 195. There exists one other manuscript painted by a French artist but under strong Byzantine influence. It is a Latin psalter fragment now in the Vatican Library, MS. Rossiana 529. The sole historiated miniature seems to be related to the Riccardiana psalter, but the facility of the artist in the Byzantine idiom suggests an attribution to Constantinople during the Latin empire. See H. Buchthal, *Miniature Painting in the Latin Kingdom of Jerusalem* (Oxford, 1957), pp. 94-95. [J. F.]

24. Little has been written on the monuments of this area. For Arta see the articles by A. K. Orlandos in Αρχεῖον τῶν βυξαντινῶν μνημείων τῆς Ἑλλάδος, II (1936), 88-202, and D. M. Nicol, *The Despotate of Epirus* (Oxford, 1957), pp. 196-215. There are some brief accounts and photographs in J. A. T. Degrand, *Souvenirs de la Haute-Albanie* (Paris, 1901).

Scutari, held by Venice from 1396 to 1474, and the fortress there is Venetian in plan. At Berat the impressive castle on the hilltop has on the gateway the monogram of Michael I Ducas (Angelus) "Comnenus" (1204-1215), the first ruler, but the walls show varying styles of masonry from the large well-cut blocks of the lower courses to the small rubble of the top; an irregular enceinte with alternate square and semicircular projecting towers crowns the top of the hill, with a large polygonal keep at the highest and strongest point, where the mountain side breaks away precipitously; a casemate ending in a bastion stretched down the hillside with walls built in places across steep rock cliffs. It suggests the design of Byzantine fortifications, such as those of Antioch, and was probably chosen by the despots because of preëxisting remains, but much of its history, even of its various occupations, remains uncertain. At Lesh (Alessio) the castle is inferior and later work: it was the center in the fifteenth century of Scanderbeg's rally against the Turks, and was destroyed by them on their capture of it; the present ruins may date from that period. The same is probably true of Kroia and Petrela; the fortress of Elbasan is Turkish work. Canina above Avlona (Valona) has a polygonal tower, similar to that at Berat.

Arta was the capital of the despotate. Here there is not only fortification, mainly Venetian and Turkish in its present state, but also a group of churches which in their architecture and ornament recall a culture, limited and provincial, but not without genuine individuality in its fusion of Byzantine and Italian elements. In the narthex of the chapel of St. Theodora (d. about 1270) there is a tomb, remade but embodying a slab on which are represented two half-length angels, with between them, under an arch supported on knotted columns, the sainted queen, a large figure protecting the smaller effigy of her husband, Michael II, or perhaps of her son Nicephorus. With its curious flat and linear relief this carving is probably a copy of an earlier thirteenth-century relief, but even at second hand it brings a close contact with the arts of the despotate.

Passing eastward, central Thessaly was controlled by Trikkala, with a strong keep on the highest point of the hill and a base court, divided by a fortified wall, sloping down from it. Much of the castle still stands, curiously dominated by a nineteenth-century clock tower with elaborate crenelations, but the rebuildings have been too frequent and its history is too obscure to allow of any exact chronological analysis. To the north and on the sea controlling the coastal route, the castle of Platamon stands on a cliff, its ruins still an impressive spectacle. It has little known history. Its outer enceinte,

of which the walls stand with their battlements, is built of strong rubble with some ancient blocks in the lower courses. An irregular hexagon, it forms a spur at the weakest point of the slope. Within the angle of the spur is an inner court some 130 feet broad, then a third court surrounding a polygonal tower, still complete with its battlements. There is a careful strategic planning of the whole in relation to its parts which we look for in vain in the Frankish castles of Greece (pl. LXIIb). Inland the castle of Servia, dominating the valley of the Haliacmon on the ancient frontier of Thessaly and Macedonia, had long been a fortified place, but its present walls and towers date probably from the thirteenth century, when it was held for a time by the despot of Epirus. As at Platamon the outer enceinte ends in a spur at its weakest point, but here the second enceinte crowns the summit at the farthest point from the spur and there is no keep; only a strong semi-polygonal tower on the walls, which seems earlier work. The masonry is small evenly laid rubble with reinforced corners, and the towers, though much damaged, still made an imposing circuit.

B. Rhodes

Captured by the Turks in 1522, the island of Rhodes remained for four hundred years an Ottoman dependency, a place of little history and gradual decay. The walls and palaces of the knights crumbled a little, wooden balconies were hung on their walls, the churches were converted into mosques, but there was no systematic change, and the splendid masonry, so unlike crusading building in Greece, proved enduring. Writing in 1844, Eugène Flandin could describe it as "almost intact, seeming to wait the return of its knights," (pl. LXIVa) and de Vogüé, visiting it shortly afterward, could call it a "unique ensemble, the living aspect of a French town of the fifteenth century."[1] Two great losses have occurred since then. The church of St. John, the burial place of the grand masters, was blown up in 1856 by an explosion, the cause of which was never clearly ascertained, and the port tower built by Philibert of Naillac, grand master from 1396 to 1421, was damaged in an earthquake in 1863 and later leveled by the Turks; losses all the more regrettable because these

The essential work is A. Gabriel, *La Cité de Rhodes MCCCX-MDXXII; I. Topographie, architecture militaire*; II. *Architecture civile et religieuse* (Paris, 1921-1923). See also F. de Belabre, *Rhodes of the Knights* (Oxford, 1908); A. Maiuri, *Rodi: Guida dei monumenti e del Museo archeologico di Rodi* (Rhodes, 1919; 2nd ed., Rome, 1921); A. Maiuri and G. Jacopich, "Monumenti di arte cavalleresca," *Clara Rhodos,* I (1928), 127-181; G. Gerola, "I Monumenti medioevali delle tredici Sporadi," *Annuario della R. Scuola archeologica di Atene . . . ,* I (1914), 169-356, and II (1916), 1-101; and R. Matton, *Rhodes* (Collection de l'Institut français d'Athènes; Athens, 1949). See also British Committee on the Preservation and Restitution of Works of Art, Archives, and Other Material in Enemy Hands, *Works of Art in Greece, the Greek Islands and the Dodecanese: Losses and Survivals in the War* (London, 1946), pp. 55-60, as well as Müller-Wiener, *Castles of the Crusaders,* pp. 93-94.

1. E. Flandin, *L'Orient*: parts 11-20, *Rhodes* (Paris, 1853-1858); C. J. M. de Vogüé in the introduction to J. Delaville Le Roulx, *Les Hospitalliers à Rhodes jusqu'à la mort de Philibert de Naillac (1310-1421)* (Paris, 1913), p. v. The former is one of the many descriptions and collections of plates of Rhodes in the nineteenth century, which are of particular value owing to the disastrous explosion of 1856 and the drastic restorations by the Italians in the period 1918-1939; cf. B. Rottiers, *Description des monumens de Rhodes* (2 vols., text and atlas, Brussels, 1828-1830). See also Albert Berg, *Die Insel Rhodus, aus eigener Anschauung und nach den vorhandenen Quellen geographisch, archäologisch, malerisch beschrieben und durch Originalradirungen und Holzschnitte nach eigenen Naturstudien und Zeichnungen illustrirt* (Brunswick, 1862), and Belabre, *Rhodes of the Knights.*

buildings represented Rhodes of the fourteenth century, a Gothic Rhodes, to which de Vogüé's term "la physionomie d'une ville française" would have been more applicable than it is to the present monuments, largely rebuilt for artillery in the later fifteenth century, and under the Fascist regime restored as an expression of Italianità.

For with the Italian conquest of 1912, the restoration of Rhodes became part of a general program, much of it of a high standard of scholarship, but one where respect for the past and propaganda for the present were curiously and at times uneasily combined. Rhodes emerged as a twentieth-century Carcassonne, a late medieval fortress town in good working order, its edges clear and sharp cut, its stones scrubbed and clean, all gaps filled and mystery gone. This washed splendor had only a brief period. In the second world war, Rhodes suffered considerably from bombing and demolition. The Hospice of the Knights was hit by a bomb and the refectory destroyed. St. Paul's gate, inside which fifteenth-century cannon-balls were neatly piled, was heavily damaged, losing all its battlements. Several churches and chapels, notably the Demirli Jami, probably the Greek cathedral under Latin domination, and the Gothic Yeni Chari Jami, received direct hits and are now mainly ruins. Yet, despite destruction and restoration, much remains. Rhodes is still one of the great medieval cities, with few rivals in its picturesque completeness.

To the crusades it is an epilogue. In Cyprus there is continuity with Syria, a century when the two, Nicosia and Acre, existed side by side in the closest contact, and after the Latin kingdom perished in 1291 Cyprus was its direct heir and the refuge for its citizens. When, in the years 1306-1310, the master Fulk of Villaret occupied Rhodes, still part of the empire of Andronicus II Palaeologus but disputed between the Turks and the Genoese, it was a new venture, prompted by the needs of the order for a headquarters and a raison d'être, and directed against an island that had thitherto played little part in crusading history. The knights made of it a main bastion of western trade and influence in the Levant, and from it they controlled the other islands of the Dodecanese. In its early days, the garrison was aggressive, massacring its prisoners with pious enthusiasm as though hoping to destroy the Turks by gradual attrition. Later a more tolerant attitude prevailed. Prisoners were thought of as slaves rather than as infidels and met the endless demand for labor involved in maintaining the defenses. The masters, later called grand masters, were usually skilled authorities in eastern diplomacy. The island became a fortress for the preservation of its own position rather than a stage in the reconquest.

The town is built on the northernmost point of the island, on the eastern slope of Mt. Stephanos, still often known as Mt. Smith, a curious tribute to Sir Sidney Smith, who established an observatory there during the Napoleonic war, and whose eccentricities endeared him to the Near East. The ancient acropolis on its summit and, below, the temple of Apollo and the theater, lie outside the medieval fortifications. The classical city, probably planned in 408 B.C., covered a wide area, very different from the small port that the knights occupied, and its parallel street plan is still discernible from the air.[2] Little is known with certainty about the state of the town at the time of its capture by the Hospitallers, and even the capture itself is curiously undocumented, some accounts referring to a siege of two months, others of two years.[3] A sphere of Genoese influence in the last half of the thirteenth century, Rhodes was in 1300 raided by the Turks, and the hold of Byzantium upon it was obviously precarious. It does not appear to have been strongly defended, but the Byzantine citadel must have been the basis of resistance to the knights, and was probably taken over by them as their own strong point. The town was divided into two main blocks, the citadel or *collachium*, the residence of the knights, and the lower town. The citadel enclosed the northern quarter in a circuit of walls, an area 850 feet from north to south and 1,225 feet from east to west. Within it were the palace of the grand master, the arsenal, the church of St. John, and the hospital; along its main thoroughfare, the "Grand rue du Chasteau," the modern Street of the Knights, were the *auberges* of the various *langues*, the divisions of the order according to region and language. At the northeast corner the walls of the citadel joined the port wall running down the northern arm of the harbor and ending in the tower of Naillac. South and southeast of the citadel lay the town, surrounded by a defensive system of a main wall and ditches.

In the same month, September 1307, that the pope, Clement V, authorized the occupation of Rhodes by the knights, Philip IV ordered the arrest of the Templars throughout his dominions. It was in good time that the Hospitallers had moved into action. Five years later the lands and goods of the Temple were transferred to the Hospital. Much of this new wealth no doubt passed into other hands;

2. J. Bradford, "Fieldwork on Aerial Discoveries in Attica and Rhodes," *The Antiquaries Journal,* XXXVI (1956), 57-69.

3. See J. Delaville Le Roulx, *Les Hospitaliers en Terre Sainte et à Chypre (1100-1310)* (Paris, 1904), pp. 275-281; A. S. Atiya, *The Crusade in the Later Middle Ages* (London, 1938), pp. 256-290.

some of it for a time seems to have been dissipated in high living by the European commanderies; but the increment must have been substantial, and the rapid building of the walls of Rhodes owed much to the downfall of the brother order.

Ludolph of Suchem, who visited Rhodes during the grand mastership of Hélion of Villeneuve (1319-1346), tells us that the city was fair (*pulcherrima*) and strong, built with high walls and impregnable advance works (*propugnacula inexpugnabilia*) "out of huge stones which it would seem impossible were placed by human hands."[4] Allowing for Ludolph's enthusiastic exaggeration, this seems to imply that the town was now walled with a curtain and lower outer wall and that much of it was composed of reused classical material. The arms of Hélion in fact exist on the walls, but reset along with those of Giovanni Battista Orsini (1467-1476), so that they in no way date the gateway between the town and citadel where they now appear. The earliest works certainly dated are the two rectangular towers on the north wall of the citadel, where the arms of Juan Fernández de Heredia (1377-1396) are still *in situ*. His successor, Philibert of Naillac, was much occupied with the building of the castle at Bodrum, but at Rhodes his name was linked with a celebrated construction, the square tower at the end of the mole on the north side of the main harbor. Demolished after the earthquake of 1863, it is reasonably well known from detailed accounts and drawings of it and even from an early photograph. Its most characteristic features were its gallery of machicolations, which supported the platform walk, the four round towers carried on corbels (*échauguettes*), and the central octagonal tower. Its total height was about 150 feet above sea level.[5] Striking and conspicuous in effect, it was still medieval in its theories of defense, and it was not until the next grand mastership, that of Anton Fluvian (1421-1437), that provision for artillery first appears at Rhodes, in the form of rectangular gunports at parapet level in St. George's tower. John of Lastic, grand master from 1437 to 1454, continued the strengthening of the fortifications, and his arms occur frequently on the southwest stretch of the walls, always regarded as the most vulnerable point and in fact that at which the Turks broke through in the final siege.

The scheme of defense as it existed in the first half of the fifteenth century consisted of the citadel, the northern and western walls of

4. Ludolph of Suchem, *De Itinere Terrae Sanctae liber,* ed. F. Deycks (Bibliothek des litterarischen Vereins in Stuttgart, XXV; 1851), p. 27.

5. See an etching based on a photograph by D. E. Colnaghi in C. T. Newton, *Travels and Discoveries in the Levant* (2 vols., London, 1865), I, 199.

which formed part of the main circuit, but which on the south and east was separated from the town by an inner wall with rectangular projecting towers. The curtain walls surrounding the whole were of no great thickness; round towers protected the angles, square or round towers the gateways, and on some of the longer stretches of wall there were small rectangular towers, which projected through the lower wall or *fausse-braie*, in front of the curtain.[6] Most of these towers were detached from the curtain and accessible from it only by wooden bridges, so that, should the tower be destroyed, it would not bring down a stretch of the curtain with it. Beyond the *fausse-braie* was a ditch about fifty feet wide, which could be controlled by the projecting towers (fig. 15). Much of this, the *fausse-braie*, the detached towers, is in line with common Byzantine practice.

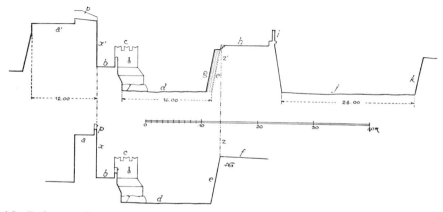

15. Defenses of Rhodes before and after enlargement. After A. Gabriel. *a.* inner wall *b.* fausse-braie *c.* tower on fausse-braie *d.* first level *e.* original escarpment *f.* outside level *g.* new escarpment *h.* earthwork *i.* battlements of earthwork *j.* new ditch *k.* escarpment

The Hospitallers in Rhodes did not continue the tradition of their Syrian castles. The battering of the walls and rows of machicolation that characterize Krak des Chevaliers are on the whole absent, and the machicolation was confined to one or two towers, such as that of St. Athanasius, built by Lastic. Heredia had been for a time governor of Avignon while the papal city was being fortified, between 1350 and 1368. Avignon was a great school and center of architecture, and the palace of the grand masters undoubtedly owed something to its vast papal prototype, but the continuous machicolations of the city walls of Avignon are not repeated in the island. The stone was the local yellowish sandstone, generally cut in small blocks and set in

6. Gabriel, *La Cité de Rhodes,* I, 17-18.

mortar. Much of the work was carried out by Turkish prisoners, but the local masons obviously had a considerable degree of competence and in particular their mortar has proved exceptionally durable. The masonry throughout is admirable work, and the heraldic sculpture carefully placed to set it off. Little care was taken for aesthetic effects. The wide ditches which surround the walls give them a sense of less height than they in fact have, and Rhodes suggests a businesslike efficiency rather than a prestigious dignity, though Naillac's tower must have added an impressive feature to the general scheme.

Rhodes in 1444 was besieged by a force from Egypt, a siege that lasted for some forty days, in which considerable damage was done to the fortifications by the enemy's artillery. Even more threatening than the Egyptian siege was the capture of Constantinople by the Turks in 1453, and its demonstration of the new power of artillery against the most famous walls known to the medieval world.

The grand master Peter Raymond Zacosta (1461-1467), in his short rule of six years, introduced a new scale and new methods of defense works. The Egyptian attack had been most fiercely concentrated on the northeast, from the bay of Mandraki, and here, with a liberal grant from Philip the Good of Burgundy, Zacosta built the tower of St. Nicholas, which, with much reconstruction, still survives. As originally designed it was a central round tower, 57 feet in diameter, surrounded by a polygonal outer wall, with gunports in each of its twenty sides. At the end of the mole leading to the castle was a smaller round staircase tower, from which the outer wall was reached by a drawbridge to a postern defended by machicolations. The polygonal scheme, evolved in a special form for the limited space of St. Nicholas, was carried further in the defenses of two of the main gateways, those of St. John (Koskinou) and of St. George, though the plan of the latter is now obscured by later additions. The Koskinou gate was already protected by a square tower, standing free of the curtain. Zacosta enclosed this tower with a barbican, springing from the wall of the *fausse-braie* and in height halfway between it and the original tower.[7] This barbican was four-sided, but the two outermost sides meet in a point making a salient and thereby providing a wide field of fire for their gunports (fig. 16). Already Zacosta's predecessor, James of Milly from Auvergne (1454-1461), had used a slightly pointed salient on a tower strengthening the

7. B. H. St.J. O'Neil, "Rhodes and the Origin of the Bastion," *The Antiquaries Journal*, XXXIV (1954), 44-54.

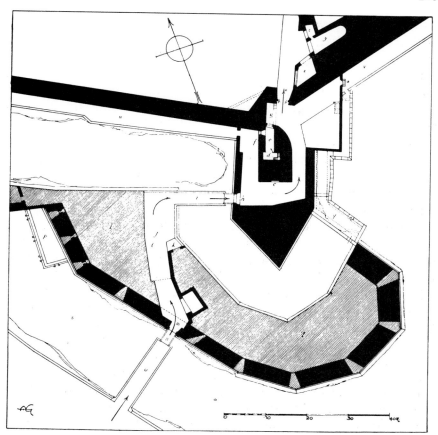

16. Plan of the Koskinou gate, Rhodes: Zacosta's salient and d'Aubusson's boulevard. After A. Gabriel

curtain east of the Koskinou gate, but the salient here was solid and, being behind the *fausse-braie*, had no field of fire for artillery. It is Zacosta's barbican, or boulevard to use the term most generally associated with these Rhodian developments, that initiates the most original period of the fortifications, a period particularly associated with the genius of Peter of Aubusson.[8]

This remarkable man, a younger son of the lords of Monteil-au-Vicomte in Marche, joined the order shortly after the repulse of the Egyptian army, when he himself was about twenty-three years old and already an experienced soldier. Serious-minded and dedicated, he had studied all sides of his profession, including mathematics and

8. D. Bouhours, *Histoire de Pierre d'Aubusson, grand-maistre de Rhodes* (Paris, 1676; 4th ed. with additions by M. de Billy, Paris, 1806; tr. as *The Life of the Renowned Peter d'Aubusson, Grand Master of Rhodes, Containing Those Two Remarkable Sieges of Rhodes by Mohamet the Great, and Solyman the Magnificent,* London, 1679).

engineering, studies which he could now put to good purpose. A skillful diplomatist, both in the internal bickerings among the langues and in negotiations with the papacy or the Turks, he was also a heroic fighter, and in the breach of the walls on July 27, 1480, rallied the defense, though himself wounded five times. In his fanatical devotion to the holy war, he recalls the unquestioning faith and frank intolerance of an earlier age. While ready to give some splendor to the church of St. John and the state rooms of the grand master's palace, he himself maintained a primitive simplicity and enforced the strictness of the rule on these celibate warriors in their pleasant island by penalties of fasting and public discipline. He was even more severe towards the inhabitants of the town: the Jews were expelled and their children taken from them and brought up as Christians; women who, during periods of peace with the "infidel," had given themselves to visiting Turkish sailors, were condemned to be burned alive. Pope Innocent VIII in 1489 created this dour and inflexible soldier cardinal-deacon of St. Hadrian, surrendered in his interest the papal rights of nomination to certain commanderies in the order, and abolished the orders of the Holy Sepulcher and of St. Lazarus, transferring their goods to the Hospitallers. The Turks feared and admired him, and Bayazid II presented to him, from the treasury of Constantinople, the right hand of the Baptist, a relic which the grand master subjected to careful authentication.[9] When Aubusson died in 1503 and was laid out in the church of St. John, there were on one side the vestments of a cardinal, on the other the hacked and battered armor he had worn in the defense of Rhodes. Devout, honorable, learned, and pitiless, harsh to himself as to others, he was already almost an anachronism, a throwback to the original crusaders.

The works carried out by Aubusson under Orsini were concerned mainly with the strengthening of the walls so as to withstand artillery fire and to provide gun emplacements for their own cannon. It was now that many of the detached towers were linked to the curtain and their lower chambers filled up with solid masonry. Resistance had become more important than flexibility of movement between semi-independent units. Much of Orsini's work was concentrated on

9. When, on the dispersal of the knights from Malta, the emperor Paul I of Russia became grand master, this relic and the icon of Our Lady of Phileremos were taken to Russia. They were last heard of in the royal palace at Belgrade before the second world war: H. Scicluna, *The Church of St. John in Valetta: Its History, Architecture and Monuments, with a Brief History of the Order of St. John from its Inception to the Present Day* (Malta, 1955), p. 134.

the sea front, and this was completed in the early years of Aubusson's grand mastership by the building of the Sea gate. Facing the main port, it is an impressive erection, where more thought has been given to decorative effect than is usual in Rhodes. It remains, however, a medieval building, whose twin round towers and heavily machicolated parapet strikingly recall the fourteenth-century gateway of Fort St. André at Villeneuve-lès-Avignon.

In 1480, two years after the completion of the Sea gate, Rhodes had to endure the first of its two great sieges by the Turks. The enemy landed on May 23, and their earliest objective was the tower of St. Nicholas, by gaining which they hoped to prevent any supplies or reinforcements being brought to the harbor. Failing in a great attack on the tower on June 19, they switched their artillery, whose power was such as the knights had not yet experienced, to the southwest walls. So hard-pressed here was the garrison, that many of the houses behind the tower of Italy were pulled down, and a second line of defense with a ditch and stakes was hastily improvised. On July 27 the Turks made their great assault and penetrated the city, but were eventually driven back with such loss that their commander Mesih Pasha raised the siege. William Caoursin, vice-chancellor of the order, wrote an account of it, *Obsidionis Rhodiae urbis descriptio*, and in one manuscript of the work (Bibl. nat., lat. 6067) there are three views of the town during the siege operations, which show the fortifications before the remodeling of them that was now to be undertaken. In Bernard of Breydenbach's account of his journey of 1483 there is another drawing of Rhodes, very carefully executed (by Erhard Reuwich), down to the damage in the tower of the church of St. John, hit during the siege (fig. 17).[10]

Much had been learned from this hard-pressed attack on the town. The field of defensive artillery fire now emerged as the dominant consideration, and Aubusson sought to extend it by a series of projecting boulevards well in advance of the older fortifications. The earliest, still hesitant and unprogressive in form, was probably the rectangular wall with three tiers of gunports, linked to the *fausse-braie*, between the Koskinou gate and the tower of Italy on the southeastern stretch of the walls. Beyond it an earlier round tower is enclosed by a rectangular wall, with gunports but no solid emplacement (pl. LXIVb). These rapidly planned expedients, where the Turkish attack had been most damaging, were followed by four

10. Caoursin's *Descriptio* was printed with others of his works at Ulm in 1496 as *Obsidionis Rhodie urbis descriptio* For Breydenbach see H. W. Davies, comp., *Bernhard von Breydenbach and his Journey to the Holy Land, 1483-4: A Bibliography* (London, 1911).

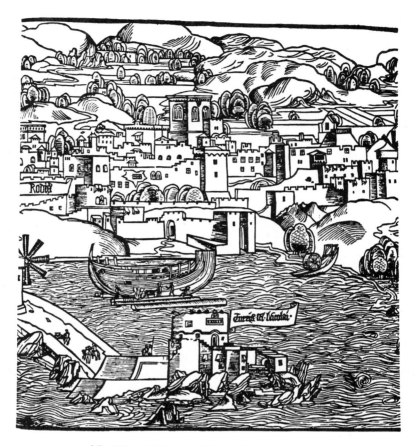

17. City of Rhodes. Erhard Reuwich, 1486

large polygonal boulevards, those of Spain, England, the Koskinou
gate (enclosing Zacosta's earlier scheme), and Auvergne. In these the
covered space of the boulevard was separated by a ditch from the
tower it protected. Inside the covered part of the boulevard were
vaulted casemates, connected by passages, but much of the area was
solid masonry. The outer walls were immensely thick and in the later
examples the walls are battered. After his election to the cardinalate
in 1489 Aubusson placed the cardinal's hat above his arms, most
usefully for the dating of his constructions. The boulevard of
Auvergne (1496) belongs to this later period. It is the largest of all
these boulevards and its four sides form an obtuse angle, a spur,
flatter but similar in scheme to the smaller spur which it encloses and
which, resembling as it does that of the Koskinou gate, was probably
the work of Zacosta, though the tower of St. George behind it bears
the arms of Fluvian. This boulevard passed through the *fausse-braie*
to gain the curtain, and the tower gateway was blocked up (fig. 18).
First and foremost the boulevard of Auvergne is a large gun

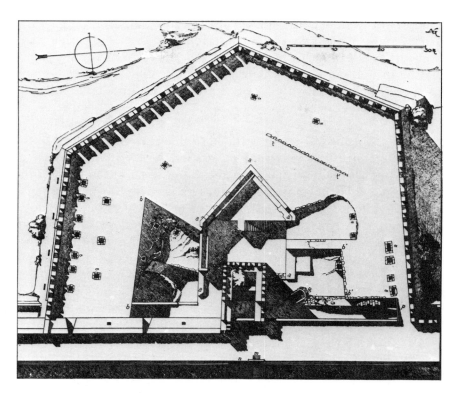

18. Sketch diagram of the Boulevard of Auvergne, Rhodes. After A. Gabriel

emplacement, controlling the western approaches to the town. In it the Rhodian boulevard is most fully developed, and there is for it no clear European prototype. The Turkish threat and Aubusson's invention begot this new stage in the art of fortification. Aubusson's other works were numerous. The tower of St. Nicholas was strengthened with a form of boulevard. Along the southwest of the walls he more than doubled the width of the ditch, building down the middle solid earthworks, revetted in carefully cut stone, using the escarpment of the first ditch as the inner wall; on the outer side was a parapet so that these earthworks could be manned (fig. 15). It is these works that today give such an appearance of solidity to Rhodes's defenses, while at the same time masking the view of the original curtain and detracting from its sense of height.

Aubusson's successors continued his work. Emery of Amboise (1503-1512) is particularly associated with the Amboise gate, at the northwest corner of the town, an entry, guarded by squat, rounded towers, into a broad earthwork dividing the ditch, and providing the main access to the palace area. Fabrizio del Carretto (1513-1521) was continuously active in building, particularly in improving the

gunports by widening the splays, but his most important boulevard, that of Italy, though fine in detail, is round in form and springs only from the *fausse-braie*. It has none of the implications for the future that lie in the boulevard of Auvergne. Philip Villiers de l'Isle Adam, his successor, had only a year of rule before in the summer of 1522 the final siege began.

These problems were not restricted to the town of Rhodes. On the island the knights held seventeen castles, of which today that at Lindos, pitched high on the rock above the town in the ruins of the old acropolis, is the most complete. Orsini seems to have taken a particular interest in these outposts, for he largely rebuilt Pheraclos and repaired Archangelos, whose ruins still overlook the road to Lindos.[11] Of the castle built by Hélion of Villeneuve in the village named after him on the pleasant slopes of Mt. Paradisi there were considerable remains when Flandin sketched it about 1850, and it appears to have been a handsome Gothic building, more residence than fortress; parts of its walls are still standing. At Monolithos C. T. Newton saw some frescoes which he thought western, and the arms of Aubusson above a chimney-piece.[12] The smaller islands—Alimnia, Chalce, Simi, Telos, Nisyros, Calymnos, Leros, Lipsos, Carpathos, and Castellorizzo—all had their fortresses, built generally on rocky hilltops, based on Hellenic foundations, but all occupied and rebuilt by the knights and showing in most cases traces of the same indefatigable and continuous program that is illustrated by the walls of Rhodes.

Farther afield, under Philibert of Naillac, the order erected the castle of Bodrum on the coast of Asia Minor, the site of the ancient Halicarnassus. In 1344 Smyrna had been recaptured by the crusade launched by pope Clement VI. Its garrisoning had been entrusted to the Hospitallers, and for sixty years its defense was a heavy charge upon them. The arms of Heredia and of the admiral of Rhodes, Dominic de Alamania, are still to be seen inserted in the prison wall and almost certainly come from the castle of St. Peter, built by the knights and, though much altered, not finally pulled down until 1872.[13] Smyrna fell to Timur (Tamerlane) in 1402, and Naillac, anxious to retain some hold on the mainland, occupied Bodrum and began the construction of a castle there, another St. Peter (Bodrum, meaning a vault or dungeon, is a corruption of Petrounion), which

11. Belabre, *Rhodes of the Knights,* pp. 171-190.
12. Newton, *Travels and Discoveries in the Levant,* I, 199.
13. F. W. Hasluck, "Heraldry of the Rhodian Knights Formerly in Smyrna Castle," *Annual of the British School at Athens,* XVII (1911), 145-150.

remained in the hands of the order till 1523.[14] This building operation, begun under a German knight, Hesso Schlegelholtz, has a special interest, for the materials were drawn from the mausoleum of Halicarnassus, which the knights found a ruin, recently overthrown by an earthquake, and which they proceeded to use as a quarry. No sacred associations hallowed the spot, though a tradition grew up that Bodrum was the Tarshish where the three Magi left their ships, and some sarcophagi were in the fifteenth century shown as their tombs. Such ingenious identifications were not sufficient to invest the ruins with any saving sanctity. The sculptures belonged to a pagan cult and were best ground down for mortar. Some lions carved in the round pleased the knights, and these were incorporated in the castle beneath armorial slabs; some reliefs, fragments of a frieze, a battle of the Amazons, were inserted in the walls; an imperial statue, a late work of little quality, was placed in a niche on the water tower.

When in 1522, in a last effort to strengthen the castle, a French knight, de la Tourette, and some others found the main tomb chamber, "a fine large square apartment, ornamented all round with columns of marble, with their bases, capitals, architrave, frieze and cornice engraved and sculptured in half relief," they for a while "entertained their fancy with the singularity of the sculpture and then destroyed it." The tomb itself they did not enter that day, and when they returned the next day it had already been broken into and plundered. De la Tourette survived the siege to tell his story to the French antiquary d'Alechamps, who in turn told it to Claude Guichard, who gives it in his *Funerailles et diverses manieres d'ensevelir des romains, grecs et autres nations,* published at Lyons in 1581.[15] The garrison of St. Peter in 1522 were desperate men, and

14. Delaville Le Roulx, *Les Hospitalliers à Rhodes,* pp. 284-291; C. T. Newton and R. P. Pullan, *A History of Discoveries at Halicarnassus, Cnidus, and Branchidae* (2 vols. and atlas, London, 1862-1863), particularly vol. II, appendix I, "Description of the Castle of St. Peter at Budrum" (pp. 645-666, and plates XXXII-XXXVIII of the atlas); Newton, *Travels and Discoveries in the Levant;* K. Herquet, *Juan Fernandez de Heredia, Grossmeister des Johanniterordens, 1377-1396* (Mülhausen, 1878), pp. 100-115; A. Maiuri, "I Castelli dei cavalieri di Rodi a Cos e a Budrúm (Alicarnasso)," *Annuario della R. Scuola archeologica di Atene . . . ,* IV-V (1921-1922, publ. 1924), 275-343; L. A. Maggiorotti, *Architetti e architettura militari,* I (*L'Opera del genio italiano all' estero;* [ser. 4,] *Gli architetti militari;* Rome, 1933), 79-101; A. Maiuri, "Il Castello di S. Pietro nel Golfo d'Alicarnasso," *Rassegna d'arte antica e moderna,* [n.s.,] VIII [=XXI] (1921), 85-92; F. W. Hasluck, "Datcha-Stadia-Halikarnassos," *Annual of the British School at Athens,* XVIII (1912), 211-216; Müller-Wiener, *Castles of the Crusaders,* pp. 91-92. For the identification with Tarshish cf. *The Itineraries of William Wey, Fellow of Eton College: To Jerusalem, A.D. 1458 and A.D. 1462, and to Saint James of Compostella, A.D. 1456* (London, 1857), p. 94.

15. Claude Guichard, *Funerailles & diverses manieres d'ensevelir des romains, grecs, & autres nations, tant anciennes que modernes* (Lyons, 1581), pp. 379-381.

even in Rhodes they thought little of antiquities. "They lie about despised, abused, unvalued, exposed to wind and rain, to snow and tempest, which wretchedly consume and waste them, so that pity for their cruel lot moved me as if it had been my father's unburied corpse: I made a sonnet on them and hung it on a statue's neck." So wrote the young Fra Sabba of Castiglione, come in 1505 to join the order, and the lady to whom he wrote was Isabella d'Este, queen of all collectors. He secured for her, amongst other works, a marine monster lasciviously embracing a nymph "lately found among the ruins of Halicarnassus," and he hoped to visit that site to see a new tomb opened in 1507, but when the greater find of 1522 was made, in those grim last days, the young "idolator," as the Spanish knights called him, was safely back in Italy.[16]

Bodrum was a base from which the Turkish fleet could be watched, and with the Hospitaller castle on the nearby island of Cos it provided a secure port for the knights' vessels. Much damaged by the French bombardment in 1916, the castle was partially repaired by the Italians in 1919. It was also carefully planned and described. Built largely of the greenish stone of the mausoleum on a promontory which the knights converted into an island by a large ditch, it remains one of the most impressive of medieval fortifications. Isolated though it was, the Hospitallers brought to it all their resources in decorative work as well as in military skill. More than two hundred carved shields of arms have been noted on its walls; in addition to the antique reliefs and lions, there were some figure panels (St. George, above Lastic's shield; the Virgin and three saints) of the usual Rhodian style; and, even in the anxious years 1519 and 1520, the façade of the small chapel within its walls was redecorated with some well-cut ornament of the late Gothic style, mixed with the Renaissance detail that Aubusson had introduced during his grand mastership. The earliest work was a central keep, based on Greek and Selchükid foundations, with two large rectangular towers connected by a vaulted hall, the larger having a corbeled corner turret; on the curtain wall, facing the mainland, was a round tower, standing within the angle of the wall, and a semicircular tower, joined to the curtain; on the south corner a square tower, on which are many arms of the English langue, controlled attack from the sea. This stage of the building, as dated by the arms upon it, was completed by 1431. The outer enceinte on the land side was constructed mainly under Lastic and his successor Milly, that is between 1437 and 1461.

16. A. Luzio, "Lettere inedite di Fra Sabba da Castiglione," *Archivo storico lombardo,* ser. 2, III (1886), 91-112.

Building at Bodrum was continuous: there was a period of particular energy in the 1490's under Aubusson, who had in the Spaniard de Boxolis an energetic captain of the castle, probably serving a third term of office in the post. Then at the end under Fabrizio del Carretto, with Thomas Sheffield and de Hambroeck as captains, a last desperate effort was made to set up outer boulevards with gun emplacements such as had been introduced at Rhodes. Del Carretto's two boulevards, here and at the citadel of Cos, are examples of the final development of the order's fortifications, the climax of a story that at Bodrum can be traced through all its stages (pl. LXVb). Nowhere is the story of the order, its international nature, its zeal and energy, more clearly visible. And here and there inscriptions on the walls give more intimate and moving testimony: "Cum Christo vigilemus et in pace requiescamus," "Nisi dominus custodiret . . . ," and the harassed, defiant, ungrammatical inscription of captain James of Gâtineau, still in place between two ancient lions, "Propter catholicam fidem tenetur locum istum F. Iac. Gatineau Cap. 1513." These carved inscriptions are an old Hospitaller custom, and those at Bodrum are successors to the warning against pride cut on the walls of Krak des Chevaliers.

Begun somewhat later, in the mid-fifteenth century, the castle of Cos, on a smaller scale but a considerable and well-preserved building, shows a similar development. It is a quadrilateral with a double enceinte, the outer dating from Aubusson and Amboise and including a great artillery bastion which is a twin to that at Bodrum.[17] The town walls are earlier, dating from the grand mastership of Heredia. To the knights this was the island of Lango, with its capital Narangia, and it always ranked as the most important of their island holdings. Apart from the main castle of Narangia, there were also castles at Pili, on a high rocky summit, and at Andimachia; the latter has Aubusson's crest above the main entrance, which is protected by a round bastion, not unlike that built by Fabrizio del Carretto at Rhodes: the latter's arms appear on the wall.

Rhodes, however, was the heart of the whole enterprise. The palace of the grand master seems to have been completed in its earliest form under Hélion of Villeneuve, but like so many of the island's buildings was enlarged and modified under Aubusson and del Carretto.[18] A rectangular fortress, the entrance protected by semi-

17. Gerola, "I Monumenti medioevali delle tredici Sporadi," *Annuario della R. Scuola archeologica di Atene . . . ,* II (1916), 28-46.

18. P. Lojacono, "Il Palazzo del Gran Maestro in Rodi: Studio storico-architettonico," *Clara Rhodos,* VIII (1936), 289-365.

circular machicolated towers similar to those of the Sea gate, with rectangular towers at other points on the walls, it must have presented a massive and impressive appearance. The great hall was the scene of the chief councils and decisive events of the history of the order. Aubusson ordered tapestries from Flanders and other furnishings for it, and under him its original severity must have given way to a more elaborate decoration. Today, completely rebuilt, externally with much scholarly care, internally with a display of Fascist splendor, it has ironically become a monument to the Italian occupation rather than a memorial of its original builders.

The church of the order was that of St. John, within the citadel.[19] The disastrous explosion of 1856, in which many lives were lost, may have been caused by some forgotten store of powder in its vaults. Nothing now remains, but earlier drawings and descriptions and some excavations carried out in 1934 make it possible to reconstruct the plan with some certainty. It was composed of a nave and two aisles, divided by columns, the nave roofed with a wooden barrel vault strengthened by cross beams, the aisles with sloping roofs also of wood. The crossing and transepts, which had no projection but which opened on the north into the sacristy, on the south into a chapel, were covered with stone ribbed vaults; the main apse was square, projecting some way from the eastern wall; a detached rectangular campanile, the watch-tower of the knights, stood to the southwest of the church. The main building may have been fourteenth-century work carried out under Syrian and Italian influences. Its general scheme was certainly not one local to the island. It was, however, constantly altered and embellished. Aubusson, under whom it was much enriched with relics and other gifts, built himself a funeral chapel. The church was the burial place of the grand masters, and their tombs and memorials were a marked feature of the interior. The campanile, damaged in the siege of 1480, was restored by Aubusson and Amboise, and some of the later work in the church may well have been reparation of similar damage; Breydenbach's drawing shows a large gap in the parapet.

The cathedral church of St. Mary was also within the citadel. The building, long the Kantousi mosque and recently restored, is a strange compromise between two types of architecture. On the plan

19. P. Lojacono, "La Chiesa conventuale di S. Giovanni dei Cavalieri in Rodi: Studio storico-architettonico," *Clara Rhodos,* VIII (1936), 245-288; Rottiers, *Monumens de Rhodes,* pls. XL and XLII. The Italian reconstruction of this church on a different site as the new cathedral is based on Rottiers's drawings but cannot be considered altogether successful. The eastern end has been much altered since it passed into the hands of the Orthodox church.

of an inscribed cross, which should naturally be centered in a cupola, it has in fact a continuous rib vaulting covering the nave. In Rottiers' day the tracery of the windows and even some of the glass could still be seen, and his drawings of the former show them to be fifteenth-century work. The early church was probably a Byzantine building, taken over by the knights, and the Gothic roof an attempt to westernize it in its second century of Catholic use.[20]

Near the cathedral, in the square from which the Street of the Knights led westward to the palace, was the hospital, a witness to the early aims of the order and still a central part of its activity. Mentions of it occur as early as 1311. A group of buildings near the auberge of Auvergne, bearing the arms of the master Roger de Pins (1355-1365), may be the original edifice, but the hospital as it has survived to the present day was begun in 1440 and completed by Aubusson in 1489.[21] Inscriptions, some of them found during the Italian work of restoration, date the stages of the building with some precision, and record the foundation bequest by Fluvian of 10,000 florins. Built on vaulted storehouses around an open courtyard, the great ward (160 feet by 38) was roofed with wooden beams and divided by a row of octagonal pillars, and in the center of the eastern wall there was a five-sided apse, which formed the chapel for the daily mass and which projected as an architectural feature over the doorway of the eastern façade. The decoration is an elaborately stylized foliage, less exuberant than that of Cyprus and with a certain Renaissance regularity in its design. Everywhere, as usual, are the arms of the grand masters under whom the work was carried out.

Within the citadel the various *langues* or nations had their *auberges* or hostels. Their façades still line the main thoroughfare, and much of their carved detail remains (pl. LXVa). From the arms and inscriptions it is clear that here too extensive work was done in the closing years of the fifteenth century and early years of the sixteenth. This may have been partly due to damage in the siege of 1481, but it is a singular testimony to the vitality and determination of the order. The auberge of Provence was enlarged in 1511 through the generosity of Charles Aleman de la Rochechenard, prior of St. Gilles, a great benefactor of the order. The auberge of Spain, the largest of the langues, was built under Fluvian, but increased and

20. F. Fasolo, "La Chiesa di S. Maria del Castello di Rodi," *L'Architettura a Malta dalla preistoria all' ottocento: Atti del XV Congresso di storia dell' architettura, Malta, 11-16 settembre, 1967* (Rome, 1970), pp. 275-300. [J. F.]

21. G. Gerola, "Il Restauro dello spedale dei Cavalieri a Rodi," *L'Arte,* XVII (1914), 333-360; A. Maiuri, "L'Ospedale dei Cavalieri a Rodi," *Bollettini d'arte del Ministro della pubblica istruzione,* [n.s.,] I (1921), 211-226.

remodeled under Amboise. That of France, restored in 1921-1922 but much damaged in the second world war, was begun in 1492. The tradition of the auberges, as seen at Rhodes, was perpetuated in Malta, where in the early buildings at Birgu the houses of the knights in many details recall the buildings from which the order had been driven.[22] Fortunately, amidst the devastation of a siege severer than any Rhodes ever knew, these early auberges escaped with only minor damage.

In the town of Rhodes, as opposed to the citadel, there have been more changes and freer adaptation of buildings. Of its many churches few remain, and it is not always possible to identify the fragments that in places survive incorporated in later constructions. The three apses of St. Mary du Bourg (to accept the most likely identification) still stand with a broad road passing between them and the remains of the west end.[23] Even less can be traced of St. Mary of the Victory, built by Aubusson to celebrate the defeat of the Turks in the siege of 1480. The curious church transformed into the 'Abdul-Jelil mosque, now roofless as a result of bombardment, has two aisles, ending in apses, and some carved consoles similar to those in the hospital. It may be a Latin church of the early fifteenth century. Better preserved is the charming building known as the Kurmali madrasah, a small domed church, Byzantine in plan but with details that suggest that it was built in the time of the knights. Possibly it may be the Greek church of St. Mark, which was ceded in 1457 to the Franciscans. Wiser than the Lusignans in Cyprus, the grand masters acted as arbitrators between the Latin and Greek metropolitans. Rhodes in fact played something of a mediatory part in the Council of Florence in 1439. There were ecclesiastical disputes, but they were kept within bounds.[24] The Orthodox churches all have domes over the crossing and are cruciform in design, but in some the cross pattern is inscribed in a normal form of nave and two aisles, in others free-standing (nave and transepts). The Demirli mosque was hit by a bomb in 1944; the central apse still stands, with some fragments of fresco, a well-painted hand, and patches of ecclesiastical vestments. The Dolapli mosque, a free-standing cross, is fortunately intact. It is undoubtedly a work of the fifteenth century.

Of civil buildings, the finest, now a municipal library, may have

22. James Quentin Hughes, *The Building of Malta during the Period of the Knights of St. John of Jerusalem, 1530-1795* (London, 1956).

23. H. Balducci, *La Chiesa di S. Maria del Borgo in Rodi, fondata dal gran maestro Hèlion de Villeneuve, la cattedrale di Rodi, la chiesa di Santa Caterina della Lingua d'Italia* (Pavia, 1933).

24. C. Torr, *Rhodes in Modern Times* (Cambridge, 1887), pp. 70-74.

been the Bailliage du Commerce: it still has considerable decorative
work, including an elaborate pinnacled relief with the arms of
Amboise and a doorway framed in marble; on the lintel an angel
holds shields with the arms of Amboise and the cross of the order,
skillful work that suggests Italian workmanship. A similar Renais-
sance style is found in the reused marble carvings of a doorway in the
Suleiman mosque, a nineteenth-century reconstruction. Many of the
houses retain windows and doorways of medieval design; a border of
twisted rope pattern recurs constantly, with stylized foliage and
sometimes animals worked in flat relief. Nowhere in the capital of
the island, however, does this kind of domestic façade reach the
luxuriance of some of the late medieval houses in the little town of
Lindos. It is a type of ornament which has already been noted in the
niche shrines of Geraki and is curiously compounded of motifs from
many parts. In Lindos it reached its climax and remained in vogue till
modern times.[25]

As with building, so with carving. It is under Aubusson that a new
range of ornamental detail appears, naturalistic foliage carved with
some competence, figures modeled with some feeling for roundness
of form, and throughout a freer undercutting of the detail.
Particularly are these changes to be seen in his great armorial slabs,
and it is largely to its heraldry that Rhodes owes its particular
character. A hundred and fifty shields of grand masters survive, apart
from those of other knights on the façades of the auberges. Cut in
white or bluish marble, they stand out magnificently from the
rougher masonry of the walls. It was under Fluvian, the Catalan, in
the second quarter of the fifteenth century, that elaborate surrounds
were added to the simple shield, but his St. George and the Dragon,
framed in the rope molding which here makes its first Rhodian
appearance, is a crude work, flat relief without modeling, clearly by
some local hand. A carved fragment in the museum shows, with finer
handling, a combat between a mounted knight and a lion, possibly a
legend of the master Dieudonné of Gozon (1346-1353), rather than
that of St. George, though both combatants defeated a dragon,
rather than a lion-like beast.

As in Cyprus, there survive in Rhodes—or in museums elsewhere to
which they have been taken—a number of tomb slabs.[26] As late as

25. See above, p. 225, and M. Montesanto, *La Città sacra (Lindo)* (Collezione di
opere e di monografie a cura del Ministro delle colonie, no. 12; Rome, 1930).

26. E. Rossi, "Memorie dei cavalieri di Rodi a Constantinopoli," *Annuario della R.
Scuola archeologica di Atene . . .*, VIII-IX (1925-1926, publ. 1929), 331-340; G. Jacopi,
"Monumenti di scultura del Museo archeologico di Rodi, II," in *Clara Rhodos,* V-2 (1932),
41-43.

1826 Rottiers saw and drew in the church of St. John the tomb of Fabrizio del Carretto (the fine armorial relief in the museum at Istanbul, an eagle holding the Carretto arms, may well come from it), and found various other fragments. The normal design was a sarcophagus, generally antique in origin, covered with a flat slab on which there was an inscription or an effigy engraved or shown in low relief. The sarcophagus of Peter of Corneillan (d. 1355), now in the Rhodes Museum, served until the Italian occupation as a drinking trough; the cover is in the Musée de Cluny. Slightly earlier is a fragment in the Rhodes Museum of the tomb slab of Bernard, bishop of Lango (Cos); this is engraved on the stone. A slab in the museum of Istanbul, for a burgher, William Beccario, who died in 1374, is hollowed out into a low relief, much worn and probably always crude work. In the last days of the knights the reverse of this tomb slab was used to cut the arms of Castile and Aragon, supported by an eagle, for the façade of the auberge of Spain, the boldest and most lively of all the Rhodian armorial carvings. The script of Beccario's inscription is Gothic black-letter, as it is also on the tombstone, found in the Suleiman mosque in 1931, of Peter de la Pymoraye, a Breton knight who died in 1402. Here the technique is similar, the figure hollowed out in flat relief, but the work is somewhat abler. The wording and lettering of the inscription recall those on the tomb slab of another Breton knight, Oliver Bouchier (d. 1387), in the church of the Incoronata at Naples, but the Neapolitan example is more fully modeled and the forms more rounded.[27] The average work in Rhodes remains provincial, though a tomb slab at Istanbul and one of a grand master (possibly Fluvian or Lastic) in Rhodes are reasonably skillfully carved in a technique of higher relief. On the whole the most successful Rhodian memorials are those carved with wreaths and armorial bearings and lettered in Renaissance script, such as that of Nicholas of Montmirel (d. February 20, 1511), inscribed above "Domine in te confido" and below in English "As God will."

The knights found in Rhodes an established tradition of Byzantine wall painting. The frescoes of the rock chapels of Mt. Paradisi,[28] probably twelfth-century work, may be taken as an example of this school. This tradition undoubtedly endured, but, as in Cyprus, certain western elements modified the work under the Hospitallers. Unfortunately we know it only in much-damaged

27. S. F. Bridges, "A Breton Adventurer in Naples," *Papers of the British School at Rome,* XIX (1951), 154-159.

28. C. Brandi, "La Capella rupestre del Monte Paradiso," *Memorie dell' Istituto storico-archeologico di Rodi,* III (1938-1946), 1-18, pls. I-XXII.

fragments or in copies of works now perished, rapidly deteriorating, or recently restored. From time to time new evidence emerges from under Turkish whitewash, and scattered throughout the chapels and churches of the smaller islands there are remains of paintings, some of which suggest western influence. No sufficient photographic corpus has yet been made for any comparative work to be possible. Rottiers in the early nineteenth century saw traces in the grand master's palace of scenes from the history of the order, and describes in a building, used as a Turkish house, a fresco of Dieudonné of Gozon killing the dragon, which he had copied in a version that appears merely as a fantasy of the romantic movement. His copies of the frescoes in the sunk tomb chapel at Our Lady of Phileremos are again so crude as to give merely the subject and little indication as to style.[29] Some far closer copies were made by Auguste Salzmann between 1860 and 1870, but by that time the frescoes had largely perished. They represented biblical scenes in the upper row while below a row of knights and ladies knelt beside their protecting saints; skeletons were shown also overshadowing some of the figures. In feeling such an arrangement is purely western. Salzmann's copies and the vague traces of original work that still remain show that in execution they were flat and crude, but the direction of the scheme must have been in western hands. The armor suggests a fourteenth-century date. Belabre drew and reproduced some frescoes in a chapel on the walls, where the outer enceinte, beyond the Sea gate, joins the inner wall; these frescoes included a large mounted St. George, very similar to versions in relief of the same subject, one of which is at Rhodes, another at Bodrum; but Belabre's drawing can hardly be regarded as reliable, and the chapel was damaged in the second world war. Its doorway bore the arms of Peter of Culan, who was lieutenant-general under Heredia from 1382 to 1395.[30]

There are no illuminated manuscripts which can with certainty be assigned to Rhodes as place of origin. There is however an important missal, now preserved in London in the grand priory at St. John's Gate, Clerkenwell. By its arms it can be identified with the missal which Bosio in his chronicle tells us was made for the grand prior of St. Gilles, Charles Aleman de la Rochechenard, and presented to the

29. Rottiers, *Monumens de Rhodes,* pp. 151 and 239, pls. XXVIII and LXI-LXVII; G. Schlumberger, "Fresques du XIVe siècle d'un caveau funéraire de l'église de Notre-Dame de Philérémos (ou Philerme) à Rhodes," *Fondation Eugène Piot, Monuments et mémoires,* XIX (Paris, 1911), 211-216, pls. XXI and XXII. The frescoes were much restored by the Italians.

30. Belabre, *Rhodes of the Knights,* pp. 91-92, frontispiece, figs. 74, 75, 76; Gabriel, *La Cité de Rhodes,* I, 67; Gerola, "I Monumenti medioevale delle tredici Sporadi," *Annuario della R. Scuola archeologica de Atene . . . ,* I (1914), 211.

chapel of the knights in 1504.[31] Its decorations are contemporary work of a lavish nature, armorial bearings intermixed with naturalistic flowers and winged dragons; the scenes, set in landscapes where island castles recall Rhodes itself, are stylistically near the French schools of the time, nearest perhaps to those of Lyons and central France. They are framed in Renaissance arches and pilasters. The seven choral books presented by Villiers de l'Isle Adam to the church in Rhodes still survive in Malta, with the chants as used by the knights, and here too the decoration seems Flemish or northern French.[32]

Of the other arts, little remains of all the luxury of equipment which amazed pilgrims and visitors in the church of St. John or the palace of the grand master. The treasure of St. John taken to Malta was pillaged by Napoleon or carried to the court of Paul I of Russia, where little is known of it since the revolution of 1917. One fine piece of wood-carving survives, the doors of the hospital which were presented to the Prince de Joinville in 1836 and are now in the Musée de Versailles. They are dated 1512 and therefore belong to the last period of Hospitaller art in the island. Twenty-four Gothic panels are surmounted by the arms of Amboise and Villiers de l'Isle Adam and framed in spiral columns. It is a splendid piece of curvilinear decoration, and has all the flat richness of surface that characterizes this Franco-Levantine art. Fragments of similar work, which formed the chapel screen at Bodrum, existed there built into the Moslem pulpit, until the chapel was turned into a museum. On Patmos, the most sacred spot of the knights' territory but one that was entirely controlled by Greek monks, the convent of St. John possesses a rich treasure of manuscripts, plate, and woven fabrics, but it is all Byzantine work and owes nothing to western influence. The monastic buildings, surrounded by their twelfth-century walls and in their present form mainly seventeenth-century work, seem to have been little altered during the period of the knights.[33]

31. G. Bosio, *Dell' Istoria della sacra religione et illma militia di San Giovanni Gierosolimitano,* I (Rome, 1594), 497. Two pages of the missal are reproduced in the *St. John's Gate Picture Book,* published in 1947 by the Grand Priory in the British Realm of the Most Venerable Order of the Hospital of St. John of Jerusalem.

32. Scicluna, *The Church of St. John in Valetta,* p. 185. Music seems to have been cultivated in Rhodes: we hear of an Englishman skilled in an instrument composed of four flutes joined together (Bouhours, *Histoire de Pierre d'Aubusson,* p. 175).

33. Gerola, "I Monumenti medioevale delle tredici Sporadi: Le isole dei monaci di 'Patmos'," *Annuario della R. Scuola archeologica di Atene . . . ,* II (1916), 84-99; G. Jacopi, "Le Miniature dei Codici di Patmo," *Clara Rhodos,* VI-VII (1932), 571-591 (161 pls.), and "Cimeli del Ricamo, della pittura e della toreutica nel Tesoro del Monastero di Patmo," *Clara Rhodos,* VI-VII (1932), 707-716 (123 pls.).

VII

PAINTING AND SCULPTURE IN THE LATIN KINGDOM OF JERUSALEM 1099–1291

The recent growth of the available corpus of crusader art has stimulated renewed interest in the field. In view of the new material, mostly painting, and fresh studies, it is worth considering where we now stand. The nature of crusader art (and architecture) is clearly much more complex than was originally understood. The old theory of a colonial transfer of artists who worked in their native style, a thesis originally formulated from a study of the architecture and carried over to the sculpture, can no longer serve. No doubt this phenomenon existed in crusader art, but the totality of painting and sculpture known today demonstrates that it is only one aspect of a remarkably diverse artistic development under the patronage of western European and Levant-born crusaders.

Given the illustrated manuscripts, icons, frescoes, and mosaics that survive from the Latin kingdom of Jerusalem, it is possible to identify two major phases in the first two hundred years of crusader art. The first dates from the conquest of Jerusalem on July 15, 1099, to its

A number of persons and institutions have rendered the writer substantial assistance in the course of his studies on crusader art in general and in the preparation of these remarks in particular. He would like to acknowledge his gratitude to the following: Father B. L. Antonucci, Church of the Annunciation, Nazaret; B. Bagatti, OFM, and A. Storme, Museum of the Convent of the Flagellation, Jerusalem; P. Benoit, OP, and Ch. Coüasnon, OP, École biblique et archéologique française, Jerusalem, and Jean Trouvelot, architect for the crusader church at Abū-Ghosh; Michael Burgoyne, British School of Archeology, Jerusalem; I. Dakkak, director of the al-Aqṣā mosque restoration project, and Mr. Taḥboub, secretary to the Supreme Moslem Council, Jerusalem; Dr. N. Fıratlı, National Archeological Museum, Istanbul; Elias Friedman, ODC, Stella Maris Convent, Mt. Carmel; Dr. B. Narkiss, The Hebrew University, Jerusalem; Mrs. Inna Pommerantz and Dr. L. Y. Rahmani, Israel Department of Antiquities and Museums, Jerusalem; Dr. C. L. Striker, director of the Kalenderhane Camii project, Istanbul; Mr. Dan Urman, secretary to the Survey of Israel, Jerusalem; and Dr. Kurt Weitzmann, Princeton University. Finally, his thanks go to the American Council of Learned Societies, to the National Endowment for the Humanities, and to the University of North Carolina, Chapel Hill, for the financial help which made the research possible.

surrender on October 2, 1187, following the catastrophe at Hattin. The second encompasses the hundred years from July 12, 1191, to May 18, 1291, during which Acre was the *de facto* capital of the kingdom. In this century there was only limited access to the holy city, negotiated by Frederick II, from February 18, 1229, until August 23, 1244, when Jerusalem was overrun by the Khorezmian Turks.

The best-known monument from the earlier period, though certainly not the earliest work of painting, is "Queen Melisend's Psalter," to be dated probably between 1131 and 1143.[1] Several artists executed the miniatures of this codex and their work gives us a broad introduction to crusader painting in the first half of the twelfth century. Basilius, the artist of the twenty-four full-page introductory miniatures, paints in a strongly Byzantine tradition, visible especially in the Crucifixion (pl. XXXIXa). The austere style with its slender, attenuated forms, the specific iconography of the dead Christ with four nails, and the number and arrangement of the figures who surround him show that Byzantine models have been followed quite closely. Nonetheless, Basilius was surely a westerner who had carefully studied Byzantine art. On occasion his Latin background emerges, as in the miniature of the women at the sepulcher (pl. XXXIXb). Byzantine practice was to depict the scene with two women, based on St. Matthew's gospel, while the three Marys are drawn from St. Mark's narrative, which was the standard tradition in western Europe. Otherwise, with the exception of the handling of the gold ground as a neutral foil, the scene is done in the Byzantine manner; these telling details alone seem to reveal something of Basilius's native tradition.

A second artist, who did the eight initials for the Psalter, was Basilius's equal in ability but painted in a more sumptuous and exotic decorative technique. The overall effect of oriental splendor in the *Beatus* "B", derived from painting in black directly on a burnished gold ground, is blended with a western pictorial vocabulary such as the interlace, the mask head, the clambering figures in the vines, and David with his harp (pl. XXXIXc). These elements demonstrate a good knowledge of English art on the part of this painter, but the "Islamic" technique is most closely comparable to several manuscripts of the Monte Cassino school about 1100. It is thus likely that this artist was a south Italian transmitting northern European ideas

1. "Queen Melisend's Psalter," London, British Library, MS. Egerton 1139; see above, pp. 126-129.

from sources he had studied at the famous and venerable Benedictine abbey of Monte Cassino.

A third artist, far less accomplished than either of the other two, executed a series of nine portraits to illustrate the prayers after the Psalter. He follows Byzantine models closely as with the Virgin and Child enthroned (pl. XXXIXd), an image based on the Virgin *Nikopoia* type. But his style is more linear and decorative than that of Basilius and his figures more wooden and doll-like. Lacking the knowledgeable ease of working from Byzantine sources demonstrated by the well-trained Basilius, this painter copies carefully but never succeeds in overcoming his strong roots in western Romanesque painting.

Melisend's codex epitomizes the melange of cultures which made up crusader Jerusalem and manifested themselves in the paintings found in products of the scriptorium of the Holy Sepulcher. The strength of the Byzantine influence is particularly notable, showing that aristocratic patronage at court sought to rival that at Constantinople even while the variety of western artistic backgrounds evident in the paintings points to the peculiarly crusader nature of the work.

Ecclesiastical commissions of the same period show similar characteristics. In a sacramentary, partially preserved now in Cambridge at the Fitzwilliam Museum, and a missal now in the Bibliothèque nationale, Paris, the illustrations for the preface to the canon of the liturgy show closely related compositions (pls. XLa and b respectively).[2] Their similarities derive from use of a common model, because in style their artists are clearly different, the Cambridge manuscript painter being related to the Paris codex painter in a manner somewhat parallel to Basilius and the painter of the saints' portraits in the Psalter. That is, the Cambridge artist is the more assured in working with Byzantine prototypes as seen in the elongated, strongly modeled figures with flowing draperies, whereas the Paris artist emphasizes stocky proportions and flat linear pattern including more copious interlace and animated scrollwork for the initial itself. This does not mean that the Cambridge painter, probably a south Italian, is equal in ability to Basilius. He is not, but his familiarity with Byzantine models is nearly comparable. The Paris painter on the other hand goes at his task with the same selfconscious diligence as the painter of the saints' portraits. In a historiated initial with the women at the sepulcher the Paris artist meticulously follows Byzan-

2. The sacramentary fragment, Cambridge, Fitzwilliam Museum, MS. McClean 49; the missal, Paris, Bibliothèque nationale, MS. latin 12056; see above, pp. 129-130.

tine iconography while translating his figures into labored Romanesque hybrids (pl. XLIc). He is obviously much more at home with the lively foliage, showing assured handling of English decorative ideas. Indeed, the sophistication of his ornament suggests that the codex was slightly later than the Melisend Psalter, a product of the same atelier.

The earliest icon attributable to Jerusalem at this period parallels these manuscript illustrations in some aspects. Overall, however, it is more strongly western in nature and was done later than the manuscripts, possibly shortly after the Second Crusade (pl. XLVa). The enthroned Christ blessing and holding an open book is characterized by flowing linear drapery typical of northern France under strong English influence in the first half of the twelfth century. On the other hand the facial type, though perhaps based on work from Shaftesbury abbey in Dorset, is convincingly Levantine, as is the rich color palette of the draperies. Moreover, this "Channel School" artist working in Jerusalem is aware of Byzantine painting, as the ornament on the front panel of the throne suggests. If, therefore, most of the manuscript painters were deeply immersed in Byzantine traditions, either from their south Italian background or through service in the Holy Sepulcher scriptorium, this icon painter seems by contrast to have been a rather more recent arrival in the holy city.

An artist from the Channel region of northern France is of course something we might readily expect, given the wealth of crusader manpower from this area. What is surprising is the relatively small French influence in the Holy Sepulcher atelier. Probably the presence of an English prior in the church of the Holy Sepulcher in the years before 1127 may help explain the strong English influence, though further study of this workshop may bring to light additional French examples.

It should be kept in mind that the scriptorium at the Holy Sepulcher was probably a product of the second quarter of the century. Moreover, despite the unique central significance of this church for Christianity, it appears that the church of the Nativity in Bethlehem was equally an early object of crusader patronage. Indeed, Bethlehem gives us the earliest documented painting, the widest range of crusader style in the twelfth century, and mosaic work of 1169, all under the roof of its unique church. This is not surprising given the importance of the site, especially since the church of the Nativity was the coronation church for crusader kings until 1131, when king Fulk and queen Melisend were the first rulers crowned in Jerusalem at the Holy Sepulcher.

The most extensive ensemble of crusader work in the church of the Nativity is on the twenty-eight columns of the nave and aisles where, for the most part, individual saints' portraits were painted (pl. XXXIb).[3] One image, on column five in the south aisle, depicts the Virgin and Child, and a Latin painted inscription dates the work to May 15, 1130 (pl. XXXIIIb). Despite the imposing jeweled throne with a high back on which the Virgin sits, there is no strong Byzantine influence here. Instead the stiff linearity of the draperies and the tender relationship of a mother who gently holds her baby close to her cheek bespeak a western Romanesque painter, possibly from Italy.

No particular order for the execution of these works has as yet been proposed. The suggestion that they were done as *ex votos* patronized by pilgrims to the Holy Land seems likely. So far, however, precise western parallels have not been found for such a series of large icons on columns, and no search for stylistic comparisons has been undertaken. Nor has an explanation been offered for why the 1130 painting was done in the south aisle and not in the nave proper. No other dated inscription survives. What is clear is the wide variety of styles present in the series, suggesting itinerant artists who worked through most of the twelfth century and possibly longer.

On the north side of the church there are no painted images on the columns of the north aisle. But many of the more strongly Byzantine-influenced paintings appear on the north nave columns. On column 10, St. John the Evangelist (pl. XXXIIb), identified by Greek and Latin inscriptions, wears handsomely painted Comnenian-style draperies, strongly modeled and with extensive highlights. On column 4, St. George (pl. XXXIIa), again identified by both Greek and Latin inscriptions, is a virile youth with curly golden hair. He stands, wearing a long cloak and holding a spear and a shield. His thinly painted agitated linear draperies are, however, quite different from those of St. John.

On the south side St. Fusca, a third-century virgin martyr at Ravenna, appears on column 10 of the nave (pl. XXXIId), and St. Margaret, a fourth-century martyr at Antioch in Pisidia, is on column 7 of

3. See above, pp. 120-123. For the column paintings see also the descriptive surveys by L. Dressaire, "Les Peintures exécutées au XII^e siècle sur les colonnes de la basilique de Bethléem," *Jérusalem*, XXVII (1932), 365-369; V. Juhasz, "Las Pinturas de los cruzados en la Basilica de Belén," *Tierra Santa*, XXV (1950), 313-318, 349-353; R. W. Hamilton, *The Church of the Nativity, Bethlehem* (reprint of 2nd rev. ed., Jerusalem, 1968), pp. 69-81; and S. de Sandoli, *Corpus inscriptionum crucesignatorum Terrae Sanctae* (Jerusalem, 1974), pp. 211-226. Though these paintings are generally referred to as frescoes, the medium seems to be some kind of oil-base paint applied directly onto the column.

the south aisle (pl. XXXIIIc). Both are identified by Greek and Latin inscriptions. They wear strongly outlined and modeled Romanesque drapery with geometric clarity in the angularity of the hems and "V" forms beneath the knees of their long undergarments. Yet another version of the western Romanesque style is seen in the St. Bartholomew on column 2 of the south aisle, identified by a Latin inscription only (pl. XXXIIIa). His compact draperies flow in linear rhythms over the body while a more painterly softness gives a suggestion of texture to the cloth.

Two other examples will assist in further demonstrating the range and quality of these styles. St. Leo, on column 6 of the south aisle, with a Latin inscription (pl. XXXIIId), is one of the few figures with the face well preserved. Leo, probably to be identified with pope Leo the Great (440-461), is depicted as a bishop, blessing in the western manner and holding a staff. The strong bearded head is composed in basically schematic designs of hair, ears, beard, nose, eyes, and miter with only the slightest suggestion of modeling for plastic effect. It is an excellent example of Romanesque painting and a worthy counterpart to the crusader mosaics in the church.[4] By contrast, the kneeling pilgrim of St. James with the shell conspicuously displayed on his scrip (pl. XXXIIIe) is much later than St. Leo. The long swinging curve of his cloak, the irregular waves in his hair, and the near-three-quarter pose of the figure all bespeak the awakening interests of Gothic painting.

In quality these artists are not all masters of the first rank. But given the large number who worked here, the level is consistently very high indeed. A surprising aspect is the fact that at present few of these paintings can be related directly to work elsewhere in the crusader states. One fortunate exception is the handsome figure of Elijah on the eighth column of the south side of the nave, identified in Greek and Latin (pl. XXXIIc). The iconography of Elijah being fed in the wilderness by ravens (III Kings 17:1-7) is in this case an early representation, no doubt due to the important cult of Elijah in the Holy Land, of a theme later quite popular. But stylistically the draperies with the linear strip effect on the lower leg are paralleled in a separate crusader work done at the north end of the narthex of the church of the Nativity. There during the twelfth century a small cru-

4. Extant crusader and Byzantine material does not as yet enable us to propose precise dating for the column paintings. See for comparisons the frescoes from Gethsemane, the Damascus gate chapel, and the Choziba monastery in the Wādī al-Qilt cited above, chapter III B, note 9. See also the Byzantine heads tentatively dated as eleventh-century from the monastery of the Holy Cross, Jerusalem, published by H. Swarzenski, "Two Heads from Jerusalem," *Bulletin, Museum of Fine Arts, Boston,* LIV (1956), 34-38.

sader chapel was fashioned and decorated with a cycle of images including, on the main east wall, the so-called Deësis group.[5]

One must be cautious in studying the frescoes of this chapel because of the extensive restorations carried out in 1950. However, by comparing photographs of the chapel before restoration (pl. XXXVIa) with the Deësis as seen now (pl. XXXVIb), the basic iconography can be verified and the linear strap style of the draperies, now heavily overpainted, can be seen on the figure of Christ. It is unlikely that the same artist executed both Elijah and the Deësis. Nonetheless, given the extent of crusader decoration at Bethlehem, some kind of atelier must have been organized there to manage the painting and perhaps the training of artists, resulting in stylistic affinities of the sort mentioned. Unfortunately, no manuscripts with illustrations can as yet be attributed to Bethlehem to help fill in the overall picture of the development, but careful study of the extant frescoes (and mosaics) is urgently needed to clarify the sources of style and iconography, to explain why some styles appear more prominently than others, and to date the paintings.

The strong Byzantine character of the iconography of the Deësis in the chapel combined with western Romanesque style is a feature of crusader art already met in the Melisend Psalter. The other extant crusader work in the church of the Nativity was in mosaics in which the style and iconography are more purely Byzantine.

In the Grotto of the Nativity a mosaic depicting the birth of Christ (pl. XXXIa) is somewhat comparable in drapery style to the mosaics of the transepts. We know from an inscription in the main apse that in 1169 during the reigns of king Amalric and emperor Manuel Comnenus a certain Ephrem, who was a monk, a painter, and a mosaic worker, worked on these mosaics. It is likely that the same workshop, including the famous Basilius who worked on the angels of the nave, carried out the handsome—though damaged and blackened—work downstairs. Indeed, shortly thereafter a Greek pilgrim to Bethlehem, John Phocas, enthusiastically described in detail the Grotto mosaic, and his text, the first mention of such a mosaic, is worth quoting *in extenso:*

I leap for joy as I write, and am altogether in the spirit within that holy grotto. . . . The artist has painted with a skillful hand [ἔγραψεν ὁ τεχνίτης] in that

5. Despite the recent origin of the term "Deësis" (see Chr. Walter, "Two Notes on the Deesis," *Revue des études byzantines,* XXVI [1968], 311 ff., and "Further Notes on the Deesis," *Revue des études byzantines,* XXVIII [1970], 161 ff.), it is a valuable part of the art-historical vocabulary; it is used here to refer to the figure of Christ flanked by the two interceding figures of the Virgin Mary and St. John the Baptist.

grotto the mysteries which there took place. In the apse is figured the Virgin re-clining upon her bed, with her left hand placed beneath her right elbow, and leaning her cheek upon her right hand as she looks at her infant, showing her in-nate modesty in her smiling expression and in the colour of her cheeks; for her colour is not changed, nor is she pale, like one who has recently borne a child, and that for the first time; for she who was thought worthy to bear a child who was more than man must also have been spared the pains of childbirth. Beyond her are the ox and the ass, the manger and the babe, and the company of shepherds in whose ears the voice of Heaven rang so that they left their flocks, allowing their sheep to pasture unwatched upon the grass beside the spring, giving their dog charge of them, while they raised their necks heavenwards, listening eagerly to the sound of the voice, standing in various attitudes, as each thought that he could stand most easily; their shepherds' crooks appear useless, but their eyes are fixed upon Heaven, and drawing their right hands backwards as if to hurl a dart, they eagerly strain their ears: yet they did not need to hear the voice a second time, since eyes are more trustworthy than ears; for an angel meeting them shows them the babe lying in the manger. The beasts do not turn round to be-hold this sight, but stupidly betake themselves, the one to the grass, and the other to the above-mentioned spring; but the dog, a creature that is savage with strangers, appears to be intently gazing upon the unwonted spectacle; while the Magi, leaping from their horses, bearing their gifts in their hands, and bending their knees, present them to the Virgin with awe.[6]

Phocas gives us eyes to see what is now partly lost. The very large Virgin in the center, in draperies highlighted by gold, has directly be-hind her the Child in a tomb-like manger into which peer the ox and the ass (now invisible). She is surrounded by fragments of Joseph and the wise men to the left, fragments of the angels along the upper cen-ter, and the washing of the Child to the lower right (parts of three figures are visible). Two shepherds, one young, one old, are to be seen at the upper right. In sum, every figure Phocas refers to except the dog and the ass are fragmentarily present. Beneath the whole scene appears part of the glorious verse from Luke 2:14, to which however Phocas makes no reference whatsoever, probably because it is in Latin.

Of the extensive crusader work in monumental painting that was to be seen in Jerusalem in the twelfth century almost nothing sur-vives. Pilgrims mention paintings in St. Anne's, the Coenaculum and the chapel of the Dormition on Mt. Sion, the Tomb of the Virgin, and the Grotto of Gethsemane, of which little remains. But it was in the church of the Holy Sepulcher that the most extensive decoration was carried out, described partially by Theoderic about 1172.[7] Of

 6. "The Pilgrimage of Joannes Phocas in the Holy Land (in the Year 1185 A.D.)," tr. Aubrey Stewart, *PPTS,* V-3 (London, 1896), 32-33; see also above, p.120.
 7. "Theoderich's Description of the Holy Places (circa 1172 A.D.)," tr. Stewart, *PPTS,* V-4 (London, 1896), 7-21; see also above, pp. 118-119.

that the only mosaic extant is the Christ of the Ascension in the vault of the Latin Calvary chapel (pl. XXX). This impressive work, like the Grotto Nativity now barely visible under a coat of soot and grime, represents the figure of Christ in a deep purple robe. He is seated, holding a book and with the right arm raised, probably originally in blessing, though the hand is now missing. The pose is somewhat unusual in that the book is held over the straightened-out leg, perhaps a Latin variation of a Byzantine model. The draperies with their complex curvilinear rhythms are unlike those in the mosaics of Bethlehem, although as in them the style, indeed the awesome concept of Christ overall, is basically Byzantine. But the probable presence at Bethlehem of crusader mosaicists trained in the Byzantine tradition seems also to have recurred here. Indeed, the appearance of strongly Byzantine-style mosaics with Latin inscriptions is found elsewhere in the Mediterranean region at this period, as at Monreale and in the Palatine chapel at Palermo in Sicily, as well as in Jerusalem and Bethlehem.

Close study of these crusader mosaics may eventually enable us to decide more surely whether the artists were crusaders or Greeks in the service of Latin patrons. As for the date of the Ascension mosaic, it was probably done before the consecration of the Holy Sepulcher in 1149 but after the earthquake of 1114.[8] Patronage was intensified in the church of the Holy Sepulcher, especially in the second quarter of the twelfth century after it became, from 1131 on, the coronation site of the crusader kings.

Besides Bethlehem two other major crusader fresco projects executed in the Jerusalem region but outside the city survive fragmentarily. The earlier and more important is found in the crusader church at Abū-Ghosh. Now the property of the French government, the church seems originally to have belonged to the Hospitallers. No consensus has emerged on the date of the church or indeed its twelfth-

8. It has been suggested that this mosaic is Byzantine, done for another location in the Holy Sepulcher and moved to its present site by the crusaders. Pending investigation of the relevant technical matters, it is not yet possible to exclude this possibility, but the combination of the Byzantine style of the image, the variation in the pose of Christ, and the Latin inscription suggest crusader work.

The photograph published here, taken in 1973, when compared to J. Schweig's excellent flattened-out image of about 1934 (published in S. Runciman, *A History of the Crusades*, vol. III, pl. XI, and in W. Harvey, *Church of the Holy Sepulchre: Structural Survey, Final Report*, frontispiece), suggests how dirty the mosaic has become in the intervening period.

It is unfortunate that the fresco of the Ascension in the narthex chapel of the church of the Nativity is almost totally destroyed. Having been done after the Calvary chapel mosaic, it would have been a valuable comparative monument.

century name, which some say is St. Jeremiah.[9] Probably erected in
the 1140's, the church has the character of a fortress with remarkably
heavy walls and a spring in the crypt. Inside, in the nave, was an ex-
tensive series of frescoes which the moisture from below has relent-
lessly flaked from the walls. It is hoped that the conservation work
now (1975) in progress will stop the slow destruction of the frescoes
remaining. All that survives is located in the eastern apses and the
two adjoining bays of the nave and aisles. The three apses contain
fragments of, on the north, the Deësis, in the center, the Anastasis,
and on the south, Paradise seen as the Three Patriarchs with souls of
the blessed in their laps. Other major fragments survive of the Cruci-
fixion on the wall of the south aisle and the Dormition of the Virgin
on the wall of the north aisle. The style and iconography are strongly
Byzantine, but again the inscriptions are in Latin. The Deësis in the
north apse is nearly invisible now, but we know what it looked like
in 1907, thanks to the careful watercolors of M. le comte de Piellat
(pl. XXXVb). The most significant aspect of the iconography revealed
by this document is the enormous high-backed throne on which
Christ is seated. This dissociates the Abū-Ghosh fresco from the
Deësis in the Melisend Psalter and that in the Bethlehem narthex
chapel and relates it to an older type which seems to have been re-
vived by the crusaders here alone.

The fresco of the Three Patriarchs with the souls of the blessed is
the best preserved of the three apses; though in poor condition in-
deed, the three main figures of Abraham (center), Isaac (left), and
Jacob (right) can be dimly discerned in the photograph (pl. XXXIVa)
with the aid of M. de Piellat's watercolor as a guide (pl. XXXIVb).
Furthermore, one can see a soul being brought to Abraham at the
left center, an angel to the right center, and a flower below a tree at
the far right.

The iconography of the Three Patriarchs was common in Byzan-
tine art but appears seldom in the west, apparently under Byzantine
influence as in the sculpture at St. Trophime, Arles.[10] Even in Byzan-
tine art, however, it is rare to find it in an apsidal composition as

9. The sources are vague on the date of the crusader church at Abū-Ghosh, formerly
known as Qaryat al-'Inab. If Abū-Ghosh is to be identified with Qiryat Ye'arim, then the
church may be dated 1098-1137; see Clermont-Ganneau, *Archeological Researches in Pales-
tine*, II (London, 1896), 60-63. Or if Abū-Ghosh is to be identified, as seems more likely,
with the twelfth-century Emmaus, then it seems to be a church built under Hospitaller con-
trol in the 1140's. The name St. Jeremiah seems to be found in the sources only since the
sixteenth century; see Enlart, *Les Monuments des croisés dans le royaume de Jérusalem*, II
(Paris, 1928), 315-319.

10. A. K. Porter, *Romanesque Sculpture of the Pilgrimage Roads*; vol. IX, *Provence*
(Boston, 1923), pl. 1370.

here. Indeed, the programmatic arrangement of the deaths of Jesus and Mary on the lower walls of the nave with scenes of Christ's Resurrection and the Second Coming focused high in the apses seems to be a crusader and not a Byzantine choice.

The fragments are mostly too small or too blurred by the seepage of water to be of much assistance in the study of style. However, some bits of drapery in the Dormition scene and the head of one of the blessed in the bosom of Jacob are clear and sharp. The head (pl. XXXVa) shows, quite in contrast to that of St. Leo in Bethlehem, an extraordinary three-dimensional plasticity and the beginnings of the "spectacled" eye convention that later becomes so characteristic of Acre painting (see, for example, pl. XLII). Characteristics of this kind strongly suggest that these frescoes were done late in the twelfth century, possibly after 1170 but certainly before 1187, when the crusaders lost control of this church.[11]

The other remnant of crusader frescoes which partially survives is to be found in the little pilgrims' church at Bethphage, east of Jerusalem between the Mount of Olives and Bethany. Theoderic, who traveled to the Holy Land about 1172, tells us about the shrine he saw:

A mile from Jerusalem is Bethany, where stood the house of Simon the leper, and of Lazarus and his sisters Mary and Martha, where our Lord was frequently received as a guest. Bethany stands near the valley of Olives, in which the mount ends towards the east. So on Palm Sunday our dearest Lord Jesus Christ set out from Bethany, came to Bethphage, which place is half-way between Bethany and the Mount of Olives, and where now a fair chapel has been built in His honour, and sent two of His disciples to fetch the ass and her colt. He stood upon a great stone which may be seen in the chapel, and sitting upon the ass went over the Mount of Olives to Jerusalem, and was met by a great crowd as He descended the side of the mountain.[12]

Theoderic does not, however, mention the series of frescoes which were painted on the large, truncated, slightly tapering stone; possibly

11. Runciman, *A History of the Crusades,* III, 381, says that Greek artists working in Palestine for the emperor Manuel in 1170 may have also worked here. The possibility exists, but unless comparable painting from the monuments executed for Manuel comes to light or unequivocal written documentation is found, there is no way to verify the suggestion. Unfortunately, photographs of the fresco fragments found at the monastery of St. Euthymius (now al-Khān al-Aḥmar) have not been published, and nothing remains today *in situ* of the twelfth-century painting. See D. J. Chitty, "The Monastery of St. Euthymius," *Palestine Exploration Fund, Quarterly Statement* (1932), pp. 188 ff., especially pp. 196-197. The published frescoes from the related cave monastery of St. Theoctistus, on the other hand, are not stylistically similar to those at Abū-Ghosh. See D. J. Chitty, "Two Monasteries in the Wilderness of Judaea," *Palestine Exploration Fund, Quarterly Statement* (1928), pp. 134 ff., especially pp. 146 ff. and pl. V, fig. 7.

12. "Theoderich's Description . . . , " *PPTS,* V-4, 34-35.

they had not yet been executed.[13] The Franciscans also had restorations carried out on the extant fragments here in 1950 as in the Bethlehem chapel, but the overpainting is much less, and one can discern the original parts of the frescoes more readily. Of the scenes that survive, the Raising of Lazarus is perhaps the best example (pls. XXXVIIa, b, and c). The iconography is strongly Byzantine, with Lazarus standing and wrapped like a mummy as Christ, blessing in the Greek manner, calls him forth from the tomb which has been unsealed.

Again because of the restorations, the style must be dealt with cautiously. Nonetheless, the Romanesque tradition seems here to have been infused with a classicizing influence from Byzantine sources resulting in forms of strength and clarity that are reminiscent of the work at the Sigena chapter house. The Bethphage paintings are earlier and much more modest in quality than those at Sigena, to be sure. They appear to have been done shortly before 1187. It is especially notable that the Lazarus artist at Bethphage chose to follow a Byzantine model so faithfully, just as Basilius had done in the Melisend Psalter. There was, after all, a totally different version of the scene, possibly reflecting crusader buildings at Bethany, visible for all to see on the historiated lintel of the Holy Sepulcher (pl. IIa). It seems that his accomplished style had the effect of imposing iconographical conservatism. Finally, it is worth noting that the program of the frescoes on the rock is somewhat puzzling. If the stone marks the spot where Christ mounted the ass, it is curious that this scene does not appear in the cycle. Perhaps the explanation may be sought in some kind of sculpture for which the stone was a pedestal. Unfortunately no pilgrim mentions any such image, but the east side of the stone with the crowds waving palms includes no figure of Christ and the reason may have been his presence on top of the stone.

One final work from twelfth-century Jerusalem was originally published by Vincent and Abel in 1926.[14] An altar was found in their excavations of the crusader oratory of St. Stephen outside the Damascus gate (pls. XXXVIIIa and b). This altar, for which they present a detailed drawing, at one time had fresco paintings depicting Christ enthroned and the Twelve Apostles standing on each side with scrolls or books. These frescoes have now disappeared completely, but underneath the painting there were incisions into the stone delineating the figures and the round-arched arcade.

13. See above, chapter III B, note 9.
14. Vincent and Abel, *Jérusalem nouvelle,* II, fasc. 4 (Paris, 1926), 769 ff., fig. 320, and pl. LXXX: 1.

Such altarpieces were, of course, very popular in the west during the twelfth century.[15] But this frescoed stone altar with handsome classical-style moldings is unusual in the combination of a typically western program with local materials and a sculptural tradition that had survived in the Holy Land from early Christian times. It was fully painted, perhaps with metal medallions attached above the arcade in the cut circles in the stone. The altar must have been an impressive focus for the oratory of St. Stephen, done sometime before Jerusalem fell in 1187. With it as a model we can attempt to imagine the splendor of the altars in the larger crusader churches inside the city, altars of which nothing survives.

These examples of monumental crusader painting of the twelfth century in and around Jerusalem do not exhaust the extant remains in the Latin kingdom. But there can be no doubt they are the finest survivals in quantity and quality. Together with the manuscript illustrations and the icons, they present us with a varied picture of painting during the twelfth century in the Holy Land. Among the most notable characteristics of this work the predominance of ecclesiastical patronage stands out. While there was of course royal patronage as well, for books such as the Melisend Psalter, the church dominated the scene. It is of course possible that the column paintings at Bethlehem were commissioned by private patrons, but these may have been ecclesiastical donors as well. There is no way of knowing at present. Nonetheless, despite the dominant role of the church as patron, the art produced for it is characterized by its diversity. If there is a unifying trait characteristic of all the painting it is the strength of the Byzantine influence, notably stronger than in most parts of the west at the same period. Otherwise, stylistically we find a variety that is most obvious in the frescoes, less so in the mosaics, and least in the manuscripts. Of course the miniatures, so far as we now know, all emanated from a single scriptorium where there was a rather unified artistic approach. The monumental painting done by itinerant artists naturally tended to exhibit more local, individual characteristics. Finally, we can see that a variety of western traditions from both the north and the south of Europe are blended with the Byzantine. Remarkably, however, very little French influence can be discerned in the work. Less surprising is the absence of German characteristics or direct Islamic influence; it seems to have been too soon for either of these.

15. See, for example, the retable from Lisbjerg (1140) or the shrine of Santo Domingo from Silos (1140/50): Peter Lasko, *Ars sacra, 800-1200* (Harmondsworth, 1972), figs. 179 and 266 respectively.

The situation in crusader painting changes markedly in the thirteenth century. In the difficult years from 1229 to 1244 Jerusalem retained only a shadow of its former glory as the artistic center of the crusader states. Acre took over the position Jerusalem had formerly held, but painting started to flourish there only after 1250. No monumental painting equivalent to the work found in and around Jerusalem survives from the thirteenth century in the Latin kingdom. Indeed, the most important frescoes known from this period come from Constantinople during the Latin empire. In manuscripts and icons French influence emerges as the most potent western tradition, growing strongest in the last ten years before 1291.

After 1187 Jerusalem never fully regained its central importance in painting, but during the period of access negotiated by Frederick II one splendid work seems to have been done there, commissioned by the emperor for his third wife, Isabel of England, about 1235-1237. Despite the precedent of the Melisend Psalter, the Riccardiana psalter is illustrated in an entirely different way.[16] Following German practice, the initials beginning major divisions of the psalter are decorated with scenes from the life of Christ. The *Beatus* initial is the most elaborate (pl. XLIa). Isaiah and Habakkuk foretell the Annunciation and Nativity respectively, with David between the two standing prophets. The artist composes the program so that as one's eye moves from left to right, one goes from Old Testament to New Testament image, from prophet and ancestor to the living reality of the advent of Jesus. This is painted with iconography strongly Byzantine once again (though distinct from that of the Melisend Psalter), but the style is Sicilian and the interplay between the letter B and the copious figural decoration is wholly western as well. Thus the blend of east and west in crusader art continues, but the components change somewhat from those found in the twelfth century.

Shortly after the Riccardiana psalter was executed Jerusalem was definitively lost to the Khorezmian Turks, in 1244, and the way was open for Acre to become the chief artistic center as it had been the political and military capital since 1191. The impetus for Acre's new role in the visual arts seems to have come from the visit of Louis IX to the Holy Land between 1250 and 1254.

The French king was instrumental in the establishment of a major new scriptorium in Acre. The Arsenal Bible, one of its earliest products, seems to have been commissioned for Louis himself and it set

16. The Riccardiana psalter, Florence, Biblioteca Riccardiana, MS. 323; see also above, pp. 129-130.

the standard for later production.[17] The manuscript contains Old Testament selections translated into Old French. It is decorated with large, mostly full-page frontispieces for each book like those for Judith and Job (pls. XLIIa and b).

Most of the miniatures have a strong Byzantine iconographic tradition behind them, but no such sources exist for the Judith or Job images. Indeed, for the latter the most important parallel is found in a giant German Bible at Erlangen done in the Salzburg School. And the artist also seems to have looked with interest at his surroundings in Acre, as the convincingly painted camels and men wearing turbans demonstrate. For the Judith frontispiece one finds sources in a variety of thirteenth-century French works including the Souvigny Bible and the *Bibles moralisées*, and even in some Catalan Bibles from Roda and Ripoll.[18] Needless to say, the format of scenes in roundels is French, as is the strong use of Gothic pink and blue for the frames and interstices.

In style the artist is French, a Gothic painter working under Byzantine influence. Some aspects of his style would long mark the Acre scriptorium, especially the black-line drapery, the stocky proportions of his freely moving figures, and the "spectacled" eye convention with the line back toward the ear.

The most fascinating stylistic parallel with the work of this master, apparently a newcomer to Acre in 1250, is found not in the Latin kingdom but in the Latin empire. In Constantinople artistic patronage by the Latins has been known since Weitzmann argued that Byzantine manuscript painters continued working there after 1204.[19] But in 1967 Dr. C. L. Striker, in his excavations at Kalenderhane Camii, discovered a chapel clearly painted by a crusader artist (pls. XLVIIIa and b).[20] The apsidal fresco fragments depict a large standing figure of St. Francis of Assisi flanked by ten scenes from his life, an adaptation of the standard thirteenth-century Italo-Byzantine icon retable. The painting must have been done sometime between

17. The Arsenal Bible, Paris, Bibliothèque de l'Arsenal, MS. 5211; see also above, pp. 132-133.

18. H. Buchthal, *Miniature Painting in the Latin Kingdom of Jerusalem* (Oxford, 1957), p. 57.

19. K. Weitzmann, "Constantinopolitan Book Illumination in the Period of the Latin Conquest," *Gazette des beaux-arts*, ser. 6, XXV (1944), 201 ff.

20. For the crusader chapel at Kalenderhane Camii see above, chapter VI A, note 3, and C. L. Striker and Y. D. Kuban, "Work at Kalenderhane Camii in Istanbul: Fourth Preliminary Report," *Dumbarton Oaks Papers*, XXV (1971), 257-258. The author would like to express his gratitude to Dr. Striker for kindly interrupting work on the publication of the Kalenderhane Camii to arrange for the photographs used herein. Furthermore, he has graciously supplied information, incorporated in these remarks, soon to appear in the Fifth Preliminary Report.

1228, when Francis was canonized, and 1261, when the Latin empire fell. But so close is the style of the fresco painter to that of the Arsenal Bible master that it is not impossible that they worked together or may even have been the same person. The draperies are in some instances very close, as for example the striped garment of Judith compared to a fragmentary figure in the chapel frescoes (pl. XLVIIIb). Other draperies in the frescoes, such as the friars' habits (pl. XLVIIIa), are softer with more highlights and less sharply defined linearity than in the manuscript. Similarly, the eyes are less insistently outlined, but shaded, giving the face more plasticity. Until the frescoes are fully published the exact relationship between the two ensembles cannot be resolved. There can be little doubt, however, of the close ties in painting between Acre and Constantinople around 1250.

The closest parallel to the Arsenal Bible among other Acre manuscripts is the Perugia missal (pl. XLIb).[21] One of the few extant ecclesiastical books in Latin executed in the Acre scriptorium, the missal was painted by two masters, the first Venetian and the second French. It was the French artist who did the Resurrection for the initial R. His style is obviously close to that in the Arsenal Bible. The Resurrection scenes show decided western iconographic characteristics with some Byzantine influence. Christ emerges from the tomb, after which the three Marys find only the angel. Though overall basically western in concept, the unusual nude Christ may be based on a Greek model instead of the normal clothed figure.

Like Jerusalem, Acre became a center for panel painting as well as manuscript illumination, but there is far more material extant in both from the latter school. Among the icons an equally wide range of western artistic backgrounds can be discerned in combination with Byzantine traditions as seen in the Acre manuscripts. An unusual panel with the Deësis and fourteen apostles is now in the collection at St. Catherine's monastery (pl. XLVb). Though clearly using a Byzantine model, the crusader painter added Mark and Luke to the Twelve and executed the work in a remarkably vigorous style. Formally there is no doubt that it belongs within the Acre school. While a certain German flavor suggests itself in the expressionistic heads, the activated masses of drapery seen here are also found in the Venetian artist of the Perugia missal. But the artist of this icon, like the second painter of the Perugia codex, is probably French, as his basic figure style demonstrates, also suggesting a date in the 1250's. This is

21. The Perugia missal, Perugia, Biblioteca Capitolare, MS. 6 (formerly 21); see also above, pp. 131-132.

a striking case of the richness of the artistic and cultural melange which is one of the unique features of crusader painting.

One of the most magnificent panels from Acre now at St. Catherine's is a large, double-faced icon depicting the Crucifixion on the front and the Anastasis on the back (pls. XLVIa and b). This master is surely an Italian working under Byzantine influence, as a comparison with work of Giunta Pisano will demonstrate. But the crusader characteristics also show that the work was done in Acre and not in the west. On the front we see the unusual gestures and poses of Mary and John as well as the massive beveled cross peculiar to crusader painting. The three-nail crucifixion, coming from northern Europe, again demonstrates the remarkable blend of ideas in the Latin kingdom. The Anastasis, unlike the Crucifixion, is rare in Italian art. But the Byzantine tradition is altered, with Eve as an old woman, reflecting Italian painting of the same period (1250-1275), with unByzantine stress on the large jeweled cross as a vehicle of deliverance, and with an extensive use of pink color, derived no doubt from Gothic painting.

It is indeed the French element which more and more asserted itself in Acre painting as the second half of the century wore on. In fact, in panel paintings there is striking evidence that parallels and corroborates what is found in the manuscripts. There is another icon at St. Catherine's (pl. XLVIIa) depicting Saints Theodore and George as mounted crusaders, with inscriptions in Greek. Kneeling below is a diminutive donor whom the inscription identifies as coming from Paris. Thus not only is this a painting done by a French artist under Byzantine influence, but it is a work commissioned by a pilgrim from the heart of France as well.

In the manuscripts the increased interest in Old French texts of history on the part of secular patrons in Acre stimulated the production of many codices of the *Histoire universelle*, the *Faits des romains,* and the *History of Outremer* translated and continued from the Latin of William of Tyre. In the closely related cycles of illustrations that decorate codices of the *Histoire universelle*, the images faithfully reflect the text in presenting the Trojan ancestry of French chivalry. Famous episodes of ancient history are depicted as part of the cultural world of thirteenth-century France. In the Brussels and London manuscripts the killing of Hector depicts a cowardly Achilles lancing the Trojan hero from behind as he leans down to take the helmet from the body of Patroclus (pls. XLIIIa and b).[22]

22. The Brussels and London *Histoire universelle* codices, Brussels, Bibliothèque royale, MS. 10175, and London, British Library, Add. MS. 15268; see also above, pp. 133-134.

The London codex is the more significant work of art, one of the finest manuscripts from the Acre school, probably executed in 1286 as a coronation present for king Henry II of Cyprus. In the frontis-piece (pl. XLIV) the western Creation cycle is modified with bust-length images of the Creator looking like a Byzantine pantocrator. Its unusual border recalls manuscripts of the Koran in format, and the Arab musicians indicate the artist's interest in local Arab culture, another developing feature of the Acre school.

In view of the intensifying French influence in the Acre scriptor-ium from about 1275 to 1291, it is not surprising that some of the latest paintings were almost purely French in concept. There is in St. Catherine's monastery an icon of the *Maiestas Domini* painted about 1285 that demonstrates this for panel painting (pl. XLVIIb). It is not great art; the painter seems to be timidly attempting to work in un-familiar materials. The style and iconography are basically French, however, and there are a number of manuscripts which can be attri-buted to Acre from this period that are also purely French Gothic in style.[23]

In sum, painting at Acre in the thirteenth century was very differ-ent from that at Jerusalem and its surrounding area in the twelfth century, or even during the period from 1229 to 1244. Patronage was no longer centered on the clergy and the crown. Significant com-missions came also from soldiers as well as from pilgrims. While reli-gious icons continued to be executed in increasing numbers, interest in manuscripts turned to vernacular texts and secular illustrations, re-flecting the taste in France after 1250. The rich blend of western tra-ditions under Byzantine influence continued as well, but French con-cepts now increasingly dominated. Italy was strongly represented, and German ideas appeared as English ones disappeared. New was a stronger Islamic influence.

These examples of crusader painting indicate a development which differs significantly from that of crusader sculpture. There are, of course, special problems connected with the sculpture. Less of it sur-vives, and much of what does is non-figural ornamental work. Much of the extant material is badly damaged. Moreover, the nearly con-stant presence of Byzantine influence seen in the painting is hardly to be expected in sculpture. After all, Byzantium, as a result of iconoclasm, never experienced a rebirth of monumental stone sculp-ture comparable to that in the west in the eleventh and twelfth cen-turies.

23. See the forthcoming book by the present author, *Crusader Manuscript Illumination at St. Jean d'Acre: 1275-1291* (Princeton, 1976).

Nonetheless, the crusaders' experience in painting can help us look with fresh eyes at their sculpture. Questions must be raised: What was distinctively crusader about the sculpture? Do the varied western artistic traditions visible in the painting also contribute to the sculpture? Is there any development in the sculpture comparable to that in the painting? What contribution, if any, did Byzantium make to crusader sculpture?

Jerusalem in the twelfth century was the major center for sculpture, as it was for painting. Within the holy city it was the church of the Holy Sepulcher on which extensive attention was focused during the first fifty years. The consecration of the church on July 15, 1149, completed the essential transformation from a Byzantine shrine to a greatly enlarged crusader church, incorporating the major holy sites commemorating the events surrounding the death and resurrection of Jesus Christ. This is the church, much restored, that stands at present, but the pilgrim today entering the parvis in front of the main entrance façade on the south side (frontispiece) no longer sees the last significant surviving figural sculpture *in situ.*

The two lintels over the main doors (frontispiece, pls. IIa and b, IIIa and b) were removed in 1929 and deposited on indefinite loan in what is now the Rockefeller Museum. Tolerated for centuries by Moslems, the lintels were in danger of destruction from stone decay. The dense white crystalline limestone was losing its outer surface through blistering. To save the sculpture a binding medium was injected below the carved surface to prevent its loss. This treatment preserved the two works but has produced an ugly bloated muddy appearance (pls. IIIa and b), a condition which must be taken into account in any stylistic analysis.

The lintels were clearly done by different artists. The historiated one has been connected with southern France and Italy.[24] Most recently it has been compared to a Bethesda sarcophagus.[25] The vine scroll lintel has been related to southwestern France. They were probably carved at different times, as the molding configuration suggests (pls. IIa and b), but their dates are still unresolved. In content there is a growing consensus that they were meant to introduce the pilgrim to what was to be found inside the church.

In quality these lintels are the best figural sculpture extant from the Holy Sepulcher or the Hospitaller complex directly to the south.

24. For references see above, chapter III A, note 6.
25. A. Borg, "The Holy Sepulchre Lintel," *Journal of the Warburg and Courtauld Institutes,* XXXV (1972), 389-390.

The only comparable work appears in a group of carvings from the Hospital area, now in the Greek Orthodox Patriarchate, such as the architectural fragment with an archer (pl. VIIa). But here the style is quite different — Deschamps called it Burgundian — intensely plastic with strongly linear draperies. The zodiac cycle on the north door porch of St. Mary Latin is badly damaged and hard to see (pl. IVa).[26] But the style seen there with elongated figures and rumpled draperies is quite different from the lintels or the Orthodox Patriarchate group (although like the iconography it is basically western). Yet another style is found in the modest corner console, said to have been found near St. Mary the Great, now in the Museum of the Convent of the Flagellation (pl. IVb). Once identified as the insignia of the Hospital or the Kiss of Judas, this modest sculpture seems only to represent two doll-like bearded men.[27] This group of figural sculptures from closely contiguous locations in the Holy Sepulcher-Hospital quarter, all dating from between 1125 and 1175, demonstrates that there was little interrelationship among the ateliers. Nonetheless, each artist was surely from Europe and most, if not all, were from France.

The situation with regard to non-figural sculpture is somewhat different. The extraordinarily rich ensemble of architectural sculpture on the south façade of the Holy Sepulcher (frontispiece), including cornices (pl. Ia), capitals, imposts, and tympana (pl. Ib), has recently been studied and found to reflect long-standing local tradition from Roman times.[28] The upper cornice may in fact be reused Roman sculpture,[29] but the capitals of the Calvary door, based on Justinianic models, are probably the work of local Christian sculptors working for the Latins. This problem of reuse as opposed to crusader imitation of earlier work is a thorny issue indeed. Are the handsome capitals found at St. Mary the Great (pl. VIa) twelfth-century or pre-crusader? On the one hand, the modern capitals carved for the church of the Redeemer and based on a medieval model show the practical possibility for copying, even today. On the other hand, the extremely

26. In view of the state of St. Mary Latin in the nineteenth century it is remarkable that any of the sculpture is left; see the photograph published by Vincent and Abel, *Jérusalem nouvelle,* vol. II, fasc. 4, fig. 396, and above, p. 86. For the iconography of the sculpture see the descriptions in de Vogüé, *Les Églises de Terre Sainte*, pp. 258 ff., and his engravings on pl. XVIII. Note that de Vogüé and Enlart confused St. Mary Latin (or Minor) with St. Mary the Great (or Major), reversing the identifications in their publications.

27. B. Bagatti, *Il Museo della Flagellazione in Gerusalemme* (SBF: Jerusalem, 1939), pp. 130-131, no. 223.

28. N. Kenaan, "Local Christian Art in Twelfth Century Jerusalem; part II, The Decorative Sculpture of the Façade of the Holy Sepulchre Church," *Israel Exploration Journal,* XXIII (1973), 221-229.

29. Ch. Coüasnon, *The Church of the Holy Sepulchre in Jerusalem* (London, 1974), p. 60.

large size of these capitals for a relatively small church suggests that they may indeed have been reused, though if so, it is remarkable that they are in such excellent condition.[30]

The same problem exists all over crusader Palestine for different types of capitals. There are fine spiky acanthus capitals, of which excellent examples are found in the crusader chapel at Beth Gibelin (pl. XIVb), built about 1134, and in the later church at Ramla (pl. XVIb). Many of these Byzantine-style capitals are probably reused from earlier buildings. There are the thick, curved-leaf capitals based on Levantine Early Christian models as found in the crusader churches at Gaza, Ramla, and Sebastia (pls. XVIa and b, XVIIIa), all three probably dating from the third quarter of the twelfth century. There are also diminutive versions on the lantern of the Qubbat al-Mi'rāj, probably built originally as the crusader baptistry to the Temple (pl. Xa). Few of these capitals seem to be reused material.

Crusader use of older types of capitals is more often found in imitations or reinterpretations of pre-crusader models. There are, for example, many versions of the Corinthian capital. At the Tomb of the Virgin is a handsome, more plastic interpretation of the Byzantine spiky-leaf type (pl. Vb). The capital at St. James has lamb-like animals amidst articulated and thick curving leaves (pl. Vc). Sometime after 1167 at the church of the Resurrection in Nablus, the main portal shows increased plasticity of the leaves as well as a taller, slenderer drum shape for the capital (pl. XVIIb). But when the crusaders decorated the entries to the Grotto in the church of the Nativity about the same time, they reverted to a more conservative, leafy-style capital reminiscent of the façade of the Holy Sepulcher (pl. XIVa). On the pulpit of Burhān-ad-Dīn on the Temple platform there are crusader capitals in the southwest corner which reinterpret an earlier Byzantine round-bodied exemplar (pl. Xd). All these variations of Corinthian-type capitals continue the classical tradition in the Holy Land through the twelfth century, and many were probably the work of local Christians.

The distinctive western contributions in capital sculpture are to be found in other kinds of ornament. Some of this ornamentation is abstract, some has fauna and flora, some is a unique style of foliate decoration, and some, of course, is figural sculpture. Romanesque inclinations toward abstract ornament are well represented in the west and appear also in the Latin kingdom. The austere decoration of St. Anne's church (pl. XIIIa) converts even the eminently three-

30. The plan of St. Mary the Great is published by Vincent and Abel, *Jérusalem nouvelle,* vol. II, fasc. 4, p. 957.

dimensional Corinthian capital into a two-dimensional pattern and introduces a wide range of geometric form such as the pierced spiral volutes (pl. XIIIb). No other major crusader church received such charmingly simple ornament, but other crusader buildings have decoration clearly informed by the same love of abstract form. In the cloister of the Holy Sepulcher is one example (pl. Va). The church of St. Abraham in the Haram at Hebron (pl. XVa) has many clustered capitals in the main nave (pl. XVb) which translate foliate capitals into vigorous ornament.

Flora and fauna often appear together in capitals, as already seen in the example from the church of St. James. Sometimes the animals dominate the design, as do the griffins on capitals of the aedicule of the Ascension (pl. Vd) or the St. Peter Gallicante double capital, which also has scowling demons' heads (pl. VIb). The most interesting versions blend flora and fauna together. In the Aqṣâ mosque, the upper double capital on twisted columns intertwines birds and plants to express the unity of nature in a characteristic Romanesque manner (pl. IXa). On the west side of the Qubbat al-Miʻrāj are paired capitals (pl. Xb). In the interior, to the left, there are the extraordinary fan-shaped leaves Enlart compared to a capital in the church of St. Julien at Donzy-le-Pré.[31] To the right, partly destroyed, are fighting birds composed to suggest the dynamic vitality of nature to be seen in their sinuous vine-like poses as a parallel to the explosive design of the plants on the companion piece.

These examples of crusader sculpture on the Ḥaram ash-Sharīf bring us to the second major center in the city of Jerusalem. Most of the crusader work found on the Ḥaram is, except in the Qubbat al-Miʻrāj, not *in situ,* but on materials reused by the Aiyūbids, the Mamluks, or the Ottomans. The abundance and quality of the sculpture reflects the importance of the Temple area for the crusaders. After the conquest of Jerusalem, the royal residence was initially located in what is now the Aqṣâ mosque. The Dome of the Rock was turned into a church, eventually dedicated in the 1140's as the Templum Domini, though canons had been installed in 1099. A monastery served by Augustinians was erected just to the north of the Temple platform. Meanwhile, the Templars carried out much construction at the south end of the Ḥaram. Given lodgings in a wing of the royal palace by Baldwin II, the Templars later took over the entire complex when the king moved to new quarters adjacent to the citadel. The knights enlarged the Aqṣâ to the east and west, and building on

31. Enlart, *Les Monuments des croisés,* vol. I, pp. 123–124, and album I, pl. 24, fig. 75.

their convent church was going on in the 1170's. In addition, just outside the main entrance to the Ḥaram from Temple Street the crusader church of St. Gilles was erected.

After the return of the Ḥaram to Islam in 1187 some of these Christian buildings were dismantled. As a result today one finds extensive fragments of crusader sculpture in the Ḥaram. In particular there are concentrations in the Aqṣâ mosque (pls. VIIIa and b), in the Dome of the Rock, and in the entry area of the Bāb as-Silsilah (pl. IXb), along with scattered fragments elsewhere as in the *minbar* (pulpit) of Burhān-ad-Dīn (pl. Xd) and in the Bāb Ḥiṭṭah (pl. Xc). Some pieces have also made their way to various museums (pl. VIIb), and two extraordinary works were found in Latrun and later taken to Istanbul (pl. XIa). Unlike the sculpture from the Holy Sepulcher-Hospital complex ateliers, much of this sculpture with its beautiful "wet-leaf" foliage is quite unified in style. Yet despite its obvious high quality it has not been possible to trace any clear development in its form; nor can we be sure to which buildings it belonged or even when it was done.

The sculpture in the Bāb as-Silsilah, including the portion of the rose window in the *Sabīl* of Suleiman (drinking fountain; pl. IXb), does not belong to the main corpus of the "wet-leaf" sculpture (with two fragmentary exceptions). Fabre's old suggestion that these carvings may have belonged to the church of St. Gilles still seems the best.[32] Indeed, foundations for a cruciform crusader building have now been found nearby, north of Wilson's arch. And the rose window in the *Sabīl* is an early type, with round arches, diminutive columns, and a carved floral design at the center.

As for the "wet-leaf" acanthus sculpture, the variety of surviving pieces has so far defied explanation. Strzygowski's proposal that some of the small-scale pieces were used for the sarcophagus of Baldwin V is a possibility.[33] Clearly most of the extant material was used for larger-scale architecture (pls. VIIIa, Xd, and XIa) or its decoration (pls. VIIb, VIIIb, Xc). For these the destroyed Templar buildings or the Augustinian monastery are possible sources.

In regard to dating, the lovely sinuous form of the "wet-leaf"

32. Fabre, "La Sculpture provençale en Palestine au XIIe siècle," *Echos d'Orient*, XXI (1922), 50.

33. J. Strzygowski, "Ruins of Tombs of the Latin Kings on the Haram in Jerusalem," *Speculum*, XI (1936), 499 ff.; see above, p. 91. It should be noted that Elzear Horn supposed the tomb he drew was that of Baldwin V because it was "so small" (*Ichnographiae monumentorum Terrae Sanctae (1724-1744)*, 2nd ed, tr. E. Hoade, SBF: Publications, No. 15 [Jerusalem, 1962], pp. 74-75 and fig. 10). Many of the fragments Strzygowski cites are too large and not appropriate for the "furniture" he refers to.

strongly suggests a date no earlier than the second half of the twelfth century, while the rigorous clarity of the patterning in the foliate ensembles bespeaks Romanesque tendencies (pls. VIIIb, Xc). Furthermore, the figure style of the heads found on the Istanbul capitals (pl. XIb) and on parts of the *dikkah* (podium) in the Aqṣâ mosque also demonstrate Romanesque handling. The last word on these sculptures is, however, far from written, and a full-scale study is needed.[34]

Little figural sculpture survives on the Ḥaram because of Moslem strictures against human images in holy places. However, on the al-Ghawānimah minaret in the northwest corner there survive three damaged crusader capitals which apparently belonged to the chapel of the Repose (pls. XIIa and b).[35] All three capitals depict angels ministering to Christ. The unusual iconography with the seated Christ seems to have been tailored by the crusaders to the specific requirements of this pilgrim shrine. The sole marble capital which has been battered least has been weathered most (pl. XIIb). The look of softness is due to the wind and rain, but the figure style is somewhat visible and clearly quite different from the sculpture done in the Holy Sepulcher-Hospitaller ateliers. The artist was surely French and he certainly worked after 1150, but nothing else by his hand is known as yet from the Holy Land.

Outside Jerusalem the extant figural sculpture presents the same story of itinerant western artists working on a single project in their own native style. From Acre little survives of the twelfth-century sculpture, but a holy-water basin decorated with heads has recently been attributed there, probably executed by a south Italian in the first quarter of the century (pl. XXIIIb).[36] At the cathedral of St. John the Baptist in Sebastia, a sculptor probably from Languedoc worked on historiated capitals for the main portal in the third quarter of the century. Now in Istanbul, these capitals depict scenes from St. John's life including the feast of Herod and Salome's dance (pls. XVIIIb and c). Typical of crusader carving, they are recut on capitals from an earlier building, and once again their iconography focuses on the holy site the capitals decorate, the burial place of St. John.

It is rare to find much figural sculpture in crusader castles. One important exception is at Belvoir where two handsome pieces were found by Israeli excavators.[37] The larger work includes a hovering

34. For links between the wet-leaf acanthus style in the Latin kingdom and in southern Italy see F. Jacobs, *Die Kathedrale S. Maria Icona Vetere in Foggia* (diss., Hamburg, 1968), pp. 102-128.

35. See above, pp. 91-92.

36. Barasch, *Crusader Figural Sculpture in the Holy Land,* pp. 13-65.

37. *Ibid.,* pp. 187-207; see also above, pp. 85-86. A third piece is now on exhibit and will be published in the final report—a fine bearded head on an engaged capital.

angel on a slab beveled at the left side (pl. XIXa). Angels are common in crusader painting, but in sculpture only those on the al-Ghawānimah minaret and the Sebastia capitals and this one, totally unrelated, are known. Until the excavation at Belvoir is fully published it will not be possible to decide where in the chapel the slab was likely to have been placed. The other piece is a delightful head of a smiling boy attached to some kind of molding (pl. XIXb). Works with such a lighthearted spirit are unusual in the Latin kingdom. Both pieces were probably executed during the blossoming of Belvoir, 1175 to 1182. Stylistically they agree with such a date in terms of their mature Romanesque forms. However, they surely were done by separate artists. Despite the Hospitaller control of the castle no connection can be made with work done elsewhere for the order, nor is there any tie to the brilliant sculpture being carved about this time in Nazareth. Once again these seem to be isolated works by itinerant artists. Both artists probably came from southern Europe, but while the smiling boy master was possibly French, the angel sculptor may have been Italian.

Without doubt the most remarkable crusader figural sculpture extant was done in Nazareth.[38] Indeed there is little Romanesque carving that can match it in quality. Over a long period of time a number of sculptures in a closely related style have come to light (pls. XX, XXI, and XXII). All except one piece (pl. XXIIb) have an unquestioned Nazareth origin; all are cut from the same stone and appear to have been done in the same workshop. The paired bearded heads and five capitals (pls. XXa, XXIa and b) were the first objects found, in 1867[39] and 1908, respectively. More recently excavations by the Franciscans between 1955 and 1968 have brought to light another capital, a torso of St. Peter with unusual iconography (pl. XXb), and the lower torso and legs of another figure (pl. XXIIa), to list only the major pieces of which photographs have been published. In 1967 T. S. R. Boase connected the Chatsworth torso with the Nazareth group as well (pl. XXIIb).[40]

Until a proper archaeological publication of all the new material is in hand it will not be possible to assess fully the significance of the Nazareth sculpture. Nonetheless, it is apparent that when the crusaders enlarged the church at the place they believed to be the site of the Annunciation, the sculpture prepared to decorate it was much

38. See above, pp. 103-105 and note 30.

39. Conder and Kitchener, *Survey of Western Palestine;* vol. I, *Galilee,* pp. 328-329.

40. T. S. R. Boase, *Castles and Churches of the Crusading Kingdom* (London, 1967), pp. 90, 91, 93, and see above, p. 105.

more extensive than previously suspected. It is not yet possible to date this project with any certainty, but archbishop Lietard (1158-1181) was probably the patron. If, as seems probable, all the extant sculpture belongs to the same ensemble, the crusader church may have had a program including life-sized figures of apostles (and prophets?) with historiated capitals above depicting their lives.

Despite the unique features of the Nazareth sculptures their typically crusader characteristics should not be overlooked. The style is decidedly western, brought from France. It has been connected with Plaimpied specifically,[41] and more recently discussed as the product of a workshop staffed by French artists from several regions but with a Burgundian *chef d'atelier*.[42] The sculptors appear to have centered their work in Nazareth. The only exception may be a small non-figural fragment of an interior edicule discovered on Mt. Tabor (pl. XXIIIa).[43] Apparently unfinished, this work is comparable in form and quality to the Nazareth material. Iconographically, the extraordinary cycles of the lives of the apostles on the capitals is well known. It cannot be surprising that the focus in these works is on apostles traditionally closely associated with the Levant.

The Nazareth group forms the culmination of crusader sculpture in the twelfth century. In 1187, not long after these works were finished, Saladin overran the Latin kingdom. Five of the capitals, apparently not yet in position on the church, were hidden away. Other sculptures survived with less care, and we await the complete report of their discovery.

Compared to the twelfth century, little crusader sculpture from the thirteenth century survives. This is partly because of the great destruction the thirteenth-century centers suffered, especially Acre, but also because the greater construction campaign had been undertaken in the period of the first Latin kingdom. Nevertheless, a clear distinction can be drawn between Romanesque and Gothic sculpture in the crusader states just as it can be distinguished in the architecture.

Taking the latter as an example first, in terms of church portals, it is well known that early in the twelfth century the crusaders used pointed arches derived from Arab sources. The entrance doors to the Holy Sepulcher, dedicated in 1149 (frontispiece), the main entry to the church in Gaza, done after 1150 (pl. XVIa), and the entrance

41. P. Deschamps, "Un Chapiteau roman du Berry, imité à Nazareth au XIIe siècle," *Fondation Eugène Piot, Monuments et mémoires,* XXXII (1932), 119-126; see also above, p. 104.

42. Barasch, *Crusader Figural Sculpture,* pp. 73-114, 155-164.

43. Enlart, *Les Monuments des croisés,* vol. II, pp. 391-394, album II, pl. 150[bis], fig. 477.

portals to the church of the Resurrection in Nablus, built after 1167 (pl. XVIIa), all show this feature. But the architectural concept of these doors is still based on Romanesque principles stressing strength and stability. The pointed arches themselves are extremely broad, and their voussoir moldings emphasize the thickness and heaviness of the wall through which the doors are cut. Other decoration of the doors such as the godroons at the Holy Sepulcher and the columns on the popular fluted socles focus attention on the formidable three-dimensionality of the architecture. The Nablus door was an extremely handsome example of this desire to express plasticity (pls. XVIIa and b). The paired round moldings in the voussoirs above each capital grow smaller as one moves from the tympanum to the outer surface, culminating in relatively insubstantial leaf designs above the engaged polygonal pilaster. Thus as one enters the church, the archway visually expresses the transition from forms of nature to the monumental architecture of the church with its heavy wall.

There is a notable difference between these doors and the thirteenth-century portal of St. Andrew's church carried off as a trophy after the fall of Acre, later to be erected in Cairo as the entrance to the madrasah-mausoleum of sultan an-Nāṣir Muḥammad, where it is still to be seen (pl. XXVa). Here the arch is tall and slender, the elements that articulate it are thin, more linear, and the whole effect stresses a flatter, less three-dimensional entry. Furthermore, the decorative sculpture of the very small capitals (pl. XXVb) has changed strikingly from the acanthus types seen in the twelfth century. The foliage is lush and young with leaves that seem by their naturalistic quality to invite identification. Viollet-le-Duc in his *Dictionnaire d'architecture* long ago discussed how such naturalistic foliage was used in French Gothic sculpture. Here is the same phenomenon, with the leaves opened out as they were carved in France in the first half of the thirteenth century.

There are of course other examples of this Gothic foliage *in situ* in the crusader states. The cathedral of Notre Dame at Tortosa, surely the finest extant Gothic church on the mainland, also has rich flora in the capitals carved in the thirteenth-century phase of the building (pl. XXVIII). In Acre itself the east wall of the west hall of the *grand manoir* of the Hospitallers still stands, partly rebuilt, but with the original architectural sculpture intact (pl. XXVIa). Here shafts and clusters of capitals are visible amidst the housetop playground debris of dwellings that abut the present government hospital for the insane. One console (pl. XXVIb) in particular, in the center of the wall, though badly weathered, has vigorous foliage whose leaf designs bear some resemblance to those of St. Andrew's.

The Hospitaller complex in Acre has yielded other bits of sculpture which help to distinguish its various building phases from the mid-twelfth century into the thirteenth. *Fleurs-de-lys* found on consoles in the so-called refectory probably were carved in the second half of the twelfth century.[44] A handsome capital now in the Municipal Museum, almost surely from the Hospitaller church of St. John (now the Arab school just opposite the museum), was probably carved to decorate the interior after the crusaders retook Acre in 1191 (pl. XXVIc). Not as stylized as the *fleurs-de-lys* and yet not so three-dimensional as the St. Andrew's or the Hospitaller west hall foliage, their form is nonetheless convincingly naturalistic. Perhaps the closest comparison in concept is to be found in sculpture from the now mostly destroyed monastery of St. Brochardus in the Wādī as-Sīyāḥ just south of Mt. Carmel. Excavations there have shown that the church was built in two phases: an earlier Romanesque of the late twelfth century and a later Gothic of the mid-thirteenth.[45] One of the few sculptures recovered from the church (pl. XXIVe) shows a plant decorating some kind of polygonal piece that must have been executed for the enlarged Gothic church.

Much of the crusader figural sculpture from the thirteenth century is equally fragmentary. A handsome eagle surmounting a lion is found today in the Municipal Museum at Acre (pl. XXVIIa). [46] Despite the abstract character of the beveled forms, as in the lion's mane, it has been connected with the visit of Frederick II to Acre and the Holy Land in 1228-1229. Actually, however, this phase of crusader art is one of the least well understood and most in need of careful study. Other less well preserved sculpture from thirteenth-century Acre is also to be found in the Municipal Museum. A console with a forceful, beardless, but lined man's head with a fearsome expression is recognizably a Gothic work despite its severe weathering (pl. XXVIIb).

44. The *fleurs-de-lys* are published by Z. Goldmann, "The Hospice of the Knights of St. John in Akko," *Archaeology*, XIX (1966), 185, and "Le Couvent des hospitaliers à St. Jean d'Acre," *Bible et Terre Sainte*, no. 160 (1974), p. 11, fig. 5.

45. B. Bagatti, "Nota storico-archeologica sul monastero di S. Brocardo in seguito ai lavori praticati nel 1958," *Acta Ordinis Carmelitarum Discalceatorum*, III (1958), 278-288.

Other handsome foliate sculpture is known from the castle of the Teutonic Knights at Montfort, rebuilt after 1229, but few pieces can be found today. See B. Dean, "The Exploration of a Crusaders' Fortress (Montfort) in Palestine," *Bulletin of the Metropolitan Museum of Art, New York*, XXII, part II (1927), especially p. 29. See also the handsome floral capitals in the northern and eastern gatehouses at Caesarea Maritima from the rebuilding of Louis IX in 1251: M. Benvenisti, *The Crusaders in the Holy Land* (Jerusalem, 1970), p. 139.

46. M. Barasch, "An Unknown Work of Medieval Sculpture in Acre," *Scripta Hierosolymitana*, XXIV (Jerusalem, 1972), 72-105. See also Joshua Prawer, "A Crusader Tomb of 1290 from Acre and the Archbishops of Nazareth," *Israel Exploration Journal*, XXIV (1974), 241-251.

Many such consoles survive *in situ* from the twelfth century, as for example on the drum of the Holy Sepulcher (frontispiece) or the east end of the Beirut cathedral (pl. XXIXb). From the thirteenth century, however, the consoles of the great north tower in the Château Pèlerin are among the only surviving examples from the Latin kingdom (pl. XXIVa).[47] This castle was begun in the winter of 1217/1218 and when completed became the headquarters for the Knights Templar, impregnable until evacuation in 1291 after the fall of Acre. In the upper story of the north tower three consoles with human heads have somehow survived the weathering by intense winter wind and rain that has so severely pitted most of the stone remains there. The left-hand console with its fleshy face and long wavy hair is reminiscent of the one from Acre mentioned above (pl. XXIVb). The cluster of three heads in the central console is too damaged to be seen well (pl. XXIVc). But the right-hand console miraculously preserves a handsome bearded face which even today conveys some of the sensitivity of carving characteristic of the best French work in the high Gothic period (pl. XXIVd). These consoles give us a tantalizing glimpse of what crusader sculpture in the thirteenth century could be at its best.

In short, the monumental sculpture done in the Latin kingdom between 1099 and 1291 seems to be the product of a variety of artists: some local Christians, many from France, some from Italy, and possibly a few from Germany, whose influence has only vaguely been discerned in the now-scattered fragmentary material from Montfort. One may expect the identification of some Spanish contributions as well.

In non-figural sculpture a clear distinction can be seen in foliate capitals between those of Romanesque and Gothic style. During the twelfth century the influence of local tradition from Roman-Early Christian-Byzantine times plays a major role along with the styles of western Europe. One significant result is the uniquely crusader "wet-leaf" acanthus style, which blends concepts from both traditions. In the thirteenth century the artistic centers move from the more strongly traditional inland area to the coast, where itinerant western artists predominate. Interest shifts from the Corinthian acanthus to Gothic naturalistic foliage.

In figural sculpture western artists, mostly French, prevailed throughout the duration of the Latin kingdom. Jerusalem yields in the twelfth century a rich variety of styles. None however is of the outstanding quality found in Nazareth. Knowledge of thirteenth-

47. It should be noted that some figural sculpture in capitals was found *in situ* at Montfort but is now lost. See Dean, "The Exploration of a Crusaders' Fortress," p. 27, fig. 28.

century figural sculpture is still fragmentary, but curiously very little carving of any kind seems to date from after the 1250's.

No serious attempt can be made to relate crusader painting to the sculpture until all the key monuments are adequately studied. Production methods in the two media indicate nothing surprisingly different from what is known of ateliers in the west except the unusual importance of itinerant artists from widely scattered regions. Sculpture tended to be a highly differentiated local art, as did monumental painting, whereas there was greater unity in manuscript illumination and icons which, being easily portable, could be distributed from Jerusalem or Acre. It is worth noting, however, that the sculpture points to a major center for which as yet no painting is known, Nazareth. Oddly enough, our picture of thirteenth-century Acre seems entirely out of phase artistically, the extant sculpture dating mostly from before 1250, the painting mostly after 1250 with Louis IX as the pivotal figure. Future study should help determine whether this is purely the result of chance survivals or whether sculpture in fact preceded painting there, unlike Jerusalem. The Byzantine influence so strongly seen in the painting appears only occasionally in large-scale sculpture, as in capitals. But it is more important in the so-called minor arts like the ivory covers of Melisend's Psalter. It should be mentioned incidentally that a few other such diminutive works have been found, like the handsome Bethlehem candlesticks with their niello inscriptions to curse would-be thieves (pl. XLIX).[48] Other portable crusader sculptures in ivory, precious metals, or wood may yet be identified in western museums to help clarify crusader developments in this area as well.[49]

Crusader art was not merely a colonial transplant of western ideas to the east. Taken as a whole, the crusader experience in the Latin kingdom of Jerusalem between 1099 and 1291 was beginning to produce a fruitful blend of cultures, western, Byzantine, and Islamic among others, which yielded painting and sculpture unique in style and iconography, a distinctive chapter in the history of medieval art. The tragedy is that because of war and destruction much of crusader art is lost. The works of those who lived by the sword have been destroyed by it.

48. See above, p. 139.

49. Heribert Meurer has recently argued that several reliquaries now in western Europe originated in crusader Jerusalem. See his "Kreuzreliquiare aus Jerusalem," *Jahrbuch der Staatlichen Kunstsammlungen in Baden-Württemberg,* XIII (1976), 7–17. See also W. Fleischhauer, "Das romanische Kreuzreliquiar von Denkendorf," *Festschrift für Georg Scheja* (Sigmaringen, 1975), pp. 64–68. My thanks to Dr. H. E. Mayer for drawing my attention to these articles.

CRUSADER ART
AND ARCHITECTURE:
A PHOTOGRAPHIC SURVEY

Modern scholarship on the history of the crusades begins in the early nineteenth century. Between 1807 and 1832 Friedrich Wilken published his *Geschichte der Kreuzzüge* in seven volumes, and between 1812 and 1822 J. F. Michaud produced his *Histoire des croisades*, also in seven volumes, the latter having reached by 1838 its fifth edition, "revue, corrigée et augmentée, d'après le voyage de l'auteur en orient."[1] Despite the remarkably broad scope of these works, especially that of Michaud, who made a point of visiting the Levant in furtherance of his professional studies, neither author has much to say about the visual arts in relation to the crusaders. Wilken discusses at length only the destruction of works of art during the terrible sack of Constantinople in 1204.[2] Michaud deals briefly with scenes in the famous St. Denis crusader window.[3] And neither work contains a single illustration, except maps.

In fact, through the first sixty years of the nineteenth century illustrations of crusader artistic work, mainly architecture, were still found almost exclusively in publications of travelers to the Near East such as John Carne, A. and L. de Laborde, David Roberts, and W. H. Bartlett.[4] These popular illustrations, mainly rather romantic drawings of buildings and scenery, fired the interest and imagination of western Europeans but were not intended for the scholarly study of

1. Friedrich Wilken, *Geschichte der Kreuzzüge naeh morgenländischen und abendländischen Berichten* (7 vols., Leipzig, 1807-1832); J. F. Michaud, *Histoire des croisades* (7 vols., Paris, 1812-1822; 5th ed., 6 vols., Paris, 1838).
2. Wilken, *Geschichte der Kreuzzüge*, V (1829), appendix II, pp. 12-42.
3. Michaud, *Histoire des croisades*, I (1838), 110, note 1, and 208, note 1, and II (1838), 180, note 2.
4. John Carne, *Syria, the Holy Land, Asia Minor, &c., Illustrated, in a series of views drawn from nature* . . . (3 vols., London, Paris, and New York, 1836-1838); A. and L. de Laborde, *Voyage de la Syrie* (Paris, 1837); David Roberts, *The Holy Land, Syria, Idumea, Egypt & Nubia* (2 vols., London, 1842); W. H. Bartlett, *Walks about the City and Environs of Jerusalem* (London, 1844).

crusader architecture. Other artists also visited the Near East and did sketches that were never published. The young architect Charles Barry made a study trip through the Levant between 1817 and 1820, and W. Holman Hunt set out in 1854 for Syria, but here again the purpose was not primarily the investigation of crusader buildings.

The advent of photography opened up new possibilities for accurate reproduction, and with the introduction of collodion toward the mid-nineteenth century a number of photographers took the field. Albums began to appear, such as those by Auguste Salzmann and Francis Frith.[5] Again, however, these pictures were chiefly general views of Jerusalem and other places in the Near East, although many of the photographs are of considerable historical interest to scholars.

In the meantime serious work with measured drawings had begun to appear. Among the earliest was a history of the church of the Holy Sepulcher by Robert Willis published in 1849 in the second edition of George Williams's *The Holy City*[6] But the landmark studies with better drawings, including plans and sections and some illustrations (although there were no photographs), appeared in 1860 and 1871, the work of Count Melchior de Vogüé and Baron E. G. Rey respectively.[7] In *Les Églises de la Terre Sainte* de Vogüé wrote the first systematic survey of crusader ecclesiastical architecture as an extract from his account of his Levantine travels. Rey discussed crusader military architecture eleven years later, part of his wide-ranging studies on the crusader states.

As a result of the works of de Vogüé and Rey, historians of the crusades began to deal with crusader art and architecture. In 1883 Hans Prutz published his *Kulturgeschichte der Kreuzzüge,* which included a chapter entitled "Die bildenden Künste bei den Franken und die Einwirkung der Kreuzzüge auf die bildenden Künste im

5. Auguste Salzmann, *Jérusalem: Étude et reproduction photographique des monuments de la ville sainte . . .* (2 vols., Paris, 1856); Francis Frith, *Egypt, Sinai, and Palestine* (London, Glasgow, and Edinburgh, [1860]), supplementary volume.

6. George Williams, *The Holy City: Historical, Topographical, and Antiquarian Notices of Jerusalem* (2nd ed., 2 vols., London, 1849), with "An Architectural History of the Church of the Holy Sepulchre," by Rev. Robert Willis, in vol. II, pp. 129-294, with six plates. For Jerusalem as a whole the architect-engineer to Surayya Pasha published detailed drawings in 1864; see Ermete Pierotti, *Jerusalem Explored, being a Description of the Ancient and Modern City with Numerous Illustrations Consisting of Views, Ground Plans, and Sections,* tr. T. G. Bonney (2 vols., London and Cambridge, 1864).

7. C. J. Melchior de Vogüé, *Les Églises de la Terre Sainte* (Fragments d'un voyage en Orient, Paris, 1860); E. G. Rey, *Étude sur les monuments de l'architecture militaire des croisés en Syrie et dans l'île de Chypre* (Collection de documents inédits sur l'histoire de France, series 1: Histoire politique; Paris, 1871).

Abendlande."[8] Prutz had studied the written sources carefully and he knew the works of de Vogüé, Rey, and Viollet-le-Duc, among others. He presents a concise survey of crusader art in the Holy Land, identifying several key problems, but his reliance on the written word rather than the visual image is reflected in the total absence of any illustrations to his text.

Coincidentally in the same year, 1883, Rey published another important book on the crusades entitled *Les Colonies franques de Syrie.*[9] He too devotes a chapter to crusader art but limits it to "l'art industriel." By this he means metalwork, glass, textiles, and such, but he also mentions "l'évangéliaire de la reine Melisende." This is, of course, the psalter of Melisend in the British Library, which is included because of the carved ivory plaques on its binding in the "plus beau style bysantin," no reference being made to the miniatures in the manuscript. Like Prutz, Rey has no drawings or photographs to illustrate his text.

The next major contributions to the knowledge of crusader art and architecture were made in publications on Palestinian archaeology by Charles Warren, C. R. Conder, and H. H. Kitchener, and by Charles Clermont-Ganneau. The survey of western Palestine got underway in Jerusalem in 1867, and after several seasons in Judaea, Samaria, and Galilee, the publications were issued in four volumes between 1881 and 1884.[10] Basically the crusader material is presented in the form of archaeological reports, but the text together with the measured drawings and pictorial engravings is still an invaluable resource for crusader studies today. And one special later benefit of the project was *The Latin Kingdom of Jerusalem* by C. R. Conder.[11] Though completely without illustrations, it is one of the first histories of the crusades written since William of Tyre by someone who knew the land of Syria-Palestine intimately. Clermont-Ganneau started archaeological work in Palestine, also under the aegis of the Palestine Exploration Fund, between November 1873 and November 1874. His findings were subsequently published in two volumes, and in this and other work he was one of the first to in-

8. Hans Prutz, *Kulturgeschichte der Kreuzzüge* (Berlin, 1883), pp. 416-435.

9. E. G. Rey, *Les Colonies franques de Syrie au XII^me et XIII^me siècles* (Paris and Geneva, 1883), pp. 211-234.

10. *The Survey of Western Palestine: Jerusalem,* by Charles Warren and C. R. Conder (London, 1884); *The Survey of Western Palestine: Memoirs of the Topography, Orography, Hydrography and Archaeology,* by C. R. Conder and H. H. Kitchener; vol. I: *Galilee* (London, 1881); vol. II: *Samaria* (London, 1882); vol. III: *Judaea* (London, 1883).

11. C. R. Conder, *The Latin Kingdom of Jerusalem, 1099 to 1291 A.D.* (London, 1897).

clude photographs for illustrations of significant crusader material, along with various types of drawings.[12]

The scholarly labors of these men in the second half of the nineteenth century laid the foundations for the great contributions to come. In 1899 Camille Enlart published *L'Art gothique et la Renaissance en Chypre* in two volumes.[13] Here was the major breakthrough in the use of photographic reproductions for crusader art and architecture, there being a total of 34 plates, as well as copious drawings and figures in the text. It was the first adequately illustrated serious study of crusader artistic endeavor in a major region of the Levant.

Enlart was followed by the Dominicans L. H. Vincent and F. M. Abel, who began in 1912 their monumental series of publications on Jerusalem, Bethlehem, Hebron, and Emmaus.[14] With rigorous scholarship they investigated the medieval and other monuments at these sites, presenting them with meticulous drawings and numerous invaluable photographic reproductions. These studies remain to this day the standard works for the archaeology of the relevant crusader monuments.

Enlart continued his major contributions to crusader studies with the publication from 1925 to 1928 of the first general survey of crusader art and architecture in the Latin kingdom of Jerusalem.[15] Furthermore, *Les Monuments des croisés . . .* included the most extensive set of illustrations on crusader material to date, there being a total of 196 plates comprising over 600 pictures in the two-volume atlas alone.

12. Charles Clermont-Ganneau, *Archaeological Researches in Palestine during the Years 1873-1874,* vol. I, tr. A. Stewart (London, 1899); vol. II, tr. John Macfarlane (London, 1896). Photographic reproductions seem to have been used for crusader material as early as the 1880's. Clermont-Ganneau himself published plates with crusader seals in his *Études d'archéologie orientale,* vol. I (Bibliothèque de l'École des Hautes Études: Sciences philologiques et historiques, fasc. 44; Paris, 1880), pl. III D, E. But photographic reproductions seem to have come into widespread use for scholarly publications only in the 1890's. The first *Quarterly Statement of the Palestine Exploration Fund* to use them was for 1891, and the *Revue de l'Orient Latin* launched its first volume in 1893 with such illustrations.

13. Camille Enlart, *L'Art gothique et la Renaissance en Chypre* (2 vols., Paris, 1899).

14. *Jérusalem: Recherches de topographie, d'archéologie et d'histoire;* vol. I: [L.] Hugues Vincent, *Jérusalem antique* (Paris, 1912); vol. II: Vincent and F. M. Abel, *Jérusalem nouvelle* (Paris, 1914-1926); Vincent and Abel, *Bethléem: Le Sanctuaire de la Nativité* (Paris, 1914): Vincent and E. J. H. Mackay, with Abel, *Hébron: Le Ḥaram el-Khalîl, sépulture des patriarches* (2 vols., text and album, Paris, 1923); and Vincent and Abel, *Emmaüs: Sa Basilique et son histoire* (Paris, 1932), which equates 'Amwās with Emmaus.

Four years before Vincent and Abel's publication on Bethlehem, a more limited but still useful illustrated volume on the church of the Nativity at Bethlehem appeared under the auspices of the Byzantine Research Fund: W. Harvey et al., *The Church of the Nativity at Bethlehem,* ed. R. Weir Schultz (London, 1910).

15. Camille Enlart, *Les Monuments des croisés dans le royaume de Jérusalem: Architecture religieuse et civile* (Bibliothèque archéologique et historique, vols. VII and VIII), text in 2 volumes (Paris, 1925 and 1928) and atlas in 2 albums (Paris, 1926 and 1927).

Enlart's successor in the Levant was Paul Deschamps, whose intensive studies of crusader castles were initiated with a magisterial publication on Krak des Chevaliers in 1934.[16] Among other features it contains the finest measured drawings ever done for any work of crusader architecture.

At this point it is useful to observe that the focus in these art-historical and archaeological studies by de Vogüé, Rey, Vincent, Abel, Enlart, and Deschamps was overwhelmingly on architecture. Enlart alone dealt extensively with sculpture and to a certain extent with other arts, but always in the context of architecture as the subtitle to *Les Monuments des croisés . . .* makes clear: *Architecture religieuse et civile*. Indeed, crusader sculpture had only begun to attract attention independently as a result of the first Nazareth excavations published by Père Viaud in 1910 and a series of articles by Père Germer-Durand, Abel Fabre, and Paul Deschamps, all with good photographs for their day.[17]

It was, appropriately enough, T. S. R. Boase who in 1939 was among the earliest in a widening group of scholars who began to challenge French dominance of scholarship in crusader art and architecture.[18] His work in this field continued, with two general books published recently,[19] and regrettably now terminates with the posthumous publication of the chapters in the present volume, which con-

16. Paul Deschamps, *Les Châteaux des croisés en Terre Sainte;* I, *Le Crac des Chevaliers* (2 vols., Paris, 1934; Bibliothèque archéologique et historique, vol. XIX), and II, *La Défense du royaume de Jerusalem* (2 vols., Paris, 1939; Bibliothèque archéologique et historique, vol. XXXIV). The third part to this series, on the county of Tripoli, is now in press.

17. Prosper Viaud, *Nazareth et ses deux églises de l'Annonciation et de Saint-Joseph d'après les fouilles recentes* (Paris, 1910); J. Germer-Durand, "La Sculpture franque en Palestine," *Conférences de Saint-Étienne . . . 1910-1911* (Paris, 1911), pp. 233-257; Abel Fabre, "La Sculpture provençale en Palestine au XIIe siècle," *Echos d'Orient,* XXI (1922), 45-51; Paul Deschamps, "La Sculpture française en Palestine et en Syrie à l'époque des croisades," *Fondation Eugène Piot, Monuments et mémoires,* XXXI (1930), 91-118; and *idem,* "Un Chapiteau roman du Berry, imité à Nazareth au XIIe siècle," *Fondation Eugène Piot, Monuments et mémoires,* XXXII (1932), 119-126. An earlier article by A. J. B. Wace on Frankish sculpture in Greece, "Laconia; V, Frankish Sculptures at Parori and Geraki," *Annual of the British School at Athens,* XI (1905), 139-145, seems to have been little noticed.

18. William Harvey had carried out structural surveys of both the church of the Holy Sepulcher and the church of the Nativity during the British mandate. These reports were published with copious photographs as *Church of the Holy Sepulchre, Jerusalem* (London, 1935) and *Structural Survey of the Church of the Nativity, Bethlehem* (London, 1935). One of Josef Strzygowski's last articles was on crusader sculpture: "Ruins of Tombs of the Latin Kings on the Haram in Jerusalem," *Speculum,* XI (1936), 499-508. In 1939 T. S. R. Boase published "The Arts in the Latin Kingdom of Jerusalem," *Journal of the Warburg and Courtauld Institutes,* II (1938/39), 1-21, an important select survey with considerable importance given to crusader sculpture and painting.

19. T. S. R. Boase, *Castles and Churches of the Crusading Kingdom* (London, 1967), and *Kingdoms and Strongholds of the Crusaders* (London, 1971).

stitute the first general survey of crusader monuments throughout the Levant.

While Boase was working, however, two German-born scholars, Hugo Buchthal and Kurt Weitzmann, made the most dramatic discoveries for crusader art since World War II. In 1957 Buchthal published twenty-one illuminated manuscripts which he convincingly attributed to crusader ateliers in Jerusalem and Acre.[20] Shortly thereafter, Weitzmann identified a large number of icons now in the monastery of St. Catherine's, on Mt. Sinai, which, he persuasively argued, were also done in crusader Jerusalem and Acre.[21] These studies have opened up a facet of crusader art previously unknown to modern scholarship. Moreover, they have stimulated further study in painting and the rethinking of problems in other art forms, especially sculpture. Finally, they have continued to push the standards of reproduction of visual material for the growing corpus of crusader art steadily higher. In the meantime major French contributions to crusader architectural studies continued with the publication in 1969 of Antoine Bon's *La Morée franque*, incorporating research stretching back to the 1930's.[22]

One result of the new strides in the study of crusader art and architecture has been the increased attention and importance given such material in publications on the crusades by non-art historians. Steven Runciman included a chapter on "Architecture and the Arts in Outremer" in his third volume of *A History of the Crusades*,[23] and more recently Joshua Prawer devoted a long chapter to "The Arts" in his *The Latin Kingdom of Jerusalem*.[24] Moreover, both authors included a small selection of photographic reproductions. Things have come a long way since 1883.

Anyone seriously interested today in the art and architecture of the crusaders must rely heavily on the art-historical and archaeological studies noted above. In particular, the drawings and photographs published by de Vogüé, Rey, Viaud, Vincent, Abel, Enlart, Des-

20. Hugo Buchthal, *Miniature Painting in the Latin Kingdom of Jerusalem* (Oxford, 1957).

21. Weitzmann has published a series of articles on these icons pending final publication as part of the studies from the Michigan-Princeton-Alexandria expedition to St. Catherine's monastery. His two major articles are "Thirteenth Century Crusader Icons on Mount Sinai," *Art Bulletin*, XLV (1963), 179-203, and "Icon Painting in the Crusader Kingdom," *Dumbarton Oaks Papers*, XX (1966), 49-83. For his other articles see above, chapter III B, note 20.

22. Antoine Bon, *La Morée franque: Recherches historiques, topographiques et archéologiques sur la principauté d'Achaïe (1205-1430)* (Bibliothèque des Écoles françaises d'Athènes et de Rome, fasc. 213; 2 vols., Paris, 1969).

23. Steven Runciman, *A History of the Crusades,* III (Cambridge, 1954), 367-386.

24. Joshua Prawer, *The Latin Kingdom of Jerusalem* (London, 1972), pp. 416-468.

champs, Buchthal, Weitzmann, and Bon are indispensable.[25] It is in
the context of these publications that this volume with its album of
photographic reproductions takes form.

In preparing his survey T. S. R. Boase chose photographs to illus-
trate each major region as adequately as possible, that is, the main-
land crusader states (the Latin kingdom of Jerusalem, the county of
Tripoli, and the principality of Antioch), Lusignan Cyprus, the
Frankish Morea, and the Hospitaller strongholds of the Aegean. Out-
side the kingdom of Jerusalem, however, his selection inevitably con-
centrated on military and ecclesiastical architecture, reflecting the
major emphasis of the study of crusader art from the mid-nineteenth
to the mid-twentieth century. Wherever possible, he included some
architectural sculpture in the manner of Enlart, as well as some
manuscript illumination from Buchthal's material.

The photographs added by the present author were chosen from a
completely different point of view, with the intention of emphasizing
the salient achievements of crusader painting, both monumental and
small-scale, and of crusader sculpture, both figural and ornamental.
Primary considerations in the choice of examples were the impor-
tance of the works in terms of quality, and the desire to represent as
full a range as possible of crusader style and iconography. This proce-
dure, not unexpectedly, yielded material drawn — with one major
exception — solely from the Latin kingdom of Jerusalem. This results
partly from the obvious preëminent importance of the Latin king-
dom in the crusader Levant and partly from the fact that little is
known at present of painting and sculpture in Antioch, Latin Con-
stantinople, Frankish Greece, or the Aegean area (not to mention
Edessa) beyond the carvings Boase had already included.

The emphasis, in the resulting album, on art (though not on archi-
tecture) from the Latin kingdom does not misrepresent the situation
as we now know it in terms of crusader artistic endeavors. Almost all
the significant extant painting and sculpture of high quality in the
twelfth and thirteenth centuries comes from the Latin kingdom of
Jerusalem, which was, after all, the heart of crusader holdings and
aspirations. On the other hand, major architecture is substantially
represented in all the regions, and the plates reflect this; if there is

25. Other useful photographs are published by W. Müller-Wiener, *Castles of the Crusaders,*
tr. J. M. Brownjohn (London, 1966). For crusader sculpture the most recent collection is by
M. Barasch, *Crusader Figural Sculpture in the Holy Land* (New Brunswick, N.J., 1971), in-
cluding a large number of photographs of the Nazareth capitals. But the best reproductions
of the Nazareth capitals remain in P. Egidi, "I Capitelli romanici di Nazaret," *Dedalo,* anno
I (1920), 761-766.

less architecture than in preceding surveys, this is because publications before 1950 placed their heaviest emphasis there, so that repetition here is unnecessary. This is not to deny that much work remains to be done on crusader architecture, such as surveys of Jerusalem and Acre and excavations in these cities and Caesarea Maritima as well as other castles. Nonetheless, it is time that the other arts begin to receive more adequate study.[26]

One should bear in mind that this album, though attempting a representative survey, is still only a selection and not an exhaustive corpus. Indeed, some well-known, often-published crusader works like the Melisend Psalter ivory plaques are omitted in favor of less familiar material such as the Mt. Tabor edicule fragment (pl. XXIIIa). Although few of the monuments included in this collection are previously unpublished, the reader should find a welcome number of new photographs, including many of works on which much further study remains to be done.

26. The *Encyclopedia of World Art* (15 vols., New York, Toronto, London, 1959-1968) refers only very briefly to architecture in Lebanon and Syria and to armor as far as crusader art is concerned. C. R. Dodwell, *Painting in Europe: 800-1200*, in The Pelican History of Art (Harmondsworth, 1971), refers briefly to painting in "The Crusading Kingdoms," pp. 155-158, and figs. 172-174. Though only a short section, dealing mainly with Byzantine influence and limited to mosaics and manuscript illumination, with no mention of fresco painting, it is nonetheless the first notice taken of crusader painting in recent surveys of medieval art. The general survey *Art of the Medieval World* by George Zanecki, which has just appeared (New York, 1975), gives commendable coverage to crusader architecture, painting, and sculpture of the twelfth century in a section entitled "Romanesque art of the crusading kingdom" (pp. 328-333).

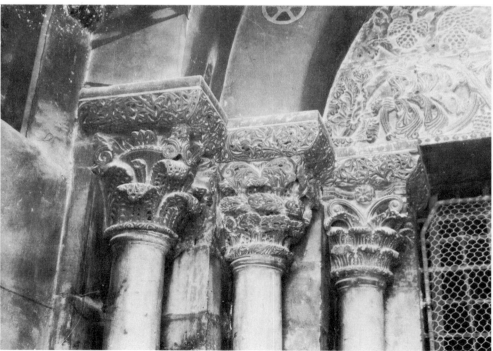

I. Church of the Holy Sepulcher, Jerusalem, south façade: *a.* upper cornice *b.* capitals on the west side of the entrance to the chapel of Calvary

289

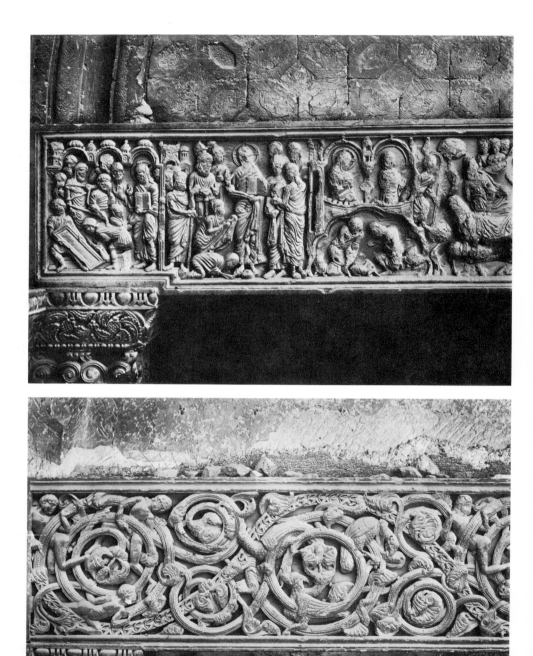

II. Church of the Holy Sepulcher, Jerusalem, south façade: *a.* figural lintel from over the west door, left side (max. ht. 68.0 cm., *in situ* before 1929) *b.* vine scroll lintel from over the east door, left side (max. ht. 63.8 cm., *in situ* before 1929). Rockefeller Museum, Jerusalem

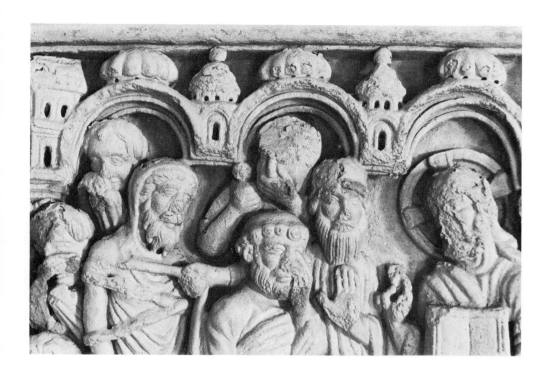

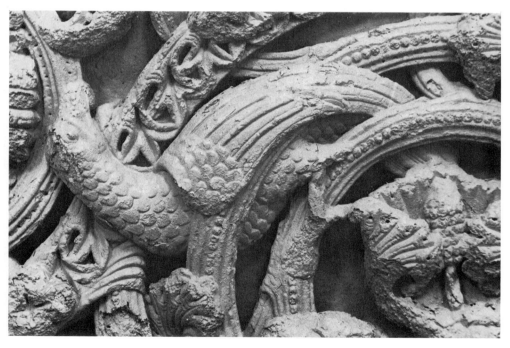

III. Church of the Holy Sepulcher, Jerusalem, details of lintels: *a.* the raising of Lazarus,
detail of the figural lintel *b.* bird, detail of the vine scroll lintel. Rockefeller Museum,
Jerusalem

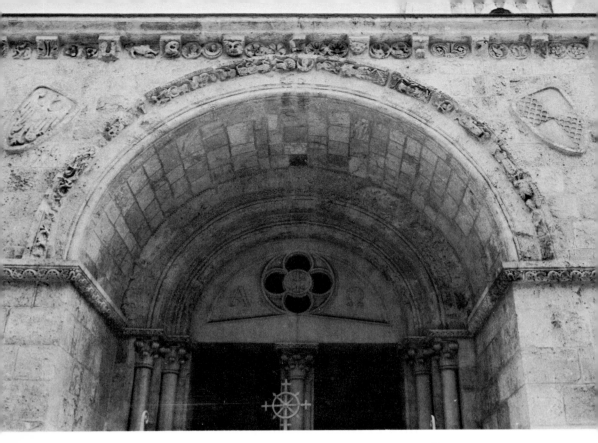

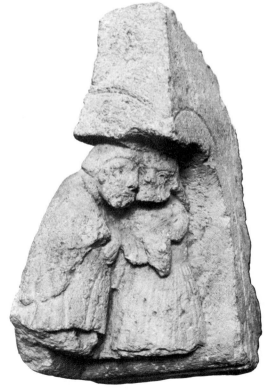

IV. *a.* Church of St. Mary
Latin, Jerusalem, north entrance
arch with signs of the zodiac
b. corner console, two men.
Museum of the convent of
the Flagellation, Jerusalem

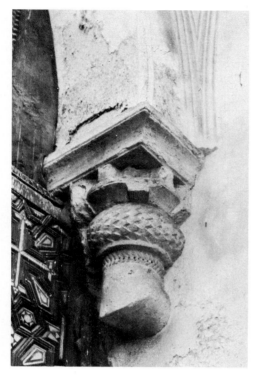
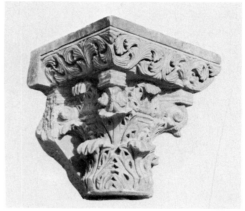
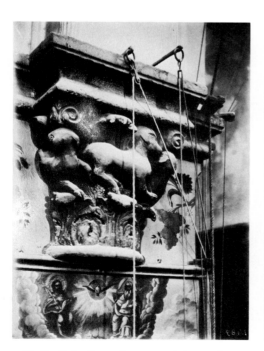
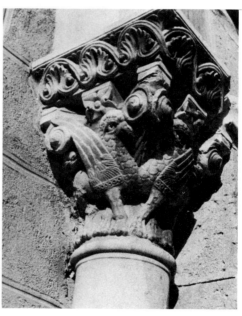

V. Capitals, Jerusalem: *a.* cloister of the church of the Holy Sepulcher *b.* tomb of the
Virgin *c.* church of St. James *d.* edicule of the Ascension

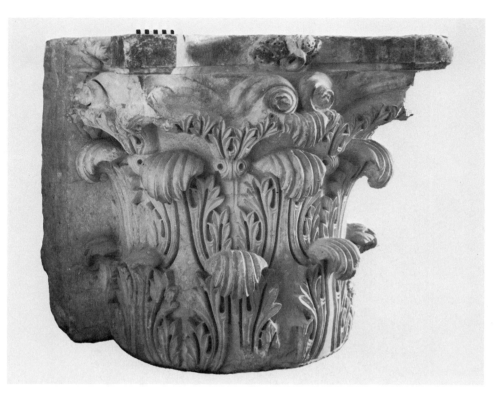

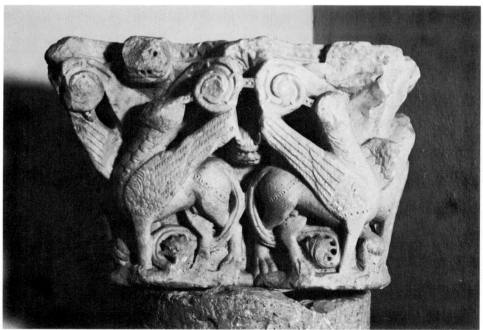

VI. Capitals, Jerusalem: *a.* church of St. Mary the Great. Convent of St. Abraham, Jerusalem *b.* church of St. Peter Gallicante (31.1 cm. high). Convent of St. Peter in Gallicantu, Jerusalem

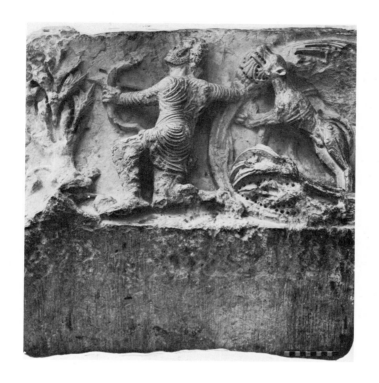

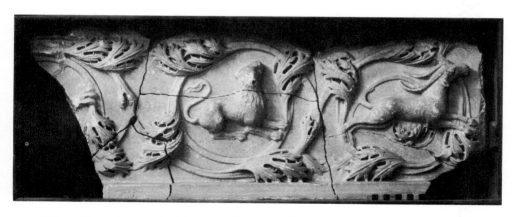

VII. *a*. Voussoir carved with archer. Museum of the Greek Orthodox Patriarchate, Jerusalem *b*. carved slab with acanthus and animals. Museum of the convent of the Flagellation, Jerusalem

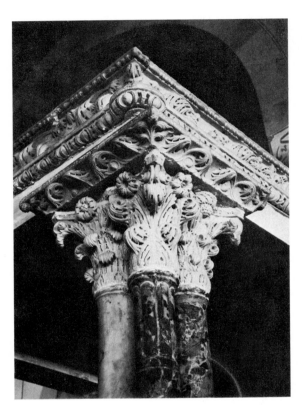

VIII. Aqsâ mosque, Jerusalem:
a. corner capitals of the
dikkah (podium) *b*. carved
slab with acanthus and
interlaced columns

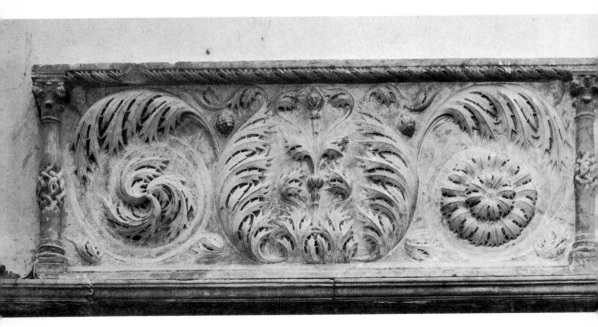

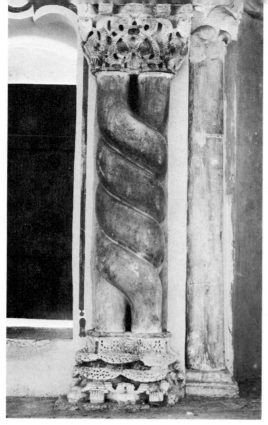

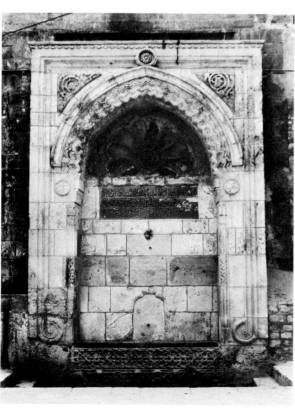

IX. *a.* Aqṣâ mosque, Jerusalem,
twisted columns with
double capitals *b. sabīl*
(drinking fountain) of sultan
Suleiman, with rose window,
Bāb as-Silsilah, Jerusalem

297

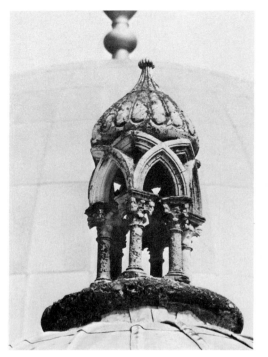

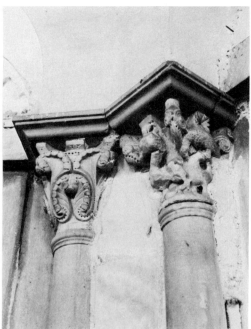

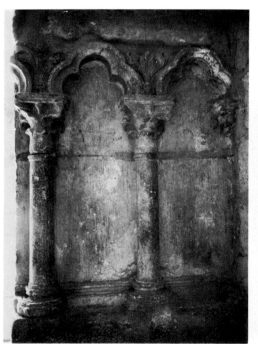

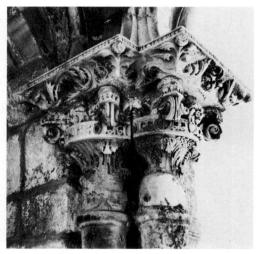

X. *a.* and *b.* Qubbat al-Mi'rāj, Jerusalem, lantern and interior capitals *c.* arcading in the Bāb Ḥiṭṭah, Jerusalem, detail *d. minbar* (pulpit) of Burhān-ad-Dīn, Jerusalem, southwest corner capitals

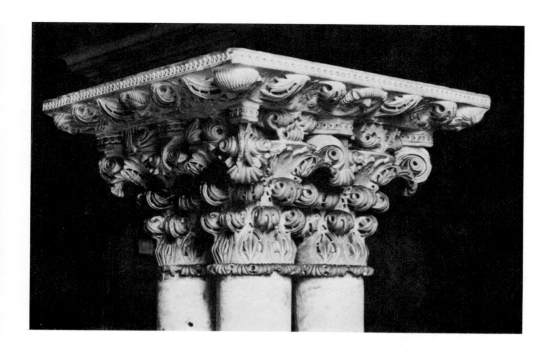

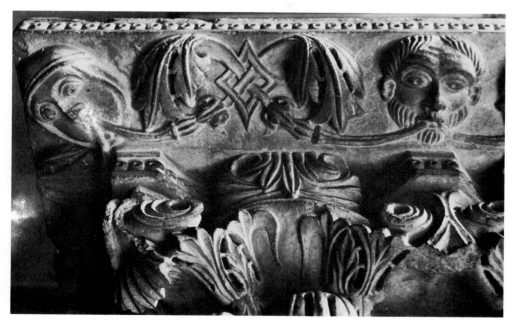

XI. *a.* Triple capitals from Latrun *b.* detail: heads and acanthus. National Archeological
Museum, Istanbul

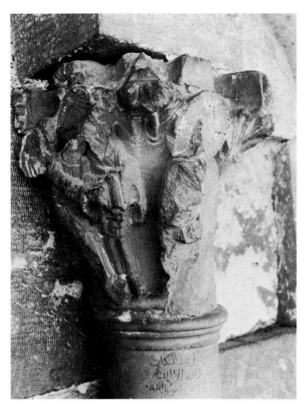

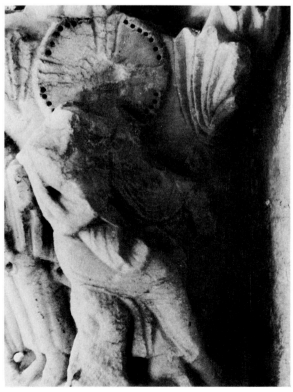

XII. Al-Ghawānimah minaret, Jerusalem: *a.* Christ ministered to by angels, capital on the east face (32.0 cm. high) *b.* Christ, detail of a capital on the west face (31.5 cm. high)

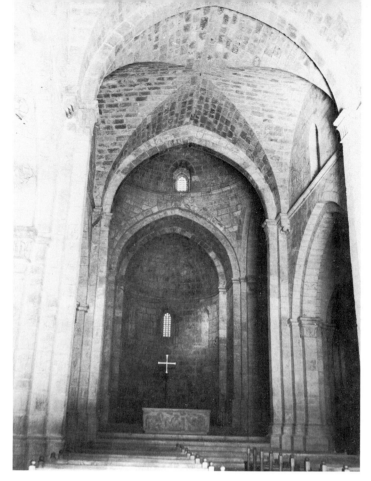

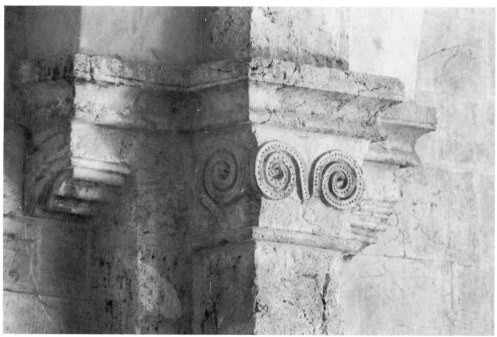

XIII. Church of St. Anne, Jerusalem: *a.* main nave *b.* capital in the south aisle

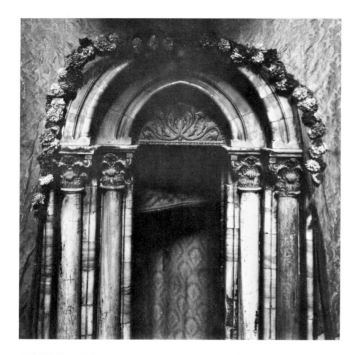

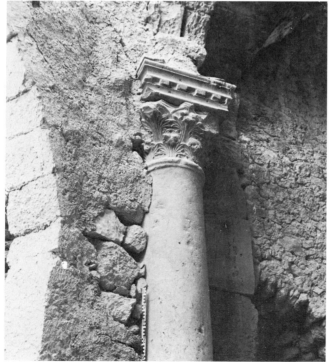

XIV. *a.* Church of the
Nativity, Bethlehem, south
entrance to the grotto
b. fortress chapel, Beth
Gibelin, capital *in situ* at the
apse entrance

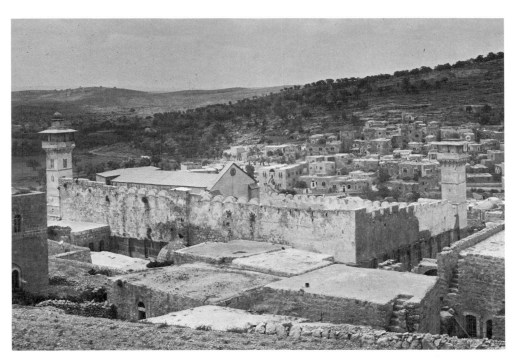

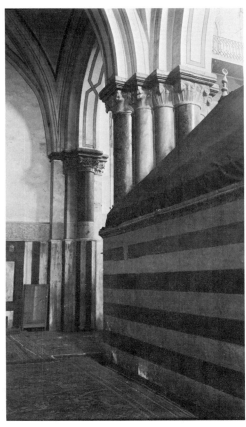

XV. *a*. Church of St. Abraham, Ḥaram
al-Khalīl, Hebron, now the Masjid Ibrāhīm
b. church of St. Abraham, Hebron, capitals
in the main nave

303

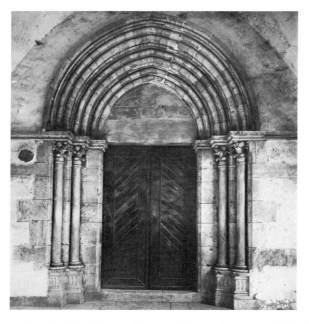

XVI. *a.* Cathedral of St. John the Baptist, Gaza, now al-Jāmiʿ al-Kabīr (the great mosque): main door
b. cathedral of St. John the Baptist, Ramla, now al-Jāmiʿ al-Kabīr: main nave looking east

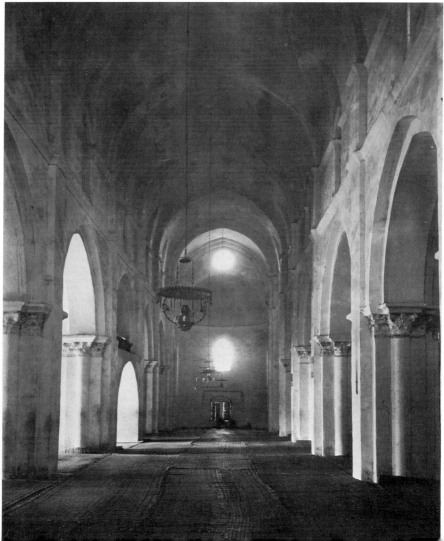

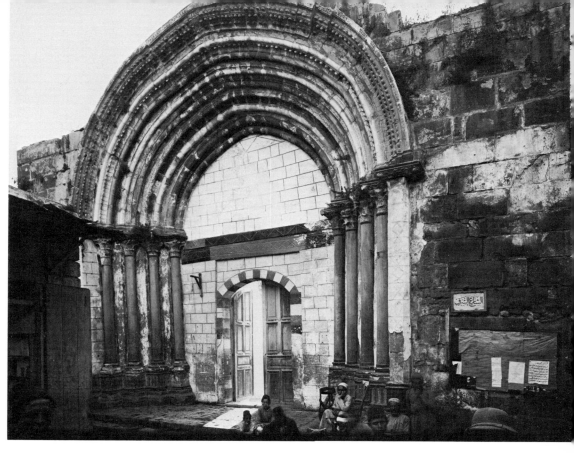

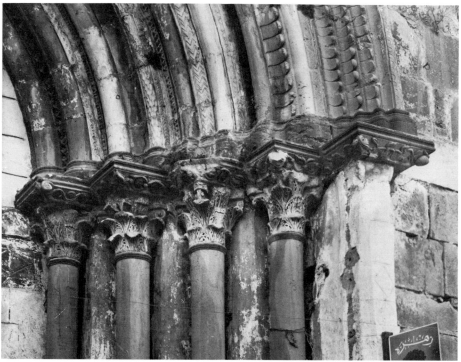

XVII. Church of the Resurrection, Nablus, now al-Jāmiʻ al-Kabīr: *a.* main door
before the earthquake of 1927 *b.* detail, capitals on the right side of the main door

305

XVIII. Cathedral of St. John the Baptist, Sebastia: *a.* nave capitals *in situ* *b.* Herod's feast, capital from the west door (49.0 cm. high) *c.* the dance of Salome, capital from the west door (49.0 cm. high). *b* and *c*, National Archeological Museum, Istanbul

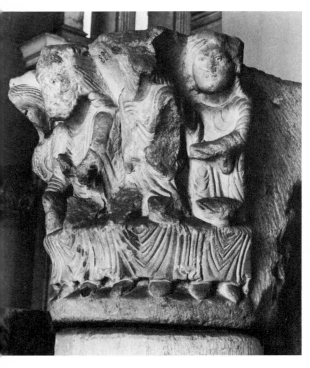

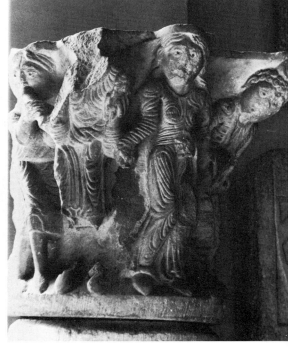

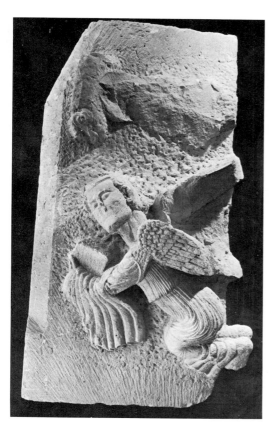

XIX. Castle of Belvoir:
a. angel from the castle chapel
(slab 115.0 cm. high x 58.0
cm. wide). Rockefeller
Museum, Jerusalem
b. smiling boy. Israel Museum,
Jerusalem

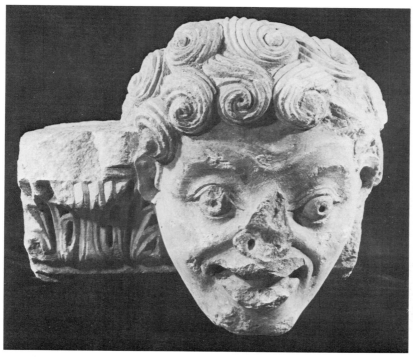

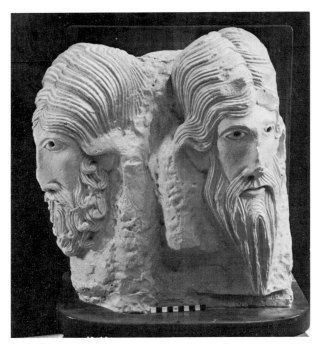

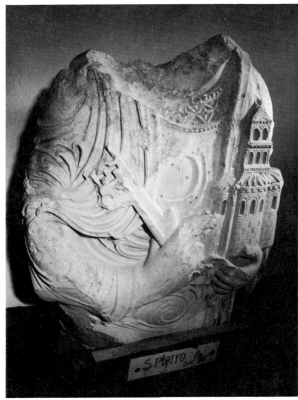

XX. Cathedral of the
Annunciation, Nazareth:
a. paired bearded heads. Greek
Orthodox Patriarchate, Jeru-
salem *b.* St. Peter (72.2 cm.
high x 50.0 cm. max. width).
Museum of the convent of
the Annunciation, Nazareth

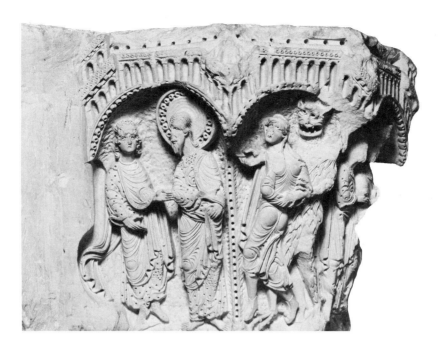

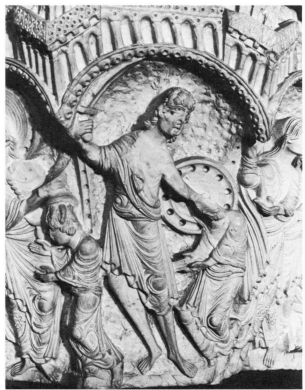

XXI. Cathedral of the
Annunciation, Nazareth:
a. capital with scenes of St.
Bartholomew or St. James
(42.9 cm. high) *b.* capital,
detail, the execution of
St. James

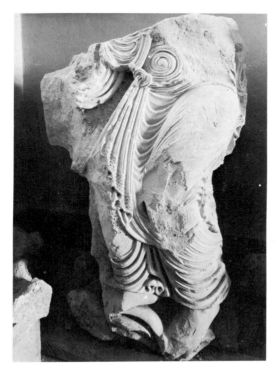

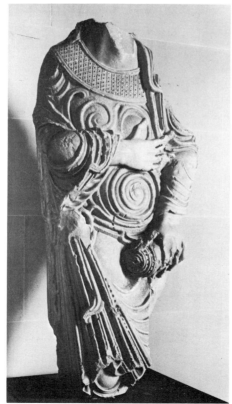

XXII. *a.* Fragment of torso and legs (max. ht. 81.0 cm.), from the cathedral of the Annunciation, Nazareth. Museum of the convent of the Annunciation, Nazareth *b.* torso at Chatsworth, collection of the Duke of Devonshire

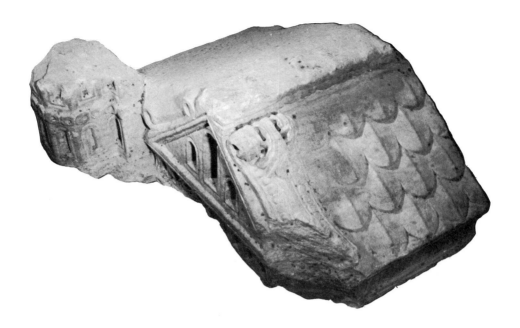

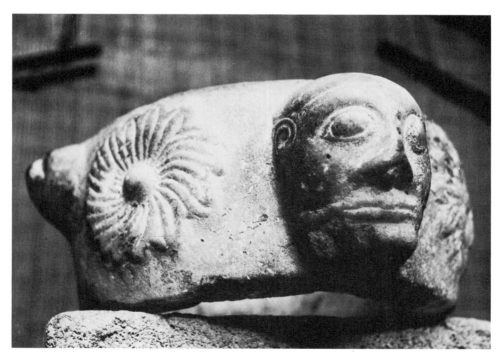

XXIII. *a.* Abbey church of the Holy Savior, Mt. Tabor, fragment of edicule (roof: 44.0 cm. wide x 25.0 cm. deep x 20.2 cm. high, excluding tower). Museum of the convent of the Annunciation, Nazareth *b.* holy-water basin (rosette diameter 10.0 cm.), from Acre. Municipal Museum, 'Akko

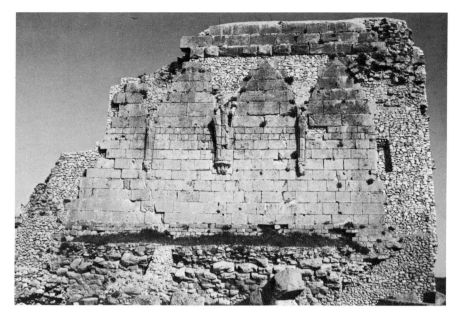

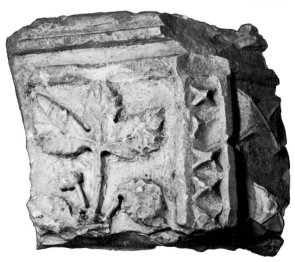

XXIV. *a*, *b*, *c*, and *d*. Château Pèlerin, great north tower: *a.* tower looking east *b.* left corbel, beardless head *c.* center corbel, three heads, damaged *d.* right corbel, bearded head *e.* carved architectural fragment from the monastery of St. Brochardus, Wādī as-Sīyāh. Carmelite Museum, Stella Maris convent, Mt. Carmel

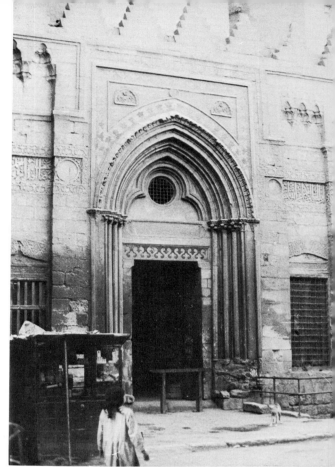

XXV. West door from the church of
St. Andrew, Acre, now the main door
to the madrasah-mausoleum of sultan
al-Malik an-Nāṣir Muḥammad
(d. 1341), Cairo: *a.* the door *b.* detail,
capitals on the left side

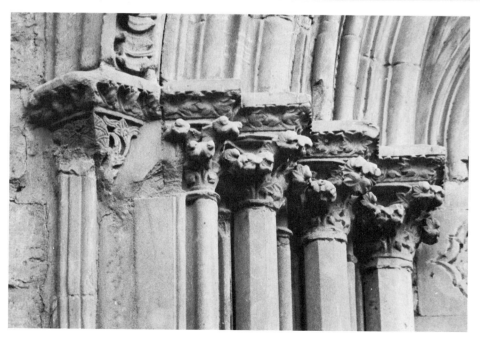

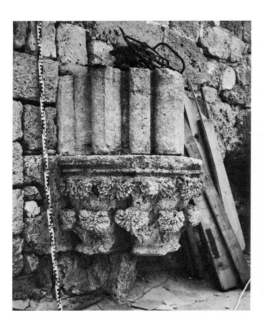

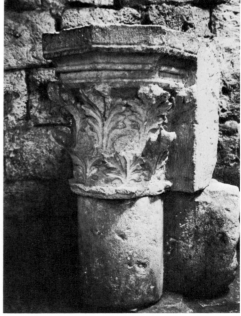

XXVI. *a.* Corbelled capitals and shafts *in situ* (see arrows), east wall of the west hall of the Hospitaller *grand manoir,* Acre, now the outer west wall of the Government Mental Hospital, 'Akko *b.* central corbelled capitals and shafts, east wall of the west hall *c.* floral capital (36.5 cm. high, excluding column shaft) from the Hospitaller church of St. John, Acre. Municipal Museum, 'Akko

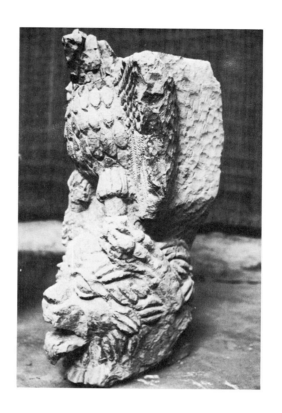

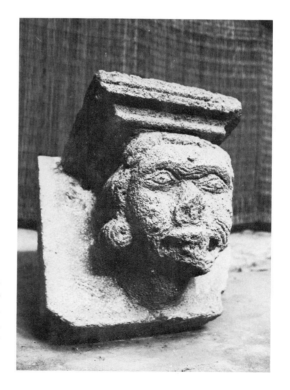

XXVII. Sculptures from
Acre: *a*. architectural sculp-
ture with lion and eagle (max.
ht. 51.5 cm.) *b*. corbel with
beardless head (rear slab 36.0
cm. high x 40.5 cm. wide).
Municipal Museum, 'Akko

315

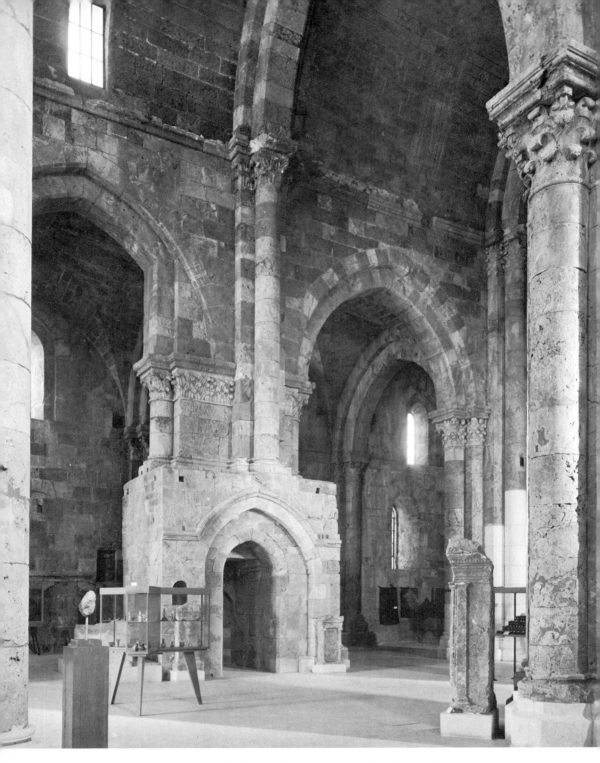

XXVIII. Cathedral of Notre Dame, Tortosa, main nave

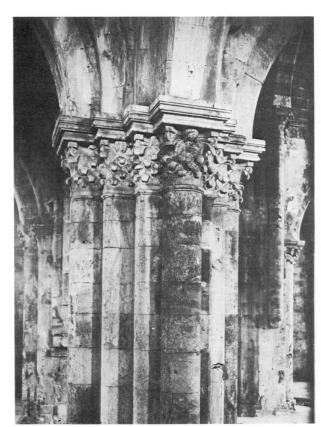

XXIX. *a*. Cathedral of Notre
Dame, Tortosa, detail of
capitals *b*. cathedral of St. John
the Baptist, Beirut, now al-Jāmi'
al-Kabīr (the great mosque):
eastern apses

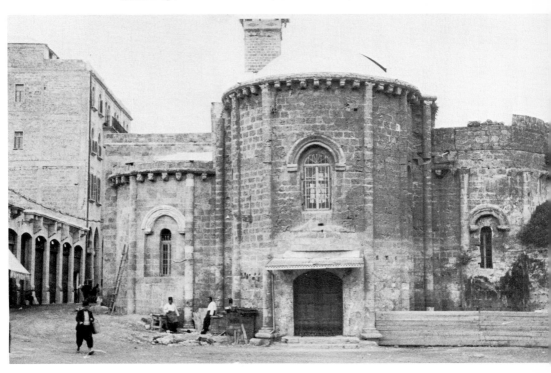

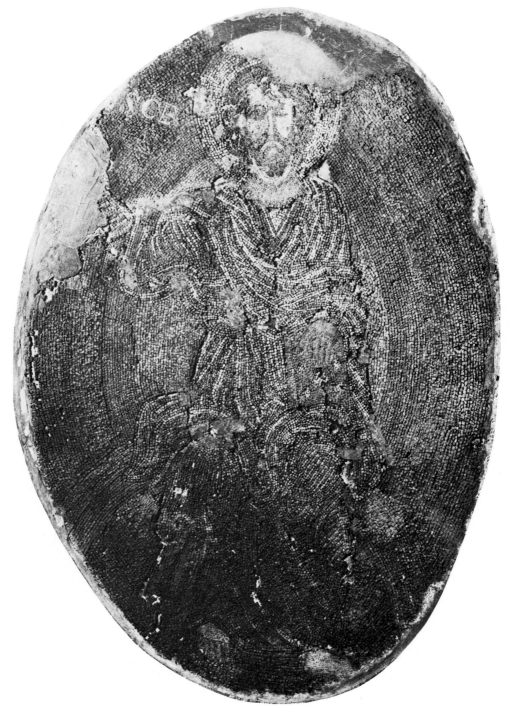

XXX. Church of the Holy Sepulcher, Jerusalem, Calvary chapel: Christ of the Ascension mosaic

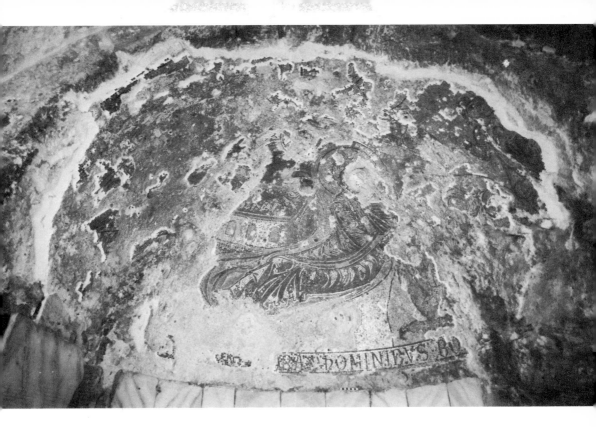

XXXI. Church of the Nativity, Bethlehem: *a.* grotto mosaic, the Nativity of Christ *b.* main nave

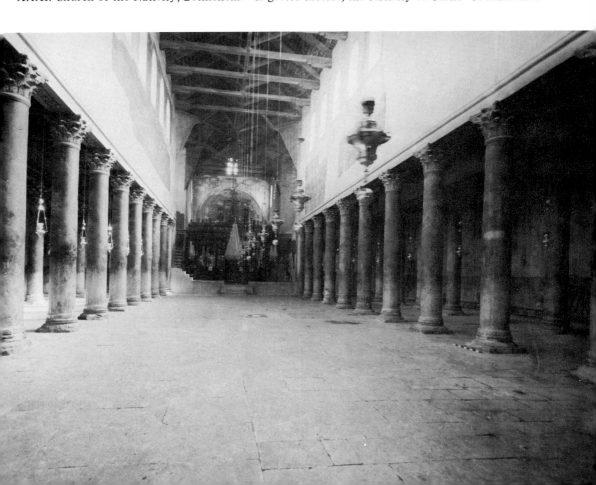

XXXII. Church of the Nativity, Bethlehem, nave column paintings: *a.* St. George, fourth column north side *b.* St. John the Evangelist tenth column north side *c.* Elijah, eighth column south side *d.* St. Fusca, tenth column south side

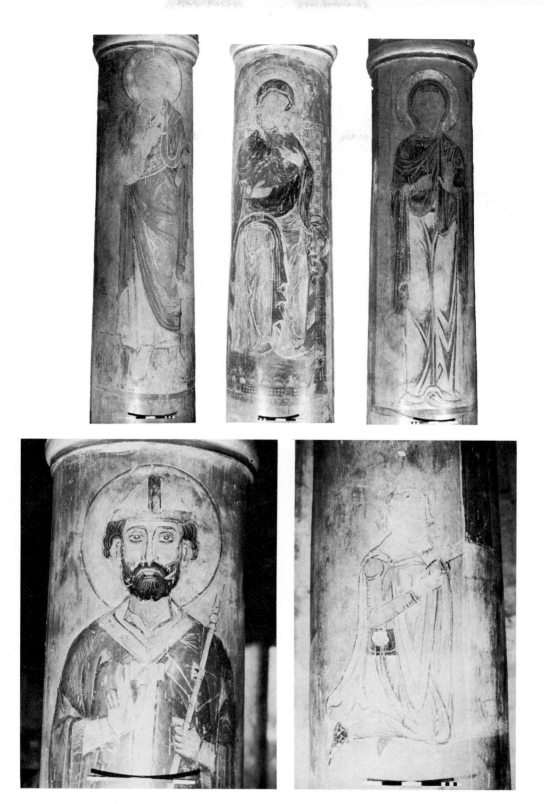

XXXIII. Church of the Nativity, Bethlehem, south aisle column paintings: *a*. St. Bartholomew, second column *b*. Virgin and Child, fifth column west side *c*. St. Margaret, seventh column *d*. detail of St. Leo, sixth column west side *e*. detail of pilgrim at the feet of St. James, first column

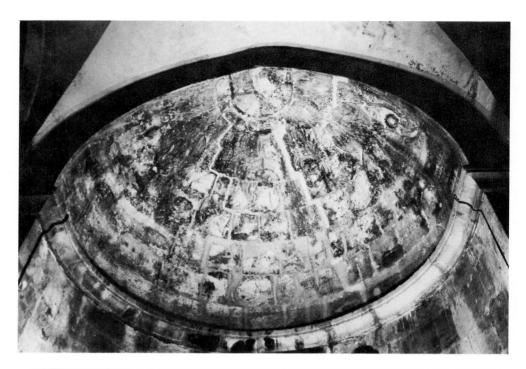

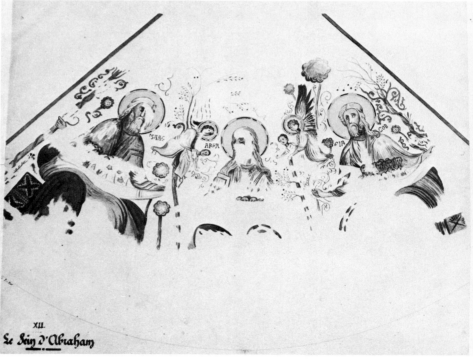

XXXIV. Church of St. Jeremiah (?), Abū-Ghosh: *a.* south apse, remains of fresco of the three patriarchs, Abraham, Isaac, and Jacob, with the souls of the blessed *b.* watercolor of the south apse fresco, by M. le comte de Piellat, 1907

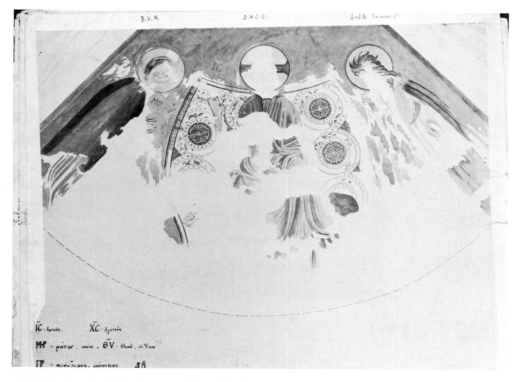

XXXV. Church of St. Jeremiah (?), Abū-Ghosh: *a.* south apse, detail, souls in the bosom of Jacob *b.* watercolor of the Deësis, the north apse fresco, by M. le comte de Piellat, 1907

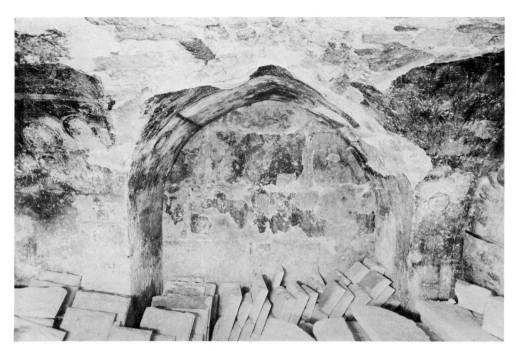

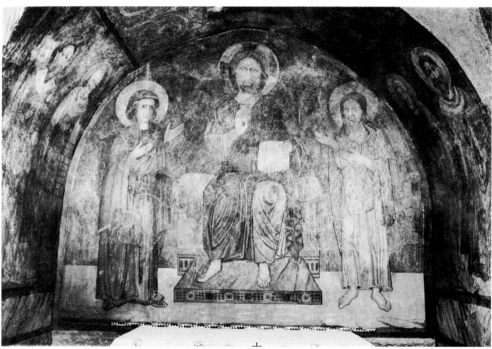

XXXVI. Church of the Nativity, Bethlehem, northern narthex chapel: *a.* the Deësis before
restoration work *b.* the Deësis after restoration by C. Vagarini, 1950

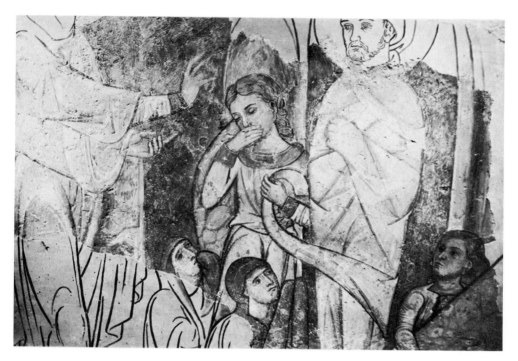

XXXVII. Pilgrims' chapel, Bethphage, stele with frescoes restored by C. Vagarini, 1960:
a. south side, the raising of Lazarus *b*. detail, Mary and Martha *c*. detail, boy to the left
of Lazarus

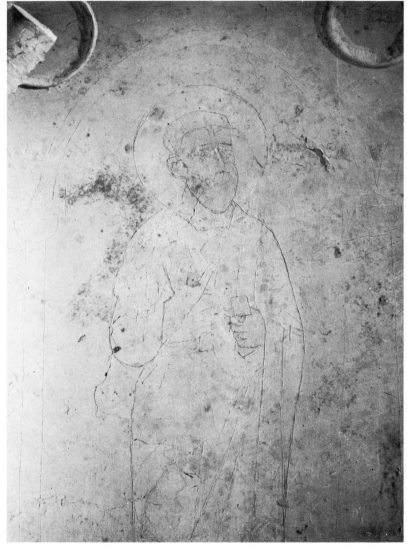

XXXVIII. Church of St. Stephen, Jerusalem: *a.* painted and incised altar
with Christ and the Twelve Apostles, now in the École biblique et archéologique
b. detail of apostle number five

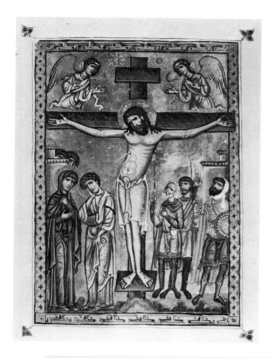

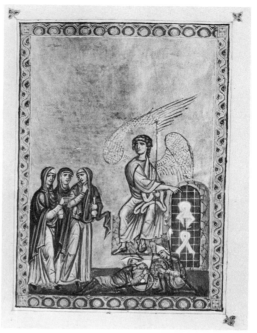

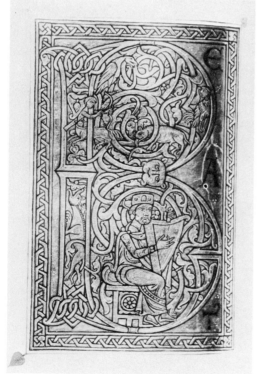

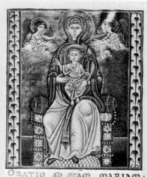

ORATIO AD SCAM MARIAM·
SCA MARIA succurre misens·
iuua pusillanimes· refoue fle
biles· ora pro pplo· intercede
pro clero· intercede pro deuoto fem-
neo sexu· sentiant oms tui leuamen
quicuq· celebrant tuum nom· Sa
MARIA uirgo regis semp munch ma
ter castissima· ora ꝛ intercede ꝓ cunctis
fidentibz tuis patrociniis· ut nob dns

XXXIX. Psalter of queen Melisend, London, British Library, MS. Egerton 1139: *a.* the Crucifixion (14.0 x 10.0 cm.), folio 8r *b.* the three Marys at the sepulcher (14.0 x 10.0 cm.), folio 10r *c.* illuminated initial "B" for the start of the Psalter "Beatus vir . . ." (13.5 x 8.5 cm.), folio 23v *d.* Virgin and Child enthroned (8.0 x 6.8 cm.), folio 202v

327

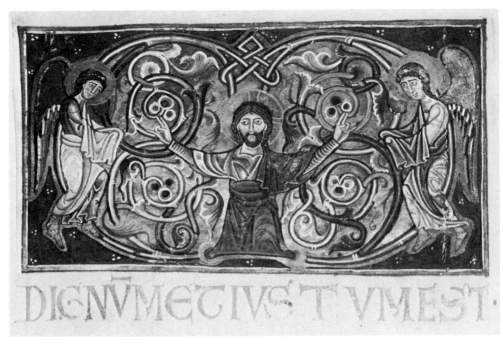

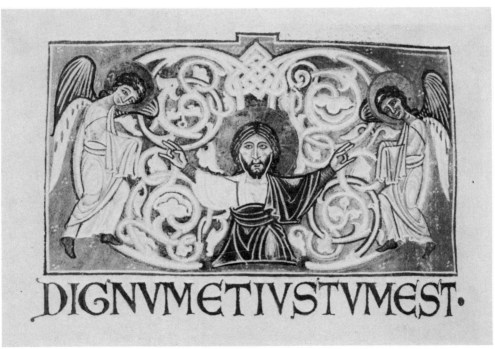

XL. *a.* Sacramentary, Cambridge, Fitzwilliam Museum, MS. McClean 49, folio 4v, illumi-
nated initial "V" for the start of "Vere dignum . . ." (6.0 x 10.8 cm.) *b.* Missal, Paris,
Bibliothèque nationale, MS. latin 12056, folio 168v, illuminated initial "V" for the start of
"Vere dignum . . ." (6.3 x 10.9 cm.)

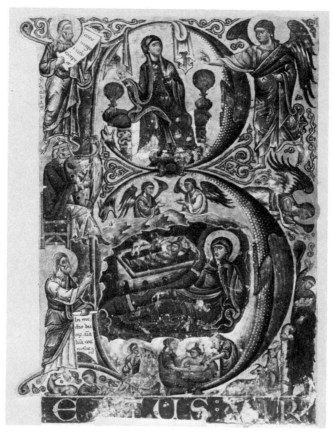

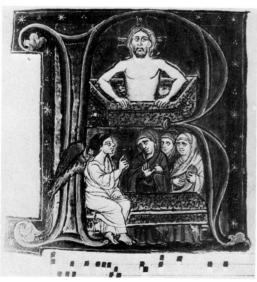

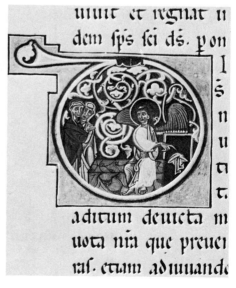

XLI. *a.* Psalter, Florence, Biblioteca Riccardiana, MS. 323, folio 14v, historiated initial "B" with Annunciation and Nativity for the start of Psalter "Beatus vir . . ." (15.9 x 10.4 cm.)
b. Missal, Perugia, Biblioteca Capitolare, MS. 6, folio 187r, historiated initial "R" with the Resurrection of Christ and the three Marys at the sepulcher, for the start of "Resurrexi . . ." (6.9 x 5.7 cm.) *c.* Missal, Paris, Bibliothèque nationale, MS. latin 12056, folio 121v, historiated initial "D" with the two Marys at the sepulcher, for the start of "Deus qui hodierna die . . ." (7.2 x 7.4 cm.)

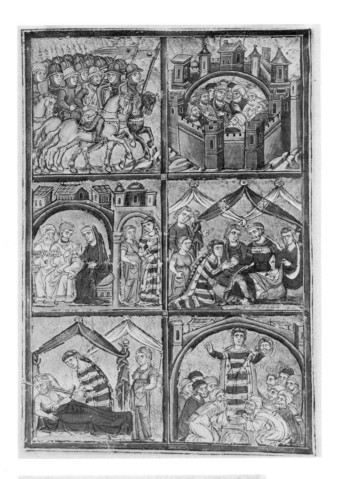

XLII. Bible selections, Paris, Bibliothèque de l'Arsenal, MS. 5211: *a.* frontispiece to Judith (22.2 x 14.3 cm.), folio 252r *b.* frontispiece to Job (15.2 x 13.8 cm.), folio 269r

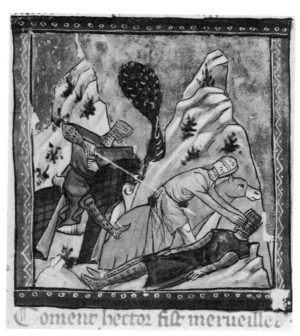

XLIII. *Histoire universelle:*
a. Achilles kills Hector (7.9 x
7.8 cm.), Brussels, Bibliothèque
royale, MS. 10175, folio 130r,
miniature panel *b.* Achilles kills
Hector (12.0 x 16.2 cm.),
London, British Library, MS.
Add. 15268, folio 114v,
miniature panel

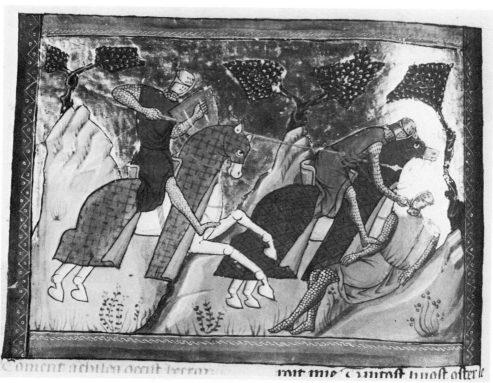

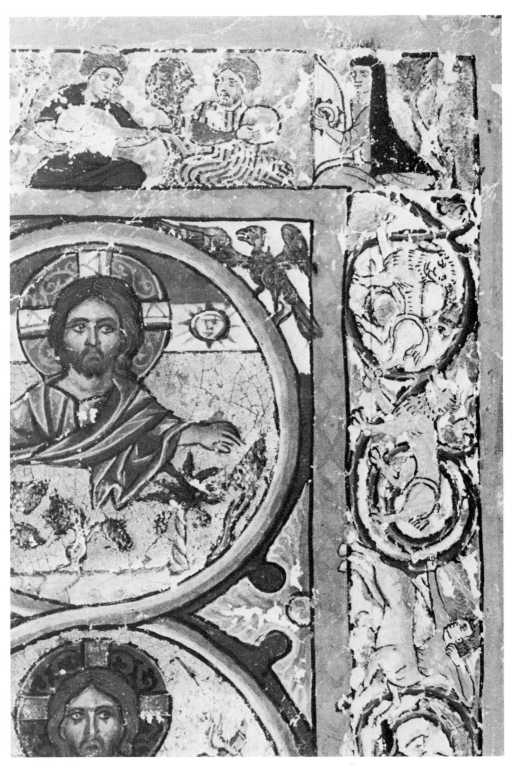

XLIV. *Histoire universelle:* detail of the Creation miniature, with scenes in the border,
London, British Library, MS. Add. 15268, folio lv

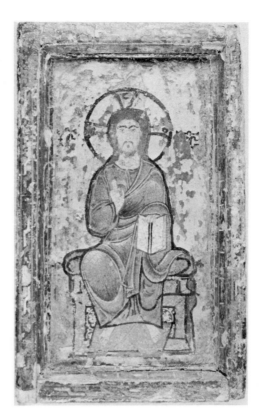

XLV. Icons, monastery of St.
Catherine, Mt. Sinai: a. Christ
enthroned (28.6 x 16.4 cm.)
b. the Deësis and fourteen apostles
(66.0 x 45.6 cm.)

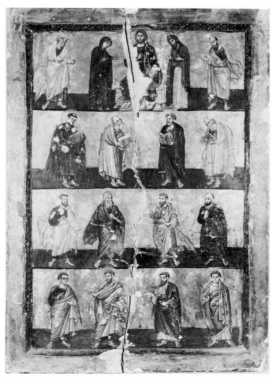

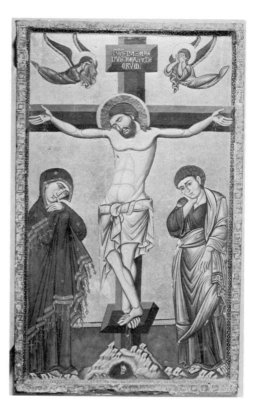

XLVI. Icon (120.5 x 67.0 cm.),
monastery of St. Catherine, Mt.
Sinai: *a.* front, the Crucifixion
 b. back, the Anastasis

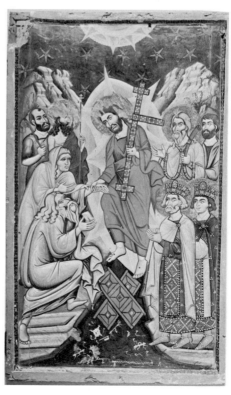

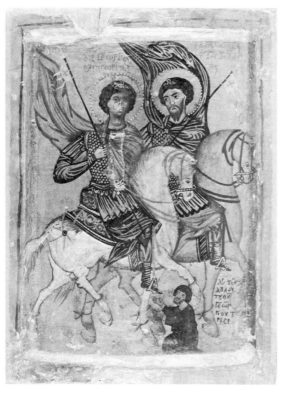

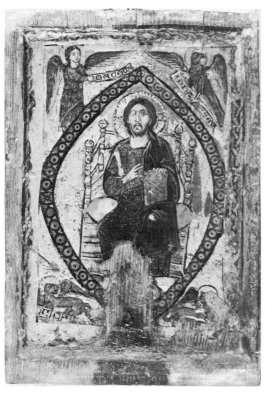

XLVII. Icons, monastery of St. Catherine, Mt. Sinai: *a.* Saints Theodore and George with a pilgrim from Paris (32.5 x 22.2 cm.) *b. Maiestas Domini* (21.1 x 13.8 cm.)

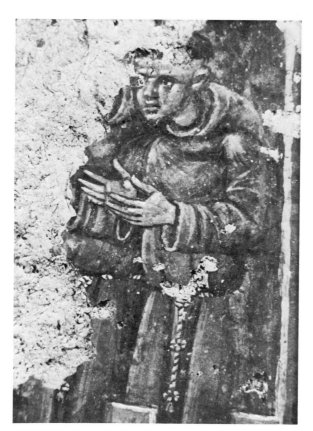

XLVIII. Details of frescoes of
the life of St. Francis, chapel of
St. Francis, Kalenderhane Camii,
Istanbul: *a.* friar in the upper
left scene *b.* fragment of a
figure in a yellow garment with
green stripes

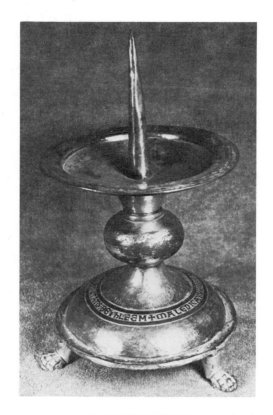

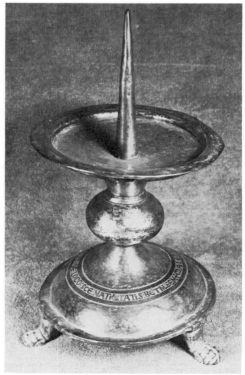

XLIX. *a* and *b*. Pair of inscribed
candlesticks from the church of
the Nativity, Bethlehem.
Museum of the convent of the
Flagellation, Jerusalem

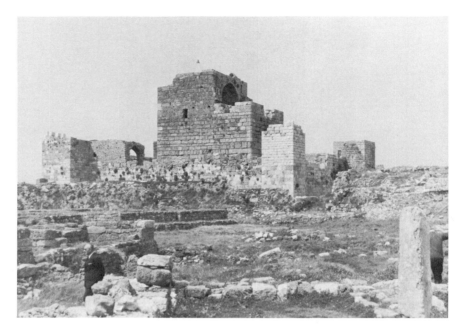

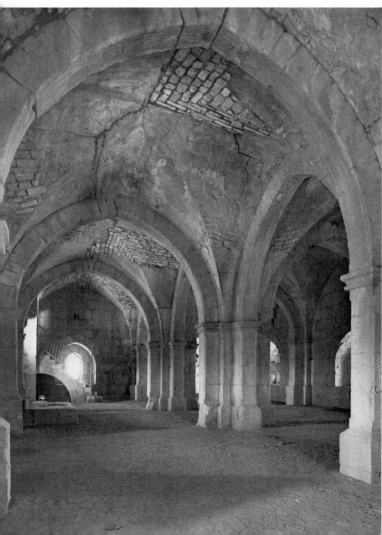

L. *a.* Castle of Gibelet
(Jubail) seen from the south
b. castle of Chastel-Blanc
(Burj Ṣāfīthā), the upper
chamber

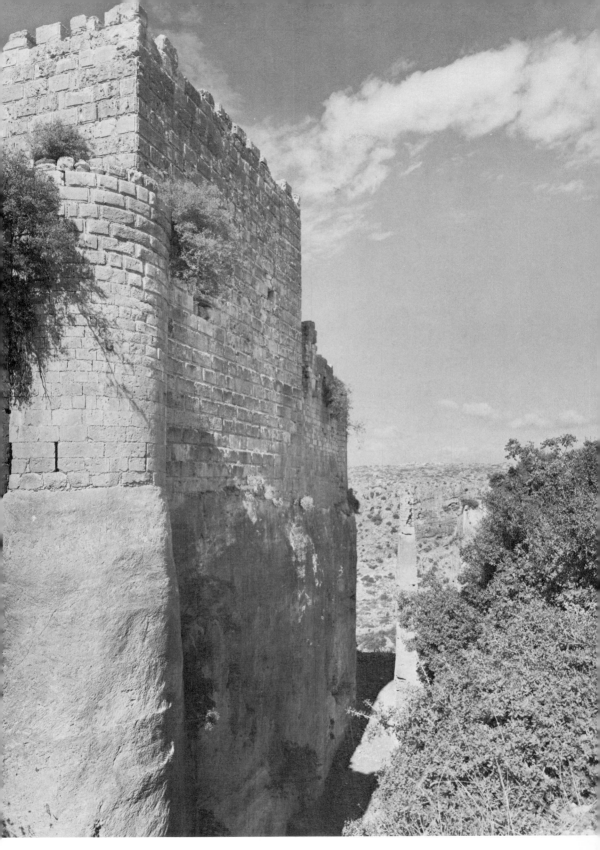

LI. Castle of Saone (Ṣahyūn): the keep, ditch, and rock pillar

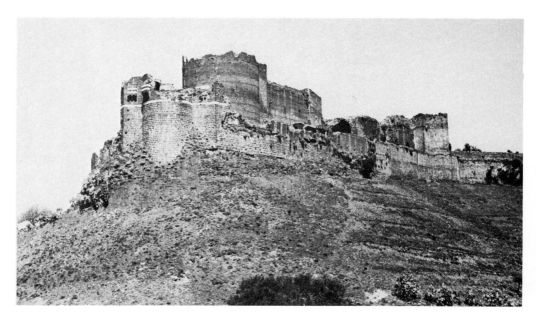

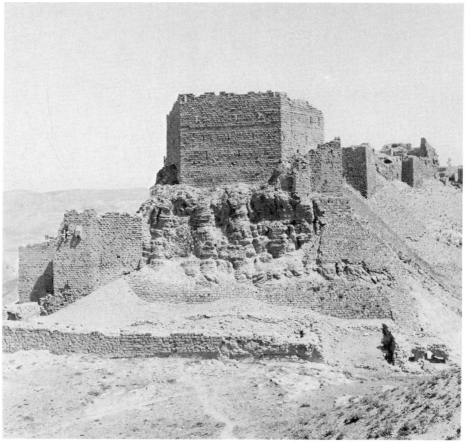

LII. *a.* Castle of Margat (al-Marqab) seen from the south *b.* tower of the castle of
Kerak seen from the south

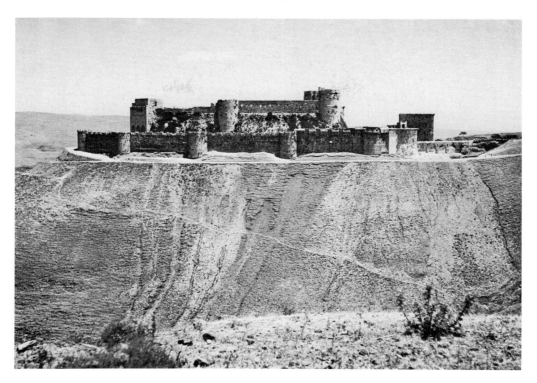

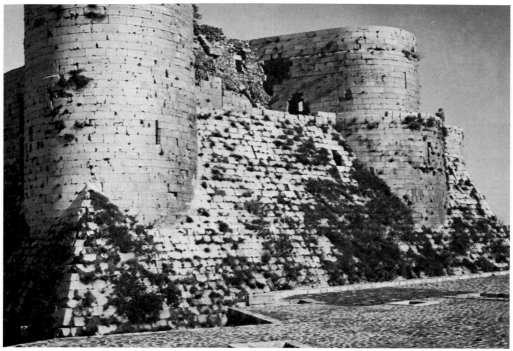

LIII. Krak des Chevaliers: *a.* view from the west *b.* the southern talus

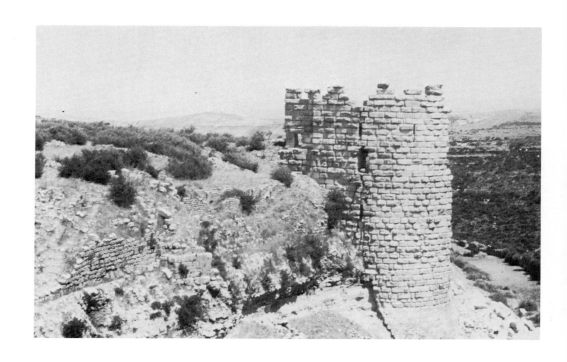

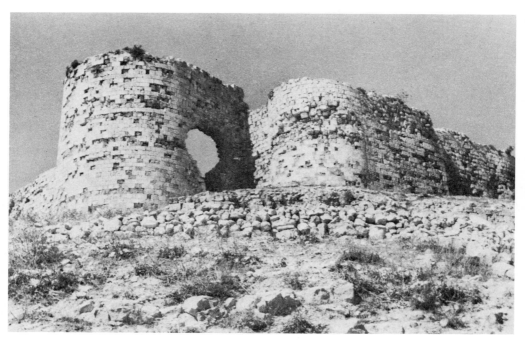

LIV. *a.* Castle of Cursat (Quṣair) *b.* castle of Seleucia (Silifke)

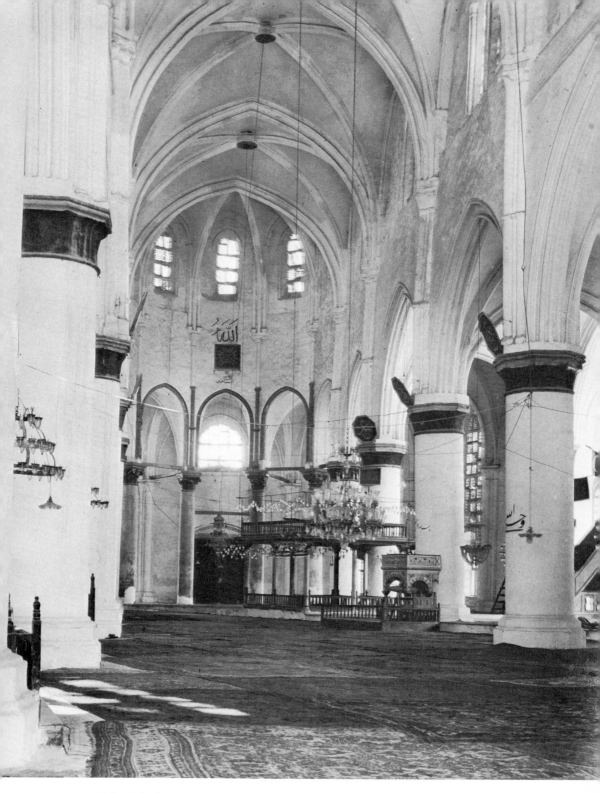

LV. Cathedral of Hagia Sophia, Nicosia, now the Selimiye Camii: main nave

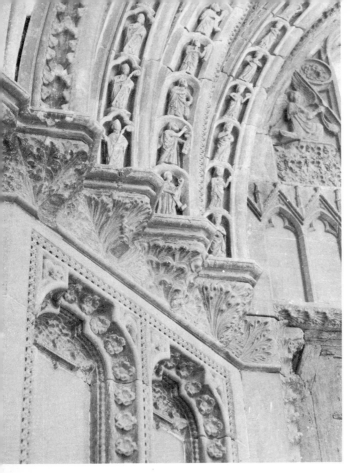

LVI. *a.* Cathedral of Hagia Sophia, Nicosia (the Selimiye Camii): voussoirs of the west portal *b.* church of St. Peter and St. Paul, Famagusta, capitals of the north portal

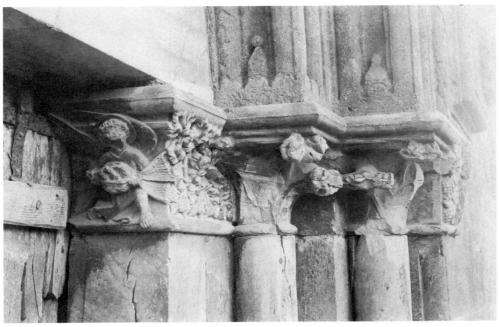

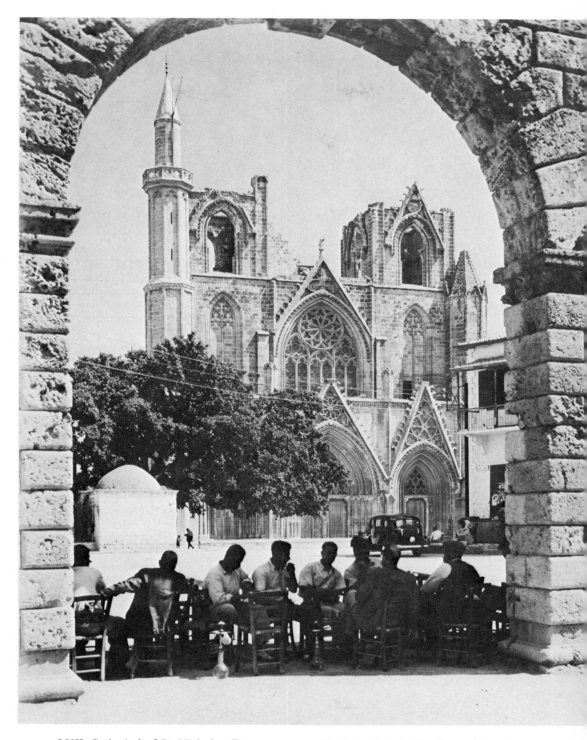

LVII. Cathedral of St. Nicholas, Famagusta, now the Lala Mustafa Camii: west façade

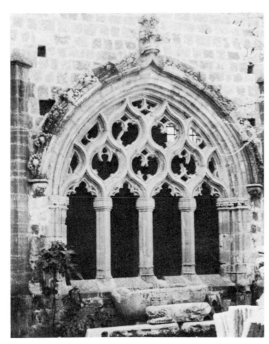

LVIII. *a*. Window from the Lusignan palace, Nicosia, now in the Lapidary Museum *b*. Famagusta: cathedral of St. George of the Greeks, left, and cathedral of St. Nicholas, now the Lala Mustafa Camii, right

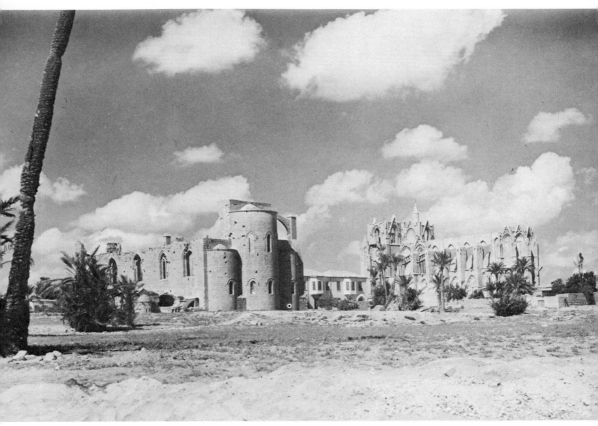

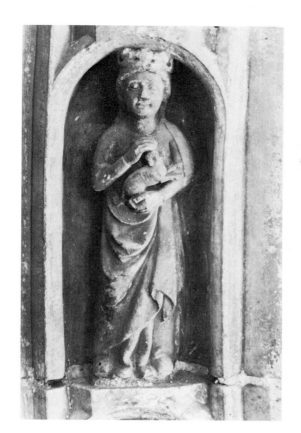
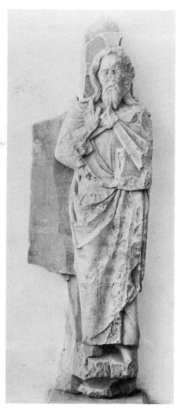

LIX. *a.* Cathedral of Hagia Sophia, Nicosia: voussoir figure of a queen from the west portal
b. Pancyprian Gymnasium, Nicosia: standing figure of Christ blessing *c.* tympanum of the
Ascension. Pitt-Rivers Museum, Farnham, Dorset

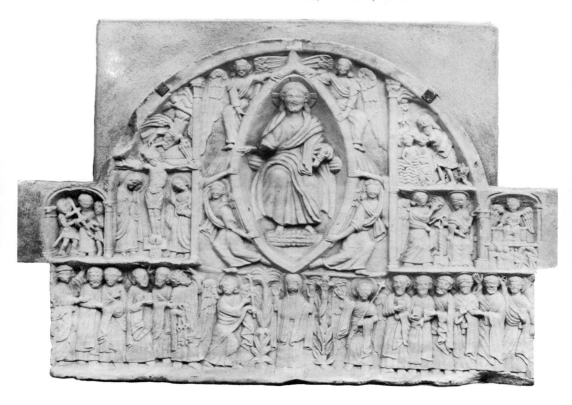

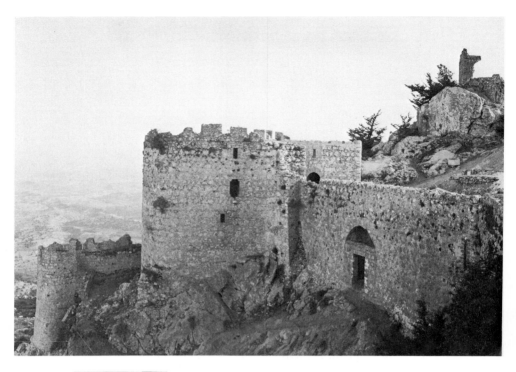

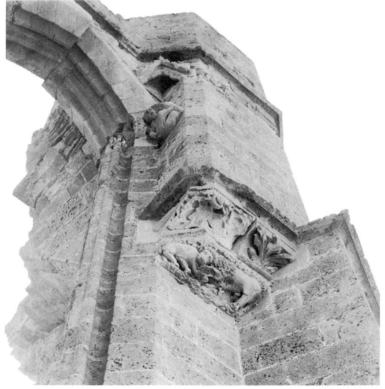

LX. *a*. Castle of Kantara *b*. church of St. George of the Latins,
Famagusta, carved corbel

348

LXI. *a.* Castle of Clermont (Castel Tornese) *b.* castle of Bodonitsa

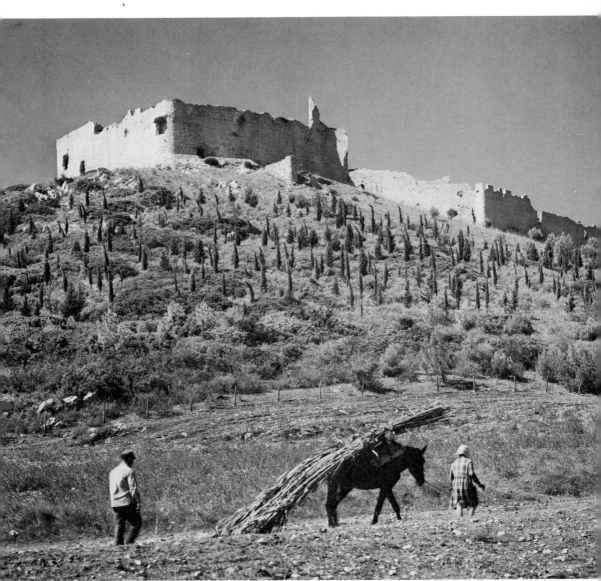

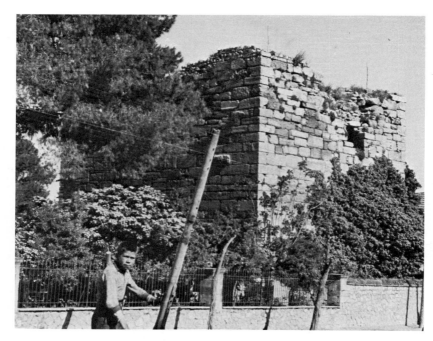

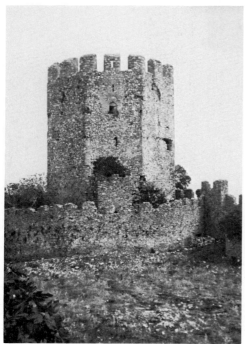
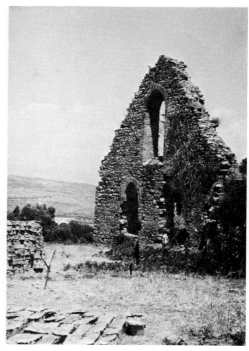

LXII. *a.* Castle of the St. Omer family at Thebes *b.* castle at Platamon, polygonal keep
c. abbey church, Isova, west façade

350

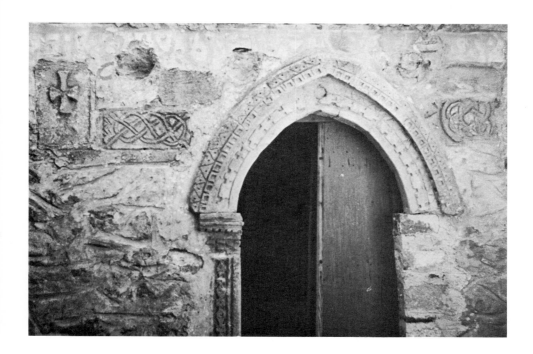

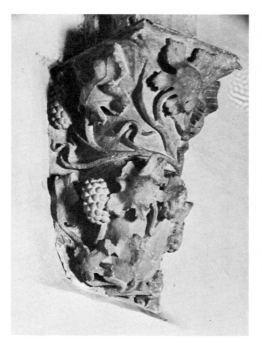

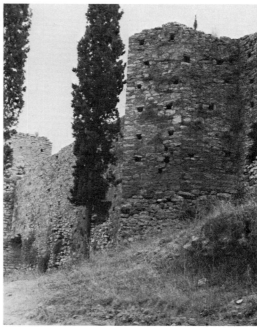

LXIII. *a.* Church of Zoodochos Pege,Geraki, sculptured doorway *b.* church of Hagia Paraskeve, Negroponte, capital *c.* castle of Androusa (Druges)

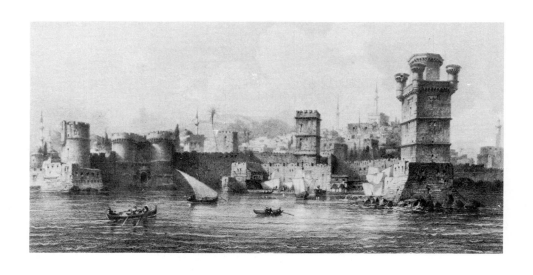

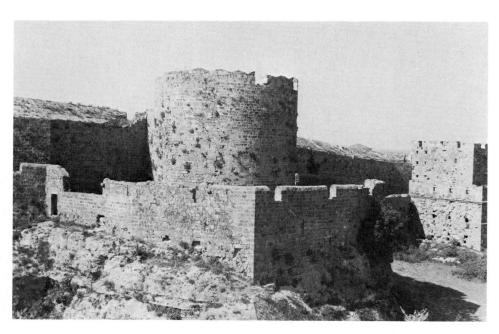

LXIV. *a.* View of Rhodes, from Flandin, *L'Orient* (1853–1858) *b.* fortifications of Rhodes, southeastern walls

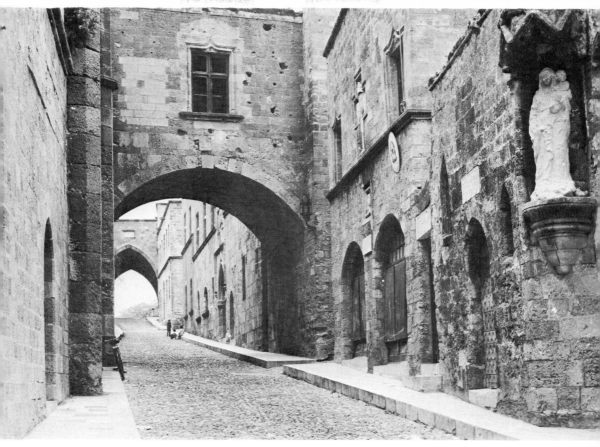

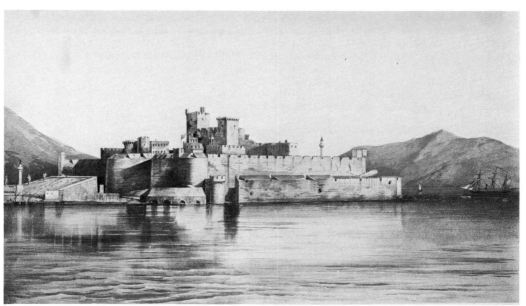

LXV. *a.* Rhodes, the Street of the Knights *b.* castle of St. Peter, Bodrum

B. Bagatti, OFM, and by authority of the Custody of the Holy Land, Jerusalem, with all rights reserved: Plate XXXVIa. Dr. A. Bon: Figure 13. Conservateur-en-Chef, Bibliothèque royale, Brussels, and the Warburg Institute, London: Plate XLIIIa. Dr. H. Buchthal, and the Biblioteca Riccardiana, Florence: Plate XLIa. Dr. H. Buchthal, and the Biblioteca Capitolare, Perugia: Plate XLIb. Michael Burgoyne: Plate XXV. The Syndics of the Fitzwilliam Museum, Cambridge, and the Courtauld Institute, London: Plate XLa. The Trustees of the Chatsworth Settlement, and the Courtauld Institute, London: Plate XXIIb. The late Sir Alfred Clapham, and the Society of Antiquaries, London: Figure 2. Dr. Richard L. W. Cleave: Plate LIIb. Dr. Jaroslav Folda: Plates III, IV, VIb, IXb-XIII, XIVb, XVIIIb, XVIIIc, XXIII, XXIV, XXVI, XXVII, XXX, XXXIV, XXXV,XXXVIb-XXXVIII, XLIX. Dr. Jaroslav Folda, and by authority of the Custody of the Holy Land, Jerusalem, with all rights reserved: Plate XXb. Mr. C. H. M. Gould: Plates LIIIa, LIIIb. The Israel Department of Antiquities and Museums, Jerusalem, and the University of North Carolina Photograph Archive, Chapel Hill: Plates VIa, XIX, XXXI-XXXIII. American Colony, Jerusalem: Plates XXIXa, La. The former Department of Antiquities in Palestine, Jerusalem: Plates Vb, VIIa, VIIb, VIIIa, VIIIb, XVIIIa, XXa. École biblique et archéologique française, Jerusalem: Plates II, Vc, IXa. École biblique et archéologique française, Jerusalem, and the University of North Carolina Photograph Archive, Chapel Hill: Plates XIVa, XV-XVII. Mr. C. N. Johns: Figure 8. Mr. Karl Katz, and by authority of the Custody of the Holy Land, Jerusalem, with all rights reserved: Plate XXIa. Mr. A. F. Kersting: Plates XXVIII, LI, LV, LVII, LIXa, LXIa. Mr. D. J. King: Figure 7. Professor A. W. Lawrence: Plates LIVa, LXIVb. Trustees of the British Library, and the Courtauld Institute, London: Plate XXXIX. Trustees of the British Library, and the Warburg Institute, London: Plates XLIIIb, XLIV. The Courtauld Institute of Art, London: Frontispiece, Plates XXIb, XXIIa; Figures 4, 5. The Courtauld Institute, London, and Mr. R. W. Hamilton: Figure 3. The Courtauld Institute, London, and Mr. William Harvey: Plates Ia, Ib, Va. The Department of Antiquities, Nicosia: Plates LVI, LVIIIa, LVIIIb, LX; Figures 9-12. Conservateur des Manuscrits, Bibliothèque nationale, Paris: Plates XLb, XLII. Conservateur des Manuscrits, Bibliothèque nationale, Paris, and the Warburg Institute, London: Plate XLIc. The Pitt-Rivers Museum, Farnham, Dorset: Plate LIXc. Professor R. C. Smail: Figure 6. Dr. C. L. Striker, Director of the Kalenderhane Camii Project, Istanbul: Plates XLVIIIa, XLVIIIb. Mr. J. Thomson: Plate LIVb. The late Mr. R. Traquair: Plate LXIIIb; Figure 14. The late Mr. D. J. Wallace: Plates LXIb, LXII, LXIIIa, LXIIIc. Professor E. K. Waterhouse: Plates Vd, XXIXb, LIIa, LIXb. Photos by courtesy of Dr. K. Weitzmann, published through the courtesy of the Michigan-Princeton-Alexandria Expedition to Mt. Sinai: Plates XLV-XLVII.

GAZETTEER
AND NOTE ON MAPS

This gazetteer has been prepared to fill a variety of functions. Every relevant place name found in the text or on the maps is here alphabetized and identified, variant spellings and equivalent names in other languages are supplied, and the map location is indicated. Thus it not only serves as an index to the maps, and a supplement to them, but is itself a source for reference on matters of historical geography and changing nomenclature.

In the gazetteer, alphabetization is by the first capital letter of the form used in maps and text, disregarding such lower-case prefixes as *al-* and such geographical words as Cape, Gulf, Lake, Mount, and the like. The designation "classical" may mean Greek, Latin, biblical, or other ancient usage, and the designation "medieval" generally means that the name in question was in common use among speakers of various languages during the crusades, or appears in contemporary sources.

On the maps may be found nearly every place name occurring in the text, except a few whose exact locations are unknown, a few outside the regions mapped, several in areas overcrowded with names, some of minimal importance or common knowledge, and some which occur only in Professor Folda's text, which was received after the preparation of the maps was far advanced. The map of Jerusalem is new; the other nine maps are revised versions of those appearing in volumes II and III of this work.

All maps for this volume have been designed and prepared in the University of Wisconsin Cartographic Laboratory under the direction of Randall P. Sale, assisted by Michael L. Czechanski and James Hilliard. Base information was compiled from U.S.A.F. Jet Navigation Charts at a scale of 1:2,000,000. Historical data have been supplied by Dr. Harry W. Hazard (who also compiled the gazetteer) from such standard works as Sprüner-Menke, Stieler, Andree, and Baedeker for Europe, Lévi-Provençal for Moslem Spain, Rubió i Lluch and Bon for Frankish Greece, and Honigmann, Dussaud, Deschamps, Cahen, and LeStrange for the Near East. Additional information was found in *The Encyclopaedia of Islām* (old and new editions) and *İslâm Ansiklopedisi,* in Yāqūt and other Arabic sources, in *The Columbia Lippincott Gazetteer of the World,* on Michelin and Hallweg road maps, and of course in the text of this volume.

Abū-Ghosh: village—see Qaryat al-'Inab.

Acarnania (classical), Akarnanía (modern Greek): district of western Greece—I1e2: 10.

Achaea (Latin), Akhaïa (modern Greek): district of northern Morea—I2e2: 10.

Acre; Ptolemaïs (classical), Saint John or Saint Jean d'Acre (medieval), 'Akkā (Arabic), 'Akko (Israeli): city, port—L1f3: 1, 5.

Acrocorinth; Acrocorinthus (Latin), Akrokórinthos (modern Greek): rock dominating Corinth—I3e3: 10.

Acropolis: hill in Athens (I4e3: 3, 10).

Adalia or Satalia (medieval), Attalia (classical), Antalya (Turkish): port—K1e4: 1, 3.

Adrianople; Hadrianopolis (classical), Edirne (Turkish): city—J2d4: 1, 3.

Adriatic Sea; Hadria or Mare Hadriaticum (Latin)—GHd: 2, 3, 10.

Aegean Sea; Aigaion Pelagos (classical Greek), Mare Aegaeum (Latin), Ege Denizi (Turkish)—IJde: 1, 3, 7, 10.

Aegina (Latin), Engia (medieval Italian), Ekine (Turkish), Aíyina (modern Greek): island—I4e3: 10.

Aetolia (Latin), Aitolía (modern Greek): district of central Greece—I2e2: 10.

Afāmiyah: town—see Apamea.

Afántos, or Afándos: town—see Aphandou.

Agram (German), Zágráb (Hungarian), Zagreb (Croatian): city—H1c5: 3.

Aigaion Pelagos—see Aegean Sea.

'Ain Karīm (Arabic): village—L1f4: 5.

'Ain Silwān: pool—see Siloam.

'Ain Zarbâ, or 'Ain Zarbah: town—see Anazarba.

Aitolía: district—see Aetolia.

Aíyina: island—see Aegina.

'Ajlūn (Arabic): town—L1f3: 5.

Akarnanía: district—see Acarnania.

Akche Hisar: town—see Kroia.

Akhaïa: district—see Achaea.

'Akkā, or 'Akko: city—see Acre.

'Akkār (Arabic), Gibelcar (medieval): fortress—L2f1: 6.

Akova or Matagrifon (medieval: kill-Greek), Ákovos (modern Greek): castle—I2e3: 10.

Akrokórinthos: rock—see Acrocorinth.

Akrotiri; Akrotíri (modern Greek): peninsula and town—K3f1: 9.

Alamannia: region—see Germany.

Alaya; Scandelore or Candeloro (medieval), 'Ala'īyah or 'Alāyā (Arabic), Alanya (Turkish): port—K2e4: 1, 3.

Albania; Shqipni or Shqipri (Albanian): region NW of Epirus—HId: 3, 10.

Aleppo; Ḥalab (Arabic), Haleb (Turkish): city—L3e4: 1, 6.

Alessio: town—see Lesh.

Alexandretta, Gulf of; Sinus Issicus (classical), Iskenderun Körfezi (Turkish)—L1e4: 6.

Alexandria (classical), al-Iskandarīyah (Arabic): city, port—J5f4: 1, 3.

Alfiós: river—see Alpheus.

Algeria; al-Jazā'ir (Arabic): region between Morocco and Tunisia—DEFef: 2.

Aliákmon: river—see Haliacmon.

Alignan-du-Vent (French): village—E4d2: 2.

Alimnia; Limonia (medieval Italian), Liman (Turkish), Alímnia (modern Greek): island—J3e4: 7.

Alivérion: town—see Haliveri.

Allemania: region—see Germany.

Alma Daghï: mountain range—see Amanus.

Alpheus or Alpheios (classical), Charbon (medieval), Alfiós (modern Greek): river—I2e3: 10.

Alps: mountain range—FGc: 2, 3.

Alsace (French), Alsatia (classical), Elsass (German): region west of the upper Rhine—Fc: 2, 3.

Amalfi (Italian): port—G5d5: 3.

Amanus (classical), Gavur, Alma, or Elma Daghï (Turkish): mountain range—L2e4: 6.

Amboise (French): town—E2c3: 2.

Ambracia: town—see Arta.

Ambracian Gulf, or Amvrakikós Kólpos—see Arta, Gulf of.

Ammōkhostos: port—see Famagusta.

Amphissa, or Amfíssa: town—see Salona.

'Amwās: village—see Emmaus.

Amyūn (Arabic): town—L1f1: 5, 6.

Anamur (Turkish): town—K3e4: 1.

Anatolia; Rūm (medieval Arabic), Anadolu (Turkish): region south of the Black Sea—JKLde: 1, 3.

Anazarba; Anazarbus (classical), Anavarza (Armenian), 'Ain Zarbâ or 'Ain Zarbah (Arabic): town, now abandoned—L1e3: 6.

Ancyra: city—see Ankara.

Andalusia; al-Andalus (Arabic), Andalucía (Spanish): region of southern Spain—CDe: 2.

Andimachia; Antimacheia (classical Greek), Antimachia (Italian), Andimákhia (modern Greek): town on north coast of Cos (J3e4: 3).

Andravida, or Andreville (medieval), Andravídha (modern Greek): town—I2e3: 10.

Andria (Italian): town—H2d4: 3.

Andros; Andro (medieval Italian), Andria (Turkish), Ándros (modern Greek): island—I5e3: 3.

Androusa; Ithomē (classical Greek), Druges (medieval), Androúsa (modern Greek): town—I2e3: 10.

Anglure (French): village 23 miles NW of Troyes (E5c2: 2).

Angoulême (French): town—E1c5: 2.

Anjou (French): region of NW France—D5c3: 2.

Ankara (Turkish), Ancyra (classical), Angora (medieval): city—K3e1: 1.

Antakya, or Anṭākiyah: city—see Antioch.

Antalya: port—see Adalia.

Antalya, Gulf of—see Pamphylia Bay.

Antaradus, or Anṭarṭūs: port—see Tortosa.

Anti-Lebanon; al-Jabal ash-Sharqī (Arabic: the eastern mountain)—L2f1: 5, 6.

Anti-Taurus: mountain range—L1e3: 6.

Antimacheia, or Antimachia: town—see Andimachia.

Antioch; Antiochia (classical), Anṭākiyah (Arabic), Antakya (Turkish): city—
L2e4: 1, 6.

Antioch, Pisidian; Antiochia (classical): town, now abandoned in favor of
Yalvach, 100 miles NNE of Adalia (K1e4: 1, 3).

Antiphonitis; Antifonítis (modern Greek): monastery—K4e5: 9.

Apamea (classical), Afāmiyah or Qal'at al-Muḍīq (Arabic): town, now unimpor-
tant—L2e5: 6.

Apanokastro; Apanókastron (modern Greek): castle on west coast of Naxos
(J1e3: 3).

Aphandou or Aphantos (medieval Greek), Afántos or Afándos (modern Greek):
town—J4e4: 7.

Apolakkía: town—see Polakia.

Apollonia-Sozusa: town—see Arsuf.

Apulia (classical), Puglia or Puglie (Italian): region of SE Italy—Hd: 3.

Aqaba, Gulf of; Khalīj al-'Aqabah (Arabic)—Kg: 1.

Aquitaine (French), Aquitania (classical): region of western France—Dcd: 2.

Arabia (classical), Jazīrat al-'Arab (Arabic): peninsular region east of the Red
Sea—LMNgh: 1, 5.

Arachova; Arákhova (Greek): village—I3e3: 10.

Aradus: island—see Ruad.

Aragon; Aragón (Spanish), Araghūn (Arabic): region of NE Spain—DEd: 2.

Aras (Turkish), Araxes (classical): river—N5e1: 1.

Arcadia (classical), Mesaréa (medieval Greek), Arkadhía (modern Greek): district
of northern Morea—I2e3: 10.

Arcadia (medieval), Cyparissia (classical), Kiparissía (modern Greek): town—
I2e3: 10.

Archangelos; Arkhángelos (modern Greek): town—J4e4: 7.

Archipelago (from Greek Aigaion Pelagos): islands of the Aegean Sea (IJde: 3).

Ardeal: region—see Transylvania.

Arelas: town—see Arles.

Argolid or Argolis (classical), Argolís (modern Greek): district of eastern Morea—
I3e3: 10.

Argos; Árgos (modern Greek): town—I3e3: 3, 10.

Arīḥā: town—see Jericho.

al-'Arīmah: village—see Aryma.

Arkadhía: district—see Arcadia.

Arkhángelos: town—see Archangelos.

Arles (French), Arelas (classical): town 45 miles NW of Marseilles (F1d2: 2).

Armena: castle—see Larmena.

Aroánia: mountain—see Chelmos.

Arsuf; Apollonia-Sozusa (classical), Arsur (medieval), Arsūf (Arabic): town, now
unimportant—K5f3: 5.

Arta; Ambracia (classical), Narda (Turkish), Árta (modern Greek): town—I1e1:
3, 10.

Arta, Gulf of, or Ambracian Gulf; Amvrakikós Kólpos (modern Greek)—Ie: 10.

Arwād: island—see Ruad.

Aryma (medieval), al-'Arīmah (Arabic): village—L2f1: 6.

Ascalon; Askhkelon (classical), 'Asqalān (Arabic): port, now unimportant, near
modern Ashqelon—K5f4: 5.

al-'Āṣī: river—see Orontes.

Asia Minor (classical): region equivalent to western Anatolia (JKde: 1, 3).

Asinou; Asínou (modern Greek): village—K3e5: 9.

Askas (Greek): village—K4f1: 9.

'Asqalān: port—see Ascalon.

Assailly (French): village—E5c5: 2.

Assisi (Italian): town 68 miles ESE of Siena (G2d2: 2, 3).

Astypalaea (classical), Stampalia (Italian), Ustrapalia (Turkish), Astipálaia (modern Greek): island 30 miles WSW of Cos (J3e4: 3).

al-Athārib (Arabic), Cerep (medieval): fortress—L2e4: 6.

Athens; Athēnai (classical Greek), Cetines or Satines (medieval), Athínai (modern Greek): city—I4e3: 3, 10.

Athlith, or 'Atlīt: castle—see Château Pèlerin.

Athos, Mount; Áyion Óros (modern Greek): monastery—I5d5: 10.

Atlantic Ocean—2.

Atlas, High: mountain range—Cf: 2.

al-Aṭrūn: village—see Latrun.

Attalia: port—see Adalia.

Attica (Latin), Attikē (classical Greek), Attikí (modern Greek): district of eastern Greece—I4e3: 10.

Aubusson (French): town—E3c5: 2.

Aulon: port—see Avlona.

Austria; Ostmark (German): region east of Bavaria, smaller than modern nation—GHc: 2, 3.

Autremencourt (French): village—E4c1: 2.

Auvergne (French): region of southern France—Ecd: 2.

al-Auwalī (Arabic: the nearer): river—L1f2: 5.

Avesnes-sur-Helpe (French): town—E4b5: 2.

Avignon (French), Avenio (classical): city—E5d2: 2.

Avlona (medieval), Aulon (classical), Valona (Italian), Vlonë or Vlorë (Albanian): port—H5d5: 3, 10.

Ayas (medieval), Lajazzo (Italian), Yumurtalik (Turkish): port—L1e4: 1, 6.

Aydin; Aydîn (Turkish): district of western Anatolia, equivalent to classical Lydia—Je: 1, 3.

Áyion Óros: monastery—see Athos, Mount.

Áyios Ilárion: castle—see Saint Hilarion.

al-'Āzarīyah: abbey—see Bethany.

Baalbek; Heliopolis (classical), Ba'labakk (Arabic): town—L2f1: 5, 6.

Bāb al-Ajal: fort—see Le Destroit.

Baden (German): district of SW Germany—Fc: 2, 3.

Baghdad; Baghdād (Arabic): city—M5f2: 1.

Baghrās (Arabic), Pagrae (classical), Gaston (medieval), Baghra (Turkish): town—L2e4: 6.

al-Baḥr al-Aḥmar—see Red Sea.

Baḥr Lūt—see Dead Sea.

Bairūt: port—see Beirut.

Baisan; Scythopolis or Bethshan (classical), Bethsan or Bessan (medieval), Baisān (Arabic): town—L1f3: 5.

Bait Jibrīn or Jibrīl: town—see Beth Gibelin.

Bait Laḥm: town—see Bethlehem.

Ba'labakk: town—see Baalbek.

Balarm: city—see Palermo.

Balāṭunus or Qal'at al-Mahalbah (Arabic): village—L2e5: 6.

Baleares (Spanish): island group—Ede: 2.

Baltic Sea—HIab: 2, 3.

Bamberg (German): city—G1c1: 3.

Bāniyās: port—see Valania.

Banyas; Paneas or Caesarea Philippi (classical), Belinas (medieval), Bāniyās (Arabic): town—L1f2: 5.

Bar (French): town, now Bar-le-Duc—F1c2: 2.

Bara: island—see Paros.

Barletta (Italian): port—H2d4: 3.

Barqah: region—see Cyrenaica.

Basilicata: region—see Lucania.

Batnos: island—see Patmos.

al-Batrūn: town—see Botron.

Bavaria; Bayern (German): region of southern Germany—Gc: 2, 3.

Beaufort: castle (in Syria)—see Belfort.

Beaufort (French), Leuctrum (Latin), Léftro (modern Greek): castle—I3e4: 10.

Beauvoir: castle (in Palestine)—see Belvoir.

Beauvoir or Belvedere (French), Pontikókastron (modern Greek): castle—I2e3: 10.

Beersheba (classical), Bīr as-Sab' (Arabic), Be'er Sheva' (Israeli): town—K5f4: 5.

Beirut; Berytus (classical), Bairūt (Arabic): port—L1f2: 1, 5, 6.

Belen Boghazı̇̀: pass—see Syrian Gates.

Belfort or Beaufort (medieval), Shaqīf Arnūn or Qal'at ash-Shaqīf (Arabic: fort of the rock): castle—L1f2: 5.

Belgrade; Beograd (Serbian: white town): city—I1d1: 3.

Belhacem (medieval), Qal'at Abū-l-Ḥasan (Arabic): village—L1f2: 5.

Belinas: town—see Banyas.

Bellagrada: town—see Berat.

Bellapais or Bella Paise (medieval): monastery—K4e5: 9.

Belmont (French): abbey and castle—L1f1: 5, 6.

Belmont: castle at Qaryat al-'Inab (L1f4: 5).

Belvedere: castle—see Beauvoir.

Belvoir or Beauvoir (medieval), Kaukab al-Hawā' (Arabic: star of the sky): castle—L1f3: 5.

Beograd: city—see Belgrade.

Berat; Pulcheriopolis (classical), Bellagrada (medieval): town—H5d5: 3, 10.

Berytus: port—see Beirut.

Bessan: town—see Baisan.

Beth Gibelin (medieval), Betogabri or Eleutheropolis (classical), Bait Jibrīn or Bait Jibrīl (Arabic), Bet Guvrin (Israeli): town, now village—K5f4: 5.

Bethany; al-'Āzarīyah (Arabic), 'Eizariya (Israeli): abbey and fort—L1f4: 5.

Bethesda: pool near Jerusalem, possibly Birkat Isrā'īl (4).

Bethlehem; Ephrata (classical), Bait Lahm (Arabic: house of flesh): town—L1f4: 5.

Bethphage: village near Bethany (L1f4: 5).

Bethshan, or Bethsan: town—see Baisan.

Betogabri: town—see Beth Gibelin.

al-Biqā‘ (Arabic: the hollow), Coele-Syria (classical): district of central Lebanon—L1f2: 5, 6.

Bīr as-Sab‘: town—see Beersheba.

Birgu or Vittoriosa (Maltese): town—G5e5: 3.

Birkat Isrā‘īl, or Isrā‘īn (Arabic): pool (now filled in) in Jerusalem, north of al-Ḥaram ash-Sharīf—4.

Bistritsa: river—see Haliacmon.

Bitsibardi (medieval Greek), Isova (medieval), Trypētē (classical Greek), Tripití (modern Greek): village 15 miles NW of Karytaina (I3e3: 10).

Black Sea—JKLd: 1, 3.

Blanche Garde (medieval), at-Tall aṣ-Ṣāfiyah (Arabic: the glittering hill): castle—K5f4: 5.

Blgariya: region—see Bulgaria.

Bodonitsa or Boudonitsa (medieval), Pharygae (classical), Mendhenítsa (modern Greek): village—I3e2: 10.

Bodrum or Budrum (Turkish), Halicarnassus (classical), Petroúnion (modern Greek): town—J3e3: 3.

Boeotia (Latin), Boiōtia (classical Greek), Voiotía (modern Greek): district of eastern Greece—I4e2: 10.

Bohemia; Čechy (Czech): region north of Austria—GHbc: 2, 3.

Boixols: town—see Boxolis.

Bordeaux (French), Burdigala (classical): city, port—D5d1: 2.

Borysthenes: river—see Dnieper.

Bosnia; Bosna (Serbian, Turkish): region west of Serbia—Hd: 3.

Bosporus (classical), Karadeniz Boghazï (Turkish: Black Sea strait)—J5d4: 1.

Bosra; Bostra (classical), Buṣrâ (Arabic): town—L2f3: 5.

Botron (medieval), Botrys (classical), al-Batrūn (Arabic): town—L1f1: 5, 6.

Boudonitsa: village—see Bodonitsa.

Bouillon (French): town—F1c1: 2.

Boulogne-sur-Mer (French): port—E2b5: 2.

Bourges (French): town—E3c3: 2.

Bourgogne: region—see Burgundy.

Bourtsi; Boúrtsi (modern Greek): fort on island in Nauplia harbor (I3e3: 10).

Bourzey (medieval), Qal‘at Barzah (Arabic): castle—L2e5: 6.

Boxolis or Boixols (Spanish): town—E2d3: 2.

Brabant (French, Flemish): district east of Flanders—E5b4: 2, 3.

Brandenburg (German): district of northern Germany—Gb: 2, 3.

Breidenbach or Breydenbach (German): town—F4b5: 3.

Brenthē: castle—see Karytaina.

Brienne-la-Vieille (French): village—E5c2: 2.

Brittany; Bretagne (French), Breiz (Breton): region of NW France—Dc: 2.

Budrum: town—see Bodrum.

Buffavento (medieval): castle—K4e5: 9.

Buḥairat al-Ḥūlah—see Hulah, Lake.

Buḥairat Ṭabarīyah—see Tiberias, Lake.

Bulgaria; Blgariya (Bulgarian): region south of the lower Danube—IJd: 1, 3.

Bullis: town—see Canina.
Bulunyās: port—see Valania.
al-Buqai'ah (Arabic: the little hollow): valley—L1f1: 6.
Burdigala: city—see Bordeaux.
Burgundy; Bourgogne (French): region of eastern France—EFc: 2.
Burj Ṣāfīthā: castle—see Chastel-Blanc.
Buṣrâ: town—see Bosra.
Byblos: town—see Jubail.
Byllis: town—see Canina.
Byzantium: city—see Constaninople.

Caesarea Maritima or Palestinae (classical), Qaisārīyah (Arabic), Sedot Yam (Israeli): port, now unimportant—K5f3: 5.
Caesarea Philippi: town—see Banyas.
Caiffa, or Caiphas: port—see Haifa.
Cairo; al-Qāhirah (Arabic): city—K2f5: 1, 3.
Calabria (Italian): region of SW Italy—He: 3.
Calchi: island—see Chalce.
Callidromon, Mount; Koukos (medieval), Kallídhromon (modern Greek)—I3e2: 10.
Calvary: hill—see Golgotha.
Calycadnus (classical), Saleph (medieval), Selef or Gök (-Su) (Turkish): river—K5e4: 1.
Calymnos; Calymna (Latin), Calino (Italian), Gelmez (Turkish), Kálimnos (modern Greek): island NW of Cos (J3e4: 3).
Candeloro: port—see Alaya.
Candia: island—see Crete.
Candia (medieval), Heracleum (Latin), Iráklion (modern Greek): port—J1e5: 3.
Canina (medieval), Bullis or Byllis (classical), Kanine (Albanian): town, now unimportant—H5d5: 10.
Canterbury: town—E2b4:2.
Carcassonne (French): town—E3d2: 2.
Carchi: island—see Chalce.
Carmel, Mount; Jabal Mār Ilyās (Arabic: Mount St. Elias), Karmel (Israeli)—K5f3: 5.
Carpathos; Scarpanto (Italian), Kerpe (Turkish), Kárpathos (modern Greek): island—J3e5: 1, 3.
Carretto (Italian): village near Cáiro Montenotte, 34 miles west of Genoa (F4d1: 2, 3).
Carthage; Carthago (Latin): town—G1e4: 2, 3.
Carystus (Latin), Káristos (modern Greek): town—I5e2: 10.
Caspian Sea—NOde: 1.
Castel Basso: castle—see Katokastro.
Castel de Fer: castle—see Siderokastron.
Castel del Monte (Italian): fortress—H2d4: 3.
Castel Tornese: castle—see Clermont.
Castellorizzo; Megista (classical), Meis (Turkish), Kastellórizo (modern Greek), Castelrosso (Italian): island—J5e4: 1.
Castiglione della Stiviere (Italian): town 24 miles west of Verona (G2c5: 3).

Castile; Castilla (Spanish), Qashtālah (Arabic): region of north central Spain—Dd: 2.

Catalonia; Cataluña (Spanish), Catalunya (Catalan): region of NE Spain—Ed: 2.

Cattavia; Kattaviá (modern Greek): town—J3e5: 7.

Caucasus; Kavkaz (Russian): mountain range—MNd: 1.

Čechy: region—see Bohemia.

Cefalù (Italian), Cephaloedium (Latin): town—G5e2: 3.

Ceos; Keōs (classical Greek), Tziá (medieval Greek), Zea (Italian), Morted (Turkish), Kéa (modern Greek): island—I5e3: 10.

Cephalonia; Kephallēnia (classical Greek), Kephallōnia (medieval Greek), Kefallinía (modern Greek): island—I1e2: 10.

Cephissus (Latin), Kēphisos (classical Greek), Kifissós (modern Greek): stream—I4e2: 10.

Cerep: fortress—see al-Athārib.

Cerigo (Italian), Cythera (Latin), Kythēra (classical Greek), Kíthira (modern Greek): island—I3e4: 10.

Cerines: town—see Kyrenia.

Cetines: city—see Athens.

Chalandritsa (medieval), Khalandrítsa (modern Greek): town—I2e2: 10.

Chalce or Khalkē (classical), Carchi or Calchi (Italian), Herke (Turkish), Khálki (modern Greek): island NW of SW tip of Rhodes (J3e4: 3).

Chalcidice (Latin), Khalkidikē (classical Greek), Khalkidhikí (modern Greek): peninsula—I4d5: 10.

Chalcis: town—see Negroponte.

Champagne (French): region of NE France—EFc: 2.

Champlitte-et-le-Prélot (French): town—F1c3: 2.

Chanakkale Boghazi: strait—see Dardanelles.

Chankiri: town—see Gangra.

Charbon: river—see Alpheus.

Chartres (French): town—E2c2: 2.

Chastel-Blanc (medieval), Burj Ṣāfīthā (Arabic): castle—L2f1: 6.

Chastel-Neuf (medieval), Ḥūnīn (Arabic): castle—L1f2: 5.

Chastel-Rouge (medieval), Qal'at Yaḥmur (Arabic): fortress—L1f1: 6.

Château Gaillard (French): castle at Les Andelys (E2c1: 2).

Château Pèlerin or Athlith (medieval), 'Atlīt (Arabic), 'Atlit (Israeli): castle—K5f3: 5.

Châtillon-sur-Loing (French): town, now part of Châtillon-Coligny—E3c3: 2.

Chaumont-en-Bassigny (French): town—F1c2: 2.

Chelmos, Mount; Aroánia or Khelmós (modern Greek)—I3e3: 10.

Chiarenza: town—see Glarentsa.

Chios; Scio (Italian), Khíos (modern Greek), Sakiz (Turkish): island—J1e2: 3.

Chorasmia: region—see Khorezm.

Cilicia (classical): region of southern Anatolia—KLe: 6.

Circassia: region north of western Caucasus—Md: 1.

Citó: town—see Zeitounion.

Clarence: town—see Glarentsa.

Clermont (French): Khelōnatas (classical Greek), Khloumoutsi (medieval Greek), Castel Tornese (medieval): castle—I2e3: 10.

Clermont (French): town, now part of Clermont-Ferrand—E4c5: 2.

Cluny (French): abbey—E5c4: 2.

Coele-Syria: district—see al-Biqā'.

Coliat (medieval), al-Qulai'ah (Arabic: the small fort): fortress—L2f1: 6.

Conques (French): abbey—E3d1: 2.

Constantinople; Byzantium or Constantinopolis (classical), İstanbul (Turkish): city, port—J4d4: 1, 3.

Copais, Lake; Kōpais Limnē (classical Greek): lake, now filled in—I4e2: 10.

Corfu; Corcyra (Latin), Kerkyra (classical Greek), Corfù (Italian), Kérkira (modern Greek): island—H5e1: 3, 10.

Corinth; Korinthos (classical Greek), Kórinthos (modern Greek): city—I3e3: 3, 10.

Corinth, Gulf of; Korinthiakós Kólpos (modern Greek)—I3e2: 10.

Corneillan (French): village—D5d2: 2.

Coron; Korōnē (medieval Greek), Koróni (modern Greek): town—I2e4: 3, 10.

Corsica; Cyrnus (classical), Corse (French): island—Fd: 2, 3.

Corycus (classical), Goṛigos (Armenian), Le Courc (medieval), Korgos (Turkish): port—K5e4: 1.

Cos; Kós (Greek), Lango or Stanchio (medieval Italian), Stankoi (Turkish): island—J3e4: 3.

Coucy-le-Château (French): village—E4c1: 2.

Coustouges (French): village—E3d3: 2.

Crete; Candia (medieval Italian), Krētē (medieval Greek), Kandia (Turkish), Kríti (modern Greek): island—IJe: 1, 3.

Crimea; Krym (Russian): peninsula—K4c5: 1, 3.

Croatia; Meran (medieval), Hrvatska (Croatian): region of NW Yugoslavia—Hc: 3.

Croia: town—see Kroia.

Culan or Culant (French): village—E3c4: 2.

Cursat (medieval), Quṣair or Qal'at az-Zau (Arabic): castle—L2e4: 6.

Cyllene: town—see Glarentsa.

Cyllene, Mount; Kyllēnē (medieval Greek), Killíni (modern Greek)—I3e3: 10.

Cymru: region—see Wales.

Cynaetha: town—see Kalavryta.

Cyparissia: town—see Arcadia.

Cyprus or Kypros (classical), Kípros (modern Greek), Kîbrîs (Turkish): island—Kef: 1, 9.

Cyrenaica (classical), Barqah (Arabic): region between Tripolitania and northern Egypt—If: 3.

Cyrnus: island—see Corsica.

Cyrus: river—see Kura.

Cythera: island—see Cerigo.

Dalmatia; Dalmacija (Croatian): region east of the Adriatic Sea, equivalent to classical Illyria—Hd: 3.

Damascus (classical), Dimashq or ash-Sha'm (Arabic: the left): city—L2f2: 1, 5.

Damietta; Dimyāṭ (Arabic): port—K2f4: 1.

Dampierre; Le Vieil Dampierre (French): village—E5c2: 2.

Danmark: region—see Denmark.

Danube; Donau (German), Duna (Hungarian), Dunav (Serbian, Bulgarian), Dunărea (Rumanian): river—J5c5: 1, 2, 3.

Daphne; Daphnē (classical Greek), Dhafní (modern Greek): monastery—I4e2: 10.

Dardanelles; Hellespontus (classical), Chanakkale Boghazï (Turkish): strait—J2d5: 1.

Darsous: town—see Tarsus.

Darum or Daron (classical), ad-Dārum (Arabic): town—K5f4: 5.

Dauphiné: district—see Viennois.

Dead Sea; Baḥr Lūṭ (Arabic: sea of Lot), Yam Hamelah (Israeli)—L1f4: 1, 5.

Degir Menlik; island—see Melos.

Denmark; Danmark (Danish): region, then including the southern part of Sweden—FGHab: 2, 3.

Deutschland: region—see Germany.

Dhafní: monastery—see Daphne.

Dhístos: village—see Dystos.

Dhodhekánisoi: island group—see Dodecanese.

Dieudamour: castle—see Saint Hilarion.

Dijlah, or Dijle: river—see Tigris.

Dimashq: city—see Damascus.

Dimyāṭ: port—see Damietta.

Dio Caesarea: town—see Saffūrīyah.

Diyār-Muḍar (Arabic): region east of the Euphrates—L4e4: 6.

Dnieper; Borysthenes (classical), Dnepr (Russian): river—K3c4: 1, 3.

Dniester; Tyras (classical), Dnestr (Russian), Nistru (Rumanian): river—K1c4: 1, 3.

Dodecanese; Dōdekanēsos (medieval Greek: 12 islands), Dhodhekánisoi (modern Greek): island group—Je: 3.

Dolomites; Dolomiti (Italian): mountain range—G2c4: 2, 3.

Don; Tanaïs (classical): river—L5c3: 1.

Donau; river—see Danube.

Donzy-le-Pré (French): village 39 miles NE of Bourges (E3c3: 2).

Doornijk: town—see Tournai.

Douro (Portuguese), Duero (Spanish), Duwīruh (Arabic): river—C2d4: 2.

Dramelay: village—see Trémolay.

Druges: town—see Androusa.

Duna, Dunărea, or Dunav: river—see Danube.

Durazzo (Italian), Epidamnus or Dyrrachium (classical), Draj (Turkish), Durrës (Albanian): port—H5d4: 3, 10.

Dystos (medieval Greek), Dhístos (modern Greek): village—I5e2: 10.

Ebro (Spanish), Ibruh (Arabic): river—E1d5: 2.

Edessa; Roucha or Rochas (medieval), ar-Ruhā' (Arabic), Urfa (Turkish): city—L4e3: 1, 6.

Edirne: city—see Adrianople.

Ege Denizi—see Aegean Sea.

Egripos: island—see Euboea.

Egypt; Miṣr (Arabic): region of NE Africa—Kfg: 1, 3.

Egypt, Upper: region along the Nile south of Cairo—Kg: 1.

Eider (German): river—G1b1: 2.

Eire: island—see Ireland.

'Eizariya: abbey—see Bethany.

Ekine: island—see Aegina.

Elbasan (medieval, Albanian): town—I1d4: 10.

Elbe (German), Labe (Czech): river—F5b2: 2, 3.

Eleutheropolis: town—see Beth Gibelin.

Elis; Ēlis or Ēleia (classical Greek), Ilía (modern Greek): district of NW Morea—
 I2e3: 10.

Elma Daghî: mountain range—see Amanus.

Elsass: region—see Alsace.

Ely: town—E1b3: 2.

Emesa: city—see Homs.

Emmaus; Nicopolis (classical), 'Amwās (Arabic), Imwas (Israeli): village, not
 biblical Emmaus, 9 miles WNW of Jerusalem (L1f4: 1, 5).

Engia: island—see Aegina.

England: region—DEb: 2.

English Channel; La Manche (French: the sleeve): arm of the Atlantic between
 England and France (2).

Ephrata: town—see Bethlehem.

Epidamnus: port—see Durazzo.

Epirus; Ēpeiros (classical Greek: mainland), Ípiros (modern Greek): region west
 of Thessaly—I1e1: 3, 10.

Episcopi; Episkopí (modern Greek): town—K3f1: 9.

Erdély: region—see Transylvania.

Erlangen (German): town 24 miles SSE of Bamberg (G1c1: 3).

Escandelion: castle—see Scandelion.

Eskihisar: town—see Laodicea ad Lycum.

España: region—see Spain.

Este (Italian): town—G2c5: 3.

Estives: city—see Thebes.

Euboea (classical), Evripos (medieval Greek), Egripos (Turkish), Negroponte
 (Italian), Évvoia (modern Greek): island—I5e2: 10.

Euphrates (classical), al-Furāt (Arabic), Firat Nehri (Turkish): river—N4f5:
 1, 6.

Evros: river—see Maritsa.

Eynihal: town—see Myra.

Famagusta; Ammōkhostos (classical Greek), Famagosta (medieval Italian):
 port—K4e5: 9.

Feke: town—see Vahka.

Feraklos: village—see Pheraclos.

Fília: district—see Triphylia.

Filírimos: castle—see Phileremos.

Filistīn: region—see Palestine.

Firat Nehri: river—see Euphrates.

Flanders; Vlaanderen (Flemish): region of NE France and northern Belgium—
 Eb: 2.

Florence; Firenze (Italian): city—G2d2: 2, 3.

Fokís: district—see Phocis.

Fort St. André, at Avignon (E5d2: 2).

Fossanova (Italian): convent, and village—G4d4: 3.

France: region, smaller than modern nation—DEFbcd: 2.

Franconia; Franken (German): region of western Germany—FGbc: 2, 3.

Frisia (classical), Friesland (Dutch, German): region of NE Netherlands and NW Germany—Fb: 2, 3.

Fulda (German): river—F5b4: 2, 3.

al-Furāt: river—see Euphrates.

Gadres: town—see Gaza.

Galicia; Galich (Russian), Halicz (Polish): region of NW Ukraine and SE Poland, larger than modern Polish province—Ibc: 3.

Galilee; Hagalil (Israeli): region of northern Palestine—L1f3: 5.

Galilee, Sea of—see Tiberias, Lake.

Gangra or Germanicopolis (classical), Chankîrî (Turkish): town—K4d5: 1.

Gardiki (medieval), Pelinnaeon or Larissa Kremastē (classical Greek): castle—I3e2: 10.

Gascony; Gascogne (French): region of SW France—Dd: 2.

Gaston: town—see Baghrās.

Gastouni; Gastounē (medieval Greek), Gastogne (medieval), Gastoúni (modern Greek): town—I2e3: 10.

Gastria; Gastriá (modern Greek): village—K4e5: 9.

Gath (classical): ruined ancient town, near modern Qiryat Gat, 14 miles ESE of Ascalon (K5f4: 5).

Gâtineau (French): village 20 miles NE of Saintes (D5c5: 2).

Gavur Daghî: mountain range—see Amanus.

Gaza; Gadres (medieval), Ghazzah (Arabic): town—K5f4: 5.

Gelmez: island—see Calymnos.

Genoa; Genua (Latin), Genova (Italian): city, port—F4d1: 2, 3.

Georgia; Sakartvelo (Georgian): region south of the western Caucasus—MNd: 1.

Geraki (medieval), Geronthrae (classical), Yeráki (modern Greek): town—I3e4: 10.

Germanicia: town—see Marash.

Germanicopolis: town—see Gangra.

Germany; Alamannia or Allemania (medieval), Deutschland (German): region of north central Europe—FGbc: 2.

Géronville (French): chateau at Macau—D5c5: 2.

Ghazzah: town—see Gaza.

al-Ghūṭah (Arabic): district SE of Damascus—L2f2: 5.

Gibelcar: fortress—see 'Akkār.

Gibelet: town—see Jubail.

Gibraltar; Jibraltar (Spanish), Jabal Ṭāriq (Arabic): rock—C5e4: 2.

Gibraltar, Strait of; az-Zuqāq (Arabic)—C5e5: 2.

Gitonis: town—see Zeitounion.

Glarentsa, Chiarenza, or Clarence (medieval), Cyllene (Latin), Kyllēnē (classical Greek), Killíni (modern Greek): town—I2e3: 10.

Gök-Su: river—see Calycadnus.

Golgotha, or Calvary: hill in Jerusalem (L1f4: 1, 5; 4).

Gorigos: port—see Corycus.

Gortys: district—see Skorta.

Gozon (French): chateau near St. Rome-de-Tarn, 63 miles NNE of Carcassonne (E3d2: 2).

Graville (French): village, now part of Graville-Sainte Honorine—E1c1: 2.

Greece; Hellas (Greek): region, smaller than modern nation (Ide: 10).

Guadalquivir (Spanish), al-Wādī al-Kabīr (Arabic: the great river): river—C4e4: 2.

Guadiana (Spanish, Portuguese), Wādī Anah (Arabic): river—C3e3: 2.

Gymno (medieval), Yimnón (modern Greek): village—I4e2: 10.

Ḥabrūn: town—see Hebron.

Hadria, or Mare Hadriaticum—see Adriatic Sea.

Hadrianopolis: city—see Adrianople.

Hagalil: region—see Galilee.

Haifa; Caiphas or Caiffa (medieval), Haifā (Arabic), H̲aifa (Israeli): port—L1f3: 5.

Hainault; Hainaut (French), Henegouwen (Flemish): district south of Flanders—Efb: 2, 3.

Ḥalab, or Haleb: city—see Aleppo.

Haliacmon (classical), Bistritsa (Macedonian), Aliákmon (modern Greek): river—I3d5: 10.

Halicarnassus: town—see Bodrum.

Halicz: region—see Galicia.

Haliveri (medieval), Alivérion (modern Greek): town—I5e2: 10.

Ham (French): town—E3c1: 2.

Hambroeck (medieval): village, probably Hambrücken, 75 miles SW of Würzburg (F5c1: 2, 3).

al-Ḥaram ash-Sharīf: Temple district in Jerusalem (4).

Ḥārim (Arabic), Harenc (medieval): town—L2e4: 6.

Hattin, Horns of; Ḥaṭṭīn or Ḥiṭṭīn (Arabic): hill battlefield—L1f3: 5.

Hauran; Ḥaurān (Arabic): district of southern Syria—L2f3: 5.

Hebron; Ḥabrūn or Khalīl (Arabic), Saint Abraham (medieval): town—L1f4: 5.

Hebrus: river—see Maritsa.

Hejaz; al-Hijāz (Arabic): region of western Arabia—Lgh: 1.

Heliopolis: town—see Baalbek.

Hellas: region—see Greece.

Hellespontus: strait—see Dardanelles.

Henegouwen: district—see Hainault.

Heraclea: castle—see Siderokastron.

Heracleum: port—see Candia.

Heredia (Spanish): village—D3d3: 2.

Herke: island—see Chalce.

Hermon, Mount; al-Jabal ash-Shaikh or Jabal ath-Thalj (Arabic: the hoary, or snow-covered, mountain)—L1f2: 5.

Hesse; Hessen (German): district of NW Germany—Fb: 2, 3.

Hibernia: island—see Ireland.

Hierosolyma: city—see Jerusalem.

al-Hijāz: region—see Hejaz.

Ḥimṣ: city—see Homs.

Hinnom, vale of; Wādī ar-Rabābi (Arabic): valley south of Mt. Sion—4.

Ḥiṣn al-Akrad: fortress—see Krak des Chevaliers.

Hispania: region—see Spain.

Ḥiṭṭīn: battlefield—see Hattin, Horns of.

Holland (Dutch): region north of Brabant—Eb: 2, 3.

Holstein (German): region south of Denmark—FGb: 2, 3.

Holy Land—see Palestine.

Homs; Emesa (classical), Ḥimṣ (Arabic): city—L2f1: 1, 6.

Horeb, Mount—see Sinai, Mount.

Hromgla; Qalʻat ar-Rūm (Arabic: fort of Rome), Ranculat (medieval), Hromgla (Armenian), Rum Kalesi (Turkish): fortress, now town—L3e3: 6.

Hrvatska: region—see Croatia.

Hulah, Lake: Buḥairat al-Ḥūlah (Arabic)—L1f2: 5.

Hungary; Magyarország (Hungarian): region of central Europe—HIc: 3.

Ḥunīn: castle—see Chastel-Neuf.

Hypatē: town—see Neopatras.

Ibelin (medieval), Jabneel or Jamnia (classical), Yabnâ (Arabic), Yavne (Israeli): village—K5f4: 5.

Ibruh: river—see Ebro.

Ifrīqiyah: region—see Tunisia.

Ilan-kale (Turkish): castle—L1e3: 6.

Île de France (French): region around Paris (E3c2: 2).

Ileros: island—see Leros.

Ilía: district—see Elis.

Iliaki: island—see Telos.

Imwas: village—see Emmaus.

İnjirli: island—see Nisyros.

Ipáti: town—see Neopatras.

İpiros: region—see Epirus.

Iráklion: port—see Candia.

Īrān: region—see Persia.

Ireland; Hibernia (Latin), Eire (Gaelic): island—Cb: 2.

Iron Gate; Đerdap (Serbian), Porṭile de Fier (Rumanian): gorge in the Danube—I3d1: 3.

al-Iskandarīyah: city—see Alexandria.

İskenderun Körfezi, or Issicus, Sinus—see Alexandretta, Gulf of.

Isova: village—see Bitsibardi.

İstanbul: city—see Constantinople.

Istria (Italian), Istra (Croatian, Slovenian): peninsula—Gc: 3.

Italy; Italia (Italian): peninsular region, now a nation—FGHde: 2.

Ithomē: town—see Androusa.

Itil: river—see Volga.

İzmir: city—see Smyrna.

İznik: town—see Nicaea.

Jabal Anṣārīyah or Jabal Bahrāʼ (Arabic): mountain—L2e5: 6.

al-Jabal ash-Shaikh, or Jabal ath-Thalj—see Hermon, Mount.

al-Jabal ash-Sharqī: mountain—see Anti-Lebanon.

Jabal aṭ-Ṭūr—see Olives, Mount of, and Tabor, Mount.

Jabal Lubnān—see Lebanon, Mount.

Jabal Mār Ilyās—see Carmel, Mount.
Jabal Mūsâ—see Sinai, Mount.
Jabal Tābūr—see Tabor, Mount.
Jabal Ṭāriq: rock—see Gibraltar.
Jabneel, or Jamnia: village—see Ibelin.
Jacob's Well: village, now abandoned—L1f3: 5.
Jaffa; Joppa (medieval), Yāfā (Arabic), Yafo (Israeli): port, now joined to Tel
 Aviv—K5f3: 5.
Jarbah: island—see Jerba.
al-Jarīd: district—see Jerid.
al-Jazā'ir: region—see Algeria.
Jazīrat al-'Arab: region—see Arabia.
Jehoshaphat (classical): valley, confused in crusader period with Kidron, but
 probably north of Jerusalem (L1f4: 1, 5; 4).
Jerba; Meninx (classical), Jarbah (Arabic): island—G1f2: 2, 3.
Jericho; Arīḥā or ar-Rīḥā (Arabic): town, now village—L1f4: 5.
Jerid; al-Jarīd (Arabic): district of SW Tunisia—F4f2: 2.
Jerusalem; Hierosolyma (classical), al-Quds (Arabic: the holy), Yerushalayim
 (Israeli): city—L1f4: 1, 4, 5.
Jeyhan: river—see Pyramus.
Jibraltar: rock—see Gibraltar.
Jisr ash-Shughūr (Arabic): bridge, now town—L2e5: 6.
Joinville (French): town—F1c2: 2.
Joppa: port—see Jaffa.
Jordan; al-Urdunn (Arabic): river—L1f4: 1, 5.
Jubail (Arabic: small mountain), Byblos (classical), Gibelet (medieval): town—
 L1f1: 5, 6.
Judea; Judaea (classical): region of south central Palestine—L1f4: 5.
Jumièges (French): village—E1c1: 2.

Kafr Jinnis: abbey—see Ramatha.
Kakopetria; Kakopetriá (modern Greek): town—K3f1: 9.
Kalamata (medieval), Pharae (classical), Kalámai (modern Greek): town—I3e3:
 10.
Kalavryta (medieval), Cynaetha (classical), Kalávrita (modern Greek): town—
 I3e2: 10.
Kálimnos: island—see Calymnos.
Kallídhromon: mountain—see Callidromon.
Kalopanayiotis; Kalopanayiótis (modern Greek): town—K3f1: 9.
Kandia: island—see Crete.
Kanine: town—see Canina.
Kantara; al-Qanṭarah (Arabic: the bridge), Kantára (modern Greek): town—
 K4e5: 9.
Karadeniz Boghazı: strait—see Bosporus.
al-Karak: fortress—see Kerak.
Karaman (Turkish): region of south central Anatolia—Ke: 1.
Káristos: town—see Carystus.
Karmel—see Carmel, Mount.
Karpass: peninsular district—K5e5: 9.

Kárpathos: island—see Carpathos.

Karytaina (medieval), Brenthē (classical Greek), Karítaina (modern Greek): castle, now village—I3e3: 10.

Kastellórizo: island—see Castellorizzo.

Katakolon; Katákolon (modern Greek): town—I2e3: 10.

Katokastro; Castel Basso (Italian), Katókastron (modern Greek): castle on east coast of Andros (I5e3: 3).

Kattaviá: town—see Cattavia.

Kaukab al-Hawā': castle—see Belvoir.

Kavkaz: mountain range—see Caucasus.

Kenilworth: castle—D4b3: 2.

Keōs, or Kéa: island—see Ceos.

Kephallēnia, Kephallōnia, or Kefaliniá: island—see Cephalonia.

Kēphisos: stream—see Cephissus.

Kerak; Kir-hareseth (classical), Krak des Moabites or Krak of Moab (medieval), al-Karak (Arabic): fortress, now town—L1f4: 1, 5.

Kerkyra, or Kérkira: island—see Corfu.

Kerpe: island—see Carpathos.

Kerýnia: town—see Kyrenia.

Khalandrítsa: town—see Chalandritsa.

Khalīj al-'Aqabah—see Aqaba, Gulf of.

Khalīl: town—see Hebron.

Khalkē, or Khalkí: island—see Chalce.

Khalkidikē, or Khalkidhikí: peninsula—see Chalcidice.

Khalkís: town—see Negroponte.

Khelmós: mountain—see Chelmos.

Khíos: island—see Chios.

Khirbat al-Mafjar (Arabic): village—L1f4: 5.

Khirokitia; Khirokitía or Khoirokitía (modern Greek): battlefield—K4f1: 9.

Khloumoutsi, or Khelōnatas: castle—see Clermont.

Khorezm; Chorasmia (classical), Khʷārizm (Persian): region of the lower Oxus river—not in area mapped.

Kîbrîs: island—see Cyprus.

Kidron: valley SE of Jerusalem—4.

Kifissós: stream—see Cephissus.

Killíni: mountain—see Cyllene.

Killíni: town—see Glarentsa.

Kionia, or Kióni: village—see Zaraca.

Kiparissía: town—see Arcadia.

Kípros: island—see Cyprus.

Kir-hareseth: fortress—see Kerak.

Kíthira: island—see Cerigo.

Kiti; Kíti (modern Greek): village—K4f1: 9.

Kolossi (medieval), Kolóssi (modern Greek): fortress—K3f1: 9.

Koluri: island—see Salamis.

Kōpais Limnē—see Copais, Lake.

Korgos: port—see Corycus.

Korinthiakós Kólpos—see Corinth, Gulf of.

Kórinthos: city—see Corinth.

Korōnē, or Koróni: town—see Coron.

Kós: island—see Cos.

Kós: town—see Narangia.

Koukos: mountain—see Callidromon.

Koulourē: island—see Salamis.

Kozan: town—see Sis.

Krak de Montréal (medieval), ash-Shaubak (Arabic): fortress, now village—L1f5: 1.

Krak des Chevaliers or Le Crat (medieval), Ḥiṣn al-Akrad (Arabic: stronghold of the Kurds): fortress—L2f1: 1, 6.

Krak des Moabites, or of Moab: fortress—see Kerak.

Krētē, or Kríti; island—see Crete.

Kroia; Croia (Italian), Akche Hisar (Turkish), Krujë (Albanian): town—H5d4: 10.

Krym: peninsula—see Crimea.

Kura; Cyrus (classical): river—N5e1: 1.

Kyllēnē: mountain—see Cyllene.

Kyllēnē: town—see Glarentsa.

Kypros: island—see Cyprus.

Kyrenia; Cerines (medieval), Kerýnia (modern Greek): town—K4e5: 9.

Kythēra: island—see Cerigo.

L'Assebebe: fortress—see Subaibah.

L'Isle Adam (French): town 10 miles NNW of Paris (E3c2: 2).

La Cava: castle SE of Nicosia (K4e5: 9).

La Glisière: castle—see Vlesiri.

La Manche—see English Channel.

La Marche: district—see Marche.

La Portelle: pass—see Syrian Gates.

La Roche-sur-Ognon (French): castle in Burgundy (Fc: 2).

La Rochechenard (French): village, probably Rochechinard, 53 miles SSE of Lyons (E5c5: 2).

La Sola: town—see Salona.

Labe: river—see Elbe.

Lacedaemon, or Lakedaimōn: town—see Sparta.

Laconia (classical), Lakōnia or Lakōnikē (medieval Greek), Lakonía (modern Greek): district of SE Morea—I3e4: 10.

al-Lādhiqīyah: port—see Latakia.

Lajazzo: port—see Ayas.

Lambousa; Lámbousa (modern Greek): village—K4e5: 9.

Lamía: town—see Zeitounion.

Lamia, Gulf of, or Malian Gulf; Maliakós Kólpos (modern Greek): bay—I3e2: 10.

Lampron (Armenian), Namrun (Turkish): fortress—K5e3: 1.

Lango: island—see Cos.

Langres (French): town 70 miles ESE of Troyes (E5c2: 2).

Languedoc (French): region of southern France roughly equivalent to county of Toulouse (Ed: 2).

Laodicea ad Lycum (classical), Eskihisar (Turkish): town, now abandoned in favor of Denizli—J5e3: 1.

Laodicea ad Mare: port—see Latakia.

Lapater: town—see Neopatras.

Lardos (Greek): village—J4e4: 7.

Larissa Kremastē: castle—see Gardiki.

Larmena (medieval), Armena (medieval Greek): castle—I5e2: 10.

Larnaca; Lárnaka (modern Greek): town—K4f1: 9.

Las: castle—see Passava.

Lastic (French): village near Saint Flour, 39 miles west of Le Puy (E4c5: 2).

Latakia; Laodicea ad Mare (classical), al-Lādhiqīyah (Arabic): port—L1e5: 6.

Latrun; Laṭrūn or al-Aṭrūn (Arabic), Le Toron des Chevaliers (medieval): village—L1f4: 5.

Lausitz: region—see Lusatia.

Le Courc: port—see Corycus.

Le Crat: fortress—see Krak des Chevaliers.

Le Destroit or Pierre Encise (medieval French), Bāb al-Ajal (Arabic): fort guarding rock cleft—K5f3: 5.

Le Grand Mayne or Le Grand Magne (medieval): castle, probably at Maina but possibly at Porto Kaio (both: I3e4: 10).

Le Mans (French): city—E1c3: 2.

Le Petit Mayne (medieval French): castle, possibly at Mikrománi, 6 miles WNW of Kalamata (I3e3: 10).

Le Puy-en-Velay (French): town—E4c5: 2.

Le Toron des Chevaliers: village—see Latrun.

Le Vieil Dampierre: village—see Dampierre.

Lebadea: town—see Livadia.

Lebanon, Mount; Jabal Lubnān (Arabic)—L2f1: 5, 6.

Lefkoniko; Lefkonikó (modern Greek): town—K4e5: 9.

Léftro: castle—see Beaufort.

Leipsos: island—see Lipsos.

Lemesós: port—see Limassol.

Leon; León (Spanish): region of northern Spain—Cd: 2.

Leontes: river—see Litani.

Leros; Lero (Italian), İleros (Turkish), Léros (modern Greek): island (J2e3: 3) NW of Calymnos.

Les Andelys (French): town—E2c1: 2.

Lesh (Albanian), Lissus (classical), Alessio (Italian): town—H5d4: 10.

Leucas or Leukas (classical), Leucadia or Santa Maura (medieval), Levkás (modern Greek): island—I1e2: 3, 10.

Leuctrum: castle—see Beaufort.

Levádhia: town—see Livadia.

Levkōsia: city—see Nicosia.

Li Vaux Moysi (medieval), al-Wu'airah or Wādī Mūsâ (Arabic: the valley of Moses): town—L1f5: 1.

Lietuva: region—see Lithuania.

Limassol; Nemesos (medieval Greek), Lemesós (modern Greek): port—K4f1: 9.

Limoges (French): city—E2c5: 2.

Limonia, or Liman: island—see Alimnia.

Lindos; Líndhos (modern Greek): town—J4e4: 7.

Lipsos; Leipsos (classical), Lipso or Lisso (Italian), Kocha Papasi (Turkish), Lipsoí (modern Greek): island (J2e3: 3) NW of Leros.

Lissus: town—see Lesh.

Litani; Leontes (classical), al-Līṭānī (Arabic): river—L1f2: 5.

Lithuania; Lietuva (Lithuanian): region east of Poland, larger than modern state—IJab: 3.

Livadia; Lebadea (classical), Levádhia (modern Greek): town—I3e2: 10.

Locris (classical): district of central Greece—I3e2: 10.

Lod: town—see Lydda.

Loire (French): river—D3c3: 2.

Lombardy; Lombardia (Italian): region of NW Italy—FGcd: 2, 3.

London: city, port—D5b4: 2.

Lorraine (French), Lothringen (German): region of eastern France—Fc: 2, 3.

Lucania (medieval), Basilicata (modern Italian): region of southern Italy—Hd: 3.

Lusatia (medieval), Lausitz (German), Łużyca (Polish): region of eastern Germany and SW Poland—GHb: 3.

Lusignan (French): town—E1c4: 2.

Lydda; Saint George (medieval), al-Ludd (Arabic), Lod (Israeli): town—K5f4: 5.

Lyons; Lyon (French): city—E5c5: 2.

Macedonia (classical), Makedhonía (modern Greek), Makedonija (Serbian): region east of Albania—Id: 3, 10.

al-Maghrib: region—see North Africa.

al-Maghrib al-Aqṣâ: region—see Morocco.

Magyarország: region—see Hungary.

Maina; Máni (modern Greek): castle—I3e4: 10.

Maina; Mainē (medieval Greek), Máni (modern Greek): peninsular district—I3e4: 10.

al-Majah: village—see Modin.

Makedhonía, or Makedonija: region—see Macedonia.

Malatia, or Malatya: city—see Melitene.

Malian Gulf, or Maliakós Kólpos—see Lamia, Gulf of.

Malmesbury: town—D3b4: 2.

Malta; Melita (classical), Māliṭah (Arabic): island—G5e5: 3.

Malvasia: fortress—see Monemvasia.

Mandraki: harbor of Rhodes (8).

Máni: castle, district—see Maina.

Marash (Armenian, Turkish), Germanicia (classical), Marʿash (Arabic): town—L2e3: 1, 6.

Marche; La Marche (French): district of NW France—E2c4: 2.

Margat (medieval), al-Marqab (Arabic): fortress—L1e5: 6.

Maritsa; Hebrus (Latin), Evros (medieval Greek), Merich (Turkish): river—J2d5: 1.

Marmara, Sea of; Propontis (classical), Marmara Denizi (Turkish)—J4d5: 1.

Marseilles; Massalia (classical Greek), Massilia (Latin), Marseille (French): city, port—F1d2: 2.

Martoni (Italian): village near Carinola, 28 miles NW of Naples (G5d5: 3).

Matagrifon: castle—see Akova.

al-Mauṣil: city—see Mosul.

Mediterranean Sea—D/Ldef: 1, 2, 3, 5, 6, 7, 9, 10.

Megarid: district NE of Corinth—I4e2: 10.

Megista, or Meis: island—see Castellorizzo.

Melita: island—see Malta.

Melitene (classical), Melden (Armenian), Malatia (medieval), Malatya (Turkish): city—L4e2: 1.

Melos; Mēlos (classical Greek), Milo (medieval Italian), Degir Menlik (Turkish), Mílos (modern Greek): island—I5e4: 10.

Mendhenítsa: village—see Bodonitsa.

Meninx: island—see Jerba.

Menteshe (medieval), Mughla (modern Turkish): region of western Anatolia, equivalent to classical Caria—Je: 1, 3.

Meran: region—see Croatia.

Merich: river—see Maritsa.

Mesaoria; Mesaréa (modern Greek): plain around Lefkoniko—K4e5: 9.

Mesaréa: district—see Arcadia.

Mesopotamia (classical): region between the Euphrates and the Tigris—LMef: 1.

Messenia; Messēnē (medieval Greek), Messíni (modern Greek): district of SW Morea—I2e4: 10.

Messina (Italian): port, city—H1e2: 3.

Mestre (Italian): town 5 miles NW of Venice (G3c5: 3).

Methōnē, or Methóni: port—see Modon.

Mézières (French): town, now attached to Charleville—E5c1: 2.

Milan; Milano (Italian): city—F5c5: 2, 3.

Milly (French): village—E5c1: 2.

Mílos, or Milo: island—see Melos.

al-Minā' (Arabic): modern port in Lebanon, on site of medieval Tripoli (L1f1: 5, 6).

Minho (Portuguese), Miño (Spanish), Minyuh (Arabic): river—C2d3: 2.

Minōa: fortress—see Monemvasia.

Miṣr: region—see Egypt.

Mistra; Myzithra (medieval Greek), Mistrás (modern Greek): town—I3e3: 3, 10.

Modin; al-Majah (Arabic), Modi'im (Israeli): village, now abandoned—K5f4: 5.

Modon (medieval), Methōnē (medieval Greek), Methóni (modern Greek): port—I2e4: 3, 10.

Monemvasia; Minōa (classical Greek), Malvasia (medieval), Monemvásia (modern Greek): fortress, now town—I4e4: 10.

Monferrato: district—see Montferrat.

Monolithos; Monólithos (modern Greek): town—J3e4: 7.

Monreale (Italian): town—G4e2: 3.

Mont Escové (medieval), Pendeskouphi (medieval Greek): fortress 2 miles SW of Corinth (I3e3: 10).

Montaigu-sur-Champeix or Montaigut-le-Blanc (French): castle—E4c5: 2.

Monte Cassino (Italian): abbey 75 miles ESE of Rome (G3d4: 2, 3).

Monte Croce (Italian): village near Florence (G2d2: 2, 3).

Monteil-au-Vicomte (French): village 50 miles WNW of Le Mans (E1c3: 2).

Montferrat (French), Monferrato (Italian): district of NW Italy—F4c5: 2, 3.

Montfort (French), Starkenberg (German), Qal'at al-Qurain (Arabic): castle—L1f2: 5.

Montlhéry (French): village—E3c2: 2.

Montmirel (French): village near Canisy, 60 miles WSW of Graville (E1c1: 2).

Montréal (medieval): fief surrounding Krak de Montréal (L1f5: 1, 5).

Moravia; Morava (Czech): region SE of Bohemia—Hc: 3.

Morea (medieval), Peloponnesus (classical), Peloponnēsos or Moreas (medieval Greek), Pelopónnisos (modern Greek): peninsular region of southern Greece—Ie: 3, 10.

Morocco; al-Maghrib al-Aqṣâ (Arabic: the farthest west): region of NW Africa—CDef: 2.

Morphou; Mórphou (modern Greek): town—K3e5: 9.

Morted: island—see Ceos.

Moselle (French), Mosel (German): river—F3b5: 2.

Mosul; al-Mauṣil (Arabic), Musul (Turkish): city—M4e4: 1.

Moulki; Moúlki (modern Greek): village—I4e2: 10.

Moutoullas; Moutoullás (modern Greek): village—K3f1: 9.

Msailha (medieval), Musailah (Arabic): castle—L1f1: 5, 6.

Mughla: region—see Menteshe.

Musul: city—see Mosul.

Myra (classical), Eynihal (Turkish): town, now abandoned for Finike—J5e4: 1.

Myzithra: town—see Mistra.

Nabî' Samwīl (Arabic: prophet Samuel): village—L1f4: 5.

Nablus; Shechem or Neapolis (classical), Nābulus (Arabic): town—L1f3: 5.

Naillac (French): chateau at Le Blanc, 50 miles north of Limoges (E2c5: 2).

Naksa: island—see Naxos.

Namrun: fortress—see Lampron.

Naples; Napoli (Italian): city, port—G5d5: 3.

Narangia (medieval), Kós (modern Greek): town on north coast of Cos (J3e4: 3).

Narda: town—see Arta.

an-Nāṣirah: town—see Nazareth.

Nauplia (classical), Návplion (modern Greek): port—I3e3: 10.

Navarino, Old Navarino, or Zonklon (medieval), Pylos (classical Greek): port, now superseded by New Navarino—I2e4: 10.

Navarino, New (medieval), Neokastron (medieval Greek: new castle), Pílos (modern Greek): port—I2e4: 10.

Navarre; Navarra (Spanish): region of northern Spain—Dd: 2.

Naxos; Nicosia (medieval Italian), Naksa (Turkish), Náxos (modern Greek): island—J1e3: 3.

Nazareth; an-Nāṣirah (Arabic): town—L1f3: 5.

Neapolis: town—see Nablus.

Negroponte: island—see Euboea.

Negroponte (medieval Italian: black bridge), Chalcis (classical), Khalkís (modern Greek): town—I4e2: 3, 10.

Nemesos: port—see Limassol.

Neokastron: port—see Navarino, New.

Neopatras or Lapater (medieval), Hypatē (classical Greek), Ipáti (modern Greek): town—I3e2: 10.

Neuilly-sur-Marne (French): town—E3c2: 2.

Nicaea (classical), İznik (Turkish): town—J5d5: 1, 3.

Nicopolis (classical), Nikopol (Bulgarian): town—I5d2: 1, 3.
Nicopolis: village—see Emmaus.
Nicosia; Levkōsia (medieval Greek), Nicosía (modern Greek): city—K4e5: 9.
Nicosia: island—see Naxos.
Nile; Baḥr an-Nīl (Arabic): river—K3f4: 1, 3.
Niort (French): town—D5c4: 2.
Nistru: river—see Dniester.
Nisyros; Nisiro (Italian), İnjirli (Turkish), Nísiros (modern Greek): island SW of Cos (J3e4: 3).
Nivelet (medieval): fief in Messenia assigned to the lord of Geraki after Geraki itself was lost.
Normandy; Normandie (French): region of northern France—DEc: 2.
North Africa: al-Maghrib (Arabic: the west): region from Morocco to Cyrenaica, north of the Sahara.
North Sea—DEFab: 2, 3.
Norway; Norge (Norwegian): region west of Sweden—not in area mapped.
Novara (Italian): town—F4c5: 2, 3.

Oberpfalz: region—see Palatinate, Upper.
Oder (German), Odra (Czech, Polish): river—G5b2: 2, 3.
Oldenburg (German): city—F4b2: 2, 3.
Olives, Mount of, or Olivet; Jabal aṭ-Ṭūr (Arabic): hill east of Jerusalem (L1f4: 1, 5).
Ophel, Mount: hill SE of Jerusalem—4.
Orontes (classical), al-ʿĀṣī (Arabic): river—L1e4: 5, 6.
Ostmark: region—see Austria.

Padua; Padova (Italian): city—G2c5: 2, 3.
Pagasitikós Kólpos—see Volos, Gulf of.
Pagrae: town—see Baghrās.
Palaestina: region—see Palestine.
Palaiokastrítsa: castle—see Sant' Angelo.
Palatinate; Pfalz (German): region of western Germany—Fc: 2, 3.
Palatinate, Upper: Oberpfalz (German): region of southern Germany—Gc: 3.
Palermo (Italian), Balarm (Arabic): city, port—G4e2: 3.
Palestine; Palaestina (classical), Filisṭīn (Arabic): region west of the Dead Sea and Jordan—KLf: 1, 5.
Paliri (medieval): castle on west coast of Naxos (J1e3: 3).
Palmyra or Tadmor (classical), Tadmur, now Tudmur (Arabic): caravan town—L4f1: 1, 6.
Pamphilon (medieval), Uzunköprü (Turkish): town—J2d4: 1.
Pamphylia: region—see Tekke.
Pamphylia Bay, or Gulf of Antalya—K2e4: 1.
Paneas: town—see Banyas.
Paphos; Páphos (modern Greek): town—K3f1: 9.
Paradisi, Mount; Paradísi (modern Greek)—J4e4: 7.
Paris (French): city—E3c2: 2.
Paros; Paro (medieval Italian), Bara (Turkish), Páros (modern Greek): island (J2e3: 3) west of Lipsos.

Passava, or Passavant (medieval), Las (medieval Greek): castle—I3e4: 10.

Patmos; Patmo (Italian), Batnos (Turkish), Pátmos (modern Greek): island (J2e3: 3) west of Lipsos.

Patras (medieval), Pátrai (modern Greek): port, city—I2e2: 3, 10.

Pavia (Italian): town—F5c5: 2, 3.

Pēdēma: village—see Pidhima.

Pedhoulas; Pedoulá or Pedhoulás (modern Greek): town—K3f1: 9.

Pedias; Pediás (modern Greek): river—K3e5: 9.

Pelagonia (classical): district of NW Macedonia—I2d4: 10.

Pelendria; Peléndria (modern Greek): town—K3f1: 9.

Pelinnaeon: castle—see Gardiki.

Pelion, Mount; Pílion (modern Greek)—I4e1: 10.

Peloponnesus, or Pelopónnisos: peninsula—see Morea.

Pendeskouphi: fortress—see Mont Escové.

Perigord; Périgord (French): district south of Limoges—E1c5: 2.

Persia; Īrān (Persian): region of SW Asia—Nf: 1.

Pescia (Italian): town—G1d2: 3.

Petite Mahomerie: fortress—see al-Qubaibah.

Petra Deserti (classical): ancient city 2 miles WSW of Wādī Mūsâ ("Li Vaux Moysi," L1f5: 1).

Petrela; Petrelë (Albanian): town—H5d4: 10.

Petroúnion: town—see Bodrum.

Pfalz: region—see Palatinate.

Pharae: town—see Kalamata.

Pharygae: village—see Bodonitsa.

Pheraclos; Feraklos (modern Greek): castle, now village—J4e4: 7.

Phileremos; Filírimos (modern Greek): hilltop castle—J4e4: 7.

Phocis (classical), Fokís (modern Greek): district north and west of Lake Copais—I3e2: 10.

Piave (Italian): river—G3c5: 2.

Pidhima; Pēdēma (medieval Greek), Pídhima (modern Greek): village—I3e3: 10.

Piedmont; Piemonte (Italian): region of NW Italy—Fcd: 2.

Pierre Encise: fort—see Le Destroit.

Pili; Pyli (classical), Pilí (modern Greek): town on north coast of Cos (J3e4: 3).

Pílion—see Pelion, Mount.

Pílos: port—see Navarino, New.

Pirineos: mountain range—see Pyrenees.

Piscopi: island—see Telos.

Pisidia (classical): region north of Pamphylia (Tekke, JKe: 1, 3).

Plaimpied (French): village—E3c3: 2.

Platamon or Platamona (medieval), Platámon (modern Greek): port, now village—I3e1: 10.

Poggibonsi (Italian): town 14 miles NW of Siena (G2d2: 3).

Polakia or Polacchia (medieval), Apolakkiá (modern Greek): town—J3e4: 7.

Poland; Polska (Polish): region east of Germany—HIb: 3.

Pomerania; Pommern (German): region of NE Germany—GHb: 2, 3.

Pontikókastron: castle—see Beauvoir.

Porţile de Fier: gorge—see Iron Gate.

Porto Kaio; Pórto Káyio (modern Greek): village—I3e4: 10.

Portugal: region, now nation—Cde: 2.
Potamiou; Potamioú (modern Greek): village—K4e5: 9.
Propontis—see Marmara, Sea of.
Provence (French): region of SE France—EFd: 2, 3.
Prussia; Preussen (German), Prusy (Polish): region of NE Germany—HIab: 3.
Ptolemaïs: city—see Acre.
Puglia, or Puglie: region—see Apulia.
Pulcheriopolis: town—see Berat.
Pylae: pass—see Thermopylae.
Pyli: town—see Pili.
Pylos: port—see Navarino.
Pyramus (classical), Jeyhan (Turkish): river—L1e4: 6.
Pyrenees; Pyrénées (French), Pirineos (Spanish): mountain range—DEd: 2.
Pyrga; Pyrgá (modern Greek): town—K4f1: 9.

al-Qāhirah: city—see Cairo.
Qaiṣārīyah: port—see Caesarea.
Qal'at Abū-l-Ḥasan: village—see Belhacem.
Qal'at al-Mahalbah: village—see Balāṭunus.
Qal'at al-Muḍīq: town—see Apamea.
Qal'at al-Qurain: castle—see Montfort.
Qal'at ar-Rūm: fortress—see Hromgla.
Qal'at ash-Shaqīf: castle—see Belfort.
Qal'at az-Zau: castle—see Cursat.
Qal'at Barzah: castle—see Bourzey.
Qal'at Yaḥmur: fortress—see Chastel-Rouge.
al-Qanṭarah: town—see Kantara.
Qaryat al-'Inab or Abū-Ghosh (Arabic): village—L1f4: 5.
Qashtālah: region—see Castile.
Quarantine, Mount of: hill east of Jerusalem (L1f4: 1, 5).
al-Qubaibah (Arabic), Petite Mahomerie (medieval): fortress, now village—L1f4:
 5.
al-Quds: city—see Jerusalem.
al-Qulai'ah: fortress—see Coliat.
Quṣair: castle—see Cursat.

Ramatha (medieval), Kafr Jinnis (Arabic): abbey—K5f4: 5.
Ramla; Rama or Rames (medieval), ar-Ramlah (Arabic: the sandy): town—K5f4:
 5.
Ranculat: fortress—see Hromgla.
Rangia: village—see Villeneuve.
Ravenna (Italian): port, now town, 64 miles NE of Florence (G2d2: 2, 3).
Red Sea; al-Baḥr al-Aḥmar (Arabic)—Lgh: 1.
Rheims; Reims (French): city—E5c1: 2.
Rhine; Rijn (Dutch), Rhin (French), Rhein (German): river—E5b4: 2, 3.
Rhodes; Rhodus (Latin), Rhodos (classical Greek), Ródhos (modern Greek):
 city, port—J4e4: 7, 8.
Rhodes; Rhodus (Latin), Rhodos (classical Greek), Rodos (Turkish), Rodi
 (Italian), Ródhos (modern Greek): island—Je: 1, 3, 7.

Ridefort (French): chateau, location unknown.

ar-Rīhā: town—see Jericho.

Rijn: river—see Rhine.

Ripoll (Catalan): town 48 miles east of Boxolis (E2d3: 2).

Rochas: city—see Edessa.

Rochechouart (French): town 20 miles west of Limoges (E2c5: 2).

Rochefort (French): castle, possibly Bourzey (L2e5: 6).

Roda del Ter (Catalan): town 56 miles ESE of Boxolis (E2d3: 2).

Ródhos, Rodos, or Rodi: city, island—see Rhodes.

Rome; Roma (Italian): city—G3d4: 2, 3.

Rossiya: region—see Russia.

Rouen (French): city—E2c1: 2.

Ruad; Aradus (classical), Arwād or Ruwād (Arabic): island—L1f1: 6.

ar-Ruhā', or Roucha: city—see Edessa.

Rūm: region—see Anatolia.

Rum Kalesi: fortress—see Hromgla.

Russia; Rus (medieval), Rossiya (Russian): region of eastern Europe—JKab: 1, 3.

Ruthenia (medieval): eastern Galicia, not equivalent to modern Czechoslovak province—IJc: 3.

Ruwād: island—see Ruad.

Sabastīyah: village—see Sebastia.

Sachsen: region—see Saxony.

Safad; Saphet (medieval), Safad (Arabic), Tsefat (Israeli): town—L1f3: 5.

Saffūrīyah (Arabic), Sepphoris or Dio Caesarea (classical), Sephorie (medieval), Tsippori (Israeli): town—L1f3: 5.

Sāfīthā (Arabic): village just west of Chastel-Blanc (L2f1: 6).

Sagette, Sagitta, or Saidā': port—see Sidon.

Sahara; as-Sahrā' (Arabic): desert—DEFGfg: 2.

Sahyūn: castle—see Saone.

Sailūn: plain—see Shiloh.

Saint Abraham: town—see Hebron.

Saint Aventin (French): village—E1d3: 2.

Saint Denis (French): town—E3c2: 2.

Saint George: town—see Lydda.

Saint Gilles-du-Gard (French): town—E5d2: 2.

Saint Hilarion or Dieudamour (medieval), Áyios Ilárion (modern Greek): castle—K4e5: 9.

Saint John, or Saint Jean d'Acre: city—see Acre.

Saint Omer: castle on the Cadmea, above Thebes (I4e2: 10).

Saint Omer (French), Santaméri (modern Greek): castle—I2e3: 10.

Saint Omer (French): town—E3b5: 2.

Saint Peter: castle at Bodrum (J3e3: 3).

Saint Peter: castle at Smyrna (J3e2: 1, 3).

Saint Simeon (medieval), as-Suwaidīyah (Arabic), Süveydiye (Turkish): port—L1e4: 6.

Saintes (French): town—D5c5: 2.

Sakartvelo: region—see Georgia.

Sakîz: island—see Chios.

Salamis (classical), Kouloure͞ (medieval Greek), Koluri (Turkish), Salamís (modern Greek): island—I4e3: 10.

Saleph: river—see Calycadnus.

aṣ-Ṣāliḥīyah (Arabic): suburb north of Damascus (L2f2: 1, 5).

Salona or La Sola (medieval), Amphissa (classical Greek), Amfíssa (modern Greek): town—I3e2: 10.

Salonika: city—see Thessalonica.

Salzburg (German): city 175 miles SE of Bamberg (G1c1: 3).

Samaria: district of northern Palestine—L1f3: 5.

Samaria: village—see Sebastia.

San Severino Lucano (Italian): village—H2d5: 3.

Sant' Angelo (medieval), Palaiokastrítsa (modern Greek): castle on Corfu—H5e1: 10.

Santa Maura: island—see Leucas.

Santaméri: castle—see Saint Omer.

Santo Domingo de Silos: town—see Silos.

Saone (medieval), Sigon (classical), Ṣahyūn or Ṣihyaun (Arabic): castle—L2e5: 6.

Saphet: town—see Safad.

Sardica: city—see Sofia.

Sardinia; Sardegna (Italian): island—Fde: 2, 3.

Sarmadā (Arabic): village—L2e4: 6.

Saronic Gulf: Saronikós Kólpos (modern Greek)—I4e3: 10.

Sarus (classical), Seyhan (Turkish): river—K5e4: 6.

Sarvantikar; Sarouantiḳar (Armenian): fortress—L2e3: 6.

Satalia: port—see Adalia.

Satines: city—see Athens.

Savoy; Savoie (French): region of SE France—F2c5: 2, 3.

Saxony; Sachsen (German): region of northern Germany—Gb: 2, 3.

Scandelion or Escandelion (medieval): castle—L1f2: 5.

Scandelore: port—see Alaya.

Scarpanto: island—see Carpathos.

Schachten (German): village, probably in Hesse (Fb: 2, 3).

Schlesien: region—see Silesia.

Schwaben: region—see Swabia.

Scio: island—see Chios.

Scotland: region north of England—CDa: 2.

Scutari (Italian), Scodra (classical), Shkodër (Albanian): port—H5d3: 3.

Scythopolis: town—see Baisan.

Sebastia (medieval), Samaria (classical), Sabasṭīyah (Arabic): village—L1f3: 5.

Sedot Yam: port—see Caesarea.

Segna (Italian), Senj (Croatian): port—G5d1: 3.

Seine (French): river—E1c1: 2.

Selef: river—see Calycadnus.

Seleucia Trachea (classical), Selevgia (Armenian), Silifke (Turkish): port, now town—K4e4: 1.

Sepphoris, or Sephorie: town—see Saffūrīyah.

Serbia; Srbija (Serbian): region east of Dalmatia—HId: 3.

Servia; Sérvia (modern Greek): town—I2d5: 10.

Seyhan: river—see Sarus.

Shaftesbury: town 40 miles west of Winchester (D4b4: 2).

ash-Sha'm: city—see Damascus.

ash-Sha'm: region—see Syria.

Shaqīf Arnūn: castle—see Belfort.

Shaqīf Tīrūn: fortress—see Tyron.

ash-Shaubak: fortress—see Krak de Montréal.

Shechem: town—see Nablus.

Shiloh; Sailūn (Arabic): plain—L1f3: 5.

Shkodër: port—see Scutari.

Shqipni, or Shqipri: region—see Albania.

Shughr Baqās (Arabic): village, formerly forts of Baqās and ash-Shughr—L2e5: 6.

Sicily; Sicilia (Italian), Ṣiqillīyah (Arabic), Trinacria (medieval): island—Ge: 2, 3.

Siderokastron (medieval), Heraclea (classical), Sidhirókastron (modern Greek: castle of iron): castle—I3e2: 10.

Siderokastron or Castel de Fer (medieval), Sidhirókastron (modern Greek): castle, now town—I2e3: 10.

Sidon; Ṣaidā' (Arabic), Sagette or Sagitta (medieval): port—L1f2: 1, 5.

Siebenbürgen: region—see Transylvania.

Siena (Italian): town—G2d2: 2, 3.

Sigena (Spanish): convent 70 miles WSW of Boxolis (E2d3: 2).

Sigon, or Ṣihyaun: castle—see Saone.

Sigouri; Sígouri (modern Greek): castle—K4e5: 9.

Silesia; Schlesien (German), Ślask (Polish), Slezsko (Czech): region north of Moravia—Hb: 3.

Silifke: port—see Seleucia.

Siloam; 'Ain Silwān (Arabic): pool south of Mount Ophel—4.

Silos, now Santo Domingo de Silos (Spanish): town 80 miles SW of Heredia (D3d3: 2).

Silpius, Mount (classical), Ziyaret Daghî (Turkish)—L2e4: 6.

Sími: island—see Syme.

Sinai; Sīnā' (Arabic): peninsula—Kfg: 1.

Sinai, Mount, or Mount Horeb; Jabal Mūsâ (Arabic: mountain of Moses)—K4g2: 1.

Sinus Issicus—see Alexandretta, Gulf of.

Sion or Zion, Mount: hill south of Jerusalem—4.

Ṣiqillīyah: island—see Sicily.

Sis (Armenian, medieval), Kozan (Turkish): town—L1e3: 1, 6.

Skorta; Gortys (classical Greek), Skortá (medieval Greek): district of central Morea—I3e3: 10.

Ślask, or Slezsko: region—see Silesia.

Slovakia; Slovensko (Slovakian): region east of Moravia—HIc: 3.

Smith, Mount—see Stephanos, Mount.

Smyrna (classical, medieval), İzmir (Turkish): city, port—J3e2: 1, 3.

Sofia; Sardica (classical), Sofiya (Bulgarian): city—I4d3: 3.

Solun: city—see Thessalonica.

Spain; Hispania (classical), España (Spanish): region south of the Pyrenees—CDEde: 2.

Sparta or Lacedaemon (Latin), Spartē or Lakedaimōn (classical Greek), Spárti (modern Greek): town–I3e3: 10.

Srbija: region–see Serbia.

Stampalia: island–see Astypalaea.

Stanchio, or Stankoi: island–see Cos.

Starkenberg: castle–see Montfort.

Stavrovouni; Stavrovoúni (modern Greek): mountain–K4f1: 9.

Stazousa; Stázousa (modern Greek): village, now part of Kalokhorio–K4f1: 9.

Stephanos, Mount, or Mount Smith–J4e4: 7.

Stymphalia (classical), Stimfalía (modern Greek): village 1 mile SW of Zaraca (I3e3: 10).

Styria; Steiermark (German): region of southern Austria–HIc: 3.

Subaibah (Arabic), L'Assebebe (medieval): fortress–L1f2: 5.

Suchem (German): parish, probably Sudheim, 11 miles SE of Paderborn.

Sudan; as-Sūdān (Arabic): region south of Egypt–Kh: 1.

Sumbeki: island–see Syme.

Ṣūr: port–see Tyre.

Sūriyah: region–see Syria.

Sūs (Arabic): region of western Morocco–Cf: 2.

as-Suwaidīyah, or Süveydiye: port–see Saint Simeon.

Swabia; Schwaben (German): region of SW Germany–G1c2: 3.

Syme; Symē (classical Greek), Simi (medieval Italian), Sumbeki (Turkish), Sími (modern Greek): island (J3e4: 3) WNW of Rhodes city.

Syria (classical), ash-Sha'm or Sūriyah (Arabic): region–Lef: 1, 6.

Syrian Gates; La Portelle (medieval), Touṛn (Armenian), Belen Boghazi (Turkish): pass over the Amanus range–L2e4: 6.

Ṭabarīyah: town–see Tiberias.

Tabor, Mount; Jabal Tābūr or Jabal aṭ-Ṭūr (Arabic), Tavor (Israeli)–L1f3: 5.

Tadmor, or Tadmur: town–see Palmyra.

Tagus (classical), Tajo (Spanish), Tejo (Portuguese), Tājuh (Arabic): river–C1e2: 2.

at-Tall aṣ-Ṣāfiyah: castle–see Blanche Garde.

Tall Ḥamdūn (Arabic), Tilhamdoun (Armenian), Toprakkale (Turkish): castle, now village)L1e4: 6.

Tanaïs: river–see Don.

Ṭarābulus ash-Sha'm: city–see Tripoli.

Tarsus (classical, Turkish), Darsous (Armenian): town–K5e4: 1.

Ṭarṭūs: port–see Tortosa.

Taurus (classical), Toros Daghlari (Turkish): mountain range–KLe: 1.

Tavor–see Tabor, Mount.

Tēganion: village–see Tigani.

Tejo: river–see Tagus.

Tekke (Turkish): region of SW Anatolia, equivalent to classical Pamphylia–JKe: 1, 3.

Telos; Piscopi (Italian), İliaki (Turkish), Tílos (modern Greek): island–J3e4: 3.

Terre oultre le Jourdain: fief–see Montréal.

Tevere: river–see Tiber.

Thabaria, or Tevarya: town—see Tiberias.

Thebes; Thēvai (classical Greek), Estives (medieval), Thívai (modern Greek): city—I4e2: 3, 10.

Thermaic Gulf, or Gulf of Salonika; Thermaïkós Kólpos (modern Greek)—I3d5: 10.

Thermopylae (classical), Pylae (medieval), Thermopílai (modern Greek): pass—I3e2: 10.

Thessalonica (medieval), Therma (classical), Solun (Macedonian), Salonika (Italian), Thessaloníki (modern Greek): city, port—I3d5: 3, 10.

Thessaly; Thessalia (classical), Vlachia (medieval), Thessalía (modern Greek): region of northern Greece—Ie: 3, 10.

Thēvai, or Thívai: city—see Thebes.

Thrace; Thracia (Latin), Thrakē (classical Greek), Thráki (modern Greek), Trakya (Turkish): region south of Bulgaria—Jd: 1, 3.

Thuringia; Thüringen (German): region of central Germany—Gb: 2, 3.

Thymiana (Greek): village on east coast of Chios (J2e2: 3).

Tiber; Tevere (Italian): river—G3d4: 2, 3.

Tiberias; Thabaria (medieval), Ṭabarīyah (Arabic), Tevarya (Israeli): town—L1f3: 5.

Tiberias, Lake, or Sea of Galilee; Buḥairat Ṭabarīyah (Arabic), Yam Kinneret (Israeli)—L1f3: 5.

Tigani; Tēganion (classical Greek), Tigáni (modern Greek): village—I3e4: 10.

Tigris (classical), Dijlah (Arabic), Dijle (Turkish): river—N4f5: 1.

Tilbury: town—now part of Thurrock—E1b4: 2.

Tílos: island—see Telos.

Tintern: abbey—D3b4: 2.

Toprakkale, or Tilhamdoun: castle—see Tall Ḥamdūn.

Toron (medieval): fortress—L1f2: 5.

Toros Daghları: mountain range—see Taurus.

Torre de' Passeri (Italian): town—G4d3: 3.

Tortosa; Antaradus (classical), Anṭarṭūs or Ṭarṭūs (Arabic): port—L1f1: 6.

Toscana: region—see Tuscany.

Toulouse (French): county—Ed: 2.

Tourn: pass—see Syrian Gates.

Tournai (French), Doornijk (Flemish): town—E4b5: 2.

Tours (French): city—E1c3: 2.

Trakya: region—see Thrace.

Transylvania; Siebenbürgen (German), Erdély (Hungarian), Ardeal (Rumanian): region SE of Hungary—IJc: 1, 3.

Trave (German): river—G1b2: 3.

Trémolay or Dramelay (French): village—F1c4: 2.

Treviso (Italian): town 16 miles NNW of Venice (G3c5: 3).

Trikkala; Tricca (classical), Tríkkala (modern Greek): town—I2e1: 10.

Trinacria: island—see Sicily.

Triphylia (classical), Trifília or Fília (modern Greek): district of western Morea—I2e3: 10.

Tripití: village—see Bitsibardi.

Tripoli; Tripolis (classical), Ṭarābulus ash-Sha'm (Arabic): city, port—L1f1: 1, 5, 6.

Tripolitania: region east of Tunisia—GHfg: 3.

Troödos; Tróodos (modern Greek): mountain—K3f1: 9.

Troyes (French): town—E5c2: 2.

Trypētē: village—see Bitsibardi.

Tsefat: town—see Safad.

Tsippori: town—see Saffūrīyah.

Tudmur: town—see Palmyra.

Tunisia; Ifrīqiyah (Arabic): region of North Africa—FGef: 2, 3.

Tuscany; Toscana (Italian): region of central Italy—Gd: 2, 3.

Tyras: river—see Dniester.

Tyre; Tyrus (classical), Ṣūr (Arabic): port—L1f2: 1, 5.

Tyron (medieval), Shaqīf Tīrūn (Arabic): cave fortress—L1f2: 5.

Tziá: island—see Ceos.

al-Urdunn: river—see Jordan.

Urfa: city—see Edessa.

Ustrapalia: island—see Astypalaea.

Utrecht (Dutch): city—F1b3: 2, 3.

Uzunköprü: town—see Pamphilon.

Vahka; Vahga (Armenian), Feke (Turkish), fortress, now town—L1e3: 1.

Valachia: region—see Wallachia.

Valania (medieval), Bulunyās (medieval Arabic), Bāniyās (modern Arabic):
port—L1e5: 6.

Valenciennes (French): town—E4b5: 2.

Valona: port—see Avlona.

Varosha or Varoshia; Varósha (modern Greek): suburb SE of Famagusta—K4e5:
9.

Venice; Venezia (Italian): city, port—G3c5: 2, 3.

Verona (Italian): city—G2c5: 3.

Via Egnatia (medieval): road across the Balkans from Durazzo to Constan-
tinople—HIJd: 10.

Viennois (French); district of SE France now called Dauphiné—EFcd: 2.

Villaret (French): village near St. André-de-Majencoules, 45 miles NW of Saint
Gilles (E5d2: 2).

Villehardouin (French): castle near Troyes (E5c2: 2).

Villeneuve (French): town, probably Villeneuve-lès-Avignon, 1 mile NW of
Avignon (E5d2: 2).

Villeneuve (French), Rangia (medieval): village on slope of Mount Paradisi
(J4e4: 7).

Vistula; Wisła (Polish), Weichsel (German): river—H4b1: 3.

Vitry-en-Artois (French): village 26 miles SW of Tournai (E4b5: 2).

Vittoriosa: town—see Birgu.

Vlaanderen: region—see Flanders.

Vlachia: region—see Thessaly, Wallachia.

Vlesiri, Vlisiri, or La Glisière (medieval): castle, possibly at modern Besere, 7
miles NNE of Katakolon (I2e3: 10).

Vlonë, or Vlorë: port—see Avlona.

Voiotía: district—see Boeotia.

Volga (Russian), Itil (Tatar): river—N3c4: 1.
Volos, Gulf of; Pagasētikos Kolpos (classical and medieval Greek), Pagasitikós
 Kólpos (modern Greek)—I3e1: 10.

al-Wādī al-Kabīr: river—see Guadalquivir.
Wādī al-Qilt (Arabic): valley wsw of Jericho (L1f4: 5).
Wādī Ānah: river—see Guadiana.
Wādī ar-Rabābī: valley—see Hinnom.
Wādī as-Sīyāḥ (Arabic): valley south of Mount Carmel (K5f3: 5).
Wādī Mūsâ: town—see Li Vaux Moysi.
Wales; Cymru (Welsh): region west of England—Db: 2.
Wallachia; Vlachia (medieval), Valachia (Rumanian); region north of Bulgaria—
 IJd: 1, 3.
Weichsel: river—see Vistula.
Weser (German): river—F3b2: 3.
Westminster: abbey and quarter in London (D5b4: 2).
Westphalia; Westfalen (German): region of NW Germany—Fb: 2, 3.
Winchester: city—D4b4: 2.
Wisła: river—see Vistula.
Wittenberg (German): town—G3b4: 3.
al-Wuʿairah: town—see Li Vaux Moysi.
Württemberg (German): region of SW Germany—Fc: 2, 3.
Würzburg (German): city—F5c1: 2, 3.

Yabnâ, or Yavne: village—see Ibelin.
Yāfā, or Yafo: port—see Jaffa.
Yam Hamelah—see Dead Sea.
Yam Kinneret—see Tiberias, Lake.
Yeráki: town—see Geraki.
Yeroskipos; Yeroskípou (modern Greek): village—K3f1: 9.
Yerushalayim: city—see Jerusalem.
Yimnón: village—see Gymnos.
Yumurtalik: port—see Ayas.

Zagreb, or Zágráb: city—see Agram.
Zante (Italian), Zacynthus (classical), Zákinthos (modern Greek): island—I1e3:
 10.
Zaraca (classical), Kionia (medieval), Koióni (modern Greek): village—I3e3: 10.
Zea: island—see Ceos.
Zeitounion; Lamia (classical), Gitonis or Citó (medieval), Zitouni (medieval
 Greek), Lamía (modern Greek): town—I3e2: 10.
Zion, Mount—see Sion, Mount.
Ziyaret Daghỉ—see Silpius, Mount.
Zonklon: port—see Navarino.
az-Zuqāq—see Gilbraltar, Strait of.

INDEX

COMPOSED BY THE COMPOSING ROOM, GRAND RAPIDS, MICHIGAN
MANUFACTURED BY NORTH CENTRAL PUBLISHING CO., MINNEAPOLIS, MINNESOTA
TEXT IS SET IN PRESS ROMAN, DISPLAY LINES IN GARAMOND

Library of Congress Cataloging in Publication Data (Revised)
Setton, Kenneth Meyer, 1914–
A history of the Crusades.
Bibliographical footnotes.
CONTENTS: v. 1. The first hundred years, edited
by M. W. Baldwin.–v. 2. The later Crusades, 1189–
1311, edited by R. L. Wolff and H. W. Hazard.–
v. 3. The fourteenth and fifteenth centuries, edited
by H. W. Hazard.–v. 4. The art and architecture
of the Crusader states, edited by H. W. Hazard.
1. Crusades. I. Title.
D157.S482 940.1'8 68-9837
ISBN 0-299-06820-X (v.4)

A History of the Crusades

Volumes I–IV

ADDENDA & CORRIGENDA

Titles of volumes IV, V, and VI, on pages ii of volumes I and II, should read *The Art and Architecture of the Crusades, The Impact of the Crusades on Islam and Christendom,* and *An Atlas and Gazetteer of the Crusades, with Bibliography.*

All maps in the series, including those of volumes I and II, have been compiled by Harry W. Hazard and executed by the Cartographic Laboratory at the University of Wisconsin, Madison.

Volume I

Page x Under XVII: *for* Amalric I *read* Amalric (also in title, page 528; in headings of odd pages 529–561; in text, page 548, line 18; page 624, under 1163; and page 669, under Amalric I)

Page xi Line 7: *for* Alexius I Comnenus *read* Alexius Comnenus (also in caption, page 342)

Page xxxi Under *MPG, PG*: delete *MPG,*; *for* 161 vols. *read* 167 vols.

Under *MPL, PL*: delete *MPL,*; *for* 1844 *read* 1841

Page 501 Line 30: *for* accomodation *read* accommodation

Page 636 Under Corfu: *for* Corfu (Italian) *read* Corfu; Corfù (Italian)

Page 659 Under Speyer: *for* Spires *read* Spire

Page 662 Under Tuy: *for* Tuy (Spanish) *read* Tuy; Túy (Spanish)

Under Vistula: *for* Wisla *read* Wisła (also page 663, under Wisla); *for* HIb *read* H4b1

Page 667 Under 'Abbādids: *for* 1068–1091 *read* 1069–1091 (also page 693, under al-Mu'tamid)

Page 704 Under Toulouse: *for* II *read* 11

Volume II

Page xxiii Under *BAS*: *for* Michele Amari, *Biblioteca arabo-sicula, read Biblioteca arabo-sicula,* ed. Michele Amari

Under *PG*: *for* 161 vols. *read* 167 vols.

Under *PL*: *for* 1844 *read* 1841

Page 45 Footnote, line 26: *for* C. W. Wilson *read* C. R. Conder

Opp. page 123 Map 6, J1d4: *move* VOLERON northwestward, above small bay; I5d5, *delete* Mount Caryae

Page 147 Line 12: *for* in 1186 *read* in 1187 (also page 201, lines 28–29)

Page 162 Line 30: *for* 94,000 *read* 84,000

Page 164 Line 21: *for* in 1180 *read* in 1179

Page 165 Line 24: *for* king *read* ruler

Page 172 Note 49, line 2: *delete* in July 1201; lines 4–6: *for* there is . . . reject the passage *read* the date of this consecration is not certain, but leans toward 1202, while following Cerone in connecting 1201 with an archbishop Siegfried of Magdeburg (who seems never to have existed; Ludolph of Kroppenstedt held the see from 1192 to 1205). Cerone and Faral reject the use of this passage to support 1201;

1

Page 180 Line 14: *for* August 23 *read* August 25

Page 201 Line 15: *for* Angelus Comnenus *read* (Angelus) "Comnenus" (also page 236, line 2)

Page 203 Line 28: *for* kingdom *read* lordship (also page 206, line 15; page 238, line 22)

Page 206 Line 18: *for* of the kingdom *read* of Romania

Page 210 Line 14: *for* 1214 *read* 1215 (also in next line and page 242, line 5)

Page 214 Line 1: *for* nephew-in-law *read* stepnephew-in-law

Line 36: *for* purple *read* purple in 1225

Page 217 Line 26: *for* (1230–1236) *read* (1230–1237)

Page 222 Line 24: *for* ten years *read* seven years

Lines 27–28: *for* (1236–1244) *read* (1237–1244)

Page 226 Line 11: *for* (1236–1271) *read* (1231–*c.* 1267)

Opp. page 227 Map 10: brown shadings should be as on map 9, overleaf

Opp. page 235 Map 11: *insert* Gulf of Volos (I3e1); *delete* Cephissus (I3e2), Daphne (I3e3), Mount Caryae (I5d5); *move* Vostitsa (I2e2) ENE near coast, Geraki (I2e3) southeastward ESE of Sparta, St. George (I2e3) southeastward near Crèvecoeur, *and* Makriplagi (I4e2) southwestward ENE of Arcadia

Page 236 Line 7: *for* king *read* lord (also page 240, line 17)

Page 240 Line 29: *for* Angelus Comnenus *read* Ducas (Angelus) "Comnenus" (also page 259, line 38; page 266, line 26; page 271, line 1)

Page 244 Line 1: *for* In *read* In or before

Page 245 Line 28: *for* Grapella of Verona *read* Grapella dalle Carceri

Lines 29–31: *replace with* Carceri, sister of Narzotto, who died without issue in 1255. In

Line 32: *delete* however,

Line 35: *delete* which had belonged to his wife and

Page 246 Line 16: *for* Mt. Caryae *read* Mt. Karydi

Line 31: *for* Angelina Comnena *read* Ducaena (Angelina) "Comnena" (also page 261, line 31; page 263, line 31)

Page 256 Line 37: *for* William II *read* Gilbert II; *for* Gilbert *read* William

Page 257 Line 7: *for* duke *read* lord (also lines 10 and 27; page 259, line 38)

Page 262 Line 18: *for* Negroponte *read* Euboea

Page 267 Line 16: *for* who was *read* whose mother was

Page 271 Line 25: *for* Boeotia *read* Thessaly

Lines 26–27: *replace with* entrenched on the banks of the Cephissus, near Halmyros, where, as Raymond Muntaner

Page 377 Footnote, line 21: *for* [1892–1894] *read* [1893–1894]

Page 448 Line 29: *for* "Starkenburg" *read* "Starkenberg"

Page 507 Line 21: *for* Göyük *read* Güyük (also page 615, line 2; page 652, line 31)

Page 543 Line 1: *for* Starkenburg *read* Starkenberg (also page 576, line 7; page 581, line 34)

Page 626 Line 5: *for* Germanus *read* Germanus II

Page 656 Line 25: *for* 1292 *read* 1293

Page 658 Line 9: *for* 1305 *read* 1301

Page 717 Line 13: *for* Ögödai *read* Ögödei (also lines 19 and 24)

Page 719 Line 25: *for* Öljaitu *read* Öljeitu

Page 722 Line 8: *for* Dominican *read* Franciscan; *for* Rubrouck *read* Rubruck

Page 760 Under 1224 autumn: *for* purple *read* purple (1225)

Page 761 Under 1229 (about) *for* 1229 *read* 1228

Page 766 Under Alpheus: *for* K2e3,11 *read* I2e3,11

Page 773 Under Caryae, Mount: *delete* whole entry

Under Cassandrea: *for* Cassandrea *read* Cassandra; *delete* or Potidaea *and* or Potídhaia

Under Cephissus: *for* −I4e2,11 *read* near Halmyros

Page 775 Under Corfu: *for* Corfu (Italian) *read* Corfu; Corfù (Italian)

Page 776 Under Daphne: *for* village–I3e3,11 *read* monastery 5 miles WNW of Athens

Page 780 Under Galilee: *for* L1f3 *read* L1f3,16

Under Geraki: *for* I2e3,11 *read* I3e4,11

Under Geranea: *delete* whole entry

Page 785 Under Kariaí: *delete whole entry* After Kars entry: *insert* Karydi, Mount— hill north of Megara.

Page 789 Under Makryplagi: *delete* Geranea (classical),; *for* I4e2,11 *read* I3e3,11

Page 791 Under Melfi: *for* H1d4,1 *read* H1d5,1

Page 792 Under Montfort: *for* Starkenburg *read* Starkenberg (also page 802, under Starkenburg)

Page 795 Under Pallene: *for* Cassandrea *read* Cassandra

Page 796 Under Potidaea: *delete whole entry*

Page 798 Under Rubrouck: *for* Rubrouck *read* Rubruck

Page 799 Under Saint Hilarion: *for* K4e5, *read* K4e5,20.

Page 801 Under Silesia: *for* Śląsk *read* Śląsk (also page 802, under Śląsk)

Page 802 Under Speyer: *for* Spires *read* Spire

Page 807 Under Volga: *for* (Tartar) *read* (Tatar)

Page 812 Under Achaea, line 11: *for c.* 1229 *read c.* 1228 (also in next line); line 16: *for* 1301–1306 *read* 1301–1306 (1307); line 17: *for* 1306–1313 *read* 1307–1313; column 2, line 1: *for* 1313–1318 *read* 1313–1318 (1321); line 4: *for* Angelina Ducaena *read* Ducaena (Angelina) "Comnena"

Page 813 Under Agnes of Montferrat: *for* Boniface (II) *read* Boniface

Page 814 Under Albertino of Canossa: *for* Thebes *read* Thebes (in 1308)

Page 815 Under Alexius Strategopoulus: *for* caesar *read* caesar (*fl.* 1261)

Under Amédée Pofey: *for* Thessalonica *read* Romania

Page 816 Under Andrew Ghisi: *for* 1259 *read* after 1259

Under Angelus "Comnenus": *change to* Ducas (Angelus) "Comnenus"; line 2: *delete* "Ducas"; line 3: *for* 1204–1214 *read* 1204–1215 *and for* 1214–1230 *read* 1215–1230; line 4: *for* 1236–1271 *read* 1231–c. 1267 *and for* 1271–1296 *read c.* 1267–1296; line 7: *for* 1230–1236 *read* 1230–1237 *and for* 1236–1244 *read* 1237–1244; line 8: *for* 1271–1318 *read c.* 1268–1318; line 9: *for* 1271–1295 *read c.* 1268–1295; line 10: *for* 1303–1318 *read*

1302–1318; line 11: *for* Angelina *read* Ducaena (Angelina)

Under Angevins, line 4: *for* 1268–1285 *read* (1266) 1268–1285

Under Anna Angelina Comnena: *change to* Anna ("Agnes") Ducaena (Angelina) "Comnena"; *for* 1259–1278 *read* 1258– 1278; *for* 1280–1284 *read* 1280–1286

Under Anna Cantacuzena (Palaeologina): *for* (Palaeologina) *read* ("Palaeologina"); *for* 1272–1296 *read* 1265–1296

Page 817 Under Aragon: *for* kings of *read* kings of (Aragon-Catalonia)

Under Archipelago: *for* Sanudos *read* Sanudi (also page 861, under Sanudos)

Page 818 Under Asen: *for* 1186–1196 *read* 1187–1196 (also page 822, under Bulgaria)

Under Athens: *for* (1205–1308) *read* (1204–1308); *for* Angelina Comnena *read* Ducaena (Angelina) "Comnena" (also page 835, under Helena, twice; page 837, under Hugh of Brienne; page 839, under Irene; page 841, under John Asen; page 847, under Manfred; page 852, under Nicholas II of St. Omer; page 870, under William de la Roche and under William II of Villehardouin)

Page 820 Under Barcelona: *for* 580 *read* 580; count of, 21

Page 821 Under Berke Khan: *for* 1256– 1266 *read* 1257–1266 (also page 833, under Golden Horde)

Under Berthold I: *for* 1207–1217? *read* 1211–1217?

Page 822 Under Boniface II: *for* II *read* I (also page 850, under Montferrat); *for* king *read* lord

Under Boniface III: *for* III *read* II (also page 850, under Montferrat)

Under Boniface VIII: *for* Gaetani *read* Caetani

Under Boniface of Verona: *delete* (dalle Carceri); *for* lord *read* triarch of Euboea and lord

Under Bulgaria: *for* king of *read* kings of

Page 823 Under Byzantine emperors, line 14: *for* (1258–1261) *read* (1259–1261) (also page 849, under Michael VIII); line 16: *for* (1295–1320) *read* (1294–1320) (also page 849, under Michael IX)

Page 824 Under Carintana dalle Carceri: *for* cousin *read* sister; *for* 1220–1225:

Page 824, *continued*
read (d. 1255),; *delete whole third line except* 245
Under Caryae, Mount: *delete whole entry*
Under Catalonia: *for* 372 *read* 372; kingdom of, *see* Aragon
Under Catherine of Courtenay: *for* 1285–1308 *read* 1283–1308
Under Charles, son of Philip III of France: *for* Charles *read* Charles of Valois; *for* count of Valois *read* count of Anjou
Under Charles I of Anjou, line 5: *for* 762 *read* 762; king of Albania 1272–1285
Page 825 Under Clement V: *for* de Gouth *read* de Got
Under Conradin: *for* king of Jerusalem *read* king of Sicily 1254–1258, of Jerusalem
Page 826 Under Constance ("Anna"): *for* (after 1244) *read* 1244–1254 (d. 1307)
Under Councils: *for* (1438–1442) *read* (1438–1445) (also page 830, under Ferrara and under Florence
Page 827 Under Dalle Carceri: *replace whole entry with* Dalle Carceri, *see* Carintana, Grapella, Narzotto, *and* Ravano dalle Carceri
Under De la Roches: *for* 1205–1308 *read* 1204–1308; *for* 1205–1225 *read* 1204–1225
Page 828 Under Demetrius: *for* Angelus Comnenus *read* Ducas (Angelus) "Comnenus" (also page 841, under John, and John I, and John II; page 847, under Manuel; page 849, under Michael I–deleting "Ducas"–and Michael II; page 852, under Nicephorus; page 865, under Theodore; and page 866, under Thomas)
Under Demetrius Chomatianus: *for* (in 1224) *read* (from 1217)
Under Demetrius of Montferrat: *for* Boniface II *read* Boniface I; *for* king of Thessalonica *read* lord of Thessalonica 1207–1209, king
Under Dietrich I: *for* 1195–1221 *read* 1197–1221
Under Dominicans: *delete page* 722
After Ducas entry: *insert* Ducas (Angelus) "Comnenus", *see* Angelus "Comnenus"
Page 829 Under Enrico Dandolo: *for* c. 1193–1205 *read* 1192–1205 (also page 868, under Venice)
Under Epirus: *for* 1204–1214 *read* 1204–1215; *for* 1214–1230 *read* 1215–1230;

for 1236–1271 *read* 1231–c. 1267; *for* 1271–1296 *read* c. 1267–1296
Page 830 Under Eustace: *for* forces *read* forces (*fl.* 1209)
Under Eustorgue of Montaigu: *for* c. 1215–1250 *read* 1217–1250
Under Felicia: *delete* (dalle Carceri) (also page 845, under Licario)
Page 831 Under Frederick, son of Frederick I: for 1169–1191 *read* 1167–1191
Under Frederick II: *for* emperor of Germany and Sicily 1211 *read* king of Sicily 1197–1250, emperor of Germany 1212
Page 832 Under Geoffrey I of Villehardouin: *for* 1209–c. 1229 *read* 1209–c. 1228
Under Geoffrey II: *for* c. 1229–1246 *read* c. 1228–1246
Under Germanus: *for* Germanus *read* Germanus II
Under Germany: *for* 1211–1250 *read* 1212–1250
Page 833 Under Gilbert of Verona: *for* (dalle Carceri) *read* II
Under Göyük: *for* Göyük *read* Güyük (also page 850, under Mongols); for Ögödai *read* Ögödei (also page 850, under Mongols; page 853, under Ögödai)
Under Grapella: *for* (dalle Carceri) of Verona, nephew of William I *read* dalle Carceri, son-in-law of William I of Verona; *for* 1255–1264: *read* (d. c. 1264),
Page 834 Under Guy I de la Roche: *for* Thebes, *read* Thebes 1211–1225, great
Under Guy Pallavicini: *for* after 1237 *read* 1237
Page 835 Under Helena, daughter of John Asen: *for* (after 1235), *read* 1235–1237:
Under Henry (Pescatore): *for* Malta *read* Malta (in 1210)
Under Henry VI: *for* emperor of Germany *read* king of Germany 1169–1190, emperor
Under Henry, son of Baldwin V: *for* Henry *read* Henry d'Angre; *for* Latin emperor of Romania 1205–1216 *read* regent of Romania 1205–1206, Latin emperor 1206–1216
Page 836 Under Hermann of Salza: *for* c. 1210–1239 *read* 1209–1239 (also page 865, under Teutonic Knights)
Under Heṭoum I: *for* 1226–1269: *read* 1226–1269 (d. 1270),
Under Heṭoum II: *for* 1289–1292, 1294–

1296, 1299–1305 *read* 1289–1293, 1295–1296, 1299–1301 (also under Heṭoumids)

Under Heṭoumids: *for* 1292–1294 *read* 1293–1295; *for* 1305–1307 *read* 1301–1307 (also page 845, under Leon IV)

Page 837 Under Honorius IV: *for* Jacob *read* James

Under Hugh of Coligny: *for* knight *read* crusader (*fl.* 1204)

Under Hugh of Sully: *for* commander, *read* vicar of Albania 1279–1281:

Page 838 Under Il-khans: *for* Öljaitu *read* Öljeitu (also page 853, under Öljaitu)

Page 839 Under Irene Angelina Comnena: *for* 1240–1241: *read* 1237–1241 (d. after 1246),

Under Isabel (Zabēl): *for* 1295–1310 *read* 1293–1310

Under Isabel (de Ray): *for* Athens *read* Athens (from 1207)

Page 840 Under James I: *for* Aragon *read* Aragon-Catalonia (also page 855, under Peter II and Peter III)

Under James II: *for* Aragon and Sicily *read* Sicily 1285–1296, of Aragon-Catalonia

Under James II of Avesnes: *for* Negroponte 1204–1209 *read* Euboea 1205–1205

Under Jeremiah Ghisi: *for* co-lord of Tenos *read* lord of Scyros

Page 841 Under Joan (of Châtillon): *for* (d. 1354) *read* (d. 1355)

Under John Angelus Comnenus: *for* 1236–1244 *read* 1237–1244

Under John I Angelus Comnenus: *for* duke *read* lord; *for* 1271–1295 (d. 1296) *read c.* 1268–1295

Under John II Angelus Comnenus: *for* duke *read* lord; *for* 1303–1318 *read* 1302–1318

Under John de la Roche: *for* duke *read* great lord

Page 842 Under John of Parma: *for* general *read* general (in 1249)

Under John of Procida: *for* Sicilian leader *read* Italian diplomat (*fl.* 1279)

Under John V Palaeologus: *for* grandson *read* great-grandson

Page 843 After Kars entry: insert Karydi, Mt., battle of (1258), 246

Page 845 Under Latin empire, line 6: *for* 1217–1218 *read* 1217–1217; line 18, *for*

1273–1285 *read* 1273–1283; line 19, *for* 1273–1308 *read* 1283–1308

Under Leo Sgourus: *for* (d. *c.* 1208) *read* (d. 1208)

Under Licario: *after* Vicenza *insert* (*fl.* 1276)

Page 846 Under Mahaut: *for* (d. 1331) *read* (1321, d. 1331)

Page 847 Under Maio Orsini: *for* 1194–1238 *read* 1194–by 1260

Under Manuel Angelus Comnenus: *for* 1230–1236 *read* 1230–1237

Under Marco Gradenigo: *for* (in 1261), *read* 1258–1261:

Page 848 Under Maria: *for* illegitimate *read* (Beloslava), illegitimate; *for* (after 1230), *read* 1225–1237:

Under Maria Comnena, daughter of Manuel I; *for* 1180–1182 *read* 1179–1183 (also page 859, under Renier of Montferrat)

Under Maria Lascaris, daughter of Theodore II; *for* (after 1257), *read* 1256–1258:

Page 849 Under Michael I: *for* despot *read* ruler; *for* 1204–1214 *read* 1204–1215

Under Michael II: *for* despot *read* ruler; *for* 1236–1271 *read* 1231–*c.* 1267

Page 850 Under Montfort: *for* Starkenburg *read* Starkenberg (also page 863, under Starkenburg)

Page 851 Under Muḥammad I: *for* 1249–1277 *read* 1249–1253, caliph 1253–1277

Under Narzotto: *for* Felicia (dalle Carceri) *read* Felicia

Page 852 Under Neopatras: *for* dukes of, *see* Angelus *read* lords of, *see* Ducas (Angelus)

Under Nicephorus Angelus: *for* 1271–1296 *read c.* 1267–1296

Under Nicholas III of St. Omer: *for* Thebes *read* half of Thebes

Page 853 Under Oberto of Biandrate: *for* Oberto *read* Oberto, count; *for* 1207–1209 *read* 1207–1211

Under Orsinis: *for* 1194–1238 *read* 1194–by 1260; *for* 1238–1304 *read* by 1260–1304

Under Othon de Cicon: *for* 1250–1278 *read* 1250–*c.* 1264

Page 854 Under Othon de la Roche: *for* lord *read* great lord; *for* 1250–1225 *read* 1204–1225

Under Otto IV: *for* emperor *read* king; *for* (crowned 1209) *read* –1209, emperor 1209–

Page 855 Under Peter Barbo: *for* (in 1216), *read* 1216–1218:
Under Peter of Courtenay, son of Baldwin II: *for* 1217–1218 *read* 1217–1217
Page 856 Under Philip of Courtenay: *for* 1273–1285 *read* 1273–1283
Under Philip of Savoy: *for* 1301–1306: *read* 1301–1306 (1307),
Under Philip I of Taranto: *for* 1294–1332 *read* 1294–1331; *for* 1306–1313 *read* 1307–1313
Page 857 Under Ptolemy of Lucca: *for* Italian *read* Dominican
Page 858 Under Ravano dalle Carceri: *for* lord of Negroponte *read* triarch of southern Euboea 1205–1209, lord of Euboea
Under Raymond Berengar (I): *for* 1082–1131 *read* 1096–1131
Page 859 Under Renier Zeno: *for* 1252–1268 *read* 1253–1268 (also page 868, under Venice)
Under Richard Orsini: *for* 1238–1304 *read* by 1260–1304
Under Robert II, son of Robert I: *for* 1285–1289 *read* 1284–1289
Page 860 Under Roger de Flor: *for* (d. 1306) *read* (d. 1305)
Under Rubrouck: *for* Rubrouck *read* Rubruck (also page 870, under William of)
Page 863 Under Sicily, line 14: *for* 1212–1250 *read* 1197–1250; *insert* Conradin 1254–1258; line 17, *for* 1291–1327 *read* 1285–1296
Page 865 Under Tenos: *for* lord of *read* lords of; *for* Ghisi *read and* Andrew Ghisi
Under Thamar: *for* 1309: *read* 1309 (d. 1311),
Under Theodore, Orthodox bishop: *for* (c. 1205) *read* (in 1208)
Under Theodore Angelus Comnenus: *for* 1214–1230 *read* 1215–1230; *for* "emperor" at *read* at; *for* 1224–1230 *read* 1224 ("emperor" 1225)–1230
Under Theodore I Lascaris: *for* emperor at *read* emperor (1205) at
Page 866 Under Thessalonica: *for* Angelus *read* Ducas (Angelus); *for* kings of *read* lords of; *for* Boniface (II) *read* Boniface (I); *for* 1209– *read* 1207 (king 1209)–
Under Thomas Aquinas: *for* Italian *read* Dominican
Under Thomas I: *for* 1205–1212 *read* 1205–c. 1211

Under Thomas II: *for* 1212–after 1258 *read c.* 1211–after 1258
Under Timur: *for* 1369–1404 *read* 1369–1405 (also under Timurids)
Under Toros III: *for* 1292–1294 (d. 1296) *read* 1293–1295 (d. 1298)
Page 870 Under William IV: *for* Boniface II *read* Boniface I
Under William de la Roche: *for* 1256–1264? *read* 1259–1264
Under William I of Champlitte: *delete* I; *for* prince *read* prince (I)
Under William of Rubrouck: *for* Dominican *read* Franciscan
Under William I of Verona: *delete* (dalle Carceri) (also under William II)
Under William II of Verona: *for* triarch of central Euboea 1263–1275: *read* (d. 1271),
Under William II of Villehardouin: *delete* II; *for* prince *read* prince (II); *delete* Carintana dalle Carceri,
Page 871 Under Yolanda of Montferrat: *for* Boniface III *read* Boniface II; *for* 1285–1316 *read* 1284–1316

Volume III

Page iv Caption: *for* Pothière *read* Pothières
Page 2 Map 1, Fe: *for* Hammād *read* Ḥammād
Page 19 Line 1: *for* Angelo *read* Angelo Acciajuoli (also page 142, line 9)
Opp. page 26 Map 2, Ge: *for* Cefalú *read* Cefalù
Page 31 Line 6: *for* 1334 *read* 1337
Page 47 At end: *add* believed was an impending attack, Andronicus dispatched to the
Page 107 Line 23: *for* Boeotian *read* Thessalian (also page 108, line 2); line 24: *for* Chaeronea *read* Halmyros
Page 171 Line 4: *for* as *read* not near Thebes, as; line 5: *for* "in a beautiful plain near Thebes." *read* but near Halmyros
Page 172 Note 7: *for* Hanover *read* Hanau
Page 197 Line 12: *for* Falieri *read* Falier
Page 231 Note 12: *first numeral in last line should be* CDXX

Page 276 Note 188: *for* Auxerre *read* Osimo

Page 281 Note 2: *for* Armenia, 1291–1375" [forthcoming] *read* Armenia," *The Cilician Kingdom of Armenia,* ed. T. S. R. Boase (Edinburgh, 1975), pp. 111–138.

Page 289 Note 15: *delete* [forthcoming]

Page 290 Note 16: *for* Zeitschrift für Neogräzistik *read* Byzantinische Forschungen

Page 292 Note 24: *for* 63–71 *read* 235–243

Page 297 Line 26: *for* Racanelli *read* Raccanelli (also page 797, under Racanelli; page 803, under Smyrna)

Page 299 Line 28: *for* twice *read* finally

Page 301 Line 25: *for* Ottobono *read* Ottobuono (also page 752, under Cattaneo)

Page 351 Line 36: *for* 1343 *read* 1346

Opp. page 434 Map 12, Ed: *delete* La Cava

Map 13, Ce: *for* Cacéres *read* Cáceres, *for* Jérez *read* Jerez, *for* Montanchez *read* Montánchez; De: *for* Andujar *read* Andújar, *for* Jucár *read* Júcar; Ed: *for* Peñiscola *read* Peñíscola

Map 14, Ce: *for* Jérez *read* Jerez; De: *for* Cambil *read* Cambíl

Map 15, De: *for* Alora *read* Álora; Ed: *for* Cornellà *read* Cornellá

Opp. page 513 Maps 17 and 18: *insert* Indian Ocean, Norway, *and* Persian Gulf; *insert* Ili on river flowing into lake NE of Tashkent (just above arrowhead in map 18 pointing ENE toward Mongolia)

Opp. page 646 Map 20, G3c1: *for* Tyń *read* Týn

Page 668 Under 1149: *for* Inab *read* 'Inab

Page 681 Under Amwās: *for* Amwās *read* 'Amwās (also page 695, under Emmaus)

Page 682 Under Appollania-Suzusa: *for* Suzusa *read* Sozusa

Page 683 Under Athos, Mount: *for* 3, 4 *read* 3

Page 690 Under Castell dell' Uovo: *for* Castell *read* Castel

Under Cephissus: *for* –I4e2:4 *read* near Halmyros (I3e1:4)

Page 691 Under Chaul: *for* 17, 18, *read* 18 (also page 694, under Diu; page 701, under Hormuz)

Under Chu: *for* –17, 18 *read* west of the Ili (17, 18)

Page 692 Under Conza: *for* 19 miles WSW of Melfi (H1d5:2) *read* –H1d5:2

Page 694 Under Dodecanese: *for* 2, 3 *read* 2

Page 697 Under Fossanova: *delete whole entry*

Under al-Fūrat: *for* al-Fūrat *read* al-Furāt

Page 699 Under Haifa: *for* –L1f3:21 *read* 7 miles SSW of Acre (L1f3:16, 21)

Page 700 After Haliveri entry: *insert* Halmyros (ancient Greek), Almirós (modern Greek): town 26 miles east of Domokos (I3e1:4).

Page 701 Under Ili: *for* Siberia *read* Turkestan

Under Imil: *for* –17, 18 *read* NE of the Ili (17, 18)

Page 704 Under Karelia: *for* not in area mapped *read* –17, 18

Page 706 Under La Cava: *for* town–E1d5:12 *read* castle SE of Nicosia (K4e5:10)

Page 710 Under Malabar: *for* –17, 18 *read* not in area mapped

Page 713 Under Moscow: *for* (17, 18) *read* (18) (also page 714, under Muscovy)

Under Moselle: *for* 1, 2 *read* 1

Page 717 Under Ostmark: *for* nation *read* region

Page 721 Under Rahova: *for* –I4d2:3 *read* 47 miles west of Nicopolis (I5d2:2, 16)

Page 723 Under Sahara: *for* as-Ṣahrā' *read* aṣ-Ṣahrā'

Under Saint Aventin: *for* –E1d3:15 *read* 14 miles north of La Broquière (E1d2:15)

Page 727 , Under Sofia: *for* –I4d3:3 *read* 83 miles SE of Nish (I2d2:2)

Page 728 Under Tabia: *for* –I3e3:4 *read* 9 miles NE of Karytaina (I3e3:4)

Page 729 Under Tekke: *for* 2, 16, 21 *read* 2, 16

Page 732 Under Via Egnatia: *for* 3, 4 *read* 4

Page 734 After Wesel entry: *insert* Weser (German): river–F4b2:2.

Under Wettin: *for* –G2b4:20 *read* 10 miles NW of Halle (G264:20)

Page 736 Under 'Abd-al-'Azīz, al-Manṣūr: *for* Mamluk *read* Burjī Mamluk (also page 738, under Aḥmad [twice]; page 746, under Barkuk and Barsbey; page 760, under Faraj; page 771, under Inal; page 772, under Jakmak; page 773, under Janbalat; page 776, under Ka'itbey, Kansuh

Page 736, *continued*
[thrice], Khairbek, and Khushkadam;
page 786, under Muḥammad [twice]; page
802, under Shaikh; page 805, under Tatar;
page 806, under Timurbogha; page 807,
under Tumanbey I and II; page 808, under
'Uthmān; and page 811, under Yelbey and
Yūsuf)

Page 737 Under Achaea, principality: *for*
1301–1306 *read* 1301–1306 (1307); *for*
1313–1321 *read* 1313–1318 (1321); *for*
1386–*c.* 1395 *read* 1387–*c.* 1395

Under Adam of Usk: *for* English *read*
Welsh

Page 738 Under Adorno: *for* 1384–1390
read 1384/1396 (also page 763, under
Genoa)

Under Aegina: *for* Antonello, *and* Alioto
II *read* Alioto II, *and* Antonello

Under Aeneas Sylvius: *for* Piccolomini
read (Eneo Silvio Piccolomini)

Page 740 Under Alfonso II: *for* Aragon
read Aragon-Catalonia (also under Alfonso
IV and V; page 742, under Aragon, king-
dom; page 745, under Barcelona, county;
page 761, under Ferdinand I and II; page
772, under James I and II; page 774, un-
der John I; page 783, under Martin I; page
793, under Peter II, III, and IV; and page
797, under Raymond Berenguer IV)

Page 741 Under Amadeo VIII: *for* 1416–
1434 *read* 1416–1440 (also page 801, un-
der Savoy)

Under 'Āmir: *indent 2nd and 3rd lines*

Under Andronicus III: *for pages* 48–51
read 47–51; *for* (d. *c.* 1360) *read* (d. *c.*
1365)

Under Andronicus IV: *for* 1376–1379:
read 1376–1379 (d. 1385),

Under Andros: *add* ; lord of, *see* P. Zeno

Page 742 Under Angelo: *for* Angelo *read*
Acciajuoli, Angelo

Under Angevins, line 13: *for* Joanna I *read*
Joanna

After Ankara entry: *insert* Anna Cantacu-
zena ("Palaeologina"), niece of Michael
VIII; despoina of Epirus (after 1296), 176

Under Anna of Savoy: *for* (d. *c.* 1360)
read (d. *c.* 1365)

Under Aquinas: *for* Italian *read* Domini-
can

Page 743 Under Archipelago: *for* Sanudo
read Sanudi

Page 744 Under Athens, duchy: line 25,

for 1205–1225 *read* 1204–1225; line 30,
insert Martin (I of Sicily) 1391–1402;

Page 746 Under Bartholomew (Carbone de
Papazurri): *for* de Papazurri *read* de' Pa-
pazzurri; *for* 1363–*c.* 1364 *read* 1363–
1365

Page 747 Under Bertrandon of La Bro-
quière: *insert* frontispiece,

Page 748 Under Boniface VIII: *for* (Gene-
dict Gaetani) *read* (Benedict Caetani)

Page 750 Under Campofregoso: *for* 1370–
1378 *read* 1371–1378 (also page 763, un-
der Genoa)

After Cantabria entry: *insert* Cantacuzena,
Anna, *see* Anna Cantacuzena

Page 751 Under Cardinals: *for* 1439–1462
read 1439–1463

Under Carthusians: *for* 126 *read* 126, *and*
see Certosa

Under Castell dell' Uovo: *for* Castell *read*
Castel

Page 752 Under Catalonia: *insert* kingdom
of, *see* Aragon-Catalonia

Under Certosa: *for* mausoleum *read* Car-
thusian monastery

Page 753 Under Chalcocondylas, Laonicus:
for (d. *c.* 1464) *read* (d. *c.* 1490)

Under Charles I of Anjou: *insert* king of
Albania 1272–1285,

Page 754 Under Conominas: *for* Greek
read Catalan

Page 755 Under Constantine de Mauro: *for*
(-Nicholas) *read* (-Nichola) (also page 783,
under Mauro)

Under Constantinople: *for* 1275–1282
read 1275/1282; *for* 1445–1450 *read*
1443–1450 (1451); *for* 1454–1456 *read*
1454/1465

Under Conza: *add* ; archbishop of, *see*
Philip

Page 758 Under Dominicans: *insert* T.
Aquinas,

Under Ducas . . . John II: *for* 1303–1318
read 1302–1318 (also page 805, under
Thessaly)

Under Ducas . . . Thomas: *for c.* 1290–
1318 *read* 1296–1318 (also page 759, un-
der Epirus)

Under Durazzo, duchy: *for* Joanna, *read*
Joanna, Ladislas,

Page 759 Under English: *delete* Adam of
Usk,

Under Ephesus: *for* emir *read* emirs; *for*
'Isâ *read* 'Isâ, Khiḍr

Under Epirus, line 2: *insert* despoina of, *see* Anna Cantacuzena;

Page 760 Under Fadrique, Alfonso: *for* Aragon *read* Sicily

Under Falieri: *for* Falieri *read* Falier (also page 808, under Venice)

Page 761 Under Flanders: *for* count of *read* counts of; *insert* Philip II (of Burgundy) 1384–1404

Under Foscari, Paul: *for* 1375–*c.* 1395 *read* 1375–1387; *for* 1386–*c.* 1395 *read* 1387–*c.* 1395

Under Franciscans: *insert* A. Ballester, *and* Francis (of Neopatras),

Under Frederick II, column 2, line 1: *for* 1198)–1212 *read* 1198)–1250

Page 763 Under Gattilusi: *for* Lesbos, *read* Lesbos 1355–1462:

Page 765 Under Gregoras: *for* 1359 *read* 1360

Under Gregory XII: *for* Corraro *read* Correr

Under Gregory III Mammas: *for* 1445–1450 (d. 1459) *read* 1443–1450 (1451, d. 1459)

Page 766 Under Guy "de Lusignan," son of Hugh IV: *for* 1343 *read* 1346

Page 767 Under Helena, mother: *for* Byzantine *read* Roman

Under Henry of Bar: *for* (in 1395) *read* (d. 1397)

Page 769 Under Hospitallers, line 19: *insert (among priors)* Ferlino of Airasca,

Under Hugh IV, duke of Burgundy: *for* Hugh, IV *read* Hugh IV

Page 773 Under James of Lucerne: *for* (in 1366), *read* 1366–1367:

Under Joan of Châtillon: *for* Walter *read* Gaucher

Page 774 Under John XI Beccus: *for* 1275–1282 *read* 1275–1279, 1279–1282; *for* (d. 1288 or 1297) *read* d. 1296

Page 775 Under John de Noyer: *for* 1307–1326: *read* (d. 1326),

Under John of Biandrate: *for* prior *read* prior of Lombardy

Under John of Nevers: *for* John *read* John ("the Fearless")

Under John of Randazzo: *for* Frederick II *read* Frederick II of Sicily

Under John of Vienne: *for* (in 1395) *read* (d. 1396)

Page 776 Under Khiḍr: *for* emir of *read* emir of Ephesus (to 1348), of

Page 777 Under Koran: *insert* frontispiece, Under Ladislas, son of Charles III: *for* Ladislas *read* Ladislas of Durazzo

Page 778 Under Lazarus: *for* (1341– *read* (before 1341–

Page 779 Under Lombardy: *for* priors of *read* Hospitaller priors of

Under Louis I, son of Charles V: *for* duke of Orleans *read* duke of Touraine 1386–1391, of Orleans

Under Louis, son of Amadeo VIII: *for* 1434–1465 *read* 1440–1465 (also page 801, under Savoy)

Page 780 Under Louis I of Clermont: *for* 1327–1341 *read* 1327–1342

Under Louis II of Clermont: *for* (d. 1410), *read* 1356–1410:

Page 781 Under Machaeras: *for* (*c.* 1487) *read* (*fl.* 1426)

Under Mahaut of Hainault: *for* 1313–1321 (d. 1331) *read* 1313–1318 (1321, d. 1331)

Page 782 Under Marie of Bourbon: *for* 1328–1343 *read* 1328–1346

Under Marie of Les Baux: *for* (d. 1347), *read* 1332–1347:

Page 783 Under Marquesa: *for* Naupactus *read* Lepanto

Under Martin I: *for* ("the Older") *read* ("the Elder")

Under Martin I ("the Younger"): *for* 1409 *read* 1409, titular duke of Athens 1391–1402

Under Maure, Erard III le: *for* d. 1388 *read* d. 1387?

Page 784 Under Melissenus: *for* (after 1500) *read* (d. 1585)

Under Metochites: *for* archdeacon *read* Orthodox archdeacon

Under Michieli: *for* Michieli *read* Michiel (also page 788, under Negroponte)

Under Milan: *for* lord of *read* tyrants of; *for* 1378–1385 *read* 1354–1385, J. G. Visconti 1385–1395

Page 785 *Move* Mohammed *entry to follow* Mohács *entry*

Page 788 Under Negroponte: *for* Zeno *read* Zeno (2)

Page 790 Under Orsini, Richard: *for* 1238–1304 *read* by 1260–1304

Under Ostia: *for* cardinal-bishop of *read* and Velletri, cardinal-bishops of

Under Othon de la Roche: *for* 1205–1225 *read* 1204–1225

Page 791 *Move* Ourique *entry to follow* Ottoman *entry*

Under Palaeologina, Maria: *for* (d. after 1308) *read* (d. 1308)

Page 792 Under Patras: *for* Angelo *read* Angelo Acciajuoli

Under Paul of Smyrna: *for* of Smyrna *read* ,Latin archbishop of Smyrna 1345–1357; *for* 1366–c. 1370 *read* 1366–1370

Under Pavia: *insert before tyrant* bishop of, *see* I. Tacconi; count of, *see* P. M. Visconti 1402–1412;

Page 793 Under Peter dalle Carceri: *for* (to 1328), *read* 1318–1328:

Page 794 Under Peter Thomas: *insert* bishop of Coron 1359–1363,

Under Philip, bishop of Salona: *for* (d. 1356), *read* of Conza 1351–1356:

Under Philip II ("the Bold"): *for* 1404 *read* 1404, count of Flanders 1384–1404

Under Philip III ("the Good"): *insert* frontispiece,

Under Philip of Bar: *insert* brother of Henry; *for* (in 1395) *read* (d. 1396)

Under Philip of Savoy: *for* 1301–1306 *read* 1301–1306 (1307)

Page 795 Under Pius II: *for* Sylvius *read* Sylvius, or Eneo Silvio

Page 796 Under Pothières: *insert* frontispiece,

Page 798 Under Rocafort: *for* Bernat *read* Bernard

Under Roger, archbishop of Patras: *for* by 1347 *read* 1347

Page 801 Under Sanudo, Marino: *for* (d. c. 1334) *read* (d. 1337)

Under Schiltberger: *for* traveler *read* crusader

Under Scholarius: *for* –1456 *read* –1456, 1462–1463, 1464–1465

Page 802 Under Sicily: *for* 1197–1212 (1250) *read* 1197–1250

Page 803 Under Simon Atumano: *insert* bishop of Gerace 1348–1366,

Under Smyrna: *for* 1327–1344 *read* 1328–1344; *for* 313, *and see* Paul *read* 313; *insert* archbishop of, *see* Paul; *insert* (among captains) O. Cattaneo,

Under Stephen, archbishop of Thebes: *for* 1311–by 1326 *read* 1312–by 1326

Page 804 Under Tacconi: *for* titular *read* bishop of Pavia and titular; *for* 1311–1342 *read* 1311–1319

Page 805 Under Thamar: *for* (div.) *read* (div., d. 1311)

Page 806 Under Toulouse: *for* priors of *read* Hospitaller priors of

Page 807 Under Umur: *for* (d. 1348), *read* 1334–1348:

Page 808 Under Velletri: *for* cardinal-bishop of *read* cardinal-bishops of

Page 809 Under Vienne: *for* council of *read* council of (1312)

Under Visconti, Bernabò: *for* lord *read* tyrant; *for* 1378–1385 *read* 1354–1385

Under Visconti, John: *for* 1376–1390 *read* 1378–1402, of Milan 1385–1395

Under Visconti, Philip: *for* duke *read* count of Pavia 1402–1412, duke

Page 810 Under Walter I (V): *for* I (V) *read* V; *for* duke *read* duke (I)

Under Walter II (VI): *for* II (VI) *read* VI; *for* duke *read* duke (II)

Under Walter III (VII): *for* III (VII) *read* VII

Page 811 Under William of Trémolay: *for* French crusader *read* marshal of Burgundy

Under William (II) of Villehardouin: *delete* (II); *for* prince *read* prince (II)

Under Wittelsbach: *add* ; *see also* emperor Louis IV

Page 812 Under Zeno, Peter, Venetian admiral: *for* admiral *read* bailie at Negroponte 1331–1333

Under Zeno, Peter, Venetian envoy: *for* Venetian envoy (in 1403), *read* lord of Andros 1384–1427:

Volume IV

Map 3 Gc: move dot for Milan east, to the north of Pavia, as on map 2

Map 4 *For* Aqsa mosque *read* Aqṣâ mosque

Map 5 L1f1: *for* al-Batrūn (Botron) *read* Botron

L1f4: enlarge the designation JUDEA and spread out in the style of SAMARIA above

Map 10 I4e2: *for* Mouki *read* Moulki

Page 367 Under Fossanova: *for* Fossanova (Italian) *read* Fossanova; Fossanuova (Italian)